\$2995

H83 2006

ALSO BY ROBERT HUGHES

Things I Didn't Know
A Jerk on One End
American Visions
The Culture of Complaint
Lucian Freud
Frank Auerbach
Barcelona
Nothing If Not Critical
The Fatal Shore
The Shock of the New
Heaven and Hell in Western Art

GOYA

Colorad Christian University Library 8787 W. Alameda Ave. Lakewood, Colorado 80226

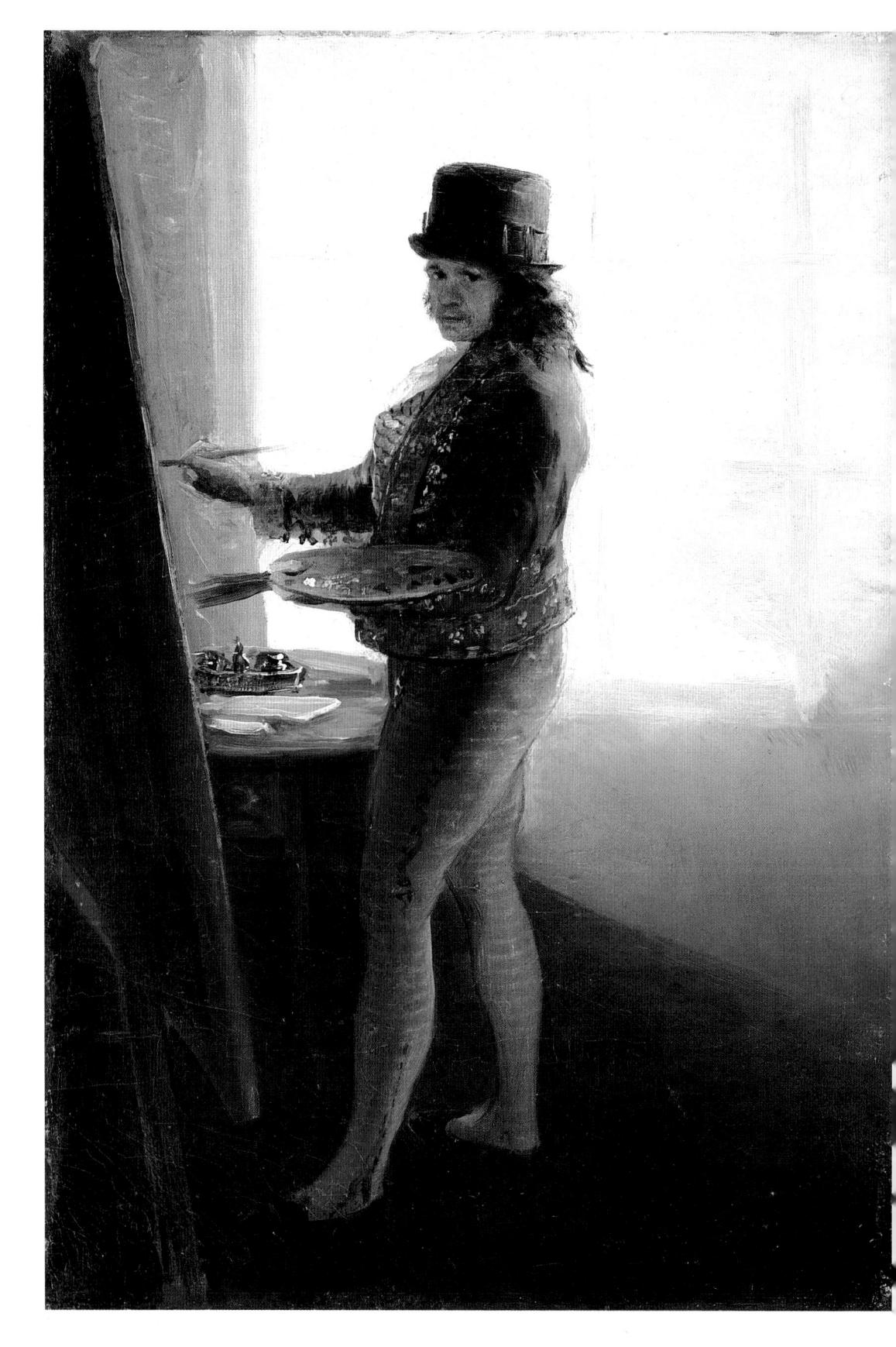

ROBERT HUGHES

ALFRED A. KNOPF · NEW YORK · 2006

THIS IS A BORZOI BOOK PUBLISHED BY ALFRED A. KNOPF

Copyright © 2003 by Robert Hughes All rights reserved. Published in the United States by Alfred A. Knopf, a division of Random House, Inc., New York, and in Canada by Random House of Canada Limited, Toronto.

www.aaknopf.com

Knopf, Borzoi Books, and the colophon are registered trademarks of Random House, Inc.

Library of Congress Cataloging-in-Publication Data Hughes, Robert [date] Goya / Robert Hughes. p. cm.

Includes bibliographical references and index.
ISBN 0-375-71128-7

1. Goya, Francisco, 1746–1828. 2. Goya, Francisco, 1746–1828— Criticism and interpretation. 3. Artists—Spain—Biography. 1. Title.

> N7113.G63H83 2003 760'.092—dc21

[B]

2002043281

Manufactured in China Published November 12, 2003 First Paperback Edition, November 7, 2006

Frontispiece:

Goya, *Self-portrait in the Studio*, 1794–95. Oil on canvas, 42 x 28 cm. Museo de la Real Academia de Bellas Artes de San Fernando, Madrid.

For Doris

with all my love

CONTENTS

	Acknowledgments	ix
I	Driving into Goya	3
2	Goya's Beginnings	13
3	Coming to the City	46
4	From Tapestry to Silence	83
5	Witches and Angels	144
6	The Caprichos	178
7	The Fall of the Bourbons	217
8	War with Napoleon	262
9	The Restoration	321
0	Exile in France	367
	Notes	405
	Bibliography	411
	Index	415

ACKNOWLEDGMENTS

The person to whom I owe most in writing this book is Doris Downes, who gave me the strength to do it after a near-fatal car crash on a desert highway in Western Australia in 1999. I will always be grateful for her strength, her immense love, and her faith that I could take on this subject at a time when much of my world seemed to be disintegrating and my body along with it. This book is dedicated to her and to her sons, my new stepsons, Garrett and Fielder.

The affection of Fielder and Garrett Jewett did much to console me for the loss of my own son, Danton Hughes, a loss beyond tears, and to make me realize that life does, indeed, go irrepressibly on. Danton yearned to be an artist, but died too young. May death grant him a peace which life did not.

Since May 1999, I have had a dozen operations on my broken bones and an aggregate of six months of hospitalization in Perth, Sydney, and New York. This is not the place to write about the Australian press, the Australian legal system, or the cultural insecurities that beset some quarters of my former homeland (except to say that West Australian justice is to justice what West Australian culture is to culture). Instead I would prefer to thank those who helped me: friends, relatives, and doctors. Chief in the former two categories, apart from Doris, who is sui generis, are Malcolm Turnbull and his wife, my niece Lucy Hughes-Turnbull, who went to enormous and sacrificial trouble to stay in Perth and hold my hand for the five weeks I was in the intensive-care unit of Royal Perth Hospital, incapable of speech; who then chartered an air ambulance to fly me to Sydney; and who, after my eventual discharge some months later from St. Vincent's Hospital, allowed me to stay in their house for two months more. At the time, Malcolm was heading up the campaign to turn Australia into a republic, and Lucy was becoming the deputy mayor of Sydney. Only those who have seen The Man Who Came to Dinner can form the slightest impression of their suf-

x · Acknowledgments

ferings. For many reasons, Uncle Wu swears never to do any such thing to them again.

Friends (chiefly Cathy Lumby, Bill Leak, Colin and Kay Lanceley, and John Alexander) provided much sympathy, hope, and good cheer. Of inestimable importance to me were, of course, those who treated me and, at the outset, saved my life. Jimmy Fishhook from the Bidyadanga Settlement found the wreck on the road with me in it. My friend Danny O'Sullivan, in whose boat I had been fishing that day, came to the spot at once and comforted me in my semiconscious delirium. I was and always will be deeply grateful to the Volunteer Fire Department of Broome, W.A., who got me out of the wreck after hours of patient and compassionate effort.

In Broome Hospital, I was taken care of by its chief executive, Dr. Jeff Moffett, Dr. Barbara Jarad, Dr. Bruno Petroni, and Ms. Donna Cox. In Royal Perth Hospital, the person in charge of my case was the chief executive, Dr. Peter Harrigan. The surgeons of Royal Perth did exacting microsurgical work restoring the mobility of my left hand. In St. Vincent's Hospital in Sydney, I was lucky enough to come under the care of that distinguished orthopod, Dr. Michael Neil, who operated several times on my right tibia, fibula, anklebone, knee and femur, along with my right elbow, which had been crushed to a mosaic. Finally, in New York, thanks to the intervention of my dear and old friend Peter Duchin, I made the acquaintance of Dr. David Helfet, chief orthopedist at the New York Hospital for Special Surgery. A surgical genius and regarded as such by all who have come under his care, Dr. Helfet operated on me half a dozen times, with the result that three and a half years after the accident I am almost back on my feet. My gratitude to him has no limits. Without all of these people and the multitude of nurses (especially Alison Gill of the New York Hospital for Special Surgery) who looked after me, this book could never possibly have been written. Nor could it have been done without the particular generosity of the New York Public Library in letting me use the Allen Room.

In a way—one which I would have been more than happy to have avoided—the same could be said about the car crash itself. Perhaps, if life is fully experienced, there is no waste. It was through the accident that I came to know extreme pain, fear, and despair; and it may be that the writer who does not know fear, despair, and pain cannot fully know Goya.

ALSO BY ROBERT HUGHES

Heaven and Hell in Western Art
The Shock of the New
The Fatal Shore
Nothing If Not Critical
Barcelona
Frank Auerbach
Lucian Freud
The Culture of Complaint
American Visions
A Jerk on One End

GOYA

DRIVING INTO GOYA

THAD BEEN THINKING about Goya and looking at his works for a long time, off and on, before the triggering event that cleared me to write this book. I knew some of his etchings when I was a high-school student in Australia, and one of them became the first work of art I ever bought—in those far-off days before I realized that critics who collect art venture onto ethically dubious ground. My purchase was a poor second state of Capricho 43, El sueño de la razón produce monstruos ("The sleep of reason brings forth monsters"), that ineffably moving image of the intellectual beset with doubts and night terrors, slumped on his desk with owls gyring around his poor perplexed head like the flying foxes that I knew so well from my childhood. The dealer wanted ten pounds and I got it for eight, making up the last quid with coins, including four sixpenny bits. It was the first etching I had ever owned, but by no means the first I had seen. My family had a few etchings. They were kept in the pantry, face to the wall, icons of mild indecency—risqué in their time—in exile. My grandfather, I suppose, had bought them, but they had offended my father's prudishness. They were the work of an artist vastly famous in Australia and wholly unknown outside it, a furiously energetic, charismatic, and mediocre old polymath called Norman Lindsay, who believed he was Picasso's main rival and whose bizarre mockoco nudes—somewhere between Aubrey Beardsley and Antoine Watteau, without the pictorial merits of either and swollen with cellulite transplanted from Rubens—were part of every Australian lawyer's or pubkeeper's private imaginative life.

That was what my adolescent self fancied etchings were about: titillation. Popular culture and dim sexual jokes ("Come up and see my etchings") said so. Whatever was on Goya's mind, though, it wasn't that. And as I got to know him a little better, through reproductions in books—nobody was exhibiting real Goyas in Australia all those decades ago; glimpsing El sueño de la razón was a fluke—I realized to my astonishment what extremity of the tragic sense the man could put onto little sheets of paper. Por que fue sensible, the woman despairing in the darkness of her cell, guilty and always alone, awaiting the death with which the State would avenge the murder of her husband. ¡Que se la llevaron! ("They carried her off!"): the young woman carried off by thugs, one possibly a priest, her little shoes sticking incongruously up as the abductors bend silently to their work. Tántalo ("Tantalus"): an oldish man, hands clasped, rocking to and fro beside the knife-edge of a pyramid in a despair too deep for words, and, across his knees, the corpse-rigid form of a beautiful and much younger woman whose passion cannot be aroused by his impotence. I could not imagine feeling like this man—being fourteen, a virgin, and full of bottled-up testosterone, I didn't even realize that impotence could happen but Gova made me feel it. How could anyone do so? What hunger was it that I didn't know about but he did?

And then there was the Church, dominant anxiety of Goya's life and of mine. Nobody I knew about in Australia in the early 1950s would have presumed to criticize the One, Holy, Roman and Apostolic Church with the ferocity and zeal that Goya brought to the task at the end of the eighteenth century. In my boyhood all Catholicism was right-wing, conservative, and hysterically subservient to that most white-handedly authoritarian of recent popes, Pius XII, with his foolish cult of the Virgin of Fatima and the Assumption. In Goya's time the obsession with papal authority, and the concomitant power of the Church, was even greater, and to openly criticize either in Spain was not devoid of risk. I remember how my Jesuit teachers (very savvy men) used to say "We don't try to justify the Inquisition anymore, we just ask you to see it in its historical context"—as though the dreadful barbarity of one set of customs excused, or at least softened, the horrors of another; as though hanging and quartering people for secular reasons somehow made comprehensible the act of burning an old woman at the stake in Seville because her neighbors had testified to Inquisitors from the Holy Office that she had squatted down, cackling, and laid eggs with cabbalistic designs on them. It seemed to us schoolboys back in the fifties that, however bad and harshly enforced they were, the terrors of Torquemada and the Holy Office could hardly have compared with those of the Gulag and the

Red brainwashers in Korea. But they looked awful all the same, and they inserted one more lever into the crack that would eventually rive my Catholic faith. So it may be said that Goya—in his relentless (though, as we shall see, already somewhat outdated) attacks on the Inquisition, the greed and laziness of monks, and the exploitive nature of the monastic life—had a spiritual effect on me, and was the only artist ever to do so in terms of formal religion. He helped turn me into an ex-Catholic, an essential step in my growth and education (and in such spiritual enlightenment as I may tentatively claim), and I have always been grateful for that. The thought that, among the scores of artists of some real importance in Europe in the late eighteenth century, there was at least one man who could paint with such realism and skepticism, enduring for his pains an expatriation that turned into final exile, was confirming.

Artists are rarely moral heroes and should not be expected to be, any more than plumbers or dog breeders are. Goya, being neither madman nor masochist, had no taste for martyrdom. But he sometimes was heroic, particularly in his conflicted relations with the last Bourbon monarch he served, the odious and arbitrarily cruel Fernando VII. His work asserted that men and women should be free from tyranny and superstition; that torture, rape, despoliation, and massacre, those perennial props of power in both the civil and the religious arena, were intolerable; and that those who condoned or employed them were not to be trusted, no matter how seductive the bugle calls and the swearing of allegiance might seem. At fifteen, to find this voice—so finely wrought and yet so raw, public and yet strangely private—speaking to me with such insistence and urgency from a remote time and a country I'd never been to, of whose language I spoke not a word, was no small thing. It had the feeling of a message transmitted with terrible urgency, mouth to ear: this is the truth, you must know this, I have been through it. Or, as Goya scratched at the bottom of his copperplates in Los desastres de la guerra: "Yo lo vi," "I saw it." "It" was unbelievably strange, but the "yo" made it believable.

A European might not have reacted to Goya's portrayal of war in quite this way; these scenes of atrocity and misery would have been more familiar, closer to lived experience. War was part of the common fate of so many English, French, German, Italian, and Balkan teenagers, not just a picture in a frame. The crushed house, the dismembered body, the woman howling in her unappeasable grief over the corpse of her baby, the banal whiskered form of the rapist in a uniform suddenly looming in the doorway, the priest (or rabbi) spitted like a pig on a pike. These were things that happened in Europe, never to us, and our press did not print photographs of them. We Australian boys whose

childhood lay in the 1940s had no permanent atrocity exhibition, no film of reallife terror running in our heads. Like our American counterparts we had no experience of bombing, strafing, gas, enemy invasion, or occupation. In fact, we Australians were far more innocent of such things, because we had nothing in our history comparable to the fratricidal slaughters of the American Civil War, which by then lay outside the experience of living Americans but decidedly not outside their collective memory. Except for one Japanese air strike against the remote northern city of Darwin, a place where few Australians had ever been, our mainland was as virginal as that of North America. And so the mighty cycle of Goya's war etchings, scarcely known in the country of my childhood, came from a place so unfamiliar and obscure, so unrelated to life as it was lived in that peculiar womb of nonhistory below the equator, that it demanded special scrutiny. Not Beethoven's Muss es sein—"Must it be so? It must be so"—written at the head of the last movement of his F Major String Quartet in 1826. Rather, "Can it be so? It can be so!"—a prolonged gasp of recognition at the sheer, blood-soaked awfulness of the world. Before Goya, no artist had taken on such subject matter at such depth. Battles had been formal affairs, with idealized heroes hacking at one another but dying noble and even graceful deaths: Sarpedon's corpse carried away from Troy to the broad and fertile fields of an afterlife in Lycia by Hypnos and Thanatos, Sleep and Death. Or British General Wolfe expiring instructively on the heights of Quebec, setting a standard of nobly sacrificial death etiquette for his officers and even for an Indian. Not the mindless and terrible slaughter that, Gova wanted us all to know, is the reality of war, ancient or modern.

What person whose life is involved with the visual arts, as mine has been for some forty-five years, has not thought about Goya? In the nineteenth century (as in any other) there are certain artists whose achievement is critical to an assessment of our own perhaps less urgent doings. Not to know them is to be illiterate, and we cannot exceed their perceptions. They give their times a face, or rather a thousand faces. Their experience watches ours, and can outflank it with the intensity of its feeling. A writer on music who had not thought about Beethoven, or a literary critic who had never read the novels of Charles Dickens—what would such a person's views be worth, what momentum could they possibly acquire? They would not be worth taking seriously. Goya was one of these seminal artists.

The main reason that I started thinking about Goya with some regularity lay in the peculiar culture whose tail end I encountered when I went to live and work in America in 1970. It had almost been eviscerated of all human depiction. Of course it had plenty of human *presence*, but that was another matter. Here

was America, riven to the point of utter desolation over the most bitterly resented conflict it had embarked on since the Civil War. Vietnam was tearing the country apart, and where was the art that recorded America's anguish? Well, there was art—most of it, with a few honorable exceptions like Leon Golub, of a mediocre sort, the kind of "protest" art more notable for its polemics than its esthetic qualities. But in general there was nothing, absolutely nothing, that came near the achievement of Goya's *Desastres de la guerra*, those heartrending prints in which the artist bore witness to the almost unspeakable facts of death in the Spanish rising against Napoleon, and in doing so became the first modern visual reporter on warfare. Nor did there seem to be any painting (and still less, any sculpture) produced by an American that could have sustained comparison with Goya's painting of the execution of the Spanish patriots on the third of May, 1808. Clearly, there were some things that moral indignation could not do on its own.

What did modernity lack that Goya had? Or was that the wrong question to ask? Was it rather that an age of mass media, our own age, so overloaded with every kind of visual image that all images were in some sense replaceable, a time when few things stood out for long from a prevailing image-fog, had somehow blurred and carried away a part of the memorable distinctness the visual icon once had? Perish the thought. But the thought stuck. It would neither perish nor be resolved. Of course, Goya was an exception. It seems that geniuses (a word that, despite all the pecking and bitching of postmodernist criticism, must survive because there is no other that fits certain cases of human exception) are fated to be. But the fact that at the end of the twentieth century we had (as we still have) no person who could successfully make eloquent and morally urgent art out of human disaster tells us something about the shriveled expectations of what art can do. So how could someone have managed it with such success two centuries earlier? There is no convenient answer, no wrapping in which to package such a mystery, which is nothing less than the mystery of the tragic sense itself. It is not true that calamitous events are bound, or even likely, to excite great tragic images. Nearly sixty years after the bomb bay doors of the Enola Gay opened to release Little Boy, and a new level of human conflict, over Hiroshima, there is still no major work of visual art marking the birth of the nuclear age. No esthetically significant painting or sculpture commemorates Auschwitz. It is most unlikely that a lesser though still socially traumatic event, such as the felling of the World Trade Center in 2001, will stimulate any memorable works of art. What we do remember are the photos, which cannot be exceeded.

Goya was an artist wholeheartedly of this world. He seems to have had no

metaphysical urges. He could do heaven, but it was rather a chore. The angels he painted on the walls of San Antonio de la Florida, in his great mural cycle of 1798, are gorgeous blondes with gauzy wings first, and messengers of heaven's grace only second. They would not carry such grace if they were not desirable. For him, it seems, God chose to manifest himself to humankind by creating the episodically vast pleasures of the world.

Goya was a mighty celebrant of pleasure. You know he loved everything that was sensuous: the smell of an orange or a girl's armpit; the whiff of tobacco and the aftertaste of wine; the twanging rhythms of a street dance; the play of light on taffeta, watered silk, plain cotton; the afterglow expanding in a summer evening's sky or the dull gleam of a shotgun's well-carved walnut butt. You do not need to look far for his images of pleasure; they pervade his work, from the early tapestry designs he did for the Spanish royal family—the *majas* and *majos* picnicking and dancing on the green banks of the Manzanares outside Madrid, the children playing toreadors, the excited crowds—right through to the challenging sexuality of *The Naked Maja*.

But he was also one of the few great describers of physical pain, outrage, insult to the body. At that, he was as good as Matthias Grünewald, the Master of the Isenheim Altarpiece. It is not at all inevitable that an artist is as good at pain as he is at pleasure. An artist can handle one without convincingly suggesting the other, and many have. Hieronymus Bosch, the fifteenth-century Netherlandish mystic whose paintings were so avidly collected by the gloomy Spanish monarch Felipe II and, enshrined in the royal collections, would in due course exercise such influence on the fascinated Goya, was not—despite the title of his most famous painting, The Garden of Earthly Delights—especially good at depicting the marvels of sensuality. His hells are always genuinely frightening and credible, his heavens scarcely believable at all. Exactly the opposite problem arises with his great Baroque antitype, Peter Paul Rubens. Look at a Rubens Crucifixion, that noble and muscular body hammered with degrading iron spikes to the fatal tree, and you hardly feel there is any death in it: its sheer physical prosperity, that abundance of energy, defies and in some sense defeats the very idea of torment. Rubens's damned souls are actors, howling their passion to tatters; one does not feel their pain, except as a sort of theological proposition. The rhetoric overwhelms and displaces the reality (if one can speak of "reality" in such a context). But Goya truly was a realist, one of the first and greatest in European art.

I once had an illusion that I met him. This was after an auto accident in 1999. The impact smashed my body like a toad's; so much of the skeletal structure on

my right side was broken, disjointed, or pulverized that my chances of survival were rated extremely low. The doctors and nurses, at Royal Perth Hospital and later at St. Vincent's in Sydney, labored immensely to pull me through, but it took nearly seven months' hospitalization, more than a dozen operations, more pain than I had imagined possible, and, at the outset, some five weeks in a coma in intensive care. The peculiarity of intensive care is that, while those who do not know about it assume that the patient is unconscious, one's consciousness—though not of one's immediate surroundings, or of people coming and going—is strangely affected by the drugs, the intubation, the fierce and continuous lights, and one's own immobility. These give rise to prolonged narrative dreams, or hallucinations, or nightmares. They are far heavier and more enclosing than ordinary sleep-dreams and have the awful character of inescapability; there is nothing outside them, and time is wholly lost in their maze. Much of the time, I dreamed about Gova. He was not the real artist, of course, but a projection of my fears. The book I meant to write on him had hit the wall; I had been blocked for years before the accident.

In my dream narrative he was young and something of a street tough—a majo, dressed, I later realized, in the bullfighter's jacket of his 1794-95 selfportrait (frontispiece). He had a gang of friends around him, scornful fellow majos, and they all judged me to be a ridiculous intruder, so far out of his depth as to be a clown. Our encounter took place in the gloomy, cavernous cells of a lunatic asylum or plague hospital—another location familiar from Goya's paintings. But these rooms, with their dim light and reverberant echoes, were also an airport: the airport, for some unfathomable reason, of Sevilla. (Sevilla plays little part in Goya's life; he never lived or worked there, although he did a large painting of its patron saints Justa and Rufina for its cathedral.) My one desire, seemingly my single hope, was to get out of there and somehow drag myself onto an Iberia domestic jet that would carry me away from this awful place, where I had no business to be. The stones were old, but the furniture was oppressively cheap and new: Formica tables, weird mazes of slippery plastic curtains, electronic security scanning gates. Goya delighted in making me walk, or rather hobble or crawl, through the scanners, which emitted repeated squeals and buzzes of alarm. Then he and his friends would turn me around and make me go back, cackling with laughter at the efforts of this inglés asqueroso (disgusting Englishman) to do the impossible and free himself. It was impossible because they had attached a bizarre metal framework to my right leg, which prevented me from getting through a door or crawling through one of the tempting gaps in the outer walls of the prison-airport. The framework had the

crude heaviness of eighteenth-century rural ironwork, but it was made of highly polished stainless steel and another metal, which I surmised to be titanium. This, at least, had some correspondence with reality. The doctors at Royal Perth had fitted to my right leg, whose tibia, fibula, knee joint, and femur had been all but pulverized by the collision, a therapeutic device called an Isikoff brace. The limb was encircled by rigid plastic rings from which sharp spikes protruded inwards; these were screwed through the flesh into the broken pieces of bone, holding them in a spatially correct anatomical relation to one another so that they could begin the slow process of knitting together. I would have to wear this prosthesis for months. In my dream, or hallucination, it became the contraption for restraint and torment that Goya had applied to me.

One does not need to be Dr. Freud to recognize the meaning of this bizarre and obsessive vision. I had hoped to "capture" Goya in writing, and he instead imprisoned me. My ignorant enthusiasm had dragged me into a trap from which there was no evident escape. Not only could I not do the job; my subject knew it and found my inability hysterically funny. There was only one way out of this humiliating bind, and that was to crash through. Or so it seemed. Through all the pain and psychic confusion, Goya had assumed such importance in my subjective life that whether I could do him justice in writing or not, I couldn't give up on him. It was like overcoming writer's block by blowing up the building in whose corridor it had occurred.

Why did he seem so urgent? I couldn't imagine hallucinating in that way about Delacroix or Ingres, whose work I also adore. But many people, myself included, think of Goya as part of our own time, almost as much our contemporary as the equally dead Picasso: a "modern artist." Goya seems a true hinge figure, the last of what was going and the first of what was to come: the last Old Master and the first Modernist. Now, it's true that in a strictly existential sense this is an illusion. No person "belongs" to any time other than his own. There are modernist elements in other artists too; it's just that in Goya they are more vivid, more pronounced than in his contemporaries. There is nothing "modern" about Anton Raphael Mengs, the top dog of painting at the court of Carlos III in Madrid. One could hardly make a case for the modernity of that wonderfully inventive and sprightly painter Giambattista Tiepolo, who just preceded Goya at the Spanish court. But the kind of modernism I mean is not a matter of inventiveness. It has to do with a questioning, irreverent attitude to life; with a persistent skepticism that sees through the official structures of society and does not pay reflexive homage to authority, whether that of church, monarch, or aristocrat; that tends, above all, to take little for granted, and to seek a continuously realistic attitude to its themes and subjects: to be, as Lenin would remark in Zurich many years later and in a very different social context, "as radical as reality itself."

You could say, for instance, that Goya was a man of the old world, because he was so clearly fascinated by witchcraft and absorbed by the ancient superstitions that surrounded the Spanish witch cult. These he illustrated again and again, not only in the monumental and fantastically inventive series of satirical prints known as the Caprichos but in a number of his paintings, including the deeply enigmatic Pinturas negras, the Black Paintings, which he made to decorate the walls of his last Spanish home, the Quinta del Sordo, across the river from Madrid. You might say, then, that witchcraft was a continuous presence in Gova's imaginative life. But was it witchcraft itself that so fascinated him—the practice of enchantment, white and black magic acting upon reality, experienced by Gova as a fact of life in the real world—or was it the peculiarity of the social belief in it, distressing a rationalist artist as a vestige of a world that was better off without such superstitions? Affirmation or denunciation? Or (a third possibility) did he view witchcraft as a later Surrealist might, as a strange and exceedingly curious anachronism that bore witness to an unreformable, atavistic, stubborn, and hence marvelous human irrationality?

But he was also one of the new world that was coming, whose great and diffuse project the English called Enlightenment, the French *éclaircissement*, and to which the Spanish attached the name *ilustración*. This was the rationalizing and skeptical current of thought that had flowed across the Pyrenees and down into Spain. Its fountainhead was the writings of the Englishman John Locke. But its immediate influence on Spanish intellectuals came from France: from Montesquieu's *Persian Letters* (1721), from Voltaire, Rousseau, and Denis Diderot's gigantic *Encyclopedia*, that summation of eighteenth-century ideas, which appeared sequentially from 1751 to 1772.

Goya's friends were *ilustrados*, men and women of the Enlightenment. He painted their portraits, and those of their wives, children, mistresses. At the same time he painted people who were very much not *ilustrados*, representatives of the traditional regimes of Church and State, sometimes powerful ones. Goya tended to paint according to commission. There is little sign of ideological or patriotic preference in his choice of subject. Even a partial list of Goya's clients before the defeat of Napoleon in Spain shows a fairly even distribution of political views between conservative Spaniards, Spanish liberal patriots, and French sympathizers. In the first category, those he painted included the duchess d'Abrantès, Juan Agustín Ceán Bermúdez, the conde de Fernán

Núñez, Ignacio Omulryan, and of course Fernando VII. In the second, there were Jovellanos, the actor Isidoro Máiquez, and that fiery defender of Zaragoza, José Palafox. In the third, the priest Juan Antonio Llorente and the conde de Cabarrús—not to mention that fierce ultra and Bonapartist, France's ambassador to Spain, the young Ferdinand Guillemardet.

But on balance he was certainly of the *ilustrado* party, and were there any doubt, it would be dispelled by his graphic works, especially the *Caprichos*. Most of the Spanish artists who were Goya's contemporaries—Agustín Esteve, Joaquín Inza, Antonio Carnicero, and others—left no trace of opinions about society and politics in their work. They were craftsmen; they made their likenesses, did the job expected of them, and that was all. Goya was a very different creature; he could see and experience nothing without forming some opinion about it, and this opinion showed in his work, often in terms of the utmost passion. This, too, was part of his modernity, and another reason why he still seems so close to our reach, though we are separated by so much time.

GOYA'S BEGINNINGS

There years separate the two paintings that, between them, show the scope of the artist's career. Although their subject is the same, their mood and meaning, as well as the way in which they are painted, are utterly different. Yet they were painted by the same man: Francisco Goya y Lucientes. We expect an artist to change in thirty years. But to change so much? To remake himself from top to bottom, into so apparently different an artist, and with such compulsive force? Such a change can happen when youth turns to age, and sometimes art historians call it the coming of a "great, late style." It is radical, but not with the comparatively weak radicalism of youth. Coming as it does after a long life, when there is so little time left, it has a seriousness beyond mere experiment or hypothesis. It says: look at this and look at it hard, because it may be the last you'll hear from me.

In each work he was painting the feast day of San Isidro, the patron saint of Madrid, where Goya lived. Each year it falls on May 15, and it is one of the city's biggest occasions for celebration and jollity. The person it commemorates was, according to legend (or hagiography, to be polite), an eleventh-century laborer who was tilling the soil in the meadows and flats beside the Manzanares, the river that gives Madrid its water, when his hoe struck a "miraculous" fountain in the earth, which thereafter never ceased to flow. Gradually, it became a place of pilgrimage; those who went there sometimes found that their diseases and infirmities were cured by drinking the water from San Isidro's well. In the sixteenth century a hermitage was built on the spot by Empress Isabel after her Hapsburg husband Charles V (Carlos I of Spain) and their son Felipe drank the

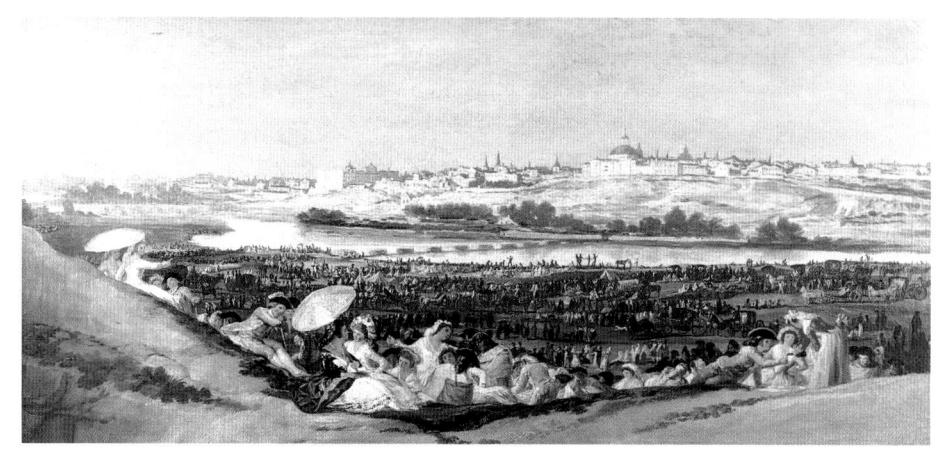

Goya, *La pradera de San Isidro (St. Isidro's Meadow)*, 1788. Oil on canvas, 44 x 94 cm. Museo Nacional del Prado, Madrid.

water and were cured of their illnesses. The hermitage became a church, which, expanded and remodeled in a neoclassical style in the early eighteenth century, still stands today, looking back across the Manzanares to the city. By the time Goya was born, in 1746, so many *madrileños* crossed the Segovia bridge each May 15 and converged on the slopes and meadows below the church of San Isidro that the spot had become a combination fairground, picnic ground, and religious gathering place.

They would come in their spring finery, the men in tricornes, breeches, and stockings, the women as delicate as butterflies with their parasols to ward off the sunshine, their carriages and barouches well furnished with picnic hampers; bowing and chatting to one another, passing compliments, and each swallowing a pious draft of holy water from the well.

This was the scene painted by Goya in 1788 in a brisk oil sketch almost small enough to have been done on the spot, *en plein air*; though it was almost certainly made in his studio from memory and pencil scribbles. Goya was then a man of forty, a late starter, his career scarcely even begun. Forty was not youngish for the time, but it was for Goya, who would defy all actuarial probabilities of the day by living to the age of eighty-two. His picture is happy and festive. The people in it are those he wants to be among, those, you might feel, that he wants to be: the young man in the foreground, for instance, leaning forward on his cane, gazing with happy absorption at the bouquet of women under the elliptical saucer of the white parasol. Goya would like to be their friend, their social equal, their sexual partner. He would like to know the girl in the red

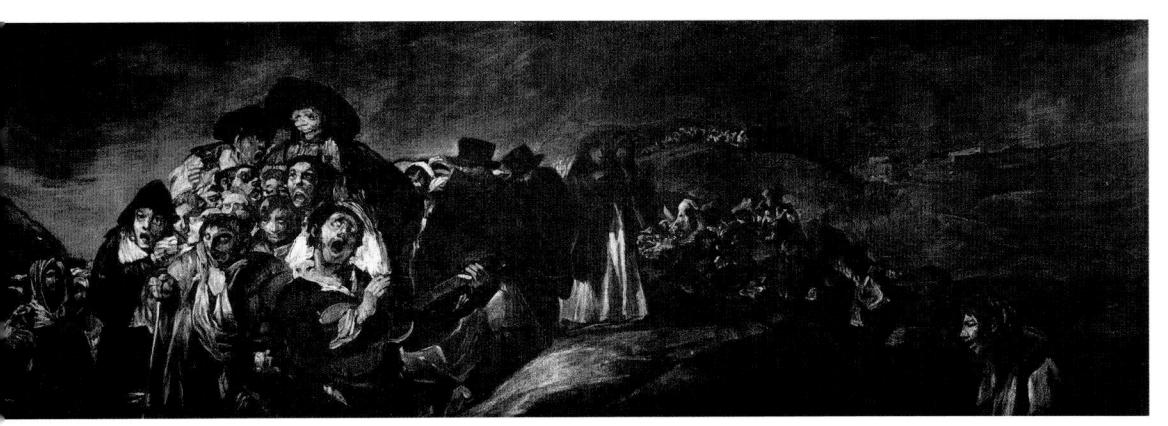

Goya, *Peregrinación a la fuente de San Isidro (The Pilgrimage of St. Isidro)*, 1821–23. Oil on canvas, 140 x 438 cm. Museo Nacional del Prado, Madrid.

jacket and the yellow skirt, who bends forward to fill the glass of a young man who leans forward to receive the drink. Goya's vision of this feast day of San Isidro is as uncomplicated and without strain as a Renoir boating-party scene. It is all decorum and shared pleasure.

In the distance, across the swiftly brushed gleam of the Manzanares, two big buildings look down on the merrymakers. One building has a single dome, the church of San Francisco; to the left of it is the Pardo, one of the various royal palaces in and around Madrid. Before long, Goya hopes, the scene he is painting will become the sketch for a huge full-scale preliminary study, or cartoon (meaning that the design was done on *cartone*, paper), which will then be woven in wool to mural scale—Goya meant it to be almost twenty-five feet wide—and placed in one of the rooms of the Pardo palace. He expects it to help bring him fame, and propel him on his trajectory of success, in the course of which he will become the chief court artist, first painter to the king.

This did not happen in the way Goya hoped and expected. Later in the same year, 1788, the king—Carlos III, the Bourbon monarch of Spain—would die, and the Pardo palace would fall into disuse: no more new paintings and decorative schemes, including tapestries, would be done for it. There would be no full-size cartoon of the happy open-air crowds on San Isidro's day, and no tapestry based on such a cartoon. But the small sketch would be absorbed eventually into the collections of the great museum of the Prado, where it remains as one of the very few completely unshadowed images of collective social pleasure in Goya's work.

The second picture, traditionally titled *The Pilgrimage of San Isidro*, also hangs in the Prado, in the galleries reserved for what are called Goya's *Pinturas*

negras, the Black Paintings of his old age. It was painted sometime between 1821 and 1823, when Goya was in his mid-seventies and had only a few years left to live in Spain. (Before long he would leave the land where, except for a brief youthful sojourn in Italy, he had lived all his life, and move across the French border to Bordeaux, where he died at eighty-two in 1828.) A little earlier he had purchased a house outside Madrid, on the far bank of the Manzanares looking back at the city from roughly the same vantage point as the pilgrims to the miraculous spring of San Isidro. This new residence was called the Quinta del Sordo, the Deaf Man's Farmhouse. It drew its nickname, by mere coincidence, not from Goya himself, who was indeed as deaf as a stone by then and had been for decades, but from the previous owner, a deaf farmer. We have only an imperfect idea of what this two-story place looked like, since it was demolished later in the nineteenth century to make way for a railway siding, which now bears Goya's name. Goya, however, covered the internal walls with paintings, done in oil directly on the plaster. The Pilgrimage of San Isidro is one of these.

It is very big, indeed panoramic—four and a half feet high by fourteen wide—though not as big as the tapestry was projected to have been thirty-three years before. It is also one of the few paintings from the Deaf Man's House that can be plausibly connected to an actual event, even though Goya did not sign, date, or title it. It may be that some other *romería*, or pilgrimage, in some other part of Spain where Goya had been—Andalucía, for instance—supplied the inspiration for this picture. But the sight of the Madrid procession was right on Goya's doorstep, he had seen it year after year, and it is reasonable to suppose that the subject is indeed the veneration of San Isidro. That the painting, along with the others in the Deaf Man's House, should have survived at all is not far short of miraculous, for in 1873 the property was bought by Baron Frédéric d'Erlanger, a wealthy Frenchman with real-estate interests in Spain. Unlike most of his developer confrères from then to now, d'Erlanger did care about the visual arts and thought that Goya's murals—bizarre, mostly incomprehensible, and almost illegibly dark—were worth saving.

Their existence had been noted before by Goya's friend Bernardo de Iriarte, who visited the house in 1868, long after Goya's death, and saw them on the walls, assigning his own brief titles to them. But it is more than possible that the Black Paintings might have perished through damp, vandalism, and neglect if the Baron d'Erlanger had not arranged to have the painted plaster—which was not true fresco but oil paint, and therefore highly vulnerable to everything that can go wrong with an absorbent, friable plaster surface—lifted from the walls

and remounted on canvas. This work began in 1874. In the process, a certain amount of editing and "correction" went on at the hands of the restorer, one Martín Cubells: for instance, early (prerestoration) photos suggest that the horrific main figure in *Saturn Devouring His Son* had a partly erect penis before Cubells toned it down in the interest of public decency. It seems extraordinary, when you think of it, that a penis (erect or not) could have been considered more offensive to public taste than the spectacle of a cannibal father ripping a long red gobbet of meat off the corpse of his dead child; but who can say that the same fatuous censorship might not be inflicted on it today?

D'Erlanger had the remounted Black Paintings shipped off to Paris to be shown at the Exposition Universelle of 1878. One would like to report that they caused a sensation, but they did not. Journalists who mentioned them at all dismissed them as the work of a Spanish madman, although they were very much admired by some of the Impressionist painters who saw them. Goya was not a famous figure in France, not even then, but cognoscenti like Manet and Delacroix greatly admired him on the basis of his prints, which were becoming quite well known, and the Black Paintings revealed an aspect of Goya even more extreme, imposing, and bizarre than was to be found in his small-scale graphic work. Still, their display in a corridor next to an ethnological exhibition half a century after Goya's death did not attract much attention, and in 1881 the baron sent the Black Paintings back to Spain, giving them to the Prado.

The new *Pilgrimage of San Isidro* is the reverse of the old one in every way. It is dark, near-hysterical, and threatening, without the smallest trace of the sweet festive qualities of the old design. The colors are funereal: browns and blacks predominate, with only an occasional trace of white. The painting contains no picnickers, parasols, or pretty girls. What it shows instead is a sluggish snake of thoroughly miserable-looking humanity crawling toward the viewer across an earth as barren as a slag heap. Two or three women are visible, but most of the people in the painting, insofar as their gender can be made out at all in the enveloping gloom, are male. The most clearly distinguishable woman is pushed off to the right, her face in profile, a mask of lamentation. No picnic baskets, glasses, or other props of *plein-air* enjoyment are to be seen.

As it reaches the picture plane, the serpent of Goya's human misery rises up and expands like the hood of a cobra, and we see what it is made of: faces, every one of them contorted in a rictus of extreme expression, singing out of key together, some of them (one feels) just howling like dogs or monkeys. Mouths like craters, mere black holes, a visual cacophony of darkness giving vent to itself.

In this mound of humanity, some divisions of class can be seen. A pair of male figures, whose faces are sunk in the gloom, can be identified as middle class by the cylindrical black hats they are wearing. But the spearhead of this human mass is proletarian, or less than that: mendicants and would-be ecstatics in rags, utterly absorbed in a vision that we, as onlookers, cannot identify or share. The guitarist in the foreground is so caught up in his praise song, or raucous *cante jondo*, or whatever it is, that he seems beyond communication.

This is Goya's vision of humanity in the mass, in the raw, almost on the point of explosion. It is painted in a way that seems to have no precedent, fiercely and with a broad brush: swipes of ocher and umber, deep holes of black, the forms of nose, cheekbone, forehead, ear, and the sunken eye socket with the dangerous-looking highlight inside it forming themselves, as it were, out of the rough paste of paint.

No earlier artist had conveyed the irrationality of the mob, especially the mob inflamed by a common vision—religious, political, it makes no difference—with such unsentimental power. What is more, the expressive roughness of the paint, the urgency with which it is applied, and the theater of expression on the crowd's individual faces—angry, stupefied, cunning, close to madness—amount to an assault on silence. Which they collectively are. They have the ferocity of creatures trying to make themselves heard from the other side of a sealed glass. They are the creatures of Goya's own deafness. They jostle at the surface of the painting, but the artist cannot hear them and never will. Hence the violence of his representation, the caricatural will to make audible what will always be silent to him.

SAY THE WORDS "Spanish art," and four names at once leap to most minds: Velázquez, Goya, Dalí, and Picasso, with Doménikos Theotokópoulos, a.k.a. El Greco, a Greek artist who worked in Toledo, a close fifth.

For many people, El Greco is too pious and mannered to be wholly satisfying, while Picasso is too difficult to comprehend as a whole: his most popular works, from his Blue Period, are still his weakest, sentimental and derivative, while his greatest achievement, the co-invention of Cubism, remains too obscure to win an unrigged vote. The colossal popularity of Picasso flows from his protean energy and unquestionable genius. But it also represents the triumph of publicity over accessibility, of curiosity about the man over real love of his work. Much the same is true about Dalí: a genius at publicity but ultimately a self-destructive one, an artist of extraordinary power in his youth—for nothing

can ever diminish the marvelous poetry of his work in the 1920s and his film collaborations with Luis Buñuel—but a catastrophically self-repeating bore in his old age.

By contrast, Velázquez has next to no personal myth. We know so little about him that he almost vanishes behind his paintings—not at all an unhealthy situation in an age obsessed and blinded by "personality" and celebrity, but one that makes him difficult for people raised on late-twentieth-century ideas of artistic achievement to approach. What was he "really" like? We do not know and never will. No diaries, no letters, no self-disclosure: a seamless, expressionless, and polished mask that gives us virtually no grip on the paintings he made.

The most accessible of the four, it seems, is Francisco Goya y Lucientes (1746–1828). But even there, or perhaps especially there, one needs to be careful. It may be a cliché, but it is nonetheless true, that no great artist surrenders easily to the prying eye, and that none is altogether likely to be self-explanatory. On the one hand, much of Goya's art has a revolutionary character. On the other, Goyas that are not a bit satirical or hostile have been credited with subversive intent, and much of his work consists of portraits that, fairly seen, are not in the least derogatory of those who commissioned them. The idea of Goya as an artist naturally "agin' the system" is pretty much a modernist myth. But it is based on a fundamental truth of his character: he was a man of great and at times heroic independence, who never betrayed his deep impulses or told a pictorial lie. One of the abiding mysteries of Goya seems to be that so fiery a spirit, so impetuous and sardonic, so unbridled in his imagination, could ever have adapted not just occasionally but consistently, for more than forty years, to the conditions of working for the successive Bourbon courts.

But perhaps it is not so mysterious after all. The first biography and study written about Goya appeared well after his death, and were written by Frenchmen: Laurent Matheron's *Goya* (Paris, 1858) and Charles Yriarte's *Goya: Sa biographie, les fresques, les toiles, les tapisseries, les eaux-fortes*...(Paris, 1867). These authors, neither of whom had known Goya personally, admired him and his work so intensely that they felt obliged to make a French romantic hero out of him: that is to say, a revolutionary, an anti-monarchist, a turbulent and erotic figure with a wild youth behind him and a fiercely ingrained resistance to any sort of interference with his artistic autonomy.

There was, in fact, some basis to their claims, though they were not entirely trustworthy. The reality was, as the early-twentieth-century scholar Enrique Lafuente Ferrari put it somewhat cautiously, that Goya "viviera muy agitados años juveniles." The stories of fiery temperament intersected with another

aspect of the Goya legend that was also part truth and part exaggeration: that he was not learned, not well educated in any formal sense—a sort of brilliant primitive risen from the working class. "Deprived of a literary education in his earliest years," wrote Matheron, "he scarcely opened a book during the formation of his intellectual faculties, which were absorbed by other matters."

In his zeal to claim Goya for the radical party and make him into a sub-Pyrenean Frenchman, Charles Yriarte went even further, declaring that Goya was "an encyclopedist," one of the "great demolishers" of Spanish orthodoxy, respecting "neither family nor throne, nor the God of his fathers."²

This was wildly exaggerated, but it lies at the root of the once commonplace idea that Goya had somehow managed to install himself at the Spanish court as an underminer of the dignity of the Bourbons. It is a durable fancy because it fits the perennial belief in the subversiveness of art, but it is quite untrue. His portraits of the Bourbons and their attendant nobles were not, as twentieth-century writers have often argued, acts of hostility or satire. Even when he was painting someone he had reason to dislike, such as the last king he served, Fernando VII, he was able to do it, if not with flattery, at least with a reasonable degree of equanimity. Goya the indignant ironist, the protester against death and injustice, mainly appears in his graphic work, which, though publicly (and unsuccessfully) offered for sale during the artist's lifetime, did not come into being through any act of royal or noble patronage. The closest King Carlos IV came to active involvement in the *Caprichos* was not in underwriting their creation; it was in permitting Goya to sell him the original copperplates after the publication had failed, in return for a royal pension granted to his son Javier.

Except for Pablo Picasso, no Western artist in the last 150 years seems to have so dominated the culture of his country during his own lifetime as Goya. Yet, curiously enough, this is a retrospective illusion, caused by the simple fact that, to our eyes, he was by far the best painter in Madrid in the 1790s. His position was never entirely secure at court and had little grip on the public's imagination. Admittedly, what counted in those days was not public opinion, simply because the "general public" did not buy or commission paintings—only a small elite was interested or had the money. But in matters of art, in late-eighteenth-century Madrid, there was no cozy question of democratic consensus on quality. This meant that a newcomer had to be careful what he imitated, and sure about committing himself to mentors: all the rest was a minefield of concealed diplomatic blunders. You did not just become well known through native ability, though of course you did not acquire a name without it.

Goya was much less known in his own day than he is now, and fewer people,

even in Spain, knew his work at first hand. He acquired a fairly large educated audience, which was the best a painter then could expect. People did not go for artists merely because other people, even their social superiors, thought they were "new" or "exciting." The idea of art for a mass audience had not yet been born. Probably if you added up the total number of people in Spain in 1800 who had some awareness of this painter, it would be no more than a fraction, and a tiny fraction at that, of the number of people today who would recognize—whatever shadings you may wish to give the verb—the name of a merely fashionable star like Damien Hirst, let alone that of Jackson Pollock. Two hundred years ago, the words "famous artist" did not mean what they do today.

Goya's career was long—unusually so, given the life expectancy of his day in Spain, when even the well-off could rarely hope to live much past fifty and workers seldom got to see the far side of thirty-five. We are apt, today, to forget that eighteenth- and early-nineteenth-century Spain was, in an extreme and literal sense, a culture of death.

It was not that more people died then than now. Everyone dies, sooner or later. But today, barring the horrors of mass slaughter (the specialty of the twentieth and twenty-first centuries), they die later. Then, they died sooner. The culture of death, in other words, was not the property of the old. Long working lives were rare and, when they occurred, remarkable. In most of eighteenthcentury Europe, with Spain at the lower end of the scale, the normal expectation of life for the poor oscillated between twenty-seven and thirty-two years.³ This was a factor in the reverence and respect paid to old age, something that has almost vanished from our own culture. Quite simply, to reach old age was an achievement, a kind of triumph. When teenagers were as vulnerable to fatal diseases as eighty-year-olds, when the causes of epidemics were not understood, when antibiotics were unknown and medicine was hardly even a science, it was not possible to sweep death under the carpet, as modern Americans have done. Spaniards in Goya's lifetime routinely died of afflictions that would scarcely force them to be hospitalized today, and there were many more of these afflictions: it is very unlikely that an immensely wealthy, cosseted, prominent woman in Madrid today would die at forty of a combination of tuberculosis and dengue (breakbone) fever, but that was what happened to the duchess of Alba, to whom Goya's name is forever linked. As communications improved and the limits of the Spanish empire expanded, so did the opportunities for death from new contagious diseases, plagues, and epidemics. As cities grew, sucking in and concentrating the previously more dispersed population of the Spanish countryside, so did the danger—indeed, the near certainty—of infec-

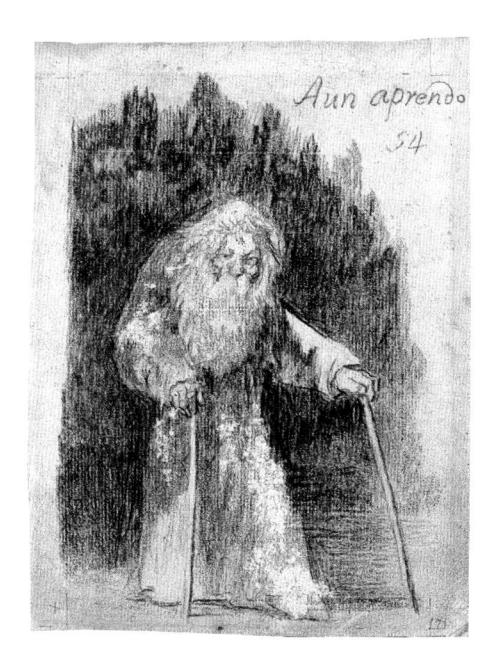

Goya, Bordeaux Album I, 54, *Aún aprendo* ("I'm still learning"), 1824–28. Black chalk, 19.1 x 14.5 cm. Museo Nacional del Prado, Madrid.

tion from poisoned and polluted water and every kind of urban filth. To live to the age of eighty-two, as Goya did, was a great stroke of biological luck. To do so while staying sane and working right up to the end—for there is no evidence of senile decay or dementia in Goya's last years, although physical infirmities did, of course, take their toll—was well-nigh miraculous. He was a tough, tenacious old bird, and he had every right to make, toward the end, that inspiring drawing of an ancient, bearded man, like Father Time or Kronos himself, hobbling along with the aid of two canes, "god-on-sticks" as the English critic Tom Lubbock⁴ aptly called him, with the scrawled caption "Aún aprendo"—"I'm still learning."

Goya was exceptionally productive. He made some seven hundred paintings, nine hundred drawings, and almost three hundred prints, two great mural cycles, and a number of lesser mural projects. In his time he had a few competitors but no real rivals. He was that rarity, an artist born, raised, and working in a society strikingly short of pictorial talent who attained an astonishing level of achievement without much stimulus from peers. Goya knew quite a lot about Watteau and, in his tapestries emulated Watteau's designs (bequeathed to him by Titian) for the fête champêtre, the idealized picnic of likeminded souls betokening social harmony in the open air. But there was no one else in Spain doing designs of this sort, with two exceptions: a much inferior French artist Madrid-trained named Michel-Ange Houasse and Carlos III's court painter

Luis Paret y Alcázar (1746–99), the same age as Goya, who did pleasing but superficially decorative, provincial rococo genre scenes of gallantry.

Europe had no one else like Goya, and it didn't know about Goya himself, because Spanish art had no access to the north. But then, there was no one else like this great solitary in Spain either. He was the one and only major painter working in Spain as the eighteenth century turned the corner into the nineteenth. As far as is known, he was not significantly influenced by any of his Spanish contemporaries, although one of them, Vicente López y Portaña (1772–1850), an able classicizing follower of Mengs, did a memorably crusty and glaring portrait of Goya as an old man with palette and brushes in 1826. It shows no more trace of Goya's influence than Goya's portraits do of López's but is the only finished portrait of the great man, apart from his sparse self-portraits, that still exists.

One has the impression that Goya was not much interested in the work of his Spanish contemporaries; he gave encouragement to younger ones, like Asensio Juliá, but knew that they could have little to show him. He once declared that his real masters were Velázquez, Rembrandt, and Nature. Velázquez's works, of course, he knew intimately, being surrounded in Madrid with the largest and best collection of them in the world. He would have known Rembrandt only through prints, since so little of the Dutch master's painted work had made its way to Spain, but then Rembrandt's prints contain so much of the essence of Rembrandt, as Goya's do of Goya. They are not mere records or reproductions of paintings but fully achieved works of art in their own right, and scrutinizing them must have made clear to Goya how rich the print media could be as independent, not merely reproductive, forms of expression.

Thanks to his friendship with the Cádiz collector Sebastián Martínez, who had a large and well-stocked print cabinet, Goya had a vivid awareness—again, through prints and reproductions and the occasional copy—of English portraiture and genre painting: William Hogarth, William Blake, Sir Joshua Reynolds, John Flaxman, and others. Many of the traces of neoclassical design that appear in Goya's graphic work come, consciously or not, from Flaxman, who was also one of the chief inspirations for Josiah Wedgwood's pottery designs. Otherwise Goya cannot have been well aware of what non-Spanish artists were doing in the course of his lifetime, because their work was much less copiously engraved. Of manifest importance to him was English caricature—James Gillray, Thomas Rowlandson, Hogarth—whose violent distortions of form and fearlessly scatological humor were to affect Goya's first great print series, the Caprichos.

All this was very chancy, very unsystematic. The mechanisms of exchange of information that we take for granted as routine aspects of the "art world"—traveling exhibitions, easy access to collections, public museums, art publishing, mass reproduction—hardly existed in Goya's Spain. He made one journey to Italy, as a very young man fresh from the Spanish provinces; but although a meager sketchbook has survived from that hegira, it tells us very little of his itinerary, or what he saw, or whom he met, or what paintings made an impression on him.

He spent the last few years of his life in France, in the city of Bordeaux, which he chose more for political and family reasons than for cultural ones; he visited Paris, but one can only guess at what he might have seen there or what he thought of it. By then he was in his eighties, frail (though still, according to those who knew him, intensely curious about the life around him), and as deaf as a post. Probably he could not speak more than a few words of French.

He did not win international fame in his lifetime, or for many years after his death. In the late nineteenth century, a succession of French, English, and German artists based their aspirations as realists on their enthusiasm for Velázquez; gradually, for some, Goya's work then took over as a standard and model. (The two were not mutually exclusive, of course; Manet was only one of a number of major painters who adored them both.) From about 1900 on, Goya was one of the few Old Masters—and a recent Old Master at that—to be exempt from the polemical rejection of the past felt by many younger artists. He was, in a real sense, the last Old Master; and in an equally real sense, the first of the Moderns.

Yet when he died, in 1828, none of that would have made sense. He had few admirers and, what is even more surprising, practically no imitators anywhere in Spain. He lived in exile and obscurity, in France. Liked by the Bourbon king Carlos III, loved by his son Carlos IV, Goya was not liked a bit by the next Bourbon, Fernando VII, who was restored as king after years in exile, having been thrown out by Napoleon's occupation of Spain between 1808 and 1814. Fernando suspected Goya of disloyalty and in any case preferred the stiffer, smoother Neoclassical manner of his own chief court painter, Vicente López. After 1815, after Goya had served the Bourbons as chief painter for so long, it was as though he had gone into eclipse, his great etching series mostly unpublished (the fate of the *Desastres de la guerra* and the so-called *Proverbios*, or *Disparates*) or lapsed into semi-obscurity (as happened to the *Caprichos*); his drawings unknown; his paintings scarcely visible to the public except for three pictures in the Prado, two of which were royal portraits of the Bourbon monarchs he served, Carlos IV and Queen María Luisa. (Today, apart from drawings
and prints, the Prado owns some 150 of his pictures, though not all are genuine, a fact that its curators will sometimes admit to in private without wishing to go on the record about it. A striking example is the Milkmaid of Bordeaux, a painting done very late in Goya's life, which is accepted with joy by everyone who doesn't know his work well and rejected by many who do-including some of the curatorial staff of the Prado, who cannot vet take the risk of demoting such a popular picture.)

At the time of the Bourbon restoration, the catalog of the Prado, which had only recently switched from being a museum of natural history and become a picture gallery (one of the few permanent blessings with which the otherwise detestable archreactionary Fernando VII endowed Spain), did not even list Goya's great monuments to Spain's rising against Napoleon in 1808—his paintings of the rebellion of May 2 and the reprisals of May 3—though the Dos de Mayo was celebrated all over Spain in song and verse as the country's national day.

Outside Spain, he was just as poorly known. A set of his fiercely moralizing Caprichos was offered by a London bookseller in 1814 for twelve pounds; a few years later, nobody had bought it and its price was reduced to seven guineas.⁵ Britain's National Gallery did not acquire any Goyas until 1896, and in a famous fit of moral hysteria the greatest art critic of his age, John Ruskin, actually burned another set of Caprichos in his fireplace, as a gesture against what he conceived to be Gova's mental and moral ignobility.

SUCH AN IDEA seems very odd today; if nothing else could make you sense that Ruskin was cuckoo (and he was; as mad and depressed in old age as King Lear himself), this peculiar deed would. Yet it is not entirely out of keeping with common, popular images of Goya, all of which turn out, on inspection, to be false: invented, mistaken, or the result of accretions of legend. It is not so long ago, for instance, that most people who thought about Goya considered him mad. The assumption was based on Goya's deep interest in insanity, which can readily be deduced from some of his Caprichos, from the indisputable fact that he painted a number of madhouse scenes and was almost the first European artist to do so, and from the dark, enigmatic paintings that adorned his last home in Madrid, the Quinta del Sordo. But this is illogical. It is like saying Hieronymus Bosch was possessed by the devil because he painted such vivid and influential images of hell. Goya was fascinated by madness for two reasons. The first was that he shared the general interest in mental extremity that characterized Romanticism in European art. What was the human mind capable of when at the end of its tether? What images would it throw out, what behavior would it release? In this sense, Gova was no more mad than Shakespeare when he wrote the "mad scenes" for Lady Macbeth and Ophelia, and created the sublime, terrible, and fragmented utterances of Lear. Almost all the great artists of Goya's time, from Fuseli to Byron, were fascinated by madness, that porthole into unplumbed depths of character and motive. Gova was in some ways the greatest of all delineators of madness, because he was unrivaled in his ability to locate it among the common presences of human life, to see it as a natural part of man's (and woman's) condition, not as an intrusion of the divine or the demonic from above or below. Madness does not come from outside into a stable and virtuous normality. That, Goya knew in his excruciating sanity, was nonsense. There is no perfect stability in the human condition, only approximations of it, sometimes fragile because created by culture. Part of his creed, indeed the very core of his nature as an artist, was Terence's "Nihil humanum a me alienum puto," "I think nothing human alien to me." This was part of Goya's immense humanity, a range of sympathy, almost literally "co-suffering," rivaling that of Dickens or Tolstoy.

Was he some kind of a peasant touched by genius, as some writers have thought? Of course not: Goya may not have been a painter-philosopher like Poussin, and there may be some justification to the view once expressed that his letters are like those of a carpenter, but carpenters are not so dumb, and appearances can be most deceiving. Goya was a very smart and sophisticated man, not only in his handling of the issues, techniques, and meanings of his art, not only in his relationship to the art of others, but in the conduct of his daily life.

It was not easy to be a court artist. It required serious diplomatic talents. It offered no enforceable contracts, and an artist had to be constantly, minutely vigilant to keep himself not only from shooting himself in the foot but from being stabbed in the back by rivals or unsuspected enemies. Royal patronage was very much a matter of whim. It was even harder to be an artist who served several successive kings, the aristocracy around them, and the prepotent and often jealous figures of their successive administrations—with, all the while, the Catholic Church and its Holy Office, the Inquisition, looming in the background and sometimes barging threateningly into the foreground. Goya was not a manipulative man. He could do a little flattery when necessary, but he was not servile. He possessed, in the highest degree, the virtue of natural common sense, which the Catalans call *seny*. His mental posture was upright; his carriage,

fairly relaxed. Though his letters to Martín Zapater, his friend since childhood, may not disclose the deeper layers of his emotional life (for most people around 1800 that was not what letters were for), they do reveal a man reasonably at ease in the world, free from humbug and cant, loyal to his friends, loving to his women, and deeply protective of his relatives and dependents; a natural *señor* with a great appetite for life, an equal talent for living it, and without any weird twist to his backbone. As John Russell wrote of Eugène Delacroix (who, not incidentally, loved Goya's work and was the first French artist to collect it), he "is one of the most cogent arguments for the human race." But do not take Goya for granted. He was a great man but not necessarily a nice guy. He was tough, prickly in defense of his hard-won prerogatives. And the last half of his life was lived out under the shadow of a crippling disability that must have made him suspicious, jumpy, and, above all, given to overcompensate for lone-liness: the dreadful and unconditional loneliness of the deaf man, cut off from others and therefore bound, inevitably, to be suspicious of their motives.

GOYA WAS BORN on March 30, 1746, in the remote village of Fuendetodos in the kingdom of Aragón. From this, many people have assumed that he was a country boy who rose from obscure peasant origins to his position with the Spanish court, as official painter to three consecutive Bourbon kings: Carlos III, the "enlightened" liberal; his son Carlos IV, the stolid, blue-eyed cuckold; and his son in turn, that tyrannous weasel Fernando VII. In fact, Goya was nothing of the sort. His origins were obscure enough, but his father, José Goya, was neither a farmer nor a farmer's son. Nor did Goya reside in Fuendetodos: he and his family lived about forty miles away (or three days' journey over the vile Aragonese roads) in the medium-sized city of Zaragoza, the provincial capital of Aragón. José Goya was the son of a small-town notary—not an exalted rank, it is true, but in eighteenth-century Spain's class system a hundred times better than tilling the soil. It entitled him and his children, Francisco included, to be treated as members of the lower middle class rather than as peasants or farmers. Francisco was José's fourth child. The first had been a daughter, Rita, baptized in Zaragoza in May 1737; the second, a son, Tomás, baptized in December 1739; the third, a daughter, Jacinta, baptized in September 1743. Then came the future painter, in 1746, followed by a third son, Mariano (baptized March 1750), and a fourth, Camilo (1753).

José Goya had not followed his father into the practice of law. He had settled for being a craftsman—a gilder, not a bad trade in a culture that produced a con-

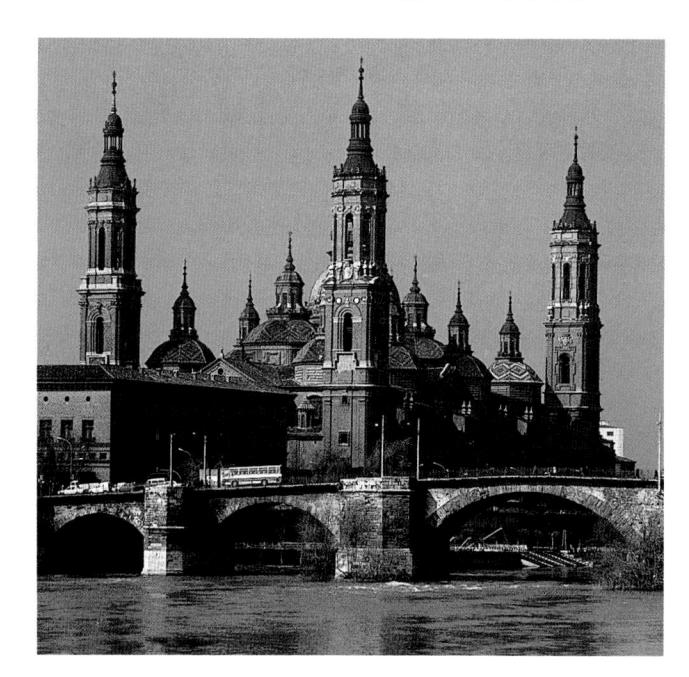

Basílica del Pilar, Zaragoza

stant demand for every kind of gold-leafed object, from decorative putti and candlesticks to picture frames and whole altar retables. At the center of this steady market for religious and decorative craftwork was the principal church of Zaragoza: the shrine, later proclaimed to be a cathedral, of Santa María del Pilar—the Virgin of the Pillar. For Spanish Catholics, this place was of great cultic significance. It commemorated the supposed vision granted to the apostle St. James the Greater (Santiago to his Spanish devotees), to whom the Virgin Mary appeared in Zaragoza near the banks of the Ebro in A.D. 40. She exhorted Santiago to evangelize the whole Iberian peninsula, converting its peoples to Christianity, then presented him with an effigy of herself and a column to stand it on—which is supposedly preserved in the church, where the faithful dutifully kiss it. The apparition of the Virgen del Pilar thus became tied in with the "liberation" of Catholic Spain from the civilization of the Arabs, which had begun with the implantation of Islamic rule there in 711. Hence the cult of the Virgin, the Pillar, and Santiago was of vast iconic importance to Spanish Catholicism, and one of its chief centers was a Gothic church, similar in style to the Cathedral of Albi, built in Zaragoza in 1515 on the spot where the Virgin supposedly made her appearance.

At the end of the seventeenth century, work began on a newer, larger, and even more splendid sanctuary. Goya's father was in charge of its gilding and part of its ornamentation. The Bourbon monarchs took a particular interest in protecting and pushing the whole project; Carlos III's favorite Spanish architect, Ventura Rodríguez—later to be a friend and ally of young Goya's—drew up the plans for the Chapel of the Pillar, which was built between 1754 and 1763. The king's chief decorator, Antonio González Velázquez, a disciple of the Italian painter Corrado Giaquinto, was put in charge of the ornamentation of its dome. The building of Nuestra Señora del Pilar was no provincial affair: it was one of the largest ecclesiastical projects in progress anywhere in Europe in the mideighteenth century. Working with its designers—admittedly, as their subordinate—gave José Gova a steady, if not necessarily intimate, contact with artists and with other craftsmen, which implies that his son Francisco was exposed to a high level of professional life as well. It is a mistake to imagine that young Gova came from under a cabbage leaf, armed only with a kind of peasant genius. This is an invention of his early biographers, including, rather surprisingly, the son of his lifelong friend and correspondent Zapater, who ignored most of the discoverable facts of Gova's childhood.

Goya's father was a tradesman, whose family roots went back to Basque ancestry. His mother, however, belonged to the lowest order of nobility, that perhaps most useless rung of eighteenth-century Spanish society, the lesser hidalguía. To be a hidalgo, male or female—the term was a contraction of hijo de algo (son of somebody)—conferred no particular privileges beyond prestige. It was a social concept invented by rapacious monarchs of the past to raise money. You bought the title, cash down. Owning it entitled you to certain minor perquisites, all to do with courtesy. The main one was that it entitled you to be addressed as "Don" or "Doña." No matter if the servants had deserted, the kitchen roof was tottering to the ground, and the very hens had abandoned the fowl yard, you were still an aristocrat of sorts. Starting with Columbus in 1492, all the expeditions of Spanish world conquest in the sixteenth and seventeenth centuries, from the Canaries to the Caribbean and thence to the rim of the Pacific, had been staffed—and many of them led—by hidalgos, which helps explain not only the rapacity with which the conquerors behaved but their parallel obsession with titles. The same held true in the civilian sphere at home in Spain: it accounts for the inflation of titles so common under Carlos III and his successors, and so ridiculous to the outsider's eye. What, exactly, did it mean to be called the Marquis of the Royal Transport? What was Carlos III's purpose in founding an Order with his own name that boasted, at the outset, two hundred knights? Only one answer seems possible: the gratification of an illusory sense of prestige that was sustained by no measurable achievement. One Spaniard in twenty—half a million people—claimed *hidalgo* status, and this privilege was more often an intolerable burden: the *hidalgo* could not do useful work, and since most had no inherited money or interest-bearing capital, this restriction made them little better than beggars. Goya's mother, Gracia Lucientes, seems not to have been averse to this, and her sense of *hidalguía*—of being something of a nob by birth—left its traces in her painter son: in his later preference, for example, for being known as Don Francisco "de" Goya.

The house in Fuendetodos was her family's property, a cottage, a stone box, the remnant of once larger landholdings. It is not known why she gave birth to this particular son there. Her other children were born and baptized in Zaragoza, and all of them were raised there. It is possible that José had been called to Fuendetodos to gild the altarpiece in its parish church (which was set up in 1740) and that his very pregnant wife went to stay with him while he completed this long job, and so gave birth to Goya there; but certainly the documents of the day show that around 1746 the Goya family was well and truly established in Zaragoza.⁷

RELATIONS BETWEEN ARAGÓN, whose capital was Zaragoza, and the more recently established kingdom of Castilla (whose centrality in Spanish politics was not confirmed until the accession of Fernando and Isabel in the late fifteenth century) had not always been easy. Traditionally, Aragón was in league with Cataluña, whose capital, Barcelona, had been a great Mediterranean power when Madrid was not much more than a cluster of mud huts. For centuries the Catalans and Aragonese had expressed their ideal of the relationship between their own count-kings and the central powers of Madrid in a pithy and exceedingly conditional oath of allegiance, recited by the *justicia* or high judge of Aragón to the monarchs of Barcelona and Castilla. The oath was seen as almost insultingly haughty but would not bear editing: "We, who are as good as you, swear to you, who are no better than us, to accept you as our king and sovereign lord, provided you observe all our liberties and laws—but if not, not."

Catalans, and Aragonese to a lesser degree, have always waxed lyrical over their medieval defiance of kingship. This gave the Aragonese, in Madrid's eyes, a reputation for being stiff-necked and stubbornly independent, irrespective of their wealth or political rank. It was put to the test several times, perhaps most memorably by the Hapsburg despot Felipe II, who, after a revolt against Madrid in Zaragoza, ordered the beheading of the latter's obstinate *justicia*, Juan de Lanuza. (In the end, tempers cooled and the king, advised that it might

not be a good idea to execute an official for supporting so ancient a tradition of relative independence as Aragón's, backed off.)

Aragón's feelings of independence were not genetic, of course, but they were a powerful current in the culture, and awareness of them was part of Goya's inheritance. They must have reinforced his personal stubbornness, his reluctance to be pushed around by teachers and patrons. And they would certainly have been raised in his mind to a heroic level in years to come, during the Spanish War of Independence, when Zaragoza underwent its purgatory by siege from Napoleon's forces, holding out for months after all hope of relief seemed to be gone, beating off the stronger French forces and thus supplying Goya with a vast confirmation of his pride in his *patria chica* and one of the chief starting points of his series of etchings the *Disasters of War*:

Fuendetodos was (and still is) a hole—poor, bare, isolated, and dry, a pueblo like thousands of others in Spain where peasants scratched a bare living from resentful soil. It had no river. The infrequent rains ran straight off the rocky slopes of the cordillera. The conditions of life there would hardly begin to change until long after World War II. In Goya's childhood they had been essentially the same for centuries: water from wells, sparse firewood for cooking laboriously gathered from shrubbery left behind in the destruction of local forests, sour wine, straw bedding, tough meat. There were icehouses made by digging holes deep in the stony soil and capping them with stone domes; ice, chopped from winter deposits, would be stored deep inside. Fuendetodos contained, according to the census, 109 people, all farmers and peasants and their families—and, of course, a priest. Naturally a certain amount of folklore has grown up around little Goya in Fuendetodos and Zaragoza, drawing pigs on a wall and catching the eye of a passing priest, the usual baby-Moses-in-the-bulrushes stuff; but there is no evidence for it, and it can be passed over. The house of Goya's infancy does survive. Like most birthplaces of artists, it reveals very little beyond the fact that Goya's family had simple furniture (though none of what is there now is original), cooked stews in pots (ditto), looked at religious pictures (ditto), and presumably had cats.

And yet, once you have seen those hardscrabble landscapes around Fuendetodos, so bare and bleak and sunstruck, with their isolated trees black in the implacable light, you also know where the landscape backgrounds of the *Desastres de la guerra* and, even more, the Black Paintings of his old age come from. Saltpeter was mined there, and marble and jasper. It is a landscape without softness, lacking even the rudiments of lyrical pleasure: a landscape of deprivation where every stone is a sharp, weighty noun. One should think of Goya walking

these hills with his dog and, sometimes, his school friend Zapater, smelling the odor of wild rosemary and thyme that rose from their boots, swearing companionably, alert to the whir of a partridge or the scurry of a startled rabbit. This blond landscape was in his genetic helix, and all his life Goya would love the feeling of masculine pursuits. He liked the *macho* life. He was good at it, and good company in the field. He was not cut out simply for the drawing room. Because he was not particularly a man of breeding, not really a *caballero*, the hunt was also his way of connecting with the life of the nobles and royals he would need to serve if he were to get on. You didn't need to be the Duke of This or That to hit a partridge, or to blaspheme victoriously when a puff of dust flew from its ass and it came pinwheeling down, feathers awry, out of the hard hot blue air.

Goya's house was built of stones, and it was tiny: three rooms up, three down, all sparsely furnished. It is hard to imagine being comfortable in it, but it was almost a palace compared with the semi-troglodytic conditions under which most Aragonese peasants then lived. In any case, he did not grow up there. Whatever kept his father in Fuendetodos did not detain the family long; they were soon back in Zaragoza, forty miles and a world away.

What kind of education did Goya the schoolboy receive in Zaragoza? The records are very defective, but most historians agree that he went to a church school, the Escuelas Pías de San Antón, which offered free education to the gifted children of the poor. (Many years later, he would do a commemorative altarpiece depicting the founder of the Escuelas Pías, San José de Calasanz, in the act of raising himself from his deathbed to receive Holy Communion. It is one of the most piercing and beautiful images of old age that this great recorder of age and infirmity would ever produce.) One of his fellow pupils at the Escuelas Pías (pious schools), Martín Zapater, became his tight friend and longtime correspondent. Some 131 letters to him from Goya, written over the period 1755 to 1801, survive. Probably the education the school offered was little more than adequate, but that still put it well above most eighteenth-century schools in provincial Spanish towns.

Goya came out able to read, write, and figure. He had some familiarity—how much one cannot say—with the work of Virgil, and there are traces of Latin in some of his picture titles and letters: for instance, a witchcraft scene in the *Caprichos* carries the caption "Volaverunt," Latin for "They will have flown." But this was also a common idiomatic phrase in Spanish, so Goya's

use of it probably indicates nothing about his knowledge of Latin one way or another.

He seems to have taken, as one essayist rather harshly put it, no more interest than a carpenter in philosophical or theological matters, and his views on painting—as we shall see—were very down-to-earth: Goya was no theoretician.

About his education as an artist, however, more is known. No one could claim that Zaragoza was any kind of Mecca for art teachers, but it did have some artists of more than merely local experience. One of these was José Luzán y Martínez (1710–85). In the 1730s Luzán had gone to Naples in the service of the Spanish ambassador there, Pignatelli, count of Fuentes, and trained under the artist Giuseppe Mastroleo. He soon acquired a rather conventional rococo fluency, and was able to set up his own teaching studio in some rooms of the Pignatelli palace on his return to Zaragoza. The connection between him and the Goya family was, at first, simple: José Luzán was a painter, but his father and two brothers were master gilders, and José Goya struck up a close friendship with one of these brothers, Juan Luzán. The upshot was that young Goya found himself apprenticed, at thirteen, to José Luzán. Such youthful, almost childish, apprenticeships were of course the rule rather than the exception throughout Europe in the eighteenth century. Later on, in a curriculum vitae he wrote in the third person, Goya would refer to spending "four years with Luzán, who taught him the rudiments of design and made him copy the best prints he possessed." No record survives of which prints these were. This copying of prints was much more than a ritual. It was generally the only access a student had, however thirdhand, to works of art of exemplary quality. Naked models were not available in prudish Spain, which had no tradition of the nude. A mere student had no access to the private collections of the rich, and there were no public museums—especially not in a place like Zaragoza. A teacher with a well-stocked print portfolio thus enjoyed an advantage, like an art school with a good slide collection.

Luzán also trained the artist who was seen as the other promising talent—in most eyes, more promising—of Zaragoza, Francisco Bayeu y Subías (1734–95). In July 1773 Goya would marry Bayeu's sister Josefa ("Pepa"), an indication of the tight-knit nature of Zaragoza's little art world. Gova's poorly documented four years with Luzán takes him down to about 1763. Seventeen years old, he was then eager to enter a wider field and get better teachers, if they could be found.

Every three years in Madrid, the Royal Academy of Fine Arts of San Fernando offered bursaries to young applicants who wished to study painting. In 1763, eight contestants including Goya took part, and five scholarships were available. The test was to copy a plaster statue of the god Silenus. Only one entry was judged worthy of a scholarship. Young Goya failed ignominiously. He tried again three years later. This time the test was to do a history painting: *The Meeting of the Empress of Constantinople and Alfonso the Wise.* The jury did not cast a single vote for Goya.

However, one of its members was Ramón Bayeu, the young brother of Francisco Bayeu; in a fine gesture of Spanish nepotism, Ramón voted for his brother and thus ensured him the scholarship. Goya had a reputation as a quick-tempered and mettlesome man, but he was too sensible to start flinging accusations around. Given Bayeu's growing reputation—he was chosen by Mengs to work with him on the frescoes for the Palacio Real in Madrid in 1763, elected to the Royal Academy of San Fernando in 1765, and became Carlos III's *pintor de cámara* in 1767, all ahead of his much younger colleague—Goya was wise to refrain from crossing him. The strategy paid off in the long run: Bayeu would become not only a brother-in-law, but an ally in Goya's dealings with the court.

It was not lost on Goya that his monarch, Carlos III, loved Italy and tended to judge all cultural events by Italian and French, rather than Spanish, standards. In 1761 he had brought the neoclassical painter Anton Raphael Mengs from Naples to run artistic affairs in his court in Madrid. In 1762 he imported the great, if now aging, muralist Giambattista Tiepolo and his two sons from Italy. Francisco Bayeu had learned his skills in Italy. Spain had produced great artists in the past, but they were all dead, buried with the *siglo de oro*, the "Golden Century" of Hapsburg power and empire. There was no coherent, or authoritative, school of Spanish painting as such. To succeed with the Bourbon court in Madrid, you had to be either Italian or an Italophile.

Goya therefore decided to go to Italy, as generations of foreign artists had done since the time of Albrecht Dürer, in the late fifteenth century. In the art of painting, Italy was still "the school of the world," though its absolute supremacy had been challenged by the growing cultural centrality of France since the time of Louis XIV. Italy contained nearly all the prototypes of classical antiquity, from the Apollo Belvedere to that battered but still mighty block of energy in stone, the Vatican Torso. Its churches, chapels, domes, vaults, and palace walls bore the greatest compendium of frescoes by leading artists—from Giotto to Veronese, Cimabue to Tiepolo—that wealth, patronage, and the desire for religious or political glory had ever brought together within the borders of one country. It was the *locus classicus* of art theory and articulate taste, of connoisseurship and intelligent patronage. Whatever could be learned about art, Italy

could teach. Since Dürer first went to Venice, generations of young foreign artists had gone there, to study, see, absorb, and submit themselves to the extraordinary challenges that an acquaintance with the higher reaches of Italian art could provide. They were also drawn by the superior status that artists, if they were any good, enjoyed in Italy, in contrast to their lesser fate as "mere" craftsmen at home. "Here I am a gentleman," Dürer wrote to his old friend Willibald Pirckheimer from Venice, in 1506; "at home I am a bum." A pattern of creative expatriation had been set for Spanish artists by Diego Velázquez, who had gone there at a high level with letters from his king and the Madrid court from 1629 to 1631, and then again from 1649 to 1651; and by Jusepe de Ribera, the prodigiously gifted son of a Valencian cobbler, who spent nearly all his creative life (c. 1611-52) in Rome, Naples, and other parts of Italy. It is true that when Goya arrived there, toward the end of the eighteenth century, the titans of the past were all dead: Titian, Bellini, Michelangelo, Raphael, Correggio, and the rest lived on only in their works. But their works were there to be seen, and that was the important thing. Besides, the taste of Carlos III's court was essentially Italian taste, and the artists the eighteenth-century Bourbon monarchs most admired—Mengs, Tiepolo, Giaquinto, to name only the more prominent ones—were mostly Italians. (Mengs was not, but he had lived there so long that he might as well have been.) Their work was to be seen in quantity in Italy. Naturally, an ambitious young artist needed to pick up tips from it.

Virtually nothing is known about Goya's Italian travels: neither his itinerary, nor his acquaintances, nor his means of support, nor—most frustrating of all—what he spent his time looking at. It is usually assumed that he went to Naples as well as to Rome and Milan. Probably he went overland through France rather than to Livorno, to Genoa, or direct to Rome by sea, because that was the cheap way to go. A recently discovered "Italian sketchbook" of Goya's, which is certainly genuine enough, is nevertheless uninformative about Goya's early sources.

The reason that so little is known about his Italian sojourn is simple. Goya is famous now; then, he was very young and utterly obscure. He kept no diary, no letters from this stage of his life survive, and nobody took notice of him. Nor is it certain what he was painting. There are, for instance, two mythological pictures attributed to his time in Rome, both from 1771: a Sacrifice to Vesta (now lost) and a Sacrifice to Pan. The Pan shows a garden glade, with a massively ithyphallic figure of the divinity rising behind a stone altar. A young woman in white holds up to him a shallow golden bowl. Its contents evidently come from an urn that her companion, kneeling at the foot of the altar, has accidentally

Goya (attributed), Sacrificio a Pan (Sacrifice to Pan), 1771. Oil on canvas, 33 x 24 cm. Private collection.

spilled. It contains a red liquid: not wine, but hymeneal blood, the symbolism being the loss of virginity. But there is no secure reason to suppose that this rather awkwardly drawn and painted image is really by Goya at all. Any one of a number of immature artists doing classical themes in late-eighteenth-century Italy could have produced it, and its style has nothing to securely connect it to Goya, whose own style was not yet formed. Its companion piece, the *Vesta* (known only from a photograph), bears the signature "Goya" on its altar, but any forger could (and would) have put it there.

Of his life in Rome, only a few morsels are known. He stayed with a friend of Mengs's, a Polish artist named Taddeo Kuntz, who lived from 1770 to 1771 in the Via Trinità del Monte, at the top of the Spanish Steps. Some evidence has turned up that for a time he shared lodgings in Kuntz's house with the Venetian engraver Giambattista Piranesi,⁸ who was then engaged in his monumental descriptions of the antiquities of Rome and had some years earlier produced his brilliant and mysterious architectural fantasies, the *Imaginary Prisons*, or *Invenzioni capric[ciosi] di carceri* (c. 1749–50). If this was indeed so, it is a most pleasing coincidence that the authors of the two greatest series of engraved *capricci* in European art, Piranesi and Goya, should have briefly lodged together.

Whether they actually did so or not, Goya was later to show the influence of Piranesi, whose massively thick-walled prisons would be reflected in Goya's madhouse scenes of the 1790s.

In the absence of facts, Goya's early biographers made up his Italian life for him: he earned lire as a street acrobat. A Russian diplomat invited him to go to St. Petersburg as a court painter. He climbed up the dome of St. Peter's to leave the highest graffiti ever scratched there. He fell in love with a beautiful young nun and plotted to abduct her from her convent one dark night. There is no evidence for these romantic stories, any more than there are grounds for the belief that he went to Italy with a troupe of bullfighters. (There is no doubt, however, about his enthusiasm for the corrida itself—dozens of later etchings and paintings will attest to that, and in one note written years later, he would sign himself jokingly "Francisco de los Toros." It would have been unnatural if he did not have an afición for bullfighting.) The "romantic" picture of young Goya is, however, quite unconvincing. He did not have a lot of dash, although he was a hard, obstinate, and meticulous worker. He was averse to risks, physical or professional. He was in no sense the conventional Spaniard—all cape, sword, and olés—imagined by nineteenth-century writers. And he seems to have had no unrealistic expectations of making a career as a Spanish expatriate in Italy, where there was too much competition. Jusepe de Ribera had brought that off brilliantly in the seventeenth century, and Diego Velázquez could certainly have done it if he had wanted to, but Goya had no such ambitions. He was homesick, perhaps, and he must have reasoned that his chances of a steady success were much wider in Spain—first Zaragoza, then Madrid—than in the Eternal City.

Before getting ready to return to Zaragoza, he entered another competition, this time in Italy, once more without success. The twenty-five-year-old artist must have reasoned that he needed academic recognition and that kudos earned in Italy were bound to impress the Spanish more than any he might gain at home in Zaragoza. The Academy of Parma had a yearly competition for young artists; this year, 1771, the assigned subject was Hannibal looking down from the Alps on the plains of Italy, which he was soon to conquer. Goya entered a painting, identifying himself in Italianate spelling as "Francesco Goia," "a Roman and student of signore Francesco Vajeu [Bayeu], court painter to His Catholic Majesty." This slightly improved provenance did him little good; Goya's Hannibal did not win, though one of the judges praised the "grandeur" of the hero's stance. The painting was sent on to Zaragoza, and has since vanished. A lively and somewhat Tiepolesque oil sketch of the same sub-

ject is sometimes attributed to Goya, but, as with the *Sacrifice to Pan*, there is no firm evidence either for or against the claim that Goya painted it.

Goya had a further motive for wanting to go back to Zaragoza. He was thinking about marriage. The prospective wife was Josefa Bayeu (1743-1812), the sister of his colleagues Francisco and Ramón. Her qualities, her character, what people (including Goya) thought of her, or what she may have said or thought about anything at all—all these are lost to history and to gossip alike. It is thought, or surmised, that a portrait by Gova of an unidentified, thin-lipped, fairly plain-faced woman in her late twenties or early thirties, now in the Prado, represents Josefa Goya. 9 If so, no one could call it a document of marital passion. There exists, however, a much later drawing from 1805, indisputably by Goya of Josefa, which shows her in profile, rather worn and coarsened by age and repeated pregnancy. But then, every known Goya self-portrait shows him to have been a fairly ordinary-looking man. Their marriage lasted without incident or scandal for thirty-nine years, and as far as is known, this was the only depiction Josefa's loving husband ever made of her. No letters, or none that survive, passed between them, perhaps because they were seldom apart, or possibly because she was unable to read and write. If she was interested in his work. she left no record of the fact. If he was unfaithful to her and she found out about it, no trace of that survives either. Some might say it was an ideal marriage, characterized by the self-effacing loyalty and stability with which she ran the Goya household. But it was not ideal; Josefa must have suffered in the extreme, because she was said to have had twenty pregnancies (probably an exaggeration), from which six sons were brought to term and only one, a boy born in 1784 whom they christened Francisco Javier, survived. (Seven of their children were recorded and baptized; the dates of the others are lost, along with the children themselves: Spanish custom required the death of a child to be registered only if he or she had lived past seven years, and infant mortality was as high for commoners as for queens.) As though this tragic cycle of birth and death weren't enough, Josefa then had to spend the last twenty years of her life, when she was past childbearing, with a deaf husband. The home, Gova once remarked to Zapater, was "a woman's sepulchre." He spoke from experience. Or perhaps the phrase was Josefa's.

The marriage, however, did cement Goya and his brothers-in-law together as a team, helping them to gather the lion's share of commissions available in Zaragoza. In the early 1770s Goya embarked on a series of church commissions. One does not think of Goya as a religious painter because his early religious work has been so thoroughly eclipsed by the *Caprichos*, the *Disasters of War*; the

Goya, *El nombre de Dios adorado por los ángeles (Adoration of the Holy Name)*, 1772. Fresco. Coreto, Basílica del Pilar, Zaragoza.

portraits, and all that followed. But his early career was founded on sacred subjects. He got the commissions because, in part, he worked cheap. One of his competitors in Zaragoza, Antonio González Velázquez, had quoted the canons of Santa María del Pilar a fee of 25,000 reales for painting the ceiling of its *coreto* (little choir) with an allegory of the Adoration of the Holy Name. Goya cannily offered to do it for 15,000 reales, and the Building Committee for the Reconstruction of the Church of El Pilar gave him the job—subject, in view of his youth and inexperience, to some fairly stiff restrictions. He had to show that he could handle "true" fresco on plaster, and this he did by painting a sample: evidently he had learned the technique in Italy, since it was by no means commonly understood or practiced in Spain.

The given subject was a Gloria—the glorification, by saints and angels in heaven, of the Name of God. The committee asked for sketches of the design, in color, which it would then send to the Royal Academy of San Fernando in Madrid for final approval. It seems likely that Goya did only one sketch, which was enough to convince the Zaragoza committee that there was no need to send it on to Madrid for the academy's opinion. Goya got his contract without further ado, and completed the work in 1772.

The design he proposed was squarely in the solidified and classicized Rococo style of Corrado Giaquinto (1703–66). Goya must have first seen the Italian

painter's work in Rome, probably in the church of Santa Trinità degli Spagnoli, for which Giaquinto, working on a commission from the Spanish monarch Fernando VI, had executed the altarpiece, The Holy Trinity Freeing a Captive Slave (1750). With this work, Giaquinto had cemented his relation with the Spanish crown so firmly that, three years later, Fernando brought him to Madrid. He had remained there for nine years, most of the time working on frescoes, sculptures, and stucco decorations for the Royal Palace, the palace at Aranjuez, and other royal sites. This had been the climax of Giaquinto's career, and he had enormous influence at the Spanish court—a foretaste, in fact, of the artistic power that the next imported artist, Anton Raphael Mengs, would wield under Carlos III. Giaquinto was first painter to the king, director of the tapestry factory of Santa Bárbara, and director of the Royal Academy of San Fernando. (All three of these exalted offices would later be filled by Mengs.) One may fairly assume that Goya, who as a young, obscure, provincial commoner would have had no access to Giaquinto's Spanish palace decorations, would have taken care to look his work up when he was in Rome in 1771. A style that echoed Giaquinto's would obviously be acceptable at court; apart from that, Giaquinto was about as good as painting in Spain got when Goya was starting out on his long career.

Hence the distinctly Giaquintan look of the fresco in the *coreto* of El Pilar: solid, handsomely fleshy groups of figures borne up on diaphanous arches of cloud, the scene dominated by an angel on the right, swinging a thurible to send up clouds of incense smoke toward the glowing, unearthly triangle that symbolizes the Trinity and bears, as an inscription, the Holy Name in Hebrew lettering. The whole scene is suffused with a golden sunset light, rendered rather smoky by time. Many of the angels in Goya's design are glorifying the Lord by singing from musical scores, or playing instruments—lutes, violins, and horn. This suits the "little choir" where the fresco is situated, for it contains a real organ and choir stalls. Apart from its esthetic merits, this work clearly shows that young Goya cannot have been subject to vertigo; the mere idea of working on a scaffolding so high in the air is enough to make one's head spin, which suggests that his later attacks of dizziness must have made him fear even more for his ability to work than they ordinarily would.

He did a number of religious commissions in Zaragoza, including some paintings for the oratory of the Chapel of the Counts of Sobradiel. The most important of them, however, is extremely hard to get at and see today. It was done for a *cartuja*, or Carthusian monastery, the Aula Dei, about fifteen miles outside the city. The Carthusians are a world-shunning, silent order, and the monastery refuses admission to women, under any circumstances. Male visitors are let in,

but on strictly limited terms—a small group once a month, for about an hour. Thus, because there is never time for a really close look at the Goyas in the Aula Dei—and in any case their position, high up on the chapel wall, prevents it—these works, which are by far the largest and most ambitious of the artist's youth, are scarcely known and not adequately studied. There can be few other works of such importance by any painter of comparable stature of which this is true. One therefore approaches the Aula Dei with curiosity and trepidation, and is not altogether disappointed.

The trouble is that several of the eleven large mural paintings, all forming a narrative of the life of the Virgin Mary, were already wrecks by the end of the nineteenth century, and others had deteriorated badly. Goya, although he had shown his competence with buon fresco in the ceiling of the choir at El Pilar, for some unknown reason chose not to use fresco at all in the Aula Dei, and instead painted the pictures—each about twenty-six to thirty-three feet long by ten high—in oils directly on the plaster walls. Moreover, he did it in a rush, and seems to have neglected the (admittedly inadequate) precautions that could be made against rising damp in the walls. Thus Goya's paint did what oil pigments inevitably do on a damp, ill-sealed surface: it bloomed, whitened, darkened, cracked, spalled, and, within a few decades, was an irreversible mess. Neglect made things worse: during the Napoleonic occupation of Zaragoza the monks were turned out of the charterhouse and the whole place was abandoned. Later came the desamortización, or seizure and sale of Church property, in the late 1830s, in accordance with the Mendizabal laws. 10 Four of the eleven paintings were completely destroyed, and all suffered irreparable damage.

Eventually the Aula Dei was reoccupied by a new group of monks, most of whom were French. These pious men wanted holy icons to aid in prayer and contemplation and decided to restore the paintings. Since at the time, the turn of the twentieth century, Goya's reputation was small among French nonspecialists, and the Carthusians, holy though they were, were more noted for the production of the sticky liqueurs known as chartreuse than for connoisseurship, they hired a pair of French artist brothers, Paul and Amadée Buffet, to repair and in some places completely repaint Goya's scenes. Little is known about the Buffets. Presumably they were chosen by the head monk, the *padre prior*. How he picked them is not known. Though the *frères* Buffet were, at least, not relations of the appalling Bernard Buffet, whose spiky and melodramatic style, based on drawing that resembled a peevish sea urchin, would enjoy such fame in Europe in the 1950s (and even today has its fans in Japan), their marriage with Goya cannot be said to have been an entire success. It is not at all difficult

Goya, *La adoración de los Reyes Magos (The Adoration of the Magi)*, right panel, 1774. Fresco. Aula Dei, Zaragoza.

for a trained eye to pick out which parts of the murals as they are today are really by Goya, and which are by the Buffets. (The monks do not particularly care about this question of authorship, and some of them regard the presence of Goya's mural cycle in their chapel as more a nuisance than a blessing; it brings visitors, and visitors are by definition a distraction.)

In 1902, the Buffets set to work. The worst damage had been on the lefthand walls of the chapel, as you look from the entrance to the altar. Accordingly, the *Presentation of the Virgin at the Temple* is now entirely the work of the Buffets; likewise the next painting, the *Annunciation* of Mary's immaculate pregnancy, and the next, the *Showing of the Infant Jesus to the Shepherds*. The fourth scene, which is in the apse, depicting the *Adoration of the Magi*, is mostly Goya but with considerable additions by the Buffets. The fifth, the *Flight into Egypt*, is compositionally all Goya, though there may be some patching and infill by the Buffets.

The picture over the entrance presumably once depicted a pair of angels holding up the sacred name of Mary (an echo of his theme in the *coreto* at Zaragoza), but the cartouche or whatever it was that bore her name has disappeared, leaving the angels holding something invisible that is adored by Mary's parents, St. Anne and St. Joachim. The angel who is speaking to St. Joachim

and pointing to the angels above clearly shows the influence of Mengs, Carlos III's court painter: he is classically conceived, sturdy, and blond.

Down the right wall the scenes begin with the *Birth of the Virgin*, a tightly swaddled little papoose adored by a multitude of onlookers and relatives, about half of whom are by Goya and the rest by the Buffets. Particularly Goyaesque is a group on the extreme left, of shepherds or peasants of some kind, with staves: their strong silhouettes are a prediction of the groups of bandits Goya would paint later, cloaked and conspiratorial. Next comes the *Betrothal of the Virgin*, which, damaged though it is, still conveys some sense of the monumental effects Goya was striving for through his use of large-scale, broadly planar drapery. A few of its passages anticipate the mature Goya and perhaps demonstrate his early knowledge of Tiepolo's compositional devices—the crowd of figures, for instance, seen from below stage level on the left.

The scene of *Mary in the House of Martha* has been much repainted by the Buffets, but the apse scene after it, showing the circumcision of Jesus by the high priest, is almost all by Goya's hand. (In general the murals that suffered

Goya, Circuncisión (Circuncision), central panel, 1774. Fresco. Aula Dei, Zaragoza.

most from damp and "restoration" are at the entry end of the church, and those nearest the altar have suffered least.) The *Circumcision of Christ*, a powerful and looming group dominated by the figure of the high priest with his horned, golden headpiece, is early Goya at his most dramatic.

The combination of Goya and his restorers, or repainters, makes a strange sight. The Buffets, it seems, were not at all interested in repairing the look of Goya's paintings, though they may well have followed the broad structure of his monumental compositions. But they redid them in a pallid style, with silhouetted profile figures and pinky-greeny-gray coloring that derived from the most respected "official" idealist painter in France at the time, Pierre Puvis de Chavannes (1824–98). Nothing could have been less like Goya. Clearly, the Buffets felt they had a complete esthetic right to do this: they had been hired to paint the same scenes in their own manner. But the incongruity is extreme, especially if one contrasts the wan and mannered forms of the Buffets with the looming, rougher ones of Goya: the fierce, ragged energy with which the wings sprout from the shoulders of Goya's angels on the entry wall, for instance, versus the mincing shyness with which the little Virgin Mary tiptoes up the steps of the Temple in the scene next to it. At least there is no confusing the originals with the additions. But one feels a sense of loss: what were these huge paintings originally like? Rather grand in conception and severe in drawing, if one is to judge from the surviving ones, such as the Betrothal of the Virgin (1774), whose strongly planar figures are imbued with a Poussinesque gravity, or the remarkable Circumcision. What seems quite certain is that, to judge from the Aula Dei murals in their impressive ruin, Goya had by now moved on to a more coherent and much less derivative level of achievement than he had reached two years earlier in his frescoes for El Pilar. Certainly, he was on his way. The Aula Dei paintings were, for instance, his first narrative cycle, his first essay in a mode that would occupy him, for years to come, in designing tapestries for the royal court. But one does not become a famous artist by working for a closed order of monks, and by painting murals where they could not, by monastic rules, be seen. Somehow, he had to get to Madrid.

Which Goya did, and quite soon.

By December 1774 he had almost finished the Aula Dei murals: the frames for them were ordered. In the spring of 1775 he went to Madrid to join his brother-in-law Ramón Bayeu. Now the Bayeu connection really began to pay off: a year later Goya had finished five tapestry cartoons, to be woven by the Royal Tapestry Factory of Santa Bárbara under the direction of his other brother-in-law, Francisco Bayeu. In 1777 Francisco was appointed director of

Goya, *Portrait of Francisco Bayeu*, c. 1795. Oil on canvas. Museo Nacional del Prado, Madrid.

the tapestry works. A stream of commissions for designs now began to come Goya's way. In time he would find their fulfillment a bore and an almost menial distraction, but they were his entry to court circles, and through them to the direct patronage of the Bourbon kings. Thanks to his in-laws, the twenty-nine-year-old from Aragón was on his way at last.

COMING TO THE CITY

HE MADRID to which Goya, the eager provincial, first came in 1774 was the youngest capital in Europe, and in some respects the least culturally interesting. It could not have compared with what he had seen in Italy, though it was certainly an improvement on Zaragoza.

Madrid had never been a great Gothic city like Barcelona, and its past was fairly meager. Unlike so many of the major cities of Spain, it did not stand on Roman foundations; it owed its origin to the Muslims, who, in the late ninth century, set up a fortress on a rocky outcrop overlooking the Manzanares River, intended to frustrate any Christian attempts to gain a military advantage in the Tagus Valley. But the Muslims left no remarkable buildings behind them, no relics of their presence that could even remind the visitor of the architectural wonders of Sevilla or Granada. The decisive turn in the city's life came in the mid-sixteenth century, when the Hapsburg emperor Charles V decided to establish his court there. He did so for the most sterile of reasons: Madrid is in the (more or less) exact geographical center of Spain. It is equally close to, and equally far from, everywhere else on that ragged quadrilateral of a peninsula. Pitching a capital there avoided favoring any locality or cultural grouping. Besides, absolute rulers tend to dislike ports: they are too open to the rest of the world, too labile, too prone to foreign influence.

Madrid grew rapidly as soon as it was declared to be the future Hapsburg capital. The population figures, rough though they are, tell the story. About 4,000 people lived in this sleepy, dusty hole in the middle of the high Spanish

plateau, separated from the sea and the rest of Europe by appalling roads, in 1530; thirty years later, there were close to 20,000; by 1598, some 60,000; and by 1621, nearly 150,000—this at a time when the population of many northern capitals was shrinking, partly due to outbreaks of plague. What drove this increase was an industry: the industry of government, the gravitational pull of the court. This fierce rate of growth slowed somewhat during the rest of the seventeenth and the eighteenth centuries. When Goya got to Madrid the city contained about 148,000 souls: not a big town, nor one that offered a broad-based or very active art market.

It could boast public baths, fountains, paved and sometimes tree-lined streets. It was also mean, dirty, and lacking in amenities, except for the rich—and it was not always exceptionally comfortable for them either. Their palaces were smaller than they would have been in Italy or London; the grandest were no more than four stories high.

Modes of interior decoration were certainly changing, in conformity with those of northern Europe. The social satirist Ramón de la Cruz, whose plays enjoyed great popularity on the Madrid stage, wrote about how cornucopias were replacing displays of lances and armor, signaling that families no longer needed to show off their descent, real or imagined, from the good old days of chivalry; and he poked fun, without much actual justification, at how painted wallpaper and printed cottons were displacing the old pictures by "Velázquez, Ribera, and other *pintorcillos* [little painters] of that kind." But if they were doing so—and not many families had Velázquezes or Riberas to take down—it was only because an international neoclassical style, as practiced by Madrid architects like Ventura Rodríguez and Juan de Villanueva, reigned in Madrid as it did in Rome, Paris, and London, and painted Chinese wallpapers and printed fabrics were part of that style. Such backgrounds can be seen frequently in the portraits by Goya.

Throughout his working life, Goya would paint in the service of a series of absolute monarchs of the Spanish Bourbon line. For thirty-nine years, from 1789 till his death in France in 1828, he was steadily employed as a court painter. For nearly thirty of those years he was first court painter, the highest cultural office Spain had to offer in the visual arts. We are apt to think of him as a great outsider, a merciless critic of the society around him and a habitual protester against war, cruelty, and the violence of unjust authority. And so he was—in his drawings and prints and some of his small paintings. But the bigger pictures, which are just as authentically his and make up the bulk of his work, tell a different story. Work for the Spanish court, supplemented by private por-

trait commissions, would be his bread and butter, and he rarely seems to have found it burdensome or chafed against its constraints—except once, in 1792–94, when the routines of production for the Royal Tapestry Factory of Santa Bárbara got him down. But this was decorative art, *fêtes galantes*, country customs and the like, technically very demanding—not direct portraiture of living men and women in whose characters one could get interested. A century later, John Singer Sargent would prosperously moan about the tedium of churning out what he derisively called his "paughtraits."

Not Goya—or not on the record, anyway. He was thankful to have such work, as much as he could get. Spain was not a country in which a painter could easily earn a good living. Patronage was very spotty and existed, to all intents, only in Madrid. The layer of people interested enough in the visual arts to buy paintings was exceedingly thin compared with the kind of art markets that flourished in France, Italy, and England. And although the Royal Academy of Fine Arts of San Fernando had been founded in Madrid in 1752, six years after Goya's birth, it never attained the career-making power that the comparable academies in Paris and London possessed—it was a lackadaisical, provincial affair.

But Madrid was extremely conscious of its own identity, and for some time before Goya's arrival it had been torn with dissension over what was, and what was not, authentically Spanish. Its more educated citizens, who inevitably came from the upper and middle classes, were often open and receptive to what was going on north of the Pyrenees, in a more intellectually and culturally advanced Europe—especially in France, and to a somewhat lesser extent in Italy. The less educated were not: they suspected whatever was foreign of being unpatriotic. This rift went very deep into Spanish culture and revealed itself in bitter divisions, as the Napoleonic invasion would show.

But there were much earlier signs of it. Every so often, a state or a culture will produce an event so peculiar that you feel it could not possibly happen anywhere else, that it epitomizes something weird about the place even though its causes turn out, on inspection, to have a logic of their own.

Such an event took place in Madrid in 1766, the seventh year of the reign of the Bourbon monarch Carlos III. It was known as the Motín d'Esquilache—the Esquilache Mutiny, or the Hat and Cloak Revolt.

Before ascending to the Spanish throne, Carlos had ruled in Naples over the Kingdom of the Two Sicilies (consisting of Naples itself and Sicily). There he formed a strong reliance on a promising Sicilian administrator named Leopoldo de Gregorio, who had been appointed to the customs service but quickly rose to be a secretary of state in Naples, and was made marquis de Squillaci when Car-

los ascended the Neapolitan throne. In 1759, when he inherited the throne of Spain, Carlos brought Squillaci with him (his name now Hispanicized as the marqués de Esquilache) and made him successively a minister of finance and, in 1763, minister for war. Esquilache would help his king in the difficult task of modernizing Spain, a project in which Carlos III ardently believed.¹

Esquilache threw himself into this project with enthusiasm, tightening up the hitherto somewhat haphazard tax laws and, especially, the laws relating to public order and delinquent behavior. As a result, he was not much liked, especially not by the lower orders. Esquilache lived rather lavishly and, worse than that, he was a foreigner. And by sheer bad luck, his six years in the Ministry of Finance coincided with a long, very severe drought, which had ruinous effects on the Spanish economy, forcing up the price of all agricultural produce, especially bread. Probably no minister, however ingenious, could have kept the prices down, but Esquilache was a handy focus of popular resentment among the almost invariably xenophobic Spaniards.

Still, ministers have been known to survive worse crises. What broke Esquilache was, of all things, a matter of dress code, which he had been pursuing as an issue of criminal law. For a very long time, Spanish men had been in the habit of wearing long capes and broad-brimmed hats. The look was a staple of Spanish fashion, almost archetypal—stylish anonymity. It was also a quite effective form of disguise: pull down the brim, swathe yourself in your *capa*, and there was a good chance that no one would see and remember your face as you scuttled from the scene of the crime. Plus, the cloak could conceal a dagger or a sword. Here was an opening for a vigilant anti-crime crusader.

In 1766 Esquilache persuaded his king to dictate a royal edict banning long capes and wide-brim *sombreros*. Thenceforth only short cloaks, three-cornered hats, and small wigs could be worn in the city. This order applied to everyone, from government employees and middle-class merchants to the indigent (not that many beggars could afford the long cloak anyway). It was enforced by bailiffs, who set up trestle tables in the city and, wielding the scissors of sartorial doom, arrested offenders and summarily trimmed their garments to length. Before long, the jails of Madrid were crowded with indignant and capeless men.

This petty harassment—imagine the state of California's banning the sale of sunglasses and ski masks on the ground that they disguised criminals, and directing all police departments from San Francisco to San Diego to arrest anyone seen wearing such accessories—was to drive *madrileños* of all kinds and classes almost berserk with fury. Long files of pro-cape demonstrators, their faces hidden from the authorities, paraded outside the jails. There were peti-

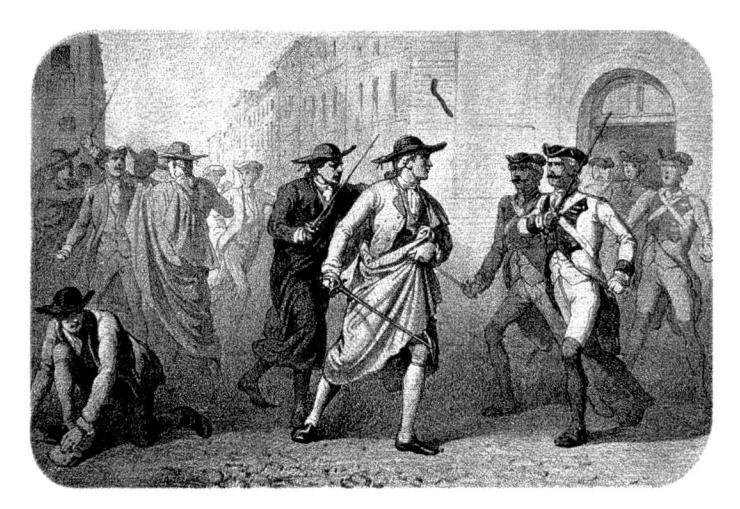

Artist unknown, Esquilache Riot in the Spring of 1766. Engraving. Museo Municipal, Madrid.

tions, satires, pasquinades, street fights. After two months of this, Madrid blew up in what has been known, ever since, as the Motín d'Esquilache. On March 23, Palm Sunday of 1766, mobs broke open the jails and emptied them. Citizens tried to storm Esquilache's town house. A number of palace guards—especially those of the Walloon infantry regiment, whose members, being foreign too, were much hated—were killed. The oil-burning streetlamps that Esquilache had installed only the year before in the streets of Madrid, a brandnew civil amenity of which he and the king were quite reasonably proud, were smashed—some 4,400 of them, each twelve feet high, iron and glass, all destroyed in a frenzy of direct protest, it seems, against illumination. To have light forced into dark corners was a sign that the king's ministers and his foreign bureaucrats did not trust them. It was an insult, like training surveillance lamps, automatic cameras, and microphones after dark on today's city streets.

The riot worked. It put an end to the career not only of Esquilache, who had to go into exile, but of other Italian officials the king had brought with him from Naples: there would be no more high-placed foreigners running things in Carlos III's administration. The ban on cloaks and hats was rescinded, but the conde de Aranda, who took over from Esquilache, solved the original problem with a masterstroke of lateral thinking: he decreed that the long cloak and the wide hat would, from then on, be the official uniform of Spain's public executioners. The items immediately dropped out of fashion with the public, in Madrid and everywhere else.

The strand of symbolism running through this was almost too good to be true, and it is worth reflecting on. Esquilache was not only a foreigner but a

bureaucratic ilustrado—one of those "enlightened," reforming busybodies from beyond the Pyrenees whose presence at court was getting more and more encouragement from the "enlightened" king, Carlos III. His desire, in the interests of public harmony and order, to disclose what had once been concealed—the weapon beneath the cloak, the face beneath the slouching hat brim—and to throw publicly sponsored light into the shadows of Madrid after dark (how could any creature but a bat object to that?) was a small but potent metaphor for the mighty project of éclaircissement—clarification and illumination of issues by the light of unaided Reason—that so inspired the liberal humanists of France, Italy, and Germany. Some of those descendants of Rousseau and Voltaire might have found Esquilache's methods high-handed and intrusive, but few would have disagreed that they pointed to some kind of public good. But for the Madrid pueblo no light at all was better than foreign light. Carlos himself was exempted from the people's blame. He was their king; hence, he had been misled or duped by the "macaronis." For these foreign advisers, with their un-Spanish ways, no opposition could be too rancorous, no blame too sharp.

The king looked eccentric to well-placed foreign visitors. But then, mutatis mutandis, so did some of the English Georges, especially the porphyria-afflicted Third. Carlos III was short and unimposing, with a complexion the color of mahogany. He did not care about fashion: "He has not been measured for a coat these thirty years, so that it sits on him like a sack," observed an English diplomat in Madrid. Nevertheless, added another, "with the greatest gentleness, he keeps his ministers and attendants in the utmost awe." The courtiers would certainly have preferred a more amusing, a more "interesting" king. His pleasures were solitary rather than communal. Orchestras were not welcome in the palace, and neither were theatrical troupes; court life was said to be sunk in monastic tedium.

Carlos III is credited with bringing the European Enlightenment to Spain and encouraging it to become *la ilustración española*. This was true to a very limited extent, but its limits were to have long inhibiting effects on Spanish thought, education, and politics. An enlightened despot is a despot still, and the signs of despotism were everywhere in Carlos III's reign, relatively benign and even (at times) open-minded though it may have been compared with those of his father, Felipe V, or, worse yet, his grandson Fernando VII. "Our lower orders have no more deeply held opinion than this," wrote Pedro Rodríguez, the conde de Campomanes (1723–1802), one of the higher administrative *ilustrados* of the day: "The king is absolute lord of the life, the goods, and the

honor of all. To cast doubt on this truth is held to be a kind of sacrilege."² All the efforts of Enlightenment thought in eighteenth-century Spain must necessarily be seen against the background of an unalterable belief in the divine right of kings, which no merely constitutional arguments had the power to confront.

For his part, Carlos III flatly refused to have any dealings with any courtier or politician who was not a punctilious Catholic, a believer in every last scintilla of church dogma, including the Immaculate Conception, that implausible article of faith to which the chaste king strongly adhered: each newly hired court scribe had to swear to uphold it. The idea of sin appalled him—how could anyone, he asked, possibly be so rash as to commit even a venial one?—and he went to Mass every morning. To call him enlightened, therefore, in the same sense as other eighteenth-century monarchs from Gustav III of Sweden to Maria Theresa of Austria, let alone Frederick the Great of Prussia or Catherine of Russia, is a very long stretch. One cannot imagine Carlos's bombarding Voltaire, as the imperious Catherine did, with invitations to come and be the intellectual ornament of the royal court (or Voltaire's accepting them, for that matter).

In most of his dealings with the world and the court, Carlos was a man of singular rigidity, perhaps the most punctilious monarch ever to occupy the Spanish throne—not that his predecessors could have been accused of informality. His favorite metaphor of political life was the clock, with its cogs and wheels ticktocking along in a regulated, invariable pattern.³ Each morning a chamberlain who slept outside his room awoke him at 5:45 precisely. The king rose, said his morning prayers, and meditated on his sins until 6:50, and at 7:00 entered the robing room, where his pulse was taken and his vital signs noted by doctors, surgeons, and herbalists. There he washed, breakfasted, and drank the first of the cups of chocolate he would consume in the course of the day, served by his Neapolitan pastry cook. (The royal appetite for chocolate was such that he was served from a giant, steaming urn that could hold gallons of it. He was, however, slightly embarrassed by his own chocoholism, and would cue his staff to replenish his cup by carefully looking the other way.) Then chapel, a visit from his sons, and at 8:00 to his study, where he worked until 11:00, conferring with his eldest son, the prince of Asturias, the future Carlos IV. Then the daily sacrament of confession, the daily meetings with the ambassadors of Naples and France. The king ate lunch on his own, but in semi-public, with courtiers watching. A painting by one of his court artists, Luis Paret, shows him at table, attended by a standing crowd (including the archbishop of Toledo, whose duty it was to recite grace) and, looking rather incongruous in the high, tapestry-

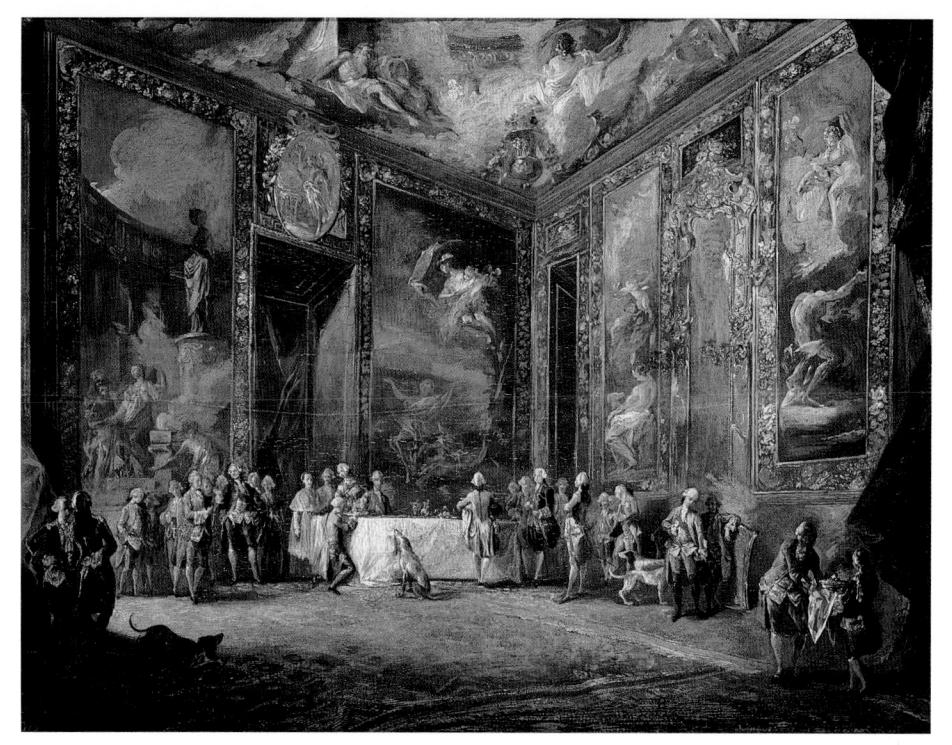

Luis Paret y Alcazar, *Carlos III Lunching Before His Court*, c. 1770. Oil on panel, 50 x 64 cm. Museo Nacional del Prado, Madrid.

hung room, several hunting dogs. Their presence did not seem incongruous to Carlos III. Just as invariable as his daily dealings with prelates and diplomats were his postprandial siestas and his evening hunts.

The evenings in royal company were said to induce a profound torpor. His majesty had scarcely any interest in either music or theater. His predecessor, Felipe V, had imported Europe's most famous tenor castrato, the Italian Carlo Broschi, who sang under the name of Farinelli, from London to perform regularly in the small theater attached to the Buen Retiro Palace. For twenty-two years Felipe showered the singer with portraits, jewelry, elaborate snuffboxes, a two-mule coach, a house and staff, and an annual salary of 135,000 reales; Carlos III viewed this as a ridiculous extravagance and had Farinelli dismissed. What he really liked was to go out shooting on the grounds of one of the royal palaces in and around the city (Goya's first major painting of the king depicted him dressed for the hunt). His two favorites were El Pardo, overlooking the Manzanares River about eight miles from the center of Madrid, whose grounds (their hunting rights reserved for the king alone) teemed with fallow deer, wild boar, and even wolves; and the royal retreat on the Tagus River at Aranjuez, some thirty miles south of the capital. He spent far more time at his retreats than in Madrid itself. As a rule, he would quit the city early in January and stay

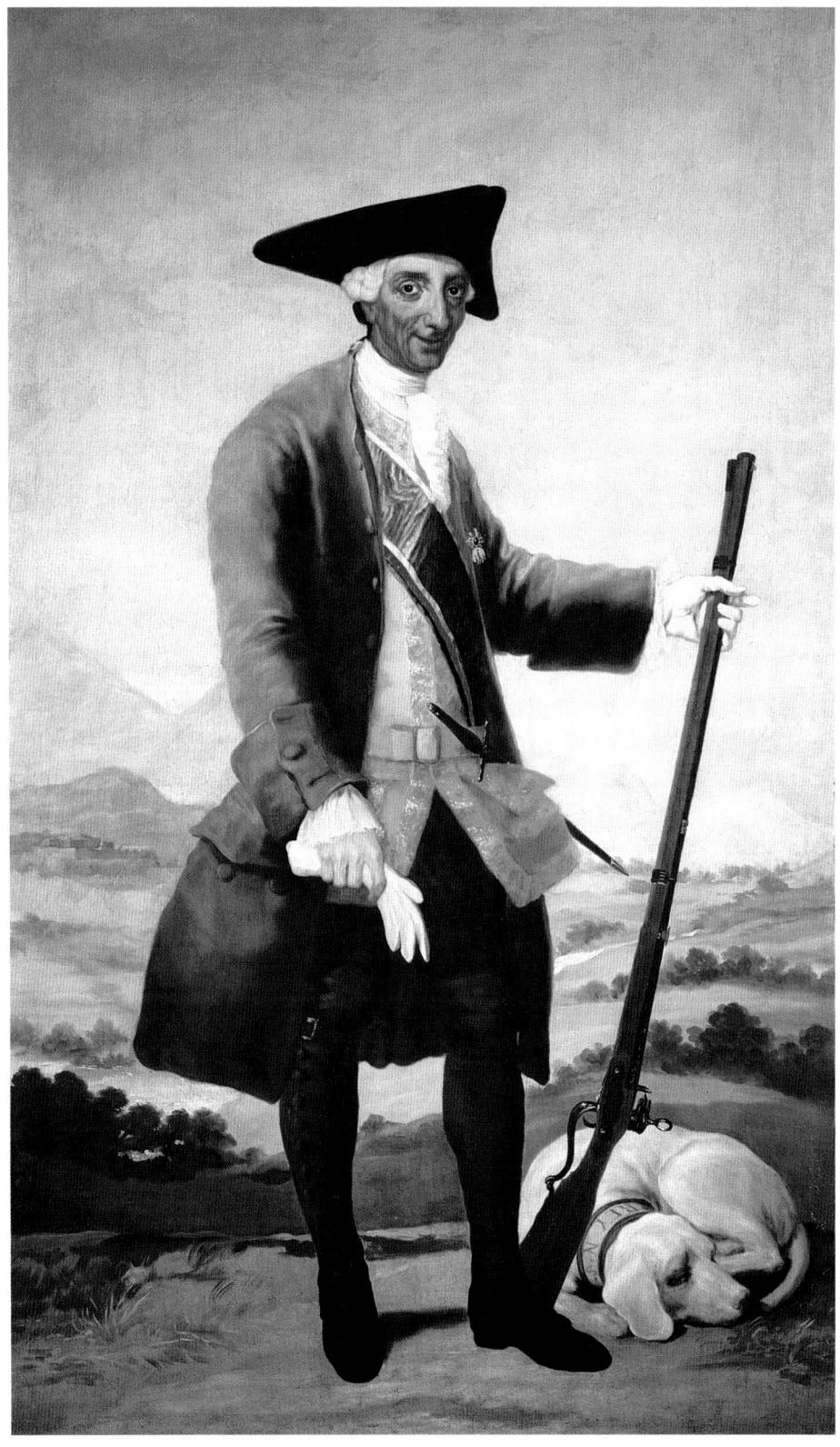

Goya, *Carlos III in Hunting Costume*, 1786–88. Oil on canvas, 210 x 127 cm. Museo Nacional del Prado, Madrid.

at El Pardo until Palm Sunday; from Easter to late July the court would move to Aranjuez, where the king would go hunting *chochas* (woodcock) and wildcats, and then relocate to La Granja for more shooting. All this shuttling between one pleasance and the next meant, as a rule, that Carlos spent only ten or twelve weeks a year in the capital, and all the rest in the country.

What was so "enlightened" about a way of life so given—indeed, so consumingly devoted—to piety and hunting? From a modern perspective, not very much. Carlos III needed the power of the Church and the support of the Inquisition. Without these, his power over the Spanish people would have been greatly diminished. If it was in the clergy's interest to keep ordinary Spaniards in a permanent state of superstition and mental sloth, so be it.

It was a condition shared by better-educated people than mere proletarians. You did not need to be an ignorant prole to believe, for instance, that in 1714 the bedsheets of Felipe V and his new bride, Isabella Farnese, emitted an unearthly glow, no matter how many times they were washed; the cause was well known—not enough Masses had been said for the repose of the soul of her predecessor, María Luisa of Savoy. Fifty, seventy-five years later, this national weakness for quasi-religious superstition had not changed, and the whole structure of faith, guilt, and fear that underpinned the power of the Church had scarcely been shaken at all by the intellectual winds blowing across the Pyrenees.

If the early education of young Spaniards (restricted, of course, to the males) was based on rote learning, coercion, and corporal punishment, the intellectual state of the universities they graduated to—assuming that they went to university at all, which most did not-hovered between farce and disgrace. Lazy, incompetent, and reactionary teachers; obsolete curricula; chairs of theology but none of physics, botany, or astronomy. In the early eighteenth century, the French abbé Vayrac made a tour of Spain and remarked in an account of his travels that, as far as philosophy was concerned, the Spanish academics and intellectuals displayed a mulish indifference to all aspects of current European thought: they were "so much enslaved by the opinions of ancient writers" that they could not begin to comprehend modern ones, just as Spanish doctors were in medicine. "Aristotle, Duns Scotus, and Thomas Aquinas are such infallible oracles to them that no one who fails to slavishly follow any one of the three can aspire to be called a good philosopher." The same inertia affected all domains of thought. During the reign of Carlos III it was considered daring, and perhaps heretical, to acknowledge the existence of Newton or Descartes. Up-to-date books on the natural sciences, and serious philosophical texts more recent than those of ancient Greece or, at best, the medieval schoolmen, were not available: they had to be smuggled in, usually from France, and paid for at bootleg prices in bookshops that were raided at intervals by heresy-hunting authorities. *Ilustrado* officials complained about the situation, but their power to abolish it was limited by the clergy. One of the complaints of Gaspar Melchor de Jovellanos, in drawing up an outline of studies for the University of Calatrava, concerned the priestly custom of reading aloud to the assembled students in the refectory at mealtimes from books full of "ignorance and superstition, swarming with apocryphal miracles, implausible and ridiculous deeds."

Carlos III nevertheless imposed some reforms on the elite schools known as the Colegios Mayores, which supplied his regime with its upper bureaucracy. It would no longer be necessary, for instance, for an undergraduate, or *visitador*, to supply proof of his "purity of blood": a necessary change, since these colleges had degenerated into closed shops for offspring of the nobility.

Before speaking at all of Spanish "enlightenment," one must first remember the absolute spiritual dictatorship of Spanish Catholicism. Other countries touched by the Enlightenment had also been affected by religions in rebellion against the power of Rome: the northern European Enlightenment would hardly have been possible without the earlier Reformation, the weakening of Roman absolutism by Luther and his descendants. There was, in other words, living space for other religions north of the Pyrenees, hideously spattered though it had often been by the blood of sectarian wars. But for Spaniards in the eighteenth century, no less than in the seventeenth and the sixteenth, the one and only religion was Catholic: *luteranos*, being heretics, were scarcely even regarded as Christians, and were placed on a level with Jews and Muslims. There was not one Spanish institution that could truthfully have been called secular; all public life was permeated and enlaced by the dictates and desires of what was called the One, Holy, Roman, Catholic, Universal, and Apostolic Church. And its chief instrument was the Inquisition, otherwise known as the Holy Office, the inflexible and dedicated enemy of the Enlightenment.

To say that posterity gave the Spanish Inquisition a bad name is, of course, to put it very mildly. It became the archetype of Protestant conceptions of Catholic cruelty, deceit, and viciousness; its image lurks behind so much Gothick fiction and pseudo-history that it became one of the master images of the eighteenth and nineteenth centuries. To some, saying that the Inquisition was not actually as bad as it has been painted is like saying that Rudolf Höss, commandant of Auschwitz, was kind to stray cats. This detail from the absurdly bloodcurdling introduction by a Protestant divine, the Rev. Ingram Cobbin, M.A., to a

Victorian edition of *Foxe's Book of Martyrs* describes, most imaginatively, the instruments of torture French occupying troops found when they burst into the dungeons of the Holy Office in Madrid:

The third was an infernal machine, laid horizontally, on which the victim was bound: the machine then being placed between two scores of knives so fixed that by turning the machine with a crank the flesh of the sufferer was all torn from his limbs into small pieces. The fourth surpassed all the others in fiendish cruelty. Its exterior was a large doll, richly dressed, and having the appearance of a beautiful woman with her arms extended ready to embrace her victim. A semicircle was drawn around her, and the person who passed over this fatal mark touched a spring which caused the diabolical engine to open, its arms immediately clasped him, and a thousand knives cut him in as many pieces.⁵

Rarely can inventive bigotry have coexisted so happily with the Victorian love of fanciful automata.

The Spanish Inquisition was first authorized by Pope Sixtus IV at the request of the rulers of Spain, Fernando and Isabel, in 1478. These "most Catholic monarchs" were perplexed and disturbed by the relative tolerance of faith that had developed in their country. Alliances had been formed between Christian and Muslim nobles. Catholic families, including some of the highest in the land, had intermarried with Jewish ones. Desirable as this may seem to a modern eye, to Fernando and Isabel it was intolerable. By 1492, the year Columbus reached the Caribbean, the bigotry fanned by the royal couple had reached a point where Spanish Jews were forced to choose between conversion and exile. Those who chose the former were named, along with their descendants, conversos or, more insultingly, marranos (pigs). Members of Muslim families who made a similar choice were known as *moriscos*. It was part of an intensive drive to burn all competing faiths out of the kingdom, which involved the forced or merely nominal conversion of the *moros*, or Muslims, who had been beaten down in the *reconquista*, the Christian "reconquest" of Spanish territory, and the complete eradication—at least in name—of Spanish Judaism. (It is a curious fact that neither Fernando nor Isabel was as personally anti-Semitic as one might assume from their appalling political conduct toward Jews. Ferdinand's own doctor, David Abenasaya, was a Catalan Jew, and the monarchs relied on Jews for financial advice. 6) Since both Jews and Arabs were deeply implanted in Spanish society and had lived in a remarkable degree of harmony with Christians until the fifteenth century, this was a difficult and even a preposterous

task; carrying it out involved savage extremes of cruelty and injustice, all of which were fully supported by the Catholic Church. There was, in fact, something suicidal about the effort. When Felipe III, egged on by the shortsighted duke of Lerma, managed in 1609–11 to expel nearly all the remaining descendants of the "Moors," or Spanish Arabs—about half a million people—he did so in full awareness of the melancholy fact that he was cutting his realm's own economic throat by getting rid of many of its shrewdest and most industrious citizens. The Inquisition embroiled Spain in endless internecine denunciations; it ruined civil liberties by plunging the realm into an obsessive pattern of denunciation and the settlement of personal scores in the name of religion; it populated the peninsula with imagined witches and their hunters, with infidel chasers and would-be heretic burners. To state that this loathsome institution was not always as bad as it was painted by the propaganda of indignant Protestants is not to whitewash it. It was meant to be a tribunal of faith. It ended up as a mechanism of social control, including sexual control.

The Inquisition was not equally active at all times. After a period of high activity in the sixteenth and early seventeenth centuries, its enquiries and persecutions began to taper off in the final quarter of the seventeenth. The last big ceremonial demonstration of its power and presence was the immense autoda-fé (literally, "act of faith") staged in the Plaza Mayor in Madrid in 1680.

The Inquisition had been created by papal order, but it was far from being a purely religious organization; its ultimate control lay with a royal council, the Suprema, which was appointed by the reigning monarch, as were all officials of the Inquisition. The crucial issue before the Holy Office was always twofold: purity of blood, and loyalty to the Church. Purity of blood (*limpieza de sangre*) was, of course, a deeply vexatious question, especially since records were not always good and hundreds of years would pass before any sort of genetic testing would become even notionally possible. But it was an obsessive issue, especially since from the sixteenth century on no one could aspire to any sort of official career without a certificate of purity of blood, of non-Jewishness. (In the eighteenth century the old and certified gentile families of Palma de Mallorca, capital of the Balearic Islands, were for this reason glad to be known by the otherwise rather derisive name of *butifarras*, "pork sausages.")

From time to time traveling Inquisitors would descend on a city or village and conduct enquiries into the religious correctness of its citizens; these would be set in motion by suspicion or outright denunciation. The penalty for heresy, or for being a "Judaizer" (one who, having abjured his Jewish faith, continued to practice it in secrecy) or an *alumbrado* (an illuminist who, in contravention of

Catholic doctrine, minimized the importance of Church ritual, or any one of a number of other contraventions), was death—usually by burning at the stake.

The Inquisitors were not allowed to torture people to death, but torture could be used to extract evidence by confession. Of the three main forms of torture, the most common was the *garrucha*, in which the victim, arms tied behind his back, was lifted by a hook and chain attached to the wrists, then suddenly dropped, which would usually dislocate the shoulders and rip apart the main tendons. In the *toca*, or water torture, the accused was tied down on a rack, his mouth forced open, and a *toca*, or linen cloth, pushed down his throat. Water was then dripped onto the cloth to simulate the sensation of drowning. The *potro* was a method of torture in which cords wrapped around a victim's body were slowly tightened. All these techniques, in experienced hands, were so effective that there was no need for clockwork maidens and other figments of the Victorian imagination. Kamen quotes from one of the abundantly detailed trial transcripts, involving a luckless woman who, in the sixteenth century, was accused of refusing to eat pork and of changing her linen on the Jewish sabbath:

She was ordered to be placed on the *potro*. She said, "Señores, why will you not tell me what I have to say? Señor, put me on the ground—have I not said that I did it all?" She was told to talk. She said, "I don't remember—take me away—I did what the witnesses say." . . . She was told to talk. She said, "Señores, it does not help me to say that I did it and I have admitted that what I have done has brought me to this suffering.—Señor, you know the truth.— Señores, for God's sake have mercy on me. O Señor, take these things from my arms—Señor, release me, they are killing me."

It may seem strange that the power of the Inquisition at its height had little or no effect on the creativity of Spanish writers, but it is nevertheless true. The Inquisition wielded its greatest power at precisely the time (from about 1500 to 1680) that the greatest works of Cervantes, Quevedo, Juan de la Cruz, Juan de Valdés, Góngora, Tirso de Molina, and a dozen others were produced. There is, perhaps, an analogy here with the flowering of creative dissident literature in revolutionary Russia. But the effect of the Inquisition on intellectual and academic life in Spain was, by contrast, catastrophic. In 1770, about the time when Goya was getting ready to move to Madrid, the spirit of enquiry at Spanish universities had been brought so low by the interventions of the Holy Office that out of thirty-three professorial chairs in Spain, twenty-nine were empty.

At the outset, Spanish *ilustración* had a derivative and secondhand character. This was particularly visible in the domain of scientific thought—for the

northern European Enlightenment was firmly planted on a belief in the primacy of scientific reason and discoverable Natural Law. There was no Spanish equivalent of Diderot's *Encyclopedia*—hardly a surprise, there being no Spanish equivalent of Diderot himself. Not one of the technological advances that we now associate with the so-called Age of Reason was made first in Spain, or came there soon or easily: not smallpox vaccination, not the steam engine linked to a flying shuttle that revolutionized fabric production in England but didn't reach Spain for half a century, not the thermometer, the mechanical seed drill, the train, or the simplest electrical generator—none of these things reached Spain, except sometimes Cataluña, for at least a generation after their use in northern Europe became commonplace. Hence eighteenth-century Spain had no governing metaphor of "invention" or "modernism" in daily life, and the thought of "advanced" ideas—even with a metaphor of scientific progress to back them up—meant very little to most people.

The same held largely true in the theoretical sciences. Eighteenth-century Spain contributed nothing to the progress of physics, mathematics, or astronomy. Its sparse population of savants took note of the fundamental revolution in chemistry achieved by Lavoisier and others but could add very little to it. Being so much an agricultural nation, though, Spain did take account of recent developments in natural history. By the 1780s, the works of the Comte de Buffon were obtainable in Spanish translation (at a price), local botanists like Antonio Palau and Antonio José Cavanilles had done much to describe and classify the flora of mainland Spain, while a good deal of work had been done on the corresponding exotica of its American colonies by such botanists as Hipólito Ruiz, José Pavón, and especially José Celestino Mutis. Mutis was a most singular figure. Perhaps more than any other natural historian of the eighteenth century, he had managed to involve the crown directly in his projects—a feat of funding and patronage that not even Joseph Banks or the great Linnaeus had managed to bring off. This was one of the areas in which Carlos III was an ilustrado. Part of the motive for this underwriting was medical: for instance, in the study and classification of numerous species of Cinchona, the plant from which quinine was extracted. Without this anti-malarial drug, the exploitation of Spain's colonies in South America would hardly have been possible. Mutis kept Carlos III's interest by means of magnificently illustrated reports and such eloquent, heartwringing descriptions of the perils of his work as this:

My Lord, the inconveniences that accompany the laborious study of nature do not horrify me. Academics, in their studies or schools, pass whole days in
Nevertheless, the well-attested principle that scientific inquiry expands with the spread of empire was less true in Spain's dominions than in those of any other eighteenth-century imperial power. There would be no great ornithological works, for instance, arising from Spanish possessions in South America until those colonies, such as Venezuela, had rebelled and won their own nationhood in the nineteenth century.

Carlos III did his best to embark on what had previously been thought of as the luxury of social reform by pulling down some of the more pointless class divisions of a too-divided Spain. He abolished the old rule whereby the minor, impoverished nobles called *hidalgos* were forbidden to work with their hands, for fear of "letting the side down." He tried to reduce the power of town councilors, who were apt to run their towns like oligarchies. He decreed that municipal offices should be open to commoners—the "vile mechanicals," carpenters, cobblers, smiths. He concerned himself with workers' rights, including the right to a safe workplace and to freedom from tyrannous employment conditions.

Carlos III also wanted to see an *internal* colonization of Spain. Huge tracts of its land, notionally fertile but wretchedly neglected for generations, remained uncultivated and barren—victims of large-scale Church and aristocratic ownership, which did nothing to develop them but would not sell them to anyone who might. It is hard to exaggerate the extent of Church power in Bourbon Spain. At the end of the eighteenth century, out of a population of some 10.5 million, the country contained about 200,000 priests, nuns, monks, and other persons under direct ecclesiastical control—one in fifty, three times the Church population of France and twice that of Italy. The disproportion of nobles and their aristocratic holdings, too, was vast. "The poorer the land, the more nobles on it," ran the saying, and in 1800 there were approximately 400,000 heads of families with some kind of noble lineage—one aristocrat for every twenty-seven inhabitants. In one area, the Basque territory of Guipúzcoa, everyone was supposed to be a noble of some kind, and aristocrats formed some 10 percent of the populations of Navarra, Burgos, and León. Out of some 22,000 pueblos

(inhabited village communities) throughout Spain, no less than 10,600 belonged to secular nobles, most of whom contributed nothing whatsoever to their maintenance, let alone to any notion of development.

This rule by lazy, incompetent, and insignificant parasites, lay or religious, was the root of the "agrarian question" over which the "enlightened" economists of Carlos's reign, such as the conde de Campomanes and Jovellanos, spilled such rivers of ink: how could one get the miserably stagnant Spanish agrarian economy, so fettered by seasonal worries and shortages of investment capital and labor, to kick over and start producing? How to raise the giant farms, with their absentee landlords and chronic lack of economic impetus, above the condition of latifundiae worked by men who were hardly better off, and sometimes worse off, than slaves? One way, Carlos and his advisers theorized, would be to ship thousands of workers into selected areas, not only from other parts of Spain but, as in their project in the Sierra Morena, from Holland and Germany as well. These immigrants would be settled in colonias, purpose-built new towns, where they would be free of the self-serving tyranny of large landowners and religious orders. As a bonus, their presence would (the authorities hoped) reduce the ever-present problem of brigandage and highway robbery. These small communities would police the wild wasteland. So they did, to a small

Anton Raphael Mengs, *Don Pedro Rodríguez*, *Conde de Campomanes*. Real Academia de la Historia, Madrid.

extent, but the idea that the general ills of rural Spain could be cured by resettlement was a chimera. The man Carlos III had put in charge of the project, Pablo de Olavide, had too many enemies, mainly in the Church. Olavide's activities in the new "colonies," which reduced the power of the Church in their lands, were bitterly resented by the clergy. Denounced and arrested by the Holy Office, he was imprisoned for heresy at the end of the 1770s. Part of the "evidence" against him was his correspondence with Voltaire and Rousseau. His property was confiscated. He was banished for life from Madrid, Sevilla, the colonies he had helped create in the Sierra Morena, and—just in case he thought of going into exile there to think his heretical thoughts—from Lima as well, though what threat he might have posed to Catholic orthodoxy from that remote colony was not made clear. Olavide was a human sacrifice who had to save his skin, after eight years' imprisonment in a monastery, by escaping to France, another *ilustrado* who was too advanced for his "liberal" monarch.

The *ilustrados* were deeply interested in economic theory and reform policies, much more so than in epistemology and abstract political philosophy. The most intelligent and practical-minded of these *ilustrados* was unquestionably Don Pedro Rodríguez, the conde de Campomanes (1723–1802), for whom, as he once put it, the invention of the sewing needle was more important than all the syllogisms of Aristotle.

Campomanes' ideas were behind Carlos III's controversial new laws favoring the dignity of work, including manual labor, and the trimming of meaningless privilege from the minor nobility. You could not call him a revolutionary, but Campomanes was very decisively a reformer, a position that sprang from his roles as economist, lawyer, and director of the Royal Academy of History. He was, with the conde de Floridablanca, the most powerful advocate of "regalist" politics, which dictated a lessening of the Church's power in state matters and a growth in the king's. Campomanes was particularly determined to rein in the Inquisition and to reduce the concentration of property, especially rural property, in Church hands, where it was slackly and poorly managed. For more than twenty years he was the chief economic officer of the Council of Castilla, a powerful post from which he issued a stream of writings on Spanish problems and solutions, inveighing against the institution of mortmain for giving so much power over land to the Church; drawing up programs to encourage industry among the working classes—for instance, by giving work to women in the silkmaking trade; and fostering the education of common people, an idea that seemed revolutionary at the time. He advocated free education for poor girls, and even reported on the lives of quite marginal groups, like the Gypsies, and how they might become socially useful—an unrealized and probably unrealizable dream. His *Discurso sobre el fomento de la industria popular* ("Discourse on the Encouragement of Popular Industry," 1771) and *Discurso sobre la educación popular de los artesanos* ("Discourse on Popular Education Among Artisans," 1774–76) are basic texts in the history of Spanish social thought.

He backed, and labored to realize, Carlos III's pet project of the colonization of the Sierra Morena, against the opposition of the Church and the Inquisition. He founded the Madrid Economic Society in 1775, and was its long-term director; this body became the model for similar societies across the peninsula, and greatly encouraged Spain's economic growth in the embryo years of industrialization, when Castilla realized that it would have to catch up with the much more advanced industrial capitalism of Cataluña. The Society didn't merely theorize; it was practical, spreading, for instance, the technical instruction that would teach metalworkers to become machinists and designers to create the machines and even drafting tools—hitherto a monopoly of the English—for making looms and spinning jennies.

As an ilustrado, Campomanes had a friend and ally in Jovellanos. Because of the latter's tragic shifts of fortune, and not least because he was a gifted letter writer and, on top of that, a friend of Goya's and the subject of one of his greatest portraits, Jovellanos has always been preferred to Campomanes by historians writing in English about the ilustrados: he has a Hamlet-like allure. Yet this is unfair to Campomanes, a less colorful man but a greater one, and the exemplar of the "enlightened" Spanish intellectual. On the whole, both men had a strength that their French brethren lacked. It was not so much a matter of intelligence as of practical government experience. It was all very well for French writers—"pointy-headed intellectuals" as they were apt to be—to have their utopian fantasies about radical and sudden transformation of the State and the nature of man, and to dream of the instant therapeutic effects of beheading kings. They could dream these dreams, and continue to believe in the rainbow beauty of their bubbles long after they had burst, because they had no experience of government or politics; they couldn't have run a provincial restaurant, let alone a country. But the Spanish ilustrados were almost all politicians themselves, and sometimes quite senior and influential ones. They knew the levers of power and which ones to pull. They had no plans to abolish kingship and set up on its pedestal some purely hypothetical notion of the volonté générale. They knew how easily the *pueblo*, the people, could turn into the *populacho*, the mob. They sensed that education precedes freedom, and not the other way around.

Part of the tragedy of the Spanish ilustración was that the idealism of its bear-

ers did them so little good. Against the entrenched opposition of the nobility and the Church they lacked the power to force reforms through, even as ministers. Generally, they were running on a meager diet of information. Ideas trickled slowly in, and often arrived in a distorted form. They were taken up in the gilded salons of Madrid, discussed in the *tertulias* over chocolate and biscuits, played with, and then left to lie inertly, amid the orts and fragments of a hundred other conversations, with little prospect of going further.

The *ilustrados*—at least the more influential ones—got the books they wanted to read. Despite the efforts of men like Floridablanca and Aranda to suppress public knowledge of the French Revolution in order to "save the system" for Carlos IV, the relevant texts almost always got through. Goya's early patrons the duques de Osuna put together a large and impressive library of Enlightenment thought from France, Italy, and Germany; the Inquisition gave them leave to assemble it, but forbade the duke's later efforts to bequeath it, as a whole, to the State. Access to "subversive" texts was largely determined by class. The poor, in any case, could not read. There was no substantial public for the dangerous stuff.

For the tiny minority of people who were literate but nowhere near the top of society, access to foreign, advanced thinking on matters of morality and human rights was impeded by the Church and obsessively opposed by the Inquisition. This body had lost some of its deadly repressive power by the 1750s. It no longer incinerated witches and heretics with the zeal it brought to the task in the Golden Century. Still, it was neither benign nor weak in matters of doctrinal conformity and the pursuit of heresy. It had not lost its paranoid suspicions, only some of its hitherto unbridled power to act on them. At one time or another the priestly terrorists of the Inquisition had pursued, interrogated, and threatened some of the finest minds and least questionable faiths in all of Spanish Catholicism: Fray Luis de León, St. Teresa of Ávila, Fray Luis de Granada, even Ignatius of Lovola, the founder of the Jesuits, all fell under its bleary suspicion. It had done incalculable damage to the framework of Spanish intellectual and educational life, and the atmosphere of surveillance and moral repression it sustained was all-pervasive in absurdly small details as well as large—that, of course, being the essence of the totalitarian mind, in which there are no areas of exemption to ideology. It mattered almost as much that boys and girls had to be segregated in dance schools as that Jews had to be persecuted for their faith. Open political discussion in the inns and cafés of Madrid was frowned on, and apt to be reported. From 1790 through 1805, regular supplements to the Church's index of banned books appeared, bringing up to date the

latest forbidden works from the French Encyclopedists. (Voltaire, in his entirety, was banned as early as 1762, as Rousseau was by 1764. Montesquieu's L'Esprit des lois made the list in 1756, and his Lettres persanes, published in France in 1721, were not translated into Spanish until 1813.) This did not mean that Spanish intellectual life in the eighteenth century was an unrelieved wasteland: it contained a few sharp and vibrant critical minds, like the Benedictine friar Benito Jerónimo Feijoo (1676-1764). The essays collected in his Teatro crítico universal (1726–39) and Cartas eruditas (1742–60) entitle him to be seen as Spain's first modern essayist, discoursing skeptically and attractively on a wide range of subjects from folk superstitions to politics and natural history. He was, he said, "the common man's disillusioner," and his *Teatro crítico* was perhaps the closest thing Spain produced to Montesquieu's Lettres persanes. And despite the cold eye of the Church, it was possible for a great ilustrado like Campomanes to produce in 1780 a combined edition of Feijoo's two vast essay collections that ran to thirty-three volumes. Manifestly, such an imposing effort was too expensive to enjoy a wide circulation, but it went straight into many ducal libraries, and was read (or at least consulted) there. Still, there were not enough Feijoos to make a decisive difference, because in addition to the Church's opposition to free minds, few Spaniards were in the habit of regular and serious reading. It was a culture of dreary illiteracy, of which few people, and certainly very few aristocrats, seemed ashamed. For a Spaniard to be engaged with the Enlightenment, first he must know how to read; second, he must as a rule be proficient in French. This reduced the number of potential ilustrados so sharply that they could hardly be expected to leaven the slothful mass of habit and piety.

Journalism, of a kind, helped—a little. Madrid held enough people to provide a public for satirical and dissenting journals with titles like *El pensador* and *El censor*. But their circulation was small, while the ferocity of their satire and the daring of their dissent were necessarily somewhat limited by State censorship and by the Inquisition. *El censor*; modeled on the English *Tatler* as run by Addison and Steele, was the longest-running of them: it stayed in publication for six years, from 1781 to 1787, not a bad lifespan for a little magazine with no subsidies. It carried no illustrations or political cartoons, but all the same its satire and polemic were an important part of the background to the great satire of Goya's *Caprichos*, which appeared more than ten years after *El censor* folded. Unlike the *ilustrados*, who were determined to change socioeconomic habits, *El censor* was against State intervention and planning. Indeed, some of its utterances sound like foretastes of a Spanish anarchism that did not yet exist: "La

absoluta libertad es la madre de la abundancia," it declared ("Absolute liberty is the mother of abundance"). It did, however, side completely with Campomanes and the *ilustrados* on fundamental matters, such as their loathing of that fruit of privilege, *ociosidad*, idleness. "For me," declared one of its essayists,

There is nothing more contemptible than an idle citizen who can combine his laziness with wealth and, consequently, with honors.... The humblest artisan... is (for me) more worthy of appreciation and, I think, of real honor than the most illustrious, the most honored, and the richest *caballero* if he is at the same time lazy and useless.

This, of course, was precisely the intuition behind the status laws Campomanes had encouraged his king to pass.

As a result of the malignant, unchecked influences of the Catholic Church, Enlightenment Spain—unlike Italy, France, England, and Germany—had inherited no existing tradition of innovative thought; no body of serious ideas on social issues; little debate on such matters as the relation between law and power, rights and duties. By tradition, Spain was short of intellectuals and speculative writers; over the centuries it had produced a considerable body of imaginative prose and verse, some of it very great indeed, from Cervantes to San Juan de la Cruz, but not a single philosopher of more than merely provincial note. In most matters that pertained to intelligence, an unsullied mediocrity prevailed. This was, of course, encouraged and preserved by the backwardness of the Church and the vigilance of the Inquisition. Spain lacked a strong and inventive bourgeoisie, that source and origin of all deep change; it had, on the other hand, an excess of priests and aristocrats, almost all of them with a vested interest in keeping the people illiterate, disenfranchised, stupefied with prayer and patriotism, and firmly under their authority, which bore down from the absolute monarchy and the Church hierarchy in Madrid. Parish priests, especially in outlying villages, tended to be as wretchedly poor as their flock; but for the hierarchy in the cathedrals of Sevilla, Burgos, and Barcelona and the established orders in the great monasteries, it was a different matter. The Church itself was colossally rich in land, real estate, bullion, and art, but it was fond of "holy poverty"—if there were no beggars, how could the benevolent earn grace in heaven by practicing the cardinal virtue of charity? It still cherished slavery as well—how could its colonies have shown a profit without it?—and its ideas about human rights, especially the rights of women, were larval. "Human rights," "universal education," and "the sovereignty of the people" were hardly more than noises and notions for 95 percent of Spaniards.

The remaining 5 percent or so, the so-called *luces* or *liberales* or *ilustrados*, were the tiny minority of educated, generally well-off, and invariably city-dwelling Spaniards who supplied most of the cultural patronage, including Goya's. But the mass of the Spanish people regarded them with contempt as Frenchified asses, *afrancesados*, whose susceptibility to foreign ideas all but disqualified them as real Spaniards. It is impossible to exaggerate how foreign the world of political ideas, even in their crudest forms, was to the *pueblo* two hundred years ago. Everything that had convulsed and remade European thought in the eighteenth century stopped at the Pyrenees and was heard below them only as dulled echoes, faint chirpings, ill-understood threats to the proper order of things. Carlos III had done very little to improve Spanish education, which was, inevitably, still in the hands of the priests.

The most intelligent order of those priests, the Jesuits, was suppressed by the king in 1766 because his ministers (chiefly the conde de Aranda) convinced him—quite wrongly—that the hand of the Jesuits had guided the Esquilache revolt, though to exactly what purpose it was never clear. Other countries got rid of their Jesuits as an "enlightened" gesture toward liberty of thought, against the Counter-Reformation; not Spain. Its motive was merely a wrongheaded one of State security; the main effect was to make Spanish education even weaker than before.

The cultural area most clearly marked by Carlos III's "enlightened" tastes and policies was that of urbanism and, in general, the visual arts. Madrid, at the outset of his reign, was a mess. Everyone agreed on that, especially visiting foreigners, who refused to walk in the city unarmed after sunset. Dark, narrow alleys, miserable street lighting, palaces and houses of little architectural merit. Windows had such small panes that they barely let in the light; iron balconies were crude; stairways and openings to the street were hardly more than dumps for other people's garbage. The streets were so ill-paved that pedestrians were known to break their ankles, and draft animals to ruin their hooves, on the sharp, wobbling stones. Drainage was poor when it existed at all. Trash collection was done mostly by wandering herds of semi-holy pigs, the property of the Convent of St. Anthony Abbot, to whose cult these animals were emblematically dedicated. (In this, eighteenth-century Madrid had something in common with nineteenth-century downtown New York, where such trash collection as existed was done by herds of half-wild pigs.) In summer the streets of Madrid were a dust bowl; in winter, a bog. Most of the plans for cleaning up the city had failed. The capital, all diplomats agreed, was the dirtiest in Europe, and a suit of clothes that in Paris or London might get passed down from father to son was a rag before a year in Madrid was up.

Even so, eighteenth-century Madrid had seen some impulse to improvement. Since Felipe V had not been overwhelmed by the expense of foreign wars, he had been able to beautify his capital to a degree, building the Puente de Toledo, several theaters, a hospice, and some important churches and starting construction of the 1,200-room Palacio Real. But the essential builder was his Bourbon successor, Carlos III, who aspired not only to reconstruct the capital but to reform the civic habits of its occupants.

In 1787, for instance, he issued orders that the servants who worked at inns should wash themselves regularly, not wear hats indoors, "and, if possible, comb their hair." His edicts on good behavior sound remarkably puritanical, though whether they were really obeyed or not is another matter. Smoking indoors in public places was rigorously forbidden, a restriction unheard of in other parts of Europe. In inns and hostels one was forbidden to smoke, read the papers, play cards, talk politics, or play billiards. Blasphemy was punished by prison. The innkeeper or bar owner was supposed to tell the local magistrate about each new guest. Carlos IV, in 1795, would add a curious rider to these: he forbade any unmarried tavern keeper to employ as a cook or a waitress any woman who had not reached the age of forty, by which time—the monarch naïvely supposed—she would have lost whatever sexual attraction she might once have had.

It seems unlikely that the Bourbon kings had much effect on the morals of drinkers in Madrid, but they unquestionably bettered the look of the city. Carlos III also made strenuous efforts with security arrangements: he appointed a guard of night watchmen, charmingly known as the *gusanos de luz* (glowworms), and added to it a corps of "useful invalids" who (rather slowly, one presumes) patrolled the dark streets in groups of twenty or thirty.

The biggest works project espoused by Carlos III—though not, of course, open to the public—was the Royal Palace itself. Nearly thirty years in the building, it was now—except for its décor, whose schemes were left incomplete by the departure of its head muralist, Corrado Giaquinto, in 1762—essentially finished. This was by far the most imposing structure in Madrid, and it clearly needed others as a foil to it. Madrid is indebted to Carlos for his decision to construct the paseo del Prado, a key road in the city plan, which carried a number of major buildings that were directed, as *ilustrado* architecture should be, to the enlargement of public knowledge. The architect Juan de Villanueva designed for him a natural-history museum, started in 1785, that would become the all-important Prado Museum; a botanical-gardens complex (1775); and an observatory, completed in 1790 just after the king's death. Another architect, Francisco Sabatini, contributed the enormous Hospital de San Carlos, only a part of which

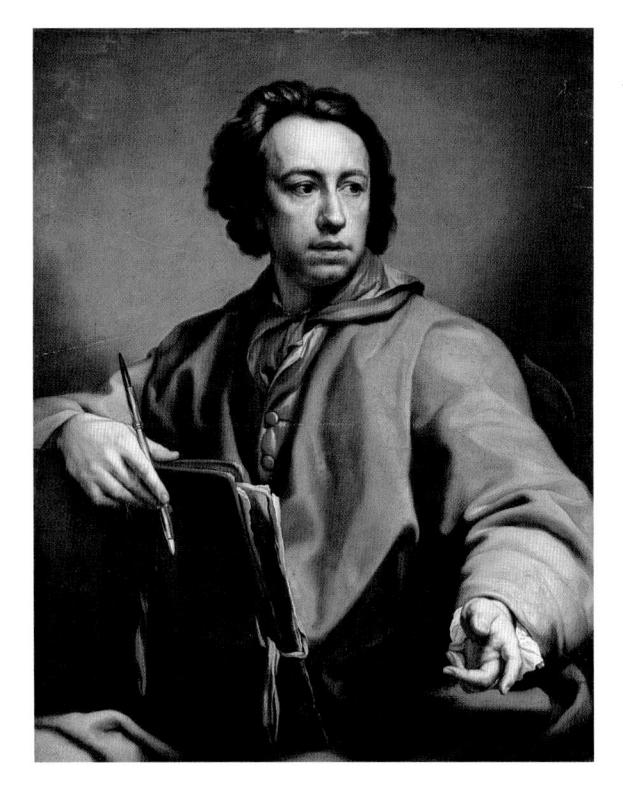

Anton Raphael Mengs, *Self-portrait*, c. 1775. Oil on panel, 102 x 77 cm. The State Hermitage Museum, St. Petersburg.

was actually finished; it is now Madrid's chief modern art center, the Museo Nacional Centro de Arte Reina Sofía. In the hope of attracting foreign artists to Madrid and concentrating Spanish ones there too, thus making the city a cultural as well as a bureaucratic capital, Carlos had Villanueva design a handsome Neoclassical home for the Royal Academy of Fine Arts of San Fernando (1773). He marked the expanding city limits with triumphal arches, and provoked the sluggish public-works bureaucracy of Spain into paying attention to projects outside the capital—the atrocious state of the roads that linked city to city, for instance, and the construction of the Imperial Canal (1768–90) in Aragón, which was the special project of his chief minister, Floridablanca.

In doing all this, Carlos III was repeating a pattern that he had already set in Italy. During his twenty-five-year reign in Naples he had commissioned a number of distinguished buildings, including the enormous royal residence of Caserta by Luigi Vanvitelli, who was in effect the director in charge of Carlos's tastes. He had also set up crafts foundations under royal patronage, such as a tapestry factory to supply decorative hangings for Caserta; a factory at Capodimonte (1743) for producing the clear, white, soft-paste porcelain ware of that

name that Carlos took such pleasure in; a majolica factory; and a workshop for pietre dure (hard-stone intaglios and mosaics). He now did essentially the same in Madrid, creating the Buen Retiro porcelain factory and staffing it with trained ceramicists imported from Naples. He underwrote a royal factory for glass, another for decorative hard-stone work. His own taste in painting was not so good, but he had the advantage of his wife's, which was somewhat more informed and refined. In 1759 Maria Amalia asked the Neoclassicist painter Anton Raphael Mengs, a friend of the "father of German art history," Johann Joachim Winckelmann, to come and work for the court in Naples. It was an invitation not to be refused, since the recent excavations at Herculaneum (1738) and Pompeii (1748) made a visit to Naples irresistible to anyone, like Mengs, with a scholarly interest in the Greco-Roman past. In some respects the move to Naples, for an ardent Neoclassicist who believed in the purity and intensity of Greek models as against the frivolous vulgarity detected in the Rococo style, may have been a letdown: what did all that profusion of Pompeian quasi-porn, the randy goat gods, the walking scrotums and flying cocks, the dirty jokes in bronze, have to do with the "noble simplicity and calm grandeur" that Winckelmann (and with him, Mengs) believed was the essence of classical art? The fact was that Mengs did not stay in Naples. He followed his patrons to Madrid almost immediately.

Seventeen fifty-nine was the year Carlos of Naples inherited the Spanish Bourbon throne, becoming Carlos III of Spain. (His queen hardly outlived the change; she died in 1761.) The royal couple set Mengs to work on the Palacio Real in Madrid, where he was to replace Giaquinto on the decoration of the new King's Apartments. From 1761 to 1769, and again from 1774 to 1776, Mengs was the most active official painter in Madrid—the man whose approval almost any other artist was going to need if his career at court was to prosper. The only painter who did not need his imprimatur was the immeasurably more talented Giambattista Tiepolo. Compared with Tiepolo, Mengs was a frigidly correct pedant, but in the 1770s the gathering fashion for Mengs in particular and Neoclassicism in general made Tiepolo look like the man on the way out: superficial, too pleasing, facile, and, thanks to his obvious (and gracefully discharged) debts to Paolo Veronese, more than slightly derivative.

It would be hard to imagine two more different painters working for the same court: Tiepolo, the unrivaled decorator and master of sumptuous caprice, and Mengs, the laborious moralist fixated on Parnassus. Mengs is one of those artists who enjoyed, in life, a fame and power that seem totally inexplicable after his death, and it extended all over Europe, not just provincial Spain.

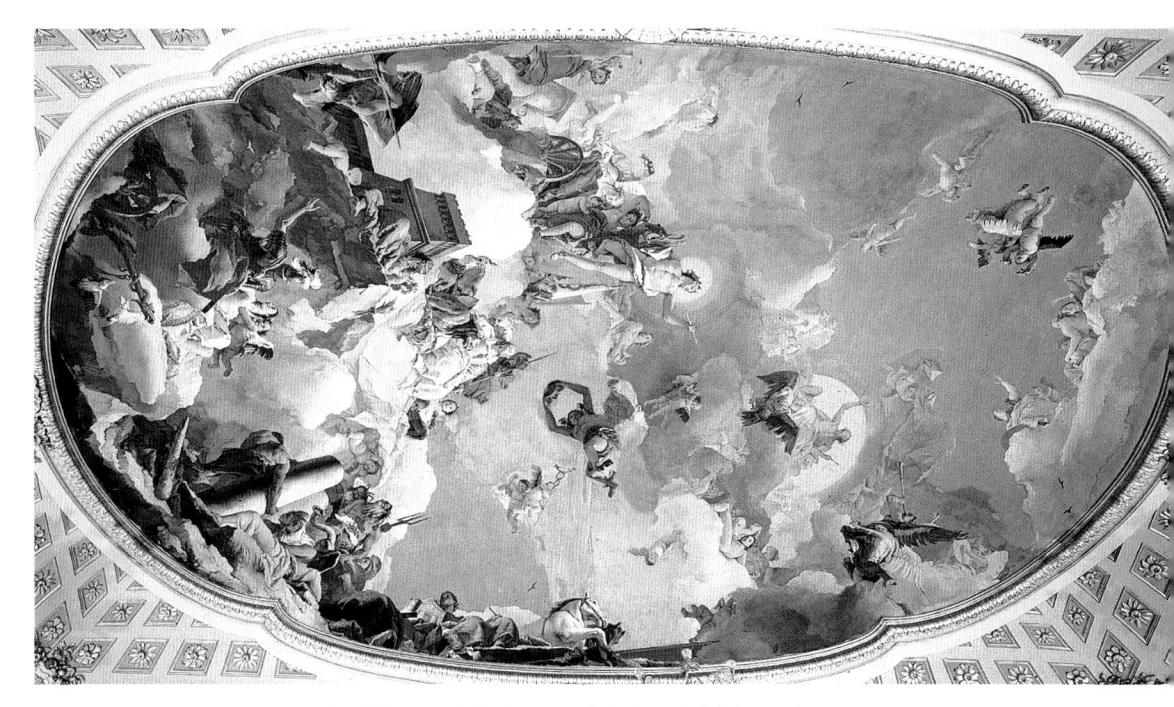

Giovanni Battista Tiepolo, *The Power of the Spanish Monarchy*, 1762–66. Fresco. Palacio Real, Madrid.

Stolid, correct, devoid of charm, insipid where strength was needed, dogmatic where fancy might have helped, thumped into shape as a "prodigy" by a failed-artist father and relentlessly promoted by the theorist of Neoclassicism, Winckelmann, whose leaden flights of pederastic dogma make even the longueurs of modern "queer theory" look almost sprightly—Mengs was one of the supreme bores of European civilization.

No question, Tiepolo was ten times the painter Mengs could ever be, and he produced the best of the works commissioned by Carlos III for the Royal Palace: the "Great Work," as Tiepolo called it, for the throne room, whose *modello* (the largest and most elaborate he had ever done, except for the 1750 sketch of *Apollo and the Four Continents* for the stairwell ceiling of the prince-bishop's palace in Würzburg) he had brought with him from Venice to Madrid in 1761. "It is enough to reflect that it is one hundred feet [long]," he wrote to a friend in Italy in 1762; "all the same, I would like to think that the completed idea will be well adapted and suited to that Great Monarchy—certainly a heavy task, but for such a Work one needs courage." The eventual result, a huge affair, was by far the most elaborate fresco ever done by royal commission in Spain: its theme, wrote Francisco José Fabre, the author of its earliest description, was "the majesty of the Spanish Monarchy, exalted by poetic beings, attended by virtues, and surrounded by its diverse states." The whole shebang,

Coming to the City · 73

in fact, including figures of Hercules (strength), Apollo (wisdom), Mercy, Abundance, Generosity, Amiability, Faith, Fortitude, Hope, Prudence, Victory, the various conquered colonies of South America, not forgetting Princely Glory (a lady with an obelisk inscribed with Carlos III's name), the Spanish Monarchy itself, and several figures of Crime, Terror, and Fury who, in the spirit of *ilustración* promoted by the king, are being banished by torch-waving cherubs signifying the Light of Human Reason.

Mengs gave Goya official help and encouragement. Tiepolo, however, directly influenced his art. It was an odd juxtaposition, since it would be difficult to imagine, at the end of the eighteenth century, two artists more unlike one another fostering the career of a third. Certainly, Goya was closer to Tiepolo than to Mengs. What Goya recognized in Tiepolo was his abundant appetite for fantasy and caprice. The older Venetian master had an unflagging power to produce *scherzi* (imaginative games) and *capricci* that bore no relation at all to the frigid Neoclassicism of Mengs. Tiepolo liked to let his imagination bubble and

Left: Goya, *Los caprichos*, plate 43 *El sueño de la razón produce monstruos* ("The sleep of reason brings forth monsters"), 1796–97. Etching and aquatint, 21.6 x 15.2 cm. Museo Nacional del Prado, Madrid.

Right: Giovanni Battista Tiepolo, Title page (unlettered) of *Scherzi*. Etching. Rosenwald Collection, National Gallery of Art, Washington, D.C.

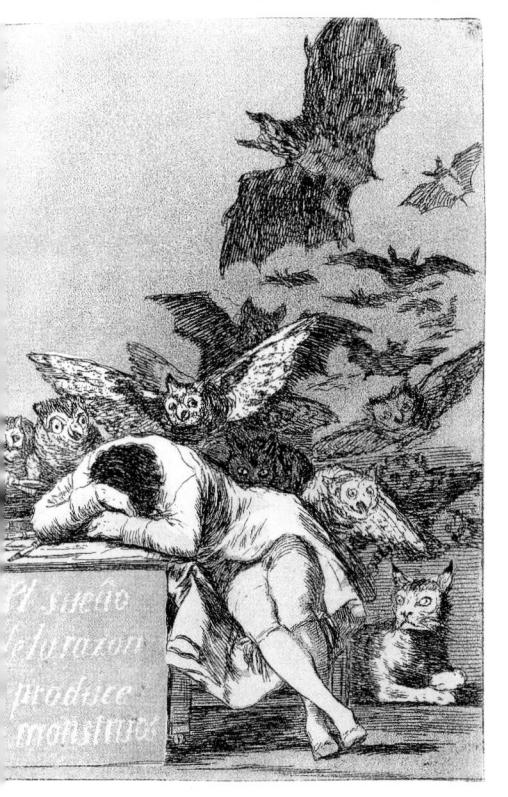

run, without much regard for the coherence of narrative stories. He loved the mysterious, the exotic, the image *all'orientale*, full of curious props and fabrics, Gypsies and magi and deliciously sexy nudes. He also populated his crowds—those swirling, spectral, and sometimes hard-to-read assemblies of fleeting figures—with darkly comic oddities, people who seem out of place or period or in some other way anomalous: just as Goya did. The most famous of all Goya's etchings outside of the *Desastres*, plate 43 of the *Caprichos*—the man asleep and dreaming on a writing desk while owls and bats flap and flutter about him to remind us that *el sueño de la razón produce monstruos*, "the sleep of reason brings forth monsters"—had its origin in the frontispiece to Tiepolo's suite of etchings the *Scherzi di fantasia* (c. 1743–57), the stone slab in the wilderness with nine ruffled-looking owls hooting and spreading their wings on and around it, which Goya would certainly have seen in Madrid.

For Goya, though, Mengs was more than a stylistic influence: he was a patron. Even more important, he was an active agent of Carlos's patronage. By 1773, Tiepolo having died three years earlier, Mengs's fame was such that, according to one English observer, "not to admire him was almost a violence against Church and State." No mere Spanish artist would omit to admire Mengs openly and vociferously. To do so would scarcely please the king, who depended heavily on Mengs's advice and opinions.

Carlos III was raising new, bare walls at such a rate in his various palaces that he needed a constant flow of new décor, so Mengs, followed by Goya's in-law Francisco Bayeu and their friend Mariano Maella, kept Goya at work at the Royal Tapestry Factory of Santa Bárbara, turning out paintings and cartoons that served as designs for tapestries. Between 1775, when he joined the tapestry factory, and 1792, when he left it under the cloud of his fatigue and gathering illness, Goya produced scores of designs, some to mural scale and all woven in Madrid. That such projects could be undertaken there at all must have been a source of some pride to the royal household: in earlier days the cartoons would have had to be sent to France, to be woven at Gobelins.

Their subject matter was essentially narrative and popular in tone. Goya's cartoons were not scenes from mythology or eulogies of great moments in Spanish history: they were genre pieces, quite complex sometimes, but almost always lighthearted, telling stories about current events and manners in the modern Spain of Carlos III. In fact, their colloquial lightheartedness seems to have been aimed far less at the pious and serious-minded king than at his son, the prince of Asturias and future Carlos IV, and the prince's Italian wife, Maria Luisa of Parma, who loved the popular theater—as Carlos III most emphati-

Artist unknown, *Portrait of Ramón de la Cru*z. Biblioteca Nacional España, Madrid.

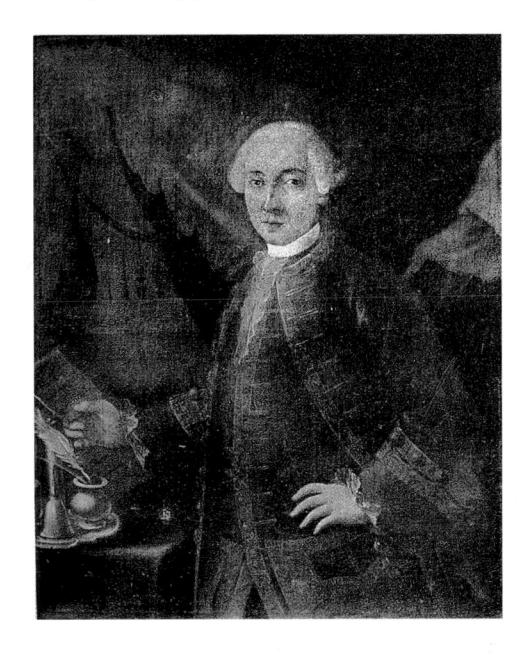

cally did not. Like hunting, music, and other diversions, it was for them a blessed relief from the stuffy confines of palace etiquette. The closest literary and dramatic parallel to the cartoons Goya made for the royals was the work of that most prolific of Spanish playwrights, Ramón de la Cruz (1731–94), which enjoyed an unflagging popularity with the Madrid public. His favorite form was a peculiarly Spanish one: the *sainete*, a kind of sketch, usually in one act and rarely lasting more than twenty-five minutes. The name derives from *sayn*, which originally meant the fat of a wild animal or the tidbits (such as the brains or liver) given as a reward to falcons from their retrieved prey: a small treat, then, for the theater audience. Cruz is thought to have written as many as 400 or even 450 of these. Unsurprisingly, not all of them have survived, but the most popular open a window into the cultural conventions, morals, and manners of late-eighteenth-century Spain in general and Madrid in particular. It was a window that Goya, who adored the theater and was in many ways its son, took great advantage in looking through.

GOYA LOVED POPULAR CULTURE, and the *sainetes* were among its most vivid expressions. This did not endear them to the guardians of elite culture, whose views Carlos III favored. They reached a majority audience (relative, of course, to the size of Madrid, which in the late eighteenth century was a small town

compared with London or Paris), but it was not a refined audience, and for the *ilustrados* that lack of refinement was, in part, directly attributable to the influence of the *sainetes* themselves and of their shorter cousins, the musical comedies, or zarzuelas, so named because they made their first appearances in the 1650s at La Zarzuela, a royal hunting lodge near the Pardo palace. The playwright Leandro Fernández de Moratín (1760–1828), a Spanish follower of Molière and very much an *afrancesado*, took the opportunity to inveigh against Cruz in a memo to Manuel Godoy in 1792. Why, he asked, had Spanish theater collapsed into vulgarity, indignity, mere crowd-pleasing? Because it was content to mirror

the life and customs of the most miserable rabble: tavern keepers, chestnut sellers, pickpockets, imbeciles, rag sellers, blackguards, jailbirds, and, all in all, the disgusting doings of the Madrid slums: such are the characters of these pieces. The cigar, the gambling house, the dagger, drunkenness, dissipation, abandonment, all the vices of such people rolled together, are painted in seductive colors. . . . If theater is the school of behavior, how can one correct vice, error, and absurdity when the same people who ought to be amending them are propagating them?

These *sainetes*, he went on, were even corrupting the "highest levels of society" with their indecent actions and foul language, and "if the low people of Madrid retain an impudent and ferocious boorishness that makes them frightening, blame the theater for it."

To this moral froth-blowing, Ramón de la Cruz riposted that he was not a degenerate but a realist: he wrote life as Madrid lived it, and his plays were not invitations to vice but social documents.

Those who have walked in his meadow on the feast day of San Isidro, who have seen the Rastro in the morning, the Plaza Mayor on Christmas Eve, the old Prado by night; those who have danced in the company of every kind and condition of person . . . in a word, those who have seen my *sainetes* cut down to the short running time of twenty-five minutes . . . let them say whether or not they are true versions of what their eyes see and their ears hear.¹¹

One thing that Cruz, most popular of Spanish dramatists, could certainly not claim was any particular subtlety in his characterization. Working at top speed for what we would now call a mass audience, he had to concentrate on drawing vividly recognizable types rather than carefully nuanced individual characters; on broadly sketched stories, not intricate plots. He had, after all, less than half

an hour per show. So he deployed a veritable army of "types." There were regional ones, like the stage Frenchman, the *gallego* (native of Galicia), the Basque, the Italian, the Swiss, and the *indiano*, who was not an "Indian" but, rather, a Spaniard, or the descendant of one, who had made his fortune in Spain's South American colonies. Other types were sorted by social standing: the semi-noble but impoverished *hidalgo*, the better-off lords and ladies known as *usías*, the husband, the wife, the widow, the bride, the *cortejo* (the gallant or, in today's slang, a "walker"), or the *petimetre*, *majo*, and *maja* (of whom more later). Still other types were classified by work and office, from chestnut vendors to masons, from the orange seller to the flower girl, the cobbler, the scribe, the lawyer, the constable, the page, the footman, and the hairdresser.

The word petimetre derived from the French petit-maître, but you had to be Spanish for it to fully apply. The petimetre was a bundle of pretensions: manners, clothing, language, all were judged (by him and others) in terms of their success in aping French and, to a lesser degree, Italian manners and artifices. The satirical papers and the comic theater of the time were full of him. He was an unending source of satirical possibility—a helpless but indefatigable fashion victim, a narcissistic fop who wanted to be everything that "real" Spaniards were not:

A giant buckle and a tiny shoe, shining white stockings, no socks, skintight knee breeches. A green English suit. Magnificent buttons with miniature portraits on them, a white embroidered waistcoat, a curly wig, a short pigtail . . . a cravat that covers the neck with a cascade of muslin, scented waters, snuff, a scarlet cloak, plenty of aplomb, and lots of money. 12

The grooming of this paragon must match his tailoring. His day begins with two hours of shaving lather, soft soap, pomades, perfumes, rice powder, little pins and big ones, tweezers, a touch of rouge on the cheeks and two artfully placed *lunares*, or beauty spots; some work with the wig, and soon one would be off to the *paseo* (stroll) on the Prado, the promenade, on which no museum had yet been built but where all Madrid, from nobleman to beggar, took the air. The *petimetre* should have two watches, not one, both laden with alarms and chimes, the better to impress people with the urgency of his affairs.

For José Cadalso, whose *Cartas marruecas (Moroccan Letters)* were an unfailing source of mirth to socially skeptical *madrileños* in the later reign of Carlos III, the *petimetre* was one of the archetypes of Bourbon Spain. (The *Moroccan Letters* are

so called because they pretend to be a three-way correspondence about Spain and its odd customs, conducted between Gazel, a newly arrived Arab diplomat; Ben Beley, his older Moorish friend; and a cristiano named Nuno Núñez. Their satirical content varies between cautiously mild and affably deadly.) The wellequipped *petimetre*, writes Cadalso, must pretend to sophistication but despise real knowledge: he must "look upon a philosopher, a poet, a mathematician, and an orator as a parrot, a monkey, a dwarf, and a clown." He should disparage his country and ancestors, but listen humbly to the advice of French hairdressers, dancing masters, opera singers, and chefs. If married, he must go for months without paying attention to his wife, and entrust the raising of his sons to a hired teacher or, for that matter, to his coachmen, lackeys, and mule drivers, rather than bother with it himself. Though it is not necessary that he should actually converse in other languages, the petimetre should have fragments of them, little phrases or single words of French and, if possible, Italian too, which he can sprinkle into his conversation and thus take on the air of a gallant: "Nel più vivo del cuore," "rifiuto," "Troppo mi sdegni perché troppo t'adóro," "adorable," "maîtresse," "volupté," and so forth. The point of this trifling was to impress not visiting Italians or Frenchmen but Spaniards (preferably women) who had never been outside the country.

When speaking pure Spanish, it ought not be simple. Especially in Madrid, a fantastically elaborate, euphuistic style was cultivated by *petimetres* and their near relatives in dandyism known as *currutacos*. The distinction between the two was not always clear, but on the whole the *currutacos* favored an even more baroque form of speech and were not afraid of being manifestly Spanish rather than faux-French. An etiquette book published in Madrid in 1796, the *Libro de la moda*, remarked of the *currutaco* that he was a sort of human butterfly, a *far-fallóne amoróso* like Mozart's Cherubino: "His delicate, ethereal, slender mechanism keeps running on nothing more than the help of juices, spirits, essences, conserves, bonbons, and liquors; he sips, tastes, drinks, samples, but never eats.... When he visits the Prado his passing is like a passage from Homer or Virgil. To achieve this effect, he has spent two hours at the mirror." The fop had to astonish with his verbal excess. Ink was not mere ink: it was "the liquor of the warty oak" (being prepared from oak galls). Paper was "shining crushed linen." A pen was an *aquilífero pincel*, an "eagle-bearing brush."

Above all, Cadalso wrote, the *petimetre*—and his equally affected other half, the *petimetra*—must be a multinational of consumption, taking his pleasures and signs of status from all over the world, not just from provincial Spain, drinking his mocha coffee in a Chinese porcelain cup, wearing a Dutch shirt whose

Goya, *El espejo indiscreto: el hombre mono* ("The indiscreet mirror: man/monkey"), 1797–99. Pen and sepia wash, 20.6 x 14.5 cm. Museo Nacional del Prado, Madrid.

cotton is woven in Lyons, reading a book bound in Paris while riding in an English coach.

The *petimetre* was a solution to one of the problems with earlier Spanish masculinity: exacerbated pride and easily offended honor. He was now a lover, not a fighter, and where better to affirm this than on his face? No more, wrote Ramón de la Cruz in his piece *El petimetre*, the hairy macho with his *cara poblada*, his "populated" or bristling face: today, the smooth skin and emulgent pomades declare, "wherever we go, that we are men of peace." In any case, the provocations to fight, the ways of giving mortal offense, have diminished. Time was, wrote Cruz, when duels and follies were common, but their frequency depended on the existence of chaste women, pious widows, virtuous wives, folk without affectations, and gentlemen who kept their word; now all that has changed, and there is much less need to resort to swordplay. You had to keep your hair on. And it was uncool to make any display of patriotism. You must speak ill of Spain; fashion advised you must joke about your ancestors and listen respectfully to the opinions of barbers, dancing masters, and cooks.

The anti-type of the *petimetre* was the *majo*, with his companion, the *maja*. The *petimetre* aspired to be taken for an upper-class Frenchman. The *currutaco*

Above: Goya, *Un majo sentado con espada* ("Seated *majo* with sword"). Drawing. Instituto Valencia
Right: Goya, *Maja*, 1824–28. Etching and drypoint, 19 x 12 cm.
The Hispanic Society of America, New York.

considered himself above everyone of his own class. The majo, by contrast, wished to be seen as entirely and truculently Spanish, and a man of the people. (Majo presumably comes from macho.) The two exactly opposite types to a large extent expressed their differences in the way they dressed and talked. You might say that the majo represented nature—Spanish nature—while the peti*metre* stood for artifice. The former regarded the latter as effete and laughable; the latter saw the former as crude and somewhat threatening, flashy, and loutish. No wonder that the ranks of the *petimetres* were full of not conspicuously highbred people trying to claw their way up the rungs of Madrid, while among the highborn and talented there was a fashion for dressing and behaving in majo or maja style. Goya's own habits of dress—and probably of conversation too, to judge from the idioms he used in his unbuttoned letters to his friends—were a fine instance of the latter. The majo style was sexier, more earthy, if that is the right word for a movement of fashion entirely confined to the cities—rural peasantry hardly had the time or the appetite for dressing up as anything. Majo fashion for men still exists, in a theatrical form. Bullfighters wear it in the arena: the tight breeches and stockings, the sash, the embroidered "suit of lights." Goya himself liked to wear it; it was natural that he should adopt the air of a tough guy in the city, like a successful artist in 1960s New York wearing a black leather jacket. Thus he appears in the *Self-portrait in the Studio* (frontispiece, c. 1794–95) half silhouetted against the white light pouring through the big window of what was probably his studio at 1, calle del Desengano: the pot hat with its candleholders stuck in the brim was part of his normal painting gear, because he liked to add the finishing touches at night, but he is not likely to have regularly worked in that embroidered, red-braided bullfighter's jacket, which, together with Goya's direct and level gaze, makes its statement clearly: I can't be fooled, I'm tough, I am a man of the people, I know what I see. I am a *majo*. Or perhaps, more precisely, a *manolo*, which was the correct term for the kind of *majo* found only in the streets and alleys of Madrid, the eponymous hero of one of Ramón de la Cruz's more popular *sainetes*.

To see what *majas* wore, one need only look at Goya's portraits of the duchess of Alba or of Queen María Luisa, who liked to display herself as a sexy woman of the people—admittedly, with less success than la Alba. However, the matter is complicated by the fact that sometimes *petimetres* and their consorts would bow to fashion by dressing as *majos* and *majas*.

Their world was Goya's world also. In due course, after graduating (as it were) to Madrid in the 1770s, Gova would turn himself into one of the greatest portrait painters of his age. To do so required a brilliant ability to perceive, and set down in pencil and paint, the nuances of individual character. This Goya developed, but it was not what his early work for the court required. There he was dealing with standard types, the cast of the theater, the human fauna of the Madrid streets, and turning the results into decorative ensembles for the palace of El Pardo and other royal residences. In effect, he would be making sainetes in paint on canvas, which would then be turned into tapestries. The royal order authorizing this was issued from the palace at Aranjuez in June 1786: "The king has been pleased to nominate Don Ramón Bayeu and Don Francisco Goya, so that under the supervision of His Majesty's artists, Don Francisco Bayeu and Don Mariano Maella, they should paint the designs to be woven in the Royal Factory... granting to each of them fifteen thousand reales a year." Fifteen thousand! It seemed like a fortune to the forty-year-old artist. "Martín mío," he crowed in a letter to Zapater,

I am now Painter to the King with fifteen thousand reales, and although I've no time I have to let you know how the King sent out an order to Bayeu and Maella to search out the best two painters that could be found to paint the car-

toons for tapestries.... Bayeu proposed his brother, and Maella proposed me. Their advice was put before the King and the favor was done, and I had no idea of what was happening to me.¹³

Now began the most exuberantly busy period of Goya's life, filled with tapestry designs, portraits, private and Church commissions, and social maneuverings. It would last about fifteen years.

FROM TAPESTRY TO SILENCE

ETWEEN 1775 AND 1792, Goya painted more than sixty cartoons for the Royal Tapestry Factory. They were full-size and in full color. Some were very large indeed, as much as thirteen feet wide. It was a good and regular job but not a very sought-after one, because the work was not open to further public exhibition—only the royal family, their guests, and servants would see it. In any case, the prestige to be won from designing a tapestry of the pueblo at work or play was nothing compared with having a portrait of Carlos IV hanging in the Royal Palace, any more than a portrait of Nell Gwyn would have brought its author the same kudos as one of King Charles. That Goya's designs would be translated into wool imposed restrictions. Tapestry could not capture the complicated surfaces created by impasto and glazing that were beginning to characterize Goya's painted works: it was inherently matte, broader in treatment, and simpler. Not infrequently, Goya found himself obliged to "edit out" some of the more complex passages of color shift and texture in the cartoons before they could be translated into weavings. The cartoons were life-size but inherently disposable; and as Bayeu complained in a memorandum, once the final tapestries had been woven from them, the designs themselves were rolled up and stored out of sight in the factory, never to be consulted again. Goya's designs vanished, but in 1868, more than three-quarters of a century after they were made, they turned up, mostly in good condition, in the basement of the Royal Palace. Most of them are now in the Prado.

Their advantage to Goya was that they set him free from doing routine eccle-

siastical commissions, whose results were quite often dull. Better still, they put him squarely in the Bourbon court, in a fairly menial capacity to be sure, but nevertheless within the orbit of royal patronage—and that was always likely to be better than work for hard-bargaining, peseta-pinching priests. The tapestry designs may have been somewhat conventional. They took city life, cleaned it up for noble and royal consumption, and submitted it to some of the conventions of the *fête galante*. But at least they let him plunge into the life he knew best: not the transcendental world of angels and saints, not the circumscribed one of Jesus doing his holy deeds, not the implausible miracles of Christian saints, but life as it was lived in the streets of Madrid and the countryside beyond.

To call Goya, in this phase of his work, a realist is putting it much too strongly. The main influence on his tapestry designs was Antoine Watteau. He did not know Watteau's work at first hand, since no examples of it had found their way into the royal collections in Madrid. But he would certainly have known it in reproduction, since engravings after Watteau were widely disseminated. By the 1770s, half a century after his death, his fêtes galantes were widely imitated all over Europe. In any case, the style had already found a practitioner in Madrid: Michel-Ange Houasse, who had obtained a place at Felipe V's court through the recommendation of the king's powerful French finance minister, the count Jean Orry, and in the last year of his life had executed two large cartoon designs for the Royal Tapestry Factory. Since Goya's task was to provide décor for the rooms of a royal family of moderately ilustrado tastes, Watteau was an ideal model, for his vision of a world of charming social harmony and exquisite manners, in which all social classes were united in the pursuit of harmonious pleasure, dancing and listening to music, was bound to appeal. In Jutta Held's words, "In the eighteenth century there was no genre painting that took for its theme fiestas and games, luxury and conversation, or the apparent leisure of the upper classes that was not affected by the ideas and esthetic models of Watteau."1

Unlike Watteau, Goya did not base his characters either on the nobility (which hardly makes an appearance in the cartoons) or on the commedia dell'arte (whose characters make none at all). He took them from cleaned-up, lower-class, town and country life—and especially from the *majos* and their consorts. He was finding stock characters doing typical things, almost exactly as Ramón de la Cruz had picked them out for his *sainetes* and farces. When Goya's tapestry scenes are violent and dramatic, as some are, it is always in a tongue-in-cheek way. We are a long way from the later works—the corrosive skepticism of the *Caprichos*, let alone the terrible didactic realism of the *Desastres de la guerra*.

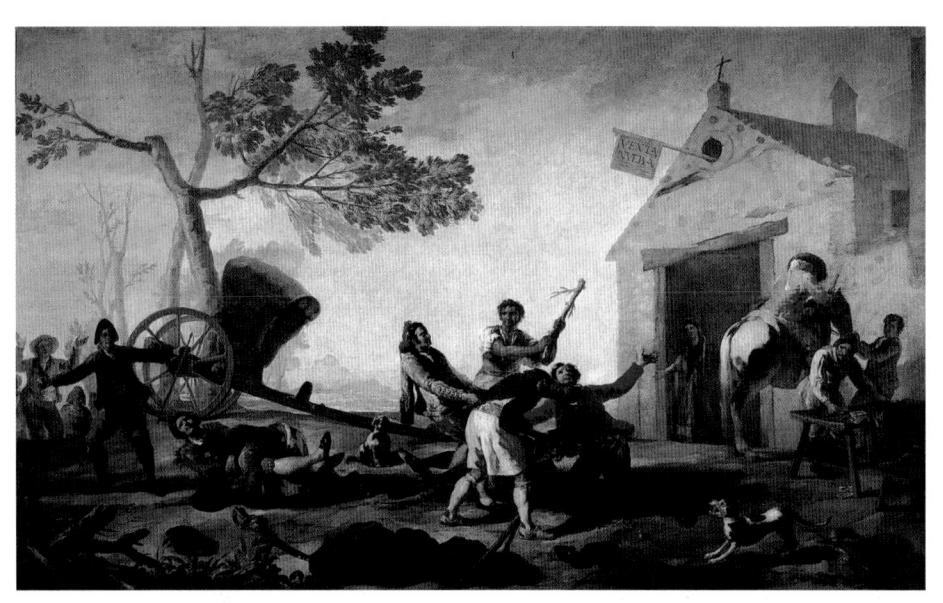

Goya, *Riña en la Venta Nueba (Fight at the New Inn)*, 1777. Oil on canvas, 275 x 414 cm. Museo Nacional del Prado, Madrid.

The spirit of the tapestry cartoons is altogether gentler, as it had to be, given that members of the royal family and their friends were to be amused by them for the foreseeable future. There is no sign yet that Goya chafed against the restrictions of turning them out, though later he would.

This was true even of the harsher passages, such as the brawl outside a country inn that was to decorate the dining room of the Pardo Palace. Fighting proles, to eighteenth-century court taste, seemed no more inherently "violent" than squabbling dogs or, at worst, lions in conflict. They could be amusing and decorative, provided that their lower status was observed and they didn't get killed or unpleasantly wounded. This was one of the ground rules of the tapestry designs, observed in such large compositions as Fight at the New Inn (1777). Coachmen and muleteers in the dress of various Spanish provinces have converged at a ramshackle country inn. Two of them, presumably Andalusians, are dressed in majo style, with short jackets and sashes; three others are in more ordinary peasant rig, implying (according to Goya's own notes that came with the sketch when it was submitted for approval) that they are from Murcia. They begin to gamble—the cards and ante money are on a table to the right, where the innkeeper is surreptitiously scooping them up—and then to scuffle, and to fight, until they are rolling around on the ground, pummeling one another with fists and sticks; a cutlass has been drawn, but it now lies disregarded. The trick of unifying this very wide and narrow composition is neatly done by the long shafts of the carriage in the background, whose shallow curve is carried further by the gesture of the red-coated brawler who throws out his arm in anger and pain toward the right of the picture; this curve is echoed by the back and tail of the furiously barking house dog. At the left, a similar extension of the sinuous curve is given by the extended arm of a man who is about to hurl a stone into the melée. Against the wall of the inn, a mounted man in a pink coat—possibly one of the horse guards who often accompanied travelers—is trying to draw a pistol, while a hostler restrains the horse.

Seen on the wall of the palace dining room, the design and its subject would have reminded Prince Carlos, María Luisa, and their guests of the "picturesque" poverty of places they themselves would never have entered: the country ventas, the lowest class of inn. The Hogarthian sign that projects from a round window in this dump's pediment, reading VENTA NUEBA, "New Inn," is belied by the architecture—the building is just a two-floor ruin. (In the oil sketch for the cartoon, another name is lettered crudely on the façade: MESÓN DEL GALLO, "Cock Inn." On top of the pediment is a bent and leaning crucifix, which must have been suppressed in the final version to spare the sensibilities of the more pious royal guests.) Such places were described in detail by the English traveler Richard Ford some years later, but there is no reason to suppose that they had changed in any way. His main advice to those seeking shelter on Spanish roads is a Spanish proverb: No le busques cinco pies al gato (Don't look for five feet on a cat). The *venta* was, in terms of comfort and cleanliness, far below the parador, the mesón, the fonda, or the posada. Accommodations for men and horses were on the same ground floor; the servants (such as there were) took no notice of the guests; the mattresses (if they existed) felt as though they were filled with walnut shells. "The accommodation for the beast is excellent," wrote Ford, from long and philosophically endured experience, but,

as regards *man*, it is just the reverse; he must forage abroad for anything he may want. Only a small part of the barn is allotted him, and there he is lodged among the brutes below, or among the trusses and sacks of their food in the lofts above. He finds, in spite of all this, that if he asks the owner what he has got, he will be told that "there is everything," *hay de todo*, just as the rogue of a *ventero* informed Sancho Panza that his empty larder contained all the birds of the air, all the beasts of the earth, all the fishes of the sea.

The poet Góngora, Ford points out, compared these country inns to Noah's ark—"and in truth they do contain a number of animals, from the big to the

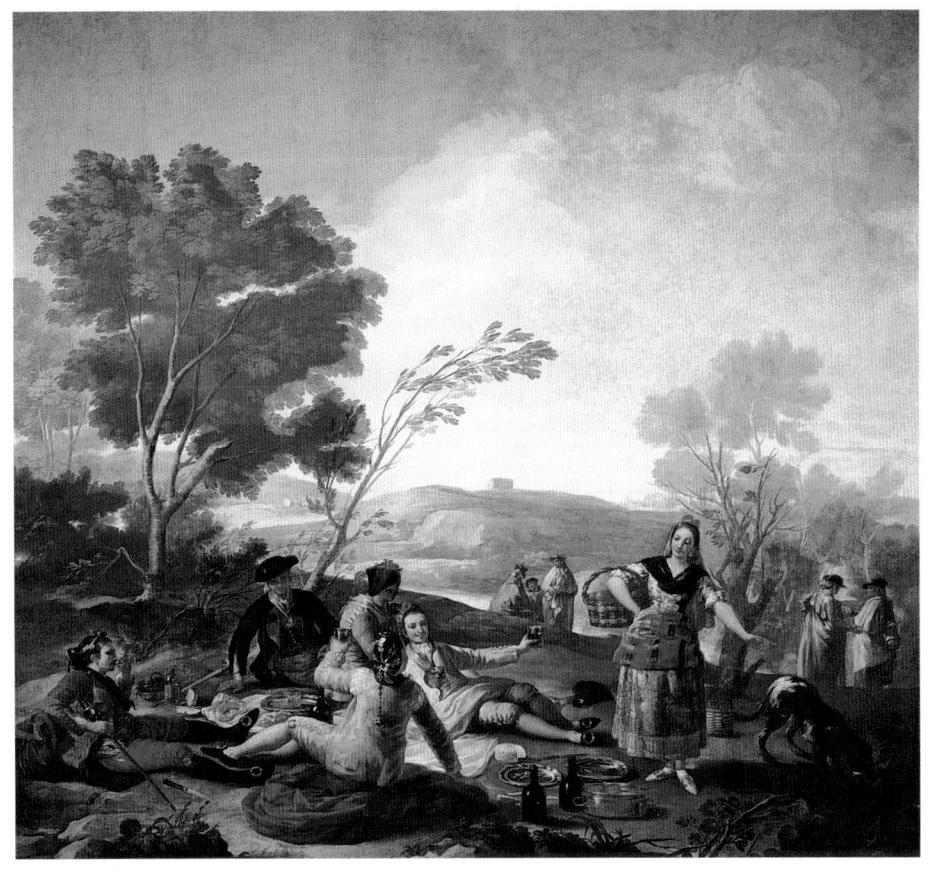

Goya, Merienda a orillas del Manzanares (Picnic on the Banks of the Manzanares), 1776. Oil on canvas, 272 x 295 cm. Museo Nacional del Prado, Madrid.

small, and more than a pair, of more than one kind of the latter." Enormous slaughters must be done every night, and the walls are stained with their results: "Hence the proverbial expression for great mortality among men, *mueren como chinches* [they die like bedbugs]."²

Naturally, Goya cleaned up the reality. Bedbugs would not do for a dining room in the Pardo Palace. But the brawl at the inn must have served to remind the royal guests how gratifyingly wide a gulf was fixed between them and their subjects.

Generally, the collective hero of the tapestries is the *majo*, just as he is onstage in the *sainetes*. In both forms, as Klingender points out, "majaism appeared as an exuberant manifestation of popular virility." It's a man's world, though with women in it. Goya's *majos* stand with their legs insolently straddled, their gestures are confident and curt, they blow eigarette smoke, and nobody and nothing gets in the way of their masculine bonding. This is made plain in one of his most spectacular tapestry cartoons, *Picnic on the Banks of the*

Manzanares (1776). Goya was very proud of it, proud enough to stress that the masterfully complex design with its variety of fully realized characters, which form a veritable theater of narrative, was "*de ynvención mía*" (of my invention). It is one of the few cartoons for which numerous preliminary drawings have survived. Most of these are of costume details, to which Goya paid special attention, careful to preserve the right look of *majo* and *maja* dress.

Five young men are having a picnic in the open air, perhaps on the banks of the Manzanares. It is a frequented place—five others are standing in small groups in the middle distance—but those in the foreground claim our attention. They are obviously having a fine time, drinking and eating, and none too abstemiously: we can see three wine bottles, and a flask may also contain wine, although it could be olive oil. The food and its containers make a handsome. scattered still life, with the gleam of the pewter dishes and the warm, beautifully rendered glow of a copper casserole. They are near the end of the meal, to judge from the broken bread and the orts of stew on one of those dishes. The majo on the left, a sturdy young guy in red britches with his hair in a net and his rapier in his hand, is sucking greedily on a homemade cigarette. Two others are boisterously raising their glasses to a sixth person who has just come within their range—a coquettish, sexy naranjera, an orange seller with her basket of ripe fruit, who is pointing offstage in a fairly unmistakable gesture of invitation: buy my oranges, says this *maja*, and you get something else to peel, though not necessarily for free. She is a figure straight out of the *sainetes* and cheap popular prints of the time, but so are the five men, and they all belong together sumptuously dressed in common cloth, having fun in a proletarian paradise. Such a painting is a middle term between the Arcadian scenes of Titian and the sardonic charm of Manet's Déjeuner sur l'herbe. Picturesque: yes. Stereotypical: that too, but a masterpiece, just as the seduction duet between Don Giovanni and Zerlina, "La ci darem la mano," is also a masterpiece.

If the orange seller is a *maja*, a woman of the people, the girl in *The Parasol* (1777) is emphatically of a higher class: a *petimetra*, in fact, dressed at the height of French fashion and straight out of the pages of a French stylebook. Instead of leading the man on, she distinguishes herself from him by gesture and gaze; she is looking at us, not at him; she is settled in her pose—the lapdog, a little spaniel, makes that clear—and she seems to accept the shade of the green parasol the young *cortejo* holds as though it were entirely her due. Goya makes no pretense about her clothes. They are of the utmost elegance: that light-pink mantle trimmed with dark fur, perhaps sable; that elegant blue bodice; the yellow skirt, given a discreet swirling movement by its folds. Color rhymes with

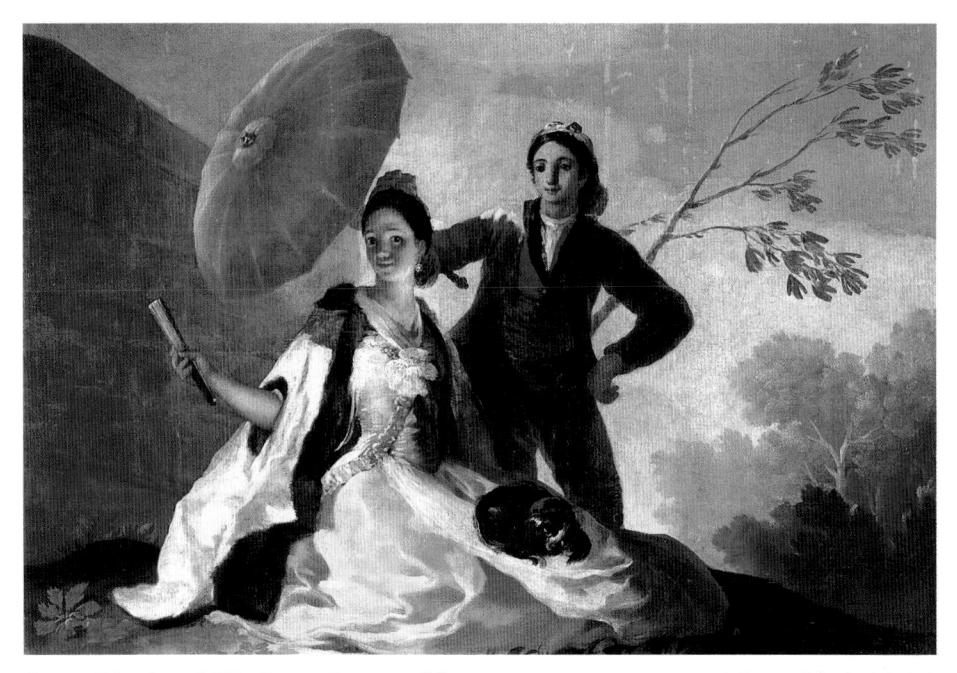

Goya, *El quitasol (The Parasol)*, 1777. Oil on canvas, 104 x 152 cm. Museo Nacional del Prado, Madrid.

color. The dark green of the quitasol echoes the similar green of the trees on the right. The girl's red turban goes with the young majo's waistcoat and even with a touch of red on the spaniel's collar. The black of the girl's hair conforms with the broad hem of her pelisse, her dog's coat, her cortejo's knotted scarf, and so on. The whole design has an Italian formality and stability: a pyramid whose background is converted into a pair of diagonals formed, on the left, by the wall vanishing in perspective and, on the right, by the slender sapling behind the young man. This fondness for steady, stable compositions based on Xs, diagonals, pyramids, and other plainly geometrical forms came from outside Spain. It was a relief from the Rococo stylization that older Spanish court painters like Paret were still engaged with. It will become one of Gova's most telling stylistic hallmarks, even (or, perhaps one should rather say, especially) when the subject itself is brutal and turbulent, as in so many of the Caprichos and the Desastres de la guerra. It is a permanent legacy to Goya from both Neoclassicism and the mid-eighteenth-century compositions he had encountered in prints and studied, in the original, in Italy.

His commission was to amuse, and one way of doing it was by depicting sports and games, such as a form of blindman's buff known as *la gallina ciega*,

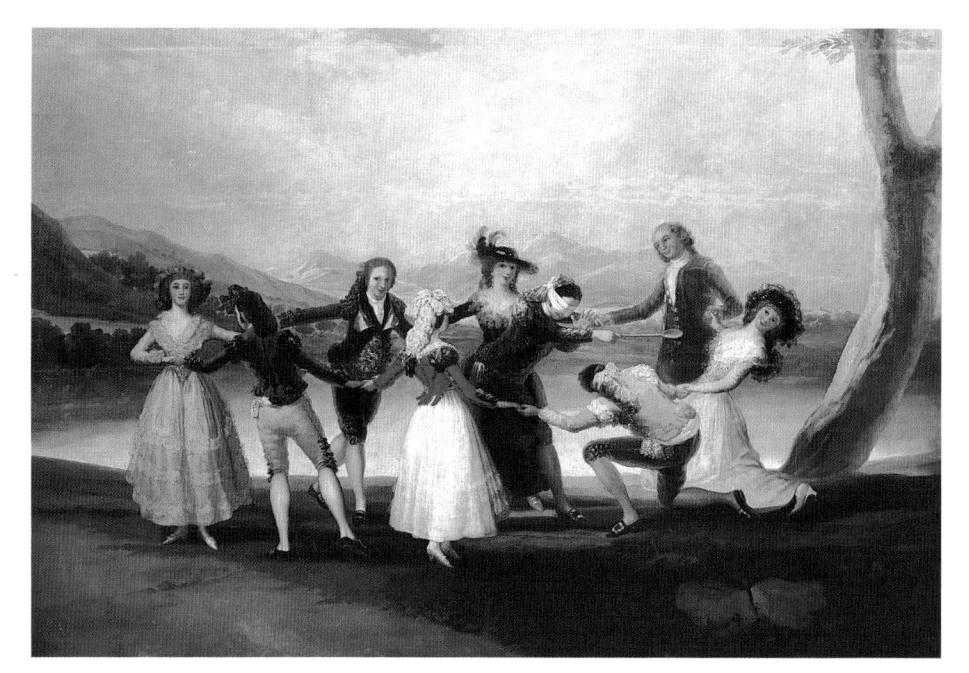

Goya, La gallina ciega (The Blind Chicken), 1788. Oil on canvas, 41 x 44 cm. Museo Nacional del Prado, Madrid.

"the blind chicken." A blindfolded man is in the center of a ring of players, who are holding hands; with a wooden spoon, he lunges at one of them, trying to touch him, but his target ducks amid general hilarity. In other tapestry designs people play on swings. They lie drunkenly on the ground, shielding their ears with their hands from the tuneless singing of a friend. This in itself is very different from Watteau, who would never have disturbed his idealized vision of relations between men and women with such a discordant and ironic note. Girls balance *cántaros*, earthenware waterpots, on their heads, a none-too-indirect reference to precious virginities that can so easily be broken.

Very occasionally a darker event intrudes in Goya's tapestries, as in one likely influenced by Carlos III's concern with the dignity of manual labor (as against the moral squalor of the idle rich). In 1778 the king's solicitor general, the enlightened economist Pedro Campomanes, had persuaded him to issue a royal decree affirming that manual work, such as tanning, was "honest and honorable; their practice does not degrade the family." Another royal edict of 1778 laid down rules and standards for masonry work, such as the proper form of scaffolding and the employer's responsibility for injuries sustained by workers. This is commemorated in Goya's tapestry cartoon of an unfortunate injured

Goya, *El albañil herido (The Injured Mason)*, 1786–87. Oil on canvas, 268 x 110 cm. Museo Nacional del Prado, Madrid.

Goya, *La primavera o Las* floreras (Spring or The Flower Gatherers), 1786–87. Oil on canvas, 277 x 192 cm. Museo Nacional del Prado, Madrid.

mason, being carried to safety from the site of a work accident by two concerned fellow workers. (Another, almost identical version has the workman sodden drunk, not hurt.) It is not clear how interested Goya was in labor reform, if at all. More likely he alluded to it because it interested his royal clientele. Images like *The Injured Mason* are not common in his early court work; his truly passionate concern with the exploitation of workers will not surface until the *Caprichos*, some fifteen years later. More often all is light and amiable, as in the funny and slightly risqué episodes of rural life.

Thus in one of a set depicting the four seasons, *Spring or The Flower Gatherers* (1786–87), a lady of quality is accepting a rose from a bouquet culled by a young servant woman (or a girl dressed as a peasant) while her daughter tugs at her hand to get her to notice the bunch of wildflowers she has picked. The punch line of the image is in the grinning peasant behind them, who is holding up by the legs a young rabbit he has caught and putting a finger to his lips to enjoin us to silence: it is spring, this is the time when rabbits start breeding in earnest, and soon the young lady is going to be in love as well.

The art historian Janis Tomlinson speculates, and she is surely right, that Goya's fondness for the popular theater of the streets and farms must have appealed to María Luisa and the future Carlos IV in a way that it did and could not to the more straitlaced Carlos III.⁵ It was for the young couple that Gova designed a set of tapestries on the theme of the annual fair held in the streets of Madrid. This was not the kind of narrative that would have seemed right among the official grandeurs of the Palacio Real in Madrid, but it suited the more relaxed atmosphere of one of the country palaces of the prince of Asturias and his amusable Italian consort, used as she was to the pleasures of the commedia dell'arte. Its centerpiece was *The Blind Guitarist* (1778). Blind guitarists and blind storytellers, like dwarves, hunchbacks, and idiots, were a steady feature of Madrid street life, whose tastes were not inhibited by considerations of political correctness. Blindness and story singing were anciently linked—there was a not-too-remote association with blind Homer. They would be regular subjects for Spanish painters from Velázquez to Picasso, and Goya's guitarist is one of the most obvious prototypes of the *misérabliste* figures from the latter's Blue Period-except that, unlike Picasso, Goya was not at all sentimental in depicting his. The design is meant as an assembly of social types, high to low. At the lowest end are the blind man and his chubby-faced little assistant and guide, his *lazarillo*, and off to the right, a hunchbacked (or perhaps merely stooping) Negro water seller, in black hat and red britches, with a water jar slung across his back. At the top of the scale is a man with a staff, wearing a yel-

Goya, *El ciego de la guitarra (The Blind Guitarist)*, 1778. Oil on canvas, 260 x 311 cm. Museo Nacional del Prado, Madrid.

low coat; this, Goya's inventory declares, is a foreign tourist, well-off to judge from his spotless finery and twin watch fobs, and he is reaching into his pocket, perhaps to retrieve some change for the poor blind man.⁶ The girl next to him, a pretty young *maja*, notices this gesture and is emphatically giving him the eye. Again, the main composition is a shallower version of Goya's favorite triangle, its apex the figure of a *majo* on horseback.

In these designs Goya comments on human types, of course, but he also has some sly observations to make about taste and history. Fashions in art, for example, change; and in his cartoon for *The Fair of Madrid* (1778), we see them doing so. Here another resplendently dressed dandy, also in yellow, has paused beside a booth whose owner is selling old, unwanted junk: carpets, a tattered

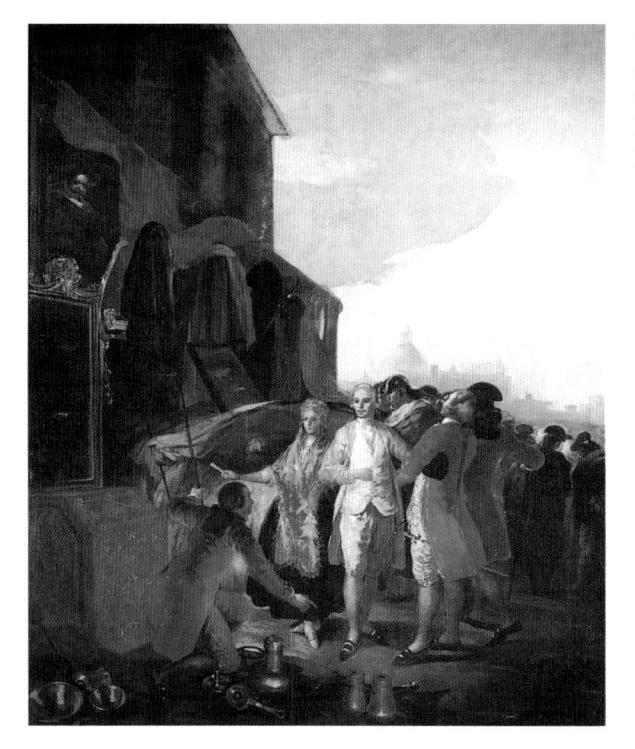

Goya, *La feria de Madrid* (*The Fair of Madrid*), 1778. Oil on canvas, 258 x 218 cm. Museo Nacional del Prado, Madrid.

blue coat on a stick, basins, copperware, furniture. And a portrait, which is hanging on the wall. It is clearly an out-of-date picture from sometime in the seventeenth century: a brown ancestor whom no one wants. The dandy's friend, a gentleman in a brilliant red cutaway coat, examines it from a distance with a quizzing glass, showing no enthusiasm. Thus, by implication, young Goya—he is thirty-two now—declares that his kind of genre painting is modern, the coming thing. The owner of the booth bows and scrapes before them, in much the same posture as that in which Goya, five years later, will show himself displaying to his first really powerful client, the conde de Floridablanca, the portrait he has just made.

The Crockery Vendor (1778) is the companion to this painting, a scene of a street transaction, with the difference (among others) that the potential clients are women, not men. The main female figure kneels on the ground of the openair market, turning and weighing a china bowl in her hand (and how beautifully painted the still life of crockery is, highlights and all!), but her eyes are sizing up the male crockery seller himself, and the placement of the old woman next to her recalls one of Goya's favorite and most often repeated sexually charged pairings, the young whore and the old *celestina*, or procuress. Behind them, a

Goya, *The Crockery Vendor*,
1778. Oil on
canvas, 155 x 132
cm. Museo
Nacional del
Prado, Madrid.

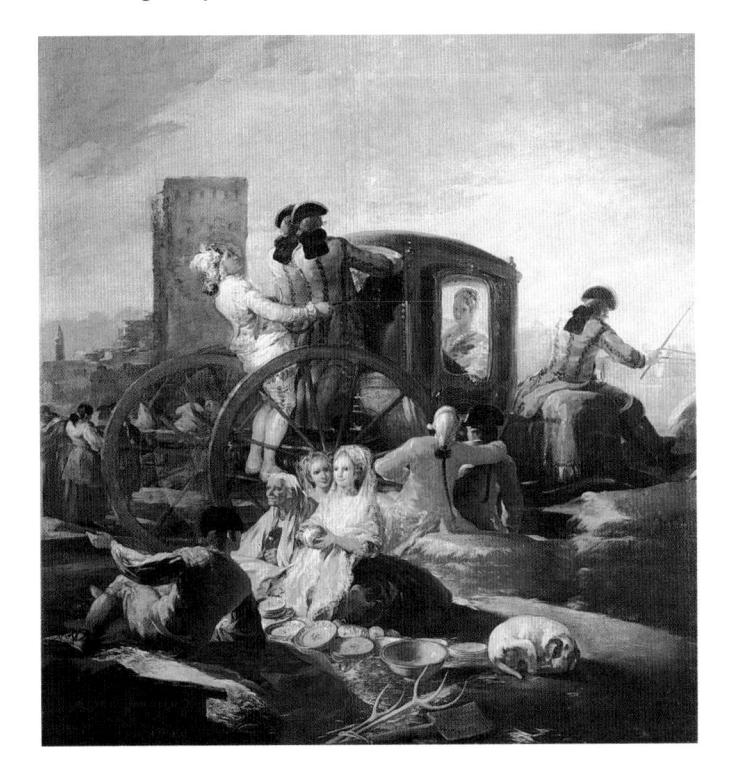

petimetre seen from the back, unmistakable in his exaggeratedly long pigtail and bright red coat, is quizzing a lady of quality in her passing coach. Isolated and framed in the bright rectangle of the vehicle's window, she looks like an icon. The girl in *The Haw Seller* (1778) is by contrast completely a maja, surrounded by majos who want only to ogle her and make a pass. Their lust bounces off her self-confident, flirtatious charm. Grinning, she casts a glance over her shoulder at you, the viewer. The red fruit in her basket, which she has picked with such effort—gathering the berries was hot, sweaty work—fairly glows, a symbol of libido ready to be let loose.

The tapestry cartoons were not the only official, or semi-official, work that came Goya's way at the end of the 1780s. There was also engraving. Spain, admittedly, had only a sparse culture of reproduction at the time. There were, as previously noted, no museums in which a young painter could study; he must therefore be content with looking at reproductions made by engravers, and the supply of these was both irregular and limited. A wide range of reproductory engravings of masterpieces could be assembled in London, Paris, and Rome, and fairly cheaply; some artists made a reasonably steady living producing them, as Marcantonio Raimondi, for instance, had with Raphael, Dürer, and

Goya, after Velázquez, Los borrachos/ Bacchus ("The drunkards/ Bacchus"), 1778. Etching on heavy laid paper, 32 x 44 cm. Rosenwald Collection, National Gallery of Art, Washington, D.C.

the Antique in the sixteenth century. But there was no equal to Raimondi, in terms of range of sources or technical quality, in eighteenth-century Madrid. Because the royal palaces were closed to the public, including nearly all artists, it was simply impossible for an aspiring Spanish painter to get much of a firsthand impression of the work of his few national masters, including even the greatest of all, Diego Velázquez. This struck many people as a cultural misfortune (as indeed it was), and among them was Carlos III's first court painter, Anton Raphael Mengs, who in 1777 had published a letter praising Velázquez to the skies and lamenting that his work, immured as it was in the strict privacy of the royal collections, was not better known. It was probably pressure from Mengs that secured permission for Gova to take advantage of his palace access and make engraved copies of some of the royal Velázquezes in Madrid, then almost completely unknown outside Spain.⁷ In this way, Goya was introduced to the difficult art and craft of etching, of which he would become a supreme master. One cannot say that his eventual genius for it showed immediately, but he learned fast, as a comparison of a crude early effort like Flight into Egypt (1770) with his technically far more sophisticated version of Velázquez's Los borrachos (The Drunkards; 1778) will show. In some ways Velázquez was a good choice to copy in black and white, because he was preeminently a tonal painter and could survive the necessarily crude translation from color. But because his transitions of tone were so uncannily subtle, he was not at all easy to imitate, especially when the only shading technique Goya had was line—he had not attempted aquatint, still less mastered it. However, the Velázquez copies forced
Goya, *El agarrotado* ("The garrotted man"). Etching. British Museum, London.

Goya to concentrate on etching for the first time, and without them we might not have the extraordinary landmarks in the history of the medium that would begin two decades later, the *Caprichos*, the *Disparates*, the *Tauromaquia*, and the *Desastres de la guerra*.

Goya's progress toward these really begins with an early etching that had nothing to do with the Velázquez copies, a study of a garrotted corpse done c. 1779. Next to *The Blind Guitarist* (15½×22½ inches), this was the largest plate he had etched so far (13 × 8½ inches), and it is unlikely that he produced the design for anyone but himself. No edition was ever made of it, and who in any case would have commissioned such a grisly souvenir of capital punishment? To be garrotted was not, in fact, the most disgraceful way to die. The Spaniards considered it relatively humane, almost dignified in comparison to hanging, where one slowly strangled on the gallows, kicking and pissing and shitting. The victim of the garrotte died sitting down, so there was a chance that the spectators might not see his excrement. His neck was encircled by an iron band, which was tightened by a screw and a worm gear, rather like a large hose clamp. The axle of the screw forced its way into the back of the victim's neck, breaking the cervical vertebrae. The operation was believed, no doubt wrongly, to be more or less painless, and certainly it was relatively quick. That Goya

chose such a subject has its own significance, for this was the first of many images of violent death inflicted on victims that would appear in his work in years to come, and it is clearly the first sign of his indignation at the power and methods of the Inquisition that would show itself so vividly in later drawings and paintings: the dead man has been made to hold a cross (as in the later plate from the *Desastres de la guerra*, "For having a clasp knife"), and attached to his chest is a scapular bearing the image of the crucified Savior on the hill of Golgotha. Plainly, he has been killed by the Inquisition for his heretical views. That Goya had seen such a corpse firsthand is strongly suggested by the figure's realism, shown in pathetic small details like the dead man's feet—one with its toes clenched in agony, the other with the toes extended in the flaccidity of death.

At around this time a somewhat more satiric, even brusque note crept into Goya's tapestry designs. He could hardly have kept it out. We know from his later work that Goya was by temperament saturnine and ironic, and given sometimes to wild flights of self-parody. He cannot have been taking the charming, unproblematic comedies of his tapestry work all that seriously, and by the late 1770s their incessant production must have begun to grate; it was not, to put it mildly, what he felt he was born to do. Another design for the apartments of the prince and princess of Asturias, *The Rendezvous* (1779–80), shows what was happening. A young woman, richly dressed, reclines morosely in the open air among rocks and thorns, her head resting on her hand. An edge of white handkerchief in that hand shows that she has been weeping. The pose, as Tomlinson has pointed out, is taken from a design in an emblem book by Cesare Ripa, showing a (male) figure in a wilderness landscape with thorns, titled *Delizie mondane*, "Worldly Delights," which are of course vain. The implication is that she is a repentant prostitute, watched by a group of *majos*.

Whatever the reasons, there was a hiatus in Goya's output of tapestry designs. In any case, they were less needed. In 1780 the king, feeling the financial pressure of his war with England, made economies, one of which was closing the Royal Tapestry Factory. This was not a crippling blow to Goya, but it was a sharp inconvenience because, boring though it often was, his tapestry work was bread and butter. Since Mengs had left the court and gone back to Rome, where he died shortly after (in July 1779), the coveted post of court painter was open. Goya applied for it but, humiliatingly, was rejected. Once again, he had had no luck with selection committees.

So he decided to confront the problem head-on. If he had no job, he could at least become an academician. The Royal Academy of Fine Arts of San Fer-

Goya, *Cristo crucificado (The Crucified Christ)*, 1780. Oil on canvas, 255 x 153 cm. Museo Nacional del Prado, Madrid.

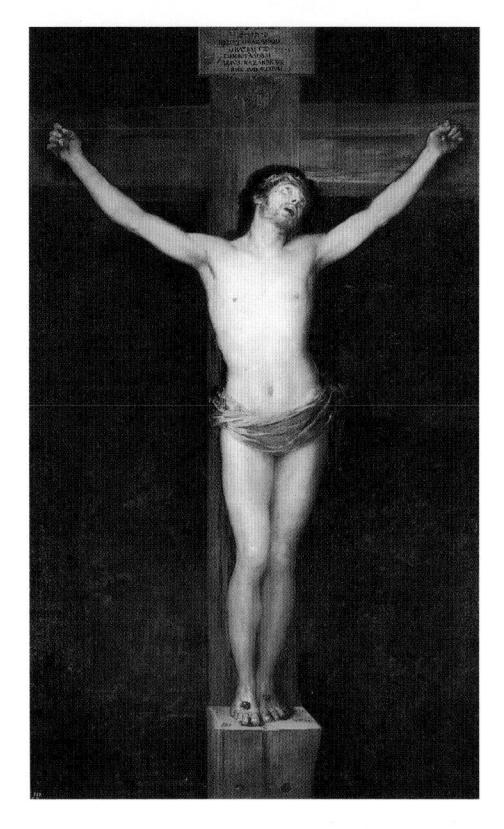

nando was not much in comparison to the reigning institutions in Paris, Rome, or London, but it kept the basic academic faith: that art was subject to teachable rules, which could be modified and broken by individual genius, and that the "artist" was by definition a cut above the "artisan" or "craftsman." Hence membership in the academy could confer prestige on an artist that he ("she" need rarely apply) might not otherwise acquire, and it was worth making certain concessions to earn that prestige. Only this, one might suspect, explains the work that Goya, in May 1780, submitted as an admission piece to the academy: a Crucified Christ. It is without much doubt the worst painting he ever did. How could the man who would emerge, some thirty years later, as the most powerful reporter of human anguish in all of Western art have produced this soapy piece of bondieuserie? The ladylike body, unmarked by torment; the absence of any kind of empathy with what real bodies underwent in the course of flogging and crucifixion; the enervated "correctness" of pose—all this combines to convey a sort of sickly, moaning piety that, if it were not for the relative liveliness of the paint and its impeccable provenance, would make you doubt it was by Goya at all.

But it worked. Goya won his membership in the academy.

It was not only a religious painting, but a history painting, which gave it in the

academics' eyes a dignity that no tapestry cartoon of sexy orange sellers and cigarette-puffing *majos* could aspire to. Perhaps this was not surprising, since Goya had made his smooth, licked Christ look stylistically as close to Mengs as possible.

Nevertheless, he had a king and queen to amuse and palaces to decorate, and it would be idle to expect that, at this stage of his career, he could have made tapestry the medium for the sort of ferocities that would before long burgeon on the printed leaves of the Caprichos. Carlos and María Luisa still wanted their comedy of manners, their bucolic amusements. But now Goya's rendition becomes more shadowed. A work like El pelele (The Straw Man; 1791–92) has a disenchanted edge to it. A traditional carnival game in which a stuffed cloth dolly of a man is tossed in a blanket or cloak by women: it was a subject Goya would return to at intervals, its last appearance in his work being in the etching Disparate femenino (1816–23) (page 368). In the tapestry design, the manikin, with its silly French pigtail and spots of rouge on its cheeks, looks vacuous to perfection, a petimetre jounced up and down at the whim of the four amused ladies—Goya's acid comment on the power of women over men, and on what seemed to him the waning of traditional Spanish masculinity, a theme repeated throughout the Caprichos and the Disparates. Goya was always on the side of the homegrown majo, whom he considered an endangered species, as against the imported fopperies of the *petimetre*—and never more explicitly so than here.

His frankest utterance about this, apart from the later Caprichos, was the painting Hercules and Omphale (1784) (page 102). It depicts one of the great images of sexual inversion bequeathed to us by the ancient world. Hercules, the hero of gigantic strength, has been condemned by the voice of Apollo speaking through the Delphic oracle to lose his famed virility. From now on he will be the slave of the queen of Lydia, Omphale, who maliciously decrees that he will be dressed in women's clothes. At the same time he must continue with his heroic deeds, like destroying a dragon and killing a dangerous bandit, Syleus. But Apollo's overriding command insists that he should be completely feminized, turned over to women's work like sewing. In Goya's painting, though Hercules is still dressed in full, shining male armor, the dragon is reduced to a mere decoration, squirming on his helmet as he struggles, not very effectively it seems, to thread a needle under the mocking eyes of Omphale. One of the queen's attendants has taken over his monster-killing sword. He is a figure of fun whose submissiveness betokens extreme anxiety, for this is the only subject of all the hundreds available that Goya took directly from the repertoire of classical myth and lore.

Goya, *El pelele (The Straw Man)*, 1791–92. Oil on canvas, 35.6 x 23.2 cm. Museo Nacional del Prado, Madrid.

Goya, *Hércules y Onfala (Hercules and Omphale)*, 1784. Oil on canvas, 81 x 64 cm. Private collection.

Goya, *La boda (The Wedding)*, 1791–92. Oil on canvas, 267 x 293 cm. Museo Nacional del Prado, Madrid.

A big work like *The Wedding* (1791–92) also has an edge that was not present in the earlier, milder tapestry cartoons. Country nuptials are in progress, and the party is leaving the church, passing by the broad, framing arch of a bridge. We see a satisfied and smiling priest; an old grandpa picking his way over the broken, dried-out pavement with a stick; a piper blowing forcibly on his rustic instrument; joyous, unruly kids; women casting sidelong glances of envy at the bride. The girl is lovely: about eighteen, composed, and dressed in her utmost finery. (Only in the original can one see that, as Tomlinson points out, ¹⁰ she has dressed so hastily, or with so little experience of fashion, that her brand-new shoes are stuck on the wrong feet.) The groom is comical and gross. His snub nose and thick lips proclaim him to be an *indiano*, the mixed-blood heir of some Spanish colonist who made his fortune in the New World; now he has come back to his father's village to find the novia of his heart's desire. Fat and anxiously mincing, his clothes out of date, he is unimpressive despite his bulk; but in this provincial town, poderoso caballero es Don Dinero (Mr. Moneybags is a mighty gentleman).

APART FROM ENGRAVINGS AND TAPESTRY DESIGNS, Goya's career in Madrid was beginning to sprout a tentative branch in another direction: church decoration. He would not get a commission in Madrid as big as his "hidden" murals for the Aula Dei outside Zaragoza—not until he came to fresco the church of San Antonio de la Florida some twenty years later—but he did get one substantial job.

The Madrid church of San Francisco el Grande was indeed a large one. It boasted the biggest dome in Spain, 105 feet in diameter. It was patronized and worshipped in by the royal family; Joaquín Eleta, confessor to Carlos III, was a Franciscan, and his order enjoyed an unchallenged supremacy in court circles after the Jesuits were expelled from Spain. Now it offered a large job for no fewer than seven painters: seven new altarpieces. Goya was among the chosen artists. The idea thrilled him. His Majesty, he wrote to Zapater, "has chosen to include me, whose commissioning letter is being sent to Goicoechea [a considerable patron of the arts in provincial Zaragoza] so that he might show it to those who have doubted my merit, and you will take it where you know it will have an effect: for the great Bayeu is also painting his picture." Translation: show it to my brother-in-law and make him jealous, make him realize that I'm treading on his tail. What was almost as important as the commission itself was the names of the other artists—a virtual list of the Madrid painting establish-

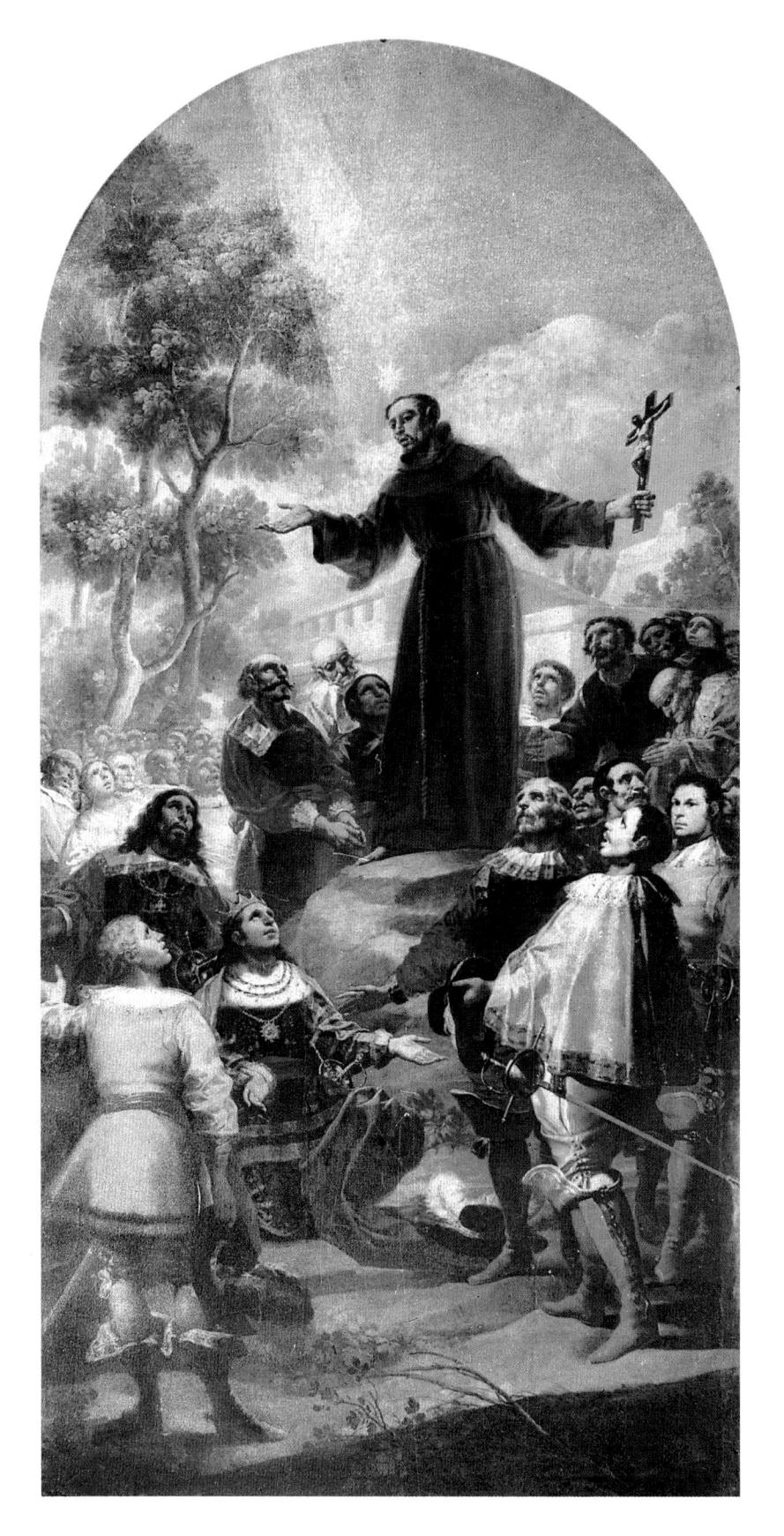

From Tapestry to Silence · 105

ment of the time, most of whom (such being the sadness of establishments) are now all but forgotten: Mariano Maella, Gregorio Ferro, Andrés de la Calleja, José del Castillo, Antonio González Velázquez, and Francisco Bayeu doing the big piece for the high altar.

Goya chose as his subject *St. Bernardino of Siena Preaching Before Alfonso of Aragón*. With his usual modesty, the painter crowed to his friend Zapater that this was the biggest painting of all the commissions. ¹³ It is a tall vertical composition showing St. Bernardino, the fourteenth-century Italian saint, standing on a rock, bathed in light from the miraculous star that had descended on him as he was reciting the praises of Mary as Queen of Angels, brandishing a crucifix, and speaking to a crowd whose main figure is Alfonso of Aragón, the Spanish king of Naples. Here Goya, as he admitted in a letter to the royal supervisor of the commission, the count of Floridablanca, departed from strict historical accuracy: the king in question had been the Angevin king Renato of Sicily, but Goya thought it more diplomatically suitable to replace him with a Spanish monarch since this was a royal Spanish church. He also inserted himself into the painting: his own likeness, in a yellow tunic, stares out at the viewer from the right side, below the extended hand of St. Bernardino with its rhetorical crucifix.

No church commission was ever awarded without politicking and backbiting, and Goya's painting for San Francisco el Grande was certainly no exception. He had his clerical critics—swarms of them, to judge from a heavily coded letter he sent to Zapater at the time. Goya mentions none by name—that would have been most imprudent—but he makes no secret of disliking them. Interestingly, he describes them in metaphorical terms that would perfectly fit the characters whom, fifteen years later, he would ridicule in the *Caprichos*.

Beloved soulmate . . . you'll kiss my ass at least seven times if I manage to convince you of the crazy happiness I get from living here, even though there's been no progress regarding the source of income you know about. How good your little room with the chocolate that brought us together was, but it offered no freedom and was not free of the various insects with their deadly weapons, made of needles and penknives, which, if you don't watch out and even if you do, will tear away your flesh and your hair as well; not only do they scratch you and look for pretexts for quarreling, but they bite, spit, stick you, and run you through; they often become food for other, bigger and worse ones . . . even when they're buried, they don't know how to be harmless, for in their cruelty they even go for nearby corpses, and you can't find a spot far enough away

from them to escape their cruelty. This infection is general in every town where you might be born, especially if you're modestly off and if you have a small dwelling place. ¹⁴

Anton Raphael Mengs, dictator of taste, had died in 1779. However, his influence lingered in Spain, and nobody forgot whom he had endorsed. It was probably due to Mengs's original interest that Goya got the most important of his early portrait commissions. Portraiture was the bread and butter of any moderately successful artist, and the earliest known portrait attributable to Goya was one of the count of Miranda del Castanar, probably done around 1773 while he was at work on the big murals for the Aula Dei, before he left Zaragoza. In 1782, working now in Madrid, he did a portrait of Antonio de Vega, a minister of the Royal Council and, later, the director of the Royal Tapestry Factory of Santa Bárbara, for which Goya was doing his cartoons. But the project for which Goya had the highest hopes was one Mengs may once have suggested: a life-size likeness of José Moñino, the count of Floridablanca (1728–1808), who was chief minister to Carlos III and, after him, the most powerful secular figure in the realm. Goya painted it in 1783.

Moñino had begun as a commoner, a lawyer in his home region of Murcia. But he became the protégé of the marqués de Esquilache, the chief administrator who was Carlos's controversial import from Italy and whose hat-and-cloak rules had provoked the Motín d'Esquilache in 1766. Carlos believed this riot had been fomented by the Jesuits. It was not true, but he had to get rid of Esquilache as a sop to popular anger. Meanwhile he set Moñino to work getting rid of the Jesuits, which he did with such acumen that the whole order was expelled from Spain in 1767. (The king threw them out not from any Enlightenment objections to them as the agents of an absolutist Church but because he felt they were more loyal to the pope than to him—and he was right about that.) Carlos III then ennobled Moñino as the conde de Floridablanca and, in 1777, made him prime minister.

This had been a shrewd appointment. Floridablanca was no radical by more northerly standards; in years to come he would vigorously oppose the French Revolution and anyone who sympathized with it. But he was a practical reformer with a strong belief in free trade and lower taxes; this alone, he believed, would stimulate economic growth in Spain, and leading *ilustrados* like Jovellanos, disciple of Adam Smith, agreed with him.

Floridablanca was particularly concerned about public works. The whole infrastructure of rural Spain had languished since the disasters of the fifteenth

Goya, *Conde de Floridablanca and Goya*, 1783. Oil on canvas, 262 x 166 cm. Banco Urquijo, Madrid.

century that had, ever since, been treated as an immense triumph: the defeat and expulsion of the Arabs, and the resulting centralization of power under Fernando and Isabel in Madrid. The Madrid court had pulled the landowning Catholic aristocracy toward it, as though into the gravitational field of a dark star; and so, by Floridablanca and Goya's time, the city was jammed with parasitical nobles and *hidalgos*, all maneuvering for privilege, while the countryside, the true source of Spanish wealth, fell increasingly empty. Canals, tunnels, dikes, dams, and irrigation networks had been brought to a high pitch of perfection under the Arab caliphs; they had turned Andalucía into a fertile garden. But in the three centuries since the *reconquista* they had largely fallen into ruin as one titled landowner after another deserted his inherited estates for an idler's life at court. The more its patrimony turned to stones and dust, the more apt this class was to regard "deep Spain," the source of its diminishing wealth, as a distant colony, and to treat those who lived in it with blind and even cruel indifference.

Whether Floridablanca could have cured this dreadful agrarian situation on his own is doubtful at best. (Not even the king could have done that.) But at least he thought it his duty to try, and his views were supported by other, more liberal exponents and theorists of statecraft, such as Campomanes and Jovellanos, the leaders of the Spanish Enlightenment. Floridablanca's concern with the problem is the partial subject of Goya's obsequious, cluttered, and emblematic portrait of him.

This is the first of Goya's "mirror" portraits, in which the subject's presumed reflection in a presumed mirror (we are the mirror; what we see is what the mirror sees) plays an active part in the story the picture tells. The count, resplendent in red silk with white stockings (not a wrinkle in them) and a pearl-colored waistcoat richly embroidered in gold thread, towers over Goya's depiction of himself, holding up a small canvas (whose face we cannot see; presumably it bears an image in progress, the likeness of Floridablanca) for his client's approval. The count holds a pair of spectacles in his right hand. A moment ago he was scrutinizing his painted likeness. Now he stares at the invisible mirror—at us—to check out the resemblance.

The scale of the two figures looks physically wrong but is, in a smarmy way, correct. Goya is closer to us than Floridablanca but looks smaller: an inferior and supplicant figure, almost crouching. He is inches shorter than his client, a declaration of size as status. Likewise, the man behind Floridablanca, with his protractor poised over a site plan on the table before him, seems much smaller than the splendiferous count. He is waiting for his chief to speak—what orders will he issue about the project the plan represents? The expression on his face is a deep deference, close to awe. He is probably the civil engineer Julián Bort. 15 Like Goya, he is dark and dun-colored, whereas the count is the very image of power, glowing with light. Indeed, most of the light in the otherwise dark room seems to shine out of Floridablanca, as in earlier religious pictures it shone out of God in heaven—an effect enhanced by the fact that so much of the other paint, including Goya's brown suit, has darkened over time, whereas the brilliant vermilion of Floridablanca's outfit has not. So he stands there like a secular god glowing in a chapel. Gova reminds us of Figaro, the little barber of Sevilla, in the presence of Count Almaviva. But the picture contains none of the cheeky anti-authoritarianism of Mozart's opera. It is completely a celebration of authority—including the penultimate authority, one step below God's, of the king.

For Carlos III is there too—not in person, but in effigy. Goya could not leave him out, since he wanted to emphasize Floridablanca's role as a conduit of royal power. This was probably the first time Goya had painted his monarch, and of course he did it from another effigy—painting, print, or bust—certainly not from life, since the little Aragonese painter was not yet a big enough figure to ask, let alone receive, a sitting from his king. We do not notice Carlos at first. But there he is, hanging on the wall at upper right above Floridablanca's head, an oval painting-within-the-painting. The benignly smiling monarch, an apparition borne up as though on a shield (and wearing, like Floridablanca, the sash of his own order), plainly confers his approval—not only on Goya's relatively little task of painting his prime minister but, more important, on the vaster project the prime minister himself has in train: the design and construction of the Imperial Canal of Aragón.

The canal was by far the biggest public-works project undertaken in all of Spanish history until well into the industrial era, and no reference to Floridablanca (including Goya's portrait) could ignore it. One may assume it had a special emblematic meaning for Goya, because, like Floridablanca himself, he was Aragonese. It was to eighteenth-century Spain, and in particular to Aragón, what the Hoover Dam was to 1930s America, or the Snowy Mountains hydroelectric scheme to 1950s Australia. The idea was huge and, in essence, simple: a canal dug clear across the peninsula, linking the Atlantic (the Cantabrian Sea) to the Mediterranean, connecting with the Ebro River near Zaragoza. This would irrigate previously sterile land along the course of the canal, and enormously benefit the Aragonese merchant economy by creating a direct maritime outlet to the Atlantic and thus to the lucrative trade in coffee, ores, slaves, chocolate, and other products with Spain's American colonies.

Such a canal had first been proposed back in the time of the emperor Charles V. The organized manpower and engineering know-how needed to carry it out—for it was truly an *impresa faraónica*, a Pharaonic enterprise—hardly existed. The money was not available. The canal lapsed for two centuries, without a shovelful of earth being turned.

It was then revived by the Bourbons, in the person of Carlos III. Its chief promoters were two: Prime Minister Floridablanca and Ramón de Pignatelli (1734–93). Pignatelli, a tireless, deeply humanistic, and irrepressibly randy cleric, was the canon of the cathedral of Zaragoza, cofounder of the Aragonese Amigos del País (Economic Society of Friends of the Country), and later, for a time, one of the reputed lovers of Queen María Luisa. He was one of the very few influential liberal clerics in Spain, outstanding for his defense of small farmers and landless laborers against the interests of the rich and powerful. He foresaw the benefits (mainly through peripheral irrigation) that the canal would offer the poor, especially the *jornaleros*, or landless day laborers.

If Pignatelli's sexual abilities were not in doubt—and they certainly

impressed Casanova, who paid admiring tribute to the cleric's uncanonical behavior in his *Memoirs*—neither were his administrative ones. It was he who organized the necessary civil works for the canal (1776–90), oversaw the planning for its navigation, and directed the irrigation schemes along its course—which increased the amount of arable land beside the canal by a factor of 30 to 250 percent.

The money was to come from the biggest investment in a public-works project ever attempted, or even conceived, in Spain up to then: 200 million reales. It was raised by Floridablanca, mostly from *empréstitos*, public loans. In the end, for reasons too complex to discuss here, the Imperial Canal failed to transform the economy of Aragón, and it received its coup de grâce from the damage inflicted on it by the French occupation of 1808–14. Hydraulic power from the unfinished canal would be of some benefit to industries around Zaragoza, but this was nothing compared with the first sanguine hopes of its success. These, in the 1780s, presented the canal as the capstone of Floridablanca's career—which was why Goya loaded his portrait with references to it. The plan that engineer Bort is measuring with his protractor is a layout for part of the canal. Large engineering drawings for it on stiff paper are propped against the table, inscribed to the *excelent/simo* count.

To make sure his client felt adequately flattered, Goya included another, quite separate emblem of Floridablanca's cultural altitude: on the floor lies a hefty leather-bound folio volume with what appears to be a small painting (now illegible, but how one would like to know what it was!) inserted between its pages like a bookmark. This tome was considered the summit of educated pictorial taste by Spaniards in the late eighteenth century: it is the *Práctica de la pin*tura (1724), a treatise by a Spanish follower of Luca Giordano, Antonio Palomino (bap. 1655–1726). Palomino, the outstanding Spanish fresco painter of his time, was also known as the Spanish Vasari for his more than 250 essays on Spanish artists, gathered in 1724 as El Parnaso español pintoresco laureado, and his volume on mathematics, perspective, and artists' techniques, El museo pictórico y escala óptica, 1715–24, which is the one we see on Floridablanca's floor. Clearly, Goya wants us to know, the count is a man who wants to grasp not only the story of artists' lives, with their attendant gossip, but something much more serious and recherché: a treatise on the nuts and bolts of art, the theory of painting, which would concern only a professional or a real connoisseur. So when we look at Goya's Floridablanca, we see a man of deep theoretical and practical culture.

Despite the obsequiousness of the portrait, the sitter was not particularly thrilled by it—which is strange, considering what an impressive apparition it

makes today in the boardroom of the Banco de España in Madrid. The prime minister was not given to hyperbole, especially when dealing with social inferiors like painters, who in general enjoyed a status not far above carpenters. Hard put to conceal his disappointment, Goya wrote to his bosom friend Zapater that "there is nothing new to report, and there is still more silence about my business with Señor Moñino than when I painted his portrait. . . . The most he said to me after liking it [was] 'Goya, we will see each other again when I have more time to spend, and apart from that I've nothing more to say.' "¹⁷

Yet though Floridablanca did not strew Goya's praises all over Madrid society, something was happening to Goya's reputation in the early 1780s. Although no letters survive to document it, he would seem to have been getting good word of mouth from a commission to paint the family of Don Luis de Borbón, which he began soon after completing Floridablanca's portrait in 1783.

Don Luis was the brother of Carlos III, an unsuccessful younger brother who had made the large mistake of abandoning the career his parents had marked out for him, that of the Church, and marrying a much younger woman, not even for property but for love. His mother, Isabella Farnese, would not hear of any choice for him but the priestly life, which poor Don Luis could not stand—he was so ill-suited to celibacy that in later years Luis Paret, a charming and gifted Rococo painter employed by Carlos III at the Madrid court, became Don Luis's unofficial pimp. This so annoyed the king, his prudish brother, that he had Paret banished to Puerto Rico from 1775 to 1778. (Paret returned to Spain but settled in Bilbao; he would not be allowed back into Madrid until 1785, the year Don Luis died.)

Don Luis had been appointed the cardinal-archbishop of Toledo when he was only seven, and became the archbishop of Sevilla in 1741, at the age of fourteen. He had absolutely no aptitude for the religious life, and was never actually ordained a priest (the usual prelude to higher ecclesiastical titles), so he was able, though much against the will of his family, to renounce his position in the Church and in 1776 to marry an Aragonese countess, María Teresa de Vallabriga (1758–1820). She was not of royal blood, and Carlos III, feeling that his brother's choice of her as a bride had insulted the dignity of the Bourbons, bitterly snubbed them both: Luis was stripped of the right to be called an infante or to use the surname Borbón, and although he was allowed to visit Carlos at court, his wife was forbidden to go with him. Carlos took this freeze-out to such absurd lengths that he even refused to hear any family news from his younger brother, getting it instead through "back channels," from his prime minister, Floridablanca.

Goya, *The Family of the Infante Don Luis de Bourbón*, 1783. Oil on canvas, 248 x 330 cm. Fondazione Magnani Rocca, Corte di Mamiano, Parma.

To work on Don Luis's family portrait, Goya was invited to his palace at Arenas de San Pedro, a day's ride from Madrid. It was the second visit the painter had made there, and clearly he got on well with Don Luis, since both men loved hunting and went shooting together. But Goya did not have in mind a figure of Don Luis *alla cacciatore*, in the field with his gun, as he would later paint both Carlos III and Carlos IV. Very much under the spell of Velázquez's *Las meninas*, he would paint a large and ambitious conversation piece: *The Family of the Infante Don Luis* (1783) is almost eleven feet wide and contains fourteen figures, all portraits (an effort comparable in size and complexity to the group portrait Goya would make of the family of Carlos IV in 1800). It is the sort of painting that only a man determined to impress future clients would make, and—significantly—Goya again painted himself into it, as he had done in the Floridablanca portrait, crouching before the easel at the far left of the canvas.

The center is occupied by Don Luis and his consort, sitting at a green-baize-covered card table. The infante is playing patience with large, vividly marked cards. The Spanish name for this game is *solitario*. Perhaps this was Goya's way

Goya, *María Teresa de Borbón y Vallabriga*, 1783. Oil on canvas, 132.3 x 116.7 cm. Ailsa Mellon Bruce Collection, National Gallery of Art, Washington, D.C.

of slyly emphasizing Don Luis's isolation within the Bourbon dynasty. The center of interest, and of the painting itself, is defined by the light source: a single candle in a plain glass draft shield. Most of the light falls on Doña Teresa de Vallabriga, who—this being an informal occasion, a country weekend—is wearing a white peignoir. Her hair is down, and a gray-jacketed *peluguero*, or hairdresser, is absorbed in braiding it. There is a pronounced contrast, but not at all a satiric one, between the youthful face of Doña Teresa and the alert but aging countenance of her husband. On either side of the card table, various members of Don Luis's (relatively) small household court are arrayed, watching to see how the game of *solitario* turns out. Gova sets up a nice variety of expressions on their faces, culminating in the cheeky grin of Francisco del Campo, the court secretary, who wears an odd-looking white headband, perhaps a bandage of some kind.¹⁸ To the left, behind Don Luis, are two of his and Doña María Teresa's children: in profile, in a blue jacket, Don Luis María; and beside him, the round, enraptured face of three-year-old María Teresa de Borbón y Vallabriga, whom Goya had painted previously in her full French finery as a child petimetra, standing on a terrace before a mountain landscape with her shaggy

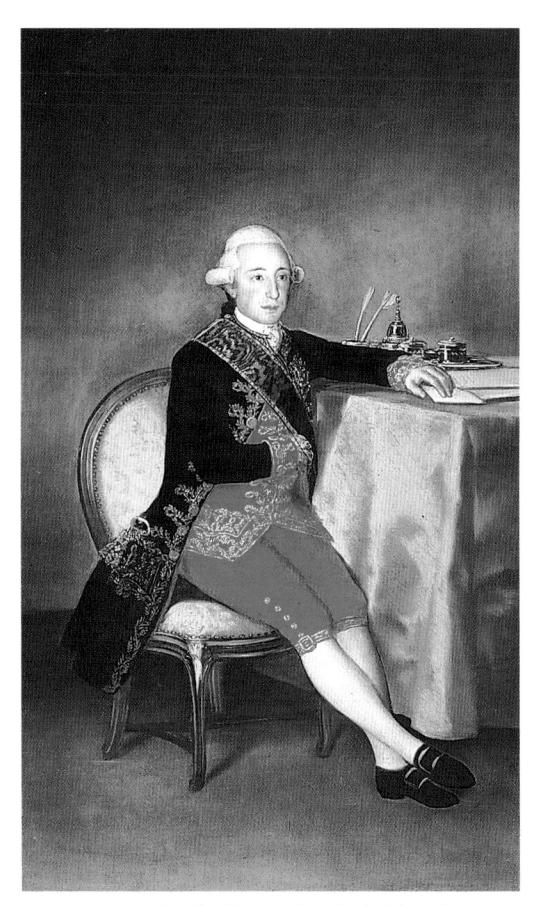

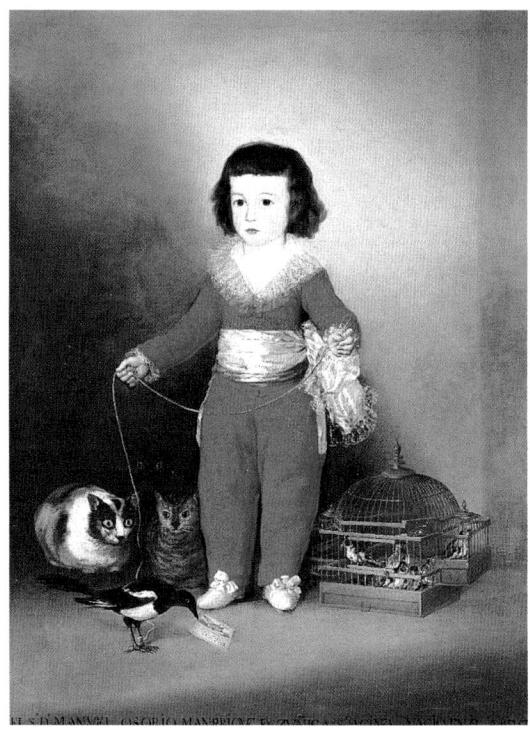

Left: Goya, *Conde de Altamira*, 1786–87. Oil on canvas, 177 x 108 cm. Banco de España, Madrid.

Right: Goya, *Don Manuel Osorio Manrique de Zúñiga*, c. 1790s. Oil on canvas, 127 x 101 cm. The Jules Bache Collection, The Metropolitan Museum of Art, New York.

white terrier. Here she is clearly fascinated, wondering what this man is up to with his pencil, brush, and canvas. Years later, in 1800, she would become the subject of one of Goya's subtlest and most deeply felt portraits as the condesa de Chinchón, Manuel Godoy's much-humiliated and constantly betrayed wife. But now she is only a child.

The lukewarm response among painters and cognoscenti to Goya's painting of St. Bernardino at San Francisco el Grande had disappointed Goya. No matter: he would concentrate on portraiture.

In 1785 he landed a commission to paint the portraits of the directors of a newly founded financial institution, the National Bank of San Carlos. The results were in the main mediocre, as paintings; but the clients did not think so, and the commission installed Goya with considerably more security as a social portraitist in Madrid. The main figure among them was the count of Altamira.

Painting him brought forth Goya's reserves of tact: Altamira was extremely short, indeed almost a midget, but he had to be flattered, not only because he was a banker and a member of the old nobility but because he had inherited a most distinguished collection. In Goya's rendering of him (1786–87), the count and the room are out of scale: he sits in what ought to be a commanding posture at a yellow-draped table, but the table is too big for him, so that in the resulting portrait he looks like a doll dressed as a powerful banker, a slightly unearthly manikin owned by an overly large child. This stiffness of gesture and awkwardness of pose is common to most of the *banquier* portraits that flowed from this commission.

Altamira was very pleased with his portrait, and almost immediately commissioned three more of his family. The Countess of Altamira and Her Daughter (1787–88) shows his wife seated on a pale-blue silk sofa, the child on her knee. The mother's face is a white mask of powder, "Japanese" in its inexpressiveness. Goya has brought to this work all his considerable skills as a painter of surfaces: the countess's pale-pink satin skirt, embroidered and sprigged, is done with marvelous subtlety, every fold in the fabric given its specific weight of attention, the whole composition pulled into focus by an eccentric spot of light just behind her arm—the isolated gleam from a few laurel leaves, no more, of the sofa's carved and gilded frame. It is clear that Goya was far less interested in the woman's character, whatever its subtleties may have been, than in the opportunity her formal wardrobe gave him for tender, virtuoso color. By comparison, his portrait of their eldest son, Manuel Osorio Manrique de Zúñiga (c. 1790s), is thoroughly emblematic. The little boy, who was four at the time, is wearing a rich red silk jumpsuit with silvery-white sash and collar. He holds a string whose other end is tied to the leg of a pet magpie (the eclectic bird, noted for picking up things here and there, has Goya's calling card in its beak, complete with a design of palette and brushes). Two cats are staring at the bird with fixated, murderous concentration, waiting for the boy's attention to stray. Nearby on the floor is a cage full of finches, which the cats will presumably polish off as well if they get a chance. On one level this may be a lighthearted painting, but on others it is no such thing. It is another example of Goya's awareness of how contingent life is: how at any moment, without warning, death can break into it, and it will be too late to save anything or anyone. Neither the magpie nor its noble young owner can relax. The price of privilege is unremitting tension, for birds as for people.

Goya was moving up the social slope as a portraitist, and beyond the Altamiras were more exalted families. The one that would have the longest and deep-

est influence on him was that of the duke and duchess of Osuna. Gova met them around 1785. By that time he was really learning to enjoy success, as witness his acquisition of fine firearms to gratify his love of hunting-he even ordered a particularly good hunting weapon from a Madrid gunsmith as a present for his friend Zapater—as well as a high-performance carriage. Gova was not indifferent to the lure of hot wheels, and the two-wheeled birlocho he gave himself was the equivalent of today's Ferrari or Lamborghini. There were only three others like it in the whole of Madrid, he boasted to Zapater. 19 It was a onehorse "English carriage," as light and maneuverable as you could imagine, "all gilded and varnished," so that "even here people stop to watch it go by." (Clearly, the prestige Spaniards attach to their forms of private transport has not changed in two hundred years.) But things went wrong. The seller took Gova out for a test drive, pulled by a horse "that I bought at the same time, already ten years old but with all the qualities it needed." He offered to show the painter what the *équipe* could do; he took the reins and went charging down the middle of the road; he lost control, and "we all went end over end, birlocho, horse, and us. Thank God, we weren't much injured." Goya's painting arm was hurt, but not broken or sprained. Wisely, he exchanged the sporty carriage for a more sedate landau, and the fiery horse for a pair of mules, explaining that since he was now on the public payroll it behooved him not to take risks with his life: a neat exercise in saving face.

It was his passion for hunting that seems to have brought him together in 1786 with Pedro de Alcántara, marquis of Peñafiel, shortly to become the ninth duke of Osuna, and his wife, María Josefa Pimentel. Goya believed, perhaps correctly, that most aristocrats liked him better for his shooting skill than for his painting talent, and that he had a reputation among them "that few competent shots earn." He did not mind this. When he said he would rather hunt than paint, he was not altogether joking. An earlier letter to Zapater shows Goya's unconstrained love of the hunt:

Friend, your last lines just killed me: you can't imagine, when you mention hunting, how much I envy you. God won't let me get away from here. For me, there's no greater amusement in the world. I've been able to get away only once, and still nobody did better: 18 kills with 19 shots: that is 2 hares, a rabbit, 4 partridges, one old partridge, and 10 quail. The one I missed was a partridge. I got particular pleasure from this luck because I went out with two of the best guns [shots] in the place. I've earned a certain renown among the hunters who, I have to say, are particularly good shots.²¹

Nowhere in his letters does Goya boast about his painting as he does about his hunting. He was a gentleman, and did not want to tempt fate.

The Osunas welcomed him, as they welcomed so many of the outstanding writers, musicians, and *ilustrados* of their time, for his artistic talents alone. This wholly remarkable couple were to be his chief patrons, apart from the royal family itself, for several years; and more than anyone else they embodied the *beau idéal* of enlightened Spanish aristocracy.

Married in 1771, the Osunas had four children by the time Gova entered their orbit. They were rich, educated, and passionately interested in whatever pertained to the arts and sciences. Theirs was not a fashionable dilettantism. The duke saw it as his serious duty to support the Madrid Economic Society and the Economic Societies of Friends of the Nation; he was a member of the Spanish Royal Academy and a friend of such leading ilustrados as Jovellanos, with whose plans for economic reform he was wholly in accord. Formerly a soldier and a diplomat, the duke had one of the great Spanish private libraries, some 25,000 volumes, particularly rich in English literature, which he planned to give to the nation—though unfortunately the government refused to let him do so, since it contained books proscribed by the Inquisition. The Osunas maintained a private theater, in which new plays were regularly performed; they were friends with Ramón de la Cruz (he of the sainetes) and the afrancesado playwright Leandro Moratín, translator of Shakespeare, Molière, and Voltaire's Candide, and author of a famous lampoon against forced and arranged marriage, El sí de las niñas ("When the girls say yes"), which closely paralleled the lampoons on matrimonial injustice made by, among other ilustrados, Goya. They counted among their friends some of the best actors of the day, such as Isidoro Máiquez, a noted liberal and another afrancesado who would pay for his beliefs by being hounded out of Spain by the Inquisition; the Osunas helped support him in exile. Both the Osunas loved music, held concerts in their palace in Madrid and their country villa El Capricho about six miles outside the city, and owned a large collection of scores by composers both old and modern (including Haydn, Rossini, and Luigi Boccherini, who conducted orchestral performances for them in 1786 after the death of Don Luis, his previous patron).

María Josefa de la Soledad Alonso-Pimentel y Téllez-Girón (1752–1834; page 119), countess of Benavente, duchess of Osuna, related to half the grandest clans in Spain (Huéscars, Albas, and so on and on), was in every way as remarkable a person as her husband, and in some respects more so. She was one of the very few women who stood out from the general ruck of eighteenth-century Spanish aristocracy by virtue of her intelligence, not merely her wealth

or breeding. Lady Holland, wife to the English ambassador at the court of Carlos IV and a woman whose social eye was never fooled, intensely respected her, calling her without qualification "the woman most distinguished for her talents, virtues and taste in all Madrid."22 The duchess was one of the few women to play a major role in Spanish public life, through the Junta de Damas (Women's Council) of the Madrid Economic Society. She had advanced and useful ideas on every public issue, from the state of women's prisons (deplorable) to children's education and the need for widespread vaccination, a recently developed medical technique that many Spanish doctors regarded as dangerous and perhaps anti-Christian, just as some right-wing loonies in America fifty years ago opposed putting fluoride in drinking water. Her home life crossed the border into public policy; her tertulias, or discussion evenings, drew the finest minds of the Spanish Enlightenment, such as Leandro Moratín. Ramón de la Cruz first produced a number of his *sainetes* in the private theater of her Madrid palace. She was patroness to Maíquez, the Kean or Gielgud of the time in Spain. Her social, political, and clerical connections were such that she was able, apparently without much difficulty, to get clearance from the Inquisition to create a large library of books proscribed by the Index, forbidden works by Rousseau, Voltaire, and others. She was, in short, the kind of person who, in our clichéclogged age, might restore the noble name of elitism: one of the great socialintellectual hostesses of Europe, a woman of enormously developed taste, sharp as a tack, wry in humor, and calmly dismissive of every sort of stupidity, superstition, and cant. Compared with María Josefa de la Soledad, the duchess of Alba was a much lesser creature, although her intellectual inferiority did nothing to diminish her fascination. But the two women had at least one thing in common. The biggest cultural fish in each one's benign social net was Francisco de Goya, although their coup, at this early stage of Goya's career, was not plainly apparent.

Goya's 1785 portrait of the condesa duquesa is one of the finest of his entire career, and when you reflect that only two years separate it from his relatively crude portrait of Floridablanca, you can indeed believe that she inspired him—like other painters, he responded to the critical intelligence of his sitters. He did not paint her as in any way a conventionally pretty woman—the face is a little too sharp-boned for that, the nose too long, the mouth a trifle thin—but the countess's eyes sum you up with a level and piercing gaze, and her posture, one hand holding its fan and the other resting on the knob of a cane or parasol, bespeaks complete self-possession. She is, as the idiom of the day used to say of perfectly confident women, *muy militar*:

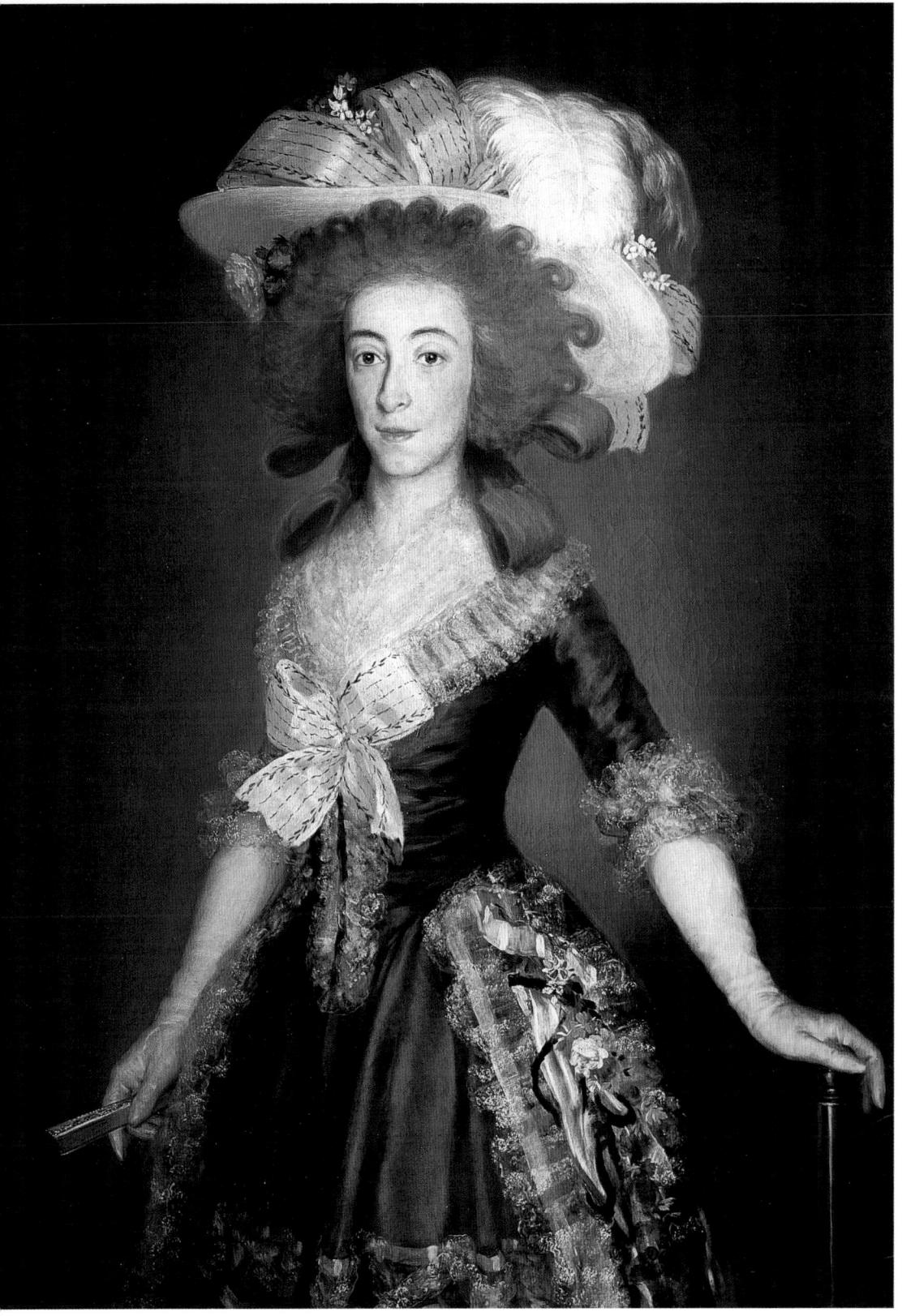

Goya, *María Josefa de la Soledad*, *Duquesa de Osuna*, *o La Condesa Duquesa de Benavente*, 1785. Oil on canvas, 104 x 80 cm. Colección Bartolomé March.

Goya has painted her in terms of subtle gradations of color, translucent glazes overlaid with delicate passages of impasto. This ability to convey ranges of visual distinction through glazes without compromising the strength of forms was Goya's reward for the time he must have spent studying the Old Masters in Don Luis's collection in Arenas, and in the Royal Palace in Madrid. The condesa duquesa's own sense of style is clearly impeccable. Her dark Prussian-blue dress is softened by cloudlets of cream lace, and Goya has taken a palpable delight in rendering the visual rhymes between the broad bow of pink silk ribbon that ornaments her bodice, the loops of the same ribbon, embellished with tiny flowers and an egret plume, in her hat, and—an exquisite touch, for which one must thank her peluquero rather than her painter—the way in which the wide stiffened curls of her hair repeat the forms of the ribbon. Discriminating in this as in all things, she had taken into her employ a French hairdresser named Brayeu, who modeled her hair on a tocado done for Marie-Antoinette. Gova sets before us a woman of great style but no frivolity, and this, in essence, was the truth about the condesa duquesa.

The whole family was the subject of one of Goya's early group portraits, now in the Prado. They are posed together as a tight-knit unit, the count and countess with their two daughters and two sons. In 1787-88, when the picture was painted, family groups were distinctly uncommon in Spanish art: Velázquez, for instance, was never once called upon to paint one. The Family of the Duke of Osuna is one of Goya's three masterpieces in this genre, the others being the family group of Don Luis and, of course, that of Carlos IV and his relatives (page 228). But it is unlike the group portrait of Don Luis's family in that the latter belongs more to the English tradition of the portrait as conversation piece, in which people are seen reacting to and conversing with one another in an imaginary narrative where they seem unaware of the painter's gaze. In the Osuna group portrait, the family looks back straight at the painter and, therefore, at us; they have no reason, so to speak, for being there except to be seen as they want to be by us. There are six pairs of eyes in the portrait, backed up by eight pairs of prominent round buttons on the tight-laced bodices of the duchess and her daughter Josefa Manuela, and everyone is staring straight at us in a friendly, slightly questioning way that makes us wonder what we are doing here. The fact that the Osunas chose the format of the family group portrait is in itself an indication of their openness to innovation. They paid Goya 4,000 reales for it. A year later, with his growing reputation, he would ask for and get 4,500 reales for the full-length, single figure he did of the conde de Cabarrús, now in the collection of the Banco de España; his standard price for a halfGoya, *The Family of the Duke of Osuna*, 1788. Oil on canvas, 225 x 174 cm. Museo Nacional del Prado, Madrid.

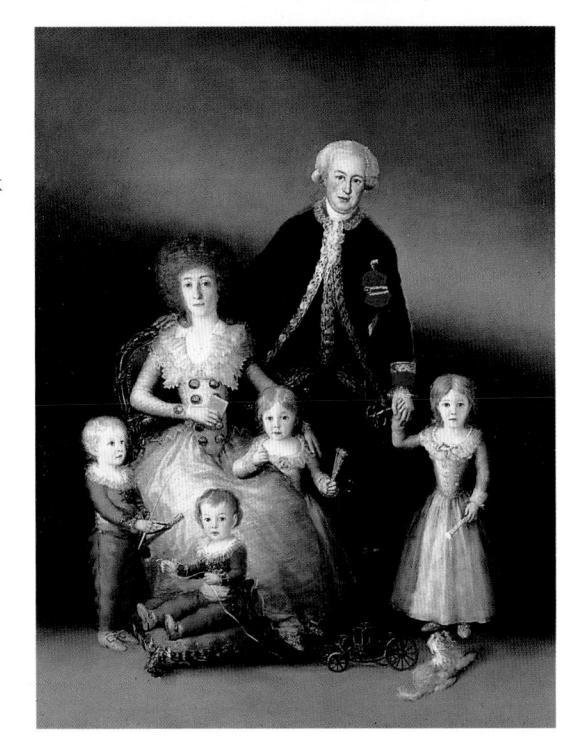

length portrait, of which he did several for the directors of the bank, became 3,000 reales.²³

The Osuna group is exquisitely painted, with soft transitions of tone and no sharp highlights or shadows. Goya has paid homage to one of the most durable traditions of Spanish portraiture, its austerity: black, white, green, a neutral brown, a touch—no more—of red. It is essentially the palette of Velázquez. The strongest color is black, the mourning black of the suit of the duke, whose father had recently died, in April 1787, leaving him the title and the obligation of three months' strict mourning, followed by nine months of lesser mourning dress. The duke is not wearing deep mourning—the silver embroidery and red details of his suit show that he is in *medio luto*, half-mourning—and so the portrait must have been painted between July 1787 and April 1788.²⁴

He looks, however, rather pictorially stiff and formal, and the schematic formality of the black and silver suit contrasts a little awkwardly with the soft way in which his face is painted—it is not quite strong enough to carry out its function as the keystone, the apex of the composition's triangle. No such problem exists with the figure of the duchess, which is much more unified, because blander throughout. She wears a beautifully rendered dress of gray mousseline de soie, finished with white lace and traces of pink. She is the epitome of fashion, down to the last hair in her coiffure; but one also notices that her only adornment is the large buttons, which carry enamel portraits, presumably of her

family. She wears no jewelry, and apparently no makeup. This relative austerity announces that she is not a frivolous showoff but an *ilustrada de primera clase*, close to her husband yet independent of him—a woman of the Enlightenment.

The Osunas' four children, who gaze at the painter with such enchanting, round-eyed composure, complete the group. From left to right, they are Francisco de Borja, Pedro de Alcántara (seated on the green cushion), Joaquina, and the elder daughter, Josefa Manuela. They have identifying attributes: the two girls, dressed in the same gray silk as their mother, hold fans; the two boys, in their green suits and pink sashes, have toys emblematic of their gender. Francisco bestrides his father's gold cane of office as a hobbyhorse, a fitting symbol, since he is the elder son and thus the heir; Pedro has a handsome little toy carriage on a string. In due course the little girls will marry other aristocrats, Francisco will inherit the title, and Pedro will become one of the first directors of the Prado Museum—a nice symmetry, since that is where Goya's portrait of them all will end up.

As Goya's relations with the Osunas became firmer and more regular, he was invited to visit them at their beautiful villa, the Alameda Palace, known as El Capricho, and to do decorative paintings for its rooms. These were an idiosyncratic mélange based on models of French Rococo decoration such as Fragonard—but with a decided twist.

The painting that shows the most incongruity between Goya's (and his patrons') imagination and the model they had chosen is *Highwaymen Attacking a Coach* (1786–87). It is French pastorale with murder in it—a most peculiar contradiction. It is as though some hostess in Bridgehampton decided, for her and her guests' amusement, to decorate her living room with a scene of armed thugs plundering a car wreck on the Long Island Expressway. Instead of the conventional and pleasant "gallant encounter" of country swains and milkmaidnymphs under Fragonard's feathery trees, we get the Frenchman's green scallops of dense foliage, the same ice-blue sky and ice-cream clouds, but with blood, hysteria, terror of rape, and stabbing going on beneath them—a situation unknown to French art of the Rococo period. Suddenly, a little Spanish realism has pushed itself into a pastoral dream.

The picture represents what must have been one of the Osuna family's worst anxieties when they made their trips between the city and their country house on the then-bucolic outskirts of Madrid. In the 1780s the roads of Spain, even those near the city, were scarcely policed at all, and banditry was common. Not chivalrous Robin-Hoodery, either: the thieves and muggers who infested the roads and lay in wait for travelers were a violent and nasty lot, and God help

Goya, *Asalto de ladrones* (Highwaymen Attacking a Coach), 1786–87. Oil on canvas, 169 x 127 cm. Private collection.

anyone who fell into their hands or, once in their power, resisted. Goya would have more to say about this in later drawings and paintings, but here he has been given, or assigned himself, the impossible task of turning bandits into a picturesque cast of characters fit for the Osunas' drawing-room wall. Presumably he was hoping to produce something along the lines of the Italian artist Salvator Rosa's woodland scenes with picturesque bandits, which had been so wildly popular among European collectors when Goya was on his visit to Rome. They were considered by many to be the acme of tormented sublimity, the wildness of nature repeated in the wildness of its human inhabitants. "Precipices, mountains, torrents, wolves, rumblings—Salvator Rosa," Horace Walpole jotted in 1739 while intrepidly crossing the Alps. What Goya did produce is a Spanish version of *atque in Arcadia ego*—death in Arcadia.

In this green glade, a coach has been bailed up. Even if we didn't notice the gilding around the coachwork and the fashionable though rather cumbersome pattern of design—two small wheels at the front and a pair of enormous ones at the rear, which made it difficult to back the coach out of the mud when it got bogged down, as often happened on those wretched roads—we would know it for a rich family's vehicle because it is drawn by four mules, the largest traction

team allowed a private owner by the sumptuary laws of Carlos III. (The royal family, and they alone, could use six animals.) Four bandits have stopped and overpowered the coach and its passengers. The driver lies dead on the sandy ground, weltering in his blood. Next to him on the ground, a bandit and a male passenger are struggling in a knot of limbs; the gleam of the señorito's silver shoe buckles is brighter than the shine on the dagger in his assailant's hand, but there is no doubt which of them is about to die. On the far right, the military guard—it was never wise to travel without one—lies facedown and dead, his red tunic the one spot of complementary color against all the surrounding green. He is still clutching the sword he drew too late before a blast from the trabuco, the blunderbuss held by the bandit who is glaring watchfully from the driver's seat of the coach, cut him down. Interestingly, the guard is lying in exactly the same pose that Goya would repeat several times in future drawings and paintings to indicate a dead body, so that it became part of his shorthand for death—the most memorable and vivid example being the dead man facedown to the left of the French firing squad in the Tres de Mayo, his hands scrabbling palms-down at the earth. Goya, archrealist though he was by the standards of his day, had a repertoire of standard poses that he would produce as signifiers of particular feelings.

Two others who had been riding in the coach, a man in *majo* dress and a woman similarly garbed, are kneeling before two of the robbers, imploring their mercy. There isn't much doubt about what is in store. The upper-class pseudo-proletarian costume of *majismo* is not going to appeal to the bandits, one of whom carries a length of rope to tie them up. Fashion has had the ill luck to meet the real thing.

The most direct reference to French Rococo pleasure outings in this little set of pictures made for the villa is *The Swing* (1787), where Goya takes his motif from Fragonard: a pretty girl swinging to and fro on a rope slung between two trees, watched by three male companions dressed as *majos* and two other girls, one of them twanging a lute. (Goya's own inventory description makes it clear that they are all Gypsies.) And yet even here a faint tremor of apprehension—a sense that the world is insecure, which is very characteristic of Goya—is allowed to intrude: the rope on which she is swinging is tied together by a large, prominent, and rather insecure-looking knot, which could come undone at any moment. The conceit is much like the improvised knot in the much later print from the *Desastres de la guerra* in which an ecclesiastic in a tiara and flowing robes is seen teetering along a slack rope above the heads of the skeptical crowd, an insecure funambulist (representing the restored Church authority

after the return to power of Fernando VII) who could crash down at any moment—"Que se rompe la cuerda," reads Goya's caption, "May the rope snap." No such malign thought is directed toward the innocent girl on the swing, but all the same we see Goya's implicit twist on the playful eroticism of a Fragonard: these are a sextet of real Gypsies, so to stress their bohemianism, their gear should be ill-maintained.

Other panels in the series depict more country pleasures. Children climb a greasy pole in the course of celebrating a saint's day. There is a country church procession (1787) in honor of the Virgin Mary, whose effigy is being carried on a platform downhill from the entrance, followed by a well-upholstered-looking priest, a bagpiper, and some town officials; though one authority finds it "bordering on satire," the satire, if it exists, is very mild.²⁵ In the end, the Osunas acquired more than twenty paintings by Goya, mostly small ones. They commissioned religious ones in memory of their relatives, including two scenes from the life of a priestly ancestor of the duchess, St. Francis Borgia. These were destined for a chapel in the cathedral of Valencia, where they were hung high on the wall: this seems to have given Gova leave to pull out all the emotional stops, for the second of the two, St. Francis Borgia at the Deathbed of an Impenitent (1788), is as melodramatic a piece of diablerie as he ever painted. In fact, it is the first of Goya's paintings in which demons take a starring role. Bat wings, saber teeth, and all, they hunch and leer in a sort of red mist over the body of the dying man, and it is clear that none of St. Francis's exhortations can

Goya, San Francisco de Borja asiste a un moribundo impenitente (St. Francis Borgia at the Deathbed of an Impenitent) (detail), 1788. Oil on canvas, 350 x 300 cm. Cathedral de Valencia.

reach him. Not even Christ's blood can: the little figure of the Redeemer on the crucifix St. Francis brandishes is so insulted by the impenitence of the sinner that he flings a handful of his own blood at him, but it does no good at all. One senses that, even though Goya does appear to have been a man of some sincere religious belief—he was an *ilustrado* but by no means an atheist, a point to which we must come back—he found this particular story a little hard to swallow.

Later he would paint a number of *brujerías*, witch paintings, and these were bought—or perhaps actually commissioned—by the Osunas. But in the meantime, a near-catastrophe struck.

Toward 1792 Goya found himself getting bored with the tapestries. Certain assumptions that were in the air in Madrid had also begun to grate on him: in particular, ideas about idealism versus naturalism that originated with Mengs, the classicist leader of academic ideas.

He let his dissatisfaction show in a report he was invited to make to the Academy of San Fernando on the subject of teaching art. In this, one of the few expressions of theory this supremely untheoretical painter ever allowed himself, Goya's opinions amounted to a rejection of Mengs and most things he stood for—especially art based on rules, precepts, or anything except observation of "divine nature." Parts of the report, indeed, might have been written by William Blake in full spate against Sir Joshua Reynolds and his *Discourses*, for example: "[T]here are no rules in painting, and . . . the oppression, or servile obligation, of making all study or follow the same path is a great impediment for the Young who profess this very difficult art that approaches the divine more than any other." It is not hard to see running through Goya's discourse the same love of the empirical, the same insistence on following observed nature rather than inherited rules and precepts, that animated the scientific thought of the Enlightenment. "What a scandal," he writes,

to hear nature deprecated in comparison to Greek statues by one who knows neither one nor the other without acknowledging that the smallest part of Nature confounds and amazes those who know most! What statue or cast of it might there be that is not copied from divine nature? As excellent as the artist may be who copied it, can he not but proclaim that when placed at its side, one is the work of God, and the other of our own miserable hands? He who wishes to distance himself, to correct [nature] without seeking the best of it, can he

help but fall into a reprehensible and monotonous manner, of paintings, of plaster models?²⁶

Without the imitation of nature there is nothing he continues; all the rest is the "oppression" of "tired styles" that lead to "nothing good in painting." It is doubtful whether the worthy members of the academy had ever heard a colleague rip into academic tendencies with such unmannerly vigor.

In terms of pedagogy, he was right, and his views on how painting could be taught were irreproachably modern. But they also betokened a certain shortness of temper, an impatience with the whole idea of repetition, for he was beginning to feel that his own work for the tapestry factory, his bread and butter, was getting oppressive and boring. A crisis was brewing, and at the end of 1792 Goya abruptly broke off work on his tapestry designs and, without explanation, left Madrid for the south. In January 1793 the secretary to the Osuna family had a note from him saying he had been ill in bed for two months; now he wanted permission to drop the tapestry projects and go to Sevilla and Cádiz for a while to recuperate. This was almost certainly postdated; probably the illness, whatever it was, caught up with Goya in Andalucía some time before, when he was staying with a friend in Cádiz named Sebastián Martínez.

It was the last letter Goya would write for some time. No one can say what laid him low and so nearly killed him. He heard loud and constant noises, buzzing and roaring and ringing, in his head. But he had more and more difficulty hearing the sounds of the real world, and could hardly make out the syllables of ordinary speech. His balance was badly affected; he could not go up and down stairs without feeling in danger of falling over. He had fainting fits and spells of semi-blindness. As happens with disturbances of equilibrium, he often felt nauseated and ready to throw up. Gradually the more humiliating symptoms receded, but from 1793 onward, after he had turned forty-six, Goya would be functionally deaf. "My dear soul," he wrote to Zapater in March, "I can stand on my own feet, but so poorly that I don't know if my head is on my shoulders; I have no appetite or desire to do anything at all. Only your letters cheer me up—only yours. I don't know what will become of me now that I've lost sight of you; I who idolize you have given up hope that you'll ever glance at these blurred lines and get consolation from them."²⁷

What was this illness? It is impossible to say, because no modern diagnosis can be made; there simply isn't the evidence. Goya's deafness is one of the insoluble mysteries of art's medical history, ranking with Vincent van Gogh's madness and depression. It has been variously attributed to Ménière's syn-

drome (auditory vertigo), botulism, polio, hepatitis, and neurolabyrinthitis (an inflammation of the nerves of the inner ear). It may have been a side effect of syphilis, one of the most common diseases in Goya's time, though if it was, it seems strange that he lived on to such a ripe age (eighty-two years) and showed no signs of syphilitic degeneration, let alone general paralysis of the insane. (He did have bouts of paralysis during the first year of his affliction, but these passed of their own accord, without significant treatment.) A further possibility is that Goya was stricken by a bout of meningitis. He hallucinated, copiously. He was, one may surmise, utterly bewildered, and he was extraordinarily lucky that he had a close, rich, and wise friend to look after him in his misery.

This savior was Sebastián Martínez. In the early 1790s, Martínez was one of the outstanding figures in Cádiz or, for that matter, in the whole business world of Spain. Born in the north-central provinces, he had set up a flourishing business in the export of wines, particularly fine sherries, for which the English had a passion. But what distinguished him from the many other wine exporters in the bustling port city of Cádiz was his enthusiasm for art. He had one of the largest collections amassed by a commoner in Spain, none of it inherited, and most acquired by the exercise of discriminating taste. How much of it was genuine, of course, we are unlikely ever to know. Probably the "Leonardo da Vinci" that the connoisseur Antonio Ponz reported seeing on Martínez's wall was not a Leonardo; few Leonardos were, in the eighteenth century. But it is likely that the works attributed to Titian, Murillo, Velázquez, Ribera, Rubens, Pompeo Batoni, and others were genuine enough, and certainly the Goyas were. The inventory of Martínez's paintings ran to 743 items, and what must have been of special additional value to Goya was the enormous collection of prints by all manner of European artists, especially English ones, which ran into the thousands. During his long convalescence Goya was free and welcome to study these at leisure, and with the intimacy that comes from fishing an image from a portfolio or a drawer and holding it in your hands: this must have been his closest contact with a wide range of master prints since his (presumably much more restricted) access to them long before in the teaching studio of Bayeu in Zaragoza. The work of Sir Joshua Reynolds, George Romney, Thomas Gainsborough, William Hogarth, and even William Blake circulated in print form in Spain, but most of them were probably collected by Martínez on his business trips to England. It is likely that Goya had his first prolonged contact with the conventions of English portraiture, of which he was to make such intelligent use throughout his career, in Martínez's cabinets d'estampes. And it would be interesting—though now, alas, impossible—to know how intensively Martínez had been collecting the satirical images of the English caricaturists

Goya, *Don Sebastián Martínez y Pérez*, 1792.
Oil on canvas, 93 x 67 cm.
Rogers Fund, The
Metropolitan Museum
of Art, New York.

Gillray, Rowlandson, and others, whose brutal, sexually freighted, and scatological imagination sometimes looks so close to Goya's, if even grosser.

Very little is known of his stay with Martínez in Cádiz. But he did paint his host in 1792, and it is one of the finest of all his portraits. It shows Martínez seated, holding a letter on blue paper that works as a dedicatory cartouche: "Don Sebastián Martínez, from his friend Goya." The paper is the brightest spot of color in the painting. The rest is low-toned and exquisitely harmonious: the dark and subtly modulated background, the yellow britches with their silver buttons and buckles, the rather sallow but finely modeled face, and, above all, the jacket. This is rendered in thin transparent washes of blue over the brown underpainting, whose net visual effect is a very subdued green. Over this ground Goya chose to lay wavering stripes of a subtle, lighter green, which convey the slight wrinkling of the well-cut cloth on sleeve, lapel, and chest. It is a marvelously discreet image of a man at peace with himself, gazing back at his depictor with calm, slightly hooded eyes. It is so composed in feeling that it hardly seems possible that Goya could have painted it after his collapse; it must belong to the brief period in 1792 between his arrival under Martínez's roof and the onset of his disease.

There is no record that Goya's wife, Josefa, went south to be with him,

though this proves nothing; perhaps she did and no one thought it noteworthy that she had. So not even Goya's near-disastrous illness throws any light on the condition of his marriage. His first task, once Goya was more or less back on his feet, was to convince art circles in Madrid—which, like art circles anywhere else at any time, fed avidly and bitchily on the misfortunes of others—that illness had not damaged his powers as an artist, even though the big tapestry cartoons he had been working on, such as *The Wedding* (bigger than 8 × 10 feet), had harshly taxed his physical strength. To do this, he would have to take up his relations with the Royal Academy of San Fernando in Madrid and start attending its meetings again. He wanted to show that the illness was, in some measure, a blessing because it had set his work on a new track: less official, more personal, and so open to development in the direction he felt impelled to take. Thus, he would be seen to have risen above the miseries of his illness without having to wait for a big commission. With this in mind, he wrote to Bernardo de Iriarte, the deputy of the academy, in January 1794: "To occupy my imagination, which has been depressed by dwelling on my misfortunes, and to compensate at least in part for some of the considerable expenses I have incurred, I set myself to painting a series of cabinet pictures." A cabinet picture was, as he did not need to explain, a small portable painting, one which did not use up a lot of wall space, could be moved around at the owner's whim, and had no architectural function. Such paintings were unofficial; they "depict themes that cannot usually be dealt with in commissioned works, where capricho and invention do not have much of a role to play. I thought of sending them to the academy, since Your Excellency knows the advantages I might expect to derive from submitting my work to the artists' criticism." 28 Very humble of Goya, who by now would hardly have given an unripe fig for the opinions of Bayeu and the rest. But the news of his illness was all over Madrid, it had undoubtedly reached the court, and Goya needed to prove that it had not diminished his ability to paint. In March 1794 the director of the Royal Tapestry Factory was writing that, according to what he had heard, "Goya finds it absolutely impossible to paint, as a result of serious illness." Rumors like that could badly harm a career, even one as apparently vigorous as Goya's.

What were these cabinet pictures? A fairly mixed lot, twelve in all, each of them painted on a thin sheet of tinplate. Three were of disasters, melodramatic events of a fairly generic sort: people fleeing from a fire at night, the survivors of a shipwreck struggling to shore, and, recapitulating his big decorative panel for

the Osunas, the holdup of a coach by robbers. A fourth, demonstrating the influence Tiepolo had on him, is a scene of strolling players in commedia dell'arte costume. A fifth depicts the interior of a prison, and a sixth the yard of a lunatic asylum. Rather oddly, the minutes of the academy's meeting on January 5, 1794 refer to these as "various subjects of national pastimes," as though being whipped by a madhouse guard and cast ashore, half-drowned, on some coastal rocks were common Spanish diversions. However, the remaining six paintings unquestionably were of pastimes, if that is what one may call the noble, ancient, and bloody ritual of tauromachy. They are all bullfight pictures.

Goya was an aficionado, an enthusiast for the bulls. Whether he got involved beyond watching the fights is unknown. He liked to boast that he had—late in life, he would say that in his young days, with a sword in his hand, he feared nothing and no one—but that is a masculine boast easily made in Spain, especially when too much time has gone by for it to be verified. It may seem curious that his tapestry commissions for Carlos III had scarcely included, among their rural and gallant subjects, a bullfight. (The one exception dates from 1780 and is a cartoon, now in the Prado, of a novillada, or nonfatal encounter between a young animal, possibly a heifer, and a novice bullfighter; it seems possible that the young torero, turning toward the viewer, is a nostalgic self-portrait.) But Carlos III despised bullfights, thought they depraved the spectators, and sought to ban them. We can assume Goya had few expectations of selling these images to his king. But there were plenty of aficionados out there who might have bought them. They were not quite Goya's first bullfight paintings. Somewhere around 1780 he had done a set of paintings of children's games, one of which (Madrid, Fundación Santa Marca) depicts a mock bullfight, with one boy under a mock wickerwork bull charging at an infant picador who is riding on the shoulders of another boy, the "horse." Though he never developed this into a tapestry cartoon—Carlos III's chamberlains would have vetoed it as unsuitable for a royal palace, especially with that vulgar pink bum of the little crying boy who has been knocked over on the ground—it is very much in Goya's cartoon manner. There was also a taurine subject among the wall decorations he did for the Osunas's country villa (1786-87), showing the apartado de toros, the selection of bulls before a corrida. But the set of eight paintings on tin that Goya made during his Andalusian convalescence in 1793-94 was the first sustained treatment he had yet given this theme, and of course the works anticipate the physically smaller but much grander, stranger, and more oneiric narrative of the etchings of the Tauromaguia more than twenty years later.

Goya painted them on metal supports, tin-coated iron sheets, each more or

less 16½ × 12½ inches. The sheets were primed with a pinkish-ocher underpainting, which invites the eye to see them as a continuous series: the preparation, struggle, and death of the fighting bull. The first, *The Pasture, or Sorting the Bulls* (1793), is set in a meadow on the stud ranch where the bulls were raised; a crowd of enthusiasts, restrained by red-coated mounted guards and the vaqueros, or mounted station hands, has assembled on foot and in coaches to observe the drama of selection of likely *toros bravos* from a herd in the foreground. In *Placing the Banderillas* (1793), we see a young bull whose mettle is being tested by toreros in a practice ring on the bull farm, a rehearsal for the eventual corrida. *The Bull's Capture* (1793) shows one of the animals brought to town, ready to fight. The town is Sevilla, as one can tell from the Torre de Oro in the middle distance, on the bank of the Guadalquivir. It is a feast day, and a small crowd has erected a greasy pole, which children are climbing. In the foreground is a bull tethered by a rope around its horns; dogs are harassing it.

Now the formal drama of the fight is about to begin. It starts inside the bullring, but there is no unity of place in this little series. Certainly the arena we see
is not the one in Sevilla; nor does it belong to Madrid, although some writers
have thought so. Indeed, the architecture of the bullring varies slightly from
one image to the next; in some, the arches that frame the *palcos*, or loges, have
Ionic capitals, in others they don't. Goya is at some pains to make the fight
seem, as it were, colloquial. In the late eighteenth century the spectators were
allowed into the arena—not, as a rule, while the corrida was in progress, but just
before the fight. They had to be cleared out before the *lidia* could properly
begin, and in *Clearing the Ring* (1793), that is taking place: a mass of the public,
including a lot of excited small boys, being shepherded back out through the
entrance gate by some *alguaciles* (bailiffs) on horseback. The touch of Goya's
brush, rapid, broken, and flickering, adds to the excitement and anticipation of
the scene.

In *Pass with a Cape* (1793), we see an event now altogether gone from modern bullfighting, one that probably never played much of a part in the ritual: a torero is fighting a bull in the foreground, while a picador is trying to herd six or seven bulls out of the ring, back through the open gates of the bull pen. What they are doing in the arena while the fight is going on is anyone's guess: perhaps Goya was just conflating two moments in time. The documentary interest of the scene lies elsewhere, in the torero's pass. He looks as though his head is on backwards, while everyone else in the picture, the hundreds in the stands as well as the picador and the *peón* with the rope, has his or hers on the right way. This is because he is leading the bull behind him with the cape, performing

Left: Goya, Pase de capa (Pass with a Cape), 1793. Oil on tinplate, 43 x 31 cm. Private collection.

Right: Goya, *Cogida de un picador o La muerte del picador (The Death of the Picador)*, 1793. Oil on tinplate, 43 x 31 cm. Private collection.

what is called the *lance de frente por detrás*. Today this well-known maneuver is less common than it was around 1900, but back in Gova's time it was a challenging invention—entailing a moment, one imagines, of pure terror, when the bull is out of sight behind your back and you can only hope and pray that the next thing you feel won't be the bull's horn shattering your femur—and because of it we know who the torero in Goya's painting is. His name was José Delgado, a star of the bullring who fought under the name of Pepe Illo or Hillo. Goya knew him, though not on the same close terms of friendship as existed between the painter and another great torero, Pedro Romero. (Illo and Romero appear in the later Tauromaquia etchings, but only Romero received the compliment of a portrait by Goya, and one of his finest at that. Delgado had written a book on bullfighting, El arte de torear, and in it he mentions this unique pass, which was to some extent his professional trademark—he claims, correctly it seems, to have invented it, "and I have always carried it off with success." Perhaps he spoke too soon: it was his fate to die on a bull's horns in the Madrid plaza on May 11, 1801, and Goya was watching from ringside. Delgado's death

caused great commotion and grief among *aficionados* in Spain and inspired not only a flurry of popular prints but also several images for Goya's *Tauromaquia* some fifteen years later—by which time the death-defying bravery of Pepe Illo had become one of the legends of the ring. One of Goya's prints of the bull-fighter's death, plate E of the *Tauromaquia*, shows him being flung upside down in the air by the enraged animal, whose left horn has transfixed Delgado through the thigh and lifted him completely off the ground.

This spectacle of what could happen to a bullfighter who miscalculates is shown in the next painting in the early series, *The Death of the Picador* (1793). It is quite the most brutal image that Goya, at the age of forty-seven, had yet painted, and one is inclined to think that its ferocity is a sign of his reaction to the onset of his deafness—a very long way, in any case, from the pastoral and sociable pleasures of the tapestry cartoons. Much more fiercely than the mayhem and highway robbery he painted for the Osunas, it announces the long thread of violence and fear that would henceforth run through his work—an important difference being that while his earlier holdup scene was depicted as a crime and an aberration, in *The Death of the Picador* Goya painted sudden agony and death as a natural, indeed an entertaining, part of the social spectacle: this is the stuff, he insists, that Spaniards (including me, voyeur that I am) pay their pesetas to see. Like it or not, he says, and most people do like it, this *is* Spain, and you cannot look away without losing some part, maybe only a few molecules but probably more, of your claims to your *ser auténtico* as a Spaniard.

The scene is the middle of the arena, and the formal encounter between men and bull has gone hideously wrong. The bull has charged the picador's horse (it is worth noting that, two centuries ago, the horse was not protected from the horns by the thick mat, a veritable armor of esparto grass, that is used to shield the flanks of the animal today) and smashed it down, tearing open its belly with its horns. On the sand beneath it is a thickly puddled clot of red intestines. Sometimes, if he was lucky and agile, the dismounted picador could scramble to put himself on the other side of the dying horse, but he has failed this time and received a terrible cornada, gored clean through his right thigh and wrenched helplessly into the air like a bug on a pin, his head and shoulders hanging over the bull's face as the beast tosses him to and fro. Barring a miracle, he is a dead man already. A horn that pierces the inner thigh, angling upward and exiting from the lower buttock, is almost certain to sever the deep femoral artery, causing a fatal loss of blood that no tourniquet can stem. And if the picador survives that, he will die of an infection caused by the tribes of bacteria the horn has picked up from the guts of the horse. Nevertheless, his companions Goya, *El naufragio (The Shipwreck)*, 1793–94. Oil on tinplate, 50 x 32 cm. Private collection.

are doing their best to get him off the horn. Two *peones* are hauling on the bull's tail with all their might and main, hoping that the wretched picador will somehow slide forward under the inertia of his own weight, free of the impaling horn. Two other picadors are attacking the bull with their *garrochas*, or spears, trying to force it to a standstill.

It was probably inevitable that, after his mental sufferings, Goya's mind would have been running in a general way on disaster and mayhem. There's no knowing exactly what the story behind Fire at Night (1793-94) might be—a close-packed, struggling mass of clothed and half-naked bodies in the flickering light of flames: a burning hospital, perhaps? Or maybe just an excuse for painting chaos for its own sake? There is no doubt about the subject of *The Shipwreck* (1793–94), although nothing about it convinces you that Goya had ever seen, let alone experienced, such a thing. It is more likely that he knew and remembered shipwreck paintings by Joseph Vernet (1714-89), since quite a few collections in Goya's provincial Spain had examples of Vernet's breaking rollers, blown spume, fanged rocks, and pathetic gatherings of sodden crew and passengers. Here, a rocky coast is dotted with the survivors of a wreck. They are crawling out of the water in the distance; in the foreground they cover a small headland, some of them obviously surviving, like the bare-bottomed woman on the left being dragged from the waves, and others, like the man sprawled on his back on the unforgiving rocks, obviously not. It is an exercise in the horrible,

Goya, *Asalto de la diligencia (Attack on a Coach)*, 1793. Oil on tinplate, 50 x 32 cm. Private collection.

the terrible, and the awful well suited to Romantic tastes for the sublime, and its climax is of course the unhappy woman in the yellow skirt who stands precariously on the rocky shelf, arms flung to heaven in a gesture of despair and imprecation.

The Attack on a Coach (1793) is a considerably grimmer replay of the subject Goya had painted earlier for the Osunas. The springtime greens, the lushness that gave that much larger panel its decorative quality, have gone, and in their place is a near-monochromatic palette of raw umbers, gray, and ocher with a high, pale, cold blue sky. The coach has been waylaid somewhere far out in rocky country, and none of its passengers is going to get a chance. Three are already dead on the ground—and a very Goyaesque touch is given by the orphan shoe of the man in yellow britches and red coat in the foreground, lying a short way from his foot, emphasizing his death. As in the Osuna picture, one robber is stabbing a man to death on the ground. The last survivor is kneeling to beg for his life, but another robber has leveled his gun and is about to shoot him.

The most powerful of the small paintings in this group, however, and the ones with most to say about Goya's state of mind in the wake of his illness, are *Interior of a Prison* and *Yard with Lunatics* (page 138), both 1793–94. We know where the madhouse scene, the *Yard with Lunatics*, actually was: a hospital in Zaragoza. The place where *Interior of a Prison* is set is not certain; perhaps there

was such a prison in Zaragoza, perhaps not. One suspects it was a composite, an architectural fantasy invented by Goya partly out of his memories of Piranesi's prisons. The architecture is huge, rudimentary, and oppressive, its dominating form a big shadow arch—the wall it penetrates must be six feet thick or more. A foggy, cold light filters through this opening, not from the world outside but from some further recess. Seven figures, all men, are chained to ringbolts, fettered, handcuffed, in various postures of misery and dejection such as men assume when time has stopped, when there is no reason to suppose that the next hour will be any different from the last. There is an almost fantastic disproportion between the thickness and weight of the iron that holds them down and the frailty of their bodies: it makes you think of the title page of Piranesi's Carceri, with its giant figure loaded with more heavy metal than (you would think) a body could bear. The theme of the painting is leaden immobility leaden in color, but also in the immense and meaningless weight of time creeping by. There is little reason to doubt that this vision of immurement, in a place whose walls are too thick for outside sound to penetrate and the only voices are the fitful utterances of prisoners, served Gova as a metaphor for his deafness.

Any trauma makes you think of worse trauma: it sets the mind worrying and fantasizing about what else might be in store, and whether you can bear it if it comes. Much of the pain is in the slow waiting. What Goya had been through in his sudden illness was not a fantasy, but it was a mystery. Neither he nor any of the doctors he might have consulted could possibly have diagnosed what was wrong with him, because such diagnosis was not within the reach of the medical knowledge of his time. (If it had been, we might have more chance of naming his affliction ourselves.) To fall badly ill, sustain grievous injury, yet not be able to name what the trouble is, know whether it is temporary or permanent, or, if the former, make any guesses about how long it will last, whether it will ruin your career and your normal social relations or eventually sheathe its claws and let you alone—all that is an experience that verges on desperation. But for Goya there was something else, something worse: deafness means isolation. It still does today, with all the therapeutic means that are at the disposal of the deaf and enable them to communicate, with some degree of fluency, with others. But in the late eighteenth century the isolation was even deeper. It plunged a man into the silent prison of the self. There was lipreading, for which one might or might not have a talent. There was sign language, crude but reasonably effective, at least for signaling basic needs as they arose. Goya understood it, for there exists a drawing he made of hand signs for the deaf and dumb. But beyond that, there was no way by which a man of Goya's psychic complexity

Goya, *Interior de cárcel* (*Interior of a Prison*), 1793–94. Oil on canvas, 42.9 cm x 31.7 cm. The Bowes Museum, Barnard Castle.

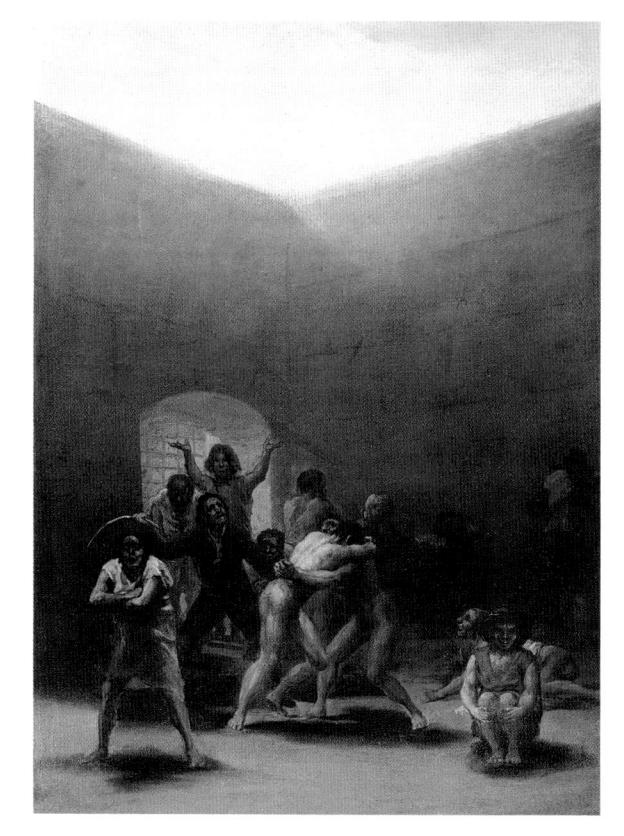

and subtlety could readily extract the meanings of the world of sound and speech through the terrible block of deafness. "Lost! Lost! Lost are my Emanations!" is the tragic cry of William Blake's Tharmas as he feels the world closing in on him, the onset of an impotence worse than sexual. An artist lives to communicate and to be communicated with, and for such a person to be immured in the prison of the self is torture. Blindness, undoubtedly, is the worst, especially for a visual artist. But fear and loathing of deafness is so general a human trait that torturers and jailers have always done their best to simulate it in creating punishment: the "dumb cell," where no sound penetrates, where no man can orientate himself socially through the sound of another's voice and the meaning of his words, is one of the traditional horrors of the carceral world.

The late eighteenth century was the heyday of the prison as isolator; not for some time to come would the idea of the prison as a reformatory institution begin to occupy the minds of European governments, trickling in from the ideas of Jeremy Bentham to emerge, in the minds of English and American reformers in early Victorian days, as the organized and (it was supposed) benignly structured penitentiary. Bury them and lock down the lid: such had been the prevalent idea before. And as bad as prisons traditionally were, madhouses were even worse, because practically no one had any idea of how to treat the mad, let alone any desire to penetrate the causes of their suffering. Madness was a given, an absolute; it lay beyond the reformer's reach. Madhouses, therefore, were simply holes in the social surface, small dumps into which the psychotic could be thrown without the smallest attempt to discover, classify, or treat the nature of their illness. This was a charter for degradation, and what made it worse was the habit, not restricted to England but ingrained throughout Europe, of using the helpless inmates as a form of entertainment: one could visit them in the asylum as one might visit the apes in the zoo, and be amused by their capering, babbling, and strange antics, which to those of a philosophical bent illustrated John Dryden's thought that "Great wits are sure to madness near allied, / And thin partitions do their bounds divide." Just as, to post-Darwinians, the monkey in the cage gave rise to thoughts about one's ancestry, so the shit-bedaubed lunatic crouched in a corner of the cell, gabbling opaquely like one of Swift's Yahoos, reminded the visitor of his own good fortune in being normal. Atrocious though it was in England, the institutional degradation of the mad was given even wider license in Catholic countries like Spain because of their traditional belief in diabolic possession as the cause of madness. To scourge or otherwise mistreat the mad was not arbitrary cruelty; it was a means

(distasteful perhaps, but necessary) of doing God's work. In any case, the idea of "patients' rights" was not yet born: just about any cruelty could be defended as exorcism.

So it perhaps appeared to the authorities who ran the provincial madhouse at Zaragoza. Anyone fears madness who has felt the wind of its passage; and one may presume that, after his disorienting and frightening illness in Andalucía, Goya was particularly worried by the thought of what could happen to him if he did, indeed, go mad. Moreover, confinement—harsh isolation without appeal for reprieve—is a powerful trope for deep deafness, a condition for which there are no strong visual metaphors. (It is not hard to come up with visual signs for blindness or sexual impotence; but for deafness?) We do not know why he paid a visit to the Zaragoza madhouse. There is some evidence to suggest that an aunt and an uncle of Goya's, both called Lucientes, were confined there between 1762 and 1766.²⁹ But there is no doubt that he went there, for on January 7, 1794, he wrote to Bernardo de Iriarte, his friend at the Royal Academy in Madrid, to say that he was at work on a new scene representing a corral de locos, "a courtyard with lunatics, in which two naked men fight with their warden, who beats them and others with sacks (a scene I saw at first hand in Zaragoza)." The "sacks" would have been the simple tunics worn by inmates, easily washed and replaced. In the finished picture the two naked men are fighting with each other, not with their warden. The warden's face expresses a despair as inconsolable as that of the miserable inmates. And there they all are, all in it together, each imprisoned by his neighbor, the miserable loonies of Zaragoza: fighting, struggling, snarling and glaring, crouched and crawling like animals on the gray stone. The light is depressing. The courtyard is open to the sky: gray sky, a silvery twilit gray, cold and dank—the two flanking figures on the left and the right, one hugging his arms around his chest and the other clutching his legs, seem to be shivering with cold. It is as though a fog is descending from the sky, chilling their bones. This pervasive dimness of Purgatory is of a piece with the light in *Interior of a Prison*, but somehow worse because even colder.

Some twenty years later, Goya would revisit this subject, but with significant differences. In *The Madhouse* (c. 1812–13), the lunatics are not exactly running the asylum, but they have constructed a world of delusory gestures of power in which they almost might be, and no keeper is lashing them into submission. One madman reclines on the flagstones, a toy crown on his head and his right hand raised in a parody of episcopal or papal blessing. Nobody takes notice of him. Another, wearing feathers in his hair, holds out his hand to be kissed by the shadowy mob of courtiers behind him. A third, cards on his head, croons to

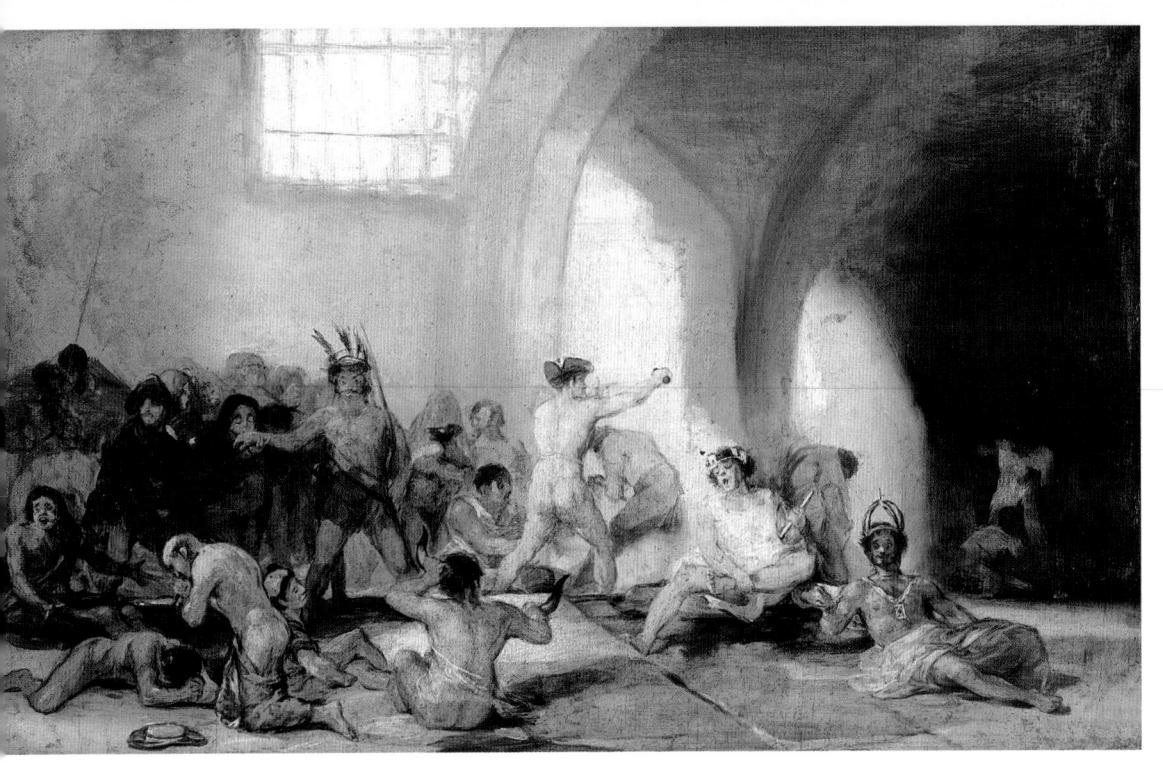

Goya, *Manicomio o Casa de locos (The Madhouse)*, c. 1812–13. Oil on panel, 45 x 72 cm. Museo de la Real Academia de Bellas Artes de San Fernando, Madrid.

himself, holding a flute or perhaps a scepter. A naked man, standing with his back to us with a tricorne hat perched on his head, is absorbed in aiming an imaginary gun at someone unseen. Another, clad only in a wisp of drapery, is doing something with the horns of a bull: perhaps remembering corrida games of his boyhood. Finally—and almost incredibly daringly for the day—there is a pair of naked men having what can only be sex in the blurred shadows to the right: just as Goya, in *The Naked Maja*, painted what are certainly the first curls of female pubic hair in Western art, so in this madhouse he made the first depiction of fellatio.

Is there any thread that links the earlier cabinet pictures of the 1790s together, despite their different subjects? There would seem to be. Nigel Glendinning was surely right when he wrote that it was Goya's depression.³⁰ He had just been stricken down into the depressive's nightmare predicament: cut off from the world and from intimate contact with others by a severe, undiagnosable, and incurable illness; alienated; lost within himself; desperately anx-

ious (as his letters to Iriarte imply) to show that things were not as bad as they seemed, that nothing was deeply wrong, that he could still function as a man and an artist. The bullfight was one superb metaphor for this. In most of the images, one sees the fighters winning over the bull, rising above its strength and dark animal nature. Organized human consciousness prevails, as in the spectacular reverse pass of Pepe Illo. They are not "happy" pictures; the brisk and heraldic colors of the arena have drained out of them. The color schemes of other cabinet paintings are not merely lacking in ebullience: they are positively funereal—the monotone of scrubby ochers and sepias in the attack on the coach, the gloomy hues of the shipwreck. Fire at Night refers to a melodramatic but unidentified moment: we see a congested mass of figures escaping from a conflagration, though no building is in view; nevertheless, the fact that several of the figures are being carried horizontally, some on sheets as though just dragged from their beds, suggests that the fire is in a hospital or lazar house and that those being rescued are patients unable to walk or otherwise fend for themselves. This would fit well, again, with Goya's own sense of helplessness in the face of his disease.

Almost as unhappy, though less catastrophic in its tone, is the one picture that should, at least, look jolly and is the closest in subject to the tapestry designs Goya had fled from producing: The Strolling Players (1793-94). Here are the familiar creatures of the commedia dell'arte, Pierrot the juggling harlequin, the dancing dwarf, pretty Columbine, on their improvised stage in front of a tent that serves them as a green room; there is the crowd, drinking it all in, with a river far off behind them—but where is the sense of enjoyment? ALEG. MEN, short for "alegoría Menandrea," is written on a scroll that hangs over the edge of the stage; this identifies the performance as a Menandrean allegory, Menander having been a Greek dramatist who specialized in short, moralizing comedies that could, at a stretch, be seen as the ancestors of Spanish sainetes. But the colors are dull, the atmosphere depressing, the movements somehow mechanical; the scene has none of the unaffected brio of Goya's tapestry cartoons. Thus, with the scenes of prison and madhouse, he reaches a nadir of lamentation for lost happiness that can be nothing if not autobiographical: the prisoners laden with thick, exaggerated chains are Goya's versions of Blake's "mind-forg'd manacles."

But Goya's deepest and most violent fears are registered in the goring of the picador. There, human skill breaks down into chaos. The man cannot be saved. The horn is in his groin. He is doomed and castrated, all at once. The artist must have seen such catastrophic events more than once: they were not

From Tapestry to Silence · 143

uncommon in the bullring. Yet one cannot doubt that the goring of the picador had an emblematic power for him. It is a terrible image of Goya's own fear of impotence—in a more general sense, of his fear of being no longer able to impose himself upon the world, brought to the surface in an acute form in his deafness.

WITCHES AND ANGELS

ARLOS III DIED in December 1788; Spain, as was customary, went briefly into mourning, and then into formal rejoicing the next month when, on January 17, 1789, the prince of Asturias assumed the throne of Spain as Carlos IV, with María Luisa of Parma as his queen and consort. Their reign, which would last nearly two decades, would bring Goya to his peak of material and social success—while being struck down with a crippling but still unidentified illness that would immeasurably deepen his art—and plunge Spain into a maelstrom of confusion, misery, and suffering such as it had never known before.

Neither Carlos IV nor his queen seems to have had any intellectual or esthetic effect on the man who was to be their court painter. Goya's relationship with them was not one of those reciprocal and fruitful affairs that sometimes, if rarely, occur in patronage. But they liked him, paid him, genuinely appreciated his work, and had enough taste to realize that whatever works by other artists they might add to the colossal royal collections built by the Hapsburg monarchs of Spain and then expanded further by Carlos's own Bourbon predecessors, Goya was clearly the best living painter in Spain.

Carlos IV has gone down in history as a political embarrassment, a royal nebbish: the ins and outs of international politics at the turn of the nineteenth century were mainly beyond him. However, one can hardly blame a not-too-bright absolute monarch for a certain clumsiness in managing his role just at the time of the French Revolution, which deposed and beheaded his own cousin Louis XVI. He was neither smart nor tough enough to save his own throne from Napoleon, and he committed one of the greatest acts of self-impoverishment in history by turning over the then-Spanish colony of Louisiana to France—only to see Napoleon sell it in 1803 to the fledgling United States of America for the unbelievably trivial sum of \$15 million, cash on the barrelhead. Since this doubled the size of the United States in one deal and opened the way to doubling it again, it is hard to admire poor Carlos's foresight.

This much, however, can be said for him: he was not, in any clinical sense, an idiot. That unhappy distinction belonged to his elder brother Felipe, who would normally have succeeded to the throne but was so feebleminded that his father had no choice but to disinherit him. He died in 1759, leaving Carlos as the future king.

In his ineffectual way Carlos did care about the well-being of his people. But his reign was also an example of the sort of gamble hereditary kingship is and must be, because it brings no guarantees of skill, energy, or intelligence. He had little acumen, but he was born to run the whole of Spain—and at a time when, five years into his reign, the very principle of kingship and its survival was flung into doubt. Immured in the palace and its rituals, Carlos hardly knew the Spain he ruled. Of Europe he knew nothing: he had to wait for the throne for two thirds of his life, frittering it away harmlessly until his father died in 1788.

By then, Carlos IV was forty years old. He was candid, stolid, and pious to the point of superstition, attending Mass at least once and often several times a day. He had ample experience of others' deference, but little of exercising direct power. He was deficient in both statecraft and cunning, and had little natural talent for acquiring either. He vacillated between advisers, delegated too much authority to others, and spent too much of his time under the thumb of his wife.

A simple soul, Carlos had been something of an athlete in his youth—fencing, boxing—but now found his main pleasure in the hunt. As a rule he hunted on foot, with dogs—a passion for the chase that was also felt by Goya, and probably helped to cement his position as painter-in-chief to the court. "As far as I'm concerned there is no better entertainment in all the world," he wrote to his friend Zapater about hunting. It is not known whether Goya hunted with his monarch, but he certainly did with his younger brother, the Infante Don Luis de Borbón. The first such excursion was at Don Luis's country lodge at Arenas de San Pedro, southwest of Madrid, in the fall of 1783, the year Goya completed the portrait of the infante with his family—an immature foretaste of the great group portrait of Carlos IV and his family that Goya would execute in 1800. "I went out hunting twice with His Highness, who is a very good shot,"

he wrote to Zapater, "and on the last afternoon he said after I had brought down a rabbit, 'This rotten dauber is even more passionate about hunting than I am!' "1

But Goya hunted only occasionally, since he had work to do. Hunting, by the king's own account, took up nearly all the royal day, leaving little time for affairs of state. "Every day without fail," he told Napoleon over a meal in Bayonne after his exile from Madrid, "in winter and summer, I went hunting until noon; I ate, and immediately returned to the hunting field until evening. Manuel [Godoy, the prime minister] kept me informed about affairs, and I went to bed only to begin again in the same way the next day." (It is not hard to imagine what contempt the fiercely concentrated Napoleon would have felt for this confession of such an empty, lackadaisical life.) Carlos IV did not care what he shot. If it ran or flew, it was fair game. He even ordered that animal carcasses were not to be buried on the royal grounds: they must be left to rot in the open air, thereby attracting crows, which His Majesty also liked to shoot.

Goya painted both Carlos IV and his father in hunting dress. He did so in homage to Velázquez's royal portrait of Felipe IV on the hunting field, which he had ample opportunity to study in his role of official painter, with access to the palace. In the 1630s, Velázquez had produced several gun-and-dog hunting portraits of members of the royal family for their hunting lodge at the Torre de la Parada outside Madrid; his image of Felipe as huntsman is quite informal, without the obvious marks of kingly status. Goya took up this cue first in his c. 1780 portrait of the aging Carlos III with his flintlock and his hunting dog curled up at his feet, standing in a luminous and open landscape. His big-nosed face, framed in the tricorne hat like the head of an affable turtle poking from its shell, looks as contented as his dog's. A benign king, whose only obvious attribute of kingship is the broad watered-silk sash of the order he founded (the Order of Carlos III) that runs diagonally across his chest. This is part of a different image of monarchy that Carlos III, in his (relative) liberalism, apparently wished to promote and be recognized by: not the remote and austere monarch far above his subjects, not the armored military hero surrounded by the attributes of command, but a man whose amiable pleasure in country pursuits linked him, by implication, to the Spanish people—a people to whose reform and improvement he felt a royal obligation.

The same feeling is present in Goya's portrait of the son, Carlos IV, done in 1799. The character of the paint has improved by now, of course; it no longer has the stiffness it had in Goya's youth but bathes its unpromising subject in a flicker and flow of light whose freedom the painter had had twenty years to per-

Goya, *Carlos IV in Hunting Clothes*, 1799. Oil on canvas, 210 x 130 cm. Palacio Real, Madrid.

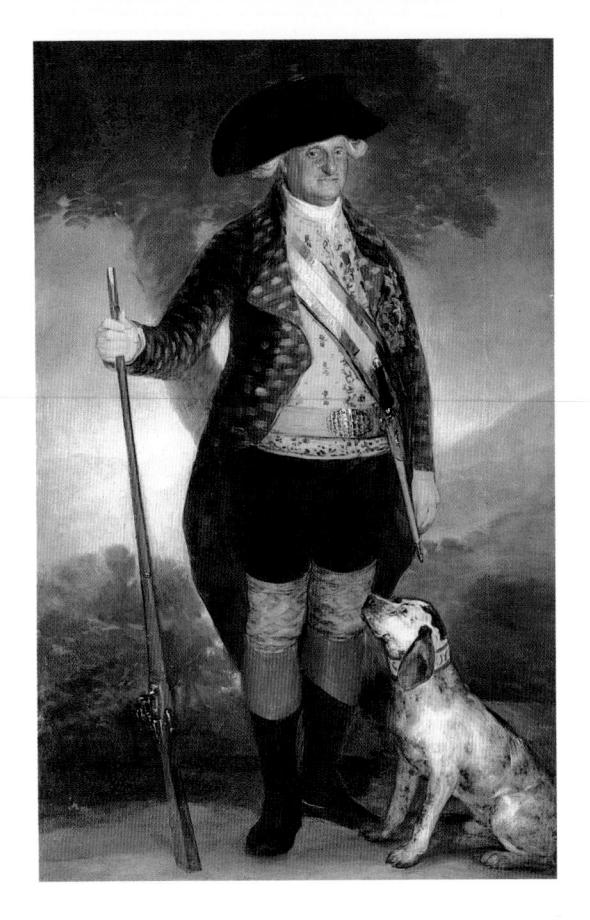

fect. Gova has endowed him with a portly dignity, if not with any flattering signs of intelligence. As in his father's earlier portrait, Carlos IV wears the blue, white, and blue sash of the Order of Carlos III, and Goya has lavished a great deal of care on his clothes and accoutrements: the faceted silver gleam of his belt buckle, the curious fabric, brown with ocher spots, of his jacket. He looks just like the man he should have been: a pink-faced country squire, adored by his dog, perfectly content with his sport and with himself. It is, in some ways, the most "English" of all Goya's royal portraits. The Englishness, one may surmise, is a real influence and not an accident. Goya would have seen English prints in the Cádiz home of his friend Sebastián Martínez when he was recovering from the illness that struck him down in 1793, and the work of Reynolds and Gainsborough, though filtered through the reproductory process of engraving, must have impressed him quite directly. This portrait also pays homage to earlier sources—for instance, the Prado's Titian portrait of Emperor Charles V and his hunting dog, which is obsequiously sniffing at his crotch, as dogs do. Carlos IV's dog, a golden or Labrador retriever (it is hard to be precise about related breeds so far back in time), is doing the same thing. It is not apparent in

Clock in the Casparini room, Palacio Real, Madrid

reproduction, but it is visible in the painting itself, that the dog's collar bears an inscription half hidden by its floppy ear: it reads, or seems to read, G-OY-, though the G is indistinct. Goya: the court painter declaring himself, perhaps not without irony, as his master's faithful hound. Or just possibly, Godoy, the name of the prime minister (though this seems less likely, since Godoy was the most powerful man in the realm next to the king, and perhaps the lover of Queen María Luisa; he would not have taken kindly to seeing himself identified as a dog, however faithful to his monarchical owner).

When he was not hunting, Carlos IV read lightly (though more than his detractors said, mainly in constitutional law) and enjoyed an undemanding level of hobbyism. Like his father, he disapproved of popular theater and did nothing to encourage it. (The *ilustrados*' hostility to the street culture of plebeian Spain. including bullfighting, and their lofty assumption that what the populacho needed was more elevating stuff, was one of the serious class rifts at the turn of the century; Carlos IV did not, however, perceive that it was a source of popular resentment.) Oddly, he practiced plumbing, though it is unlikely that he would have delved into the fecal mysteries of the palace water closets. He was a fair amateur carpenter (this being a time when wood-turning on small, elegantly constructed lathes was not an uncommon gentleman's diversion) and a moderately competent watercolorist. He also possessed a large collection of clocks and watches, which he purchased from agents all over Europe and which are preserved today in the collections of the Palacio Real in Madrid. Some of these—like the multi-movement, elaborated, almost ten-foot-tall clock, showing the time on earth, the phases of the moon, the motions of the planets, and the seasons, that stands in the salon where his portraits in formal

and hunting dress by Goya now hang—are of the utmost magnificence. Some of the smaller ones in his possession he loved to take apart, adjust, synchronize, and reassemble—a never-ending activity that helped pass the time on days when the weather was too bad for hunting. When he traveled, he took along some timepieces and a kit of watchmaker's tools. No doubt if there had been trains in those days, he would have had a model-train layout in the basement. He must have loved his guns, and known all about them: his connoisseurship of

those beautifully crafted flintlocks, with their damascened, brown-blued, and silver-inlaid barrels, engraved locks, and Circassian walnut stocks, exquisitely oiled and polished, must some of the time have made him a pleasure to talk to, whatever he may or may not have known about the family Velázquez portraits.

Unlike his father, Carlos IV genuinely loved music. He played the violin, though not well: his tempi were erratic, which made life difficult for other members of the string quartet he liked to practice with. Once, when rehearsing a piece, an Italian fellow musician made so bold as to tell the king that he should rest for three bars so that the others could catch up. Carlos felt this was impertinent and said so, though without rancor. "Kings," he observed, "need never wait for anyone."

The one area of culture in which Carlos IV achieved real distinction was his patronage of the visual arts, not just the arts of the horologist and gunsmith. Even if he had done nothing else for the art of painting, the fact that he retained Goya as *primer pintor del rey*, "first painter to the king," and contributed to his support until 1808, when the royal family was forced to flee Spain, would have been more than enough to earn posterity's gratitude. He supported other painters, too, but more as adjuncts to his architectural schemes. Decorously, Goya refrained from writing down his opinions of his king in any of his letters—and of course he kept no diary.

Carlos had a passion for architecture and understood its language well. His tastes were refined, modern, and French, running in the direction of Neoclassicism; in this he was well served by his court architect, Juan de Villanueva, best known as the designer of the Academy of Sciences, 1787, which was later converted to the Museo del Prado.

But Carlos also reached out to France when he felt so inclined, and in one of the pavilions by Villanueva that embellished the grounds of the royal palace at Aranjuez he commissioned one of the most exquisitely decorated rooms in all Spain, the Gabinete del Platino, or "Platinum Cabinet" (1805), designed by those masters of the Empire style Percier and Fontaine. Carlos liked Neoclassicism and adopted the style for Villanueva's expansion and redecoration of his pavilion at the Pardo, the Casita del Príncipe, as well as for new work in the Escorial.

He retained advisers and agents in Paris, Naples, and Rome. He kept the decorative-arts factories instituted by his father running, particularly the Royal Tapestry Factory of Santa Bárbara, which turned out hangings based on Goya's designs—somewhat to the periodic irritation of Goya himself, who wanted to break free of the relatively humble work of decorative tapestry production.

Percier and Fontaine, Salón de Platino, Aranjuez Casita del Labrador, Madrid

That Goya was unhappy about not getting more elevated and prestigious work is indicated by a letter to Zapater: "Today I went to see the king and he received me very happily. . . . He took my hand and he started playing the violin. I went in fear, because there has been someone of my profession who told him in the same room that I didn't want to serve him, and other things that vile men do." There was, of course, truth in this court backbiting. Carlos IV had wanted tapestry designs from Goya, of a "rustic and comic" nature, to ornament the walls of the royal offices in the Escorial. At first Goya jibbed at this, but he had to give in. In a contrite letter to Bayeu he apologized for the arrogant-seeming tone he had used in complaint. There is not much difference between the new cartoons and the older ones he had executed for Carlos III—except that a note of satire has made its appearance, like the first faint entry of a theme in an orchestral piece. The Goya of the earlier tapestries was not a mocker. But in a tapestry cartoon like *The Wedding* (1791–92; page 102), one sees the beginnings of what will, by the end of the decade, turn into the vast and cor-

rosive skepticism of his *Caprichos*, which sketch, among other things, the lineaments of a society in which everything from love and social status to clerical absolution from sin is up for sale.

Meanwhile, he had the Osunas to think of, and other clients as well. For the Osunas, Gova in 1797–98 produced a group of witchcraft paintings—a titillating subject for *ilustrados*. The duchess, rather as one might display a faux-naïve or campy taste for horror movies without actually believing in reincarnated mummies or creatures from the black lagoon, fancied them considerably. Brujería scenes of witchcraft—were very much a fixture of popular culture in late-eighteenth-century Spain. You didn't have to believe in devils, but their presence on your horizon offered a certain frisson to the enlightened mind, even if only as emblems of superstitions you had transcended. For the faithful, of course, there was no question about it. Witches were as real as cats (and often masqueraded as such), and the person who denied the real, actual existence of the devil and his legions was asking for nasty posthumous surprises. If one is to believe his letters. Gova did not believe in witches. He described himself to similarly enlightened friends as a skeptic, and there is no reason to doubt that he was. "Ya, ya, ya," he wrote to Zapater, "I'm not afraid of witches, hobgoblins, apparitions, boastful giants, knaves, or varlets, et cetera, nor indeed of any kind of beings except human beings."4 But not being afraid of them did not mean ignoring them: witches, warlocks, and other things that went bump in the night were too powerful as folklore for a painter like Goya, who was fascinated by culture that came out of the pueblo, to ignore.

Moreover, there was a matter of fashion. Goya was not the only artist or writer to be intrigued by the grotesque and the macabre. Other people in his circle of Madrid acquaintances knew about, and were titillated by, the fashion for the Gothick, for gratuitous shocks and horrors. The English Whig nobleman Lord Holland, for instance, kept Gaspar de Jovellanos *au fait* with English literary fashions, like the novels of Ann Radcliffe, author of *The Mysteries of Udolpho* (1794), and Horace Walpole's gothic romance set in the Middle Ages, *The Castle of Otranto* (1764). The taste for ruins, hauntings, diabolic transactions, and magic spread quite rapidly to the sophisticates of Goya's set. Matthew Lewis's novel *The Monk* (1796), whose contorted plot revolves around the doings of a fiendish *madrileña* named Matilda who corrupts an entire monastery full of Capuchins in Madrid, was presented to Jovellanos by Lord Holland; Lewis's play *The Castle Spectre* (1797) was translated into Spanish as *El duque de Visco* and performed, apparently in a somewhat bowdlerized form, in Madrid in 1803. Plays about diabolism and witchcraft were a staple of the popular Spanish the-

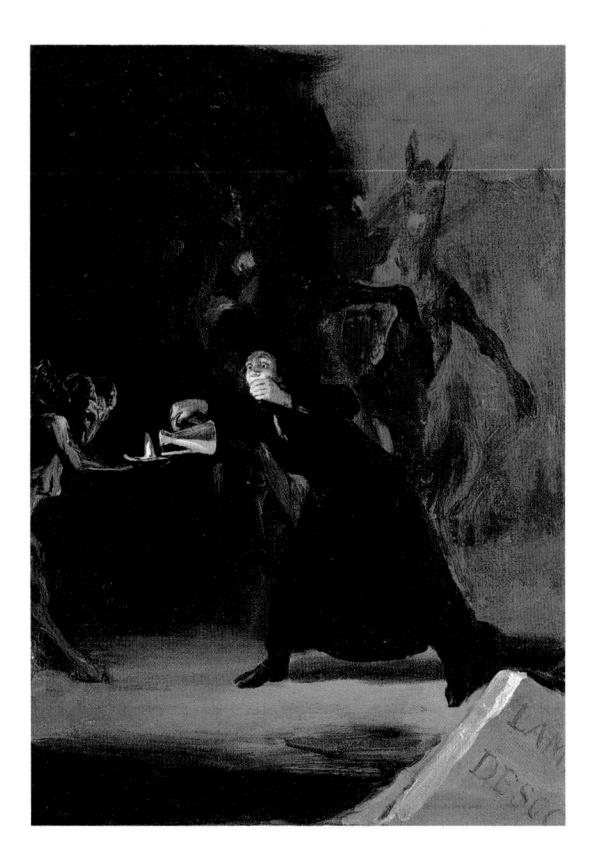

Goya, A Scene from "The Forcibly Bewitched," c. 1790s. Oil on canvas, 42.5 x 30.8 cm. The National Gallery, London.

ater in Goya's time, and the *duquesa* de Osuna was partial to them. Thus she commissioned a number of small paintings on witchcraft, diabolism, and sorcery from Goya in the late 1790s. Two have perished or been lost, surviving only as indistinct photographs—a scene in a witches' kitchen, and an encounter between Don Juan and the avenging *commendatore* he has murdered, entitled *The Stone Guest*. The latter comes from a scene in a play by Antonio Zamora, one of the many reworkings of the Don Giovanni legend. Another of the plays by this all-but-forgotten Spanish playwright supplied the motif for a second piece of Goya diablerie, which has in the foreground, written on what is presumably a prompt sheet, the fractured words LAM[PARA] DESCO[MUNAL], "monstrous lamp." This, Juliet Wilson-Bareau points out, is a fragment of a line uttered by a dimwitted and superstitious priest in a play called *The Forcibly Bewitched*, who believes a spell has been cast on him and that his soul is now being drained away:⁵

Monstrous lamp Whose vile light As though I were a wick Sucks up my life's oil. A demon with ram's horns obsequiously holds out to him a lamp, whose flame he feeds with oil from a tin cruet.

But can a picture like this, even by so distinguished an artist, be taken with the seriousness one would give to Goya's other work of the late 1790s? Surely not: it's an overwrought joke, with the priest about to vomit as he pours forth the oil or chrism of damnation—the sort of joke that a man who has largely escaped the bonds of superstition might make about the fantasy to another wised-up person. Not for a moment are we likely to feel the deep and authentic terrors emitted by some of the *Desastres de la guerra*, or for that matter some of the witchcraft scenes in the *Caprichos*. Broadly speaking, the same is true of other witchcraft paintings in the same series.

Two of these concern the propitiatory sacrifice of babies and fetuses supposedly made by witches to Satan. It was natural, perhaps inevitable, that a prescientific culture with an enormously high infant mortality rate through disease, infection, and poor nutrition would favor the production of myths about ritual child-murder by agents of the Evil One. Just as God and the Virgin were believed to watch over the healthy child, so Satan and his agents were always ready to pounce on the sickly one, to drain its vitality, suck its blood, and reduce it to skin and bones.

Like many, perhaps most, Spanish parents of the time, Goya and his wife, Josefa Bayeu, had long and painful experience of premature child-death. Josefa miscarried frequently, and of the seven children they had who lived long enough even to receive the sacrament of baptism, only one (their son Javier) survived beyond childhood. The image of the witch as child snatcher was therefore an extremely powerful one, not only for ordinary uneducated folk but for relatively elite people like Goya and his wife—and, one may guess, even for an *ilustrada* noblewoman such as the duchess of Osuna. Be that as it may, *The Witches' Sabbath* and *The Spell* (both 1797–98) place an obsessive emphasis on the abduction, torture, and sacrificial murder of infants.

In *The Witches' Sabbath*, the witches have gathered to receive their orders from and pay homage to the devil, in the form of an enormous *cabrón*, or billy goat, with curving horns like a lyre woven with oak leaves. One crone holds up an emaciated infant, who seems barely alive. A younger and relatively pretty witch, to her right, gazes raptly at Satan as she cradles her capture—a newly seized infant, fairly plump and in much better condition—in her arms: a parody of the Madonna and Child. The gray corpse of a starveling child lies on the ground to the left, and above it a half-naked crone holds up what looks like the kind of stick on which hunters strung their prey—except that these are not rab-

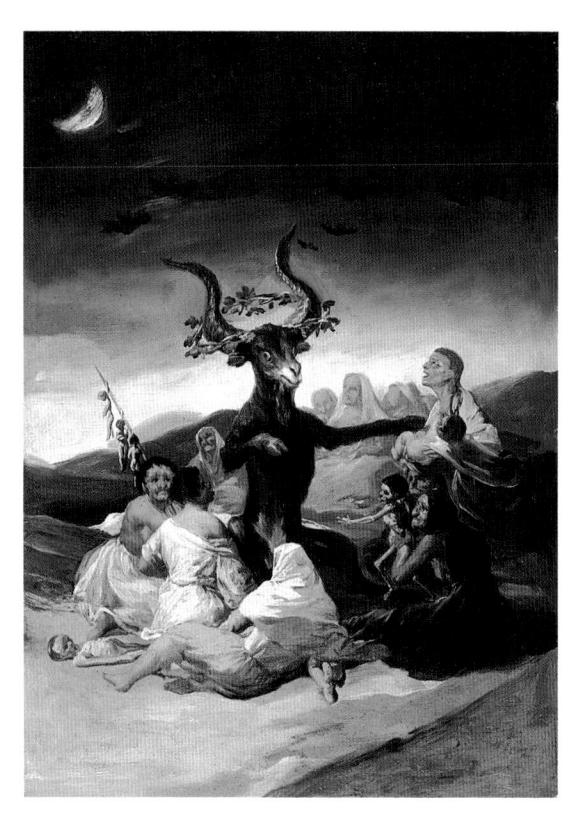

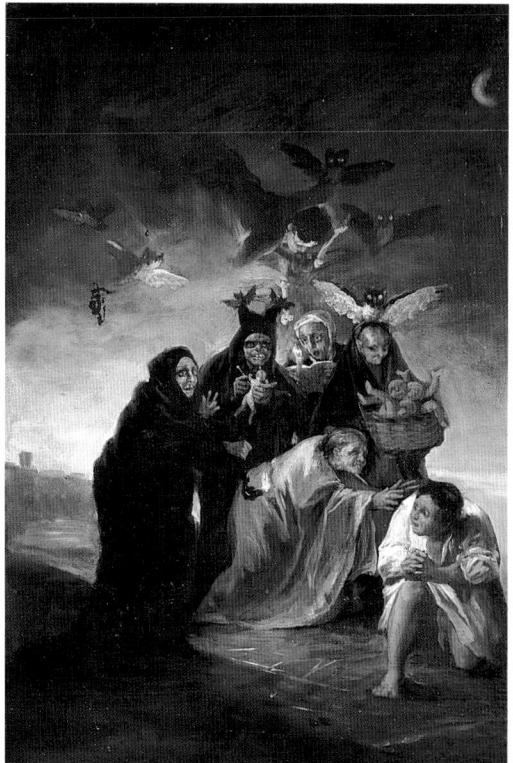

bits but a trio of dead fetuses. Satan extends his foreleg in a gesture of encouragement to the pretty witch with the plump baby, as if to say: this is the kind of sacrifice I want. The usual Gothick appurtenances of dread—bats and owls—flitter in the sky, and there is, of course, a horned moon.

The Spell is, if anything, more overwrought. It is night again, and a cluster of six witches, five on the ground and one diving down from the sky clattering human thighbones, are menacing a terrified man in a white gown (perhaps a nightshirt, for this may be a dream). One of the hags has a basket of dead babies. Another has a manikin, into which she is sticking a large pin. A third intones spells by the light of a candle, perhaps made—as such candles were meant to be—of human fat. A senior witch in a greeny-yellow gown crouches and leans toward their unhappy victim, stretching out her gnarly hands, with a nasty scowl on her withered mouth. One's feelings about this scene are roughly like those that are apt to afflict the audience during the first scene of Macbeth: yes, this was probably capable of scaring an eighteenth-century audience, but the power of these "black and midnight hags" with their depressing lack of dentistry has lapsed so far into cliché that it can no longer quite move us, no matter how receptive we would like to be to its spell.

The exception to this problem, and by far the most beautiful and powerful of Goya's Osuna witch paintings, is *Witches in the Air* (1797–98). Three witches, male,

Opposite, left: Gova, Aquelarre (Witches Sabbath), 1797-98. Oil on canvas, 44 x 31 cm. Fundación Lázaro Galdiano, Madrid. Opposite, right: Goya, Escena de brujas (The Spell), 1797-98. Oil on canvas, 44 x 32 cm. Fundación Lázaro Galdiano, Madrid. This page: Gova, Vuelo de brujos (Witches in the Air), 1797-98. Oil on canvas, 43.5 x 30.5 cm. Museo Nacional del Prado, Madrid.

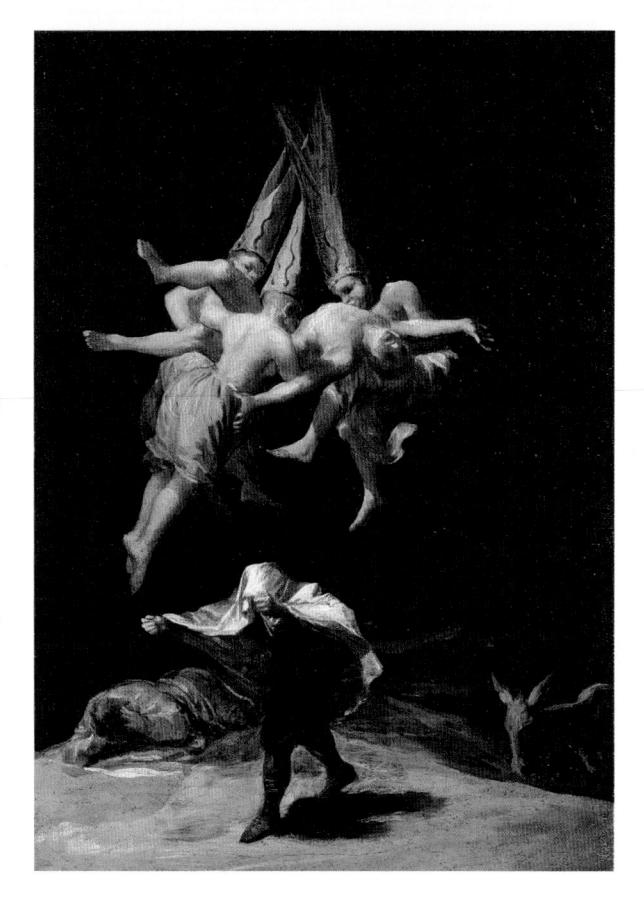

are flying in the inky night sky. Each wears a coroza, the tall conical hat (origin of the dunce's cap) that the Inquisition forced its suspects to wear at trial; but these corozas differ from the ordinary, since they are split at the top and resemble bishop's miters. Among the three of them, the witches carry another man, at whose flesh they are gobbling like owls. The arms and legs sticking out of the core of bodies make an extraordinary burst of light in the thick darkness. The victim's mouth is open in anguish, but no one can help him. There are two other "normal" people in the picture, passers by who have seen the moment. They can do nothing because the witches in the air are so palpably real, muscular, bent on their task—there is nothing ghostly about them. The "witnesses" do not want to know what they see and hear. One lies facedown on the earth, covering his ears. The other pulls a sheet over his head and tries to hurry on by, making an apotropaic figa sign with both hands—the thumb stuck between the index and second figures to ward off evil. Part of the subliminal power of this image for a Spanish Catholic in the late eighteenth century would have been a reminder of a primary Christian image, the Resurrection of Christ, which it morally inverts—the men on the ground, refusing to see a diabolic event, being the equivalent of the sleeping tomb guardians in a Resurrection, who have failed to witness a divine one.

What was Goya's attitude to the religion of his day and nation? It is a vital, a central question to which there is no certain answer. You could not be a Spaniard without having some relationship to Catholicism. Next to the monarchy, and despite the (as yet) feebly disseminated influences of northern rationalism, it was still the most powerful binding and summoning force in Spanish life: all Spaniards, consciously or not, defined themselves and their beliefs in relation to the Spanish clergy, the hierarchies and dogmas of the Church of Rome. And yet in some respects, despite the reputation Catholicism in Spain had for a relentless authoritarianism, it was quite different from its modern versions. The pope was less of an international tyrant. He was not, for instance, considered infallible when speaking ex cathedra on matters of faith and morals. The infallibility of the pope, which now so disfigures the Catholic faith, was not "defined"—the logical absurdity whereby it was infallibly promulgated as infallible, a belief supposedly binding on all Catholics—until the late nineteenth century, long after Goya's time, in the general agitation that seized a Church faced with the modernist specters of doubt and relativism. Likewise, the complete centralization of doctrinal authority in Rome had not yet developed. Local bishops had much more power, as they had had for centuries since the death of Christ. This did not necessarily mean that Spaniards, including Goya, felt freer about their religious beliefs; only that they could legitimately feel that those beliefs were Spanish, not universal, transcendent, or Roman. They were less likely to experience Spain as a religious colony of Italy.

Twentieth-century writers, in their desire to emphasize the modernist rebel in Goya, have often made him out to be irreligious, either an agnostic or an enemy of religion. But this is a crude distortion. Gova's work is full of ferocious satire against the Spanish clergy: greedy, dirty priests, dully tipsy with small vicarious powers, feeding superstitious rubbish to their flocks in order to dominate them. Priests who abuse their authority, including their sexual authority. Just plain priests, in other words, of the low sort. He never for a moment entertained the Big Lie that ordination ennobles. Yet time and again, one is compelled to feel that Goya's fierce indignation against such men is there because, in betraying the precepts of the Church, the priests have betrayed religion, and that this is the mortal sin that lies behind the more venial ones of lust and gluttony. What Goya hates most, with a cold and unrelenting passion, is hypocrisy. He does not construe the sins of the priesthood as a necessary or inevitable part of religion itself, and there is nothing phony or feigned about the treatment he accords to authentic faith, as in the frescoes of the resurrection of St. Anthony of Padua's father in the cupola of San Antonio de la Florida. His message is not écrasez l'infâme. But he is forever on the watch for that point at which the

impulses of faith, imagined as capable of setting people free, turn into enslaving superstition. Hence, too, his fascination with "black" religion, with witch-craft and sorcery. These, too, are part of the chains that bind men and women to their lesser natures, and their links can be broken only by the act of scrutiny. Looking, for Goya, is also a liberating act, as every effort to see things in their true quality must necessarily be. This made him, by Spanish standards, a most unusual kind of Catholic. But a Catholic he indubitably was—though a Catholic without priests, perhaps even without the custom of going to Mass. There is no record of his doing so, and when he died in Bordeaux, there was no priest summoned to his bedside, no confession, no last Communion.

MEANWHILE, another figure had entered Goya's social horizon. Unlike the Osunas, she was not a major patron, but she was to have a great impact on his life, and on his art. It may have been through the Osunas that Goya first met the woman to whom he is indissolubly linked by legend, rumor, and speculation. She belonged to the same level of society and was often a guest in the Osunas' town and country houses—and they, presumably, in hers.

She was María del Pilar Teresa Cayetana de Silva Álvarez de Toledo, the thirteenth duchess of Alba. She was, without question, one of the most beautiful women in Spain—a fact noted by nearly every man who met and wrote about her. She was tall, slender, with flashing dark eyes and a fine-boned face perhaps a little too long for modern tastes—surmounted by a mop of thick, dark curls. Her movements were graceful, and she was a superb dancer, with a particular liking for the seguidillas and fandangos that were all the rage in Madrid. She loved maja styles of dress, which contrasted piquantly with her aristocratic bearing. If the word had existed in the eighteenth century, she would have been formidably hip—what else could an aristocratic maja wish to be? Her taste in interior decorating equaled her dress sense: in the 1780s the Palacio de Buenavista, designed by Pedro de Arnal, where the duchess resided with her husband at the corner of calle Alcalá and paseo de Calvo Sotelo, was considered even by its notoriously snobbish French visitors to be a masterpiece of interior decoration. (Alas, it was taken over successively by Manuel Godoy, King José I, and then the Ministry of War, and by the end of the nineteenth century nothing coherent remained of its once spectacularly beautiful Neoclassical décor.)

The duke was an Anglophile and a music lover, and this is the character preserved in Goya's full-length portrait of him from 1793. Its sober colors express the sense of self-restraint and elegant control that this nobleman undoubtedly sought to project in real life: beautifully cut gray-blue britches, a sprigged,

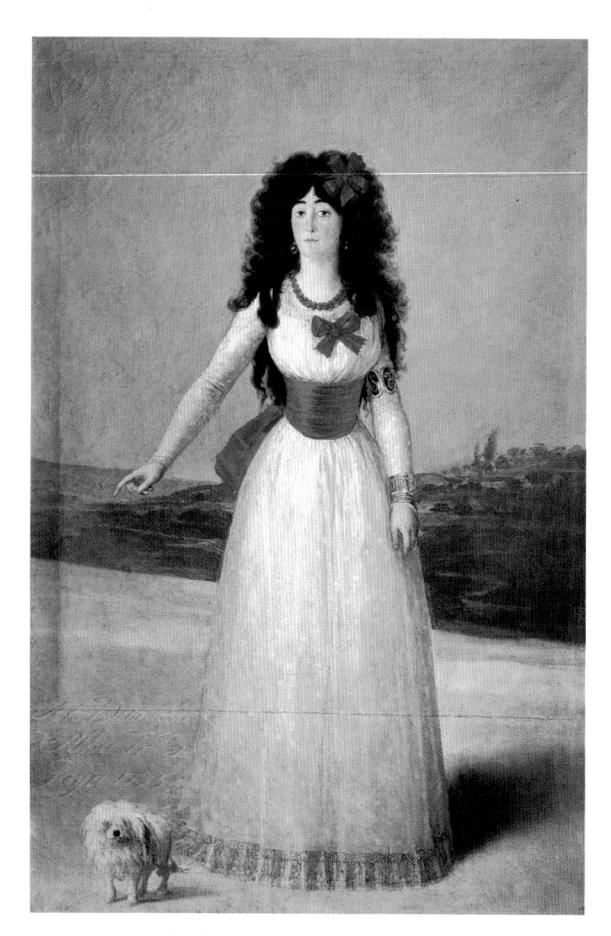

Left: Goya, *María Teresa Cayetana de Silva, Duchess of Alba*, 1795. Oil on canvas, 194 x 130 cm. Colección Casa de Alba, Madrid.

Right: Goya, *The Duke of Alba*, 1793. Oil on canvas, 195 x 126 cm. Museo Nacional del Prado, Madrid.

high-necked cream waistcoat, a moleskin jacket, and a pair of short boots, which suggest that he has just entered the salon after a turn on horseback. He has no wig and is "in his own hair," as the expression went. He leans at negligent ease on an inlaid harpsichord in the English style. He holds an open score—a work by Haydn, a great favorite in cultivated English circles.

The duchess's life was short, if intense. Born in Madrid in June 1762, she died there of a wasting illness, breakbone fever, complicated by tuberculosis, at the age of forty. In the mid-1780s, when Goya must have met her for the first time, she was in the flower of her youth and beauty, and had begun to figure in foreigners' accounts of their travels in Spain. Thus in 1785 a French traveler named Jean-Marie Fleuriot de Langle gallantly wrote that not a single hair on her head failed to excite sexual desire: "Nothing in the world is as beautiful as

she.... When she passes by, everyone leans from their windows, and even children interrupt their games to look at her." Goya felt her sexuality with the uncensorable instinct of a hound getting a scent. That he desired her, with the passionate and rather hopeless possessiveness men in their fifties and sixties can feel for much younger women, there can be little doubt: this much, as we will see, is clear from some of the *Caprichos*, which are imagined as acts of defamatory revenge against a woman to whose fidelity he has no real claim.

She, in turn, was flattered by the attentions of the most fashionable artist in Spain. They were friends. But that, in broad outline, is all we know about Gova's relationship to the duchess of Alba. Despite the acreage of scented embroidery that has been superimposed on their friendship, despite the romantic novelists and the Hollywood scriptwriters—for, inevitably, there was a film about their liaison, The Naked Maja, with the duchess played by Ava Gardner; alas, it was made too early for Cher, who really did look like her when she was young, to take the part—there is no good reason to suppose that the beauty was ever in bed with the deaf genius twice her age. He painted her portrait several times, drew her several times more, and went to stay as her guest on one of the Albas' country estates, at Sanlúcar de Barrameda, near Cádiz. Because one of these visits took place in 1796, the same year her husband, the duke of Alba, died, it has fueled much speculation. But there is really no way to know what, if anything, Goya and Alba got up to during it. The probable answer is the disappointing one that nothing sexual really happened. Alba was a flirt, and compared with the countess of Osuna, she was rather an airhead—if noblesse oblige imposed on her any of the concerns with education or social justice that the Osunas so strongly felt, there is no record of the fact in her words or anyone else's. She seems to have read little, and developed few significant friendships with intellectuals. But she was emphatically not a fool, and it would have been distinctly foolish to carry on an affair, even with a deaf and aging houseguest, in front of the numerous and no doubt inquisitive and chatty maids, majordomos, and other servants of the house when her late husband was hardly cold in his tomb. And she was not, as we will see later, Goya's model for the so-called Naked and Clothed Majas—a pity from the viewpoint of cultural folklore, but also perhaps a relief.

The first of Goya's sketchbooks, which he started keeping at around this time, offers no real clues about a possible affair. (Curiously enough, the idea of carrying a bound album of drawing paper and using it for swift jotting of things seen, as a diary almost, had not occurred to other Spanish artists, before Goya. In all, eight of his albums survive, classified by Eleanor Sayre and numbered by

her A through H, containing some 550 drawings; this can only be a remnant of the total.) It records what he was looking at in Sanlúcar: mostly women. Where did you go to see naked women in late-eighteenth-century Spain? To the whorehouse, not the drawing room. Album A contains numerous drawings of nudes, single or in pairs, and they are certainly prostitutes hired as models— Cádiz, nearby, was a coastal town, and like all ports it swarmed with buhos, night birds. The fact that some have hairdos like the duchess of Alba's means nothing, because hookers as well as duchesses were their hair maja-style, in ringlets. When we see one of them sweeping the floor (drawing "n") or picking up a chamberpot (drawing "h"), we can be sure that it is not the duchess doing the housework. Drawings have been torn or excised from the album over the years, and perhaps some of them did represent the duchess, but only two survive that certainly do. One shows her standing and arranging her hair; the other is on page "f," which shows her tenderly holding a little black girl on her lap. This child is María de la Luz, the daughter of an African slave, whom the duchess, who had no natural children of her own, had virtually adopted. This in itself was surely significant, and suggests that whatever "radical" leanings La Alba may have had were not necessarily a mere costume. Aristocrats quite often had black children as a form of décor, as pages or flunkies, but they did not involve themselves in fond relationships with them that betokened a recognition of racial equality, such as this drawing—like others Goya made of Alba and María de la Luz—suggests. The child turns up in other Goyas, too: in one small painting she is seen in cahoots with another mischievous child, a page named Luis de Berganza, tugging on the skirts of the duchess's *dueña*, a pious and ancient creature known, for her habit of constantly and ostentatiously praying, as La Beata (the Blessed One). One may see in Goya's tender records of the freedom and protective affection La Alba bestowed on this child an echo of the idealized Enlightenment sensibility that William Blake wrote of in "The Little Black Boy":

> My mother bore me in the southern wild, And I am black, but O! my soul is white; White as an angel is the English child, But I am black, as if bereav'd of light.

La Beata, that much-persecuted old beldam, was also teased by the duchess herself: a painting from 1795 shows the *dueña* clutching a crucifix and balancing rather precariously on her stick while the duchess, whose face we do not see but

Left: Goya, *La Beata with Luis de Berganza and María de la Luz*, 1795. Oil on canvas, 31 x 25 cm. Private collection.

Right: Goya, *The Duchess of Alba and La Beata*, 1795. Oil on canvas, 31 x 25 cm. Museo Nacional del Prado, Madrid.

who is recognizable by her hair and lissome figure, waves what looks like a twig of red coral in her face. (Why the old woman should be alarmed by the sight of red coral is a mystery, but there it is.)

It was at about this time that Goya did his two standing portraits of the duchess of Alba. The first, or "White Duchess," dated 1795, is in the ducal collection of the Alba family at Palacio Liria in Madrid. The second, or "Black Duchess"—she wears a magnificent black lace-trimmed skirt and black mantilla—is dated 1797 and belongs to the Hispanic Society of America, in New York (page 163). In both Alba is shown standing, full-length. The "White Duchess" is plainly a public image, or at least one imagined as being seen by the subject's family and being accepted by others as a historical document of appearance. One cannot be so sure about the "Black Duchess." She never left Goya's hands, and is recorded as having been in his studio fifteen years after she was painted. This suggests a powerful private motive, one that is in fact confirmed by the internal evidence of the painting. Janis Tomlinson thinks that "no matter how liberal a patron she might have been, it seems unlikely that she would have accepted a portrait that so mercilessly emphasized her pride and

hauteur." But why not? There was never, in the eighteenth century, a shortage of images of aristocrats looking extraordinarily grand and hoity-toity—for some portraitists, like Pompeo Batoni in Rome, they were a specialty—and there is no reason to suppose that Alba, despite her fondness for woman-of-the-people maja drag, had anything but the highest opinion of herself. But the more compelling reason to suppose that this picture is Goya's fantasy, not hers, is that she is pointing to the words traced in the sand at her feet: "Sólo Goya" (Only Goya). This is not what she feels, but what Goya hopes: she is in mourning for her dead husband, and Gova is the only man for her. It is the painter's fantasy, not the subject's, and presumably that is why the portrait did not pass into the possession of La Alba; she would hardly have wanted visitors to see so striking a declaration of a love that she did not in fact feel. In the painting she is beautiful and imperious, the yellow of her gold-embroidered blouse and the red of her facha, or knotted sash, powerfully suggest the burning coals of passion, glowing through the black filigree of lace. One can imagine the painter staring at it in the privacy of his studio and wishing it were so.

The "White Duchess" was the one for semi-public consumption. It is a marvelous study in doubling and repetition built around two themes, red and white. The only other color in the portrait is Alba's mane of black hair, which is painted with an extraordinary and sensuous softness: it cascades down her back, and two thick tendrils caress her shoulders. Her dress is very much in the French manner, not a bit like the *maja* style of the later portrait; made of gauzy white muslin hemmed with gold embroidery, it is gathered high under her breasts and cinched with a broad crimson sash. The same red is repeated in the bow on her cleavage, in the double row of red coral beads around her throat, in the five-petaled silk bow in her hair, and—not least—in the sweetly parodical red bow her living accessory, a little long-haired creature of the breed known as a bichon frise, bears on its right hind leg. Clearly, Goya had been inspired though not to the point of servile copying—by English modes of portraiture that he would have seen in reproduction, in the print cabinet of Sebastián Martínez: the lady of quality seen in a landscape with her attendant dog had often been painted by Romney, Gainsborough, and Reynolds. And the fact that the duchess is attired in a flowing white Neoclassical-style robe, probably of Bengal muslin, also attests to Gova's interest in English Neoclassicism: he is known to have made, during the 1790s, copies after engravings by John Flaxman. Sarah Symmons raises the interesting possibility that Alba's simple white dress with its red accessories and absence of expensive jewelry was also a kind of radical-chic homage to the fashionable ladies of Paris, who took to dressing

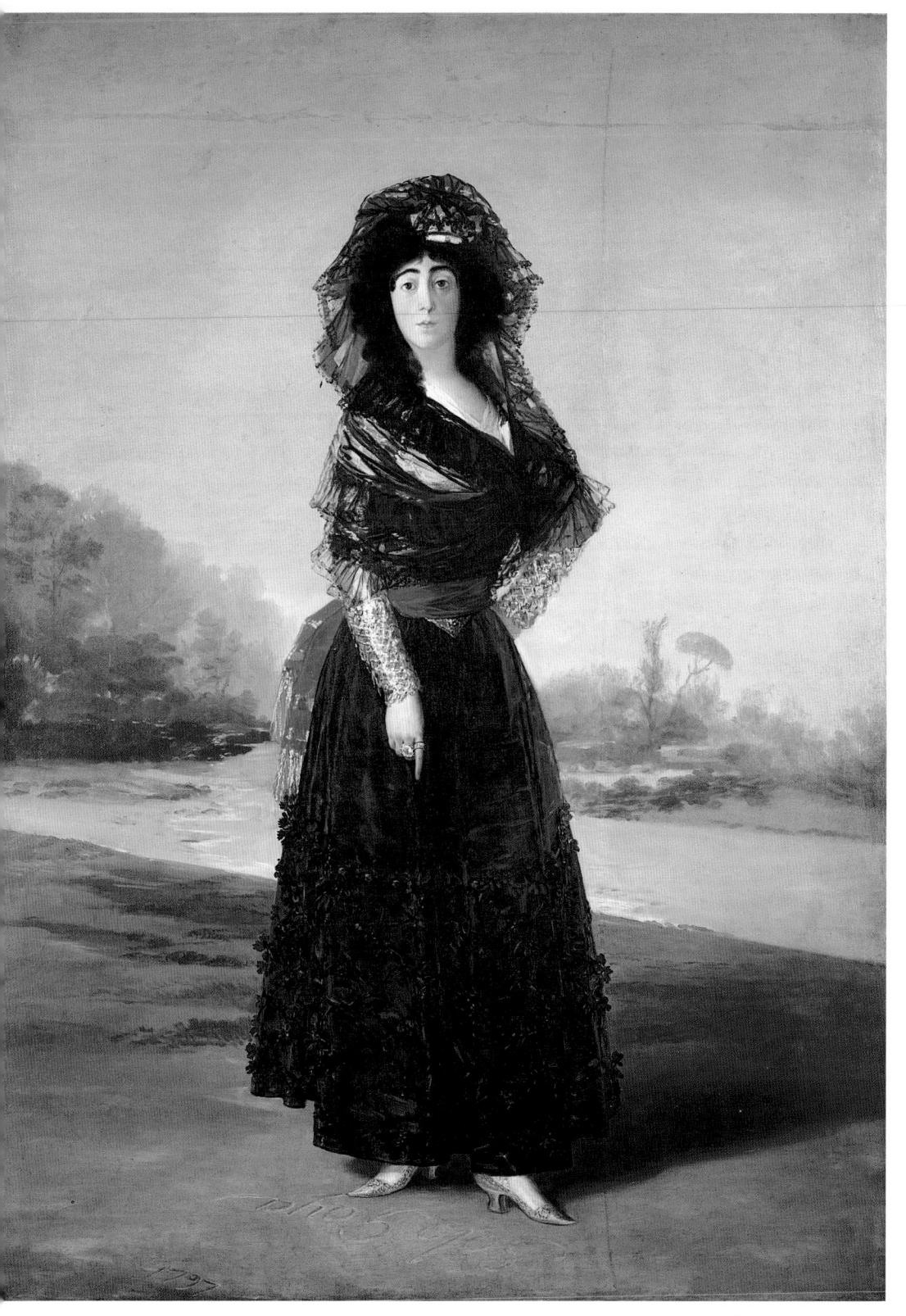

Goya, *The Duchess of Alba*. Oil on canvas, 210.2 x 149.3 cm. The Hispanic Society of America, New York.

themselves in this way to signify purity of republican ideals and the blood of the guillotined Bourbons under the Terror.⁸ It is, however, unlikely that the duchess herself would have had very pronounced anti-Bourbon or prorevolutionary feelings, or that Goya would have shared them.

The duchess of Alba was a vain beauty, with plenty to be vain about. She was as vain as the queen herself, María Luisa—who, in terms of physical beauty at least, had rather less to vaunt herself on. The index of their vanity was, of course, their mode of dress, which Goya recorded with insatiable attentiveness, curiosity, and pleasure. Detail for detail, no great tragic artist has ever been more absorbed, in his untragic moments, by the minutiae of fashion than Goya. He savored the materials, their lightness and density and transparency, the folds and crinkles, the highlights and the shot-silk undercolors in their shadows. He took immense delight in their erotic implications, and in the social language of clothes: what a French-style dress might tell you about its wearer; how a *maja*-style jacket, in its sweetly truculent Spanishness, might act as a mask, a declaration, an invitation. In an age when all portraitists had to be aware of such things, none was more alive to them—or took more pleasure in painting them—than Goya. And he would dress up for the pleasure of painting himself into a role, as in the self-portrait as bullfighter in his own studio.

His obsession—it is hardly too strong a word—with fashion mirrored that of the society he was painting. Upper-class Spanish women of the late eighteenth and early nineteenth centuries were extraordinarily clothes-conscious, even by the standards of London or Paris. So much so, indeed, that some serious observers felt that their competitive mania for the most expensive imported fabrics and laces posed a threat to the Spanish economy. Herman de Schubart, Danish ambassador to the Spanish court in the late 1790s, remarked on this with some asperity:

The unbridled taste of Spanish women for crepe, lace, embroidery, and delicate stuffs made the country dependent on other nations more advanced in the manufacture of such articles. . . . Along with fabrics and cloths, Spain also consumed an enormous quantity of finished pieces. . . . All the clothing for both men and women came from abroad. Two powerful foreign companies . . . shared the monopoly of this trade. . . . Spain had even lost the advantage of assuring for itself the distribution of all those goods. 9

No sumptuary laws, it seemed, could be passed to correct this extreme imbalance—especially when the queen herself set such a bad example with her unbridled consumption of luxury *articles de haute mode*.

Goya, Ferdinand Guillemardet, French Ambassador to Spain, 1798. Oil on canvas, 186 x 124 cm. Musée du Louvre, Paris.

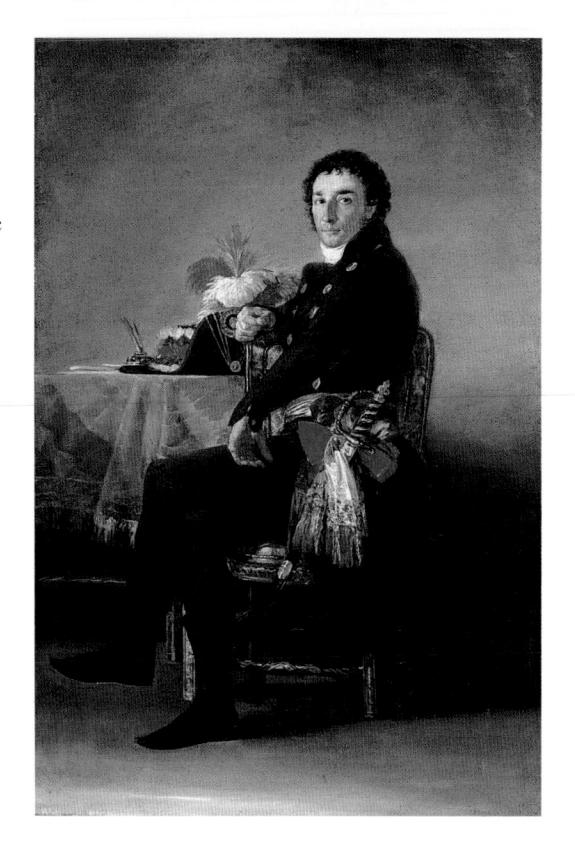

There may have been a further reason for the deepening of Goya's skills as a portraitist during the later 1790s. Deafness makes you more aware of gesture, physical expression, body language. You learn to "read" signs beyond words, to perceive the minute particulars of how faces and bodies reveal themselves. It was really in the 1790s that Goya achieved full mastery as a recorder of the human face, a mastery that was never to diminish. One sees this in two major portraits from 1798, one of a French diplomat, the other of a leading Spanish *ilustrado* who was Goya's friend. The diplomat is the first foreigner known to have been painted by Goya—a sign of the limited compass of sitters and friends within which he had worked, and the slow spread of his reputation beyond the Pyrenees: he was fifty-two when he began it.

Ferdinand Guillemardet arrived in Madrid in 1798 to take up his ambassadorial tasks. These cannot have been altogether easy, since this Burgundian country doctor had been appointed by the Convention, the most proactive of the French revolutionary assemblies, which had been elected to succeed the Assemblée Législative in September 1792 and was in turn replaced by the Directoire in October 1795. In its first session, the Convention had decreed the abolition of the monarchy, and in 1793 it sentenced Louis XVI to death. Like most of its members, Guillemardet was known, both in and now out of

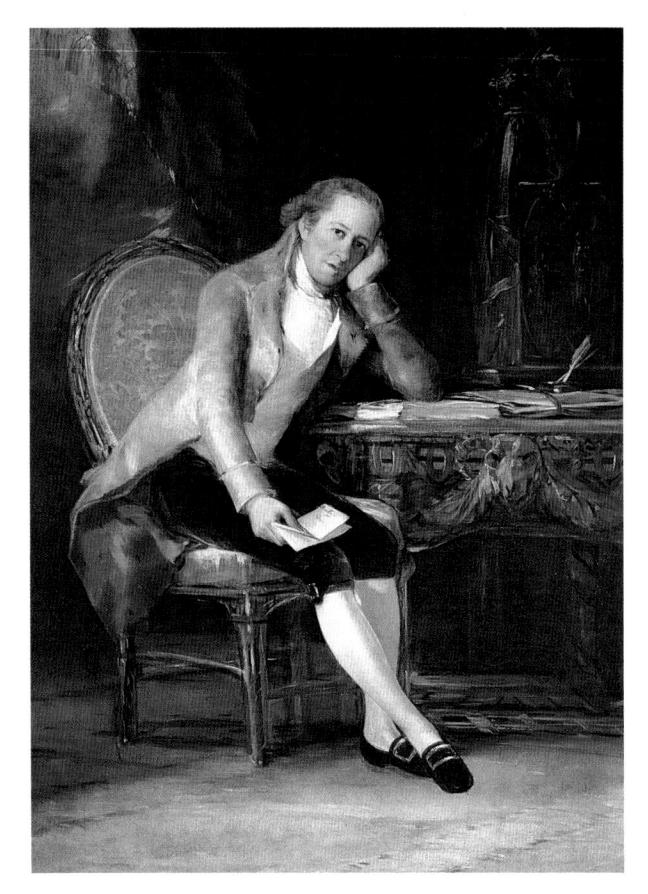

Goya, *Gaspar de Jovellanos*, 1797–98. Oil on canvas, 205 x 123 cm. Museo Nacional del Prado, Madrid.

France, as an enthusiastic regicide. What thoughts may have passed through Goya's head as he contemplated the handsome and mobile face of his young client, who had unhesitatingly voted to kill the Bourbon cousin of Goya's own patron, are beyond guessing—except that it may have been Guillemardet who gave Goya permission to carry out the long job of printing his first great series of etchings, the *Caprichos*, in one of the attics of the French Embassy, housed in the Superunda Palace in Madrid, and the artist was accordingly grateful. In the event, Goya produced one of his finest official portraits. Its pose was certainly strained: Guillemardet comes across as a young man looking for a suitably authoritative disposition of his limbs and body, and finds it in semi-profile with his left hand on his crossed thigh (the palm turned a little self-consciously toward us) while his right hand grips the chairback. His suit is Hamlet-black, his buttons are gold, his table and chair are covered in gold cloth, but what makes the picture is the visually wonderful blossoming of red, white, and blue

at his waist and on the table, formed by the cockades and dyed feathers on his hat and the colors of his sash and sword belt. Later, this portrait—of which Goya, perhaps a little diplomatically, remarked that he had "never done anything better" —went back to Paris with Guillemardet in 1800 and, by gift of his sons, became the first Goya to enter the Louvre.

Also in 1798, Goya produced what has long been regarded as one of his half-dozen outstanding male portraits, and the quintessential image of a Spanish public intellectual: his likeness of Gaspar Melchor de Jovellanos, politician, writer, and, in the apt phrase of Hugh Thomas, "A Spanish Tocqueville—but a liberal Tocqueville." Edith Helman, the deepest student of the relationship between Goya and this remarkable man, sums up the externals of their relationship:

How much could Jovellanos have contributed to Goya's artistic development? This cannot, of course, be measured, but it seems plausible that he would have guided him and advised him as he did all his friends: Cean, Vargas Ponce, Meléndez, and the rest of the Salamanca school of poets. He felt a calling to lead, to guide, to advise, and he practiced a kind of literary tutelage with his friends from Salamanca, sending them subjects for plays and counseling them on matters they should address in their poetry. . . . He could have suggested some social subjects for Goya's tapestry cartoons . . . and many years later some themes for his *Caprichos*. . . . He always recommended Goya for individual or official commissions. ¹²

When Goya painted this portrait, Jovellanos was forty-four, eight years younger than his artist friend. He was both statesman and writer, the sharpest social critic of his generation in Spain and its most accomplished prose stylist. He had a small but choice art collection that included an *Immaculate Conception* by Zurbarán, a self-portrait by Carreño, and a painting of the Virgin and Child by Murillo. He was a zealous reformer. He regarded England's industrial development as an essential model for Spain's future, and conducted a long correspondence on this issue with Lord Holland, the British ambassador in Madrid. He vividly contrasted Spain's industrial future with its exploitive colonial past in one sentence: "Coal contains as many possibilities as gold and silver: the problem is the lack of capital, and that here we prefer ignorance to enlightenment." 14

Taking his cue from Campomanes, Jovellanos worked for the suppression of the *sistema gremial*, the closed guild system into which manufacturing was divided, because he viewed it (correctly) as outdated and reactionary despite its pretensions to protect the rights of workers: the right approach to production of

goods was through open competition, which would foster variety of products and invention of new means of production. The guild system had become as great an impediment to manufacturing in eighteenth- to nineteenth-century Spain as the closed-shop union system did to twentieth-century Britain until it was broken by Margaret Thatcher.

Jovellanos campaigned to have Spanish, the vernacular, replace Latin as the language of higher education. He learned both Italian and English, and corresponded fluently with friends abroad, intellectuals in Paris and such Englishmen as Lord Holland, the former ambassador to Madrid, with whom he was on warm terms of friendship. Inspired by the writings of the eighteenth-century Italian liberal penologist Cesare Beccaria (Dei delitti e delle pene, 1764), he was greatly concerned with penal reform. In his role as playwright, which he also was, he wrote a comedy about crime and punishment, El delincuente honrado (1774). He fought for the abolition of judicial torture, and against the endless and sterile accumulation of land by the Church. Jovellanos's arguments are an essential part of the background from which the radical legislation of Mendizabal, forcing the sale of Church property, would arise four decades later. Naturally, he had few friends among the clergy and aristocracy. Some took him for an anti-clerical, even an atheist; but he was neither. Jovellanos was a fairly devout man, Catholic in most respects; he even declared that his spiritual "brother" was Thomas à Kempis, author of The Imitation of Christ. But, as one might deduce from his fondness for a text that so advocated humility, he was irreconcilably set against the greed, privilege, and excessive temporal power of the Spanish Church. To call him a red-hot abolitionist in the French manner would be quite wrong, though, and this showed in his attitude toward the Holy Office, the powerful arm of the Spanish Inquisition. He worked to limit its powers, not get rid of it altogether, much as he, like other *ilustrados*, would have liked to not because he had an affection for it, still less because he felt it was necessary to the governing of Spain, but simply because he saw the task as politically impossible: the Holy Office was too deeply rooted, and the Crown was not prepared to confront it head-on. He wanted to strip the Holy Office of its arbitrary power to ban books, but without bringing into question the right of authority to do so; thus the power of censorship ought to be shifted to the Consejo Real and the bishops when printed arguments about dogma were under consideration in order to "destroy one authority with another." Jovellanos saw the Crown specifically, the reign of Carlos III—not as an instrument of oppression, as the French did, but as a guarantor of liberties. In this he was much closer to English liberals, whose work he admired, than to French revolutionaries. In his *Elogio*,
written to Carlos III, he praised the Bourbon king as the veritable fount of all enlightened impulses: he had guaranteed "the circulation of truth"; he had stimulated the spread of useful knowledge and "sown the seeds of light in the nation," much of this being due to his wise and farsighted backing of the policies of Campomanes and, in particular, his support of the Economic Society of Friends of the Nation.

There can be little doubt that Goya's friendship with Jovellanos and his exposure (which was probably limited) to his work made the artist's view of Spanish social foibles more acute. The vision of a Spain where the clerics are torpid and self-seeking, the nobility asinine, the Inquisition a tyranny of superstition, the institution of marriage a commercialized farce—this perception of the country was shared by both men, and it is likely that its impetus flowed from Jovellanos toward Goya rather than the other way. Goya returned the favors Jovellanos showed him as best he could: for Jovellanos's *Poesías*, for instance, Goya recommended him for membership (1779) in the Spanish Academy.

Jovellanos's political career had ups and downs—more of the latter than the former. The conde de Campomanes promoted him to councilor of state; but in 1790, when his friend the economist and banker Francisco de Cabarrus was prosecuted and Campomanes refused to intervene, Jovellanos quit Madrid in protest and went into semi-retirement in his native Gijón, in Asturias, where he received a humiliatingly low post as an administrator of roads and mines. There, over the next few years, he wrote his most important work, many would say the most important politico-economic manifesto of the whole Spanish Enlightenment: *Informe sobre la ley agraria* (1795). It was a powerfully argued plea for the development of agricultural land—Spain's chief industry then—as private property. Communal lands and Church ownership must be abolished; if one owned land, one must live on it. All restraints on domestic trade, such as the innumerable district customs levies and taxes, must go. Sales taxes must be reduced, public works increased. And much more.

The *Informe* did not go straight into law, but it did rehabilitate Jovellanos's political career, because Manuel Godoy—by then, as prime minister, the de facto ruler of Spain—was impressed by it. The wheel of fortune turned so fast that by July 1797, two years after the *Informe* was published, the Inquisition was officially told not to touch the book—and a few months later, Jovellanos was summoned back to Madrid as minister of religion and justice. This did not in the least damp his zeal for depriving the Church of its power over farmland, with the result that his time in power was short. The Inquisition, frustrated in

its efforts to get rid of him, went to work on the queen. She believed the clerics and, in turn, went to work on Godoy. In August 1798 Jovellanos was once again dismissed, on Godoy's orders. He went back to seclusion in Gijón, where Godoy, wanting to fully appease the dangerous clergy, had him arrested in 1801 and flung into prison in Majorca. He remained there for seven years, and was released only by the outbreak of the War of Independence in 1808. Jovellanos became one of the leaders of the Junta Central (Central Council) of the Spanish patriots, but he had taken ill in prison and died, long before Napoleon was expelled from Spain, in 1811.

Gova painted his friend and mentor in the spring of 1798, in the very short period—a mere nine months—when Jovellanos was in high office for the second time. The portrait is a marvelous image of the troubled and pensive intellectual in power. Jovellanos is in the palace, or seems to be: the magnificence of the furniture and appointments that surround him show that he is not at home. He sits on a splendid gilt chair upholstered in gold-ocher velvet. It is, perhaps significantly, a gilt chair in the French taste, whose solidly carved luxury suggests that the man sitting in it is, indeed, an afrancesado. He is caught in the act of thought, leaning forward, head supported by his left hand, left arm resting on the table. The table is ornately carved with a pattern of gilded rams' skulls and swags of foliage. On it stands a large statue of Minerva, goddess of wisdom, whose emblematic bird is the owl, symbol of melancholy. Minerva is watching over Jovellanos as he broods among his papers, holding a letter that bears Goya's name. His posture, head on hand, is classically that of sadness and reflection, as in Dürer's Melancholia, a print that Goya would certainly have known. He seems bowed, if not exactly intimidated, by the load of his work and the cares of his ministerial office. The mobile mouth, the sparkling eyes testify to a degree of intellectual vitality that no excess of responsibility can extinguish. This tired and worried man is also a "natural" one, as befits an ilustrado; like Ben Franklin at the now-abolished French court, he is seen not wearing a wig. The painting is free and almost easy; Goya's handling of the planes, hollows, and convexities of Jovellanos's pale lilac coat is particularly beautiful, contrasting in its relaxed energies of movement with the more static and columnar forms of the white-silk-sheathed legs.

A year or so later, Goya decided to externalize his image of a wise and troubled man still further. He did this, not with another portrait recognizably of Jovellanos, but with an etching of a man in a similar but almost abandoned pose, a figure whose face is hidden from us, who has descended into a deeper melancholy, a sleep permeated by nightmares. This is, of course, the best-

known image of his etching series the *Caprichos*. In its present form it is plate 43, with its immortal title written on the side of the sleeper's desk, "El sueño de la razón produce monstruos," "The sleep of reason brings forth monsters" (page 73). The "monsters" are bats and owls flying around the sleeper in his dream. The owl, here, is not an image of wisdom; it is the stereotype of mindless stupidity, which was how owls were seen in Spanish folklore in Goya's time. The bats are creatures of night, and thus of ignorance—and possibly of bloodsucking evil as well, in their association with the devil. A sinister-looking cat glares directly at us over the small of the man's back. That this dream-haunted sleeper is not Iovellanos but Goya himself is shown by the owl on the left that offers him an artist's chalk in a holder—the better to draw incorrect and misleading images with. The assault of the forces of darkness (you can almost hear the sibilant discord of their flapping wings) is watched by an emblem of perceptive wisdom, the lynx at lower right. (We know it is a lynx, not merely a big cat, by the pointy, two-tone ears.) The lynx, it was believed, could see through the thickest darkness and immediately tell truth from error. It gave its name to, among other things, the club of Italian literary connoisseurs known as the Accademia dei Lincei. There is, one need hardly add, no exact parallel to this haunting and marvelously strong image in other art. It does, however, seem to have a distant source in an etching that Goya certainly knew, done by his predecessor as painter to the king, Giambattista Tiepolo: the title page to the Scherzi di fantasia (c. 1743-57) (page 73). It shows a battered block of stone, perhaps an altar, in the forest wilderness, with a row of owls perched atop it; these are clearly not wise Minervan birds, but wild uncouth creatures, hooting and flapping, just like Gova's. Their role in sylvan magic is stressed by emblems on the ground: a head of garlic (that traditional witch repellent) and an egg, symbol of fertility.

In the years that preceded and followed the *Caprichos* Goya turned himself into one of the greatest draftsmen in European history. Without that quality, he could never have become the printmaker he was, for etching is one of the most difficult tests of the ability to draw: it is an intolerant medium, unforgiving of small slips, demanding the utmost decisiveness from those who practice it. However, although many of his drawings are first ideas, sketches, and developments for final etchings, they are all independent works of art, and relatively few of them can be connected to the etchings themselves. For Goya, drawing was a constant and independent source of delight, an aid to memory, a record of

bizarre, funny, grotesque, and powerful things seen. Its subject was almost always people. Goya could paint and draw landscape beautifully, but that was not his main concern; and although he painted some of the finest of all still lifes, there is not a still-life study among his drawings. You might think that by 1800 or so there were no technical innovations to be made in the art of drawing, but Goya seems to have come up with a small one: he had notebooks made, sketch pads bound up with leaves of paper, so that he could carry them around and make rapid notes on the spot. He wanted immediacy, and the sketchbooks gave it to him.

We do not know how many of these pocket albums he filled in the course of his long life. There is one dating from his trip to Italy in 1770–71, and then nothing until 1796, when he was fifty; after that, eight identifiable albums survive, and they originally contained some 550 drawings, most of which have since been unbound, dismembered, and scattered through the world's collections as single sheets. (Much the same thing happened to some of Leonardo da Vinci's far more copious output of drawings and notes.) Eleanor Sayre, the first to propose a working chronology and thematic grouping for these sheets, proposed calling them "journal-albums," which is what they really are: eight diaristic groups of things seen, in Sanlúcar, Madrid, and elsewhere. She attached a different letter to each of the eight, from A through H.

Six of the albums were filled in Spain, and two belong to his last years in Bordeaux. The first of the Spanish ones, Album A, belongs to his stay at the Alba family's country *finca* at Sanlúcar de Barrameda, not far from Cádiz, in 1796. There, as a guest of the duchess of Alba, Goya was taking refuge from the strain of his illness, and the drawings in the album—of which only a few survive—are of women: two or three, at the most, of the duchess herself, and others of girls, presumably prostitutes who resembled her, who posed for him in town. The style is always elegant, the touch light, drawn with a brush and diluted ink; none of the fierce moralizing and mockery of later drawings is to be found in these little scenes of feminine intimacy. One, but only one, of the drawings, the lovely image of a girl absorbed in stretching the wrinkles from her stocking (j), will be repeated in the *Caprichos:* in plate 17, *Bien tirada está* ("It is well stretched"), where it assumes the extra content of a sexual pun.

The Sanlúcar sketches are all social-realist records of "things seen" on the street or in the bedroom. Not so in the next sketchbook, Album B, the so-called Madrid Album of 1796–97, where Goya's more familiar range—satire, allegory, dramatic mockery—becomes apparent, along with the characteristic device he used throughout the *Caprichos:* written captions that complete and explain the meaning of the visual image. The idea of captioning a drawing must have come

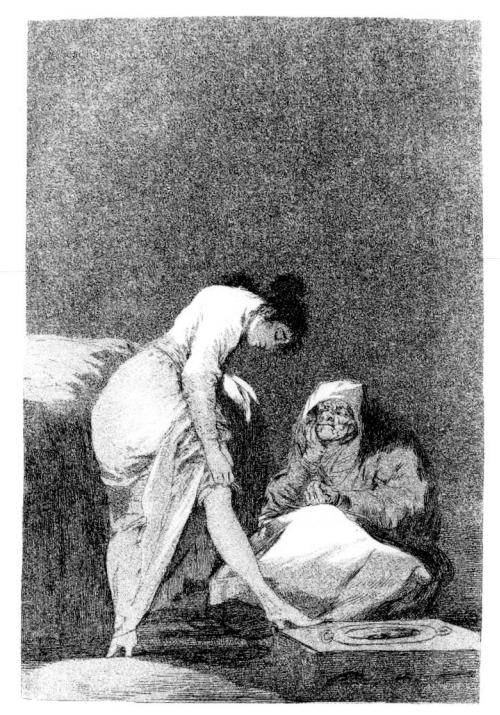

Left: Goya, Sanlúcar Album, "Young woman pulling up her stocking," 1796. Brush and India ink, 17 x 10 cm. Museo Nacional del Prado, Madrid.

Right: Goya, *Los caprichos*, plate 17, *Bien tirada está* ("It is well stretched"), 1796–97. Etching and aquatint, 21.5 x 15.7 cm.

from the English caricatures he had studied in Martínez's house in Cádiz: no Spanish artist had consistently used it before. Often the captions serve satirical ends. A delicious example is #90 in the Madrid Album. Against a background split by a steep diagonal into zones of black and gray (like the edge of the pyramid in his Capricho *Tántalo*: Goya loved these Neoclassical references), we see a young woman in a white dress, her eyes rolled to heaven in an obvious parody of the saintly expressions used by artists like Murillo. She gazes on the home of the Virgin. Her hands, however, are pointing straight down at a pair of fetters that lock her feet together—and to which an old woman in the background has the key. The young woman cannot open her legs; an intact commodity, her virginity is assured. "*Nobia*," says the caption below. "A bride-to-be. Discreet and penitent, she presents herself to her parents in this guise." To make quite sure we get the absurdity, Goya has sketched her holy, bare little feet rising, as though in saintly levitation, from the earth.

The drawings are not always satirical, but that edge is seldom repressed. An

Left: Goya, Madrid Album, 90, *Nobia. Discreta y arrepentida a sus padres se presenta en esta forma* ("A bride-to-be. Discreet and penitent, she presents herself to her parents in this guise"). Brush and India ink. Private collection.

Right: Goya, Madrid Album, 86, *Buen sacerdote*, ¿dónde se ha celebrado? ("Good priest, where was it celebrated?"). Brush and India ink. Museum of Fine Arts, Boston.

example is #23 from the Madrid Album, a pretty girl dressed for a festive *paseo* standing in front of a bull, which is separated from her only by a low stone wall. She is in a dancer's pose, arms flung up, smiling invitingly, as though at the end of a *seguidilla*. The upward curve of her arms and their inclination to the right exactly mimic the angle and upthrust of the bull's horns, thereby perhaps repeating the old saying of toreros that "the women gore worse than the bulls."

Some drawings are full of scatological humor. Madrid Album #86 shows a flustered-looking man struggling to button up his britches after going to stool: "Buen sacerdote, ¿dónde se ha celebrado?" the caption sardonically enquires, "Good priest, where was it celebrated?" The economy with which Goya delivers this corrosive image is marvelous: a line, a stroke, never a hesitation,

reminding you of later fin de siècle caricaturists like Phil May. Sometimes he is as funny (though in a dirtier-minded spirit) as Pope in *The Rape of the Lock*—"Not louder shrieks to pitying heaven are cast / When husbands, or when lapdogs, breathe their last." In Madrid #91 we see a preposterous commotion around a constipated lapdog: the weeping lady owner, the perplexed husband, the old crone fingering her rosary, a woman with her praying hands uplifted to the sky—all because, as the caption says, "The whole house is in an uproar because the poor little bitch's bowels haven't worked all day." And one of the bawdiest and funniest of his drawings celebrates animal sex: a stallion heatedly mounting a mule, which itself is being ridden on the highway by an unfortunate priest. The stallion has its hooves over the monk's shoulders and is gripping his hood in its mouth, as though it were the ass's mane. "This incident," Goya notes at the foot of the page, "occurred in Aragón when I was a boy, and the monk was very ill-treated by the horse, and so was the she-ass."

For Goya, drawing was an instrument of freedom. Only very rarely do you see him practicing poses or expressions from the earlier repertoire of other artists. He knew, better than most painters of his time, that recipes contained no guarantee of success: everything depended on that first coup d'oeil, the first moment of intersection between the real motif and the hovering, undecided nib or brushpoint, and without spontaneity that encounter could well be lost.

Goya set forth his feelings about the need for spontaneity, which were intense and felt at his very core, in a report he issued to the Academy of San Fernando in 1792, the year his illness struck, at a time when he still had more than three decades of life as a painter to go. "There are no rules in painting," he declared, in words whose echoes would be heard behind the entire history of the modernism that was to come:

The tyranny that obliges everyone, as if they were slaves, to study in the same way or to follow the same method is a great impediment to the young who practice this very difficult art, which comes closer to the divine than any other, since it makes known what God has created. Even those who have gone furthest in the matter can give few rules about the deep play of understanding that is needed, or say how it came about that they were sometimes more successful in a work executed with less care than in one on which they had spent most time. What a profound and impenetrable mystery is locked up in the imitation of divine nature, without which there is nothing good!

To imitate "divine nature," Goya seems on the point of saying (but does not quite say), one must somehow imitate nature's processes, and from that rises

the value of indeterminacy in drawing. This, at a time when official taste in Madrid was still ruled by the corseted taste of Mengs's classicism! Nature is powerful, insistent, judgmental, writes Goya, but never "faultless" in a way that the academic mind can encompass. This was an assertion of the value and, more than that, the *rights* of spontaneity as an artistic principle. In Goya's work, the spontaneity shows most clearly and vigorously in the drawings. They do not have what his sublime opposite, William Blake, called "the hard and wiry line of rectitude." Goya was perfectly capable of stealing a form or a motif from a strict Neoclassicist like Flaxman, but his drawings never look as if he did. Rather, they exalt the scribble, the puddle, the blot, the smear, the suggestive beauty of the unfinished—and, above all, the primal struggle of light and dark, that flux from which all consciousness of shape is born.

Laurent Matheron's early biography of Goya recalls an overheard conversation that, though it may not have been accurate word for word, rings true in all essentials. What the academics wanted and encouraged in their young charges, said Goya in his old age and exile, was the abstraction of "Always lines, never forms." But, he went on, "where do they find these lines in nature? Personally I see only forms that are lit up and forms that are not, planes that advance and planes that recede, relief and depth. My eye never sees outlines or particular features or details. I do not count the hairs in the beard of the man who passes by any more than the buttonholes on his jacket attract my notice. My brush should not see better than I do."

And it is Goya's ability to see that leaves one silent with admiration.

To see the old lady in sheet 2 of the so-called Black Border Album, the penand-wash strokes defining a crone whose dance, sprightly and seemingly eternal as she balances on one leg while clacking her castanets, defies old age and death along with it: "Content with her lot," says the caption, and what drawing could evoke more joy? To see another old woman tumbling downstairs, her legs waving in the air like a helpless semaphore, her mouth open in a startled O as though frozen by flash photography: how did he isolate that fraction of a second? To see the two fighting men incoherent with rage, grappling, one striving to bite off the other's nose like a rabid dog that has launched itself on its enemy. To see the peasant, the wretched *jornalero*, who has cast down his hoe and now stands in a posture of Biblical intensity, his clenched fists raised to an empty heaven and cursing a nonexistent God: "Crying out will get you nowhere," Goya scribbles below his feet. It is one of the great manifestos of realism, of the insatiable desire for truth. And its complete fulfillment would appear with the *Caprichos*.

THE CAPRICHOS

TO COMPREHEND THE *Caprichos*, one needs to know how they were made—a combination of regular etching and aquatint—and what these terms mean.

They were not Goya's first essays in the medium of print. He had made prints before, most of which were small copies after Velázquez's paintings in the royal collections of Madrid. These were straightforward etchings. If they had not been by Goya, they would hardly be remembered. They are wholly routine copies of the already much-copied works of a great painter, transposed into a purely tonal medium. Clearly they had some value to Goya as homages to an artist whose works he adored and wished to learn from; they are the means by which he absorbed, by imitation, some of Velázquez's cultural DNA; but as independent utterances they are of slight interest. The only early print of Goya's that can fairly be said to possess real and independent life is his large image of a garrotted man clutching, in his death agony, a crucifix (page 97).

An etching is a way of multiplying an image. The etching has no "original"; all impressions made from it are equally "original." To make an etching, you take a flat metal plate (usually copper, which is soft, easily scratched, and can be highly polished) and cover it with a "ground," a thin, acid-resistant coating of asphalt, mastic resin, wax, or a mixture of all three. This application can be done with a roller; in Goya's time it was more usual to form the ground into a little ball, warm the copper slightly so that the ground would melt, and then rub the plate with the ball so that an even film covered it. Next you cover the

ground with soot from an oily flame, which makes it black. Then you draw the design on it with a sharp needle, which scratches the blackened ground away and leaves a pattern of bright gold lines of unprotected copper. Now you dip the plate in a "mordant," such as weakish nitric acid, which reacts with the exposed copper and eats it away, leaving untouched the metal not protected by the ground. The result is a pattern of tiny grooves "bitten" into the copper. Clean off the ground, wipe ink over the plate, wipe it off; the wet ink stays in the bitten grooves. Put the plate in a press, lay damp paper facedown on it, and roll it out under pressure. The force of the press will squeeze the ink out of the grooves in the copper, transferring the design to the paper.

Etching, one should note, is commonly called a form of intaglio printing; but "intaglio" comes from the Italian *tagliare*, to cut, and that is exactly what the etcher does not do. The engraver cuts: he uses no acid, but directly scratches and scores the copper plate with his sharp needle, making a groove and throwing up a microscopic burr along the edge of the line. In etching there is no such burr, and this yields a subtly different visual effect.

The result, the printed sheet, is called a proof. Some parts of it will be too faint, others just right. The parts that need to go darker must be bitten more deeply by submitting them to the acid again, cleaning off, re-inking, and taking another proof. Before that is done, the passages that are right are kept as they are by "stopping-out"—laying more insoluble ground (varnish, usually) on the copper so that no more acid can reach it.

It sounds simple; it is, in fact, a very skilled and intuitive process, and master printers are almost as rare as master draftsmen. When he did his copies after Velázquez, Goya was not such a printer, and his work would scarcely engage anyone's interest were they not made by an artist who, though as yet fairly unskilled in his medium, would eventually turn into the Goya we know. But that Goya came into existence, as a printmaker, through another technical refinement in the process: aquatint.

Until the appearance of aquatint, the only way an artist could vary the tones of his print was by hatching and crosshatching: covering an area with a web or raster of lines that were closely spaced, so that their spacing made the area dark or light. The greatest master of this process was Rembrandt, who raised it to an unparalleled pitch of expressive power. No two etching techniques produce identical results; each has its own character. But there was one effect in particular that needle-etching could not duplicate: that of a flat watercolor wash, a uniform tone composed of tiny grains and speckles rather than lines. It gave a gamut of tones from delicate gray to a rich, velvety black of a density that could

not be rivaled by linear etching. This was known as aquatint. Essentially, you do it by dusting the required areas of the copper plate with fine pulverized resin, which, when heated, sticks to the copper. Immersion in an acid bath then produces a uniformly bitten tone, which prints as a continuous soft wash and not an array of lines. In Goya's time it was a new and little-exploited printing method, at least in Spain, which tended to lag behind other European countries in adopting new techniques. Because of aquatint's affinities with watercolor, it had been quite popular in England in the 1770s, though the earliest examples of it date from seventeenth-century Holland. It found only one practitioner in Italy, an otherwise obscure minor artist named Giovanni David, who published an album of his aquatint etchings in 1775. It may be that Goya's interest in aquatint came from England, whose satirical cartoonists he so admired. But wherever he got it from, and however he learned to use it—a possible candidate as his teacher is Bartolomé Sureda (1769-1840?), a gifted young engineer and polymath who showed him how to do soft-ground etchings—Goya wholly transformed its potential as a medium. He did not, of course, do this on his own. The making of etchings and engravings, as anyone who has been inside a print shop knows, is a highly collaborative business that brings together people of specialized skills that the artist may not himself possess. The collaboration is, indeed, one of the most absorbing and (when it goes well) delightful aspects of printmaking: as the great printmaker Robert Rauschenberg once remarked, it "relieves the egotistical loneliness of the artist." Goya was able to draw on the talents of several highly skilled printmakers. The chief one was a Valencian artist who was probably the best engraver in Spain at the time, grabador de Cámara to the court after 1802, Rafael Esteve y Vilella (1772–1847). Others were Joaquín Ballester (1740–1800), José Ximeno y Carrera (fl. in Madrid from 1781), and Tomás Rocafort.²

What Rembrandt did for line etching, Goya and his colleagues did for aquatint, and they did it with one astonishing burst of creativity: a series of eighty prints that Goya entitled *Los caprichos*. Without aquatint as their medium, they would not have been possible. Those deep, thick, mysterious blacks against which figures appear with such solidity and certainty, and yet with such apparitional strangeness; that darkness in which most detail is lost, so that one's eye moves into a record of states of mind rather than a description of a "real" world—such effects owe their intensity to the aquatint medium, and might not have been so available to Goya without it.

What is a *capricho*? A whim, a fantasy, a play of the imagination, a passing fancy—so say the dictionaries. The word derives from the unpredictable jump-

ing and hopping of a young goat. Goya was by no means the first artist to call his work a capricho. Italian artists had their capricci, French ones their caprices, and generally the word applied to architectural fantasies: Panini's assemblies of monuments, Hubert Robert's dramatized Roman ruins, and Piranesi's imaginary prisons (Goya owned several prints of the last). But sometimes it referred to dreamlike figures, in or out of costume, enacting their lighthearted or mysterious business, as in the capricci of Tiepolo, which Goya knew through Tiepolo's presence at Carlos III's court. Goya, however, was the first artist to use the word *capricho* to denote images that had some critical purpose: a vein, a core, of social commentary. This he made clear with the notes he made on a drawing for what was to be the first of the Caprichos, but whose final etched version got shifted to plate 43: the "Sleep of Reason" image previously discussed, with the unquietly slumbering man at his desk (perhaps Goya himself) beset by the forces of irrationality personified as owls and bats. On the flank of the desk is written "Universal language [Ydioma universal]. Drawn and etched by Francisco de Goya in the year 1797." Then, below the design, we read in a pencil scribble: "The author dreaming. His only purpose is to root out harmful ideas, commonly believed, and to perpetuate with this work of the Caprichos the soundly based testimony of truth."

The dream, of course, was a useful carrier for almost any sort of satire, just as shipwreck followed by the discovery of imagined utopias and dystopias (Lilliput, Brobdingnag) would be for Jonathan Swift: the artist falls asleep, and he is visited by images that are out of his ken or control but have an unlooked-for truth—he is granted the innocence, but the honesty as well, of a medium or visionary. Dreams are supposed to speak truth, and the dreamer cannot be blamed if the truth he speaks in turn is inconvenient, insulting, or obscure. As Tomlinson puts it, "This manner of introducing satire provided the author with a convenient alibi." Apparently, Goya was taking a leaf out of the book of one of the most famous Spanish authors, Francisco de Quevedo y Villegas (1580-1645), who in 1627 published a set of five prose satires using the convention of dreams, in which various sorts of vice and dishonesty are held up to ridicule: The Possessed Bailiff, The Last Judgment, The Dream of Hell, The World from Within, The Dream of Death. Each of the Caprichos was preceded by studies and drawings; often Goya would dampen the drawing that satisfied him and press it down on a polished copper plate, thus transferring the main lineaments of the design to the metal. Though he never used the word sueño, "dream," in the prints, it is found in many of the titles that he himself wrote on these surviving drawings. Thus the final drawing for Capricho 43 meant, originally, to be the title plate of the whole series, has written on it "Sueño uno," "Dream number one." But there was nothing unconscious about his choices of subject or satire in the Caprichos. Instead, he flatly denied that he was trying to irritate or ridicule anyone in particular: these were common follies and errors that he was after, not the deeds of any one person.

So on February 6, 1799, Goya ran an announcement in the *Diario de Madrid* that, though long, is worth quoting for the light it throws on Goya's expectations about his *Caprichos*.

The author is convinced that it is as proper for painting to criticize human error and vice as for poetry and prose to do so, although criticism is usually taken to be exclusively the business of literature. He has selected from amongst the innumerable foibles and follies to be found in any civilized society, and from the common prejudices and deceitful practices which custom, ignorance, or self-interest have made usual, those subjects which he feels to be the more suitable material for satire, and which, at the same time, stimulate the artist's imagination.

Since most of the subjects depicted in this work are not real, it is not unreasonable to hope that connoisseurs will readily overlook their defects.

The author has not followed the precedents of any other artist, nor has he been able to copy Nature herself.... He who departs entirely from Nature will surely merit high esteem, since he has to put before the eyes of the public forms and poses which have existed previously in the darkness and confusion of an irrational mind, or one which is beset by uncontrolled passion.

The public is not so ignorant of the Fine Arts that it needs to be told that the author has intended no satire of the personal defects of any specific individual in any of his compositions. Such specific satire imposes undue limitations on the artist's talents, and also mistakes the way in which perfection is to be achieved through imitation in art.

Painting (like poetry) chooses from universals what is most apposite. It brings together in a single imaginary being circumstances and characteristics which occur in nature in many different persons.

Clearly, Goya was not being entirely frank with this modest and somewhat guarded declaration of intent. "The author has intended no satire of the personal defects of any specific individual"? It's true, in a restricted sense: no one in the *Caprichos* has to suffer the caustic personal malice with which Thomas Rowlandson pilloried his invented pedant Dr. Syntax or James Gillray depicted his "Boney," Napoleon Bonaparte, the first political figure in history to be uni-

versally caricatured. Caricature was much freer in England than anywhere else in Europe; satirical printmaking had something of the status of a profession there, largely thanks to William Hogarth's agitation for the Copyright Act of 1735, which made it harder to sue or otherwise persecute artists for visual defamation.

In Spain it was otherwise. The artist who personally offended the king or his ministers, who raised the hackles of a powerful nobleman, or who aroused the ire of the Church and thus set the Inquisition on his track had little protection beyond influential friends, if he had any. To the extent that real, living political figures are referred to at all in Goya's prints, they appear so unlabeled, unnamed, disguised, and otherwise merely hinted at that, two hundred years later, they are unidentifiable. Contemporary explanations of the Caprichos are some help, but they also tend to be muted. The two earliest (both dating from about 1799-1803) are the so-called Ayala text, which once belonged to the dramatist Adelardo López de Ayala, but exists only in a version included in a biography of Goya by the conde de Vinaza in 1887; and a manuscript preserved in the Prado that was once believed to have been written with the approval of Gova himself. Both tend to agree that Gova referred to the sexual life of Queen María Teresa and the career of Godoy—and if there is any specific political event referred to in the Caprichos, it is Godoy's acquisition of power through his liaison with the queen.

This would seem to be the subject of Capricho 56, Subir y bajar ("To rise and to fall"). This is a variation on an ancient image, the Wheel of Fortune, in which the progress of man from ambition to success, thence to domination but then down to failure, is traced in the rotation of Fortune's wheel. What Goya shows is an enormous, goat-footed satyr, perennial symbol of lust, seated on the round globe of the world and kicking up his powerful legs with glee. Like a circus acrobat gripping his smaller partner, he holds a man upright, by the ankles, with no other support, as though exhibiting him as his creation. This man wears a broad but stupid-looking grin of self-satisfaction. He is wearing a military tunic with crossed bandoliers, an order glitters around his neck, a sword hangs from his belt—but for all these marks of dignity and prowess, he has no trousers on. Held erect by the deity of lust—subir y bajar has, unsurprisingly, the secondary meaning in common Spanish of erection followed by detumescence—he flourishes smoking thunderbolts to hurl at his enemies, two of whom are seen toppling into space, dethroned. His hair is on fire, or perhaps it is his brain, boiling with extravagant whims and schemes. He may be a puppet, but he is a dangerous one, even though he will eventually undergo the fate he has meted out to

Goya, *Los caprichos*, plate 56, *Subir y bajar* ("To rise and to fall"), 1796–97. Etching and aquatint, 22 x 15 cm.

his rivals. Both the commentaries written on the Caprichos by Goya's contemporaries and all the more recent nineteenth-century texts agree that this figure is none other than Godov. The Avala text names him as the "Prince of Peace," Godov's actual title conferred by Carlos IV. Lust, it says, "raised him up by the feet; it filled his head with smoke and wind, and he flings thunderbolts at his rivals." "Fortune is very unkind to those who court her," remarks the Prado text. "Smoke is the reward she gives for the toil of the climb, and she punishes him who has risen by casting him down." In 1797 Godoy, seeking the support of the Spanish left wing against the pressures that bore on him from the Church and the nobility, had formed a government whose senior posts were largely filled with ilustrado intellectuals, with Francisco de Saavedra as minister of finance and Jovellanos as minister of justice. In March 1798, Carlos IV—who was indignant at the failure of Godov's diplomatic maneuvering with France stepped in and fired Godoy in favor of Saavedra and Jovellanos. But Jovellanos's reforming zeal was so successful in alienating everyone concerned—the king, the queen, the Church, the nobility, and not least Godov—that the two ilustrados were dismissed in August and replaced by Godov shortly after. The cast-off figures of Saavedra and Jovellanos are the ones we see tumbling into space in Subir y bajar, though we do not see their faces.

Such a moment of political comment is not just rare but virtually unique in

the Caprichos. In no systematic order, Goya deals with more generalized subjects that have to do with religion, morality, love, marriage, and superstition rather than government. Nearly a quarter of the plates, for instance, represent the doings of witches, a subject of truly obsessional interest to Goya. Rather more, some twenty-five, deal with sexual mores: courtship and betrothal, seduction, prostitution, abduction, rape, and the miseries of love. The Inquisition, the wiles of charlatans and doctors, the pretensions of aristocratic lineage, the behavior of monks and priests: all come under his eye. He does not make up continuous narratives as Hogarth does in *The Rake's Progress*. Each design is a single shot. Characters do not recur, but types do: the lecherous old man, the nitwit petimetre, the grasping priest, the beautiful scheming girl who has less enchantment time left than she thinks, the scary yet comic old crone of a witch, the bizarre duende, or hobgoblin. He does not promise punishment to those he satirizes. He does not care about damnation for sin or salvation from it. What interested him, as a good and committed ilustrado (which he was some of the time, if perhaps not all of it), was the appearance of rational Truth: the light of objective and critical understanding, the light of ilustración, which would dispel the goblins and the follies, and get rid once and for all (vain hope for an artist!) of "harmful ideas, commonly believed."

One of these ideas, to judge from Gova's designs, is that women are good and faithful. Another is that men are decent and honorable. A third is that those in power deserve to be, and selflessly exercise their influence for your benefit and mine. All three of these fantasies, on which a society's official estimate of its own goodness partially relies, are pilloried as shams and delusions. Goya's peculiar slant, which lends a special power to his work, is that he will not accept (or, at best, accept only with the deepest reservations) the familiar scheme of goodies and baddies, exploiters and unknowing victims. To him, all of Madrid society—for the Caprichos, despite the appearance of a peasant or two, are an urban masquerade, a portrait of life in Spain's capital, that condenser of social extremes—is linked in a series of agreements or, to put it more bluntly, deals. I grab from you; you grab from me; each of us loses and each gets something. The note is struck right after the title portrait of Goya himself, in plate 2, El sí pronuncian y la mano alargan al primero que llega ("They say yes and give their hand to the first one who comes"). It is a marriage scene, in a huge dark church whose architecture is only faintly implied in the curve of an arch vanishing in the gloom to the right. Eleanor Sayre has shown that Goya got his idea, along with his title, from a satiric poem by Jovellanos, "A Arnesto" ("To Arnesto"), which ferociously attacks the personification of cynicism and frivolity in a

The Caprichos · 185

fictional member of the Madrid higher classes: a young lady named Alcinda, who has married a rich man just for his money and social standing, just like others who

Without invoking reason, nor weighing In their hearts the merits of the groom They say yes and give their hand To the first who comes.⁴

Goya's quote from the poem links his idea indissolubly with that of his friend Jovellanos—normally he did not use direct quotations for his titles.

At first it looks like an ordinary marriage scene, but it is a peculiar one that gets stranger as you look. Clearly, this is a girl of some prominence, celebrity even: a noble, conceivably a princess. Otherwise, what are all those proles, shoving and jostling one another for a good look, doing in the background?

Left: Goya, Los caprichos, plate 2, El sí pronuncian y la mano alargan al primero que llega ("They say yes and give their hand to the first one who comes"), 1796–97. Etching and aquatint, 22 x 15 cm.

Right: Goya, *Los caprichos*, plate 14, *¡Qué sacrificio!* ("What a sacrifice!"), 1796–97. Etching and aquatint, 20 x 15 cm.

Such people are not normally allowed in church during a rich wedding. Their presence at this one suggests a hollowness: they are there to witness a display, not an affirmation of mutual love. Such rituals are as a rule to be taken seriously—but who, then, is the topmost figure in Goya's pyramid of people moving toward the altar, the face with its broad, contemptuous grin? The girl, the "Alcinda," is beautifully dressed in a sexy Empire-style gown—one of the many afrancesado fashions that had made its way to Spain—that emphasizes her breasts, as does the bright light falling on them. She wears a mask, not out of deference to any known marital costume, but simply to tell us that she knows what we know: this is a masquerade, a social pantomime. She is young, cute, and desirable, and she has chosen a perfectly repulsive husband, short, bucktoothed, vacuously grinning (his features and expression irresistibly recall, to a modern TV watcher, a character from *The Simpsons*), and, presumably, as rich as Croesus. He wears an ermine-collared cloak, aping royalty. He goggles at his trophy bride with naïve, unmodulated lust. And, bizarrely enough, having eyes in the back of her head—an ancient expression for astuteness—she gazes back at him via a mask attached to the back of her coiffure. It is the face of a monkey, symbol of cunning and of lust. Her father, on her left, has traded her off to the highest bidder: but Goya would have us know that she is not naïve, and that she will not make her new husband very happy for very long.

The financial basis of matrimony, and the injustices it could bring, was a favorite Goyaesque theme. Clearly he is much more on the side of the pretty young girl in plate 14, ¡Qué sacrificio! ("What a sacrifice!"), than he was on the corrupt Alcinda's. Her demureness is not feigned. She is overcome with shame and resignation. These speak from every line of her facial expression and body language, from the averted face with its eyes modestly downcast to the instinctive gesture of her joined hands protecting her sex. Her family behind her, especially the man one presumes to be her father (who is covering his eyes with an expression of anguish at acquiring such a son-in-law), are, to put it mildly, unhappy at the thought of this betrothal—as well they might be. The figure of the prospective groom is one of Goya's most lacerating inventions: dwarfish, easily twice her age, hook-nosed and thick-lipped (this time Goya seems to have slid into the anti-Semitism he normally eschewed), hunchbacked, bowlegged, and overdressed to the nines with the frock coat expensively tailored to the lumpish contours of his body. This is a sacrifice indeed.

Most of Goya's images of the sexual comedy, however, have to do with prostitution, seduction, and adultery rather than marriage: he has already made his point about betrothal, that it is itself a form of prostitution.

Left: Goya, *Los caprichos*, plate 5, *Tal para qual* ("Two of a kind"), 1796–97. Etching and aquatint, 20 x 15 cm.

Right: Goya, *Los caprichos*, plate 7, *Ni así la distingue* ("Even like this he can't make her out"), 1796–97. Etching and aquatint, 20 x 15 cm.

In the adultery scenes, Godoy and the queen make more appearances—at least, so the commentators of Goya's time thought. For instance, Capricho 5, *Tal para qual* ("Two of a kind"), which shows a sword-bearing man and a handsome woman in a black mantilla chatting while two shriveled old crones who clearly have seen such things a hundred times before whisper and point in the background, is referred to in the Ayala text simply as "*María Luisa y Godoy*." But once again, there is no sign from Goya's own hand or words that he had chosen such eminent and powerful targets. The woman does not look like María Luisa, nor does the man even faintly resemble Godoy. It is more likely that the subject is a commonplace encounter on the paseo del Prado between a streetwalker and a possible client, as they size one another up. The preliminary drawing in the Prado carries, in Goya's hand, the note that "The old women laugh themselves sick because they know he hasn't a penny." Pennilessness was not a fault Godoy could have been accused of. In general, the later interpreters' too-facile assumption that he and the queen keep turning up as targets of the

Caprichos must be off the mark, because Goya was too canny to put his own livelihood, which depended so much on good favor at court, at risk. He was no fool about such things, and he would have known quite well that the queen would have put pressure on other possible clients of Goya's to ignore the work of such an impertinent commoner, whatever his talents.

The successful whore must not (or not at first) let on that she is a whore: that deflates the romantic illusion. And men do not necessarily want to know the truth. This ancient fact inspired one of Goya's more mordant *Caprichos*, plate 7, in which one of Goya's delicious, sinuous *majas* is being quizzed by a gallant through a monocle, swaying her hip toward him as he peers, like an infatuated connoisseur, at her face. "*Ni así la distingue*," the caption says: "Even like this he can't make her out." He has been made purblind by desire.

A recurrent theme in the *Caprichos*, as in some of Goya's later paintings, is the corrupt relationship between old and young women expressed in the character of Celestina, the bawd or procuress who gets innocent young girls "on the game" and serves thereafter as their adviser, helped by some access to the secrets of witchcraft. By the 1790s Celestina was a traditional figure in Spanish drama, having been written into existence in La Celestina, a dialog novel by Fernando de Rojas, in the late fifteenth century. Goya's interest in the girl/ Celestina relationship exists on several levels; on a more fundamental one, it is also about the distorted relations between mothers and daughters. Celestina is the Bad Mother, the ruthless old crone who is showing her "daughter" a way of survival, teaching her the tricks that will, in the end, encompass her downfall making the "daughter" repeat the life of the "mother." Goya stresses their complicity in Capricho 28. Chitón ("Hush") shows them sharing a secret: the girl is clearly telling her stooped mother not to blab. "Excelente madre para un encargo de confianza," says the Prado text, "An excellent mother to trust with a confidential mission." The Bad Mother (or her equivalent, the Corrupt Aunt) gives her daughter ironical but useful advice. In one of the most beautiful of the Caprichos, plate 17 (page 173), a girl is seen checking her stocking to make sure it is not wrinkled, that its seams are straight, before she goes out for the night. The diagonal of her young, outthrust leg is an exquisite form, and it is adapted with no change from a brush-and-inkwash drawing (also page 173) in Sanlúcar Album, a notebook Goya took with him on a visit he made to the country estate of the duchess of Alba at Sanlúcar de Barrameda in Andalucía in 1796. Despite one's natural wish to assume the contrary, it almost certainly does not represent the duchess dressing: the remnants of this sketchbook, which was dismembered in the nineteenth century, contain a number of sketches of naked or

The Caprichos · 189

Left: Goya, *Los caprichos*, plate 28, *Chitón* ("Hush"), 1796–97. Etching and aquatint, 22 x 15 cm.

Right: Goya, *Los caprichos*, plate 16, *Dios la perdone: y era su madre* ("God forgive her: and it was her mother"), 1796–97. Etching and aquatint, 19.6 x 14.8 cm.

half-dressed women who are not the duchess, although it may be that some of the missing ones did represent her; we simply do not know. (Because the duchess was so famous, the ones that clearly depicted her might well have been the first to go; only sixteen sketches, recto and verso of eight leaves, remain.) In the print, the old Celestina who watches her supplies the punning commentary that is also the title of the plate: "Bien tirada está," "It is well stretched"—punning because it also alludes to the girl's vagina, which will be as smooth and tight as her stocking; and of course the fact that it is "well stretched" confirms that she is no longer a virgin.

Nothing is necessarily sacred in the mother-daughter bond; it may be as ephemeral as the girl's liaison with a lover. Such is Goya's point in Capricho 16, *Dios la perdone: y era su madre* ("God forgive her: and it was her mother"). The girl, who bears a marked resemblance to the duchess of Alba—her face, which so obsessed Goya, keeps appearing in the *Caprichos* as their durable image of seductive female beauty—is taking her nightly *paseo* when she is accosted by a stooped old woman, whose face we do not see. "The young woman left home as

a little girl," runs the explanatory Prado text. "She did her apprenticeship in Cádiz, and then came to Madrid, where she had a stroke of good luck [le cayó la lotería, "she won the lottery"]. She went down to the Prado, where she heard a dirty, broken-down old woman begging for alms. She sent the old woman away." And then, in the finest melodramatic tradition of popular theater, the girl realizes that the old beggarwoman is her mother. We do not see the (presumably) soon-to-be-guilt-ridden maja making this discovery. Goya shows her in the arrogant efflorescence of her youth, and signals that she is now a prostitute by his characteristic device: the position of her feet, those tiny pointed-toe sex symbols, which are splayed outward and pointing in opposite directions, shorthand (in Goya's form language) for the opening and spreading of a girl's legs in the act of sex. Realization will come in a moment. It is foreshadowed by the ominous darkness of the scene: the lumps and clumps of indistinct, near-black shadow, the illegibility of the old woman's face. (Mama is holding up what appears to be a necklace or more probably a rosary of beads or stones, which may be the remembered object through which her daughter recognizes her after all those years.)

The predominant image of sexual transaction Goya offers is that of "fleecing," "plucking," or "skinning." This happens to both men and women, but mostly it is the prostitutes and their *celestinas* who exploit their clients, the naïve

Goya, *Los caprichos*, plate 20, *Ya van desplumados* ("There they go, plucked"), 1796–97. Etching and aquatint, 21.4 x 15.1 cm.

or rash men. In Capricho 20, Ya van desplumados ("There they go, plucked"), we see it going on. Watched by a degenerate-looking pair of friars, two sturdy prostitutes have finished with their client-victims and are now harrying them out the door with brooms. These wretched creatures with the heads of men and the bodies of plucked chickens look utterly doleful, especially the one leaning into the light of the doorway, trying in vain to take off without a feather to fly with. It may be that the baldness of their bodies is also a reference to syphilis, caught from prostitutes: loss of hair was one of the classic symptoms of advanced pox. In the next plate, Capricho 21, ¡Qual la descañonan! ("How they pluck her!"), the roles are reversed, and the sauce for the gander becomes sauce for the goose or, rather, the hen. A prostitute has fallen into the hands of the law, in the form of a magistrate, a notary, and a policeman. The magistrate, with the above-it-all expression of objective Law etched on his slightly catlike face, spreads his cloak in a parody of protection while each of the lesser officials grips and spreads apart the wings of the bird-prostitute (in the slang of the day, whores were known, among other things, as buhos, barn owls, and lechuzas, small brown owls). The poor bird herself is about to be plucked, and her face bears an expression of pain and terror; the design implies that she is being robbed ("fleeced") by the servants of the law, under the protection of those whose duty should be to prevent it.

The cruelest image of the whore-as-exploiter is in Capricho 19, *Todos caerán* ("Everyone will fall"). It invokes a technique of bird hunting that Goya, like any other hunter of his day, would have known well, but which has now almost disappeared. Thirty years ago it was still in use: one could buy from Italian or Spanish hunting outfitters a stuffed owl wired so that when one pulled on a string attached to its body, the bird flapped its wings. This was, so to speak, an anti-decoy, whose job was to repel birds rather than attract them. The hunter fixed it to the branch of a tall tree and waited for a flight of smaller birds—thrushes, robins, quail, sparrows, whatever was usual prey for the larger predators—to fly below it. A twitch on the string, and the owl flapped; terrified, the smaller birds would dive and scatter, but find themselves either caught in birdlime on nearby twigs or enmeshed in a net cunningly set out by the hunter. It sounds an implausible device, but it worked—as this author can testify, having seen it used several times by farmer-hunters in Lazio in 1965, and bought such an owl himself from a rural taxidermist.

In Goya's print the bird in the tree is a decoy, not a frightener. All sorts of male birds flutter around it, for it is a pretty bird, with abundant black ringlets and generous breasts—more than one writer has noted its resemblance to the

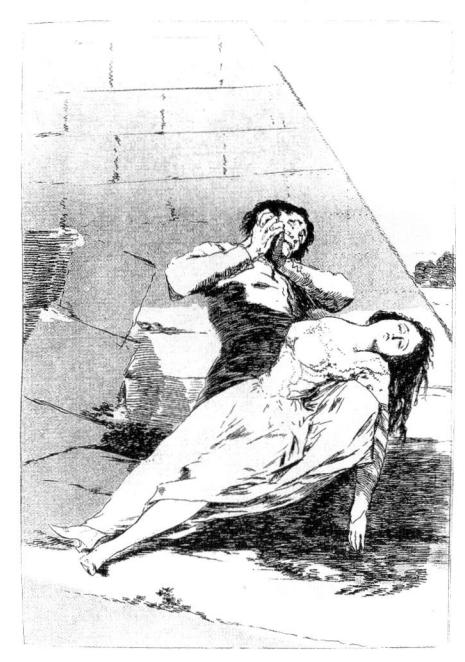

Left: Goya, *Los caprichos*, plate 19, *Todos caerán* ("Everyone will fall"), 1796–97. Etching and aquatint, 21.5 x 14.5 cm.

Right: Goya, *Los caprichos*, plate 9, *Tántalo* ("Tantalus"), 1796–97. Etching and aquatint, 20 x 15 cm.

duchess of Alba, and that of the bird immediately behind it to Goya's own full-face self-portrait drawing from c. 1795–1800 now in the collection of the Metropolitan Museum of Art. Another bird—who, one wonders, might he represent?—wears a military hat and a sword. "All sorts of ugly birds," comments the Ayala text, "soldiers, commoners, and monks, fly around a lady who is half-hen; they all fall, and the women hold them down by the wings, make them throw up and pull out their guts." This is what is going on in the lower part of the print, as two women—prostitutes, one infers from the cute little shoes of the one on the right—get to work on a captured male bird while an old celestina goes through the exaggerated gestures of prayer. With expressions of sweet concern and absorption, one of these females is holding the captive bird, already plucked, across her lap, while the other pushes a sharp rod into his anus and dribbles of vomit escape his mouth. This, Goya is saying, is the common fate of all those deluded by the promise of love: all must fall.

Though Goya had the sharpest of eyes for the bitter human comedy of mutual deception entailed in the purchase of young, lovely women by old, ugly men, he was acutely aware of the reverse side: the sadness of old lovers in the face of their own impotence. This is the theme of the infinitely sad Capricho 9, *Tántalo* ("Tantalus"). A young woman, seemingly dead and rigid as a board, is propped on the knees of an old man, who wrings his hands in grief, his face a mask of inconsolable lamentation. Is he mourning for a wife who died too young? You might suppose so, given that the sharply pitched pyramid behind them is so obviously taken from a funereal memory of Goya's youthful visit to Rome: it is the Pyramid of Cestus, which was then enclosed by a monumental cemetery. But if she is dead, then why is she dressed so fetchingly, why is her utterly wooden pose (for not even rigor mortis gets that advanced) so unlike those of the many corpses Goya drew, and what is she doing in a cemetery without a coffin? A deeper level of metaphor becomes apparent. Her rigidity is frigidity. She is alive, but what the old man is mourning is his lost power to sexually arouse her. The title of the print supports this.

Tantalus, in Greek myth, was a son of Zeus who had monstrously offended his all-powerful father. There are several versions of his mythic sin. According to one, he had perjured himself in order to steal Zeus's dog and give it to Hermes. Another has him abducting Ganymede, the cupbearer who was an object of Zeus's sexual desire. A third, given in Book XI of the *Odyssey*, was that Tantalus, having been invited to dine with the gods, committed the fearful indiscretion of tattling about the conversation at these banquets and, worse, of having stolen and shared with mortal friends the nectar and ambrosia served at their exalted table. His punishment was to be eternally plagued by hunger and thirst. Though he was immersed in water up to his neck, the river receded each time he tried to drink. A branch full of fruit hung just above his head, but it pulled away whenever he reached for it. His curse was to be "tantalized" forever.

The clergy, of course, do not escape Goya's lash. Nobody familiar with his early work, with its rich fund of religious imagery, could suppose (as it has sometimes been the fashion to do) that Goya was inherently opposed to religion, an atheist under the skin. Nothing about him is, or was, as simple as that. But he was often anti-clerical. You would need to be blind not to see, at first hand, the extraordinary laxness, hypocrisy, and greed of some of the Catholic clergy in Bourbon Spain. They were as bad as any modern Catholic priests. They praised chastity but groped boys; they praised moderation but gorged and swilled like pigs; they pretended to have access to divine wisdom but imposed the basest superstitions on the faithful to keep them obedient; they preached rubbish from the pulpit and brutally supported the Inquisition. All these bad ecclesiastical habits come under the unpitying eye of the *Caprichos*, though the

Goya, *Los caprichos*, plate 52, *¡Lo que puede un sastre!* ("What a tailor can do!"), 1796–97. Etching and aquatint, 21 x 15 cm.

remarkable fact is that the Holy Office, when the prints were published at last, made no move to ban them or discipline Goya for making them. (This does not indicate any special degree of tolerance on the Inquisition's part; rather, it probably testifies to its inefficiency.) Goya always makes it clear, at the very least by implication, that the vices and follies he is attacking do not emerge from the nature of religious faith itself, but are the result of its tyrannous exercise by imperfect men. The mood is given by Capricho 52, *¡Lo que puede un sastre!* ("What a tailor can do!"). A young woman falls on her knees, hands clasped in prayer. Behind her are other people, sketchier but equally awestruck. The object of their devotions looms over them, a giant, arms frighteningly raised, swathed in the clerical cloth of a friar's habit. Look closer, and its hands are branches that sprout leaves: it is a bogeyman, a tree in costume.

In Capricho 53, ¡Qué pico de oro! ("What a golden beak!"), a group of frailes, or monks, surrounds a pulpit on which a parrot is perched, reverently listening to it as it chatters and squawks its inane theology. Capricho 58, Trágala perro ("Swallow it, dog"), goes after the clergy who force the faithful to give credence to every kind of ludicrous doctrine, and by implication attacks the Inquisition. The title comes from a popular song against authority, chanted by the liberals against the Bourbon absolutists in the 1790s, whose refrain was "We will never cease to sing 'Swallow it / Swallow it / Swallow it, dog.' "But here, trágala car-

Left: Goya, *Los caprichos*, plate 58, *Trágala*, *perro* ("Swallow it, dog"), 1796–97. Etching and aquatint, 21 x 15 cm.

Right: Goya, *Los caprichos*, plate 79, *Nadie nos ha visto* ("No one has seen us"), 1796–97. Etching and aquatint, 22 x 15 cm.

ries no liberal suggestion. A terrified man kneels on the ground, imploring mercy from a fanatical monk. None will come; what the monk has in his hands is a clyster, a veritable Long Tom of an enema syringe, which will flush out the poor dissenter's guts with its load of orthodoxy.

Monks preach abstinence and are gluttons in secret: such is the message of Capricho 79, *Nadie nos ha visto* ("No one has seen us"), with its wine-sodden friars carousing in a cellar. They gorge themselves at table, mouths opening into those voracious chasms of darkness that were for Goya, as they are for us, the most menacing emblems of an unleashed, cannibal orality, those terrifying expressions that stir the same primordial fears as the mouth of Goya's later Saturn, tearing his child into gobbets, as if echoing King Lear: "The barbarous Scythian / Or he that makes his generation messes / To gorge his appetite." "Están calientes," declares the caption to Capricho 13: "They are hot." This image and its caption open a fan of related meanings. The monks are hot because they are hungry. They are hot because they are randy, "in heat." The end result of their oral heat is cannibalism. One of the three preliminary studies

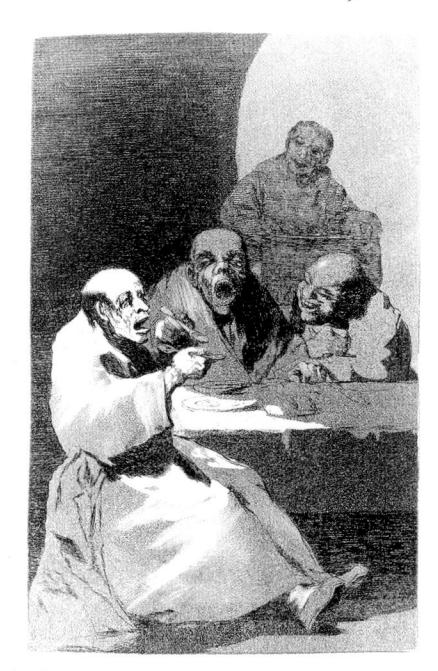

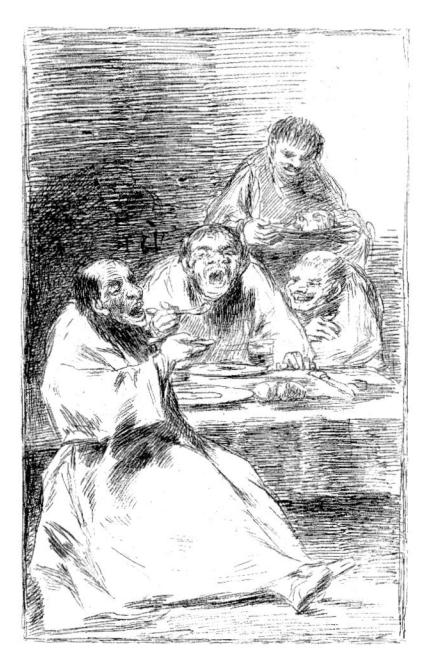

Left: Goya, *Sueño de unos hombres que se nos comían* ("Dream of certain men who were devouring us"), 1797. Pen and sepia ink, 24.2 x 16.7 cm. Museo Nacional del Prado, Madrid.

Right: Goya, *Los caprichos*, plate 13, *Están calientes* ("They are hot"), 1796–97. Etching and aquatint, 21.5 x 15.1 cm.

for this etching (Prado #20) shows the servant in the background with a cooked human head on his tray. "Sueño," Goya's inscription runs, "De unos hombres que se nos comían"—"Dream. Of certain men who were devouring us." The idea that the holy men of the Church actually eat their flock, thus perverting the Catholic belief that the real body and blood of Christ are consumed in the guise of bread and wine in the sacrament of Holy Communion—this is a savagely anti-clerical notion, and it is hardly surprising that Goya left it out of his final plate. A third drawing (Prado #433) is merely obscene, or might have seemed so at the time: the nose of the monk on the left has grown into a penis. This too Goya let drop. It was not part of his plan to lard the Caprichos with too many dirty jokes; they were meant, in an admittedly dangerous and edgy way, and with a few exceptions, to be family fun.

The last area of priestly activity satirized in the *Caprichos* was the Spanish Inquisition. It was a subject that Goya would return to, with equal and sometimes greater ferocity, in his sketchbooks after the restoration of the Bourbon

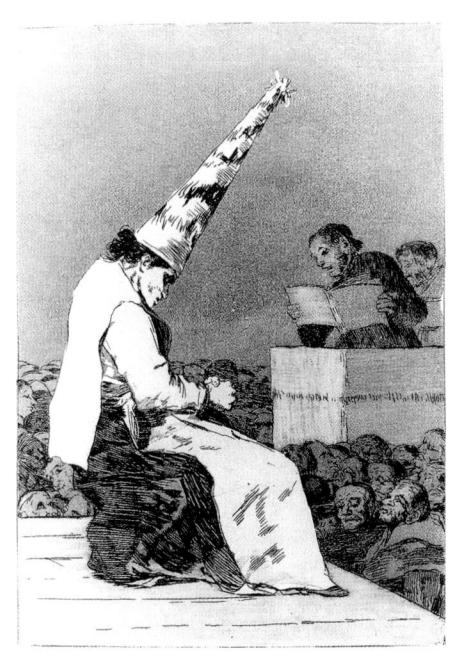

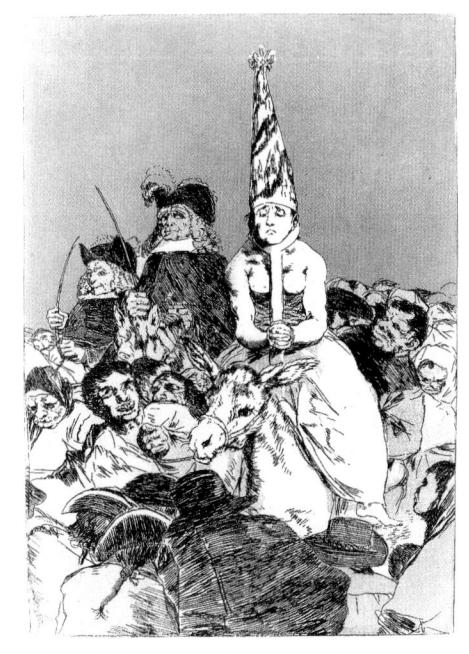

Left: Goya, *Los caprichos*, plate 23, *Aquellos polbos* ("Those specks of dust"), 1796–97. Etching and aquatint, 21.5 x 14.8 cm.

Right: Goya, *Los caprichos*, plate 24, *No hubo remedio* ("There was no remedy"), 1796–97. Etching and aquatint, 22 x 15 cm.

monarchy in the person of Fernando VII. But the Inquisition was a bugbear of the ilustrados in the 1790s, too, and Goya devoted several of his most beautiful and pathetic plates to the plight of its victims. It is often said, and will be discussed in these pages later, that the Inquisition of Goya's time was a mere shadow of its former self: it was much less arbitrary, less free to burn people alive for bad blood or heresy, and had less coercive power over its unhappy victims than it had wielded in the seventeenth or even the early eighteenth century. All that is true, but it remained a detestable institution, a tool of ideological terror, and a loathed symbol of what la leyenda negra, "the black legend" of old Spain, had meant. And Goya, passionate humanist that he was, invoked it with a corresponding hatred. In Capricho 23, Aquellos polbos ("Those specks of dust"), the convicted heretic sits on a platform raised above the voracious crowd, wearing the coroza, or conical dunce cap of infamy, and hanging his head as his sentence is read by the presiding judge. We see in Capricho 24, No hubo remedio ("There was no remedy"), a woman on donkey-back being led through the streets to her burning. Her soft breasts are bare, she is imprisoned

in a sort of wooden frame around her neck, the *coroza* is set on her head, a malignant throng of gapers and arrogant officials surrounds her. There will be other prints in which Goya, no populist, shows his disgust for the crowd, but none more powerful than this.

Not all his prison scenes, though, were of victims of the Inquisition. Perhaps nowhere in his graphic work is there a deeper expression of pathos and fellow feeling for the condemned than in Capricho 32, *Por que fue sensible* ("Because she was impressionable"). It is a portrait of a woman who was condemned to die for conspiring with her younger lover to kill her older husband—the case of María Vicenta, whose trial and execution were among the sensations of Madrid in the early months of 1798. A beautiful woman sits in jail, surrounded by a darkness of such intensity that it seems almost to be gnawing at her, eroding her fragile form. Her body, hands resting on her knees, forms a right triangle, the kind of absolutely stable and elementary composition Goya favored in his graphic work. Her head is bowed, and her expression is of silent, inward distress, a despair without surcease. High up in the cell door is a rectangular spy hole through which she can be observed. A crack of light beneath the ill-fitting door only reinforces the sense of carceral gloom. Unlike every other plate of the

Goya, *Los caprichos*, plate 32, *Por que fue sensible* ("Because she was impressionable), 1796–97. Etching and aquatint, 21.5 x 15.2 cm.

Caprichos, this one has no etched lines at all. It is entirely painterly, rendered only in brushstrokes. It is a tour de force of the aquatint medium, and its softness, its almost liquid delicacy, only serves to emphasize the terrible inequality that is its subject: the iron machinery of punishment poised to crush *una mujer sensible* into the grave.

Such pathos cannot be sustained indefinitely, and Goya knew better than to try. He would produce a broad, acidulated humor as a relief from the terrors of power. Thus his ass pictures, a run of six Caprichos (37-42) in which various kinds of learning and creative effort are ridiculed by showing them enacted by donkeys. There was, of course, nothing especially new in this metaphor: people had been insulting others by comparing them with asses and donkeys since time immemorial, and a fairly robust strain of donkey satire had flourished in Spain since the seventeenth century, when Felipe V's librarian and secretary Gabriel Álvarez de Toledo (1622–1714) penned his burlesque epic Burromaguia ("Battle of the Donkeys"). But Goya's graphic fierceness gave the idea a particularly nasty and funny edge. He used donkeys to satirize the deplorable state of Spanish education: "Might the pupil know more?" his caption to Capricho 37 (¿Si sabrá más el discípulo?) asks as a donkey foal points with its hoof at a capital A (for asno, naturally) in its donkey-teacher's spelling book. In Capricho 38, "¡Bravísimo!," two human bystanders clap enthusiastically as another donkey listens, sitting on its tail and absolutely rapt, to an ape playing the guitar; unfortunately, the ape is as ignorant as the donkey, because it is strumming the side of the guitar that has no strings. The donkey and the monkey take another turn as patron and artist in Capricho 41, Ni más ni menos ("Not more, not less"). Goya's monkey, recalling the ancient description of art as "the ape of nature," is painting a portrait of the donkey, which sits up rather grandly to have it done. This image strongly recalls Goya's first official portrait: the 1783 likeness of Floridablanca, tall and refulgent in his red suit, towering over the exaggeratedly short painter. This is only right and proper, because the donkey has its own social pretensions. In Capricho 39, Asta su abuelo ("Back to his grandfather"), it sits at a table that bears a coat of arms—whose heraldic figure is an ass—and proudly displays an illuminated book of its lineage, a sort of family tree: ass after ass after ass, stretching nobly back, no doubt, to the donkeys of the age of El Cid.

Goya's *burro* also has scientific pretensions. Capricho 40, ¿De qué mal morirá? ("What illness will he die from?"), has the ass in a suit, sitting by the bedside of a dying man and taking his pulse with its hoof. The expression on the animal's face is delicately hilarious, an absurd mixture of solicitude and puzzlement; it is

Above, left: Goya, Los caprichos, plate 37, ¿Si sabrá más el discipulo? ("Might the pupil know more?"), 1796–97. Etching and aquatint, 21.3 x 15.1 cm.

Above, right: Goya, Los caprichos, plate 40, ¿De qué mal morirá? ("What illness will he die from?"), 1796–97. Etching and aquatint, 21.3 x 14.8 cm.

Left: Goya, Los caprichos, plate 42, Tú que no puedes ("You who cannot"), 1796–97. Etching and aquatint, 21 x 15 cm.

obvious that the donkey knows nothing and can make no diagnosis, but also that in Goya's view no human doctor can either; one is as ill-trained and abysmally ignorant as the other. (As we shall see, Goya did make an exception for Eugenio García Arrieta, a doctor who would treat and care for him later, but on the whole his suspicion of Spanish eighteenth-century medicine was fully justified.)

The harshest of the donkey Caprichos is undoubtedly plate 42, Tú que no puedes ("You who cannot"). It is the Upside-Down World of earlier French and Flemish satire, the monde à rebours where normal relationships of work and social standing are inverted: two donkeys riding on the backs of men. They do so with an air of ineffable complacency. The donkey on the left even wears a spur with a cruel, star-shaped rowel on its left hind leg to remind us, and the man beneath it, who is master. Nothing recondite here. The men, in the illfitting clothes of *jornaleros*, or day laborers, are the oppressed poor; the donkeys are the rich, whose burden the poor carry. Tú que no puedes is the first half of a familiar Spanish saying: "You who cannot . . . carry me on your back." The design refers to the enormous inequalities bred within the law by inequalities of wealth, a subject dwelled on at some length by Jovellanos in his report on Spanish agriculture, the Informe (1795), one of the founding texts of the Spanish Enlightenment. He pointed out how the great burdens of tax and obligatory service to the realm had to be borne by (mainly agricultural) workers, while the upper tenth of society—nobility, priests, and the like—was exempted from them. Taking up Jovellanos's theme, Gova did not fail to add that the laboring poor were unaware of this—that they accepted it blindly and dumbly as a "natural" part of the social order and could formulate no protest against it—for the eyes of the men in the Capricho are shut; they can see nothing. Dumb as donkeys themselves, stubborn as mules, they acquiesce in their own subjection. Equally, those on top of the social heap are unable to analyze, or see correctly, why they are there or what they should be doing.

The area of the Caprichos most remote from modern experience is, inevitably, the witchcraft plates. We have all suffered from jealousy and sexual obsession; we have known liars and what they can do; we have seduced and been seduced; fooled and been fooled. We have resented the inequalities of class, the grossness of self-indulgence and drunkenness. Some of us have known the terrors and hatreds that arise from religious bigotry and persecution, and although we may not be militantly anti-clerical, there is no doubt that some

of us have felt unease or even outrage at the power of organized religion. Some of the time, therefore, and to some of us, the Caprichos are a contemporary document, and our feelings about this great series are not so distant from those that a person looking at them at the dawn of the nineteenth century might have experienced—though it is unlikely that anyone living today would feel the impulse to burn a whole bound edition of them, as John Ruskin, in a fit of moral pyromania that bizarrely paralleled the human burnings of the Inquisition. actually did. (It is an open question whether Gova might not have regarded this act as a compliment.) But one thing seems fairly certain. Few people alive today, if any, find the Caprichos that take witches for their subject even remotely as convincing, or as accessible, as the rest. And the reason for this is obvious: so few people "believe in" witches or witcheraft. Who allows for the possibility that the old woman, a shapeless blot of shadow glimpsed under the tree in some Andalusian village, really has malefic powers? Who thinks that her withered chaps are anything but a dental problem caused by the defects of medical care in the época, the long-gone days of Franco? Who thinks she can cause abortions or lay eggs with prophetic designs on them—the crime for which the last old woman burned by the Inquisition met her fate in 1781? Who imagines her stealing babies from their cradles, consorting with owls in the dark of the moon, sucking the penis of a goat (in her younger days), or flying around on a broomstick? The answer—to snip off this string of largely rhetorical questions—is practically no one. Witches are no longer part of our common culture. They belong to Hollywood horror movies, but they no longer have the power to insinuate themselves into the normal dimensions of everyday life. At least, so an educated city dweller might say. This was emphatically not the case in lateeighteenth- and early-nineteenth-century Spain, when witchcraft was a real issue—either for social and educational reformers, who wanted to banish it from public consciousness as ancient and harmful superstition; or for clergy who saw themselves locked in a perpetual struggle against witches as the devil's emissaries and playmates; or for ordinary, ignorant Spaniards who carried a belief in witchcraft, like some irradiant isotope, in the very marrow of their cultural bones.

The fact that fully a quarter of the eighty final plates in the *Caprichos* represents witches at work and, so to speak, at play does not necessarily mean that Goya was a true believer in witchcraft. But it does imply that he knew very well what power the image of the witch had over the Spanish imagination in his time.

The reasons for the wide diffusion of this primitive belief were summarized (at about the time Goya was born) by that father of the Spanish *ilustrados*, the

The Caprichos · 203

Benedictine monk Benito Feijoo, at the end of the 1720s in the second volume of his *Teatro crítico universal*. Why, Feijoo asked, did so many Spaniards share a belief in witchcraft; and why did so many more, including people of some education, find themselves fascinated by it? The causes, he argued, boiled down to five.

The first was the human tendency to recount and write down *cosas prodigiosas*, "prodigious things," wonders. Educated men shared in this: it brought them readers. The second was the habit of "often ascribing to diabolic intervention occurrences that occur naturally, or are produced by skill." Thus, Feijoo points out,

In the centuries when mathematics was little studied, there was scarcely an outstanding person in this field who was not taken for a magician by the plebs—and sometimes by more than just the ignorant—because of certain admirable things he could bring forth from such sciences. . . . Everything exceptional passes as divine or diabolic. . . . In any country, as soon as a man of some special ability, not glimpsed until then, makes an appearance, he is immediately taken for a witch by the vulgar. The country where this most often happens is our Spain.

The third reason that people found witchcraft *donde no la hay*, where it didn't exist, was "the crackpot vanity of people who want to be taken for magicians without being so." People posed as witches, an activity linked to the desire for respect: "Who would risk giving the smallest offense to a man who is believed to hold power over your life, affairs, and honor?" The fourth reason was simple malevolence: denounce a person as a witch and you can cause him or her endless grief, from social enmity to the fires of the Inquisition. And the fifth and possibly the widest cause was delusion—the person's belief that he or she really is a witch.

Sometimes it happens with subjects in whom a lively imagination is combined with a timid heart; when they get frightened and think about some serious crime—especially when the public gets perturbed by it, and justice pays it close attention—it strangely distorts the mind, opening it to fantasies and chimerical images. The horror of the crime and the severity of the punishment throw the animal spirits into such disarray that, from fear of committing the act, imagination takes it as having been committed. . . . One sees a clear example of this in ultra-scrupulous people who sometimes believe they have committed the very sins that horrify them most: cursing, blasphemy, heresy.

Feijoo, of course, was writing about the process of self-incrimination through imagined guilt that drove suggestible Spaniards to destroy themselves under Inquisitorial pressure, just as, two centuries later, it would seal the fate of many victims of Stalin's show trials. This somewhat veiled reference was about as close to an outright denunciation of the Holy Office's witch trials as Feijoo, an ordained priest, could go.

In a disguised way, Goya in the *Caprichos* drew a parallel between witchcraft and the activities of the clergy. He stressed the resemblance between witches and friars in their obedience to the hierarchy of their calling, the younger deferring to the older. In plate 47, *Obsequió al maestro* ("Homage to the master"), an apparently senior witch looks down with stony disdain at another, who is offering her (or him) the gift of a dead baby; the supplicant's gesture reminds one of a groveling postulant kissing the cardinal's ring. "*Es muy justo*," runs the Prado text: "This is quite fair, they would be ungrateful disciples who failed to visit their professor, to whom they owe everything they know about their diabolical faculties." Plate 46, *Corrección* ("Correccion"), shows a group of *brujos*, male

Left: Goya, *Los caprichos*, plate 60, *Ensayos* ("Trials"), 1796–97. Etching and aquatint, 20.5 x 16.5 cm.

Right: Goya, *Los caprichos*, plate 68, *¡Linda maestra!* ("Cute teacher!"), 1796–97. Etching and aquatint, 21 x 15 cm.

Left: Goya, *Los caprichos*, plate 65, ¿Dónde va mama? ("Where is Mama going?), 1796–97. Etching and aquatint, 21 x 17 cm.

Right: Goya, Los caprichos, plate 69, Sopla ("It's blowing"), 1796–97. Etching and aquatint, 21 x 15 cm.

witches, as seminarians, consulting "the great witch who runs the Barahona seminary"—whatever that institution may have been. Of course, Goya could not be too explicit about this: on the other side of any public criticism of clerical practices lay the ever-watchful eye of the Inquisition, which Goya had to be at pains to evade.

Other scenes of witch education are more intimate, one-on-one: in plate 60, *Ensayos* ("Trials"), a young and fairly voluptuous witch is teaching an older and scrawnier novice to levitate, under the brooding eye of the mighty he-goat Satan and close to a particularly villainous-looking familiar in the shape of a cat. Plate 68, *¡Linda maestra!* ("Cute teacher!"), shows an old witch teaching a young, pretty one to fly on that classically folkloric piece of witch transportation, a broomstick. Both it and the accompanying commentary are, of course, rife with sexual suggestion. The broomstick is a penis, *escobar* (to sweep) means in slang "to fuck," and so on.

That Goya (sometimes, at least) finds *brujería* ridiculous is suggested by Capricho 65, ¿Dónde va mama? ("Where is Mama going?"). A hugely dropsical

naked witch is borne teeteringly along by an awkward knot of other diabolical presences, the one at the bottom having an owl's face as his cache-sexe. At the top of the group, a desperately unbalanced tabby cat clutches a parasol. But if such images are grossly farcical and meant to be, it is hard to get a laugh from Capricho 45, Mucho hay que chupar ("There is a lot to suck"), with its two revolting crones sharing drugs out of a snuffbox while in front of them lies a big basket packed with the little corpses of babies. The most disgusting of the Caprichos also relates to the theme of diabolic child abuse and cannibalism: plate 69, Sopla ("It's blowing"). What is "blowing" is the anus of a small boy. A tall, wiry old *brujo* has him by the legs, as though working a bellows, and a copious blast of foul air flies from the boy's bottom to a brazier, which sets fire to it. Lighting one's own farts is an ancient and dirty trope, but Goya gives it the sinister meaning of sexual subjection. This pederastic imagery is carried through in a group just behind the brujo, where another celebrant at this unholy orgy is sucking on the hairless willy of a young boy. "Young boys are the object of a thousand obscenities on the part of old, dissipated men," declares the Ayala text.

IT IS INEVITABLE that, across so large a run of images, certain permanent traits of Goya's style would move into the foreground to be displayed as in a klieg light. Perhaps the most interesting of these—apart from the wonderful observation and recording of human types, which alone would make him the greatest master of "character" of his time—is his relation to Neoclassicism. We do not habitually think of Goya as a Neoclassical artist: his work is too disturbing and disturbed for that, or so we are inclined to imagine. But in truth, the signs of what he shared with men like Piranesi, Jacques-Louis David, the architect John Soane, and even that singular didactic fantasist Étienne-Louis Boullée are written all over the Caprichos. The most obvious of these are the compositional structures he uses, which tend to be very explicit and readily reduced to geometrical formulas—though the way he deploys them is rarely, if, ever, formulaic. He loves the diagonal and constantly uses it as the basis of his groups and figures. He often takes an image hallowed by use in classical art and gives it a severe equilibrium of forms that goes against, and sharpens, its peculiar and almost blasphemous twist in translation—a vivid example being his scene of the abduction of a helpless woman by two faceless villains, one of them possibly a hooded monk, in Capricho 8, ¡Qué se la llevaron! ("They carried her off!"). This figure group is nothing other than the classic *pietà militare*, the dead or

Goya, *Los caprichos*, plate 8, *¡Qué se la llevaron!* ("They carried her off!"), 1796–97. Etching and aquatint, 22 x 15 cm.

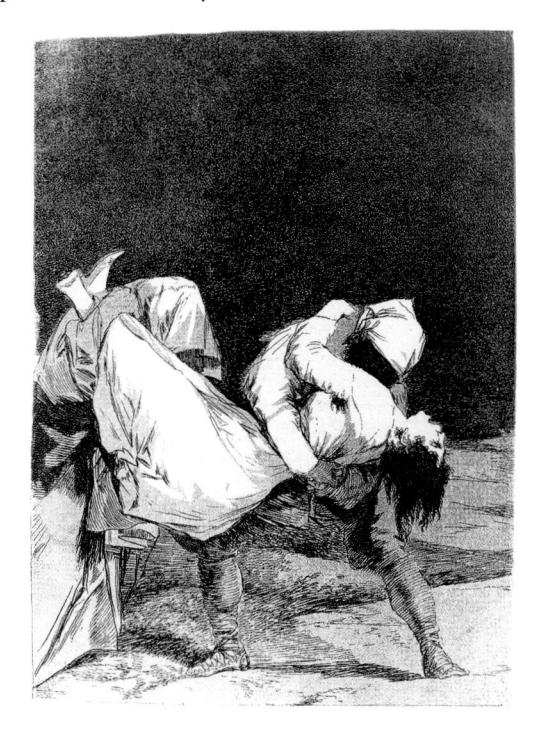

wounded warrior being carried by his companions from the field of battle, which was later adopted by Christian art as an image of the dead Christ being taken down from the cross and carried to burial. Goya enjoyed the contrast between the abstract severity of some compositions and their intense human emotions. Capricho 9, *Tántalo* (page 192), is a case in point, with its pure right-angle meeting of the axis of the girl's body and the diagonal slope of the pyramid's side: an abstract and classical quotation (from the angle of its side, the pyramid is that of Cestus, engraved by Piranesi, whose original Goya would have seen in Rome) that consorts strangely with the utter misery on the face of the lamenting man.

The *Caprichos*, in sum, covered or at least alluded to a great range of topics, and their production was a huge effort. One need only consider the numbers involved. In those days impressions from etched plates were not numbered and individually signed, as (in the interest of quality control and the maintenance of rarity) they are today. But Goya printed about three hundred sets of the *Caprichos*, which meant making some twenty-four thousand impressions, not counting the imperfect pulls that had to be thrown out and the various trial proofs made on the way to a satisfactory biting, polishing, and inking of each plate. It was a taxing labor, even for a man with a full staff of assistants, and the results

were disheartening. The publication of the *Caprichos* was announced on February 6, 1799, in an advertisement placed in the *Diario de Madrid*—Goya was unable to find regular bookshops to handle their sale. The price was one ounce of gold per set, or 320 reales—4 reales per print. And even at that low price, only twenty-seven sets were sold over the next four years. Four went to his loyal friends and clients the Osunas.

In business terms, this was a fiasco. There is no clear reason why it should have been. It has been suggested that the anti-clerical tone of some of the *Caprichos* incurred the wrath of the Inquisition, which in turn interfered with their sale; but there is no record of anything of the sort having happened. At least the *Caprichos* reached the market and the public, however feebly, while Goya was still alive. This did not happen with his other great graphic series, the *Desastres de la guerra*, whose plates were not printed until 1863, two generations after Goya's death. If the *Caprichos* were a failure, the *Desastres* were not even that. And yet from them, eventually, came a triumph of which Goya was never to be aware.

While he was laboring on the Caprichos, however, Goya found time for a spectacular public project, one in which he was at last able to combine the spontaneity and brilliance of touch he had achieved in his painting with the expressive distortion and vast cast of characters that make up the dramatis personae of his etchings and earlier tapestry designs into one mighty virtuoso effort: the frescoes of the miracle of St. Anthony of Padua in the church of San Antonio de la Florida, on what were then the outskirts of Madrid. The San Antonio frescoes were Goya's climactic feat of publicly accessible painting (since his work for the court had a very restricted public, and the *Pinturas negras* that would presently adorn his own house outside Madrid were not public at all but hermetically private, done for an audience of one, Goya himself). They are by far the most important frescoes Goya ever did, though one might feel less categorically certain about that if the Aula Dei murals, done some twenty-five years earlier, had survived without water damage and repainting so extensive that it amounted to replacement. In reality, though, it's hard to imagine that the Aula Dei, even when pristine, could have rivaled his work at San Antonio de la Florida.

San Antonio stands where one of the city gates once was (they no longer exist). In Goya's time the church was surrounded by woods and meadows at the edge of the royal park known as the Campo del Moro; today it abuts, more or less, Madrid's largest railroad station. Quite small, and built in the form of a Greek cross with a cupola over the central intersection of its arms, it was sited

on the bank of the Manzanares for the convenience of the customs officials who collected taxes and excise on incoming goods. These banes of the honest smuggler's life needed a local chapel, and San Antonio, begun in 1792 during the reign of Carlos IV, served this purpose. Its architect, Filippo or Felipe Fontana—one of dozens of Italians imported by the Bourbons to work in Madrid—described himself as "architect, painter, and stage designer": a jack-of-all-trades. (Little is known about him, but he was certainly no relative of either the great Carlo Fontana, author of Rome's San Marcello in Corso, or the less eminent Domenico Fontana, mainly known for his legendary success in setting up the Vatican obelisk in the piazza in front of St. Peter's in 1583.) Construction on San Antonio started in 1792 and finished, complete with Goya's frescoes, in July 1799.

San Antonio was known as a pilgrimage church, a sister to the church of San Isidro, where the *romerías*, or pilgrimages, were held. It is not at all certain why the church should have been dedicated to a non-Spanish saint like Anthony of Padua, except that since his canonization in the thirteenth century his cult had spread far and wide outside its Italian origins. Nor do we know how Goya came by the commission. It may have been at the prompting of his friend Jovellanos, during the fairly brief period in the late 1790s when the latter was minister of justice, before he resigned or was dismissed from office under pressure of the Inquisition in August 1798. The archives of the Royal Palace contain only one document that bears directly on the paintings of San Antonio de la Florida, and the original is lost; it survives only as a copy.⁶ It is an invoice from a druggist and colorman for pigments supplied to Goya for the project: light and dark ocher, red earth, black earth, "flower of indigo," green clay, "superfine London carmine," and so on, together with sponges, pots, and badger-hair brushes, totaling some 8,000 reales. In addition there is an intriguing item: 6,240 reales for the hire of a carriage to take Gova from his home to the church and back again at 52 reales a day, "every day from August 1 to the completion of the work." Since it is unlikely that Goya would have spent every day at the site for four months, he was almost certainly doing what artists and writers always do when they are given a travel allowance: padding it.

Certainly the commission came at a welcome time: Goya had been in serious financial doldrums since the dreadful illness with its attendant deafness brought him down in 1792, and he needed a big project to restore him to the public eye. Nevertheless, it cannot have been easy to take the task on. Goya's vertigo had been so extreme in the early phases of his illness—he could scarcely walk upstairs and keep his balance when he was convalescing in Sebastián Martínez's

Goya, *Asensio Juliá*, 1798. Oil on canvas, 56 x 42 cm. Museo Thyssen-Bornemisza, Madrid.

house in Andalucía—that he must have had many doubts and second thoughts about working on the scaffolding of a cupola thirty-three feet above the floor and almost twenty across. It would not have been as vertiginous as working on the coreto of El Pilar back in Zaragoza, but it must have been intimidating all the same. Did he have assistants? Apparently not; at least none are recorded though one would suppose that he had workmen to apply the *intonaco*, the plaster coating on whose still-moist surface he would do the fresco painting. (Most of the pigment is classical buon fresco, although there are many passages, especially in the highlights, that Goya altered and retouched a secco, with fresh pigment, once the undercoat was dry.) There does exist from this time an undated portrait of his friend and sometime assistant, the Valencian artist Asensio Juliá, inscribed "Goya a su amigo Asensio," in which this thoughtful-looking young man (who, because his father was a fisherman, bore the nickname El Pescadoret) is standing in what looks like a long dust coat in front of scaffolding that could very well be part of the setup for working inside San Antonio. Juliá is known to have copied Goya's works several times, but could he have imitated his idiosyncratic and personal gestures of drawing well enough to have convincingly done any of

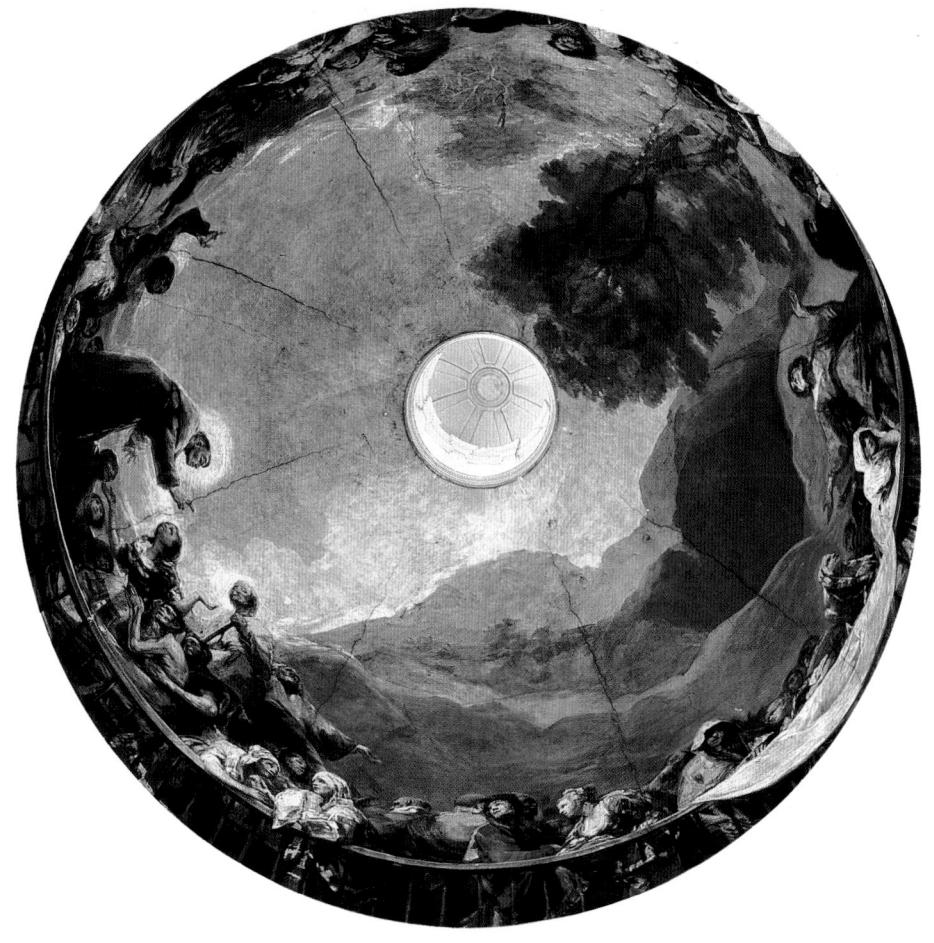

Goya, *Milagro de San Antonio de Padua (The Miracle of St. Anthony of Padua)*, 1798. Fresco. Dome, Iglesia de San Antonio de la Florida, Madrid.

the figures and faces on the scale of the cupola? It seems unlikely, but in any case is unprovable.

Whether Goya had help or not, none of the strain of working high in the dome shows in the completed work—only a radiant and diaphanous joie de vivre. The frescoes of San Antonio, with their butterfly-winged and deliciously sexy angels, are young man's art, created, in defiance of oncoming age, by a man past fifty.

The main scene of the narrative occupies the dome. It illustrates a legendary episode in the life of St. Anthony that appeared in *Christian Year*, a devotional narrative of the more fabulous moments in the lives of the saints that was compiled by a French priest and rendered into Spanish by Fr. José Isla. While in Padua, St. Anthony received news that his father, a Portuguese named Don Martín Bulloes, had been accused of murdering a man in Lisbon. With the per-

mission of his religious superiors, Anthony flew (miraculously; he was "transported" in a flash) to Lisbon and asked the judges in the murder trial to produce the victim's corpse. The saint then solemnly asked the dead man to state, before judges, witnesses, and his accused father, whether his father had killed the man. The corpse rose and spoke: no, he had not. It then sank back onto its coffin, amid general consternation and awe. Don Martín Bulloes was, naturally, acquitted.

The raising of the dead man is, of course, the core of the story on Goya's cupola. But he did it in a way that, though it had origins in Italian art, had no precedents in Spain. It is still an open question whether Gova, on his visit to Italy, would have seen any of the cupola frescoes where painted spectators crowd a circular balustrade above the viewer's head. And if he did, as is probable, we do not know which ones. No matter: Goya's version of this device is entirely his own, both in narrative intensity and in down-homeness. To begin with, he took the usual Baroque layout—heaven and angels above, Earth and people below—and stood it on its head. Here, the cupola is the zone of Earth and people, and the angels in the pendentives and the intrados of the arches are holding it all up. He has not used a formal marble balustrade; what prevents the figures, some fifty of them, from toppling into our space below is a simple ring railing of wood, the posts perhaps of iron. Behind them are blue mountains, a tree or two, and the sky-we are outdoors, in a generic landscape, not a Portuguese courtroom. Goya has gone head-on against the Baroque esthetic, with its foam and flutter of angels, saints, putti, and other heavenly fauna in a celestial, indeterminate space. It seems that before getting to work on San Antonio de la Florida, Goya made a tour of Madrid churches with his friend Leandro Moratín, who briefly noted it in his journal: "With Gova at San Plácido, Looked at the paintings."⁷ Presumably Goya wanted to bring himself up to date on what had and had not been done in terms of church ceiling painting by predecessors and rivals. Seeing their work must have confirmed his decision to steer clear of Baroque effects and go for the direct, realist look that was the hallmark of his style, especially after the *Caprichos*. Every one of these cupola figures could have been seen, and probably often was, on a Madrid street. They are real and direct; there is an architectural solidity in the folds and planes of their clothing that more than makes up for the complete absence of any depicted architecture. Some are physically attractive, others harshly caricatural, but none have the sweetness or elegance of comparable figures by, say, Tiepolo, and none represent anything beyond themselves, although they do display such a range of expression, reaction, gesture, and pose. Although they all look anchored to

the plane above, they form a major and a minor climax, one diametrically opposite to the other across the dome.

On the north side, the major climax is, naturally, the miraculous raising of the dead witness by St. Anthony, who is standing on a rock so that his whole brownrobed body is visible from tonsured head to bare feet. With a gentle but imperious gesture, he summons up the corpse, stiff and gray-brown on its rude bier, its hands clasped in an angular gesture of prayer. A man props the awakened body into a sitting position. A woman flings out her arms in a gesture of amazement and supplication. Behind her, an old and seemingly blind man in a yellow tunic, supporting himself on a stick in his left hand, holds on to her shoulder with his right, as one might touch one's daughter—and is she, perhaps, St. Anthony's sister? For the old man is St. Anthony's father, the accused, now vindicated. On the south side of the dome, directly across from this group, one sees a nameless ecstatic spreading his arms triumphantly to blurt out news of the miracle to those who have not noticed it.

From revelation to announcement, all around the circumference of the dome are dozens of other figures, an unbroken chain, each human link different in expression and action to the next, holding in common Goya's consummate painterly shorthand and the subtle exaggeration of pose and grimace that makes each character "carry" across the distance from the dome to our eyes. Some appear quite unconcerned with the miracle—the children are ignoring it, intent on squirming and clambering around on the railing. Others are leaning over the railing, absorbed in looking at us on the church floor as we look up at them, like watchers on a street balcony. In the northeast quadrant, behind St. Anthony, a furtive figure in a yellow jacket and a dark hat pulled well down turns to scuttle away: this can only be the real murderer. All Madrid, you would think, is there, except for the majas and petimetres, whose visible presence is somewhat toned down, since it would have seemed too flashy or even indecent for a church. Their cloaks, shawls, and skirts are rendered in deep, sober colors—gray-mauves, browns, indigo blues—with occasional flashes of white, pink, pale jade-green, and hot orange. Goya's color is uniquely his own. It doesn't have the champagne liveliness of Tiepolo's; indeed, it relies greatly on contrast with the sky of the cupola, which is as gray as lead.

This is a vernacular scene. You might almost be looking at a crowd in the bleachers of a bullring. And what gives it such unique vitality is the character of Goya's gestural drawing. It is wonderfully tough and succinct. He wasted no time on grace notes that would not, in any case, have been visible from thirty feet below. A slash of black paint with a blob on the end defines an eyelid and a

Goya, Milagro de San Antonio de Padua (The Miracle of St. Anthony of Padua) (detail). Fresco. Dome, Iglesia de San Antonio de la Florida, Madrid.

pupil; another slash, the shadow under a cheekbone or a mouth. Fabrics are as summarily and vividly rendered as a black suit or blue pelisse by Manet. The closer you look, the more modern the frescoes get. Once again one sees why Goya's accumulated meaning for painters could only increase as the nineteenth century moved toward the twentieth. He was trying, as he once said to his son, Javier, of his general ambitions as a painter, to capture "the magic of the ambience."

Nowhere is this magic more apparent, or more seductive, than in the figures of angels that occupy the lower zone of the church. Angels are traditionally sexless or, at most, display a sort of epicene, la-di-da masculinity that, when the angel in question is meant to be a warrior like Gabriel or Michael, looks fatuous. Not Goya's; every last one of them is beyond doubt female. Indeed, they have the kind of flat-out femininity that one associates with Delacroix slave girls and Renoir popsies, except that the average Renoir is too sluglike to bear much comparison with Goya's angels. What they really seem to be is young actresses in angelic drag. They float and flutter their rainbow wings like butterflies. They are, so to speak, generic but top-of-the-line angels; Goya was not interested in differentiating the theological niceties of angelic status, the archangels, thrones, dominations, cherubs, princes, powers, and so forth that figure in Creations and Last Judgments by other and earlier artists. Most of them are rubias, blondes, with rose-ivory skin and charming, if modestly clad, limbs. They draw back heavy curtains to frame and display the miracle happening in the dome. The curtains are shot silk, embroidered with traces of gold. The angels'

The Caprichos · 215

clothes—"vestments" is, if anything, too sacerdotal for these airborne babes—are ample and blow in the air: pink, green, gold, canary, white. The fabrics are beyond identification, but they seem both crisp and silky. Could there be any other work of art whose painter so visibly enjoyed painting its angels? Not in Spain, certainly.

Nothing is known about the reception that met the San Antonio frescoes when the church opened to the public in 1799. Later accounts tend toward a purse-mouthed reservation: the frescoes are, if not exactly pagan, then certainly more secular in spirit than they ought to be for a church. A critic named Pedro de Madrazo complained in 1880 that "the miracle performed by the saint is treated as lightheartedly as if it were the performance of a troupe of strolling acrobats, while the androgynous angels have flashing eyes and camellia-hued skin that would better become the beauty of a harlot than that of a celestial being." A fine example of how Goya's more prurient critics could manage to get the point and completely miss it, both at once.

THE FALL OF THE BOURBONS

HE Caprichos were meant to be popular art. That they did not succeed as such, that they did not find the wide public Goya hoped to reach, hardly matters now. And there is plenty of other evidence of Goya's growing desire, in the late 1790s, to use popular, sensational subjects in his painting. You could hardly call him a pop artist before his time, but it's certainly true that, just as he adapted the sensibility of the sainetes to his early tapestry cartoons, so he used events with plenty of journalistic "grip" in his later work: murders, kidnappings, rapes, intrigues, adulteries, deceptions, cannibalism he even painted a sort of narrative comic strip about the doings of a notorious robber named Pedro Pinero, alias El Maragato, and his capture and defeat at the hands of an intrepid friar named Pedro de Zaldivia. Nobody could say Goya was "above" the pleasures of a hot tabloid news story. HEADLESS BODY IN TOP-LESS BAR was the kind of headline he would have appreciated. What may have seemed vulgar in his time (although there is no record of any connoisseur's protesting this as a sin against the Holy Ghost of taste, some may privately have thought so) now looks prophetic.

Some of these small drawings and paintings from the late 1790s were closely connected to the *Caprichos*, on which he was working at the time. Most were collected by the same person, a Mallorcan businessman named Don Juan de Salas, and passed to his son-in-law, the third marquis de la Romana, to whose descendants they still belong. Of the original eleven paintings, three are lost; their subject matter is unknown. The eight survivors are mostly about one kind

of horror or another—a *guignol* of the social underside of Carlos IV's Spain, but without political content.

One of the first of them concerned a wife who had conspired with her younger lover to murder her wealthy husband, and was tried, imprisoned, and finally executed for it—always a good yarn. The victim was a rich Madrid businessman, Francisco de Castillo; the peccant wife, thirty-two-year-old María Vicenta Mendieta; the lover, her twenty-four-year-old cousin Santiago San Juan. The first image Goya extracted from this fatal triangle was Capricho 32, *Por que fue sensible* ("Because she was impressionable") (page 198), the despairing woman in prison, who is identified in early commentaries on the *Caprichos* as "the wife of Castillo." Then Goya seems to have turned to the official (and unofficial) reports of the evidence given at the trial. (He probably did not attend, but he hardly needed to: his friend Jovellanos was justice minister at the time, and another *ilustrado* friend, Juan Meléndez Valdés, was crown prosecutor, so Goya could have had easy access to the court papers.)

San Juan, María's lover and the murderer, gained admission to the house at about 7:15 on the evening of December 9, coming in from the dark street cloaked and masked. The victim had gone to bed early, suffering from a painful gumboil, and his wife had given him an opiate, probably laudanum, to make him sleepy. San Juan then swiftly entered the bedroom and gave Castillo eleven stab wounds in the chest and stomach, five of them mortal. In Goya's painting of the murder, *The Friar's Visit* (c. 1808–12) we see, in the background, the dim form of a man lying in bed, and the small glow of a fire. In the foreground is the ominous figure of a friar in his brown habit, standing just inside the street doorway with another friar just behind him, below the steps. The standing friar is the disguised lover, and María Mendieta sits on a chair before him, gazing up at his (to us) invisible face with an expression of submissive rapture, gesturing toward her prostrate husband in the room beyond. The stillness of this faceless friar is utterly menacing; one is reminded, once more, of Gova's love of popular theater, its tableaux and climactic moments. Gova was so pleased with the effect that he transposed it into another of his *Caprichos*, plate 3, Que viene el coco ("Here comes the bogeyman"): a mother gazing up with the same adoration at the hooded figure of her secret lover, whose portentous appearance in the room has scared the wits out of her child.

During the same period, from 1796 to 1800, Goya also did a number of paintings and prints that revisit an old interest of his: lawlessness and banditry. These were not fancies, but real and pressing worries for anyone who traveled the roads of Spain. Perhaps Goya's depictions were inspired by some particu-

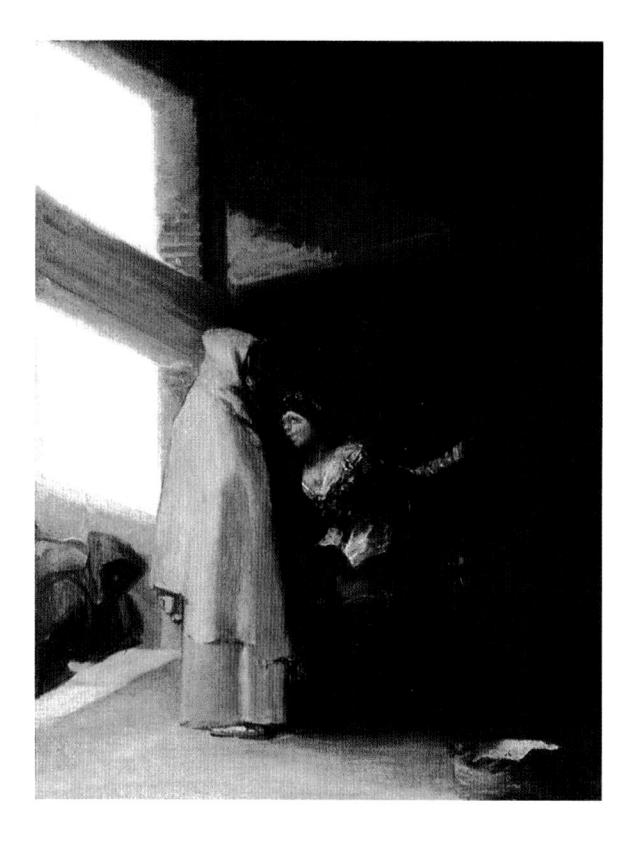

Goya, *La visita del fraile o El crimen de Castillo I (The Friar's Visit or The Castillo Affair I)*, 1808–12. Oil on canvas, 41.1 x 31.8 cm. Colección Marqueses de la Romana, Madrid.

larly brutal incidents of highway violence, but there were so many of them that it is anyone's guess whether his scenes were meant as reports or whether they are, so to speak, generic reflections on the awful fate that travelers risked. One thing is quite certain: though the common people of Spain were sometimes known to make folk heroes of their highwaymen and footpads, they were nowhere near as inclined to do so as the English, with their cults of Ben Turpin and other "likely lads" who paid for their robberies by "riding the three-legged mare" or the "horse foaled by an acorn" (the gallows) at Tyburn. Sometimes Goya depicted his footpads, smugglers, and highway bandits with a grudging or ironic realism, but he never lost sight of how bad and dangerous they were apt to be. Examples of this among his drawings include some from the Madrid Album (1796–97). A trio of rough-looking *contrabandistas* (tobacco smugglers) sit around a low fire under a tree, rolling their cigarettes and cutting their quids, their pistols and carbine ready to hand. "Good folk, we're the moralists here," runs the caption in Goya's hand, a rebuke to facile disapproval of their trade. A nasty customer in black hat and leather leggings and holding a short blunderbuss stares from the page, poised like a dancer, ready to swivel his aim in a quarter of a second. "The lawyer," Goya wrote above him, and added, "This one doesn't let anybody off, but he's not as harmful as a bad doctor." These drawGoya, Madrid Album, 89, *El abogado: Éste a nadie perdona, pero no es tan dañino como un médico malo* ("The lawyer: This one doesn't let anybody off, but he's not as harmful as a bad doctor"), 1796–97. Brush and India ink. Private collection.

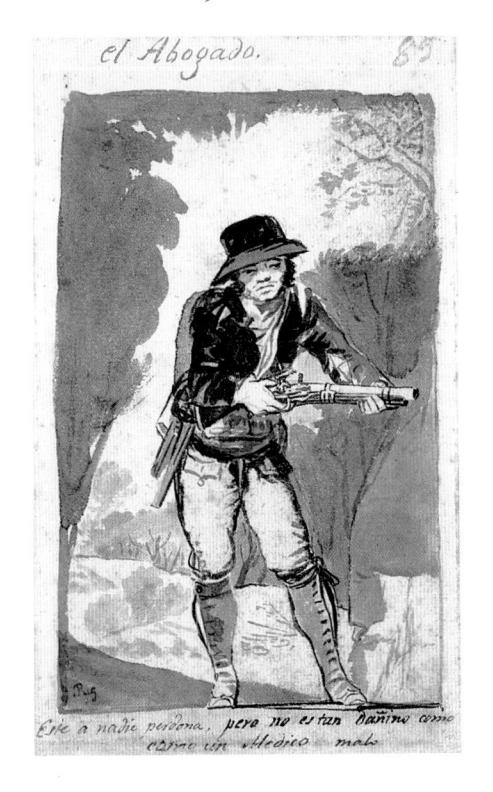

ings can be taken as (relatively) lighthearted observations. Not so the paintings of bandits at work, which are chilling in their remorseless cruelty. They open with a dark, indistinctly menacing scene: in a remote mountain landscape, a coach has been bailed up and emptied of its passengers; one of them, blindfolded, waits with bowed head for one of his captors to blow his brains out; a woman with upthrown arms begs in vain for mercy. This is bad enough, but the next two are unbearable, probably as cold and awful in their depiction of conscienceless violence as high art has ever been.

The first of these shows the bandits at the mouth of a cave or below an overhanging ledge of rock, to which they have taken their prisoners. The men have been separated from the women. One woman, raising her hands in the immemorial gesture of entreaty, is begging for their lives. No use: with firearms leveled, the bandits are about to cut the men down, and one of them, blindfolded, bows his head in resignation.

The action of the second painting has moved inside the cave mouth. One of the bandits is stripping a woman of her clothes: she is down to her white shift and will be quite naked in a moment. In the background, another bandit pauses

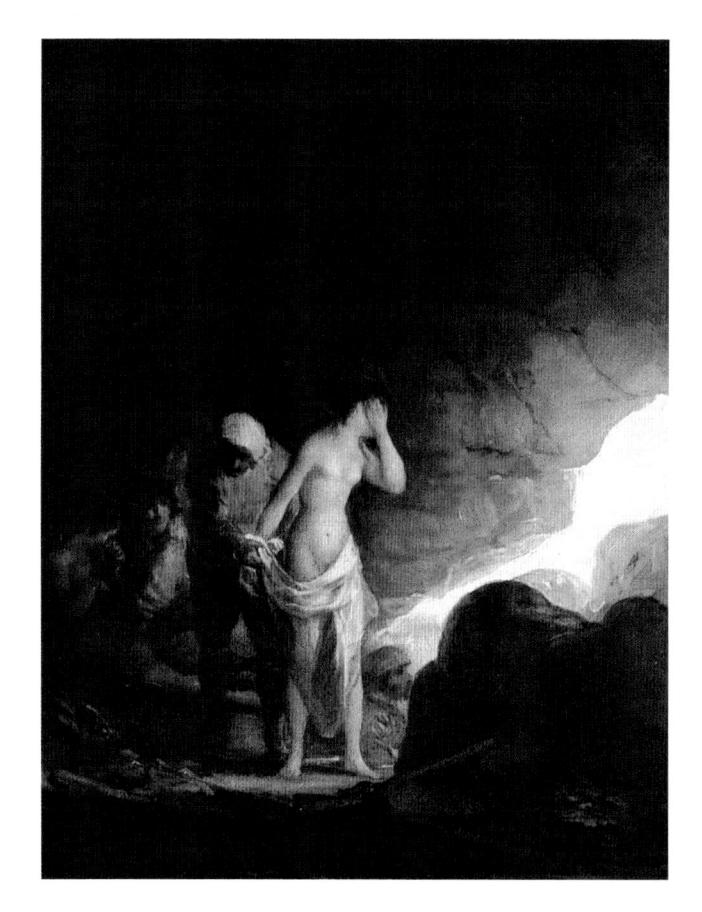

Goya, Bandido desnudando a una mujer o Asalto de bandidos II (Bandit Stripping a Woman or The Bandits Attack II), 1808–12. Oil on canvas, 41.5 x 31.8 cm. Colección Marqueses de la Romana, Madrid.

in his molestation of a second woman (her hands are clasped, but it is not clear whether she is begging for mercy or they are simply tied) to look back at his accomplice.

Why is this image so disturbing? Not merely because it depicts the prelude to rape. European artists had been doing that for centuries. It was a "normal" subject. Quite often the artist would depict the victim as gazing at you, the viewer, with an expression of distress, an appeal for help, enabling you to feel morally elevated above the violent deed, not complicit with the rapist. But here the relation between victim and viewer is different—shockingly so. The slim, beautiful, helpless woman hides her face: she is all body, reduced to anonymity, a purely sexual object. And from whom is her face hidden? You. Whose gaze does she fear? Yours. She does not want you to see. She is stricken by shame at your gaze. The bandit unveils her, as a slave merchant bares his goods, for your eyes. It is a terrible accusation of the viewer's complicity, achieved by the simplest imaginable means. "No se puede mirar," Goya would inscribe beneath one of the group murders (also in a cave) in the Disasters of War. "One cannot look."

But one must look. What is a picture for, if not to be looked at?

Goya, Bandido apuñalando a una mujer o Asalto de bandidos III (Bandit Stabbing a Woman or The Bandits Attack III), 1808–12. Oil on canvas, 41.5 x 31.8 cm. Colección Marqueses de la Romana, Madrid.

What Goya paints here is connected to one of the favorite themes of his history painting: bare, lovely Truth being unveiled by Time. (It's hardly an accident that the bandit stripping the woman looks old and weathered, like a villainous version of Father Time himself, though without the usual beard: *Tempus Edax*, Time the Despoiler.) But here the act reveals no truth beyond the miserable omnipresence of brutality in this fallen world. The act of looking is also an indictment of the viewer, an act of self-shaming: rape by association. Here, sex and impending death are most intimately linked. One is reminded that the English word "autopsy," meaning the analytical study of a newly dead cadaver, comes from the Greek root meaning "the act of seeing with one's own eyes." One also remembers how essentially Sadeian the picture is. Only the sadist finds eroticism in the powerlessness of his victim. To others, what is truly erotic is not the imposition of one person's power on another, but its very opposite: the ecstatic agreement between two people in mutual desire.

In the third picture, the dreadful possibility becomes actual. The woman has been raped and is dying. Her murderer has dragged her to the cave mouth, her track indicated by a bright streak of her crimson blood on the ground. Feebly,

Goya, Caníbales contemplando restos humanos (Cannibals Beholding Human Remains), 1800–08. Oil on wood, 32.7 x 47.2 cm. Musée des Beaux-Arts et de Archéologie, Besançon.

she raises one leg in a last effort of resistance. It is useless. The bandit has her pinned down, her left arm twisted under her back. Straddling her as if to fuck her once more, he raises his dagger, about to drive it down into her soft and helpless flesh; there could be no more brutal and explicit parallel drawn between blade and penis, especially since her poor, violated O of a mouth could be agape in a scream or open to suck.

Around 1808, Goya produced a still more hair-raising vision of appetite and crime: a pair of small paintings on wood panels depicting cannibals and their victims. It is to his credit as a painter that these utterly repulsive visions of excess do not—not quite—topple under their own weight into a sort of grim, unconscious humor, as the marquis de Sade's recitations of buggery and anthropophagy in the domain of the mad ogre Minsky tend to do.

In the first painting the cannibals are preparing their victims to be cooked. On the left, a body has been stripped and gutted and one of the cannibals is rummaging in its stomach cavity. (The skin of the cannibals is darker than that of their victims, but not dark enough to identify them as Indians, still less as Africans.) Next to this scene, enacted at the mouth of a cave, another victim

dangles from a rope while another cannibal is briskly engaged in peeling his skin off. It's worth noting that even in the act of depicting these gruesome doings Goya has stayed with one of his typical compositions, whose formality slightly cools the horror: the figures form a right-angled triangle, static in the gloom.

The second painting, Cannibals Beholding Human Remains, is more Dionysiac: a campfire scene in the (indeterminate) wild. The main figure looks frenetic, straddled in triumph across a rock—his pose is the same as that of the warlock in Capricho 65, ¿Dónde va mama? ("Where is Mama going?") (page 205), whose legs are braced to support a ridiculous assembly of brujas and familiars. In his right hand he waves a severed hand, in his left a head.

Nobody had painted such scenes before, or not with the same peculiarly secular feeling. They have no more religious import than feeding time at the zoo. The only parallels in earlier art to these cannibals' atrocities were, in classical sculpture, the flaying of the satyr Marsyas by the offended Apollo, who was bested by him in a music competition, and in Christian art, the martyrdom of St. Bartholomew, who was skinned alive rather than abjure his faith in the Christian god. Each has its pertinence to religious myth, but Goya's paintings have none at all. Moreover, they seem to have no documentary purpose, no reference to any known historical event. The idea that they depict the martyrdom of the Canadian Jesuits Jean de Brébeuf and Gabriel Lalemant by the Iroquois in 1649 is only a guess and has nothing to support it. Why should Goya have been interested in the sufferings, almost a century before he was born, of some French evangelists in Canada, a remote country that he had never been to and that was not a Spanish colony? More probably his cannibal pictures derive, though somewhat remotely and with much greater narrative intensity, from prints he may well have seen: the ferocious visual denunciations of American cannibalism done by Theodor de Bry as illustrations to the compilation of sixteenth- and seventeenth-century explorer narratives that still, a hundred years later, played a role in forming European impressions of the New World. Because de Bry's images of the appalling cruelty of Caribbeans and conquistadors were so unflattering to the Spanish, these texts were not popular in Spain—they were, in fact, one of the pillars of the leyenda negra of Hispanic atrocity in the New World, which was no legend—but this does not reduce the likelihood that Goya would have known them.

The victims in Goya's two paintings are certainly European, as is evinced by the clothes lying on the cave floor of *Cannibals Preparing Their Victims*, c. 1800–8—a buckled pump, a flat black hat—but there is nothing to connect

such garments to Jesuit costume, especially since the Jesuits did not wear shiny buckles or other sartorial grace notes. Indeed, it seems rather implausible that any European, missionary or not, would be wearing these delicate items of clothing if he were far enough out in the wild to run into real cannibals.

More likely, these small pictures are ahistorical. They reflect Gova's more general, and indisputably morbid, interest in cannibalism as a metaphor of human extremity—of the brutishness (homo homini lupus, "man is a wolf to man") and terminal cruelty of unchained appetite. This is the Gova who would paint on a wall of the Quinta del Sordo some years later his dreadful vision of Saturn ripping flesh from his own son's body; the same man who included scenes of cannibalism in the Caprichos and their related drawings, and who etched fragments of dismembered bodies impaled on trees in the *Desastres*. The purpose of the bits of European clothing scattered on the ground is to draw the maximum contrast between man in a "state of nature" (the cannibals) and others in a "state of culture" (their victims); these clothes and shoes are the leavings of a savagery that, Gova implies, is indeed the natural state of mankind and has nothing to do with the milky fantasies of intrinsic goodness and liberal gentleness indulged in by the French Enlightenment. These are pessimistic, skeptical little paintings, and it hardly matters whether they were done before or after the outbreak of war against Napoleon: they could not have been done by a man who had not known about the earlier Terror in France. Which was closer to "nature," Robespierre's self-idealized cruelty or the mock-bucolic douceur of Marie-Antoinette as milkmaid? The former, Goya insists; always, inevitably, the former, because savagery is the true state of nature, whereas gentility, mercy, and a sense of justice toward others are, if not false masks or lies, then certainly the product of consideration: which is to say, artifice. In this respect—and this only—Goya is truly a man of the eighteenth century, the same century that saw the grotesquely prophetic emergence of the marquis de Sade. Without Sade, no cultural picture of the eighteenth century is complete. because for all his impotent railing, long-windedness, and absurdly radical boasting, he was, in the end, its arch-critic of "authority." But Goya had never read Sade; no translation of him existed in Spanish, and Gova had little French.

So much of Goya's graphic work was influenced by popular art—storytelling and devotional prints—that it would be hard to say which of his images owed most to it. But certainly his set of six small paintings, c. 1806, of the capture of a fearsome bandit by an intrepid friar would stand high among them.² The bandit in question was Pedro Pinero, nicknamed El Maragato. The Maragatos were a nomadic people of uncertain ethnic origin who tended to congregate—when

they got together at all—near Astorga; they had a nationwide reputation as expert muleteers, and stuck together as closely as Gypsies or Jews. These "sedate, grave, dry, matter-of-fact, businesslike people" were proverbially honest and remarkable for their peculiar costume, with its broad-bottomed britches and huge slouch hats.³ They do not sound at all like El Maragato as depicted by Goya, and why this notorious bandit got their name is a mystery. In the paintings he is dressed like any other footpad. But he was immensely famous in his time—a sensationalist's hero of the Spanish highways, celebrated in folk song and popular prints.

Nothing about his wild career was more renowned than its end, which Goya painted. In 1804 El Maragato had been consigned to hard labor in the arsenal at Cartagena, but after two years' imprisonment he escaped and took to the roads, robbing and plundering. In June 1806 he appeared, heavily armed, at a house near Toledo and held up its (mostly male) occupants, locking them all together in a downstairs room. At which point, enter a friar named Pedro de Zaldivia with two saddlebags over his shoulder, knocking on the outer door and begging for alms for his convent. El Maragato, having ascertained that the priest was alone, hustled him at gunpoint into the room where the other captives were held. Soon afterward, the bandit decided to take the shoes from one of his prisoners to replace his own worn-out ones. This gave the priest his chance. He drew a pair of his own shoes from a saddlebag and offered them to El Maragato. But when the bandit, still holding his musket on Fray Pedro, reached for the shoes, the intrepid priest grabbed the muzzle and swung it away. In the scuffle Fray Pedro was able to twist and wrench the weapon from El Maragato's grasp; and when the bandit shoved past the priest to grab another of his guns from the saddletree of his horse, the priest unhesitatingly clubbed him with the gun butt, then shot him in the backside with a full charge of buck and smaller pellets. Fray Pedro then grabbed some rope that was lying handy and trussed El Maragato's arms behind his back, taking him prisoner. According to the popular account of this deed, Maragato-understandably stupefied by this display of unpriestly aggression—blurted out, "Ah, father! Who would have thought when I threatened you with the gun to make you enter the house, and you went in with your head and eyes down, that you would betray me like this?" To which the priest replied, "Alas, amigo, though I showed humility on the outside, on the inside I possessed all the anger of God." The bandit was taken in irons to Madrid, tried, hanged, then drawn and quartered. The friar became a legend in his own right. Goya clearly enjoyed himself in painting this legend as a semireligious event, a miracle of priestly valor—a religious comic strip, in fact,

Goya, Fray Pedro dispara contra el Maragato (Friar Pedro Shoots El Maragato), 1806. Oil on wood, 29.2 x 38.5 cm. The Art Institute of Chicago.

cousin to the cheap plain or colored prints of the lives of the saints that were sold for a few pennies under the name of *alleluias*. For such an enthusiastic hunter as Goya, the central motif of Friar Pedro shooting the flabbergasted bandit in the backside at point-blank range must have been quite irresistible—a comic prelude, one might even think, to the tragic grandeur of the executions of the Third of May.

Thus for Goya's "unofficial" work at the bridge between the centuries. What came out of his official duties? Portraiture and more portraiture.

He painted Carlos IV and María Luisa half-length, full-length, and (very much in the tradition of Velázquez) on their respective horses. But by far the greatest work of art made possible by Carlos IV's patronage (since it, and he, had nothing to do with the creation of the *Caprichos*) was Goya's group portrait of the king and his family (1800) (page 228), that still dominates its gallery in the Prado. This was almost the last image of any member of the royal family that he would make; he was never to paint Carlos IV or María Luisa again, although he did two further portraits of their eldest son, the prince of Asturias and future Fernando VII. It is an enormous, intricate, and seductive painting,

one that has been constantly misunderstood ever since Théophile Gautier referred to it as "a portrait of the owner of the corner grocery store and his wife." Today, visitors to the Prado gaze on Goya's version of the queen's aging, fifty-year-old face and the king's pop-eyed, plebeian look—so ordinary, so human—and conventionally marvel at how Gova "got away with it." There is no mystery. Goya "got away" with nothing at all, and did not try to. The idea that he had set out to satirize the patrons he depended on-who, we must implausibly suppose, must have been too dumb to see what he was up to—dies hard, but it is of course the merest nonsense. First of all, satire requires an audience, and Goya's portrait, hanging in the Royal Palace, had no audience but royalty and the court. Second, there isn't the slightest evidence in the painting of any satirical intent—which is only to be expected, since if it had contained any detectable barbs, Goya's career as first painter portraitist would have been finished there and then. And third, Goya, in the summer of 1800 at the royal retreat at Aranjuez, did no fewer than ten preliminary portrait studies for his sitters, all of which would have had to be approved by their subjects before he began work on the big picture. His motives in painting the king and queen were not those that drove his needle while etching the Caprichos. It may even be that Gova made the royal couple look somewhat nobler and more handsome than they did in real life. Only the very naïve would infer hypocrisy from this theory, but it cannot be tested either, since there is no "objective" likeness against which Gova's effigies can be compared.

Gova clearly saw this commission as a chance to invite comparison with Diego Velázquez, to show that he could emulate, or at least confidently approach, the standards set by that long-dead master. The clue to this is the fact that, as in earlier works like his portrait of Floridablanca, he included himself in the painting—an homage to Velázquez's presence in Las meninas, though less prominent. He is in the penumbra of the glittering and regal family, on the left of the painting, working on the big canvas whose stretcher slopes upward to the top lefthand corner. He gazes directly at the viewer, as does Velázquez's selfportrait at the easel in Las meninas. There is, however, an important difference. The group in Las meninas, Velázquez included, is painted as if seen from the eyeline of Felipe IV and his queen, who have just entered the chamber and whose indistinct but recognizable reflection can be seen in a mirror on the background wall. Gova's family group, including the artist himself, is painted as though the figures are looking in a mirror themselves: the mirror, as it were, of the viewer's own eye, facing them. From where he stands in the painting, Goya could have seen only the royal family's backs. Moreover, the sense of discovery

Goya, *The Family of Carlos IV*, 1800. Oil on canvas, 280 x 336 cm. Museo Nacional del Prado, Madrid.

in *Las meninas*—the infanta, the painter, and the dwarves disclosed to the royal pair as they come in—is absent from *The Family of Carlos IV*: these royal personages are obviously and intentionally posing for their likenesses to be made. It is not a slice of life, and its figures were not assembled in this way in the same room at the same time.

There are thirteen of them, apart from Goya. María Luisa stands at the middle of the painting (a slightly unusual fact in itself, given that kings traditionally preferred to occupy the center of royal portraits) with two of her children. She holds the hand of six-year-old Francisco de Paula, and her other arm protectively encircles the shoulders of the eleven-year-old infanta, María Isabel. To the right of her is Carlos IV; his figure is balanced, on the left, by Crown Prince

Fernando, the new prince of Asturias. In his blue suit he looks almost handsome—a very different creature from the slothful, thick-lipped brute whose stumpy figure would appear in Goya's portraits fifteen years later, surrounded by attributes of kingship, after his restoration as El Deseado, "the Desired One." To the right of him is Carlos's sister, looking slightly mad and haunted with her big black blot of an artificial beauty patch; between her and the infanta is an unidentified woman whose face cannot be made out—presumably she is a generic figure who stands in for the bride of the as yet unmarried Fernando. On Carlos's side of the painting, there is a clutter of nearish relatives, among them the king's brother, Antonio Pascual; the queen of Portugal; and the prince of Parma. But the central focus of the huge portrait is, as it ought to be, Carlos IV, his wife, and their heirs. By receding with dun-colored tact into the shadows of the background, Goya has emphasized the energy and glitter of symbolic decoration on the royal party: the crinkled light on the five blue-and-white sashes of the Order of Carlos III, the complicated sparkle of embroidery, stars, and sword hilts, the lavish rhyme between the golden arrows in the coiffures of María Luisa and her daughter María Isabel.

The surface is Goya at his most energetic, a free, spotted, impasted crust of pigment that keeps breaking into light, full of vitality with never a dull touch. Far from being an exercise in satire, this amounts to an excited defense of kingship: not its divinity, to be sure, but what later ages would call its glamour, its ability to bedazzle the commoner and the subject.

Carlos IV was lucky. Did ever so dim a monarch deserve such virtuoso treatment? One can reasonably see him as an esthete, if in some ways a rough-and-ready one. But about people and their motives, he had next to no judgment at all. He was incurably thick-headed about intrigues, whether political or erotic. One of his few comments to have survived occurred during a conversation at court with his father, when the son ventured his theory that men of high lineage, and especially of royal birth, need never worry about being cuckolded by their wives or betrayed by their mistresses: what woman, he asked, could feel the slightest carnal attraction to a man of inferior rank? Silence, then a sigh from the old king. "¡Carlos, Carlos, qué tonto tú eres! Todas, sí todas, son putas!" (Carlos, Carlos, what a dummy you are! They're all whores, every one of them!)

This story has lived on because it was taken quite unjustly for granted that the most flagrant "whore" of all was the highest lady in the land, Carlos IV's own Italian wife, María Luisa of Parma, who married him in 1765, when he was seventeen and she only fourteen. Nobody has ever claimed that María Luisa was a woman of outstanding moral sanctity, but there is no doubt that a tidal

wave of hypocritical accusation and innuendo was dumped on her by her enemies inside and outside the Spanish court, while many historians since have simply echoed her detractors and made her out to be a case of royal nymphomania second only to Messalina. From today's perspective, this seems absurdly overblown. Was María Luisa's sexual behavior any more worthy of censure than that of some recent royals—Prince Philip, for instance, or the former duchess of York, or that saint of kitsch sentiment Princess Di? It hardly seems likely. She did take some lovers over the years (as who, married to that stolid hunter, might not?), but they did not sign in at the palace gate, so their episodic presence in her bed is more a matter of conjecture and gossip than of ascertainable fact. They included the notoriously dissolute count of Teba, the count of Lancaster, the canon of Zaragoza Cathedral, Ramón de Pignatelli, War Minister Antonio Cornel, and a guardsman named Ortiz.

The most notorious of her liaisons, however—the longest-lasting and in the end the most fraught with consequences, both for María Luisa and for Spain as a whole—was with Manuel de Godoy (1767-1851), who, thanks to royal patronage, became the virtual dictator of the realm. Godov joined the Royal Bodyguards in 1784, and before long the queen's eye fell on him. He was tall, slender, and narcissistically handsome. He cut a fine figure on horseback, despite the palace rumor that he had caught the queen's attention by falling off his horse while on parade. He had deep, sleepy, coal-black eyes and was said to be irresistible to women. The duchess d'Abrantès thought him as vulgar as a coachman. Napoleon compared him to a bull, though he relented later, on St. Helena, and paid tribute to Godov's "genius." Lady Holland thought his look "voluptuous," though large and coarse. Her husband, England's ambassador to Madrid, liked him for other reasons and took him quite seriously—as indeed he might. "Godoy's manner," Lord Holland wrote, "though somewhat indolent, was graceful and engaging. In spite of his education, which I presume was provincial and not of the best, his language appeared to me elegant, and equally exempt from vulgarity and affectation. . . . He seemed born for a high station. Without effort he would have passed in any mixed society, for the first man in it."4

María Luisa was then in her thirties, and had been married for some twenty years. With disconcerting speed, Godoy was made welcome at the inner councils of the court. Both Carlos and María Luisa grew to like him, then to trust him implicitly, and more and more to leave decisions of state in his hands. He was made prime minister in 1792. Though Godoy was married and had a semi-official mistress plus who knows how many unofficial ones, it seems unlikely

that there was no sexual relationship between him and María Luisa, and few historians have ever doubted that there was some fire in the midst of the prodigious amount of smoke that they created. But beyond rumor, assumption, and gossip, there is no actual evidence that the two were lovers. What one sees, in fact, is the lingering effect of the all-pervasive propaganda spread by Godoy's enemies, headed up by the Church, the more conservative nobility (for such grandees could stand the idea of a career bureaucrat as court favorite but not a "low" provincial from Estremadura like Godoy), and, above all, the all-consuming malevolence of María Luisa's frantically jealous and insecure son, the future Fernando VII, who would do and say anything about anyone who seemed to menace his path to the throne. This included blackening his own mother's name, and paying cartoonists—not highly gifted ones, but malignant enough—to make broadsheet prints with obscene inscriptions satirizing her relations with Godoy, which were handed around in taverns.

All this hostility fell on Godoy not because he was a tyrant but because he was not reactionary enough. "Instead," remarks the historian Raymond Carr, "he was a mild progressive who consistently posed as the friend of enlightenment, earning for himself that hatred of priests and monks which contributed to his fall." Much of his correspondence with María Luisa has survived, and was published in the mid-1930s. It is disappointingly chaste and unscandalous; "his bond with María Luisa," says Carr, "seems to have been hypochondriacal rather than sexual in nature." What's more, Godoy and the royal couple stayed together right up to the king and queen's deaths in 1819, a relationship that lasted some four decades. However blinkered Carlos may have been, he was not stone blind, and his trust in Godoy's total loyalty could hardly have survived the discovery that his favorite and protégé was cuckolding him. But it may have been impossible to convince him of this, anyway. Floridablanca, who detested Godoy, tried in 1792 and got nowhere with the king.

Godoy started off as an obscure scion of a petty aristocratic family in the provincial north. Like many such marginal figures, he perceived that the army offered the chance of advancement, and joined it, finding his way into the palace bodyguard as a trooper. (This was not as lowly a position as it sounds: royal bodyguard troopers were the equivalent of sublicutenants in the regular Spanish army, and had to be of noble birth besides.) Because his father was a meat merchant, the son became known throughout Spain as *el choricero*—"the sausage maker." This may have also referred to Godoy's phallic prowess. Beyond his sexual self-esteem, which was realistic, he had an inflated opinion of himself as political savant and military genius, and that was less so.

But was he the moral coward, the corrupt, self-serving charlatan, that his palace enemies and posthumous detractors have made him out to be? That seems at least debatable. In eighteenth-century Spain, the cortejo—the friend, adviser, and semi-official lover of a high-placed married woman—was a recognized, almost an institutional, figure. Such was the role Godov played in María Luisa's life, but he infuriated his enemies and critics by playing it to the very limit and translating it into an unheard-of degree of political and financial leverage. Godoy was driven, more by real conviction than by self-interest, to continue the trend toward "enlightened absolutism" that had been set in motion by his patron's father, Carlos III. He tried very hard to bring about reforms in the Spanish army, but these were blocked by military vested interests. Both the Church and the aristocracy resented his ambition—encouraged by the economic theories of *ilustrados* like Jovellanos—to prime the stagnant economy of Spain by forcing them to sell off at least some of their enormous and idle landholdings. He recognized the crying need for educational reform. "For the great mass of people to emerge from their abjection and ignorance," he observed, "it is not enough that they should know how to read, write, count, calculate, and draw—they have to know how to think." Standard priestly education could not give them that, and so Godoy was in favor of starting schools run in accordance with the advanced theories of the Swiss educator Johann Pestalozzi. (In the Meadows Museum in Dallas, Texas, there is a fragment of a painting by Gova evidently commissioned to show schoolchildren the benefits of Pestalozzi's system.) At the beginning of the nineteenth century, Godoy supported the founding of the Royal Institute for this very purpose in Madrid. Not much is known about it or its success, except that its pupils, when he paid them a visit, would chant in unison:

Viva, viva, viva,
Nuestro protector,
De la infancia padre,
De la patria honor,
Y del instituto
Noble creador.

("Viva, viva, viva, our protector; father of our childhood, honor of the country, and noble creator of our institute.")

Godoy was no paragon; as his enemies kept stressing, he was greedy and a libertine. But in some respects he was also a better man, and a more genuinely

Goya, Alegoría de la industria (Allegory of Industry), 1797–1800. Oil on canvas. Museo Nacional del Prado, Madrid.

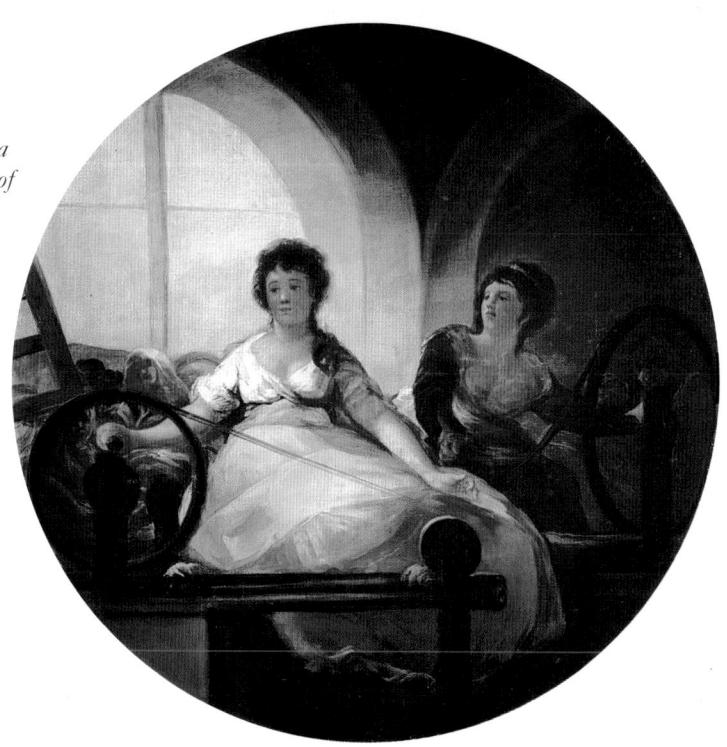

idealistic one, than many of those enemies. One of his most serious concerns, for instance, was promoting the various Societies of Friends of the Nation that had been started by Campomanes, the encouragement of industry in Spain, and in particular the employment of women in useful work. He involved Goya in this, at least peripherally. The king had given Godoy, in his capacity as prime minister, a handsome palace in Madrid, where he did a good deal of official entertaining. It needed extensive repair and redecoration. The vault of its large vestibule, facing a magnificent central staircase that all guests went up and down, featured four lunettes. For these, Godoy arranged to have Goya paint four tondos, not in fresco but in tempera on canvas, allegories of the four chief elements of Enlightenment economic thought as set forth by Campomanes and Jovellanos. Completed in 1804–6, these were *Commerce*, *Agriculture*, *Science* (lost), and *Industry*.

The finest of these was the last canvas, Goya's homage to *The Spinners*, c. 1657, Velázquez's large and complex scene of work at the Royal Tapestry Factory. There is, perhaps, a degree of piquancy in the fact that Goya's models for this improving allegory were probably whores who had been consigned, as reformatory punishment, to the San Fernando workhouse in Madrid. Goya liked to frequent this workhouse and draw in it, as one can see from several of the sketches in the Madrid Album of 1796–97. "It's clear that they are being taken off to the San Fernando workhouse," says one armed guard to another in

Goya, Madrid Album, 84, *San Fernando ¡cómo hilan!* ("The San Fernando workhouse: How they spin!"), 1796–97. Private collection.

sheet 82 as two girls, swathed in shawls to hide their faces, shuffle by; and in sheet 84 we see three women, hair close-cropped to facilitate the search for lice, wielding their spindles in one of San Fernando's rooms. The two women with their spinning wheels in *Industry* are, presumably, their sisters, and quite handsome ones at that; Gova has given the one on the left, with her ample greenand-gold skirt and her breasts loosely covered by a brightly lit white blouse, the air of a veritable goddess of industry. But she is a melancholy goddess; her thoughtful expression, tinged with sadness, seems to confirm that she is working there for penance' sake. It is possible that the image of the Fates, one of whom, Clotho, was classically represented as spinning the thread of human life, was in a corner of Goya's mind when he was doing this picture for Godoy; he was to depict those three weird sisters in years to come, in one of the Black Paintings in the Quinta del Sordo. Be that as it may, the design is beautifully organized, the large circle of the tondo canvas containing a series of other circles and near-circles; the spinner's round breasts, the spinning wheels, the round bulge of the green skirt, the women's round faces, and in the background the big semi-arches of the window openings. Anna Reuter points out that Goya lit

his figures as though the light falling on them were coming from a real architectural source, the actual lantern in the middle of the vault of the palace's antechamber.⁷

After Carlos IV was crowned king in 1788, Godoy's career took off like one of the hot-air balloons that were the wonder of public gatherings in Madrid. It would be tedious to list the favors, honors, emoluments, and promotions that were showered on him over the next few years, beginning (in 1792) with the dukedom of Alcudia, which made him much more than a peripheral noble: he was now a grandee of the first class, with income from his estates to match. He was raised to field marshal, and received into the Order of Santiago. At the end of 1792, aged only twenty-five, Godoy was prime minister, and then the "universal minister" of Spain and the Indies. By 1793, his official combined income from military and political sources totaled more than 800,000 reales, and he received more than a million reales annually from Crown estates that had been given over to him. In picturing what many Spaniards thought of Godoy's career, Lord Byron in *Childe Harold's Pilgrimage* had it right when he wrote of his emblematic Spaniard, "the lusty muleteer," who

chants "Viva el Rey!"

And checks his song to execrate Godoy,
The royal wittol Charles, and curse the day
When first Spain's queen beheld the black-eyed boy,
And gore-faced Treason sprang from her adulterate joy.

We cannot know if Carlos knew of María Luisa's affair with Godoy—if, indeed, it existed. At the very least, however, it is quite clear that the three of them formed a triangle, and were visibly attached to one another; no fit of royal jealousy disturbed the relationship. Carlos was content to let Godoy do his political and military thinking for him. In this, he was weak and lazy, but not altogether stupid, since he wanted to free himself from his father's advisers; he could be safe from the pull of bitterly competing court factions by having as chief minister a man who owed his position solely to him. María Luisa was completely under Godoy's spell: she wrote to him several times a week, often in terms of gushing devotion—"Your memory and fame will come to an end," she exclaimed in a not untypical letter of 1804, "only when the world itself is destroyed." Her son the infante Don Francisco de Paula was said to look very like Godoy. They would stay together, king, queen, and favorite, even after Napoleon forced them all into exile.

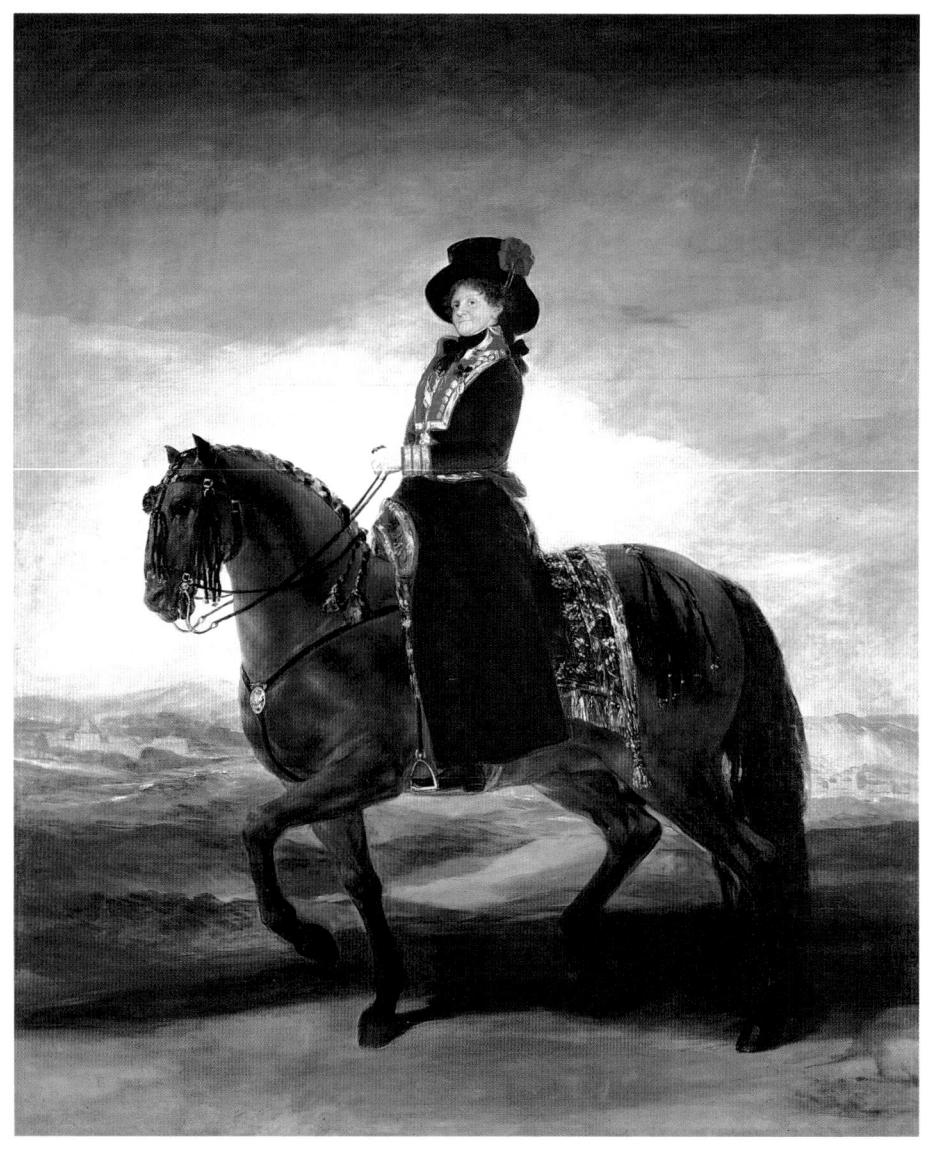

Goya, *María Luisa Mounted on Marcial*, 1799. Oil on canvas, 338 x 282 cm. Museo Nacional del Prado, Madrid.

One might suppose that a woman who could run a country through her favorite, and get her husband to do whatever she said, would have the looks and brains of Cleopatra. But such was not the case. María Luisa was warmhearted, spirited, and willful, but she was never a beauty—although she was so proud of her arms that she forbade the wearing of elbow-length gloves at court, so that anyone could see how inferior other women's arms were to hers. Her looks fell victim to the cosmetic and medical inadequacies of the age. She wore ill-fitting

dentures, having lost all her teeth by her mid-thirties, and her skin acquired a disagreeably sallow tone. She was realistic about this, at least with friends. Regarding her son Fernando, whom she loathed, she wrote to Lady Holland: "You will find [him] ugly; he is the counterpart of myself." But regal she remained, and Goya did a magnificent job of conveying this without resorting to unctuous flattery. In his 1799 portrait of her, mounted with an erect but relaxed carriage on her favorite horse, Marcial, he gives her an almost quizzical half-smile, the brown, frank eyes looking down at you in complete security. She was forty-eight by then, and some years before her fertility, of which there was no question, had deprived her of her figure.

María Luisa had never shirked her chief dynastic duty, the production of royal heirs; after her death, Godoy's longtime mistress Pepita Tudo reckoned that the queen had been with child no fewer than twenty-four times, including a number of miscarriages and stillbirths. It was a crushing gynecological burden to bear. Only seven of her children survived infancy, and of those several did not live beyond childhood. Unfortunately, her eldest surviving son, Fernando, prince of Asturias, was one of those who did, and he grew up detesting her: he, at least, had no doubts as to the position Godoy had in her heart as well as in the power structure of Spain. Moreover, he had been largely ignored by his parents, and since neither the king nor the queen put much of a premium on book learning, his education had been stunted. What there was of it he had from priests, under the charge of a nasty and Machiavellian canon named Juan de Escóiquiz. From him Fernando received an early grounding in the arts of lying, intrigue, and conspiracy, ideal for his maturation as the future Fernando VII, most suspicious and conservative of rulers. Escóiquiz loathed Godoy as a cheat and a voluptuary whose house was defiled by open prostitution, orgies, and adulteries that took place "in exchange for pensions, sinecures, and honors." He had debauched "the flower of Spanish women, from the highest classes to the lowest."9 There was nothing so bad that it couldn't be said about Godoy or believed by the young prince of Asturias. His first deep political emotion would be his hatred of the royal favorite, whose presence menaced his entire sense of self. Moreover, Fernando's deepest fears of maternal rejection were quite wellfounded. She despised her graceless poltroon of a son, and made no secret of it. All in all, few states can ever have been ruled by such a parodically dysfunctional family as this generation of the Spanish Bourbons.

Godoy wielded great power, but his own position was never inherently secure. He owed it all to the favor and patronage of the king and queen, which could be withdrawn at any time. He could never confidently rely on those for whom he had done favors, because the recipients could so easily be ingrates. Patronage bestowed on one makes enemies and malcontents of others.

But there was a more specific political problem for Godoy, and the house of Bourbon, as well. It was the French Revolution, the "marvelous event" that threatened all the thrones of Europe and reached a terrifying climax with the beheading of Carlos IV's cousin Louis XVI.

Clearly, it would have been foolish and perhaps politically suicidal for Spain to send troops into France to prop up Louis's tottering regime: the tide of revolutionary enthusiasm was running too strong, the Spanish army was too weak. But the count of Floridablanca, the cunning and increasingly reactionary chief minister whom Carlos had inherited from his father, resolved to keep the Spanish people as ignorant as possible of what catastrophes were brewing in France. He was an old ilustrado, but above all he was a Spaniard, and the enlightened ideas he had tolerated as Carlos III's chief minister were not so tolerable in these threatening times. Floridablanca therefore clamped down a strict censorship on news about France crossing the Pyrenees or entering Spanish ports. Journals were censored or banned outright, and the Inquisition was given free rein to track down leaks. Spain must not find out that its neighbor had rejected royal authority. Eminent ilustrados like the conde de Campomanes and the liberal polymath Gaspar de Jovellanos, whom Campomanes had promoted to councilor of state, found themselves retired in 1791; Jovellanos was exiled to his native Asturias. Of course, this absurd attempt at containment had no hope of success, but it threw Carlos IV's government into confusion.

The king now turned to the man who most disliked Floridablanca and yet, in many ways, closely resembled him: Pedro Pablo, conde de Aranda. Like Floridablanca, Aranda was a strong believer in "enlightened despotism" and yet an economic and fiscal reformer; he had the advantage, however, of knowing France at first hand, being a friend of Voltaire's and, in his capacity as Carlos III's ambassador to France, getting acquainted with Benjamin Franklin and John Jay. He therefore had a more sophisticated grasp of republican impulses than most Spaniards of his time and class, but this did not help him much after he replaced Floridablanca as secretary of state in 1792. Aranda did not last long either. The French republicans overthrew Louis XVI that summer, and declared France to be a republic. Aranda's francophile sympathies (such as his Freemasonry) now counted badly against him in Carlos's eyes. The Church hated Freemasons, and vice versa. Freemasonry was part of the apparatus of revolution in France, as it had been in America, where a large proportion of the Founding Fathers belonged to lodges. It therefore seemed that Aranda was

bound to side with the French revolutionaries while carrying out the impossible, contradictory task of supporting the interests of his own sovereign. This gave Godoy the opportunity to persuade Carlos to dismiss Aranda and replace him as chief minister with—Godoy himself. Aranda had been too freehanded in his attacks on Godoy's youth and inexperience. "It is true," Godoy replied in his own defense, "that I am only twenty-six years old, but I work fourteen hours a day, something that no one else has done; I sleep four, and apart from taking my meals, I never fail to look after everything that comes my way." Godoy was no military genius, but as the unfolding of his career abundantly confirms, his faults were overconfidence and lack of field experience, not laziness.

So his appointment as chief minister may not have been such an abysmal act of nepotistic folly as Godoy's many detractors, down to this day, have made out. Spain was not rich in candidates for the job, and other high-placed Spaniards could well have done worse than Godoy—though this is not saying much. His first confrontation with the newly republican French was moderately successful. It took place in 1793-95, immediately after the guillotining of Louis XVI. Carlos IV, being a Bourbon like the late Louis, had immediately laid claim to the French throne—a striking combination of folly and naïveté. The French response was to declare war on Spain. The French armies advanced into the northwest and northeast corners of Spain: the Basque country and, more important, the Mediterranean coastal area of Figueras in Cataluña. Without being able to claim full victory, the Spanish army brought them to a standstill—one of the few times the normally fractious and independent-minded Catalans united with Madrid against a threat from across the Pyrenees—and though the war itself was inconclusive, it ended in a negotiated settlement, the Treaty of Basel, in 1795. For his role in brokering it, Godoy was endowed with the resonant title of El Príncipe de la Paz, the "Prince of the Peace."

This was the high-tide mark of Godoy's popularity in Spain. It did not last. The upper nobility continued to regard him as a scheming upstart whose road to power ran between María Luisa's sheets. The clergy continued to loathe him, not only because of his much-exaggerated immorality, but for his desire to curb their wealth and power.

There was, however, one area in which Godoy's achievement—or at least the brightness of his reflected glory—cannot be gainsaid. This was his taste in art: specifically, his appetite for paintings by the resident genius of Carlos's court, Francisco Goya. By the end of the century, the royal couple's demand for Goya portraits of themselves was tapering off. He had done them full-length and half-length, standing on their own two feet and seated on horseback, and sur-

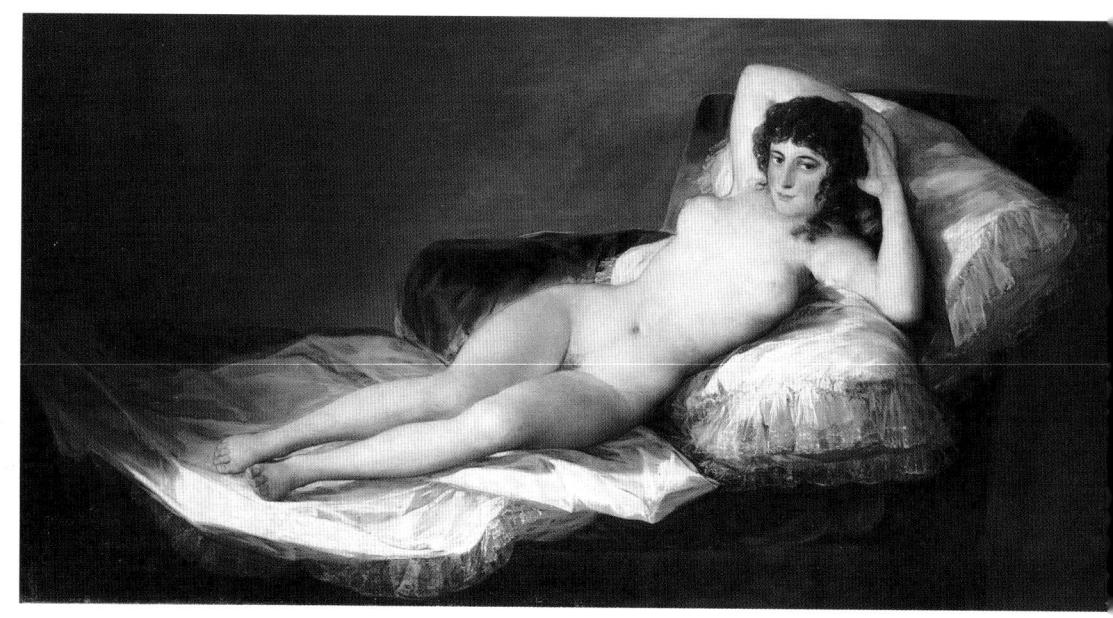

Goya, *La maja desnuda (The Naked Maja)*, c. 1797–1800. Oil on canvas, 97 x 190 cm. Museo Nacional del Prado, Madrid.

rounded by their relatives in that resplendent group portrait *The Family of Carlos IV*. Presumably the king felt that enough was enough. Nor were there remarkable affairs of state, diplomatic triumphs, or set-piece battles to be commemorated, as Velázquez had done with the surrender at Breda. Godoy became the most consistent and enthusiastic client Goya had in the first decade of the nineteenth century. The artist bragged about this in a letter to his old friend Martín Zapater. The chief minister, Goya said, had taken him for an outing in his coach, showered him with compliments, and uttered "the greatest possible expressions of friendship." And it could hardly be said that, in working for Godoy, Goya was stepping far outside the aura of the First Family.

Godoy already owned a considerable collection, whose chief treasure was the greatest nude ever painted by a Spaniard: Velázquez's *Venus and Cupid* (c. 1650), now known as the "Rokeby Venus," a present from the duchess of Alba. (This was a magnificent gift, but it says little for the duchess's connoisseurship: how could anyone with half an eye bring herself to part willingly with such a painting?) Godoy also possessed a pair of nudes of more immediate contemporary interest, painted for him by Goya: *La maja desnuda* (*The Naked Maja*, c. 1797–1800) and its more proper sister, *La maja vestida* (*The Clothed Maja*, c. 1805). Neither was dated by Goya, but *The Naked Maja* was seen in Godoy's
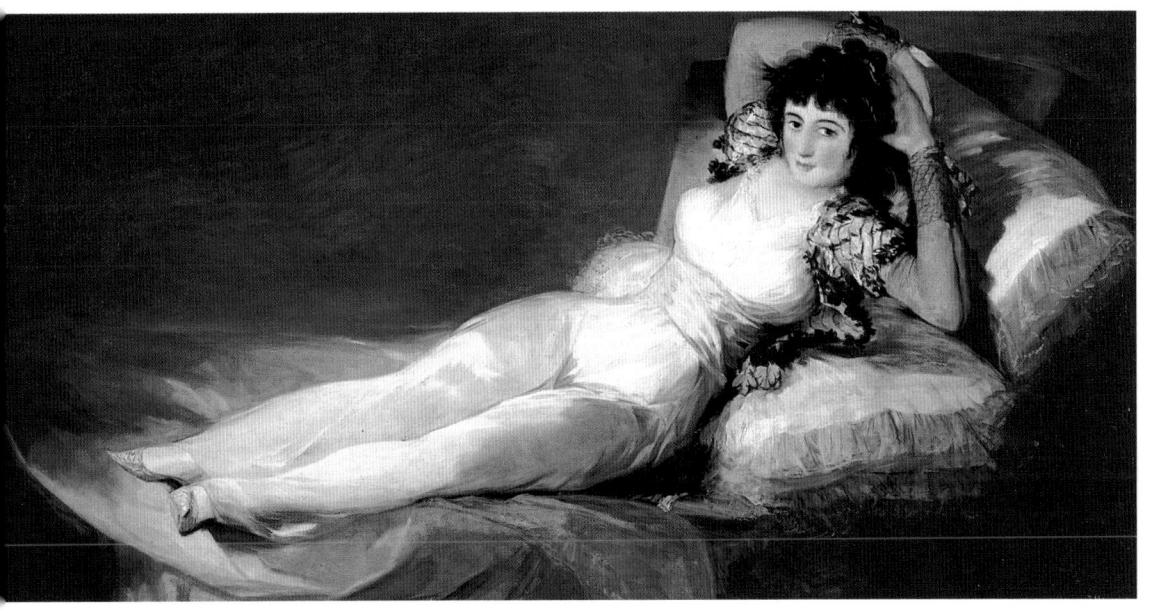

Goya, *La maja vestida (The Clothed Maja)*, c. 1805. Oil on canvas, 97 x 190 cm. Museo Nacional del Prado, Madrid.

collection by a visitor late in 1800—who, moreover, made no references to its clothed version, as anyone who saw them in the same place would certainly have done.

These paintings, especially when considered as a pair, are extraordinarily famous, but very little is actually known about them—starting with the sitter's name. One thing seems certain: whoever the lady may have been, she was definitely not the duchess of Alba—and does not look like the duchess in other portraits of Gova's, despite her black ringlets, by then a fairly generic attribute of female beauty. The duchess of Alba died young, in July 1802, having only just turned forty; the cause of her death seems to have been a combination of dengue (breakbone) fever and tuberculosis, and it seems impossible that a thirty-eight-year-old woman already suffering from two such wasting diseases would have looked as delectable as the girl in Gova's picture, with her smoothly rounded thighs and heavy, almost implausibly perky breasts. Goya did not paint her to commemorate his own affair with her. This is one of the many gaps in our knowledge of Gova's life that legend and tall stories have hastened to fill. It is more likely that she was one of Godoy's own mistresses, a fairly numerous tribe whose names have mostly been lost. Most probably she was the great love of Godoy's life, a spectacularly pretty and sexy Málagan girl named Pepita Tudo.

The two could not live together under the same roof—that would have been too much for the proprieties of Madrid society, since Godoy was aleady married to a young countess, the condesa de Chinchón, handpicked for him by no less a person than Queen María Luisa—but Godoy never ceased to love Pepita, or she him, and thirty years after he went into exile with his royal patrons, the death of his wife at last freed him to marry Pepita—which he immediately did. Occasionally she would be invited to dinners in his palace, where she would sit on one side of him, the condesa de Chinchón on the other. This was taken as fairly normal by the guests, with a few exceptions, one of whom was Jovellanos. For an *ilustrado* Jovellanos was sniffily prudish and small-minded, so much so that he felt obliged to leave the table—a silly and politically naïve gesture if ever there was one.

It is plausible, even likely, that Godoy commissioned two portraits of Pepita from Goya, one naked in or about 1797 and the later version, clothed, some eight years later. This would help explain a peculiar feature of *The Naked Maja*: her head doesn't fit well on her body, an awkwardness of drawing that one does not expect from Goya's superbly fluent hand. It is someone else's head. Presumably what happened was that, having reluctantly married the condesa de Chinchón on royal orders—"Few souls have been as sad and apathetic as hers," Godoy wrote to María Luisa—he realized he could not have a recognizable picture of his mistress, naked or clothed, in any part of the palace, however private. He therefore directed Goya to replace Pepita's head with a generic one in both versions, and something went awry in the transfer. This hypothesis could perhaps be tested by X-raying the picture, which has not been done.

Due to the repressive influence of Spanish Catholicism, there are few nudes in the history of Spanish art before, at the earliest, the mid-nineteenth century. It was not considered a respectable genre, and it says much about Spanish attitudes toward the nude that Goya, in his old age, should have been investigated by the Inquisition for painting *The Naked Maja*. The inquiry went nowhere, but an air of salacity seems to have clung to the picture ever since it left his easel. As well it might: compared with the classical and idealized nudes of the Renaissance, this is a sexy and straightforward girl, and her level gaze, which both entices and sizes up the (male) viewer, has filled more than one art critic—and, presumably, many more than one visitor to the Prado—with feelings of inadequacy verging on alarm. It is, in effect, a Spanish *Olympia*, and it rouses the same kind of feelings that are provoked by Manet's great painting in all its sharp and independent sexuality. *The Naked Maja* is defiantly herself, alluring certainly, but decidedly on her terms. She is not a sweet little thing, a passive

and receptive appeal to male fantasy, like almost any other eighteenth-century nude you might care to name. Even without her clothes (or perhaps especially so), she is a real *maja*, tough, sharp, and not to be pushed around. The art historian Fred Licht was quite right to point out that when you are looking at her, a phrase sung by Marlene Dietrich comes to mind: "*Ich kann halt lieben nur und sonst gar nichts*," "I only know how to love, nothing more." In effect, Licht adds, "Goya's *Maja* is the perfect prototype of a peculiarly modern woman who, more than a century later, will be represented by the protagonist of *The Blue Angel.* . . . Goya divorces sexuality from love." It may be that Licht takes this a little too far; one may not agree that *The Naked Maja* is a sort of implacable, devouring sex machine, "dissociated from pleasure, consolation, fecundity, and tenderness," who demands man's "submission to an inscrutable and possibly menacing force of nature." ¹²

This sounds too close to the sort of alarmist, Fatal Woman rodomontade with which nineteenth-century French critics, terrified by the specter of syphilis, used to salute Leonardo's *Mona Lisa*. Personally, I could imagine few things less scary and more enjoyable than an afternoon romp on those lacy cushions with the *maja*, but de gustibus, et cetera. And Licht is certainly right on the beam about the essential *marcialidad* and modernity of Goya's challenging cutie.

But Goya's first named portrait for Godoy was of his twenty-one-year-old wife, done in 1800. She was Carlos IV's cousin, the child of Infante Don Luis de Borbón: Doña María Teresa de Borbón y Vallabriga, the condesa de Chinchón, otherwise known—through her marriage to Godoy—as the Princess of the Peace. Queen María Luisa had personally selected her to be Godoy's bride, a fact that casts further doubt on the reality of her own alleged affair with him. There is nothing to suggest that the marriage was a close, let alone a passionate, one. It was consummated, and it produced one daughter, Carlota Luisa. Having fulfilled her matrimonial duty, María Teresa sank back into running the household; she was bored by Godoy's neglect of her, and offended by the scandalous openness with which he pursued his various affairs. Public opinion seems to have been on her side; at the Motín d'Aranjuez, the rising against Godoy fomented by Prince Fernando in 1808, some of the rebels were heard to cry, "¡Viva la inocente paloma!"—"Long live the innocent dove!" Much later, after she and Godoy had separated forever and she had moved back to Madrid while he languished in French exile with Carlos IV and his queen, she would remark to a French general that she hated Godoy so much that she could not love their child for being his daughter.¹³

Goya, *Condesa de Chinchón*, 1800. Oil on canvas, 216 x 144 cm. Museo Nacional del Prado, Madrid.

Goya's portrait of her is one of the most enchanting images he ever produced, because it radiates neither conventional power nor confident sexuality: we see a timid girl of twenty-one, her isolation magnified by the deep dark space that surrounds her and gives a tender, almost virginal glow to her white dress. But she is five months pregnant with her future daughter, and looks rather bewildered. Her fluffy blond hair is adorned with green sprigs of wheat, traditional emblems of fertility. Her arms are bare, in deference to the court fashion launched by Queen María Luisa. She looks not only vulnerable but quite defenseless, a condition underlined by the enveloping darkness of the background: a woman isolated and alone in the world. Goya saw right into her. His painting presents no mask and, as a result, it is perhaps the most perceptive, and by far the most touching and empathetic, of all his portraits of women.

It had been an arranged marriage, and the bride was neither sophisticated nor worldly: she had been raised and educated not by her mother but by nuns in a convent in Toledo. She has done her expected task, and will not get much else to do—four years earlier, in 1796, Godoy had met Pepita Tudo. It has been suggested that María Luisa arranged the marriage in an effort to distract Godoy from his new lover. If so, the scheme failed. Godoy was sexually obsessed with Pepita, so much so that he would wait in exile until his poor wife died in 1828 and then marry la Tudo, a gap of nearly three decades. Almost as soon as she married Godoy, the unhappy condesa de Chinchón—who, in the portrait, is wearing what appears to be a miniature portrait of Godoy on a ring on her left hand—was ruthlessly pushed to the periphery of her husband's life. This was the act of a scandal-proof husband, but Godoy had already developed the armor (along with the political weight) of a rhinoceros.

He looked rather like one in Goya's 1801 portrait of Godoy celebrating the Spanish army's victory under his command in an insignificant action against the Portuguese that lasted only two weeks before the Portuguese army ran away and the Treaty of Badajoz was signed on June 7; it later became known as the War of the Oranges, because the Spanish vanguard, riding toward Lisbon, had paused in the gardens of Yelves, cut some orange branches, and sent them back to Godoy, who chivalrously forwarded them by a messenger to his queen.

Seldom has so small a war been so sumptuously commemorated. We see thirty-four-year-old Godoy after victory, leaning back with immense self-satisfaction in a field commander's chair among rocks, holding a document—presumably the note of surrender. He gazes at captured Portuguese battle standards on the left. A residue of black cannon smoke rises and drifts away in the background. Everything about him—the spotless white linen, the magnificent crimson facings of his lapels, the gold embroideries on collar, cuffs, tri-

Goya, *Manuel Godoy, Duke of Alcudia*, "*Prince of the Peace*," 1801. Oil on canvas, 180 x 267 cm. Museo de la Real Academia de Bellas Artes de San Fernando. Madrid.

corne, and jacket, the unmarked yellow breeches, and the swagger stick held negligently between his legs—bespeaks a man of boundless self-confidence, whom no pollution from war can touch. Even his appreciably slimmer aide-decamp, hovering just behind Godoy's shoulder, seems built to about two thirds the scale of the Prince of the Peace. The indolence of his pose suggests a degree of laziness, but mainly power. It is possible that Goya knew other examples of such a pose: that of the reclining emperor Augustus, for instance, on the Roman cameo known as the Gemma Augusta, then in the Spanish royal collections. But in Goya's obstinately realistic sight, Godoy does not quite carry off this classical pose: he is a little too flushed and soft from years of good living in the palace, and it shows in the half-closed gaze, the overplump thighs. And it is a somewhat awkward pose. Goya, of course, knew others, including British prototypes of the standing military portrait, against the same kind of dark, rolling clouds, whether of natural storm weather or of gunpowder smoke; and it may be that this pose was dictated by the intended placement of the canvas itself, possibly over a fireplace in Godoy's Madrid palace. It may even be that the king

and queen meant the portrait of Godoy to occupy an honored place in the Salón de los Grandes Capitanes in the Royal Palace in Madrid. 14

The arrogant being in the portrait was flattering, but it was also how Godoy's growing band of enemies might have imagined him: the clerics who resented his "enlightened" and confiscatory attitude to Church property, the noble friends and backers of the prince of Asturias who wanted the road to succession kept clear for Fernando, the common people who believed he was humiliating their king by cuckolding him—far more Spaniards, in all, than Godoy himself imagined. His popularity was not increased by the military reverses Spain was suffering, such as the fiasco in 1805 at Trafalgar, which wrote an end to all Spain's historical claims to naval supremacy: there, some twenty-five miles off Cádiz, Admiral Horatio Nelson's squadron wiped out a combined Spanish-French fleet, sinking twenty-three of its ships of the line and killing 6,000 of its men. This did not redound to the glory of the Prince of the Peace, who had been promoted to the command of Spain's navy as well as her army.

If Britain now ruled the waves, it seemed that Napoleon was fast becoming the master of Europe. He crushed the combined armies of Austria and Russia at Austerlitz in December 1805, and then turned his full attention to Spain—his nominal ally.

His plan was tortuous. He could not conquer Spain by frontal attack by land or direct invasion by sea. Somehow he must smuggle his army across the Pyrenees and deploy it in Spain without raising Spanish suspicion—a much easier thing to say than to do. His solution lay in a secret treaty signed at Fontainebleau by Napoleon and Carlos IV, which arranged for the invasion and partition of Portugal: the nation was to be dismembered and divided between Spain, France, and, amazingly enough, the private estate of Manuel Godoy. The Spanish "kings of Etruria"—a title assigned by Napoleon to the Bourbon line of Carlos IV—would give up their Italian estates to Napoleon in exchange for the large tract of Portugal between the Douro and Minho rivers, plus the city of Oporto, the nation's chief wine-export center. The southern (meridional) part of Portugal, including the Algarve, would be given as an absolute fief to Godoy himself. Lucrative Portuguese colonies in Africa and the New World would be split between France and Spain. Napoleon's interest in the deal was no mystery: from French-occupied ports on the Portuguese coastline his navy could "harass and interdict" British shipping headed for the Mediterranean, and somewhat reduce their control of the seas around southern Europe.

Since the Portuguese, whatever their military shortcomings, could hardly be expected to lie down and let this happen to them without uttering a squeak, the necessary muscle for the enterprise would be provided by a French army, which Napoleon in October 1807 started moving into Spain nine days before the Treaty of Fontainebleau was even signed. Not a single Spaniard, it seems, and certainly no one in the circle of the royal family, had an inkling of what Napoleon was really up to or foresaw its deadly consequences. Godoy, in any case, was blinded to them by his ambition to have a kingdom of his very own. Before long, the emplacements of 50,000 French troops within Spain formed what a contemporary called "an unbroken chain" from Bayonne to Madrid, and more were arriving every week.¹⁵

The Portuguese guessed at Napoleon's plans by the time more than 100,000 French soldiers, under the command of Marshal Andoche Junot, had been installed in Spain. The royal family began forming plans to decamp to Brazil and, however implausibly, to conduct some kind of resistance from there. This was impossible, and Junot's troops marched into Lisbon at the end of November 1807. Meanwhile, the Spanish royals went about things in their own bumblingly naïve family way; and Godoy, the brains of the family, was too infatuated with Napoleon to see what he was up against until it was far too late.

Napoleon, however, wanted to be rid of Godoy. He correctly perceived that the favorite was the only person at the higher levels of the Bourbon court who had real skills, however scrambled they might have been by his own narcissism and his desire to curry favor with power, including Napoleon's own. He also knew something of the deep animosity that confronted Godoy, from the various conservative, pro-Fernandine interests in Spain. No matter that these hated Napoleon too: they could be put to use. So in February 1808 Napoleon dispatched his cousin Joaquim Murat, the grandduke of Berg, to march on Madrid at the head of an army of 50,000 men, take over the capital, occupy the throne, and depose Godoy.

Meanwhile Fernando had embarked on a clumsy intrigue to depose his father. His plot was spiked by Godoy, and Fernando was obliged to grovel in apology before Carlos, who unwisely pardoned him. He then started plotting again, against both Papa and Godoy.

Fernando had two things on his side. First, his faction of upper-class supporters, the anti-Godoy aristocrats, clerics, and army officers, who saw Fernando's possibilities as a mere puppet king and so were prepared to support him as a fellow reactionary as well as a future legitimate heir to the throne. Some of these jealous and ambitious nobles, who felt that their ancient entitlements were

being put at risk by Godoy's *ilustrado* sympathies, convinced Fernando that Godoy was persuading his parents to cut him from the line of succession. Notable among these was the ultra-conservative conde de Montijo, who hated *ilustrados* and was prepared to go to any lengths, including the basest demagogy, to impede the modernization of Spain. Montijo despised plebeians, but knew how to stir them up. It was an old Spanish pattern: aristocrats using the backward as pawns by appealing to their most ignorant fears.

Second, Fernando was, to some extent, liked by those people. Some merely didn't hate him, but others, royalist in the sentimental and unreasoning way that the uneducated often are, adored him without knowing him. A vast gulf was fixed between prince and commoner, but this prince was, after all, Carlos IV's eldest son. And the Spanish *pueblo* had arrived, over the years, at an intense hatred of Manuel Godoy, the *choricero* whom rumor called a crook who had put horns on the head of their king—a not much loved king but king nevertheless, and as such the keystone of the state. It was all but guaranteed, then, that the *pueblo*—or, more truthfully, the *populacho*, the mob—would oppose and distrust anything Godoy did, and that the worst thing he could do would be to meddle with the status of the royal family.

Not that the common people of Spain had much cause to love the antiguo régimen of Carlos IV and his father. Apart from the miseries with which nature, or God, had lately afflicted the country—ruined harvests, floods, droughts, epidemics of vellow fever, even a plague of grasshoppers—there were unjust monopolies and punitive taxes of every sort. The populacho hated the army, too: not only did it cost some 40 million reales a year—a tax burden that fell directly on the common people of Spain—but the poor had no defense against conscription, which the rich could easily avoid, and Spanish soldiers were notorious for the brutal arrogance of their attitude to plebeian civilians. Just as bitterly resented were the royal efforts at proletarian "improvement," which took the form of a censorious and haughty dislike of popular culture in all its forms—folk songs, zarzuelas, holiday carnivals, and especially bullfighting, which Carlos III, Carlos IV, and Godov all regarded as a barbarous and brutalizing spectacle—so much so that Godoy banned all corridas in 1805, which made him about as popular as an American president who prohibited baseball would be. These things were quintessentially Spanish, not French, and the common people of Spain were apt to resent the ilustrado kings' dislike of them as an assault on their national identity. Such things inclined them even more in Fernando's favor: he became El Deseado, "the Desired One," "the man we long for," who would deliver Spain from its ills. This pathetic illusion created a ready-made alliance

between his aristocratic supporters, the *fernandinos*, and the Spanish working class.

In March 1808 the king and queen, their family, and the court were, as usual, beginning their spring residence at the royal palace at Aranjuez, thirty miles from Madrid. Murat and his army were some seventy-five miles from the capital. His steady approach gave confidence to the growing junta of Godoy's enemies, constantly stirred up by Fernando, led by Montijo, and including the son of the late condesa de Montijo, Eugenio Palafox, the mettlesome and unforgiving count of Teba, whom Godoy had consigned to several years' exile in Portugal. His exile would have been longer, but Palafox intrepidly disguised himself as a peasant and sneaked back into Spain, reaching Madrid in March before Murat's army did. He linked up with aristocratic friends in the anti-Godoy faction. Messages came from Fernando urging them to choose the moment to strike Godoy down. So the faction headed for Aranjuez, ready to do as much mischief to the Prince of the Peace as they could. A crowd of madrileños followed Montijo and Palafox, their numbers swollen by the local peasants who joined them as they marched along, aiming to besiege Godov's palace and flush him out.

Meanwhile Godoy himself had arrived in Aranjuez and implored the king to flee (though with dignity) to Sevilla so as to be safe from whatever actions Murat might take on Napoleon's behalf—and, above all, to do it soon, now if possible, and discreetly. But Carlos wanted to do nothing in secret, and he trusted Napoleon. The emperor had been sending him reassuring letters, so friendly that he was even raising the possibility of marriage between Fernando and one of his own princesses. Carlos saw no reason to budge.

Shortly after midnight on March 18, a lit candle was seen in Fernando's palace window. This was the signal for the rising, and gunshots rang out in front of Godoy's palace. The heterogeneous rabble, or people's army (depending on how you saw them), of rebels and protesters led by their aristocratic superiors had arrived, and were looking for the Prince of the Peace. They searched his palace and sacked it, but there was no sign of the royal favorite. He had taken refuge in an attic, where he spent the next thirty-six hours hidden under a pile of old carpets, half-suffocated, with nothing to drink and only a chunk of bread, hastily snatched from the late-supper table, to eat. When Godoy emerged, exhausted, disheveled, bruised, and bleeding (a horse had trodden on him and a sword or bayonet had pierced his left thigh), the insurgents brought him before Fernando, who reluctantly obeyed his parents' heartfelt entreaties to save their favorite's life.

Fernando worked out a deal with the protesters: Godoy could live, but in detention. And there matters rested until a new outburst of anger from the insurgents forced Fernando to show himself in public and call on them to disperse. Obligingly, they did, whereupon Carlos IV gave his son what he most wanted: he abdicated in Fernando's favor. Queen María Luisa flew into a spitting rage, accusing her son of having stirred up the crowd to rebellion, which was nothing less than the truth. She denounced him as a coward, a liar, a bastard (without naming his real father), and a traitor. But with the mob outside yelling its praises of El Deseado and Carlos longing only for a little peace, there was nothing to be done.

Murat got immediate wind that the prince of Asturias was now King Fernando VII. He quickened his pace to Madrid, reaching the capital amid general acclamation on March 23. The very next day, Fernando arrived there from Aranjuez and was welcomed by the whole city, almost hysterical with collective joy at the thwarting of María Luisa and the fall of her detested favorite. People took to the streets cheering. They threw flowers. Some spread their cloaks so that the advancing horses of Fernando's carriage could trample on them. For the moment, anyone who saw the crowd would have agreed that this was truly the Desired One, the ruler Spain yearned for.

Anyone, that is, except Napoleon, his envoy Murat, and the old king. Murat, on his master's orders, refused to acknowledge Carlos's abdication and Fernando's succession. Carlos had a change of heart and retracted his abdication. In the ensuing confusion, it was decided that only Napoleon could arbitrate who was and was not the rightful king of Spain; otherwise it could turn into acclamation by mob rule. Napoleon was now poised to deliver his estocada (death stab) to the Bourbon dynasty. Courteously, amiably, but in terms that could not be refused, the master of Europe would summon the Spanish royal family to France and meet them halfway. In April, accompanied by his empress Josephine, he traveled south to Bayonne. Fernando was slightly delayed in going north to meet him; he was held up by matters of state, which included sitting for a portrait by Goya—for which, however, he could spare only two sessions of forty-five minutes each, much to the artist's frustration. (Goya would not see El Deseado again, and had to finish the portrait from memory.) By the end of April, however, all of them were assembled before Napoleon in Bayonne: father, mother, son, and Godoy. Once in the imperial presence, the ground dropped from beneath the Bourbons' feet, and they had nowhere to stand.

For the next six years—until Napoleon fell, and Fernando VII reclaimed the

throne in Madrid—their exile to France was the end of the Bourbons in Spain. They were trapped on French soil, unable to return to Spain. Napoleon bluntly told Fernando that he must now abandon all claims to the crown and return it to his father, which he did. The emperor then informed the father, now (however briefly) Carlos IV again, that he must turn over the regained crown and all rights to it to Napoleon; and this, too, was done. In return, Carlos was sent into a comfortable exile at the Château de Chambord in Compiègne, padded by a pension of 30 million reales—in effect, the price he put on the throne of Spain. He would never see his former kingdom again. That got rid of the old man and his difficult queen, and as for Fernando, he was granted a suitable exile's pension and the indefinite use of a château belonging to Talleyrand at Valencay in the Touraine. With his usual combination of hauteur and weaselly effrontery, he asked Napoleon to marry him off to one of his nieces; the emperor recoiled from this prospect—despite his hints at such an idea in his earlier correspondence with Carlos IV—but told Talleyrand to supply Fernando with actresses instead of princesses.

Godoy, shorn of all future perquisites and deprived of any possibility of return to Spain, stayed on with Carlos and María Luisa and went with them into a further exile to Rome after Napoleon fell. He remained there under their protection until 1819, when Carlos—viewed by most foreigners as a clown and by the Spanish as a bumbling defrauder whose rule had left behind it debts of some 7.2 billion reales—died. María Luisa had expired shortly before him, on January 2: in that icy winter, shivering in the vast, frigid salons of Palazzo Barberini, she had caught a cold, which rapidly turned into pneumonia. She was buried with pomp, lying in state in the throne room of the palace, where a hundred priests celebrated, one after the other, the *missa solemnis* at eleven altars. On January 6 her coffin was taken to the sacristy of Santa Maria Maggiore, where no fewer than twenty-one princes of the Church attended her final rites; finally it was moved to the crypt of St. Peter's, where it remains today, the only body of a woman ever to find interment in that exclusive and quintessentially male club of dead popes.

There is no mistaking the intensity of the bereaved king's mourning for her, but he was not at her bedside when she died: he had gone to Naples on a shooting party with his brother Don Luis. On hearing the news, he wrote a piteous letter to Godoy, who had been with her: "Friend Manuel—I cannot describe to you how I have survived the terrible blow of the loss of my beloved wife after fifty-three years of happy married life," it began, and ended, "Come and see me whenever you wish, and . . . I remain, as always, the same CARLOS." It is hardly the letter of a cuckold to his dead wife's lover.

The Fall of the Bourbons · 253

Their son Fernando, now king of Spain, acted with his usual petty viciousness. He seized everything his parents had, refused to recognize or execute their wills, and so deprived Godoy of his one security, Carlos's French pension. Godoy made his way back to Paris, there to lapse into an old age whose miseries he bore with stoic calm. He had not quite reached fifty when his political career collapsed, leaving him with nothing to do. We get a glimpse of him in his last years through the *Foreign Reminiscences* of Lord Holland. Godoy, he wrote,

is training a miserable existence as a pensioner or almost beggar in Paris, surrounded by relations, acknowledged or unacknowledged children, grandchildren, and what not—Infants, Princesses, Duchesses etc., etc., not one of whom condescends to take the slightest notice of him, or show the least tenderness, regard or even interest about one to whom some owe their station and riches, and all, more or less, their very existence!¹⁷

He lived on for more than thirty years, in a small second-floor flat in rue Michaudière; his pleasure was to take the sun in the gardens of the Palais Royal. Hardly anyone in the *quartier* knew who this harmless old duffer had been. He died, in 1851, at the age of eighty-four, more than four decades after his fall from power, and was buried in the cemetery of Père Lachaise, where his grave is rarely visited. No Spaniard, and few Europeans of his time had risen so high and so fast from such obscure origins, or gone down with such wretched finality. At least he had the satisfaction of outliving his archenemy, the Desired One, by some twenty years.

In 1808, however, it was evident to Napoleon that the Bourbon line had not quite been rooted out of Madrid: although he had the king, the queen, and the crown prince in his power in France, relatives of theirs were still ensconced in the capital, and they might conceivably have served as a rallying point for the *pueblo*'s anti-Napoleonic passions. These included the last of Carlos's sons left on Spanish soil, thirteen-year-old Prince Francisco de Paula. Napoleon ordered them all to be taken across the border to Bayonne. Word of their impending exile leaked out to the people of Madrid, who were already furious at the absence of their sovereigns—although they did not know the full extent of their collapse, and still imagined that Fernando was putting up a brave resistance to Bonaparte. Multiplied by a thousand mouths, the rumors of French duplicity and imperiousness spread. At about eight o'clock on the morning of May 2, 1808, passersby outside the Royal Palace noticed Don Antonio and his family preparing to board coaches. Suddenly a courtier raised a cry of alarm:

Murat's men were abducting the Spanish royals, and they were bound for France. Shouting and jostling, crowds of *madrileños* coalesced quickly. Long live the king and our royals, death to Napoleon, death to Godoy, Frenchies out, out, out! Because it was early in the morning, most of them were ordinary people at or on their way to work.

They attacked Napoleon's troops opportunistically, wherever they found them, without leaders and without any kind of a plan. The French were taken by surprise—an occupying army is always afraid of such uprisings and always surprised by them—but they rallied, and of course, they had the advantage of good firearms, whereas the patriots had not prepared for the uprising and so had nothing but sticks, clubs, knives, and a few *trabucos* (blunderbusses), plus whatever arms they could seize from the French in the street fighting. One must not think of this as a disciplined assault by one mass of men on another, drawn up in ranks and files. Rather, it was a matter of semi-random and bloody engagements that flared and sputtered across the city and then died just as suddenly when the citizen assailants broke away, ran, and were lost in the alleys, leaving their dead and wounded on the ground.

One of the sharpest of these encounters was in the Puerta del Sol, the main square of Madrid, when the insurgents ran into a detachment of the Imperial Guard, a body that had been put together to protect Murat. It included twenty-four Mamelukes—Egyptian mercenaries, whose disregard for the more fastidious French restraints of war, such as not gouging out the eyes or cutting off the genitals of the wounded, made them much feared. This guard was escorting a Captain Rossetti across Madrid toward the Buen Retiro when, at the Puerta del Sol, it ran into a swollen and excited crowd of citizens. The Mamelukes charged to clear the way across the square. The insurgents fought back, with knives, cutlasses, and such firearms as they had. Casualties on both sides were heavy, though in the confusion of the uprising their numbers were disputed and remain uncertain. Throughout Madrid, Murat reported to Napoleon, "several thousand" rebels were killed.

This figure was far too high; more likely there were some two hundred dead and wounded on the Spanish side, many of them in the Puerta del Sol. But there would be more, because for the next day and night the occupation troops were busy rounding up every Spaniard who might possibly have been a rebel. They were herded into captivity, sometimes interrogated, and then brought out to their deaths. The mass executions were held at various sites around the city: in the courtyard of the hospital next to the church of Buen Suceso, in the paseo del Prado (near the site of the present Ritz Hotel, across from the Prado), and at

the Mountain of Príncipe Pío, a small hill two hundred yards or so from Palacio Liria, seat of the dukes of Alba, and not far from the apartments where Goya was living.

How much of them Goya actually saw is uncertain. He cannot have been moving around from one site of slaughter to another, as agile as some modern cameraman—he was past sixty. But there is a picture created by those who knew him (though they may not have been there at the time) of Goya with a loaded blunderbuss in one hand and a little sketchbook in the other, sitting down to draw the piles of corpses by lantern light in the darkness and confusion of the Madrid night, and it doesn't seem wholly implausible. That he saw the actual shootings is most unlikely; the French would not have tolerated the presence of witnesses, especially ones with sketchbooks. If Goya did make drawings at the place of execution, none have survived, although it is quite possible and even probable that the memory of the scene passed into his other work. For although he did not begin his paintings of the May uprising of 1808 until the Peninsular War was over, that war invaded his work and inspired a series of some eighty etchings on which he was to labor, on and off, for about a decade.

IN THE MEANTIME, however, Goya had a living to earn, and his sources of income were twofold: portraiture and small cabinet pictures. Some of the latter were still lifes, most of which remained unsold by the end of his life and passed as a legacy to his son, Javier. Though a minor part of his output, some of these bodegones—the Spanish term for those arrrangements of flowers, vegetables, dead meat or fish, and other nonconscious and inert objects that have always attracted the talents of formal painters—are of great intensity and beauty, and form a parallel to Goya's human subjects. There was, of course, a long tradition of the bodegón in Spain. Not only had the Hapsburg and Bourbon monarchs avidly collected still lifes by Dutch masters like Jan Davidsz de Heem (1606–83), still life was particularly a Spanish tradition (as paintings of the nude were not) and had been brought to a striking pitch of formal and conceptual perfection by Spanish artists working under the initial influence of Caravaggio in the sixteenth and seventeenth centuries. The greatest of them, to modern tastes, was the Carthusian monk Juan Sánchez Cotán (1560–1627), whose magically pure, rigorous, and intensely spiritual arrangements of a few objects—a quince, a sliced melon, the hyperbolic paraboloid form of a cardoon, or a cabbage suspended on a string against blackness—form exquisite vegetable geometries,

Right: Juan Sánchez Cotán, Still Life with Cardoon. Oil on canvas, 63 x 85 cm. Museo de Bellas Artes, Granada. Above: Francisco Zurbarán, Still Life with Lemons, Oranges, and Tea, 1633. Oil on canvas. Collezione Contini Bonacossi, Firenze.

as precise in their underpinnings as any Piero della Francesca. Then there was Francisca de Zurbarán (1598–1664) working in a similar near-abstract and monumental vein delineating his Ideal Cities of cruets, vases, and *ollas*; and a variety of flower painters and depictors of *vanitas* images, in which images of death (skulls), the decay of objects (fruit and flowers), and their fetishization as value (jewels, goldwork) become tropes for the decay of all worldly life and its contrast to the eternal values of heaven.

Goya was not interested in the *vanitas* theme; he probably thought it rather too crude and coercive, and in any case it had dropped out of fashion with the passing of the extreme pietism of the *siglo de oro*. His still lifes were triumphs of realism, somewhat in the vein of Chardin but without the peaceable character

Goya, Aves muertas (Dead Birds), 1808–12. Oil on canvas, 46 x 62 cm. Museo Nacional del Prado, Madrid.

of that master, and with a strong emphasis on death as their content. Probably the Spanish painter to whom Goya was closest, here, was Luis Meléndez (1716-80), who was heavily represented on the walls of the royal palace at Aranjuez—some forty-five still lifes—when Goya was working there in the spring of 1800 on the studies for his huge group portrait of Carlos IV and his family. 18 But Meléndez's dead birds and slightly phosphorescent fruits have an elaborated air that is altogether lacking in Goya's more realist and straightforward approach. Goya never went in for those fantastically elaborate, virtuoso shows of material description that constitute the chief interest of so many late-seventeenth- to early-eighteenth-century still lifes: the red sheen on the lobster, the gray liquid pond within the oyster, the dewdrops on the bowed tulip. Such works are, above all, an affirmation of human fortune and supremacy: the absent owner of the kitchen has seen to it that it is made into a centralization of all the good things the earth offers, an implausible but reassuring cornucopia of bounty, almost sexual in its repetitious availability. When Goya painted a heap of dead chickens-brown, ginger, black, and white, thrown against a basket in the gloom of a pantry or kitchen—he gave them the look of what they actually

Goya, *El pavo muerto (The Dead Turkey)*, 1808–12. Oil on canvas, 45 x 62 cm. Muso Nacional del Prado, Madrid.

were, small corpses unceremoniously dealt with: they are dead (like the larger corpses that will be similarly dumped in the *Disasters of War*), and this lends them a special pathos without imposing the pathetic fallacy (dead chicken = dead man) on them.

The power with which Goya could infuse a still life is best seen in his *Dead Turkey*. It is just that: a bird propped against a coarsely woven wicker basket, in which every protuberance of the weave is rendered by a single stroke of a round brush with a brusque expertness that might have made Manet envious. But the bird itself has an extraordinary vitality, if "vitality" is a word that can be associated with the depiction of something as irrevocably dead as Goya's turkey. It is not, of course, one of those obese lumps of waddling butterball that Americans eat for Thanksgiving. It is small and wild-looking, the direct descendant of the scruffier birds that Spain introduced to Europe from its American colonies. It is dead. It is stiff. Its feathers convey rigor mortis, with that wing sticking out, above and back, like the empennage of a shot angel. Its edible black-feathered body is enclosed between the legs—thrust out like sticks behind the bird, their claws extended in death—and that wing, which so beautifully shows the mot-

tling of its feather pattern. On the turkey's face is a twofold grimace of death: the downward circumflex of the bird's eyelid, and the downward curve of its tightly shut beak. Perhaps the world is full of dead turkeys, but not one of them could be deader than Goya's. It may not stimulate appetite, but there is no doubt that it promotes as much sympathy as any other corpse in art. You can imagine Goya writing under it the same declaration of realism, a moral intent, that he scratched on one of the margins of the as yet undrawn *Disasters:* "I saw that." *Yo lo vi.*

THE WAR AGAINST NAPOLEON in Spain—the Peninsular War, as the English called it, or more simply, from the Spanish point of view, the War of Independence—would engulf the entire country. Napoleon did not want it to. He hoped for a peaceful surrender, in which the upper-class and educated Spaniards, the afrancesados, would support and ease the nation's move away from Spanish absolutism. Meanwhile, he hoped, the country would come to accept the man he proposed to install as the new king in Madrid, his own brother, Joseph Bonaparte. Before this hope entirely died, the emperor promulgated a constitution for Spain, produced at Bayonne early in July of 1808. It was signed by a tame junta of pro-Napoleonic Spanish notables, summoned there by Napoleon himself. Most of them were upper-class afrancesados, and most stood to gain something from Napoleon's imposition of rule on their country. The group most heavily represented of all in Bayonne were the Spanish aristocrats—an astonishing feat of political blindness, since they were passively voting for the measures of the very man who was determined to curtail and, if possible, abolish the powers of the nobility. The Constitution they signed into being was based on the French Constitution of 1791 and was intended to underwrite the reign of Joseph Bonaparte. It announced guarantees of individual liberty and respect for private property. It abolished all requirements of noble blood for officeholders and the Catholic hierarchy. It canceled the institution of primogeniture, which had been the chief means whereby vast aristocratic estates had been held together. It promised such measures as freedom of the press (though this was not to be granted, the document said, for two years after the Constitution took effect, and it did not apply to criticism of French policies; so this "freedom" was less than it seemed). In sum, it offered enough to liberal afrancesados, especially aristocratic ones, to neutralize them while vesting the real power of the state in Joseph Bonaparte, henceforth known officially as José I and unofficially, due to his generous habits of entertainment, as

Pepe Botellas—"Joe Bottles." The Spanish people, as such, did not believe they stood to benefit from it at all, and when it was unveiled to the public which did not happen until the spring of 1809—most of them regarded the Bayonne Constitution as an offensively cynical document imposed on them by a predatory foreigner. Better a lost Spanish absolutism, they felt, than a newfound French tyranny; and their rebellion grew. It would not end until 1814, when Napoleon was finally driven out of Spain. It is not hard to see, in hindsight, how mistaken they were in rejecting the Bayonne Constitution, flawed though it was in some respects. It would have accomplished, at a stroke, what no internal reformer—none of whom had Napoleon Bonaparte's genius—could have done. It was conservative in its loyalty to certain basic traditions of Spain. The Church, for instance, was not to be destabilized, still less abolished; but its secular powers were somewhat clipped, and the Inquisition, that hateful instrument of injustice, was done away with. It would have been an immense boon to a country so ill-handled by its Bourbon rulers. It might have brought Spain into a modern Europe, as Napoleon's constitution had brought France. It could have spared the nation years of agony and bloodshed, one of the most ghastly civil wars in history, and a legacy of chaos, factionalism, and tyranny that would last for decades more. But none of these things occurred, and Spain slid inexorably toward the rim of the pit.

WAR WITH NAPOLEON

OMETIMES THE MOST DETERMINED of invaders, equipped with strong armies and copious intelligence about its enemy, can make myopic blunders that later seem close to madness. Such, in the twentieth century, was the humiliating fate of America in Vietnam. And such, at the dawn of the nineteenth, was Napoleon's in Spain. Compared with his Grande Armée, the Spanish armed forces were nothing in Napoleon's eyes, a joke: riddled with nepotism and corruption, top-heavy with incompetent officers, antiquated in organization, badly equipped, ill-trained, and small. (When war broke out, Spain had 115,000 men in its army, of whom 15,000 were isolated in Denmark as a result of an old agreement between Carlos IV and Napoleon.) But the Spanish army's worst and apparently insoluble problem was not the lack of men—Spain in the early 1800s had a population of 10.5 million from which a larger army could be raised—but the shortage of money. In the first months of the 1808 crisis, all single men and widowers between the ages of sixteen and forty were called up, but they could not be fed, shod, clothed, or even adequately armed. The plight of these ragged, barefoot conscripts was made worse after 1810, when the Spanish colonies in America revolted and the income they had provided dried up. The cavalry needed 9,000 horses but could muster only 6,000; few of its riders even had helmets, and they were outnumbered by the far better-mounted French by a factor of two or even five to one. Some Spanish artillery units were so ill-equipped that they had to use sixteen-pound cannon made from wooden staves reinforced by hoops of iron applied by blacksmiths,

which naturally burst after one or two shots. At the battle of León, the Spanish general La Romana had 23,000 men against Marshal Soult's 13,000-but only 9,000 of La Romana's troops had firearms, and they possessed no cavalry at all. These shortages prevailed all the way down the line. Meager bread-and-water soup, gazpacho, was the best luxury the rank and file could usually expect: one Spanish general became desperate with embarrassment at Wellington's repeated invitations to dinner, because he would have to reciprocate and, "as you know, on my table there is never anything more than bread." The reason behind all this was money, or the lack of it: Spain's national income in 1807 was some 700 million reales, and seven years later, bled white by the expense of war, it had dropped to half that amount. So the idea that the Spanish army could hold out for more than a week against the greatest war machine ever built seems unlikely; yet Spain resisted for six years. It even began its fight against Napoleon with an unexpected victory, in July 1808, at Bailén in Andalucía, when an army of 20,000 French troops—mere conscripts, not battlehardened, and very inferior to the men of the Grande Armée—was surrounded and beaten. The Spaniards then made the idiotic mistake of herding the survivors together onto a barren coastal island and leaving them to perish from starvation and disease. This startled Napoleon into upping the ante, and treating the Spanish conflict as a national war instead of the police action he had had in mind: he at once sent in another 250,000 troops. It also started a long train of mutual atrocities: the War of Independence was not the simple scheme of French vandals and heretics versus pious, brave patriots that the Spanish made it out to be.

But apart from a defeat inflicted on the French at Brue in Cataluña in 1808, when 4,000 French troops were routed on the slopes of the Montserrat massif by a mere 1,000 or so Catalan irregulars (the "citizen volunteers," or *sometents*), Bailén did not set a pattern of Spanish victories. When army formed up against army, the French usually won the battles. Yet they did not win the war. The Peninsular campaign turned out to be as grievous a disaster for Napoleon's Grande Armée as its failure to conquer the immense winter wastes of Russia.

Napoleon in Spain was defeated by the military genius of Arthur Wellesley, the future duke of Wellington, at the head of his English expeditionary force. But he was also beaten by the desperate collective will of the Spanish people—not the army alone but the nonprofessional soldiers as well, who invented a way of war that Napoleon's officers and men had never encountered before.

These were the guerrillas.

The word guerrilla, one of the most common military terms in the last quarter

of the past century, means "little war" and was used after 1808 to denote the struggle between bands of irregulars, or armed civilians, small and more or less spontaneously got together, against a formal State army. It was coined and first used in Spain—though the American rebels came up with it at the same time—and bequeathed to us by this popular struggle for Spanish independence two hundred years ago. At the time, since all wars were fought by professional armies—an unprofessional conflict out of uniform being merely a police action against a rebellious mob—there was no English or French word for what *guerrillas* did or were.

They were the unexpected product of a particular time and place, and at first neither side in the War of Independence—neither the regular Spanish and English forces on one hand, nor the invading French on the other—quite knew what to make of them. Some *guerrillas* were ordinary citizens, farmers and peasants who knew the areas they were fighting in. Others were deserters from the regular army or surviving remnants of defeated and scattered regiments. They all counted on, and generally got, the support of civilians in rural areas and villages. When it was not freely given, they enforced it. To outsiders, they seemed to be romantic *banditti* made flesh—and smelly, aggressive flesh at that. English reports dilated on the savagery of some *guerrillas*:

[Near Madrid] we observed [a *guerrilla*] take rather ostentatiously from his side a long, heavy-looking silk purse.... A general disgust pervaded the minds of my comrades and myself when we beheld a number of human ears and fingers... cut off from the bodies of the French whom he himself had slain in battle, each ear and finger having on a golden ring. "Napoleon," he observed, "loves his soldiers, and so do the ravens."²

An 1811 English account of the troops of the *guerrilla* leader Francisco Espoz y Mina remarked that when a man joined his band,

he is not allowed to bring anything but a pair of sandals, half-stockings, breeches, and jacket.... His arms are all rusty on the outside, but he is particularly careful to have them well cleaned within, and good locks and flints; his bayonets are encrusted with the blood of Frenchmen.... He never takes either a regular soldier, or a regular bred officer, into his corps. He says "They pretend to have too much theory"—and he sees they fail in all their attempts.³

Espoz y Mina was among the most celebrated of the *guerrilla* leaders, but there were many others: a British report to Wellesley sent from Lisbon in 1811

listed more than one hundred bands, varying in size from a hundred to several thousand. Juan Martín, nicknamed El Empecinado (The Stubborn One), fought at Castilla la Nueva with a force of 3,000 infantry and 1,000 cavalry. Operating from ambush or attacking under the cover of night, guerrilla bands did incalculable damage to the French army and its morale. Espoz y Mina, who by his own count took part in 143 battles or engagements, was able to hold up a force of 26,000 Frenchmen who would otherwise have taken part in the battle of Salamanca in 1812: "At Placentia... I made 12,000 infantrymen prisoners and put the whole cavalry to the sword." The French refused to treat guerrillas as authentic soldiers. They were bandits, robbers, and murderers, and all who fell into their hands were shot or hanged. "Powerless to exterminate our troops," Espoz wrote, "[they] began, in 1811, to wage a total war. . . . The same fate was reserved for those who helped the volunteers, and they carried off to France an infinite number of families." Like begat like; the guerrillas staged reprisals of their own. "I always kept numerous prisoners," he continued. "If the enemy hung or shot one of my officers, I would do the same by reprisal to four of his officers; for a single soldier, I would sacrifice twenty. It was thus that I managed to horrify the enemy, hoping that he would discontinue such an atrocious system, which is indeed what occurred."5

The guerrillas fought a relentless war of attrition against the French, weakening and distracting them so that, in the end, they were less able to beat off Wellesley's professionals. In answer to this, Napoleon's military authorities brought down an iron hand on the peninsula—one that Joseph Bonaparte, a decent enough man who sincerely wished to be more a Spanish monarch than a French rey intruso, was powerless to restrain. The policies that governed the French occupation and permitted its excesses were beyond his control—deliberately left so, because Napoleon did not want his mild and softhearted elder brother to get in the way of making Spain into a satellite. His generals ignored the appointed king, and levied ruthless exactions on his ever-rebellious subjects: executions without trial, mass imprisonments and deportations, confiscations of money and matériel, looting by the rank and file, a blind eye turned to rape and mayhem. And this, in turn, produced the inevitable dynamic of misery: savage resistance, followed by yet more savage reprisals. For occupying forces used to the idea of war as a series of formal battles, it was exceedingly demoralizing to survive on territory where nearly anyone, not just uniformed soldiers, could strike at you from behind the trees and vanish back into them; where every civilian sleeve contained a knife.

It was Francisco Goya's fate and genius to become the epic poet of this

After Jacques Callot and Claude Callot, Misery of War, Musée Bargoin, Clermont-Ferrand.

process, with his etchings called *Los desastres de la guerra—The Disasters of War*—and his two great paintings of the first uprising against Napoleon's troops, on May 2–3, 1808. The *Disasters* were not quite the first serial images by an artist of total war against a resistant civilian population; those were made in 1633, at a lesser level of detail and narrative intensity, by the French engraver Jacques Callot in eighteen plates known as the *Miseries of War*, in which tiny soldiers of Louis XIV are seen doing dreadful things to tiny Huguenots. But Goya's prints are incomparably the more dramatic and varied in their narrative, more piercing in their documentary power, more savagely beautiful, and, in every way, more humanly moving: nothing to rival them has been done since, and they are the true ancestors of all great visual war reporting.

The will and courage of Goya's Spain were sustained, in part, by an impenetrable ignorance and backwardness, in which blind nationalism took precedence over all the other emotions that liberalism might have had to offer. "The Spaniards," Napoleon wrote to one of his senior officers, Marshal Bessières, "are just like other peoples, and don't belong in a separate class." They were, he remarked to another, "vile and cowardly, about the same as I found the Arabs to be." He was wrong: no people is just like other peoples, though it may seem that way to its conquerors. He was quite sure that when he displayed "the words liberty, freedom from superstition, destruction of the nobility, I will be welcomed as I was in Italy, and the genuinely nationalist classes will be with me. You'll see how they think of me as the liberator of Spain."⁶

He could not have been more wrong. Napoleon had never been to Spain. He knew nothing about the country, and spoke no more Spanish than Lyndon Johnson spoke Vietnamese. Armed with the worst advice, he simply assumed that the Spaniards would embrace his brand of "liberation" in the same way that, 150 years later, the Americans fancied that Vietnam would accept their brand of democracy as the real article for them. But the Spaniards did not. Most thought of Napoleon only as an oppressor. His mistake was to suppose that Spain, like Italy and other nations of Europe, had an educated middle class open to liberal assumptions.

Which it did not, and never had.

Goya's Spain was about as intellectually backward as a nation can be. But its backwardness sustained its resistance: all the mass of Spaniards had to hold on to was a belief in their ser auténtico, their "true identity" as Spaniards. This was not an idea, still less a constellation of ideas, but a faith. What they understood—all they understood, one is tempted to say—was nationalism, that most primitive and compelling form of difference. They were pre-ideological, and this one passion held them together. Though Catholicism was practiced all over Europe, there was something peculiarly nationalist about its Spanish form; Christ had died for the whole world, but more for Spain than anywhere else. Consequently Spain, unlike Italy or Germany, contained very little with which the large progressive promise of Napoleon's power to conquer but reform could interlock. To many in the northern nations he took over, he had the aspect of a rather complex deliverer: on one hand, a military genius with a strong autocratic bent; on the other, a man who replaced old autocracies with new constitutions, created liberal systems, and practiced his belief in human renovation. But in Spain, except to the *ilustrados*, he was a ravening monster and nothing more.

This was the particular message of the Spanish Church, which feared the French and especially loathed Napoleon. To the clergy, France was the rats' nest of atheism and freethinking, and whatever was bad for it was good for God and his vicars on earth. Catholicism, especially in Spain, had not forgotten and would never forgive the French anti-clericalism of the eighteenth century, memorably expressed in Voltaire's call *écrasez l'infâme* ("Wipe out the infamy," meaning the Church) and culminating in the attacks on clerics and the seizure of Church property during and after the days of the Terror.

Now that Napoleon was not only the generalissimo but the absolute emperor of this diabolic state on the other side of Spain's mountain border, whose sol-

diers and agents were busy with the conquest of Spain—and, not incidentally, with the seizure and looting of Church property—it was hardly surprising that the official Church view of him, trumpeted in a thousand village sermons, was that he was evil prepotent: the Emperor of Hell, easily conflated with the mythical Antichrist himself. In English popular culture, "Boney" was demonized too:

Baby, baby, he's a giant,
Tall and black as Monmouth steeple,
And he breakfasts, dines, and suppers
Every day on naughty people.
Baby mine, if Boney hears you
As he gallops past the house,
Limb from limb at once he'll tear you
Just as pussy tears a mouse.

There he was a bogey to frighten children. In Spain he was worse: he terrified adults at the core of their religious being. The obsessive tone of the Church's response to Napoleon is captured in one of the popular printed catechisms of the day, a question-and-answer outline of the positions good Catholics should take on moral matters:

"Who is the enemy of our happiness?"—The Emperor of the French.

"Who is this man?"—A villain, ambitious, the source of all evil, the end of all that is good, the summation and storehouse [depósito] of all vices.

"How many natures does he have?"—Two: one diabolic and the other human.

"From what origin does he come?"—From sin.⁷

And so on, and so forth. The Church's anti-Napoleonic diatribes naturally had more impact on the *pueblo*, the common people, than on the tiny elite of educated *ilustrados*, for the former were apt to believe everything their priests said while the latter did not, and most *ilustrados* saw in the ideas of Napoleon the possibility of relief from the Church and the Bourbons. Besides, being realists, they did not think that Napoleon could possibly lose. For a Spaniard to be an *afrancesado*, a sympathizer and even a collaborator with the French, in 1808 was by no means a necessarily dishonorable thing. It was not like collaborating with the Nazis in 1943. There was every reason for an intelligent person of moderate views and a European outlook to believe that Napoleon would bring better days of government with him. Some of them regarded the Napoleonic

Code as a legislative masterpiece and wanted it, or something based on it, for their own country. In 1808 Napoleon had abolished the Inquisition and feudalism, suppressed two thirds of Spain's religious foundations, and knocked away much of the ideological underpinning of its absolute monarchy. To some Spaniards this was a historic advance. To others, it was an atrocious intervention. Unfortunately, there were always more of the latter opinion than of the former, and since the whole country was at war, it was difficult to make any reforms stick. So many *ilustrados* threw in their lot with Napoleon that at the end of the war, when he was at last driven out of Spain, no fewer than twelve thousand liberal Spanish families voluntarily went into exile, preferring life anywhere across the Pyrenees to persecution under the restored rule of the archreactionary Bourbon Fernando VII.

In the Meantime, Spain was politically stranded. A monarchy without its monarch, patriot Spain had no unifying government and desperately needed to form one. It had to construct a new state from the ground up while fighting off Napoleon. Somehow it had to bring into play all those reserves of discipline and self-determination that had been brushed aside by the absolutist *antiguo régimen*. At first, each region of Spain cobbled together its own *cortes*, or government. But these needed to be merged in a collective affirmation of national unity. This could not happen in Madrid, which José I controlled. So the fledgling parliament—the national Cortes, with three hundred deputies—met in Cádiz. This was the one city in Spain, other than Barcelona, where a liberal, bourgeois majority could be counted on. Its only aristocracy was commercial: practical, hardheaded, and fairly tolerant men, open to northern European ideas and, though by no means anti-monarchist, opposed to royal absolutism. With the Cádiz Cortes, the Spanish middle class, led by intellectuals, stepped firmly into political life.

The new constitution this Cortes approved was by far the most radical and democratic set of decrees yet ratified by a Spanish government. Its framers (fourteen of them, including five liberal clerics) went to some lengths to dissociate their work from the existing French Constitution of 1791: they were at war with France and did not want it said that they were basing their laws on hers. Hence their somewhat implausible claims that their constitution was really a recovery of ancient Spanish *fueros* (rights) that had existed long before. So it accepted kingship but abolished what it called *la funesta política del absolutismo*, "the baneful policies of absolutism." In future, Spain would be governed by an

elected assembly that would meet every year, and whose resolutions no constitutional king could cancel. It set in place most of the freedoms that democratic states take for granted today but that had not existed in Spain before: those of assembly, choice of occupation, speech, and the press. It also guaranteed the equality of all Spanish people throughout the empire, so that (for instance) a Cuban or Venezuelan had just the same rights as a citizen of Sevilla or Madrid; canceled all forms of privilege arising from military, aristocratic, and Church authority; curtailed the monastic orders, so disproportionately powerful in Catholic Spain; and abolished such hated institutions as torture and the Inquisition. The menu of reforms seemed endless, and to conservative interests extremely threatening.

In sum, the 1812 Constitution held out a radiant promise of hope to Spanish intellectuals and *ilustrados*, of whom Goya was one. His enthusiasm for it is clear from several drawings and a large painting that he made around that time. In one drawing in Album C, *Lux ex tenebris* (1812–14), he went some way to conflate the political event with a Biblical one. Its title, with one minor change, comes from a passage in the New Testament (John 1:5, Vulgate) referring to the arrival of Christ and his teachings in an uncomprehending world: "*Et lux in tenebris lucet, et tenebrae eam non comprehenderunt*"—"And the light shone in darkness, and the darkness did not understand it."

We see a young woman flying angelically in midair. A starburst of light emanates from her face and shines from the little book she cradles reverently in both hands. Too small to be a Bible or a breviary, it is presumably the printed Constitution of 1812. Below her are the forces of human retrogression, who indeed do not understand the message of the tiny duodecimo book: a dark soup of ink in which figures of monks and priests can just be made out. These are the clergy who had mobilized against the passage of the constitutional parliament, the enemies of freedom. On the next page of Album C, Sol de justicia, the theme is restated without the flying woman: this time, an evenly hung balance, archetype of justice, hangs in the air miraculously unsupported, an apparition (it seems) from heaven, shedding light on an amazed crowd of spectators. On the left, the beneficiaries of justice renewed clasp their hands in prayer and joy, and a young woman in the foreground capers with delight. On the right, the enemies of justice recoil; a priest (with his dark silhouette turned against us, a threatening blob of shadow whose biretta resembles a black cat's ears) slinks off, while monks and nuns gape and glare with apprehension. This is, literally, the struggle between light and darkness, la luz y las tinieblas, that some Spanish writers saw in the opposition between the "Liberals" who longed for the 1812

Left: Goya, Inquisition Album, *Lux et tenebris*, c. 1812–14. India ink wash and sepia, 20.5 x 14.2 cm. Museo Nacional del Prado, Madrid.

Right: Goya, Inquisition Album, *Sol de justicia*, c. 1820. India ink wash and sepia, 20.5 x 14.2 cm. Museo Nacional del Prado, Madrid.

Constitution and the "Serviles," or reactionaries, mainly clerics, who saw the Constitution's threat to their own interests as even worse than Napoleon's.

The largest work of art Goya dedicated to the emergence of Spanish liberty from the 1812 Constitution is now in Stockholm, not Madrid. It is the enormous canvas he produced in the last years of the Peninsular War, the Allegory of the Constitution of 1812 (1812–14). It is, in a sense, a sister painting to his Allegory of Madrid (page 305), except that it contains no approving references to José I. It has three figures in it. At the center is a handsome young woman in a simple white dress who may be an embodiment either of liberty or of the Spanish nation. She is radiant from the light that streams in from the upper left corner. In her right hand, stretched out, is a small book, again the printed form of the 1812 Constitution. Her left hand holds a slender wand or scepter, emblematic of noncoercive power, and her wrist is firmly held by an old, bearded man with enormous white wings outspread, enveloping her in a blaze of protective radiance and drawing her gently away from the darkness, which the little book is

Goya, Allegory of the Constitution of 1812, 1812–14. Oil on canvas, 294 x 244 cm. National-museum, Stockholm.

dispelling. He is Time, a fact made plain by the hourglass in his left hand, just as the sand in the upper glass indicates that the glass has just been turned and that a new era full of possibility is beginning. Old Man Time is drawing Spain (or Liberty) away from the darkness of the past. In a small oil sketch for this painting, the darkness swarms with the familiar creatures of Goya's nightmares, bats and owls, like the ones pestering the dreamer in *El sueño de la razón*; but Goya eliminated these from the final version. In the foreground is another

young woman, all but naked, writing with a quill pen on a sheaf of paper, her feet reposing on an open book on the ground. Clearly, she is History: her feet steadied on the archival past, her writings illuminated by the light that streams from Liberty's side of the picture. She is naked, or nearly so, because plain, unveiled Truth is the business of History. The whole concept of Goya's picture is permeated with ideals of plainness suited to the French Enlightenment and perhaps the American Revolution: the bare, emblematic figures, the simple and unembroidered white dress whose bodice has slipped a little, not for the sake of sexual titillation, but to reveal the nipples, and hence the nourishing beauty, of Liberty.⁸

THE MOST ELOQUENT TESTIMONY to Goya's feelings about war is spelled out at length in the Desastres. Almost from the moment that the Bourbon dynasty sold out to Napoleon in Bayonne he was overcome with what he would call, in the frontispiece to the cycle of war etchings that preceded and followed his two May paintings, "Tristes presentimientos de lo que ha de acontecer"—"Sad forebodings of what is going to happen." These etchings are known, for brevity's sake, as the Desastres de la guerra (Disasters of War). Their full collective title was much longer: Fatales consequencias de la sangrienta guerra en España con Buonaparte. Y otros caprichos enfáticos—"Fatal consequences of the bloody war against Bonaparte in Spain. And other emphatic caprices." Goya lived continuously in Spain through the whole course of the Peninsular War (1808-14). He was over sixty when it started—much too old for a war correspondent, and too deaf to hear a gunshot. And yet it is not too much to claim that his Desastres created a form of their own: that of vivid, camera-can't-lie pictorial journalism long before the invention of the camera, of art devoted to reportage, claiming its power as propaganda from its immediacy as an act of witnessing. Never mind that not everything, or even not much, that is depicted in them happened in front of Gova's eyes. He was the artist who invented a kind of illusion in the service of truth: the illusion of being there when dreadful things happen. Goya made this explicit in the captions to his plates. Yo lo vi, "I saw it," he inscribed under plate 44 (page 274) in which refugees from a country village are fleeing from the advance, unseen by us, of the French soldiers; but one can't help wondering if he did see that fiercely satirical conjuncture of the mother urging her terrified child to follow her and not look back, and the village priest on the left clutching the possession most dear to him, a bulging money bag, in the same way—since Goya never failed to squeeze more juice from a good motif—that the pathetic

priest in Capricho 30 clutches his twin bags of money that are also a pair of giant testicles. Y esto también, "And this as well," is the caption to the next plate, 45, which depicts three exhausted women plodding away from the unseen threat that shadows them, bowed under the weight of infants and household possessions, the sense of their effort to just keep going reinforced by the lowering darkness of the sky above and before them, with one solitary farm animal, a young pig, scampering in front. That Goya singled these out as things he had seen is also a tacit admission that some, probably many, of the events in the Desastres were things he had not seen but only heard about from others, or put together as epitomes from less coherent impressions of his own. Which is only to be expected: if he had been present at some of those incidents, he could not have escaped with his life.

Very few of the eighty plates are dated, and none were published in Goya's lifetime. So chronology is little help in picking out any specific events to which the *Desastres* refer. However, very broadly, the images fall into three groups. Forty-six plates, 2 through 47, describe incidents of guerrilla war, the Spanish *pueblo* against Napoleon's soldiers. Eighteen more, 48 through 65, are concerned with the effects of the great famine that devastated the people of Madrid between 1811 and 1812—a famine that Goya, living in the city, experienced too, and whose effects he saw at first hand. And then there are the *Caprichos enfáticos*, or "emphatic caprices"—a run of fifteen allegorical and satirical images, editorial cartoons rather than journalistic reportage, that attack what one might call the disasters of peace—evoking the shattered hopes of Spanish liberals and *ilustrados* in the wake of Napoleon's defeat after Fernando VII returned to the throne, abolished the 1812 Constitution, and set in train an iron policy of repression, censorship, inquisitorial tyranny, and royal absolutism.

Finally, there is the very first plate of the *Desastres*, the title page of the series. *Tristes presentimientos* is not an image of war. It shows a single emaciated man kneeling on the bare earth, dressed in prophetic rags, his breast bared, his arms extended in surrender and supplication. His face, eyes rolled to the sky, bears an expression of strain and inconsolable despair. Behind him, everything is rolled darkness, and what there is of landscape is reduced to a few dimly perceptible bare rocks. He is alone in the universe, and he has been granted, as Goya's title puts it, "Sad forebodings of what is going to happen." There will be no relief, no lightening, either for him or for us. He is Job on the dunghill of Spain; he is also taken from the familiar pose of Christ in his agony in the olive grove of Gethsemane, kneeling to beseech God the Father to let the cup of sacrifice pass from his lips and spare him the torments of crucifixion—

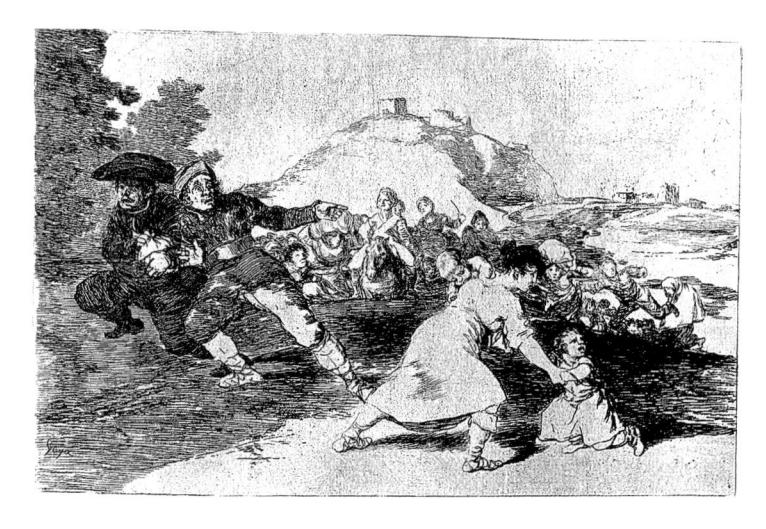

Goya, *Los desastres*, plate 44, *Yo lo vi* ("I saw it"), 1810–20. Etching and aquatint, 16 x 24 cm.

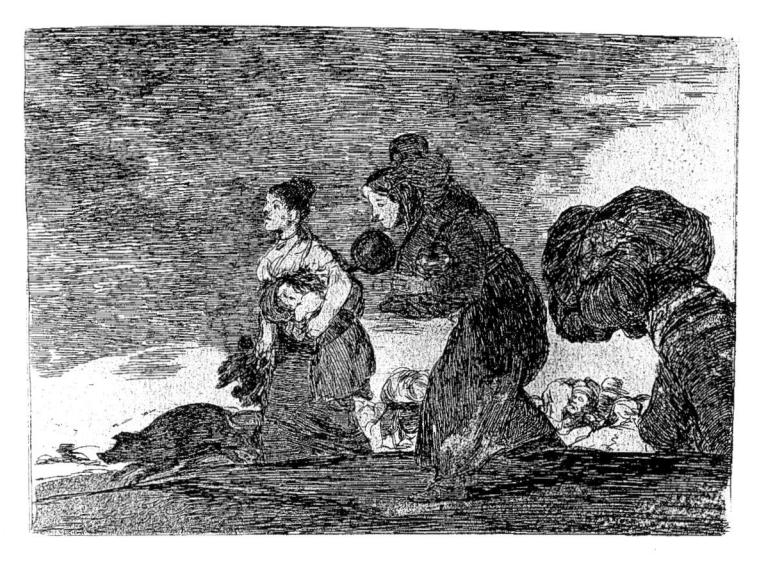

Goya, Los desastres, plate 45, Y esto también ("And this as well"), 1863. Etching and aquatint, 15 x 22 cm.

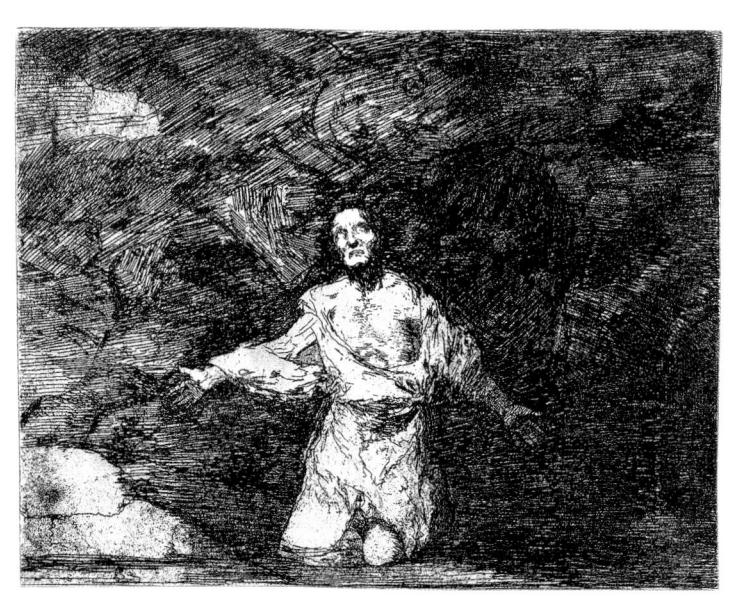

Goya, Los desastres, plate 1, Tristes presentimientos de lo que ha de acontecer ("Sad forebodings of what had to happen"), 1863. Etching and aquatint, 17.7 x 21.5 cm.

a pose familiar to every Spaniard who had seen the familiar effigies of the Passion narrative in his or her church. Like the rebel in the white shirt facing the French muskets in the *Third of May*, he is the Spanish people battered but not broken, face-to-face with a disastrous and heroic future that will be revealed in the plates to come.

DID ANY SINGLE EVENT set off Goya's decision to create this series? He was living in Madrid in May 1808, and although the stories that he actually witnessed the firing were pious inventions, he almost certainly saw some of the aftermath of the night's executions at the hill of Príncipe Pío—the outbursts of semirandom violence directed by madrileños on the street against French soldiers in the city, with poor and improvised weapons, pistols, axes, pikes. This could account for some of the incidents shown in the Desastres, such as plate 3, Lo mismo ("The same"), in which a frenzied Spaniard, his mouth agape and his eyes distended and glaring from his bony face, has raised a heavy-bladed axe to deliver the death blow to a French soldier struggling on the ground while a second patriot, seen from behind and straddling a second soldier, who is on his hands and knees, is on the point of stabbing his own victim with a knife. In Madrid, or in the countryside, or in a village? One cannot know. Goya's etching clearly reveals how he liked to explore, reuse, and recycle poses, sometimes for rather different ends. The man with the axe in Lo mismo is the very same man who, this time seen from the back, forms such a towering symbol of proletarian strength in Gova's painting The Forge (page 285); even his dress is identical except for the short waistcoat. Only the weapons and targets differ: the smith's hammer about to fall on a red-hot iron billet, the patriot's axe about to chop into the soldier.

It is also possible that the "trigger" of the *Desastres* was a visit he made to the city of Zaragoza a few months after the war began, in the first week of October 1808. Goya had been brought up in Zaragoza. His father worked there. He did his first big commissions for its churches. Zaragoza's heroic resistance to Napoleon's army became one of the legends of the Peninsular War; on a much smaller scale, it was not unlike the prodigious and nationally inspiring fight the Russian army waged against Hitler's forces at Stalingrad.

Zaragoza was first besieged in the summer of 1808 by a French force under General Baron Verdier. Its citizens forced the French to fight their way into the city literally house by house; every collapsed roof became a barricade, every cellar a bunker or a redoubt, every pile of rubble a sniper's post. One of the

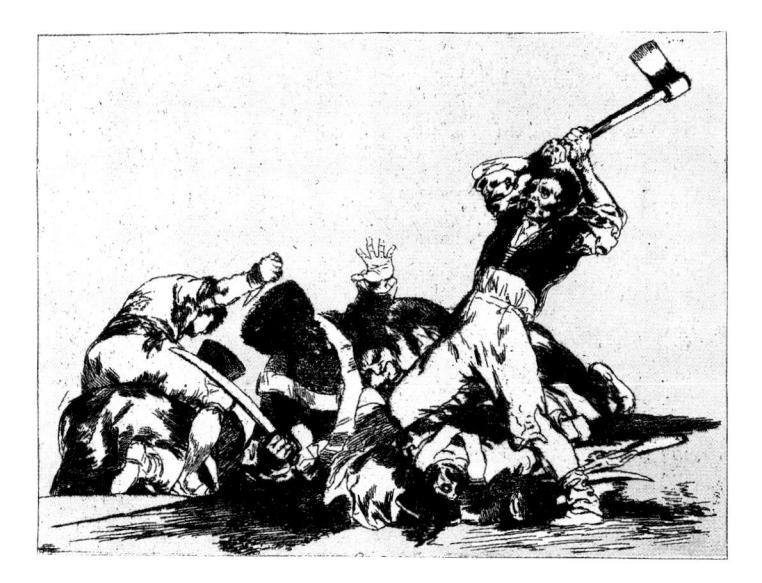

Goya, Los desastres, plate 3, Lo mismo ("The same"), 1810–20. Etching and aquatint, 17.7 x 21.5 cm.

Desastres plates, number 30, Estragos de la guerra ("Ruins of war"), depicts an appalling fragmentation, a jumbling of bodies and furniture, that seems like a prophecy of the effects of aerial bombardment or high-explosive shelling on a gutted house.

Thanks to the able generalship of the Spanish commander, Captain-General José de Palafox y Melci, the French assault failed—but only narrowly. In the lull that followed the first French siege, Palafox, a military genius but, equally, a man of invincible egotism, invited Goya to come and view the shattered remains of Zaragoza as testimony to the suffering and determination of its citizens. In a letter, Goya declared that, even though the trip meant that he could not attend the dedication of a portrait of Fernando VII he had been commissioned to do, he could not refuse Palafox's offer: it was his patriotic duty to record the evidence of the resistance. That he did go seems quite sure. He also did drawings and perhaps some oil sketches there: the diary of Lady Holland mentions that, in a wrecked house in Zaragoza once occupied by General Palafox, several studies by Goya had been found, slashed and mutilated by the sabers of the victorious French.

One great portrait emerged from that visit: his 1814 likeness of General Palafox on horseback. Goya was an able but by no means an exceptional horse painter: though the mounts on which he placed Carlos IV and his queen are certainly impressive animals, he was not as good with those beasts as Velázquez or
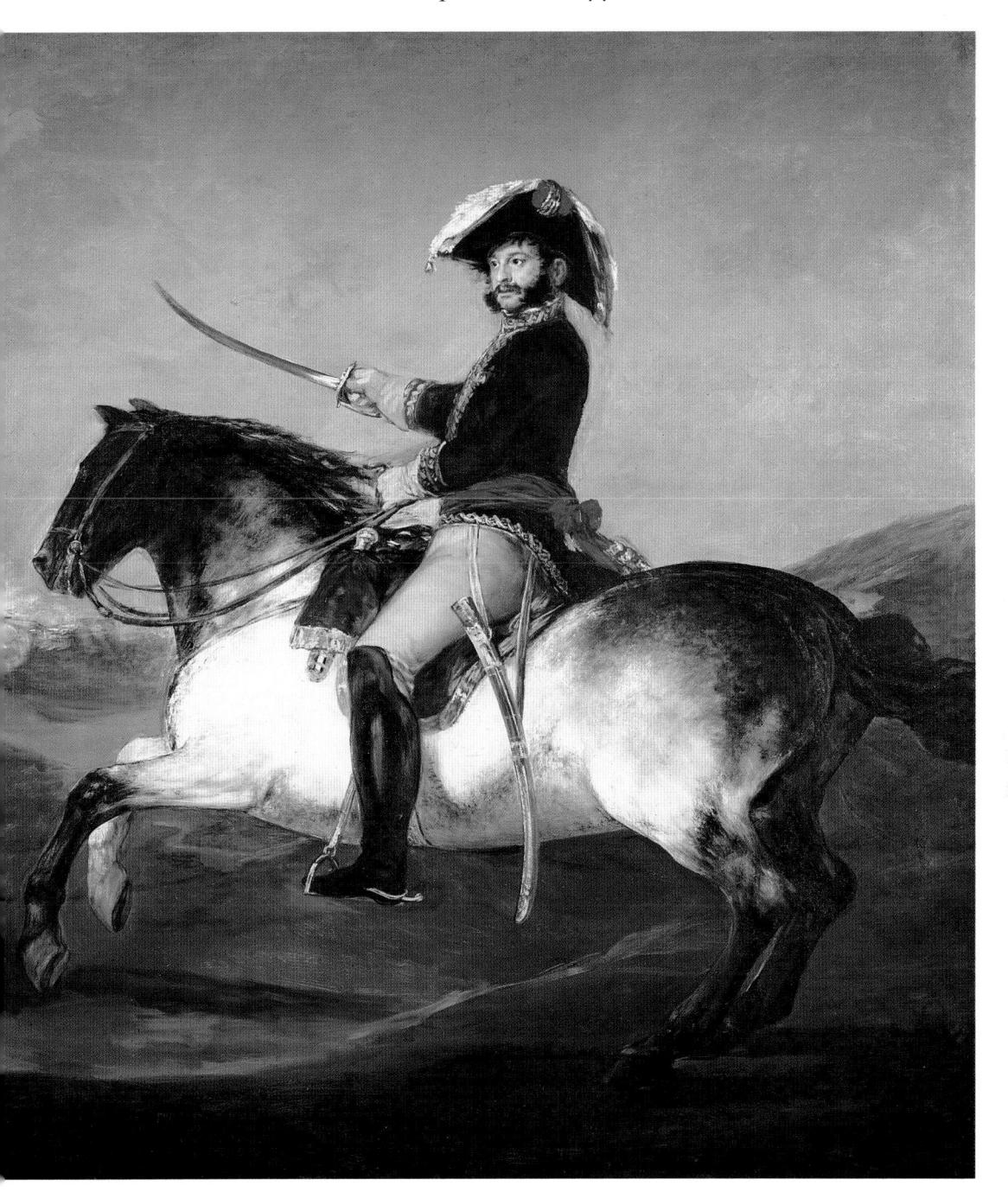

Goya, *Equestrian Portrait of General Palafox*, 1814. Oil on canvas, 248 x 224 cm. Museo Nacional del Prado, Madrid.

Stubbs. In fact, he tended to avoid doing horses, and there are very few of them (and those, only in the background) just where you might expect to see them in quantity, among the plates of the Desastres. But the ghostly white, blackshaded, pinheaded nag that plunges across the canvas of the Palafox portrait has immense energy, and suggests that one of the devilish, rawboned mounts of the Four Horsemen of the Apocalypse has been drafted into the military. Palafox himself, with his fiercely macho glare and luxuriant muttonchop whiskers, bestrides it a little awkwardly; we feel that the urgency with which his drawn saber is egging us on to the burning town on the horizon could be deflated if the animal jinked. But, as so often with Goya, one is filled with admiration at his compositional skills. The white part of the horse's body forms a rough arc, tied together (as it were) at the top by the crimson loop and knot of Palafox's sash. Only on reflection does one notice that this major arc is echoed by a minor one above: the white fur trim of Palafox's hat, which is similarly and deliberately united by the red cockade. These, plus his cuffs and the fire of Zaragoza burning on the horizon, are the only touches of bright color in the picture. The effect is wholly deliberate and yet, at first, hardly noticeable.

Goya's other depictions of an important military figure on the Spanish side were his portraits of Arthur Wellesley, future duke of Wellington. They stem from an extraordinarily beautiful and powerful head of Wellington done in pencil and sanguine, probably meant as the design for a print to be engraved by someone else. It was originally thought, from the testimony of Goya's grandson Mariano Goya, to have been made from the life in a nearby town after Wellington's victory in the battle of Salamanca (July 22, 1812). This is unlikely for a number of reasons: how would Goya, now sixty-six, have got to the front, and why would Wellington, after so long and exhausting a battle and with so much administrative work to be mopped up, have granted a sitting to an artist he did not know? The more plausible date is somewhat later—after the English Caesar entered Madrid in triumph, to be met by an ecstatic, half-starved citizenry delirious with gratitude, that August.

The drawing is a small masterpiece of insight. Wellington's face shows that he has beaten back the strain of battle, but at cost. The skin is stretched tight over the bony face of that *grand diable de milord anglais*, the mouth is resolute but tired, and the eyes have the "thousand-yard stare" of a man who has been among the cannon. It is very far from the conventional rhetoric with which artists (including Goya, sometimes) were apt to portray victorious warriors. Very probably, Goya meant it to be the basis of a portrait etching of Wellington, which—he could well have hoped—would have sold well to Spaniards in

Left: Goya, *Arthur Wellesley, 1st Duke of Wellington*, c. 1812. Red chalk drawing over graphite, 23.5 x 17.7 cm. The British Museum, London.

Right: Goya, Equestrian Portrait of the Duke of Wellington, 1812. Oil on canvas. Apsley House, London.

Madrid in the aftermath of victory. But this was not to be. After Wellington left Madrid, the French counterattacked (on November 2) and reoccupied the capital. They were driven out by the English on November 6, but installed themselves again on December 2, not to be finally expelled until late May 1813. There would have been no prospect of publishing or selling such a print under a renewed French occupation, and so the engraving was never done.

The drawing became the basis for the head of a huge but very inferior painting of the Duke of Wellington on horseback. This picture rarely appears in books on Goya, and for a sound reason: it is a wreck, in such bad condition as to be almost illegible. Moreover, it seems to have been painted on a reused canvas whose horse may originally have supported the corpulent frame of Godoy, although that is far from certain; it was more probably an abandoned portrait of the French intruder-king José I on horseback, scraped back and reused by Goya because of the shortage of canvas. By the late spring of 1813 poor Joseph Bona-

parte was, in any case, out of the picture; the defeat of his forces at the battle of Vitoria (June 21) ended in the complete triumph of the English and a veritable orgy of looting. Wellington's 15th Light Dragoons carried off José's enormous silver chamberpot (which still adorns their regimental mess) and thus earned the nickname "The Emperor's Chambermaids."

A curious and quite untrue story concerns the making of this picture: that Wellington did not like it, that he spoke slightingly of it to Goya's face in his studio, and that the hot-tempered, stone-deaf artist (whose ability to lip-read English, a language he could not speak, must have been slight indeed) was only narrowly discouraged from insulting and striking the great general. What really happened, it seems, was that while posing for Goya in the studio in Madrid, Wellington flew into a rage at one of his subordinates for acting without orders. Goya was at a loss to understand why "Lord Willington" had lost his temper, and was immensely relieved when it was explained to him that the Iron Duke was not infuriated by his likeness. Indeed, within a couple of weeks of its completion, the portrait was hung in the Academia de San Fernando in Madrid, and Goya wrote to a friend that its subject "manifested a great deal of pleasure" when he saw it. 12

ONLY TWO PAINTINGS documenting the actual work of war can be connected to Gova's 1808 visit to Zaragoza, and they were done from memory aided by nowlost sketches some years afterward, around 1810-14. They show two vital aspects of munitions manufacture that had to be carried on clandestinely by partisan groups in the wild recesses of the Sierra de Tardienta, about thirty miles outside Aragón: the making of gunpowder and the casting of shot. Each had its difficulties. Homemade gunpowder, a mixture of finely ground sulfur, charcoal, and saltpeter, is unstable and apt to explode at the smallest spark. Making small shot requires a "shot tower" from whose top molten lead can be poured. It cools in free fall on the way down, solidifying into small spheres: buckshot. A secret tower was obviously out of the question—the French could have seen it miles away. Larger-caliber lead balls need to be cast in individual molds, and that is going on in Gova's picture Making Shot in the Sierra de Tardienta. In a woodland scene of great beauty and freshness, with the pale-blue, jagged peaks of the sierra in the background, three groups of men are at work in the shade of immense oaks, which themselves have a meaning as symbols of endurance. The group on the right is melting lead over an open fire and ladling it into molds to cool. On the left, the cooled shot is being trimmed from its

Goya, Fabricación de balas (Making Shot in the Sierra de Tardienta), c. 1810–14. Oil on board, 33.1 x 51.5 cm. Palacio de la Zarzuela, Madrid.

Goya, Fabricación de la pólvora (Making Powder in the Sierra de Tardienta), c. 1810–14. Oil on board, 32.9 x 52.2 cm. Palacio de la Zarzuela, Madrid.

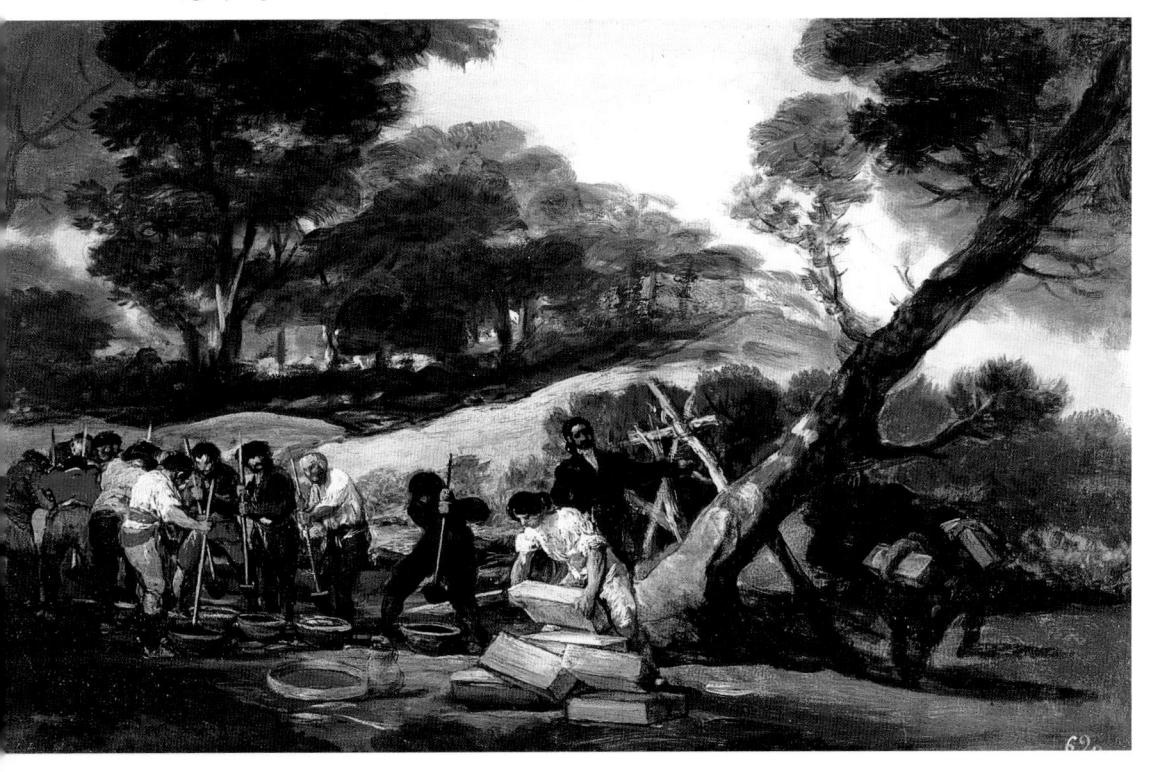

sprues with shears and stacked in pyramids. At the center, three men are working a primitive tumbling mill: a barrel on a horizontal axis, supported on posts and turned by two handles. When it is laden with the roughly trimmed shot and turned, the friction of the lumps of lead against one another wears them down like soft river pebbles, rounding them and so giving them a more ballistically efficient shape.

Goya wants to take us through the process, with careful and correct information. His respect for workers and their work demands that. He wants to be quite sure that we *know* what these men are doing for their country; that we do not see them as merely allegorical or symbolic figures; that they are real and present to us as fully skilled people, as concretely necessary to the work of war as any soldier. Goya reminds us that resistance means mutuality, teamwork, and it is not just a matter of some fine turkey cocks in gold braid saluting and presenting arms. Men *work* for freedom. The same spirit infuses the companion picture, *Making Powder in the Sierra de Tardienta*, but if anything more clearly so.

Both pictures may well represent the doings of a patriotic Aragonese named José Mallén, a shoemaker from Almudévar who organized a group of guerrillas into making powder and shot in the mountains outside Zaragoza in 1810. One of Goya's friends remarked on why Goya wanted to paint such activities: he sought to record "the hatred that he felt for the enemy; which, being his natural way of feeling, was increased on the invasion of the Kingdom of Aragón, his native land, whose immense horror he wished to perpetuate with his brushes." There can be no doubt about Goya's sincerity, any more than one need feel the least skepticism about the excuse he gave the secretary of the Academy of San Fernando explaining why he could not be at the inauguration of his portrait of Ferdinand VII: "His Excellency Don José Palafox called me to go to Zaragoza this week in order to see and examine the ruins of that city, with the intention that I should paint the glories of its inhabitants, something from which I cannot be excused because the glory of my native land interests me so much." ¹³ Goya was certainly telling the truth, and indeed there would have been no real contest between seeing the ruins of Zaragoza, so intensely interesting to a patriot journalist, and having to gaze once more on the uninspiring countenance of the future Bourbon tyrant.

Goya's image of powder making is an eyewitness's account. Gunpowder is made by crushing separately two naturally occurring ingredients, sulfur and saltpeter, and carbon, prepared by burning wood. When mixed in the correct proportions, these become an explosive compound. In the painting we see the crushing being done in the most primitive of stamping mills: a group of a dozen

or so men, each with a wooden mortar and pestle. In the foreground lies a sieve, which will sift the powders to the correct fineness. Next to it a figure in white—possibly a woman, to judge from the hair—is preparing boxes to be filled with the mixture. Other people are carrying full boxes away. Behind them stands the bearded, white-shirted powder master, probably José Mallén himself, directing the whole operation.

It was very difficult to get art materials during the war, and Goya's small paintings of shot casting and powder grinding are witnesses to that: one is painted on an irregular cedar panel that may have come from an old door, the other on a piece of pine board that bears traces of a coat of green paint from some earlier domestic use. The rarity of good materials highlights Goya's generosity in giving away his stock of fine artist's canvas, always in short supply, to the defenders of Aragón, who needed it for bandages. Under such shortages, to paint a large canvas was an act of particular emphasis: it asserted that the subject was really important. Hence it was of peculiar significance that three of Goya's biggest noncommissioned canvases were of common, ordinary working people who could not possibly have paid for them (or, probably, wanted to). Moreover, no upper-class collector was likely to want big pictures, two-thirds life-size, of unadorned and nonallegorical proletarians—a knife grinder, a female water carrier, men hammering iron at a forge—as décor for his walls. So what was going on?

Certainly, more than meets the eye.

For whom were the pictures painted?

Probably not an individual but a general public: a public that needed to have its faith in Spain as a secular reality reinforced at a moment of extreme crisis; that needed the strengths of the Spanish people as a *pueblo*, not an abstraction of class, affirmed for it; that knew it must believe in Spain's *ser auténtico* or perish. But how did Goya expect these pictures to be seen by the public in the absence of museums or other venues for temporary exhibition in the modern sense? One cannot guess.

Each of the three figures is, in his or her own way, an emblem of resistance—and not at all an abstract one. One of the features of the Zaragozan resistance most often pointed out as proof of the sheer stamina of Aragonese patriotism was the toughness and defiance of the women. Undeterred by sniper fire, shot, and shell, they fought hand-to-hand against the French soldiery and, as Goya noted in the caption to plate 5 of the *Desastres*, they were "like wild animals." They carried food and ammunition to the men on the ramparts; a woman named María Agustín became celebrated for the jug of brandy she lugged

Goya, *La aguadora (The Water Carrier)*. Oil on canvas, 68 x 52 cm. Szépművészeti Múzeum, Budapest.

around to give the men courage. And of course they also carried water, without which men cannot fight. *The Water Carrier*, with her lidded pitcher and her basket and tin cups, has to be one of these indomitable women. We see her from slightly below, towering over us. She rises up like an emanation of the Spanish earth, legs firmly apart, thickset—*la ben plantada*, "the Well-Planted One" of Catalan folklore, in person. She is painted roughly but with perfect tonal judgment; in places the pigment is almost troweled on like mortar. She is not pretty, exactly, but her youth and vigor are impressive and reassuring. You would be very grateful to see her if you were crouched stiffly behind a rock in the parching autumn sun of Aragón, breathing hot dust with the ricochets whining above.

In the same way, both *The Knife Grinder* and *The Forge* are locked into the imagery of resistance. *The Forge* is a straightforward painting of three blacksmiths at work. It is based on a sepia-wash drawing of three men digging, but here the field hoes are replaced by tools of the smithy; a long-handled hammer in the hands of the white-shirted man whose back is closest to us, and a pair of tongs with which his partner is pushing the red-hot workpiece down on the anvil. The men are as strong as horses, the forms of their muscular arms and the brilliantly articulated back are like rocks, and their faces are coarse to the point

Left: Goya, *La fragua (The Forge)*, 1815–20. Oil on canvas, 181.6 x 125.1 cm. The Frick Collection, New York.

Right: Goya, *El afilador (The Knife Grinder)*. Oil on canvas, 68 x 51 cm. Szépművészeti Múzeum, Budapest.

of peasant brutishness. They, too, are unmistakably representatives of the *pueblo*, hammering out Spain's future—to use a common phrase of the day, which may have supplied Goya with the allegorical dimension of his painting—on the anvil of its history.

In one of the more famous phrases of the Peninsular War (as famous in its time as Brigadier General Anthony McAuliffe's immortal response to the Nazis' demand for surrender at Bastogne during the Battle of the Bulge: "Nuts!"), General Palafox had promised the French "Guerra y cuchilla"—"War and the knife." The knife was the basic guerrilla tool, because it was the basic rural tool. One of Goya's Disasters (page 97) shows a dead man at the stake, garrotted by the French por una navaja—for carrying a pocketknife. It was certain death to have one found on you during a French search. Goya's knife grinder is a fairly low-looking man—as low, say, as the white-shirted martyr flinging out his arms at the French muskets in the Third of May. Low-class, low-origin, lowbrow. He

Goya, *Coloso (The Colossus)*, c. 1810–12. Oil on canvas, 116 x 105 cm. Museo Nacional del Prado, Madrid.

has the greasy sheen of sweat on his unshaven face as he crouches to his task. But the slow rotation of the big grinding wheel is inexorable, and one is put in mind of the proverbial millstones of God. You can almost hear the sibilant rasp of steel on stone. He is the Frenchies' doom: the pig-stubborn *pueblo*, who will keep sharpening when he should know he is beaten.

If this trio of large canvases obliquely commemorates the war, a fourth, probably datable to about 1810–12 (it is listed in Goya's inventory of possessions for 1812), seems directly to allegorize it. Today it is known as *The Colossus* or *Panic*, although its original title was *The Giant*. In part because of its extraordinary

War with Napoleon · 287

drama, this painting is one of the most frustratingly enigmatic Goya ever made. Who or what is this enormous, muscular figure, rising in an attitude of angry defiance like a boxer taking his stance—but a blind boxer, his eyes tight shut above the gently rolling landscape of northern Spain? Is he walking in the distance beyond the hills or rising out of the ground, a vast emanation of the Spanish earth itself? Why are those terrified people and farm animals fleeing in all directions, impelled by an inscrutable panic? They are refugees, obviously; men, women, families. Wagons are loaded with their possessions. Their livestock are scattering. It is a scene of utter confusion. You cannot know whether the giant is a benign personification of Spain, bracing and ready to beat off its attackers, or an emblem of the feared and hated power of Napoleon's army. Among the various possibilities, the most intriguing, perhaps, is Nigel Glendinning's suggestion that Goya's image illustrates a prophetic poem by the Basque writer Juan Bautista Arriaza, La profecía de los Pirineos (The Prophecy of the Pyrenees, 1808), which envisions a guardian spirit rising from the mountains to crush Napoleon.14

And then, of course, there are the images of the war that come more or less directly from Goya's own experience of its battlefields. He had been an indirect observer, since one may discount the possibility that he had ever seen battle with his own eyes. But he had certainly visited some of its sites. We do not know with any certainty how many of the *Desastres* were inspired by Goya's return visit to Zaragoza. The only one that certainly was shows a scene that he

Goya, Los desastres, plate 7, ¡Qué valor! ("What courage!"), 1863. Etching and aquatint, 15.2 x 21.5 cm.

could not have witnessed while he was there, since he went in the lull between the first and second phases of the siege.

This is plate 7, *¡Qué valor!* ("What courage!"). It is the only conventionally "heroic" plate in the whole series—heroic in that the artist presents a character as entirely courageous and worthy of admiration, neither a helpless victim, nor a person driven by terror to involuntary acts of courage, nor a bestial and atrocious intruder: in short, as a citizen in full command of her humanity. This person was already a legendary heroine when Goya reached Zaragoza: she was Agustina of Aragón, a young Zaragozan woman who, with complete disregard for her own safety, had clambered over the bodies of slain defenders on the ramparts of the city (a pile that was said to have contained the corpse of her lover) in order to fire a twenty-six-pound cannon at the advancing French. (She survived the war: a proud Spanish friend pointed her out to Lord Byron some years later as she took the air among admiring citizens on the *paseo* in Sevilla.) It is an unforgettably powerful image: the ponderous cylinder of the barrel under the control of this slender creature, whose face we do not see but whose determination radiates through every line of her body; one cannot suppress a shudder at the thought of her feet balancing precariously on the corpses of her fellow citizens as she lowers the match to the touchhole. Much of its power, of course, comes from the geometrical severity of Gova's composition, which in its way is as Neoclassical as a David: the pyramidal hill, the heavy arc of the wheel on which the cannon is mounted, and the higher pyramid of the heap of bodies culminating in the figure of Agustina all tersely combine the impression of impersonal force with individual sacrifice.

The bravery of women in defense of their home territory, their *patria chica*, is an important theme running through the *Desastres*. All witnesses to the defense of Zaragoza, French as well as Spanish, agree that the women of the town fought with unrelenting desperation, not only giving support to the fighting men by carrying water, powder, shot, and food to their positions, fortifying strongholds, and making barricades, but often by hurling themselves in Medealike fury on the invaders with whatever weapons came to hand—kitchen knives, stones, improvised pikes. In the background of plate 5, *Y son fieras* ("And they are like wild animals"), Goya has etched the epitome of such a clash: on the left, a woman holding a rock over her head, about to heave it at a Frenchman; on the right, the French soldier leveling his musket at her. Complete inequality, woman against man, the Stone Age against gunpowder warfare. But in the foreground, at least, the brave women have their moment. In front of a confused heap of figures struggling on the ground, a woman assails a

Goya, Los desastres, plate 5, Y son fieras ("And they are like wild animals"), 1863. Etching and aquatint, 17.7 x 21.5 cm.

Frenchman with a pike. Pierced in the groin, he reels back like an insect on a pin. She has her baby on her hip, as though carrying it at market time. The conjunction of the helpless child with the mother's determined assault is brilliantly theatrical.

There is, and always has been, some art about war that poses as a kind of remedy: if only everyone felt the same way as the artist, there would be no more massacres, no rape, no lunacy, and art would have demonstrated its power to mobilize the moral imagination. At no point in the *Desastres* does Goya allow himself, or us, to indulge in this sentimental fiction. He was the first painter in history to set forth the sober truth about human conflict: that it kills, and kills again, and that its killing obeys urges embedded at least as deeply in the human psyche as any impulse toward pity, fraternity, or mercy. Most of all, he drives home the undeniable message that there is nothing noble about war: that, in the words rasped from the throat of General Sherman to the graduating class of the Michigan Military Academy in 1879, "I am tired and sick of war. Its glory is all moonshine. It is only those who have neither fired a shot nor heard the shrieks and groans of the wounded who cry aloud for blood, more vengeance, more desolation. War is hell."

The truth of war lay beyond rhetoric. This was the irreducible fact that, in a time clogged and sugared with every kind of false promise about the chivalrous nobility of war, Goya brought back from the killing fields of Spain and put in

Goya, Los desastres, plate 32, ¿Por qué? ("Why?"), 1863. Etching and aquatint, 15.2 x 21.5 cm.

the forefront of his work. There were no "triumphs" to give what commentators are apt to call "balance" or "perspective" to the *Disasters*. This, too, is part of his modernity.

War turns the words of its partisan commentators into fustian. Goya bluntly and scrupulously rejected this. You never feel the presence of the kind of sentimental claptrap that likes to chatter, like some modern American "historians" of World War II, about "the greatest generation." Each of the plates of the Desastres bears a caption scrawled below it, ancestor of the captions of modern political cartoons. But they are extremely laconic, even more than the captions of the Caprichos. "That's tough!" ("; Fuerte cosa es!"), he writes under a macabre scene (plate 31) of a hairy, frazzled ape of a French soldier sheathing his blade as he turns away from the wretched body of a hanged villager, on whose feet another invader is pulling, the better to strangle him. In plate 32, the same situation—a victim slowly choking on a rope tied to a tree that is too low to suspend him, so that the strangling tension must be supplied by one soldier tugging on his legs and another shoving at his shoulder blades with his boot—is simply captioned "¿Por qué?" ("Why?"). No answer is expected; there is no "why," Goya implies, because that's the nature of war. No quieren—"They don't want it"—says the caption to plate 9, in which a French soldier is struggling to rape a resistant young woman who tries, ineffectually, to scratch his face while an older one, perhaps her mother, comes from behind him like an avenging Fury,

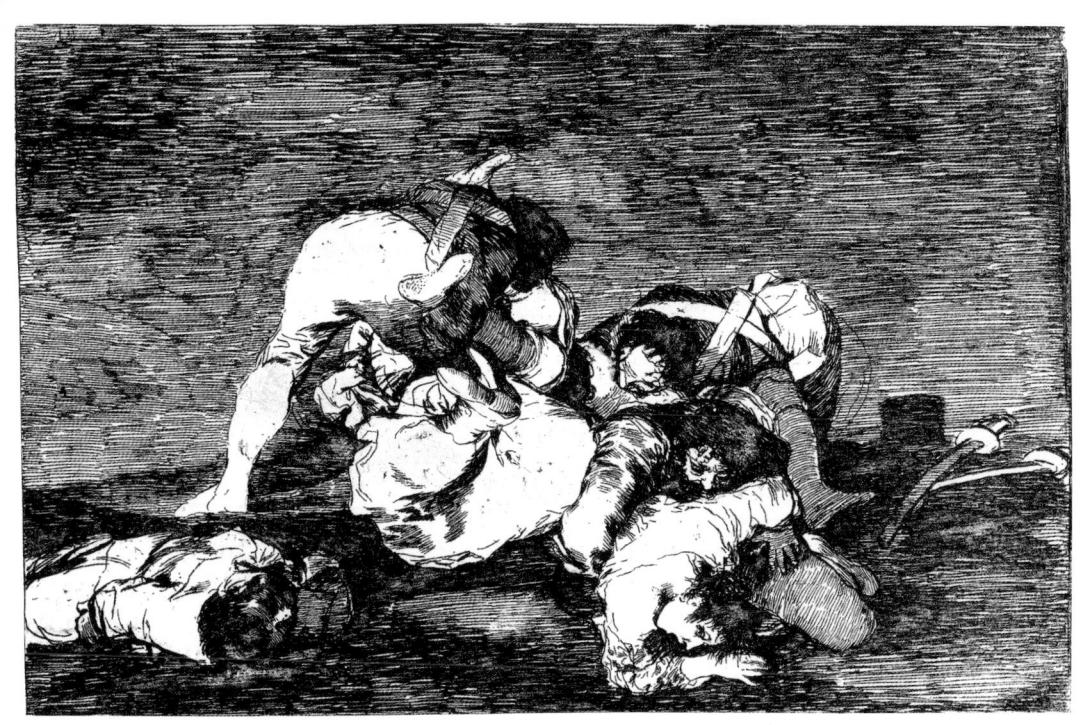

Goya, Los desastres, plate 10, Tampoco ("Nor do these"), 1863. Etching and aquatint, 15.2 x 21.5 cm.

Goya, *Los desastres*, plate 11, *Ni por ésas* ("Nor those"), 1863. Etching and aquatint, 17.7 x 21.5 cm.

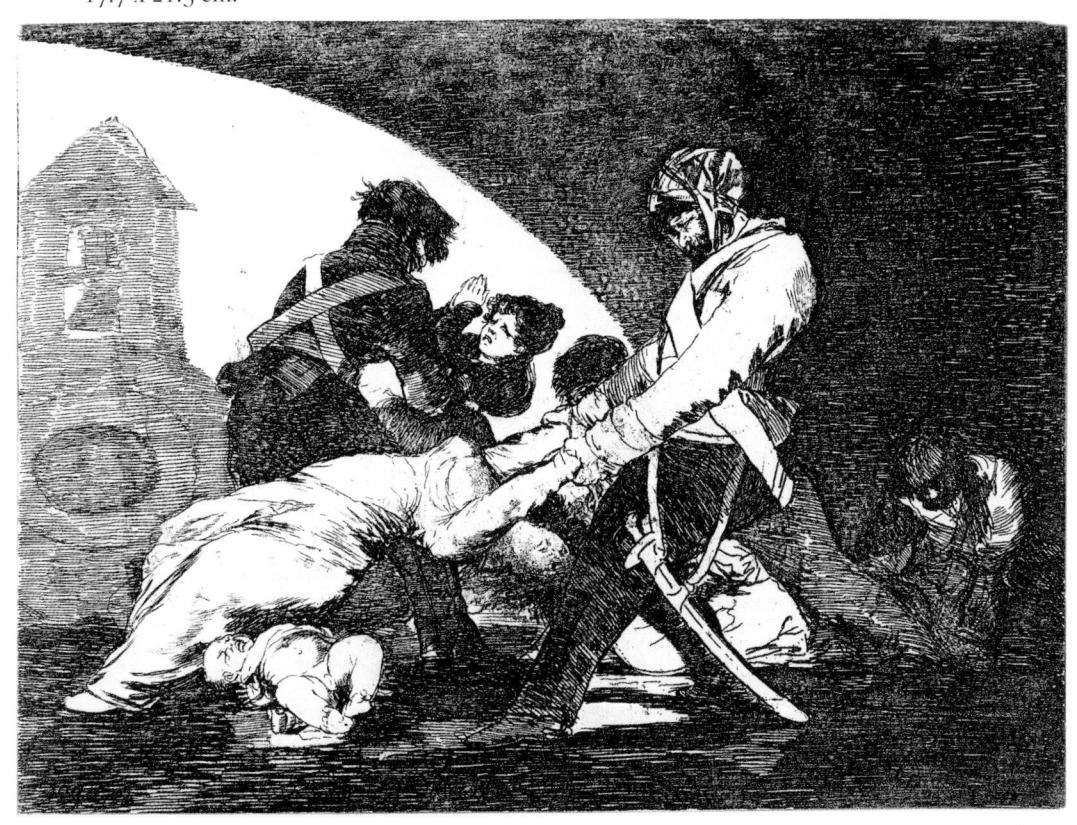

about to plunge a knife into his back. Tampoco, "Nor do these," says the next, plate 10—a chilly understatement, given the nature of the scene: a brutish and incoherent tangle of bodies, where three French soldiers (their sabers laid almost demurely aside as their penises, by implication, take over) struggle on the bare ground with their women victims, under the lowering murk of the evening sky. Ni por ésas—"Nor those"—says plate 11, compositionally the most developed of the three rape scenes, an image that shows to a sublime degree what power Goya could develop when his talent for showing awful events in terms of utter compositional starkness was fully at work. The design is like the quadrant of a clock face: half of a low arch through which light shines, and a man and a woman, brightly lit, stretched across it at forty-five degrees, like a minute hand. The man, a French soldier, is dragging his victim backward over some obstacle. There is a brutal tension in their arms, which create the unifying diagonal of the design: the man pulling, the woman's body helplessly extended. On the earth, at her feet, is a naked baby, torn from her and thrown away. Behind them, a second soldier is overwhelming another woman, who holds up her hands in a useless prayer of supplication.

You cannot always tell whose side the dead were on, or whether the atrocities are "bad" (committed by French against Spaniards) or "good" (by Spaniards against the French or traitors to the Spanish cause). This is not, of course, because Goya equated the two sides or was indifferent to Spanish suffering. On the contrary: it reflected, as in a dark mirror, what he felt the essential subject of the Desastres had to be. If he read them, as he probably did, he would surely have agreed with the words of Jovellanos's close friend, the liberal patriot Manuel José Quintana (1772-1857): "Puesto que es absolutamente necesario un sacrificio de sangre, mejor es ofrecerla en holocausto a la Patria que a la ambición de un tirano" (Given that it is absolutely necessary to shed blood, better to offer it as a holocaust to the fatherland than to a tyrant's ambition.)¹⁵ Goya's excoriating cycle of prints is neither pro-Spanish nor pro-French, but against war as such. It could hardly have retained its eloquence, its sense that, in Wilfred Owen's words, "the Poetry is in the pity," if it had been otherwise. Part of the brilliance of this series, strange as this may seem at first, is to be found in its ambivalence. Its sympathies oscillate without settling into the kind of plain resolution that one expects from propaganda. How often has one heard, or read, Gova's interpreters dilating on the sympathy and loyalty the Desastres express toward the common people of Spain? And yet there are plates that invert that simplicity.

One of them is 28, *Populacho*. A prone and broken body, lifeless or nearly so, is stretched facedown on the ground. It has been dragged there by a rope knot-

Goya, Los desastres, plate 28, Populacho ("Mob"), 1863. Etching and aquatint, 17.7 x 21.5 cm.

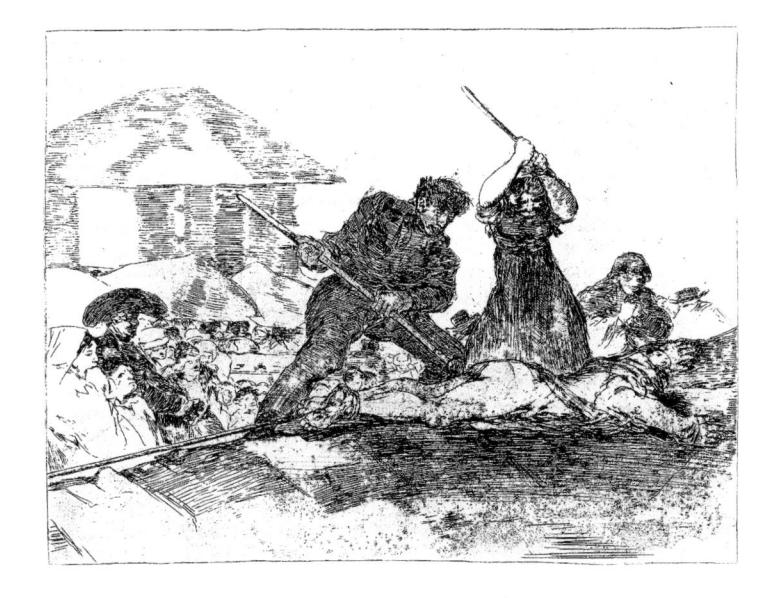

ted around its ankles. A muscular woman of the people, a villager, is whaling at it with a stick, or perhaps a metal bar. The horrible detail is what her peasant companion is doing, under the gaze of an assembled crowd. He has an implement commonly used in bullfighting, a razor-sharp sickle blade on a wooden shaft that was known, for its shape, as a media-luna, or half-moon. The medialuna was used to sever the hamstrings of bulls, to render them helpless and unable to move. The brave villager is about to shove it into the anus of the man on the ground, who—since he wears no identifiable uniform—we may take to be a civilian French sympathizer, one of the afrancesados hated by the Spanish peasantry. The title of the image is one contemptuous word, spat on the page: Populacho, which does not mean "people" but "rabble." This is not the utterance of a sentimental populist. Goya has no doubt, and leaves us none, that the patriots can be as brutal, sadistic, and depraved as the invaders; and sometimes he leaves open the question of which are the murderers and which the victims. The naked, the dismembered, and the dead wear no uniforms to identify them, which makes it impossible to know in which direction one's pity should extend.

There were cases in which the French killed and mutilated Spanish partisans, and left their wretched remains exposed as a warning to villagers and passersby. However, there were ample instances when the patriots did the same

Goya, Los desastres, plate 37, Esto es peor ("This is worse"), 1863. Etching and aquatint, 15.2 x 21.5 cm.

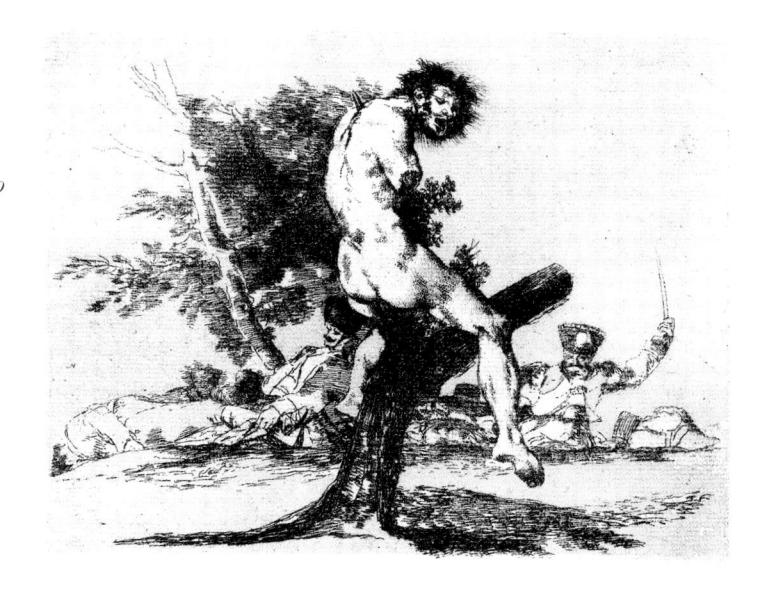

Goya, Los desastres, plate 39, ¡Grande hanzaña! ¡Con muertos! ("Great feat! With dead men!") 1863. Etching and aquatint, 16.5 x 21.5 cm.

to the French, or to other Spaniards whom they believed, without any trial at all, to be collaborators. Impartially and unblinkingly, Goya set both before his viewers. You realize, for instance, that the men hanging from the three trees by a roadside in plate 36, another one called *Tampoco*, have to be patriots because a French officer leaning on a stone with a sort of grisly detachment is contemplating them. In the same way, it is clear that the main figure in plate 37, *Esto es peor* ("This is worse")—impaled from anus to neck on the sharp branch of a dead tree, his right arm chopped off—cannot be other than a Spaniard, because the figures behind him, one brandishing a saber and the other dragging a second corpse into position for some (no doubt) equally disgusting mutilation, are

also French. But how is one to read an image like plate 39, *¡Grande hazaña! ¡Con muertos!* ("Great feat! With dead men!")? This is a sickeningly effective play on the Neoclassical cult of the antique fragment. Bits and pieces of human bodies—a headless and armless trunk, two arms tied together, a bodiless head, and a castrated corpse—are hung on a tree, to terrify the passerby. They remind us that, if only they had been marble and the work of their destruction had been done by time rather than sabers, neoclassicists like Mengs would have been in esthetic raptures over them.

But whose dismembered flesh is this? Goya offers no clue. They might be patriot bodies. Equally, they could be French ones, or the remains of *afrance-sado* collaborators, done to death by Spaniards.

The ruin of the human body is paralleled, in the *Desastres*, by what Goya sees inflicted on nature itself. Nature suffers a similar death: the process of stripping and schematization that began in the background of the *Caprichos* ten years or more earlier is now almost complete.

When Goya painted his Highwaymen Attacking a Coach for the Osunas in 1786-87, some twenty years before that, the frame for human death was an exuberantly leafing slice of nature, irresistibly alive and in ironic contrast to what men were up to. Now, one might say, man and nature are in harmony: ravaged, exhausted, equally threatened by death. The backgrounds to the Desastres are pared down to their simplest constituents: a band of earth, a hill, a dark, opaque sky, a rock. There is little or no detail. Shadows are looming and abstract, and all the more forcible for that. This is a landscape without resources. Its physical exhaustion is an emblem of the human moral exhaustion of war. Most of the trees Gova shows us are oaks—traditionally, emblems of hardiness, long life, and nobility-but they are perverted, by implication, because they no longer have the wholeness of nature; they have been reduced to stumps or turned into gallows or racks on which human carcasses are held up to execration by their enemies. The landscape of the Desastres is perhaps the first realization, in graphic art, of the landscapes that would become so ominously familiar to Europeans a century later: the almost featureless deserts of mud, shell holes, and blasted trees into which trench warfare had turned the once bountiful fields of Flanders and the Somme Valley. This is no accident, since Goya's landscape is also the first representation in art of Mother Nature plowed up and dismembered by the fury of artillery bombardment against fixed positions.

However, there is no doubt that most of the awful things done in the *Desastres* are done by the French or by their allies, such as the Polish soldiers, whom the Spanish combatants regarded as the most barbarous of all. They rape; they hack

Goya, Los desastres, plate 18, Enterrar y callar ("Bury them and shut up"), 1863. Etching and aquatint, 15.2 x 22.8 cm.

the genitals off patriots with their sabers; they hang and garrotte and strangle and bayonet, and dump their victims anonymously in mass graves; they kill women and children and priests, and set villages on fire; they pillage churches, and are seen sneaking by a dead friar in the gloom of the apse with sacks full of silver candlesticks, processional crosses, ciboria, monstrances, and chalices.

The main human response to such events is defiance, which Goya identifies over and over again. The second is disgust, the kind of impotent, life-poisoning doubt of the very possibility of human dignity that turns every speech about the hope of the transcendent human spirit into fatuous sermonizing. This appears twice, in its naked form, in the first "movement" of the *Desastres:* in plate 18, *Enterrar y callar* ("Bury them and shut up"), where two survivors,

hands and handkerchiefs stuffed to their faces to block the stench of decay, scan a heap of stripped bodies, now beginning to rot, in the hope of finding a friend or a relative. You probably won't, Goya implies, and if you do, it won't matter: the dead are dead, so just get them in the hole. Another, plate 12, *Para eso habéis nacido* ("You were born for this"), shows a similar heap of bodies filling the ground space of the etching right to its horizon line—Goya's horizontal crowd, so to speak—with one standing figure, one only: he is leaning forward, racked with nausea at the sight, puking right on the corpses. The daring of this image can perhaps be assessed from the fact that, a century later, during World War II, neither the British nor the German censors would have permitted a newspaper to publish a photo of a corpse—much less a heap of corpses, and still less a man vomiting on them.

At plate 48, the general setting of the *Desastres* changes. It becomes specific. We are now in Madrid instead of unidentified parts of provincial Spain. What we see is the suffering of people in the nation's capital, mainly from food shortage and the ensuing general starvation. Goya does not concern himself with the causes of the shortage. This is perhaps just as well, since the famine that paralyzed Madrid in 1812 was not simply the fault of the French. The worst culprits were the patriot *guerrilla* bands, who threw the supply roads from country to city into chaos and so made it next to impossible for ordinary folk to buy the staples of life: flour, legumes, meat, vegetables. The French authorities, from José I down the chain of bureaucratic command, could not handle this crisis and were powerless against it. José decreed the creation of a Charity Establishment, funded to the tune of 50,000 reales a month, but it could not possibly meet the needs of the starving city. In 1812 the municipal authorities reported to the king that

The ills afflicting this town are so great that their needs cannot be met.... [S]helters for incapacitated citizens contain more than 8,000 people, who daily receive nourishment from the town.... This... is a tiny fraction of those who clamor for the same help: houses, streets, churches all resound with the outcries of the suffering and the needy; all of them deserve a consolation we cannot give them.¹⁶

The *Desastres* images do not suggest Madrid. There is practically no architecture, and none that is identifiable, to be seen. (This had always been a trait of Goya's work: he did not care about buildings.) What he shows instead is great masses of shadow: humps and lumps of darkness that frame, or bear up as on a catafalque, the poor humans. In plate 48, the dead and dying lie in a heap, with a man who can still stand upright (but only just) holding out his cap for alms, a

gesture that doubles as pointing to the jumble of dead at his feet: "Cruel lástima," the caption tersely says, "Cruel misfortune." In plate 50, ¡Madre infeliæ! ("Unhappy mother!"), it is night, and the blackness—velvety, speckled with tiny aquatint flakes—presses in on a group of figures: three men carrying the corpse of a woman, whose head lolls downward. It is a group with several resonances in Goya's earlier work. The men carrying the helpless woman appear in the Caprichos, as in plate 8, They Carried Her Off! (page 207)—a scene of abduction and rape. In another form, bearing up a helpless male victim, they are the witch trio of his 1797–98 painting Witches in the Air (page 155). Here, they are emissaries of pity—it is too late for charity. And to the right of them is one of

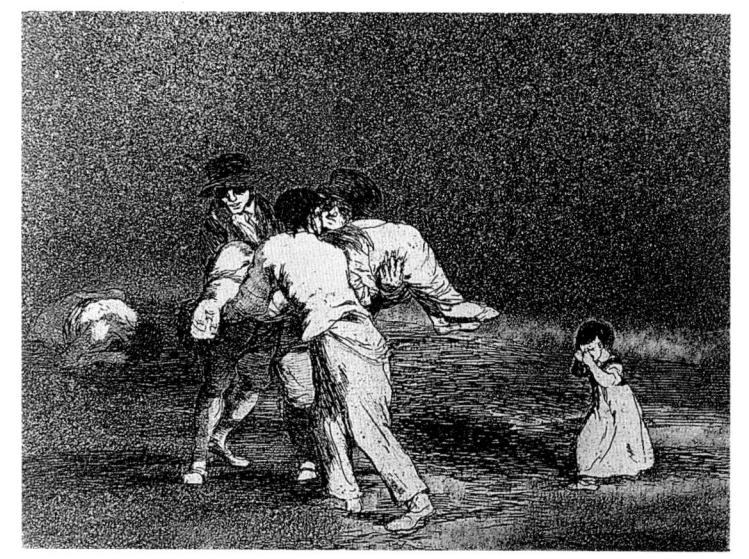

Goya, Los desastres, plate 50, ¡Madre infeliz! ("Unhappy mother!"), 1863. Etching and aquatint, 15.2 x 20.3 cm.

Goya, Los desastres, plate 64, Carretadas al cementario ("Carried off to the cemetery"), 1863. Etching and aquatint, 16.5 x 20.3 cm.

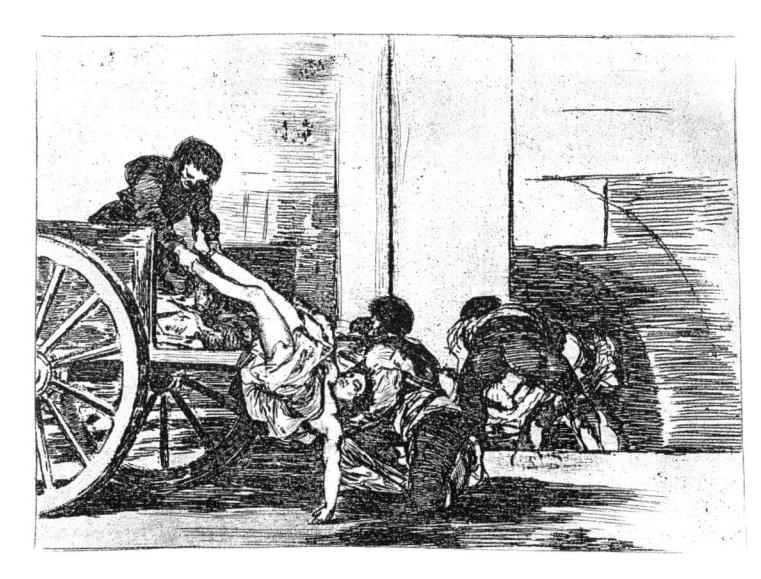

Goya, *Fernando VII in an Encampment*, c. 1814. Oil on canvas, 207 x 140 cm. Museo Nacional del Prado, Madrid.

the most heartrending figures in all of Goya's work: the little bereaved daughter, screwing her small fists into her eyes as she sobs. The space between her and her lost mother is a truly psychic space, a separating gulf of darkness that now can never be bridged, a darkness that seems to be the very essence of loss and orphanhood. It is part of the measure of Goya's power that he could take essentially the same figure group and invest it with different meanings, each of the utmost intensity, each time he used it. He quoted himself, new every time. He also quoted others: a long line of Burials of Christ connects *Desastres* images like plate 56, *Al cementerio* ("To the cemetery"), and even 64, *Carretadas al cementerio* ("Carted off to the cemetery")—that shocking glimpse of a girl's white, desirable, bare, dead legs as she is hoisted onto the cart—back to their ancient prototypes in the *pietà militare*, the dead hero being borne off to burial by his Greek or Roman comrades.

Toward the end of the series, that is to say in 1814, the war ended with the expulsion of the French from Spain and the return of Fernando VII, El Deseado, to the throne. This meant a change of work for Goya: he was obliged to reinvigorate his old job as painter to the king, left on one side by his patriotic

feelings during the reign of the rey intruso José I. Fernando did not pose for portraits now. He was far too busy. Goya based them on prewar sketches. They are among his more routine portraits. In the first, done for the town hall in Santander, Goya obeyed a fairly detailed program, to be carried out in fifteen days. The likeness of the king must be full-length, full-face, and dressed in the uniform of a colonel of the guards.¹⁷ His hand must rest on a statue of Spain gloriously crowned with laurel; beside it, on the pedestal he leans on, one must see the attributes of kingship, a crown and a mantle; at his feet will be a lion, surrounded by broken links of chain, which in Goya's rendering look rather like fragments of dog biscuit. It is a wholly uninspired performance for so great an artist, though it is no worse than the second version, now in the Prado, in which Fernando is seen in a military encampment—the sort of place that this cowardly and unmartial king, who never drew a sword in anger and hardly even knew how to stay on a horse, avoided like the plague. Nevertheless, there are horses and tents in the background, and the king's chubby hand is resting on his sword hilt.

Before long, Goya was back at work on his etchings. He saw with the utmost clarity what the restoration of Fernando was going to mean for liberty in Spain, and he devoted the last plates of the *Desastres*, the so-called *Caprichos enfáticos*, to further prophecy of horrors yet to come. As their nickname implies, these "caprices" are very close to the *Caprichos* of some fifteen years before, but they are not funny at all and are, if anything, even more laden with premonitions of doom. The old regime, its Church powers, and its aristocratic reactionaries will come back with even greater force, says plate 67, *Ésta no lo es menos* ("This isn't the least"), showing bent old toffs in frock coats carrying the wood-framed

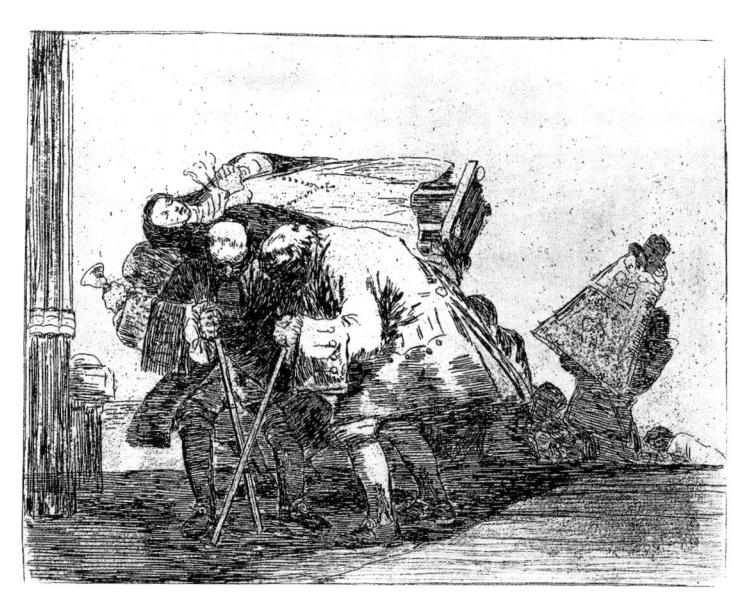

Goya, Los desastres, plate 67, Ésta no lo es menos ("This isn't the least"), 1863. Etching and aquatint, 17.7 x 21.5 cm.

Goya, *Los desastres*, plate 72, *Las resultas* ("The consequences"), 1863. Etching and aquatint, 19 x 22 cm.

Goya, *Los desastres*, plate 77, *Que se rompe la cuerda* ("Let the rope break"), 1863. Etching and aquatint, 17.7 x 20.3 cm.

effigy of a female saint with a rosary on their backs while another of them clangs a handbell to announce their approach. Like Brueghel's drawing of the blind leading the blind, a single file of cloaked men and priests descends into darkness, linked together by a rope from neck to neck, in plate 70, *No saben el camino*, "They don't know the way." In plate 71, *Contra el bien general* ("Against the general good"), a bald and heavy-lidded creature—a sort of recording demon, with a quill, the talons of a bird of prey, and vampire wings sprouting from his head—minutely inscribes laws and lists in a big book open on his lap, a clear allusion to the lists of names and the repressive laws brought in by Fernando's return. Plate 72, *Las resultas* ("The consequences"), also refers to the

monarch's return: a flock of Goya's nightmare bats, the lay and Church parasites that accompany Fernando, is descending on prostrate Spain. One of them is gobbling at the half-alive body. Plate 76, *El buitre carnívoro* ("The flesh-eating vulture"), with its half-plucked bird of prey, comic and repulsive, being harried by the Spanish *pueblo* led by a sturdy peasant with a pitchfork, tells its own story of the expulsion of Napoleon from Spain; while plate 77, *Que se rompe la cuerda* ("Let the rope break"), shows a Catholic prelate teetering along a muchmended slack rope, like an incompetent circus funambulist, just above the heads of a derisive and hostile crowd. In the original sketch for this, the cleric wore the triple tiara of the pope, a sufficient comment on Goya's religious convictions at the time. But as previously discussed, it was quite possible then, and still is now, to be both fiercely anti-clerical and deeply religious.

At their end, the *Desastres de la guerra* open outward, beyond mere human stupidity and detestable cruelty into a pessimism so vast and desolating that it can fairly be called Shakespearean. The subject, once more, is Fernando's Spain and Goya's fears for it: but those fears go beyond place and policies, becoming forecasts one would not wish to hear but must listen to. In plate 69, *Nada.* (*Ello dirá*), a cadaver rotted down almost to a skeleton is half-disinterred; before a confused mass of watchers, including a dark figure with the unbalanced scales of Justice, it displays a sheet of paper, its one message from beyond the grave. "*Nada*," it says. Nothing. It has all been for nothing: the

Goya, Los desastres, plate 69, Nada. (Ello dirá) ("Nothing. [He will say.]"), 1863. Etching and aquatint, 17.7 x 22.8 cm.

Goya, Los desastres, plate 80, ¿Si resuscitará? ("Might she revive?"), 1863. Etching and aquatint, 16.5 x 21.5 cm.

countless deaths, the misery, the rape, the pillaging, the dismemberment of Spain. And, as in Lear's words, "Nothing will come of nothing. Speak again." And this *nada* extends beyond the grave: the corpse testifies that nothing is there either: no Jesus, no angels, no eternal consciousness, no mercy, no redemption, no heaven, and, because it has already fixed itself on earth, no hell. In plate 79, *Murió la verdad* ("Truth died"), we see Goya's beautiful figure of Truth, a corpse stretched on the ground, emitting rays of light. These will soon be extinguished in the dark earth by her gravediggers, mostly priests, with a bishop—the absolutists' ally, as ever—implacably intoning the last rites over her body. The only mourner who genuinely weeps is Justice, on the right, with her now useless scales. But even so, there is still a narrow margin, the merest thread, of possibility for hope. In plate 80, ¿Si resuscitará? ("Might she revive?"), lovely bare-breasted Truth begins to shine again, to move, while those who would bury her recoil in confusion, clutching their shovels and books. A feverish and tentative hope is reborn in Goya's darkness.

And so the great cycle of etchings closes. What was their public effect? In a word: *nada*. Goya had little to fear from the reactions of Spanish patriots to the *Desastres*, although many of them would surely have taken offense at the images that show a moral equivalence between Spanish and French brutality. But the last prints, the *Caprichos enfáticos*, could have been deadly, not only to his repu-

tation, but to him. Fernando VII did not and could not put up with such bitter and piercing insults, especially since his own rule would prove utterly chaotic. In Fernandine Spain truth was no defense. So Goya kept the *Desastres* from being printed. Not only did they remain unpublished during his lifetime (which ended in 1828, five years before the monarch's); the first edition of the *Desastres* did not appear for nearly half a century after it was begun, in 1863. And so it came about that the greatest anti-war manifesto in the history of art, this vast and laborious act of public contrition for the barbarity of its author's own species, remained unknown and had no effect whatsoever on European consciousness for two generations after it was finished.

GOYA HAD HOPED, most passionately, to change people's minds about war. But in general we don't know and, in the absence of relevant letters from Goya or memoirs of his opinions by those close to him, we probably never will know exactly what the artist's frame of mind about popular Spanish patriotism and the French usually was, even assuming that it didn't fluctuate with the sway of events. Goya has often been taken for an unwavering and deeply conscience-laden crusader of the brush and the etching needle, fighting with all his imaginative powers for Spain and against France. This is untrue. No question, he hated and despised Fernando VII. But he was not a simple-minded patriot celebrating "Spain, right or wrong." Much of his sympathy was with the *afrance-sados*, and he loathed what, in a later age and another country, would be called jingoism. The complexity of his attitudes is hinted at and, in part, gauged by the peculiar career of another of his paintings, done slightly earlier.

In 1810, in Madrid, two years into the war, Goya accepted the task of painting the picture that ended up being known as the *Allegory of Madrid*. Originally the commission came from Tadeo Bravo de Rivero, a former Peruvian deputy who had come to know and admire Goya through Josefa Goya's in-laws. Bravo de Rivero had become a municipal councilor in Madrid in September 1809, and a few weeks later the mayor's office commanded him to arrange "a portrait of our present sovereign" by "the best artist that can be found." That man, the Peruvian was certain, could only be Goya. It may be that Goya was unwilling to do the job, but the price was quite high for a portrait, 15,000 reales, and—what was evidently an important aspect from the painter's point of view—José I did not have to be present in his studio: in fact he could not be, since he and his court left for Andalucía early in January 1810. Hence, Goya could not be accused of having had Napoleon's brother as his guest or studio visitor. The king's profile

Goya, Alegoría de la Villa de Madrid (Allegory of Madrid), 1810. Oil on canvas, 260 x 195 cm. Museo Municipal, Madrid.

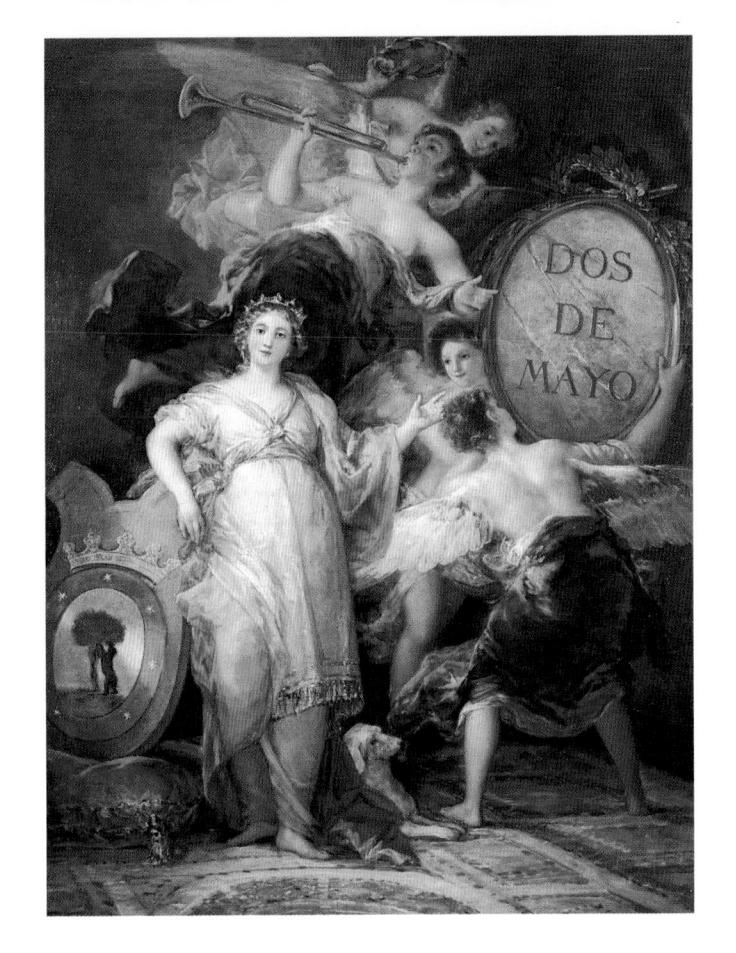

was copied from an engraving, or possibly a medallion supplied by Bravo de Rivero. Perhaps Goya would not have done it at all except for the fact that he was acutely short of money. Five years would have passed by the time he resumed his old salary of 50,000 reales as chief court painter—a quarter of a million reales lost, a small fortune. So he agreed to do the picture, and Bravo de Rivero mentioned that he had advanced the "professor" some money on his work, "corresponding to the size of the painting, which could hardly be less than 15,000 reales."¹⁸

The Allegory of Madrid is not one of Goya's greater works, but in terms of history and of an artist's relations with shifting power, it is a very interesting one. As a painting, it is a fairly standard late-Rococo glorification piece, with angels blowing trumpets, Fame brandishing a laurel wreath, the proper complement of armorial crests—the stemma of Madrid rests on a cushion at lower left; a cartouche depicts a bear picking honey from a tree—and a pretty, somewhat insipid crowned blond maiden personifying Madrid. If it had been meant as a straight portrait of José I, the composition would have been very different,

centering on and emphasizing the king. Instead, he is prominent but to one side, and his likeness was a picture of a picture, enclosed in an oval that Miss Madrid is pointing to, held up by a pair of winged geniuses and now containing—what? Originally, a profile portrait of Napoleon's brother. Clearly Goya felt few qualms about glorifying the man against whom, on the second of May in 1808, the Madrid *pueblo* had risen. Above the portrait of José I he added a flying figure of Fame, blowing her trumpet; and behind Fame, a figure of Victory, holding a laurel crown. To complete the allegorical recipe he added, sitting happily at Madrid's feet, a white dog, symbol of fidelity.

Then, in 1812, after Wellington routed Napoleon's army at the battle of Salamanca, Joseph Bonaparte and his court decamped from Madrid. It would have been improper to have Madrid pointing to him, so Goya accordingly painted him out, replacing his profile with the single word "Constitución"—the document ratified in 1812 by the Cortes in Cádiz, Spain's first genuinely liberal constitution. But the paint on the letters was hardly dry when Bonaparte came back to Madrid as king, and his portrait had to reappear, like the miraculous image of some country saint, in the oval. Whereupon the fortunes of war shifted once more, and José I was expelled, this time for good, in 1813. His effigy was painted out for the second time—not by Goya, who must have been getting fairly bored by then, but by one of his artist assistants, Dionisio Gómez—and replaced by "Constitución." It did not stay there long. The Desired One, Fernando VII, returned to Spain as king, and one of his first acts was to annul the 1812 Constitution. His policy of erasing from public places and monuments all references to the Constitution, "as if it had never been written," took some time to get around to Goya's picture, but eventually, in 1826, the oval was ordered to be repainted once more: out with "Constitución," in with the likeness of Fernando. By then Goya was living in Bordeaux and had only two years to live, and in any case El Deseado vastly preferred the work of his own rather frigid Neoclassicist court artist, Vicente López. He did not trust Gova to glorify him, and he had good reason not to. López's portrait of the royal toad stayed in the oval until ten years after Fernando's death; in 1843 the city of Madrid had it painted out and replaced with the words "Libro de la Constitucion," "Book of the Constitution." This phrase remained for nearly thirty years until it was replaced, in 1872, by "Dos de Mayo," a phrase whose patriotic significance everyone, liberal, democrat, monarchist, or black reactionary, could venerate. With that, the burlesque of allegory came to an end, and Goya's painting settled down to mean the exact reverse of what it did at first. This may be the earliest known ancestor of Stalinist-style photo retouching. Not even Generalissimo Franco, the stumpy tyrant whose narcissism knew no bounds, seems to have

War with Napoleon · 307

thought of getting another artist (Salvador Dalí, perhaps?) to insert his chinless profile into that much-revamped oval.

So Goya could and did respect the best of French influence, and he was under no illusions about the sanctity of all Spaniards, upper or lower. And yet he knew a colossal injustice had been done to the Spanish people by the Napoleonic invasion, and so he permitted no ambiguities in the creation of his two great propaganda pieces, the *Second* and the *Third of May*. Those two dates became sacred and emblematic in Spain almost as soon as they occurred. They were celebrated in folk song, in oratory, in poetry—though not, or not immediately, in painting or sculpture. They stood for the reemergence of Spain into full, heroic, modern nationhood. The *Dos de Mayo* recalled, for Spaniards, "the glories of Spain when Spain had been the strongest power in the world." Every anniversary of the Dos de Mayo would be greeted by fulsome effusions of patriotic verse:

O de sangre y de valor gloriosa día! Mis padres cuando niño me contaron Sus hechos, ay! y en la memoria mía, Santos recuerdos de virtud quedaron.

O glorious day of blood and bravery! When I was a child my parents told me Of your deeds, and in my memory Blessed recollections of virtue were fixed.

Thus wrote the esteemed Romantic poet José de Espronceda, the "Spanish Byron," in 1840, and he went on for thirty-seven stanzas.

To praise the events of the Dos de Mayo was to make a public declaration of one's own patriotism—a claim that was of particular interest to Goya once the war was over—and in 1814, with Napoleon out of Spain, Goya asked to be commissioned to paint them. He was broke, or said he was. He wrote to the council of regency, which preceded the restoration of Fernando VII. His letter has not been found, but a council document of March 9, 1814, remarks that Goya is in "absolute penury" and wants "assistance" from public funds "to perpetuate with his brush the most notable and heroic actions or scenes of our glorious insurrection against the tyrant of Europe." One can take his protestations of neediness with a grain of salt now, though it was fortunate for Spain and for

Spanish art that the regency did not. The truth about his motives, however, would seem to be a little more shaded. Goya needed to affirm his credentials as a good, loyal, anti-French Spaniard now that Fernando was back in the saddle.

While Joseph Bonaparte was ruling Spain, as we have seen, Goya had willingly done the portraits of eminent Josefinos, members of the French king's circle. Would this cause Fernando, a firm believer in censorship, who regarded painters as little more than court servants and did not particularly like Goya's work anyway, to view him as a traitor? Today we take it more or less for granted that artists will paint for whoever may be in power: work is work, and must be found where it can be. Even Josef Thorak, Hitler's sculptor laureate, author of whole series of muscular ideal youths and rock-breasted maidens personifying German nationalism and the glories of the Hitler Youth, was eventually forgiven by the repentant Germans and ended up doing idealized portraits of the rich avant-garde collector, for all the world as though he were Andy Warholwho, given the chance, would probably have served the Nazis with enthusiasm. But that was not the view of the Desired One, who on his return to Spain instituted purges wherever he felt suspicion applied—and he was a most suspicious and vengeful man. Worse still, Goya had accepted a decoration from the appreciative Joseph Bonaparte: the Order of Spain, known derisively among the Spaniards as la berenjena, "the Eggplant." In May 1814 an investigation of court personnel was launched to determine who had and had not collaborated with the French regime. It was therefore essential, not only in order to keep working as court painter for Fernando VII but also to stay free, that Goya should clear his name as a patriot. There was something a little parodic about this. It was unlikely that even the most suspicious judge or functionary would think a stone-deaf man of sixty-eight would present much of a threat to Bourbon interests, and, as for the Eggplant, Goya stoutly denied that he had ever worn it—a claim backed up by at least one witness at the investigation: his parish priest. Goya got the commission, not for a lump sum, but for a salary of 1,500 reales a month over the time he worked on it.

The two paintings, Goya's climactic utterances on war (each about eight feet by ten), titled the *Second of May 1808* and the *Third of May 1808* (pages 311 and 315) were received by Fernando VII's restored regime. Once completed, were they installed with pomp and honor on some suitable public wall, where the *pueblo* who were the collective hero of Goya's commemoration could see and reflect on them? Apparently not; they drop out of the records and do not reappear until 1834, long after the deaths of both Goya and his royal patron, when they are noted as being in storage—two decades after they were painted, and

not even on display!—in the Prado. Perhaps Fernando saw them, and that sluggish and paranoid brain felt a tiny needle prick of alarm: the glory Goya was attributing to Spanish resistance was that of ordinary people, not dynasts. Or perhaps someone else at court disliked them. They are not recorded as being on public view in the Prado until 1872, when they finally appear in the museum's catalog. One wonders why, since Goya could hardly have planted himself more firmly or passionately on the side of the Spanish people and against Napoleon's mercenaries, although that is not to say that he regarded the insurrectionary mob as angelic or the regime of Joseph Bonaparte as demonic.

The events of May 2 didn't all happen in one spot or at one time of the day. Once ignited, the insurrection flared and waned across the city from west to east. There was a particularly sharp struggle, and (one might have thought) a good emblematic one for the purposes of a history painter, that morning in the artillery park at Monteleón when, after the Spanish soldiers had been confined to barracks on Murat's orders, to prevent their giving aid to the rebels, two patriot officers among them, Velarde and Daoiz by name, gave arms to the insurgents and were killed for it. Later, in the rituals of patriotism that surrounded the return of El Deseado and the Spanish monarchy in 1814, the decayed remains of these two brave men were dug from the common grave they shared with the other victims of the massacre, and paraded across Madrid in a magnificently ornamented hearse. Velarde and Daoiz would seem to have been the only Spanish patriots killed on May 2 whose names became publicly exalted, and who might thus have been candidates for some kind of personal commemoration by Goya. The dying heroes cut down in their prime? Jacques-Louis David would have liked that, not that Goya particularly cared about David. He would have seen a print made of their death, one of four scenes of the events of May 2-3 done around 1813 by a lesser artist, López Enguidanos. But for the purposes of these works, Gova couldn't have cared less about men with names, brave as Velarde and Daoiz were. He wanted to commemorate the plebs, the pueblo. In words John Masefield used in "A Consecration" a century later, referring to the Boer War:

> Not the be-medalled Commander, beloved of the throne, Riding cock-horse to parade when the bugles are blown, But the lads who carried the koppie and cannot be known.

Goya also wanted something visually spectacular: a clash between two clearly identified sides. One incident among several stood out: the fight in the Puerta

del Sol. It presented Gova with an irresistible contrast. On one side, the civilians in their street clothes and working garb. (Later, lists—now preserved in the Municipal Archive of Madrid—with the names and occupations of the dead. the wounded, and the missing would be compiled. They included shoemakers, glassblowers, muleteers, gardeners, bakers, locksmiths, coachmen, a couple of students, and even a priest or two, but no "quality" people.) On the other side, the Mamelukes in their turbans and loose red pants and the French cuirassiers of the guard with their glittering brass helmets. And the Mamelukes—a point that must have struck Gova as ready-made for propaganda—were moros. Cairenes, north Africans. Their presence in his picture would, to Spanish eyes, seem not only exotic but of unique and especially disagreeable foreignness. When was the last time Spain had been occupied by hostile Arab troops? Why, back in the fifteenth century, before Fernando and Isabel began the "reconquest" of Spain and threw the devils out. So by painting the struggle between true-blue Spaniards and bloodthirsty foreign Moors, Gova was encouraging his viewers to revive their old anti-Arabism—to see the fight as a death struggle between two cultures, and the enraged shopkeepers, grooms, and carpenters of the Puerta del Sol as the true heirs to the nationalist glory of El Cid.

As it happens, it is only from the Mamelukes' costumes that we know the scene is the Puerta del Sol, since the records all say that a fight with Mamelukes happened in that square and nowhere else in Madrid. No building in the rather vague background Goya gives can be securely identified with the architecture of the square, either as it is now or from what little we know of its appearance in 1808. In any case, the architecture hardly counts, as usual in Goya's work. Almost the whole of the Second of May (more formally known as The Charge of the Mamelukes) is taken up with a thick mass of struggling, grappling figures, which create an impression of sluggish movement across the canvas from left to right. It is a curiously static, even congested layout, except at its center, which is filled by the smooth, white, unblemished sphere of a giant horse's ass. The violence, of which there is a lot, revolves (as it were) around this ironically serene globe. The confused look of the composition is not, one may think, due to any lack of skill on Goya's part, although some have found it less than esthetically satisfying. It mirrors the chaos of real battle in a real place, "the fog of war," with men crouching and charging, hacking at one another, and horses stumbling on prostrate bodies. It is, in short, deliberate. It is about as far from the ideal order reflected in Renaissance battle pieces—Paolo Uccello's Rout of San Romano, to take an extreme example—as painting can be.

But the Second of May contains details and elements that stick indelibly in

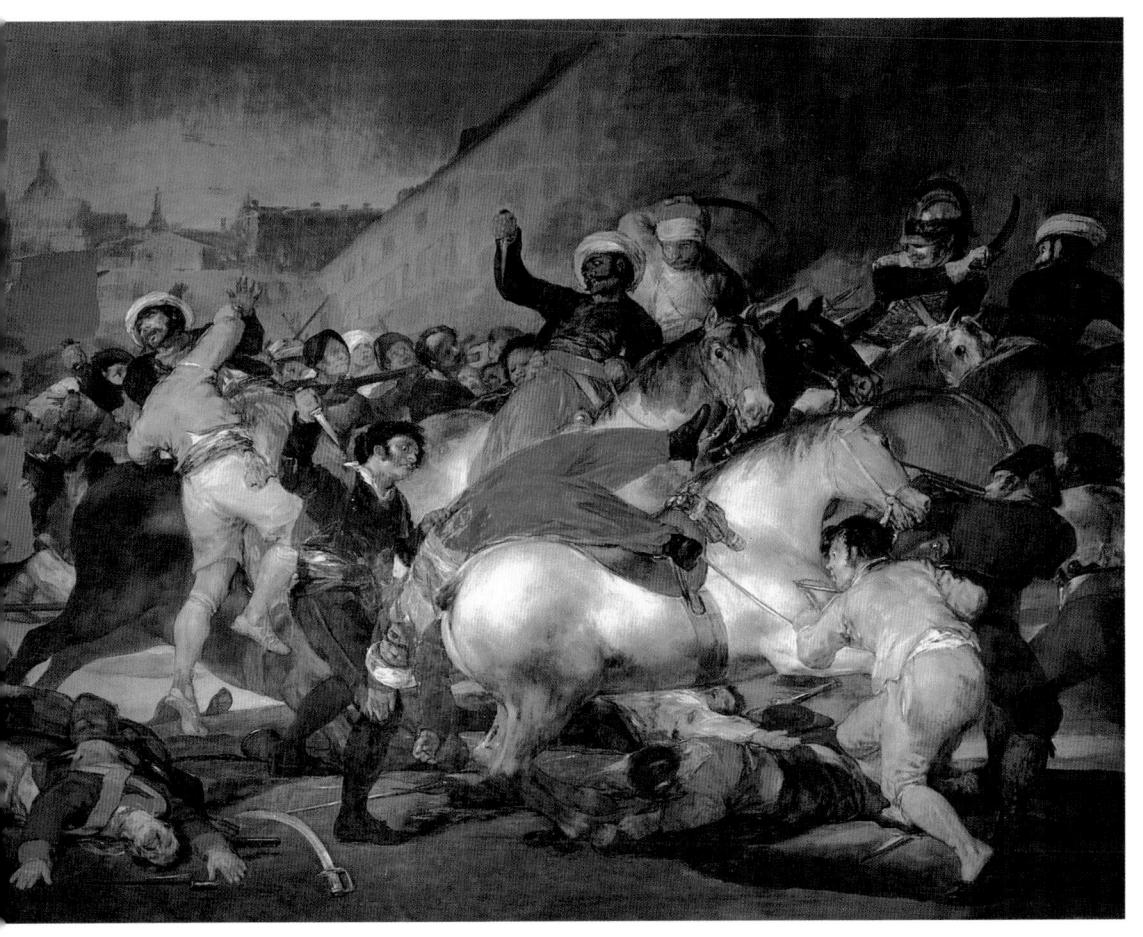

Goya, *El Dos de Mayo de 1808 en Madrid (The Second of May, 1808)*, 1808–14. Oil on canvas, 266 x 345 cm. Museo Nacional del Prado, Madrid.

one's mind because they are so vivid and so unlike anything in earlier painted battle pieces. The young man in the pale-green jacket on the right, for instance. His posture conveys that he has crept up on the white horse in the foreground and is gripping the rein its Mameluke rider has dropped. He is stabbing it above the right front leg, trying, perhaps, to find the heart or a lung. But he can't quite bring himself to put his weight behind the thrust. He is clearly scared his face, with the bulging, white-rimmed eye, conveys that—and he is poking tentatively at the poor horse's flesh, afraid to stab, afraid not to stab. Then there are the two men in the middle of the picture: the citizen stabbing at the mameluco while dragging him backward over the rump of that terrified horse. Goya would go on—from the Desastres de la guerra to the Black Paintings' vision of the two peasants, thigh-deep in quicksand, belting each other with their cudgels even as they sink to mutual death—to produce terrible images of human violence, but this is one of the worst and probably the first in which his genius for showing men in the grip of terminal aggression is allowed full rein in painted, rather than etched, form. The citizen—who is dressed in black, in the traje corto, or short jacket, of a majo, that class of proletarian dandy Goya admired and identified with—bares his teeth: not in a smile, but in an uncontrolled rictus of fury, as he stabs and stabs at the chest of his enemy. You know he couldn't hear you if you screamed in his ear. His eye is shining like his front teeth, a crazy's eye. His target, the nearly unhorsed Mameluke, is dragged back and down in a quarter-circle, his baggy red pants forming the brightest patch of color in the painting. His feet have come out of the stirrups and are arrested in midair, a comic-strip shorthand for quick movement that Goya liked and associated with violent death. (It does not appear in earlier art; you would never see it in a battle piece by Mantegna or Rubens. But Goya used it in a number of images, such as the body arrested in midfall as it is heaved into the mass grave in Charity, plate 27 of the Disasters of War. It is a freeze-frame, a snapshot before the camera was invented.) The Mameluke has been stretched backward for a while; we know that because the blood from the many stab wounds in his diaphragm and gut has run down his chest and down his hanging arms toward his hands. His mouth gapes in death. One of his turbaned comrades has bulled up on horseback (his hand, holding a dagger, is the apex of the composition) to stab the Spaniard who keeps knifing him, but he won't make it; a black-clad man in the right foreground, with his back to us, is aiming a gun at him, and an insurgent has grabbed him from behind, at the waist, and is yanking him off his saddle. The glaring face of this second Mameluke could almost belong to the majo with the knife. This, too, is part of Goya's point: how fury and fear dissolve
identity by stripping the human animal to its most primitive essences, a process, one might say, of which Goya was the supreme tragic poet. The decorum associated with earlier depictions of men at war has faltered. It shows gaps. It has almost gone. Hence, the incipient modernity of the painting. It may want to compete with the Rubenses Goya knew from the royal collections, but history has run past it, and it is too late even for someone as excessively gifted as Goya to be a Spanish Rubens—to do so, he would have had to look too far back, to a lost age when you could still speak of "glory" in war.

If the Second of May is a congested, almost confused secular documentary, the Third of May has more of the character of a religious altarpiece—dedicated, however, to the religion of patriotism. That is to say, it uses devices from religious iconography to wring responses of pity and terror from those who look at it, and its success in doing this is so complete that it has lived on for almost two centuries as the undiminished and unrivaled archetype of images of suffering and brutality in war. A list of those who have imitated it (or been "inspired" by it) would be quite long and would contain several famous names. Édouard Manet based his Execution of the Emperor Maximilian of Mexico (1867) on it. It provided a partial source for Picasso's Guernica (1937), in which the lightbulb emblem of the pitiless glare of twentieth-century awareness—substitutes for the fierce cubical lantern shedding light on Goya's execution scene. It was also the source for one of the *least* successful of all Picassos, the *Massacre in Korea*, a fatuous effort done to keep his French Stalinist friends happy, in which a group of very un-Asian-looking Korean women are menaced by a firing squad made up of robotic Yankee imperialists pointing weapons derived from the ray guns of 1950s science fiction, while their officer, in what appears to be a welding mask, brandishes a sword. (Picasso must have figured that GIs would have the very latest hardware.) Except for the Manet, later homages to and pastiches of the Third of May fall miserably short of it, and its sheer intensity defeats comparison with earlier paintings. The prosperously muscled giants in the battle pieces of Rubens are undergoing nothing, compared with those proles of Goya's facing (or unable to face) the French muskets. No Attic vase painting of Homeric battle, no Renaissance image of perfectly proportioned bodies slugging it out, no frieze of warriors encased in their cuirasses esthétiques in the manner of Poussin so impresses you with its raw truth. Of course, this is because the truth offered by previous paintings of war is not raw but manifestly cooked; while Goya's extraordinary image is not raw either, but cooked in a different and startlingly unprecedented way, so that it *looks* raw. This feigning of rawness is not the least modern thing about the Third of May.

The key figure in the painting may be the same man as the key one in the Second of May, the citizen stabbing the Mameluke. Or is he only similar, with his mustache, sideburns, and swarthy complexion? Impossible to say. Certainly his clothes are different—and would he have had time to change between the slaughter in Puerta del Sol and his arrest by the French? He kneels before the firing squad, but not in a posture of submission. It is more like devotion. Why should he be kneeling at all, in a posture associated with submission, when Goya's image is about defiance in the very jaws of death? Probably because one likely source for Goya's composition was a devotional print by an unknown artist depicting the execution at Murviedro of five Valencian monks by Napoleon's soldiers in 1812. In it, the monks are kneeling, as though praying to God. Two other points of similarity between this banal image and Goya's are that there is a dead monk in the foreground of the print, corresponding to the sprawled corpse of the patriot on the lower left of the *Third of May*; and that, whereas four of the monks are wearing black-and-white habits, one is dressed in white, like Goya's man in the white shirt, and is holding out his arms in a similar gesture of crucifixion, while the monk to the left of him wrings his hands in the same gesture of despair and supplication as the man to the left of Goya's victim.

Whatever its sources, Goya's stocky little martyr-of-the-people is one of the most vivid human "presences" in all art. In an age of unremitting war and cruelty, when the value of human life seems to be at the deepest discount in human history, when our culture is saturated with endless images of torment, brutality, and death, he continues to haunt us. He is a two-hundred-year-old equivalent of those few photo images that leaked out of Vietnam into long, emblematic life: the screaming naked girl running away from a napalm strike, toward the camera, the chinless police chief blowing out the brains of a plaidshirted suspect at point-blank range with his kicking .38 on a Saigon street. Goya's man's yellow pants and blazing white shirt are the highest tones in the painting, harshly lit by the lantern the soldiers have put on the ground so that they can see their killing. (Perhaps too harshly; this oil lamp, which presumably it must have been, throws light like acetylene lamps, which had not yet been invented. Its radiance is part of Goya's poetic license.) His eye, the big black cornea ringed in white, bulges with terror. He throws his arms up and out as though throwing his whole life, in extremis, in the face of his murderers.

This is the posture of a crucified man, linking the figure of the anonymous political martyr to that of Christ. To make sure we get the point of the comparison, Goya has referred to the marks of the stigmata, the nail wounds in Christ's

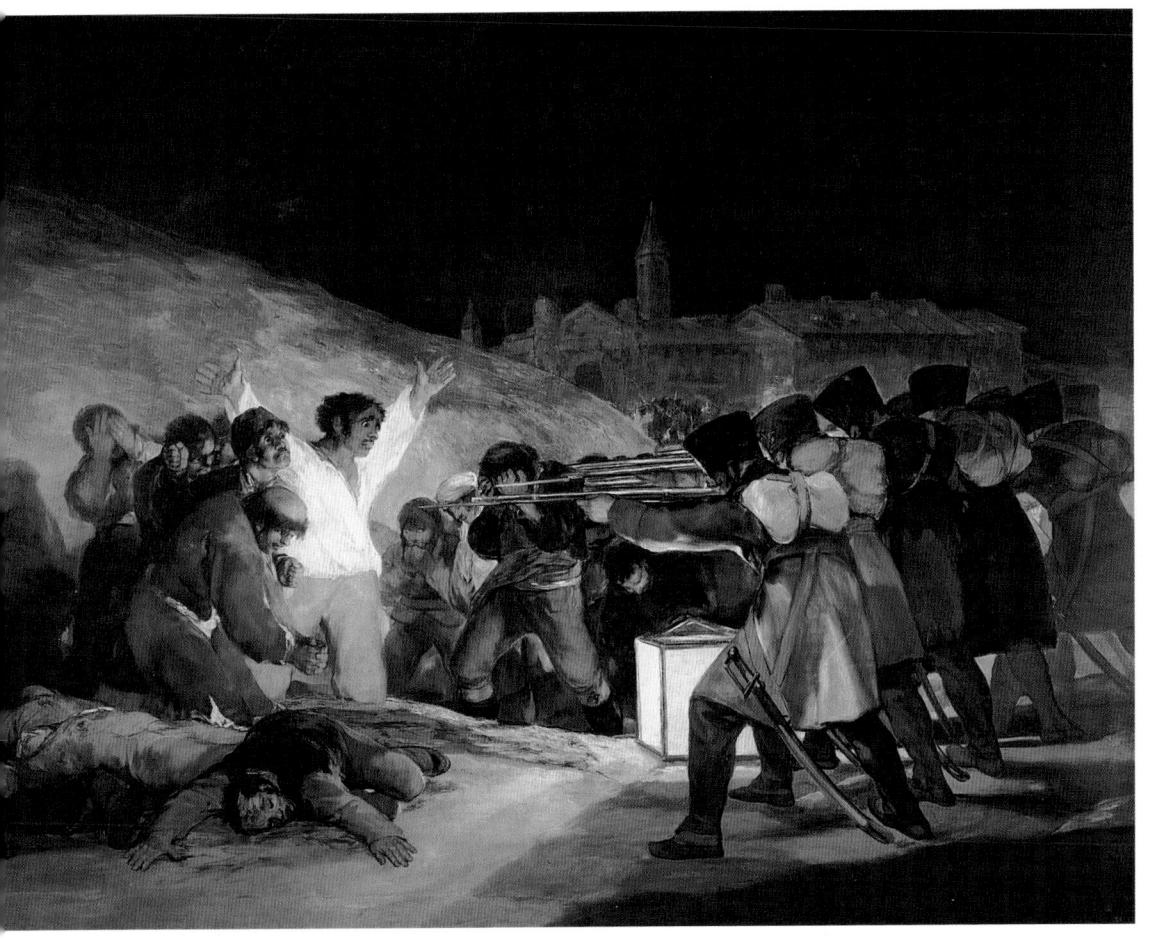

Goya, El Tres de Mayo de 1808 en Madrid o Los fusilamientos en la montaña del Príncipe Pío (The Third of May, 1808, or The Executions on Príncipe Pío Hill), 1814. Oil on canvas, 266 x 345 cm. Musco Nacional del Prado.

hands, which in moments of religious ecstasy were imprinted on the flesh of certain Catholic saints: there is a distinct (though bloodless) scar on the man's right hand, though none can be seen on his left. Too literal a transference of the stigmata could have pushed the image into corniness. And one must realize that there is nothing passive about this pseudo-Christ. Some Christs in earlier paintings than Goya's are led passively, dumbly, to Golgotha like calves to the shambles, submitting to their captors' will because the Roman authorities are enacting God's design for the sacrifice of His Son. Goya's does not submit, even at gunpoint. And there is no higher design: only tyranny replicating itself in the night.

Next to this macho Christ of the *pueblo*, a priest kneels, clenching his hands in despair. At least, one guesses he is a priest: he is tonsured, the top of his head shaven. He reminds us that there were indeed patriotic priests among the insurgents who fought the French and were slaughtered for it by the Spaniards—a theme that is taken up in several images from the *Disasters of War*.

The other men in the group show various degrees of rage, defiance, and fear. One covers his eyes with his hands: he cannot look. Neither can the man in *majo* clothes with a red sash, who is being shoved toward the killing mound at the head of the queue by the pressure of the doomed throng behind him. (He is the other possible repeat of the Mameluke stabber in the *Second of May*.) His head buried in his clawing hands is a terrible image of abandonment and hopelessness, fit to be compared with the Damned Soul in Michelangelo's Sistine Last Judgment, but the more powerful for being so laconic. One sees once again how readily Goya, lover of the stage that he was, could employ the melodramatic gestures for despair and anger that went with the popular theater of his day—and give these conventions a full human truth.

Then there are the dead men on the ground, especially the one who lies facedown in the foreground, his arms outspread and palms downward—repeating, in death, the last pose of the white-shirted victim in life, and matching the similar pose of a uniformed French soldier lying on the ground on the lower left side of the *Second of May*. The bloody earth he lies on is an occasion for one of Goya's most inspired passages of realism. The blood is pigment, of course. It has dried to a scratched, dirty russet crust, soaked into the canvas like real blood soaking into the dry clay of the hill of Príncipe Pío. The pigment lacks the artifice of painted blood; it looks like a photo of the blood in a police report, a Polaroid taken at the scene of the crime, the once-liquid stuff smeared and scribbled by the twitchy movements of a dying body.

Most of the victims have faces. Their killers do not. This is one of the most

often-noted aspects of the *Third of May*, and rightly so: with this painting, the modern image of war as anonymous killing is born, and a long tradition of killing as ennobled spectacle comes to its overdue end. The killers are, of course, the French firing squad, in the uniform of the Imperial Guard. Goya shows us their greatcoated backs, their legs, their cylindrical shakos (eight of them), their haversacks—but not their faces. The paint surface in which their mass is rendered is certainly not inert—Goya's paint was hardly capable of inertia—but it has a threatening flatness and dullness compared with the vitality of the pigment that describes the Spanish victims. The one exception to this is the sheathed saber worn by the guardsman nearest to our eye. It almost seems more alive than its bearer: a marvelous piece of paintwork, a broad swipe of yellowy orange that defines the curve of the sheath. Where else, outside of English masters (Constable, Turner), could one find such inspired spontaneity in European painting in 1814?

The French lean forward, intent on their work, leveling their muskets, bavonets mounted, at their targets. The mass of backs bristles with metallic spikes of death; it is braced against the collective recoil of those big, slow-moving, .70-caliber lead balls. This motif—vulnerable human targets transformed by terror or defiance, facing a death thrust at them by clusters of sharp metal in the hands of anonymous squads in uniform—was a new one in painting, an invention of the late eighteenth century. 19 But Goya had explored it before he set to work on the *Third of May*. Four etchings in the *Disasters* employ it. Three of these bear a specific relationship to the *Third of May* and must have served Goya as sources and notes for his enormous composition. Plate 2, Con razón o sin ella ("With reason or without it"), shows two civilian fighters launching themselves at a huddled knot of French soldiers, whose faces we do not see. Both Spaniards are meanly dressed, without uniforms; the face of one is pouring blood while he attacks with a mere knife against three bayoneted rifles. His companion grips a pike. They are hopelessly outarmed, but they fight on in a spirit of desperation, the same exaltado spirit that will suffuse the Third of May's man in the white shirt. The French guardsman closest to us, with his sabre, belt, and lumpish forwardleaning silhouette, is virtually a duplicate of the nearest guardsman in the *Third* of May.

In plate 15, *Y no hai remedio* ("And there is no remedy"), the French firing squad has been displaced to the background; we don't see the one that is about to kill the prisoner in the foreground, who is blindfolded and bound to the execution post; all we do see is the trio of barrels pointed unwaveringly at his bowed head and helpless breast, and the collapsed body of a previously shot

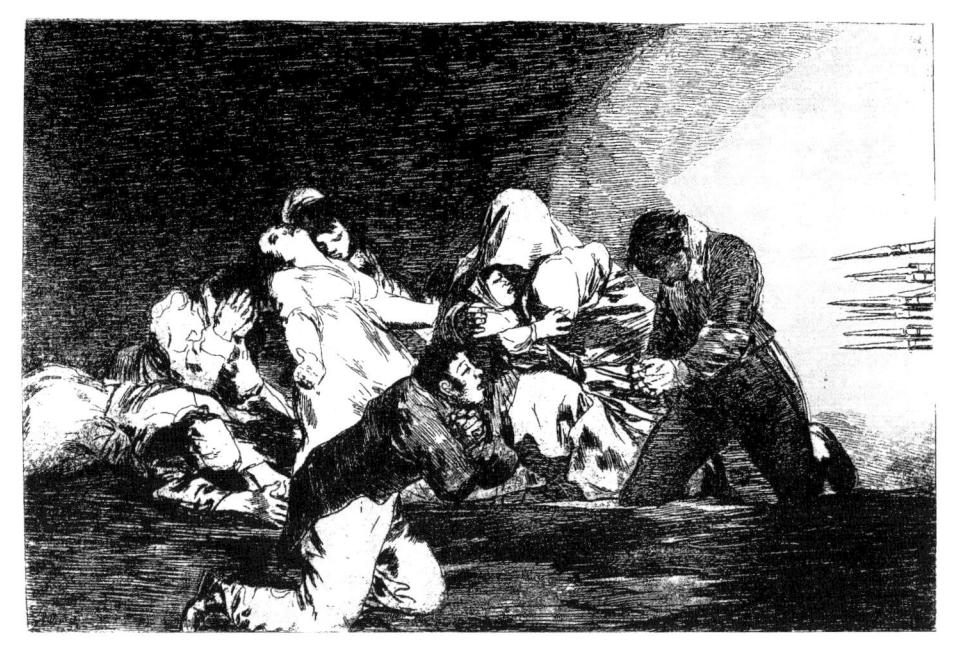

Goya, Los desastres, plate 26, No se puede mirar ("One cannot look"), 1863. Etching and aquatint, 13.9 x 21.5 cm.

man, his face half-obliterated by the bullets, lying on the ground in almost exactly the same posture as the dead man in the black waistcoat in the Third of May. In plate 26, No se puede mirar ("One cannot look"), Goya produced a dramatic masterstroke. The executioners have vanished altogether, but the threat of their presence just offstage is all the greater for it. All we see of them is a cluster of eight gun muzzles and their fixed bayonets poking in from the right edge of the frame, like a single pointing finger: pure, deadly tools. This has an astonishingly cinematic effect: a small, intrusive shape that, like the turning of a doorknob or the creak of a stair that announces the expected killer, creates panic among the wretched Spaniards who are huddled in the cave. Though "huddled" is perhaps the wrong word. *No se puede mirar* is a superb example of Goya's ability to give formal rhythm and focus to what, in another artist's hands, could be a chaotic, undifferentiated lump of bodies. He did this by stressing the angularity of poses, creating a bleak and powerful counterpoint of slopes and triangles within the heap. The woman in white, framed by the cave's darkness, rocks back in despair at the same angle given by the back of the man in the traje corto, kneeling, wringing his hands in prayer or despair, his back to the rifles.

War with Napoleon · 319

The triangle of the void between his legs matches the solid triangle of leg belonging to the kneeling man in the foreground—who, though he wears a dark jacket and trousers that place him a social cut above the working class, is as plain and ordinary a member of the *pueblo* as one could wish to see.

In the etchings all individuality, all exuberance of humanity, is concentrated in the victims alone. And so it was in the *Third of May*. Goya did not see this happening. But he imagined it so powerfully, drawing on such a rich deposit of older imagery—the Christ figure of the worker in particular—that the content of his utterance, the perception that war is a despicable and monstrous injustice, an impartial machine that kills men like cattle and, most of the time, leaves no residue of glory behind it, is the prototype of all modern views of war. What the common people of Europe discovered in their millions in the twentieth century, that atrocious epoch of failed dreams and triumphant death, a time of ideology-driven suffering beyond the previous imagination of mankind, Goya foreshadowed in the *Disasters* and then gave monumental form to in the *Third of May*.

THE RESTORATION

HE USUAL WAY of treating Fernando VII, looking back to when *el rey deseado* replaced *el rey intruso* on the throne of Spain, is to have no sympathy for him at all. And indeed it is hard to have any, because he was such an unpleasant human being, cowardly, dim, cunning, and cruel. He was perhaps the only player in the long and sometimes comic Bourbon drama who came to be detested even more than Godoy. (Even if you believed the dubious proposition, so largely created by Fernando himself, that Godoy was vice incarnate, at least you could have some admiration for his sexual potency; the royal glands of Fernando contained nothing special.) There was a long revisionist episode during the reign of Franco, who admired Fernando for slashing out the liberal Constitution and taking the side of the Church in all things. But it did not last, and Fernando is now as despised as he ever was.

And yet one wonders just what his legion of critics would have had him do to knit his broken country and bind up its wounds. By returning to Spain, Fernando came back to impossibility. The war had exhausted Spain, eviscerated and bankrupted her. The only way she could get solvent again was by exploiting her former colonies, with a crushing victory over the South American insurgents. But she could defeat them only by spending immense sums, which Spain did not have, on an armed reconquest. This was actually tried, though not hard enough. In 1815 a force of ten thousand Spanish soldiers, commanded by Pablo Morillo, was shipped to Venezuela, then in the throes of a civil war between the conservative cattlemen of the interior and the leaders of the move-

ment for independence from Spain. Once Morillo's weight was thrown behind the outback faction, they won hands down. But it was an ephemeral victory: the urge to independence was too strong. The hitherto urban rebels fell back into the sierra and, just as their Castroite descendants would in Cuba a century and a half later, formed cells and groups that punitive expeditions could not reach to destroy.

An alternative for Fernando might have been to replace the aristocratic economy with a free-market one, to expropriate the Church—in short, to implant real capitalism in Spain. But such things take time, and in any case they ran counter to everything that the king and his priestly and aristocratic ear-benders believed in. Capitalism, in Fernando's eyes, meant liberalism, an unthinkable concession.

But in any case, Spain was still at war in South America after the French had been defeated on the peninsula. Fernando stubbornly clung to the hope that he could suppress the rebellion on the other side of the Atlantic; but he was facing an aggressive and inspired foe, the Venezuelan liberator Simón Bolívar, who broke the colonial army in Colombia while his Argentinian comrade General San Martín led an army over the Andes into Chile to secure its independence. Argentina, Paraguay, and Uruguay already had theirs. Venezuela won its nationhood in 1821, Peru in 1824.

Nothing further could be done to restore the South American empire or to win back Spain's revenues from it because Spain's navy was so weak. Even if it could have spared the troops and money for a campaign on the far side of the Atlantic, it had no means of delivering the force; that could only be done by an alliance with England, the world's greatest naval power, but England had no interest in propping up a Spanish empire in decline. Thus by the 1820s the colonial system on the mainland was in most respects over, leaving only Mexico and Spain's island dominions, chiefly Puerto Rico and Cuba. So Fernando was restored as the head of a hollow empire that got hollower with each passing year, and every pressure group in Spain itself was on him. The nobility wanted a full restoration of its privileges. The Church wanted all its economic power handed back to it. The Inquisition wanted free rein. The Basques and Catalans wanted independence. The army wanted to be paid off. In the middle of this vortex of demands, Fernando VII, with his typical combination of haughtiness and insecurity—a bad combination at the best of times—accepted the most fulsome declarations of fealty from the worst and most opportunistic of his subjects.

This showed as soon as the French let him free from detention in Valencay in

March 1814 and he returned to Spain. The liberals, his natural enemies, had extracted (extorted, he believed) a promise from him to swear a solemn oath to the Constitution. But then his generals offered him full backing in the exercise of his absolute rights, and a group of ninety-six deputies known as the Persians. the conservative serviles, sent him a manifesto condemning the 1812 Constitution as an invalid and pernicious document. This stiffened Fernando's spine. On his triumphal progress south to Madrid, he passed through Gerona and Tarragona and was received with ecstasy in Zaragoza, where crowds of citizens turned out to draw his coach and cheer his passage while women strewed flowers in his path. It was a classic example of how easily the *pueblo* could become a populacho, a people turned into a rabble, when manipulated from above by the aristocrats and the Church hierarchy. They did not need to be bought. Their king had them in his pocket. On May 4, he reached Valencia, where with effortless duplicity he issued a decree: "I abhor and detest despotism . . . kings have never been despots in Spain; neither its good laws nor its constitution have ever authorized it. . . . I will deal with the deputies of Spain and the Indies, and in legally assembled parliaments." But, he added ominously, the best thing for his realms would be to abolish the "so-called" Cortes and Constitution, so that everything could go back to exactly where it had been before 1808.

And it was done. Reaching Madrid on May 13, again with delirious citizens competing to draw his coach, Fernando carried out a coup d'état that almost exactly mirrored the overthrow of his father in the Mutiny of Aranjuez six years before. His agents whipped up the mob; aristocrats manipulated it by the basest means; the army imprisoned the liberal leaders; the king declared the Cortes null and void. He was not interested in negotiating over changes in the 1812 Constitution; it must be erased, and all laws and policies stemming from it must be annulled and treated "as though such measures had never taken place." Fernando did not feel he needed an elected parliament to tell him what the *pueblo* was thinking and feeling. For that he had the reports of police spies, which he trusted more than the word of deputies.

The Cortes, under the new Constitution, had begun by swearing a four-part oath to maintain the Catholic religion, to sustain the integrity of the nation and the observance of its laws, and to proclaim Fernando VII king. This, one might have thought, would be enough for any reasonable monarch, but Fernando was not reasonable.

He did not want to abolish slavery, judicial torture, imprisonment without trial, and strict censorship. He loathed the idea that *indianos* in the colonies should have the same rights under law as Spaniards in their homelands. He did

not believe in the most elementary human rights, since these conflicted with his own absolute power. He was not merely a reactionary or a conservative: he wanted to conserve nothing if it offended his rigid absolutist principles.

In fact, he wanted to take Spain further back than it had been since the time of Fernando and Isabel. The number of convents and monasteries instantly began to swell. Universities and theaters were shut, and only the government-published *Gazeta oficial* remained of a press that was otherwise censored out of existence. The status of ministers changed, and radically: in the blink of an eye, the portfolios of state, finance, justice, war, and navy were downgraded into mere secretaryships and—to emphasize their loss of prestige—were transferred to ground-floor offices in the Palacio Real. Their terms of service rarely lasted more than two or three months. There would now be no doubt who was in charge, and why. Fernando was, because God willed it.

The king, who had railed so bitterly against the immorality of Godoy, set out to engage in every crooked practice and sexual indulgence that had supposedly disfigured the court under the reign of his enemy, from skimming defense money from a deal over rotten ships with Russia, to filling his bed with the kind of ladies that Godoy would hardly have deigned to touch with gloves on. Fernando was, in fact, married. By his death in 1833, he had had four wives, and only the last of them, his niece María Cristina, produced issue: two daughters, the elder of whom, Isabel, reigned as Queen Isabel II (1833–1870), displacing Fernando's younger brother, Carlos, as heir presumptive to the throne and thereby triggering the bitter conflicts of the Carlist wars.

At the time of his restoration, Fernando was in his first marriage, to the pale, sickly, plain, and intelligent princess of Naples. The liaison was a disaster for both sides. María Luisa detested her daughter-in-law, calling her "a half-dead frog" and "a bloodless little animal all venom and vinegar." She was afraid that, being Italian (a people the Spaniards believed were always poisoning their enemies), she would do away not only with Fernando but, more to the point, herself. Accordingly, María Luisa had the princess spied on by her confessor, her doctor, and her friends. For her part, the princess soon realized her mistake in marrying the Desired One, but by then it was too late. She had accepted him on the basis of a portrait (not by Goya), which was ugly enough but nowhere near the unpleasant reality. "My daughter is desperate," wrote the queen of Naples. "Her husband is an absolute blockhead and not even her husband in the flesh, as well as being a hulking lout who does nothing and stays all the time in his room." It is not difficult to see Fernando's desire to humiliate, insult, and frustrate a royal wife of royal origin as the outcome of his hatred for his royal

mother. For El Deseado, the trashier the woman the better: his contempt for them worked as a revenge on his exiled (and exiling) mother.³

Fernando VII was completely a radical, though not intelligently so. And like many radicals before and since, he placed his trust in the instincts of the mob. He knew the mob could be relied on to hate liberals and *afrancesados*. If he could keep the mob on his side, the aristocracy could manipulate it at will against the pointy-headed elitists and he could stay in power. That had been the lesson of Aranjuez, and Fernando never forgot it.

Perhaps the most succinct emblem of the war Fernando launched against liberals happened, shortly after his return, at the University of Cervera. This school was an artificial growth. Back in 1717, Felipe V had closed all Spanish universities as being too liberal for his tastes and set up one central institution, the University of Cervera, in a paltry town on the highway from Madrid to Barcelona that lacked even a municipal library. Its curriculum was an antiquated joke, devised by the Inquisition. (The Jesuits had once helped run the university but no longer; foolishly, Carlos III had expelled them from Spain in 1767.) But when Fernando VII paid it a state visit during a royal progress early in his reign, the chancellor of the university rose, or rather sank, to the occasion and became an emblematic figure in Spanish academic history. "Lejos de nosotros," he assured the Desired One, "la funesta manía de pensar"—"Far from us be the disastrous mania for thinking."

Fernando could not have agreed more, and his war on the *doceanistas*—the "Year-Twelvers," nickname of those who supported the 1812 Constitution—began during the night of May 10–11, 1814, when the police dragged a number of distinguished liberals from their beds to prison. Some ended up in jail in Africa, others were immured in convents and monasteries—the nuns and priests, clicking their rosary beads as they patrolled the stony corridors, made good jailers for Fernando. His hunt for suspected "traitors" soon attained manic proportions. Arbitrary arrest, imprisonment, confiscation of goods, arraignment by the newly restored Inquisition, the sundering of families, torture sometimes: these were the common fate of *liberales*. They were extraordinarily hated by the right and responded with a bitterness they had never felt before.

Consequently, civil life in Madrid descended into an insipid mixture of fear and boredom. *Tertulias*, those discussion groups so enjoyed by urban Spaniards, almost ceased to exist. So did café life, since any gathering of more than two people was viewed as potentially subversive by Fernando's numerous police spies. Plagued by surveillance, constantly threatened by authority, floods of *liberales*—perhaps as many as twelve thousand families—went into exile, most

in France, preferring an uncertain future in the territory of a recent enemy to the prospect of living under the heavy and arbitrary thumb of Fernando; more often than not they were welcomed (at first) as political martyrs whose presence in France was a compliment to its government. Some went to England; a few, to North America.

Fernando's special hatred was reserved for the declared *afrancesados*. (Of course, the categories of "liberal" and "French sympathizer" constantly overlapped.) Most of these were timid and conformist people, of superior intelligence to the instinct-driven *populacho* who so desired the Desired One. They had careers to protect. Lawyers, merchants, local administrators, cultured bureaucrats, they took the French side against the confused and hectic patriot resistance because they sincerely believed two main things: first, as noted before, that the Napoleonic system of laws and rights was morally and politically better than what the Bourbons had to offer; second, that France could not possibly lose the war.

This was, technically, a defeatist attitude, and the afrancesados were certainly collaborators. But there was every reason to think that armed resistance to Napoleon would plunge Spain into a hopeless war that it was bound to lose. Once it was lost, Spain would become a colony in the bluntest terms, ruled from Paris as a huge French fief. Therefore the best way of preserving both the Spanish throne and at least some degree of Spanish autonomy was to negotiate with Napoleon and accept his brother, José I, as a genuine king. Not one of the afrancesados would have considered himself a traitor. They were all patriots. But the capital-P Patriots had won, thanks to Wellington. The "Frenchies" had lost. Fernando now set out to wreak his revenge on them, with a grinding and obsessive minuteness that reflected his determination to give no one who had ever opposed him a second chance. His instrument for this was the mob. In 1814, a crowd of Madrid people celebrated his return to power by rioting out of control against the Cortes and the very idea of electoral, constitutional government. They destroyed most of the Hall of Sessions in the parliament, tore out a stone plaque on which the chief articles of the Constitution were engraved, and broke it in fragments. They also defaced or destroyed a number of statues and graven symbols associated with constitutional rule, chanting imbecilic slogans in praise of Fernando and absolutism:

> Vivan las cadenas, Viva la opresión; Viva el rey Fernando, Muera la Nación!

Goya, Black Border Album, 19, *No sabe lo que hace* ("He doesn't know what he's doing"). Brush and India ink, 27 x 18 cm. Staatliche Museen zu Berlin, Kupferstichkabinett.

(Long live our chains, long live oppression; long live King Fernando, death to the Nation!)

Goya made this episode the theme of a drawing from c. 1814–17. A sturdy workman is up a ladder, leaning against a pedestal. With his mason's hammer, he has just smashed a classical bust to the ground. His eyes are shut, indicating his blindness. *No sabe lo que hace*, runs Goya's caption: "He doesn't know what he's doing." It is a deliberate echo of Christ's words on the Cross: "Father, forgive them, for they know not what they do." So much for the collective wisdom of the crowd.

It seems strange, given Fernando's use of the mob as an instrument of policy, that he was not more generous or effusive with imagery of the people. But he loathed anything that smelled to him of democracy, and the most bizarre instance of this was what happened to Goya's great paintings the *Second* and the *Third of May*. Fernando's regime seems to have ignored them completely, and not placed them on view, despite the fact that Goya's images gave the credit for the May rising entirely to the Madrid *pueblo*: the paintings did not even make it into the Prado's catalog until the king was dead. This was consistent with other peculiarities of Fernandine policy. He felt that all the glory should shine

Goya, *Great Pyramid*, c. 1814. Black chalk, 29.1 x 41.4 cm. Heirs of the Marqués Casa Torres.

directly on the king, not his subjects. For six years after the end of the war, it was forbidden even to raise the idea of a monument, let alone a real monument, to the patriot martyrs of May 2–3. Then, when the so-called Trienio Liberal—the brief three-year period of Liberal government, 1820–23—was ushered in by a revolution against Fernando led by the liberal army officer Rafael de Riego, the possibility opened up again, and it is to this brief window that Goya's proposal for a monument probably belongs. Nothing he drew or painted more convincingly reveals the effect that French Neoclassical ideas and designs had on Goya than this sketch. It is odd to see Goya, who generally showed no interest at all in drawing architecture, actually designing a building: this one commemorates the dead of May 2 in an idiom exactly in sync with the utopian architects of the French Revolution, specifically Étienne-Louis Boullée (1728–99). In

April 1812, the Parliament had passed a resolution to commemorate the dead of the Second and Third of May with a *sencilla pirámide*, a simple pyramid, raised over the spot where they lay in a common grave next to the Prado. Goya's proposed pyramid was simple but enormous. It dwarfs the Prado, which is seen to its right, and the pedestrians and carriages circulating in the foreground. It would have been hundreds of feet high, pierced by a single arch right through its base—a giant gate, with a tunnel to bring the public through.

FERNANDO'S OBSESSIVELY REACTIONARY RULE boded ill for Goya, for he, like many artists both great and little, was a man of nuanced and somewhat contradictory opinions. He was, by Fernando's rigid standards, an *afrancesado*, and in any case he disliked and despised the new king and his opinions. He never said so, but his drawings and etchings amply testify to this. However, he was also, and intensely, a patriot. Goya had been faced with the dilemma of how to make a living in time of war, which is never easy for artists, whatever their convictions. From 1808 to 1814, he had taken no salary as first painter to the king from José I's administration: he clearly did not think it was right to work, in an official capacity, for the French. He had lived, he testified, on investments and on the sale of goods (jewelry, furniture), plus whatever he could pick up from portrait commissions and the sale of cabinet paintings.

As we have seen, this was not really true, but it was more true than false. Goya undertook, in 1810, the big Allegory of Madrid with Joseph Bonaparte's profile portrait, soon to be painted out and replaced by "Constitución" and, later, by "Dos de Mayo"—though he would stress later that el rey intruso did not pose for the portrait, that it was done from a medallion and entailed no direct interaction between artist and subject; they were never in the same room together. He also did portraits for clients from the French occupation, though not many. The portrait of José I was not the only picture Goya would do for the French side. He made a portrait (1810) of José Manuel Romero, who had become José I's minister of justice in 1809, then of the interior, and finally secretary of state—a man of fierce and unshakeable loyalty to the Bonapartists. Goya's rendering of this formidable presence with his piercing gaze is the only picture of a royal minister he is known to have done. In October 1810 he also painted José I's superbly elegant aide-de-camp, General Nicolas Guye, a close friend of General Hugo, the father of France's great writer Victor Hugo. Goya followed it with an enchanting portrait of Guye's little son Victor, who served José I as a royal page, looking slightly nervous in his military uniform.

In 1810–12 Gova produced one of the greatest of all his portraits, commissioned by Iosé I: the likeness of that ilustrado priest Juan Antonio Llorente, who had been appointed to the Holy Office and then worked steadily to dismantle its repressive powers from within, believing that (as he put it) there was "an enormous difference in circumstances" between the Inquisition of the fifteenth century and the form and use it had assumed by the early nineteenth, and that "the tribunal could not preserve its claim to being just if it continued to use the methods of three centuries past." Gova painted fifty-three-year-old Llorente as a sober and imposing figure, the tall black-clad cleric with the red ribbon of the Royal Order of Spain, instituted by José I. But his eyes twinkle and a sardonic smile plays around his mouth: this priest Llorente is no simple character but a brilliant intellectual and an extremely strong one, and Goya has paid full tribute to his strength. The two were friends. Llorente's Historia crítica de la Inquisición en España, published in 1818, became a fundamental text of the Spanish Enlightenment, and there are especially interesting parallels between its treatment of witchcraft and Goya's. It was a basic source for many of Goya's scenes of inquisitorial torment that had dropped out of use by Goya's time, and which the artist could not have witnessed himself. Llorente, in fact, represented whatever was best about the French administration of occupied Spain. Without for a moment compromising on his religious beliefs as a priest, he became a hero of ecclesiastical humanity. No wonder that he had to go into exile with the retreating French when Fernando VII came back into power, bringing with him all the blackest forces of repression, after 1814. There could have been no place for such men as Llorente under the restored monarchy.

Finally, Goya did a portrait of José I's sixteen-year-old Spanish mistress, Pepita, daughter of the marquis of Montehermoso. She was very pretty and "accomplished"; she spoke fluent French and Italian, sang agreeably and accompanied herself on the guitar, wrote verse in several languages, and could paint a quite commendable likeness. Her presence in the royal palace caused José I's queen, Julie, to depart in a huff for France.

So much for Goya's *Josefino* subjects. It could hardly be said that painting them made him a Bonapartist collaborator. But there remained three awkward matters to explain.

The first of these dated from 1810, when Goya was sixty-four. On José's orders, a three-man commission was set up to select fifty paintings from Spanish collections—mostly works "sequestered" from monasteries, churches, and convents that had been shut down, others confiscated from the exiled Godoy's large collection—as a gift of homage to the emperor Napoleon. Goya was one of

Goya, *Juan Antonio Llorente*, c. 1810–12. Oil on canvas, 189.2 x 114.3 cm. Museu de Arte de São Paulo.

its members. This raised in some minds, after Fernando's return, the thought of Goya the collaborator using his special knowledge of Spanish painting to do the work of plundering for the French. Actually, it meant nothing of the kind. Except for two works by Velázquez and four by Zurbarán, the commissioners picked mostly inferior work by very minor and now largely forgotten names like El Mudo, Collantes, and Cabezalero. One might suppose that Goya was contemptuously steering basement junk toward Napoleon. Apparently the French thought so too, for the works were never sent and another commission, this time without Goya, was appointed to choose new ones.

Rather more serious was the problem of the Eggplant.

In October 1808, after the Bourbons' flight to France, the newly installed José I had created a brand-new order to be bestowed on Spaniards who had shown loyalty to him. This was the Royal Order of Spain. It was a five-pointed star, dark red in color, bearing at its center the inscription "Joseph Napoleo Hispanicarun rex instituit"—"Established by Joseph Napoleon, king of the Spaniards." Because of its color, those ungrateful Spaniards promptly nicknamed it la berenjena, "the Eggplant." José I handed these out quite freely, and in March 1811 an Eggplant was bestowed on Goya for cultural services.

In Fernando VII's inflamed eyes, explaining this was going to take some fancy footwork. It was like getting a Frenchman, circa 1946, to account for his puzzling ownership of an Iron Cross. But Gova, not without some difficulty, convinced the royal investigators that he was quite innocent. He insisted that he had never worn the Eggplant, and he produced witnesses, including his parish priest, to that effect. There seemed little point in pursuing an old and infirm man—Gova was nudging seventy, a patriarchal age for a Spaniard then over the merely speculative question of whether he had worn a decoration or not. It would indeed have been a grotesque hypocrisy on Fernando's part to have persecuted Gova for possessing the Eggplant given that Fernando himself, while still in exile in Valencay, had pestered José I to give him that very honor. (This did not inhibit Fernando, after his return, from persecuting other Spaniards who had accepted it.)⁶ Besides, Goya was likely to be more valuable to Spain if he kept painting, even if Fernando rather disliked his work and much preferred his own court painter, Vicente López. Goya wanted to get on with the Second and Third of May, the pictures that would afford the ultimate proof of his unswerving patriotism. But there remained one more obstacle to the tranquil but busy postwar life he sought.

It was the Inquisition, which in 1815 decided to investigate him for obscenity. The cause was the not-yet-famous pair of portraits, the *Naked Maja* and

Clothed Maja, which a busybody who bore the exalted title of "director-general for seizures" had noticed, along with several paintings of nudes by other hands, in a Madrid storehouse, the Depósito General de Secuestros, where the confiscated collections of Godoy reposed. This bureaucrat duly wrote to the fiscal inquisitor of the Holy Office, Dr. Zorilla de Velasco of the Secret Chamber of the Court Inquisition, whose curiosity was duly piqued. He therefore wrote to an underling that Goya should be looked into:

Having to proceed against painters in accordance with rule 11 of the expurgation procedure, and given that Don Francisco de Goya is the author of two of the works which have been taken possession of . . . one of them representing a naked woman on a bed . . . and the other a woman dressed as a *maja* on a bed . . . the said Goya [should] be ordered to appear before this tribunal so as to identify them and state whether they are his work, for what reasons he did them, at whose request, and what intention guided him.

It would have been quite useful to future art historians if, in fact, Goya had been made to answer these questions in the presence of a secretary who took his responses down. One would love to know why he did the *Majas*, and for whom. But this, alas, was not to be. A passing remark by Goya to his friend Joaquín Ferrer ten years later suggests that this was not his first brush with the Inquisition: although he had given the copperplates of the *Caprichos* to Carlos IV, Goya said, and even though the king had gladly condescended to accept them, "in spite of all that, they denounced me to [the Inquisition]." Nothing came of that first denunciation, and nothing of this second one either. Perhaps the queries about the *Majas* were suppressed; in any case, no record survives of any further pressure from the Holy Office, and Goya himself never mentioned it again, which he certainly would have if anything further had happened.

Goya had always detested the Inquisition, although he ran foul of it only in his later life. It had once been as close to all-powerful as any Spanish institution could be—a direct arm of papal power, the Holy Office, founded by Pope Gregory IX in 1233 to suppress any outbreak or even hint of heresy. Through the Inquisition, dissent could be stifled, careers crushed, and even the higher circles of the court made to tremble. It was the instrument through which the essential idea of a pure and perfect Church, inerrant and incapable of compromise with heresy, could be preserved. Through fear and coercion, its effect on the intellectual life of Spain was atrocious.

What we call the "Spanish Inquisition," with its dreaded ceremonies of interrogation and torture, its autos-da-fé and burnings at the stake, in all the anti-

Semitic fury of its tribunals, came into existence at the end of the fifteenth century with the coronation of Fernando and Isabel. It guttered out about three hundred years later, in Goya's time. The last person to be burned at the stake in Spain on the orders of the Holy Office was an *ilusa*, or visionary, named María de Dolores López, who met her fate in 1781, in the reign of Carlos III. Inevitably, a huge body of documentation and legend—an essential part of *la leyenda negra*, "the black legend" of an implacably cruel Church—was to condense and crystallize around the Inquisition. Most of this was written. Goya was the first important visual artist to let his work speak out against the Inquisition while it was still in existence and presented a threat, however notional, to its critics; and he was the last and perhaps the only one to be threatened by its investigators.

The truth is that by Goya's time the Inquisition was entering its decadence. Combined with conservative royal power, it was still an irritant to open thought, but it could not eliminate what the Church defined as heresy or keep "dangerous" books out of Spain. All it could do was make access to enlightened French ideas more difficult and expensive; books had to be smuggled in, and a smuggled book was not cheap. "At the beginning of every avenue of progress, intellectual or material," wrote the historian Raymond Carr, "stood the Church with its feeble Inquisition as a symbol of Spain's distance from cultivated Europe."⁷ But by the time that the Inquisition became a theme in Goya's work, it was not much more than a symbol, albeit one freighted with unpleasant memories of much darker times. Intellectuals, writers, and liberal priests like Goya's friend the cleric Llorente struggled gamely to have this symbol expunged. Goya clearly wished to do in paint and ink what Llorente had done in prose, but he chose to indict not the Inquisition as it existed in 1810-14 but its much earlier, more sadistic and tyrannous form. His depictions of the Inquisition and its victims, which begin around 1810, are works of memory and imagination. They are grounded in fact and in the accounts of supposed eyewitnesses, but they represent things Gova had heard about, not seen. They have the same loose relation to reportage as his Desastres de la guerra: they are free artistic evocations of things that happened in the past. And the past of Goya's Inquisition images is more remote than the past of the war.

The Inquisition was not his only subject commenting on Church ceremony and superstition. In the *Procession of Flagellants* (1812–14), we see one of the spectacles of Holy Week, celebrated most famously in Sevilla but in other cities of Spain as well. Groups of pious laymen known as *cofradías* (confraternities) were organized to do honor to particular emblems of their cult, representing

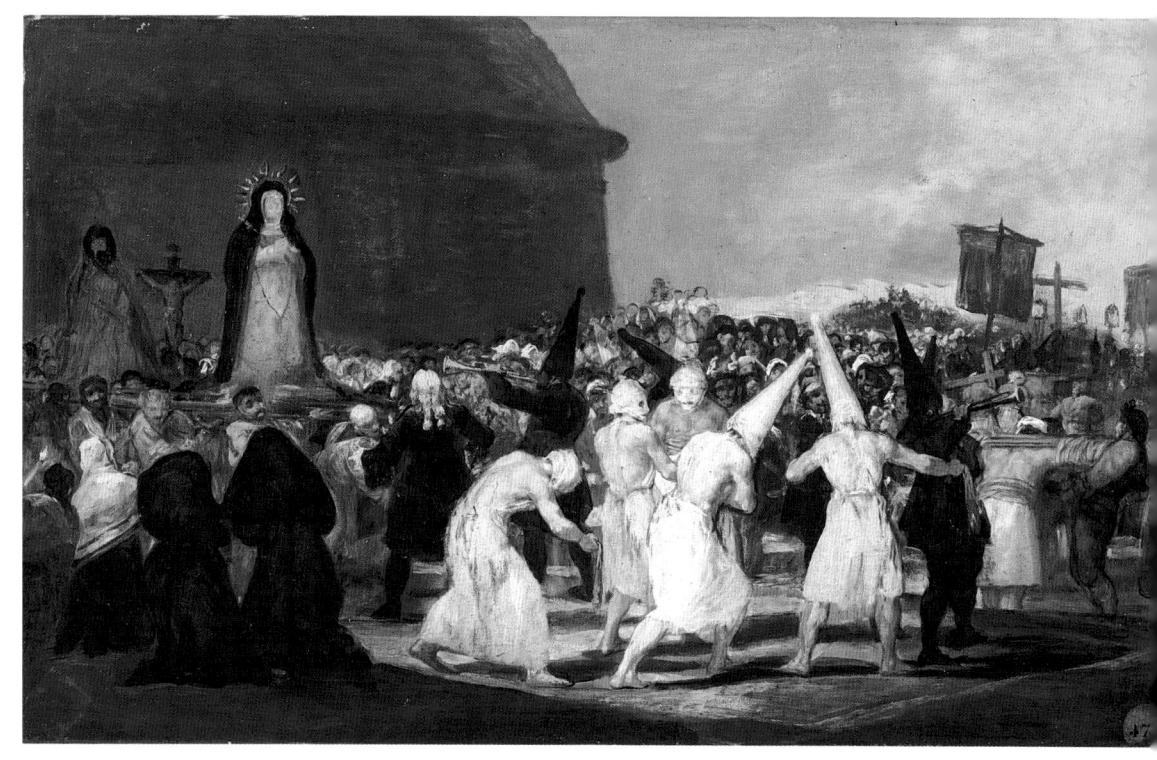

Goya, *Procesión de disciplinantes (A Procession of Flagellants)*, c. 1812–14. Oil on panel, 46 x 73 cm. Museo de la Real Academia de Bellas Artes de San Fernando, Madrid.

Christ, his saints, or, especially, the Virgin Mary. Enormous sums were spent on life-size and elaborately lifelike effigies of these holy beings, which were carried in procession (as they still are today) through the streets from their habitual resting place in a church: clothes, artificial hair, maquillage, everything contributed to a total illusionism that was, in effect, the climax of all hyper-realist tendencies in Spanish Baroque sculpture. Some members of the *cofradía* were accorded the honor of carrying the heavy effigies. Others preceded and followed it, dressed in black, masked and with conical hats, beating drums and bells and blowing cornets. And the *penitentes* (repentant sinners), who by surrendering themselves to punishment won grace through the intercession of the Virgin or a saint, were an essential part of the ritual. Garbed only in long white skirts, with their backs and chests bare and dunce-cap *corozas* on their heads, they would flog themselves and their companions with many-corded whips whose tips were armed with sharp metal or shards of glass. This flagellation produced streams of blood and scars that lasted a lifetime. To be a full-fledged and blood-initiated *penitente* was

esteemed a signal honor, and Holy Week processions were one of the classic bizarreries of Spain. So much did *ilustrado* opinion detest this sadomasochistic piety, putting it on a level with bullfighting as a sign of irrational degradation, that by 1777 the Holy Week floggings were outlawed. So when Goya (who may, just possibly, have seen one of the last ceremonies of this kind as a youth) painted a Holy Week procession complete with blood-boltered penitents, he was looking back to an older but still mythically powerful Spain. This, he was in effect saying, is the violent and superstitious culture to which the return of Fernando also returns us. It is one with the Inquisition, which the king reinstated and which Goya painted, about 1816, in a companion piece.

Gova's Inquisition Scene (c. 1816), shows the procedure known as an autillo, the formal reading of charges against the accused before the Inquisitorial tribunal. This ceremony normally took place inside a hall or a church; it had replaced the larger and even more theatrical outdoor ritual of the auto-da-fé (act of faith), in which the same procedure was enacted in a plaza in front of a larger crowd and in the presence of instruments of terror: the irons, the stake, and the pyre. Gova's small panel (it contains dozens of distinguishable figures in a space only about 18 × 29 inches) is a superb example of his ability to assemble a narrative in a close-packed but entirely coherent space, and it draws a poignant contrast between judges and victims by formal means. There are four accused heretics, each wearing the *coroza* of shame; the traces of pink pattern on each cone lend a tiny, sardonic note of party-hat frivolity to the grim scene, while the different directions in which the cones are wagging and pointing suggest the disarray and fear that dominate the minds of the prisoners as they sit, their hands clasped in dumb submission, listening to the reading of the charges. This recitation is done by the lector silhouetted against the pillar in the background, whose face is lit by a candle as he drones on over his charge book. Below him are rows of clerics, including two Dominicans—that much-feared order, the Domini canes, or "God's hounds"—in their white habits. Right below them is a figure in black, with a black skullcap and a gold pectoral cross: the chief Inquisitor, who, from the gesture of his hand, seems to be making a point to the priest to the left of him. The figure of the chief magistrate, seated in the left foreground, rhymes with the abject prisoners on the right in one of those "doublings" at which Goya was so brilliant. The prisoners slump and fidget; they are fatigued, and scared. The magistrate, who gazes abstractedly over their heads, is not scared, but he is very bored. He has seen this melancholy drama many times before, and by now it is merely procedural for him. The lives of these heretics do not matter; in any case, they are dead already. The sambenito that each wears—the word comes

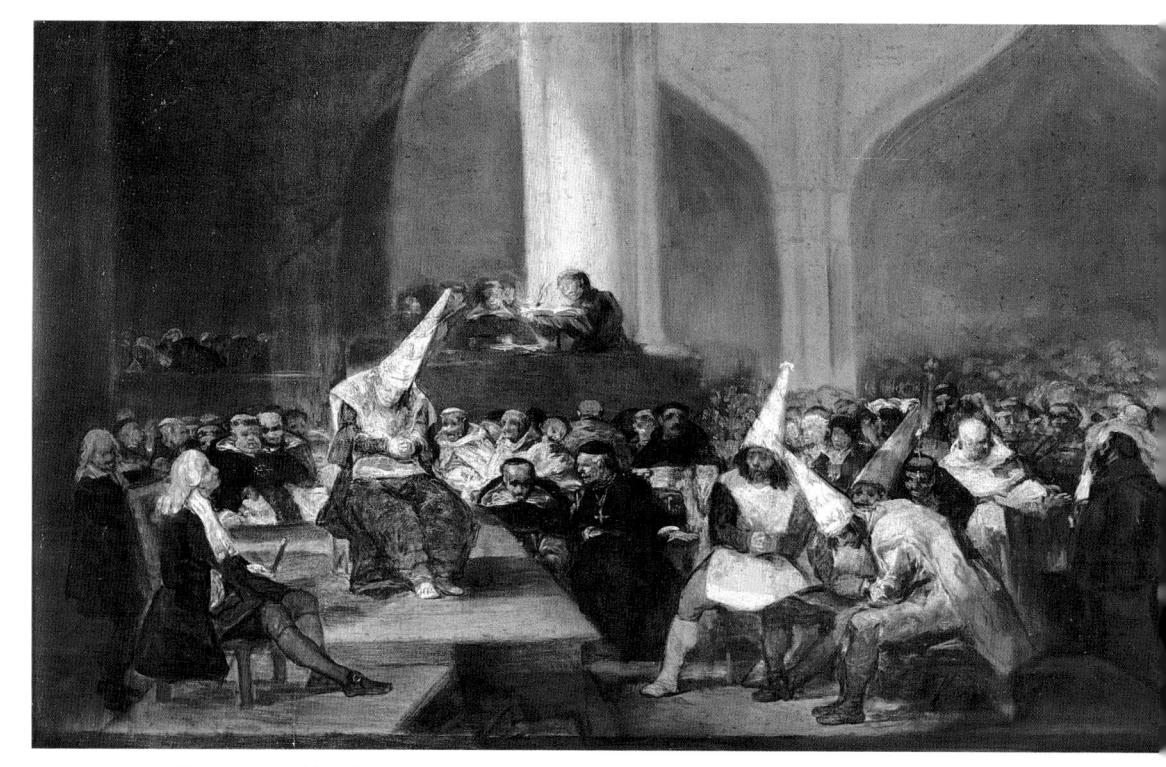

Goya, *Inquisition Scene*, c. 1816. Oil on panel, 46 x 73 cm. Museo de la Real Academia de Bellas Artes de San Fernando, Madrid.

from *saco bendito*, "blessed bag": a brilliantly conceived ecclesiastical supergraphic, a kind of chasuble, painted or embroidered with the names of their heresies and the iconic red flames of their burning—proclaims that they are destined for the stake. There will be no reprieve. But the ritual must go on, the millstones of Jesus must grind to the end. Later, each man's *sambenito* will be displayed, like the skin of an animal, on the wall of his parish church, declaring another victory over heresy.

The *Inquisition Scene* was preceded by dozens of drawings of Inquisition victims. How many, we do not know, but it was clearly a large and urgent theme for Goya after Fernando VII reinstated the Holy Office, and his visual notes on it fill most of a sketchbook known as Album C and probably dating from about 1810–14. Their constant theme, amplified by their handwritten captions, is judicial abuse: the ludicrous and deadly disproportion between the punishments meted out to the unhappy transgressors and the trivial nature of their "spiritual" offenses. Sometimes these torments and injustices happen to peo-

Goya, Inquisition Album, 109, Zapata, tu gloria será eterna ("Zapata, your glory will be eternal"), c. 1810-14. Brush with gray and brown wash, 20.5 x 14.4 cm. Museo Nacional del Prado, Madrid.

ple who might be Goya's contemporaries; sometimes, to ones who are clearly not. An example of the latter is page 109 of Album C, depicting an aged Jew in skullcap and dark caftan, sitting with bowed head and downcast eyes on the floor of a dungeon. One heavy chain secures his arms behind his back; another runs through a ringbolt in the wall to an iron collar on his neck. "Zapata, tu gloria será eterna," runs Goya's inscription ("Zapata, your glory will be eternal"). Zapata is a common name in Spain, but this one is thought to have been a pioneering medical doctor of the late seventeenth to early eighteenth century, Diego Mateo Zapata, who founded one of the earliest Spanish scientific institutions (the Royal Medical Chemical Society of Sevilla) and served with distinction as physician to the courts of Carlos II and Felipe V.8 Out of jealousy, his rivals denounced him to the Inquisition in 1721, for he was the descendant of conversos, Jews who had embraced Christianity but were suspected of doing it for opportunistic reasons, not out of "true" faith. They claimed he was a "Judaizer," who secretly practiced the Jewish faith. The Inquisition arrested Zapata and put him to the question, under torture. He spent some time in prison but was eventually released, thanks to the intercession of powerful friends (including Felipe himself and the dukes of Medinaceli). Goya's drawing depicts him as an archetype of the suffering sage; but Zapata died in 1745, the vear before Goya was born.

Ilustrado writers like Puigblanch and Ruiz de Padrón who attacked the Inquisition wrote as though its past abuses kept going on into the present. Goya used this rhetorical device as well, and after two centuries we cannot know what cruelties, if any, he had actually seen. Probably very few, perhaps none; no painter is under oath. The Inquisition's practice of torturing and burning people in public had not survived into the nineteenth century. Here, his moral anger and passionate sympathy with the victims are what count. There are styles in denunciation. In any case, one could well argue that the past practices of the Inquisition were so horrible, there could be no justification for keeping it alive now that it was weak.

Some of the Inquisition drawings depict its tortures. Others take a broader and, so to speak, more philosophical view of its methods. The torture images are sometimes linked to noted historical persons who fell into the Inquisition's hands. These include not only Zapata but older figures, notably Galileo Galilei (1564–1642), who fell into the hands of the Roman Inquisition in 1633 for his famous adoption of Copernicus's theory that the earth went around the sun, not vice versa. Goya's drawing *Por descubrir el mobimiento de la tierra* ("For discovering the movement of the earth"; c. 1810–14) shows the sage as martyr, head bowed, arms outstretched and shackled between two blocks of stone, legs extended and ironed down before him. We now know that this belief in Gali-

Goya, Inquisition Album, 94, *Por descubrir el mobimiento de la tierra* ("For discovering the movement of the earth"), c. 1810–14. Brush with gray and brown-black wash, 20.6 x 14.4 cm. Museo Nacional del Prado, Madrid.

Left: Goya, Inquisition Album, 98, ¿Por liberal? ("For being a liberal?"), c. 1810–14. Brush with gray and brown wash, 20.5 x 14.3 cm. Museo Nacional del Prado, Madrid. Right: Goya, Inquisition Album, 93, Por casarse con quien quiso ("For marrying whom she wanted") c. 1810–14. Brush with gray and brown wash, heightened with pen and brown ink, 20.5 x 14.4 cm. Museo Nacional del Prado, Madrid.

leo's carceral torments is pure myth—the Church silenced him but did not torture him, he never bore chains, and he continued to work in his own house near Florence—but Goya did not know this, and probably would not have cared if he had: Galileo was a martyr of reason to bigotry, and his proper setting was a dungeon. This outstretched and faceless figure is, in effect, a Crucifixion.

Other torture victims in Goya's Album C drawings are nameless. On page 98 in the album a woman slumps against a wooden structure, maybe part of a scaffold. Her ankles are locked down by a wooden bar. Her arms are bound behind her back. An iron ring, connected to a chain, encircles her neck. Her dress is torn and crumpled, her hair disheveled, her expression drained, her mouth slack. The simple two-word caption reads "¿Por liberal?" ("For being a liberal?"). She has been through hell. What kind of hell, Goya does not say. Perhaps a glimpse of it is afforded by the piercingly dramatic dungeon scene on page 93, Por casarse con quien quiso ("For marrying whom she wanted"). In darkness, a woman has been tied to a rack, which holds her head-down. The only highlight in the gloom is her anguished, inverted face. Her tormentors, five in

all, cluster about her. Their features cannot be made out. It is a strong image of human consciousness beset by forces of chaos, secrecy, anonymity. The fact that not a single person is known to have been tortured by the Inquisition for exercising free marital choice in Goya's time is (almost) beside the point.

Not everyone in the Inquisition drawings is being tortured. Some are merely humiliated, exposed, or otherwise mistreated without violence. One figure, wearing *coroza* and *sambenito*, is seen from the back, seated on a crude stool, while a shadowy prosecutor reads the charges: "*P.r mober la lengua de otro modo*" ("For wagging his tongue in a different way"). A woman, gagged and fettered, sits on another stool, another platform, enduring the execrations of another crowd: *P.r q.e sabía hacer ratones* ("Because she knew how to make mice")—a not uncommon charge in witch hunts at the height of the Inquisition.

Not all Goya's images of religion, and of supernatural events, from the postwar years are designed to horrify the viewer. He was capable of straightforwardly pious pictures, some of which were done for the Church itself. An example is his commission for the cathedral of Sevilla depicting the city's patron saints, Justa and Rufina, with palms, the attributes of their martyrdom. Both women were potters—an appropriate métier for the patrons of a city whose economy depended so largely on the making, sale, and export of ceramics—hence the bowls and plates they are holding. The Roman authorities had put them in an enclosure with wild beasts, which, impressed by the women's sanctity, refused to dismember them; hence the enchanting lion turned pussycat submissively licking the bare foot of Rufina. The supremacy of their faith is indicated by the marble Roman goddess, a pagan idol whose fragments lie shattered at Justa's feet. In the background is the skyline of Sevilla, its river, and the tall shaft of the city's main landmark, the Moorish *giralda*, or belltower.

It seems not to have been altogether easy to get Goya to make the right picture for the taste of the Sevilla church authorities. The commission had been set up by an old friend, Juan Ceán Bermúdez, who decades before had helped secure him the job of painting the directors of the Banco Nacional de San Carlos. To judge from a letter Ceán wrote in 1817 to a collector friend, it was not an altogether easy task. The independent-minded and crotchety old genius had to be firmly coached: the cathedral authorities were paying 28,000 reales for the painting, a very substantial fee, and they wanted to be quite sure that they got full iconographic and spiritual value for their money:

At the moment I am trying to instill in Goya the requisite decorum, humility and devotion, together with a suitably respectable subject, simple yet appro-

Goya, *Las Santas Justa y Rufina*, 1817. Oil on canvas, 309 x 177 cm. Cathedral de Sevilla.

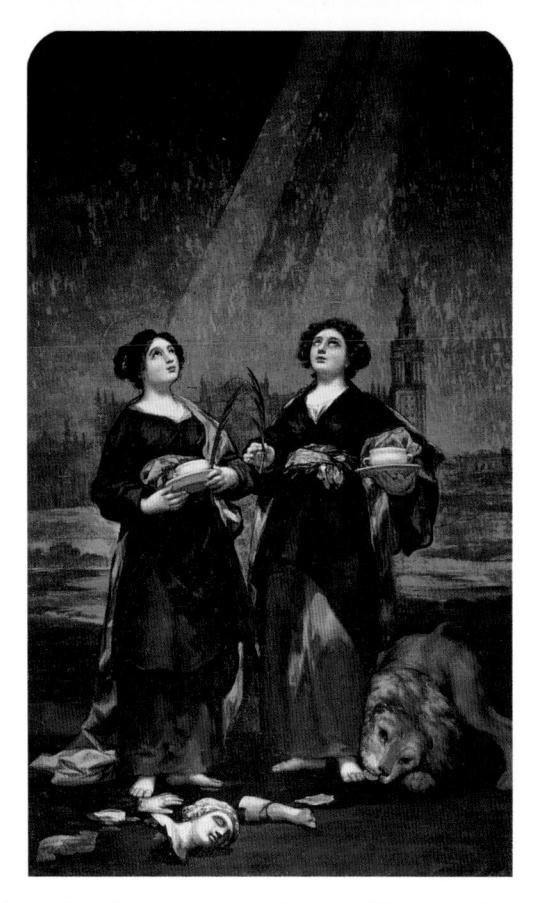

priate composition and religious ideas, for a large painting that the Chapter of Sevilla Cathedral has asked me to obtain for their church. . . .

The Chapter, although it left the details to me, wanted the painting to represent the act of martyrdom itself or some other historic occasion in the lives of these saints. But I decided that it would be more appropriate to depict the two saints on their own, full-length. . . .

The tender postures and virtuous expressions of the saints must move people to worship them and pray to them, since this is the proper object of such paintings.

You know Goya and will realize the efforts I have had to make to instill ideas into him which are so obviously against his grain. I gave him written instructions on how to paint the picture, and made him prepare three or four preliminary sketches. Now at last he is roughing out the full-size painting itself, and I trust it will turn out as I want.¹⁰

Evidently it did, because Goya needed the money and Ceán Bermúdez was in any case an old friend. What Goya's actual feelings about the girl martyrs may have been is not known, and not possible to deduce from the painting.

Goya, La Ultima Comunión de San José de Calasanz (The Last Communion of St. Joseph Calasanz), 1819. Oil on canvas, 250 x 180 cm. Museo Nacional del Prado, Madrid.

That is not the case with another icon of sainthood he produced two years later. *The Last Communion of St. Joseph Calasanz* (1819), was commissioned by the Escolapian order for its principal church in Madrid. It commemorates the moment when the founder of that order, San José de Calasanz (1557–1648), some ninety years old and close to death, insisted on rising from his deathbed to take Holy Communion before an audience of his juniors and disciples. This is a wonderful study in the frailty of determined old age, with the priest bowing forward as he administers the sacrament to the pale, white-stubbled ancient, his skin of an almost parchmentlike transparency.

How could Goya bring such feeling to this portrayal of an obscure old saint? First, because although Calasanz (like Goya himself, an Aragonese) is a largely forgotten figure today, he was not then. He was, in fact, one of the heroes of Catholic education, an almost Franciscan benefactor who, though a nobleman by birth, had devoted his life to the cause of educating the children of the poor. At the outset, living in Rome, he had tried to persuade secular teachers to admit pauper children free of charge to their classes. This failed, as did Calasanz's next effort, to persuade the Roman Senate to subsidize education for the poor.

Goya, Self-portrait, 1815. Oil on panel, 46 x 35 cm. Museo Nacional del Prado, Madrid.

Finally he and a handful of followers began to set up their own Escuelas Pías, a noble and charitable enterprise that only got them in trouble with the Catholic clergy and the Inquisition. But they kept at it, and by the time of Calasanz's death, his order was running twenty-seven "Pious Schools" in Italy, France, and Spain, including Madrid, where the church of San Antón Abad was their chief foundation.

The second reason that Goya took on this commission and carried it off with such evident care and intensity was, one may surmise, that he himself was feeling his age. He was well past seventy, and he was anxious to leave behind him a tribute to the fathers of the Escolapian order, who, so long ago in Zaragoza, had taken charge of his own education at its Pious School.

We see Goya through his own eyes at the end of the war, in a life-size head and shoulders on a panel painted in 1815. His head is cocked to one side, and the directness of his gaze suggests that he is seeing himself in the act of painting. There are no mannerisms, no signs of décor, no emblematic costume. His shirt collar is open. His forehead is like a cannonball of flesh and bone, lightly filmed, one senses, with the sweat of concentration. He is a man at work, not a court painter displaying his official position. You cannot imagine Velázquez, one of the most dedicated snobs that ever touched a brush, depicting himself in this way. And certainly it was not the way Goya depicted the Spanish nobility, let alone the king, in the seventieth year of his life.

The last royal portraits Goya would do were of Fernando VII, soon after his restoration to the throne in 1814. They are not documents of enthusiasm. In fact, his distaste for the king is almost palpable, but there is nothing in them that could be construed as an insult. Their halfhearted glorification meets the requirements of the job: to take this unmajestic lump of royalty and surround him with the necessary attributes that reflected the Spanish people's deluded view of him as El Deseado, the Desired One. The portraits were not based on actual sittings. Fernando sat for Goya only once, back in 1808, before Napoleon's invasion. To do these portraits, Goya must have dug out the sketches he did on that occasion and reused them.

The first portrait was commissioned by the city council of Santander, and its terms were very specific. The king must be painted full-length and full-face, in the uniform of a colonel of the guards, with the blue-and-white sash of the Order of Carlos III. At his feet would be a lion, and there must be broken chains between its paws, signifying the restitution of Spanish liberty. His hand must rest on an allegorical statue of Spain, on whose pedestal would repose a crown,

Left: Goya, *Fernando VII*, 1814. Oil on canvas, 208 x 126 cm. Museo de Bellas Artes, Santander.

Right: Vincente López, *Fernando VII*, 1808–11. Oil on canvas, 240 x 116 cm. Museo de l'Almodi de Xàriya

a scepter, and a royal mantle. Goya punctiliously supplied all this in fifteen days, exactly on time, for 8,000 reales. The figure of Fernando is so woodenly done that you can almost hear Goya yawning as he paints, and the lion is a lumpish creature that more nearly resembles a stuffed bear. It is a poor and unsympathetic performance, and the second portrait is little better. Now Fernando is seen in a cavalry encampment, with horses behind him. Some kind of engagement is taking place in the background, but Goya leaves it prudently unspecified: which is just as well since, as far as is known, Fernando, though he may from time to time have scrambled onto a horse for purely ceremonial reasons, never fought the French either on horseback or on foot, and was as devoid of military experience as he was of basic martial skills.

Apart from these less-than-routine efforts, the end of the war marked the close of Goya's official duties as a portraitist. The portraits of Fernando were not commissioned by the king but by city governments and agencies: the king him-

self greatly preferred the high finish and detail reliably supplied by his own court painter, Vicente López, whose 1808–11 portrait of the monarch exactly repeats the iconographic detail of Goya's Santander portrait symbol for symbol (lion, scepter, crown, and so forth) but is, if anything, even more congealed and pictorially uninteresting.

Goya did, however, complete one other official painting. It was the largest picture he ever made—some eight feet by ten—and one of the stranger productions of his long career: the grandfather of all boardroom portraits, crowded with dozens of figures set in a gloomy interior. It was intended to commemorate the patronage extended to the Junta de la Real Compañía de Filipinas by Fernando VII, who made an unexpected visit to the general session of the company's board that was held on March 30, 1815, attended by fifty-one members and shareholders. Nothing seems to have happened or been resolved at this session; it was merely ceremonial, and dull ceremony at that. Fernando stayed only an hour and a half. However, his appearance at the meeting was meant to affirm his belief in the world designs of Spain and the continuation of its empire. This faith was, needless to add, vain. It was a collective delusion of the royalist right, believed in only by Fernando and his camarilla of incompetent advisers. The Spanish economy had been completely ruined by the war, and though the Royal Company of the Philippines had once been intended as a powerful instrument of trade and control like the British East India Company, it was now so unprofitable and useless that it was hardly more than decorative. Thus Fernando's appearance was a futile gesture of belief in a hollow empire; a little more than eighty years later, Spain would lose its Philippine empire when the cannon of Commodore Dewey sent its whole navy to the bottom of Manila Bay.

For anyone who has had to endure a full shareholders' meeting of a large modern corporation, its mood is instantly recognizable. No figure gets real precedence over any other; the king is at the center of the table on the dais, but he and his flanking officials are pushed into the background, and the only emphasis he gets is a small heightening of color in his costume—plus his location at the vanishing point of the perspective. The most prominent single zone in the painting is a rectangle of sunlit, inlaid floor. It is a crowded composition that speaks, paradoxically, of emptiness and solitude; an image of droning discussion that conveys only a sense of silence; a theatrical presentation—for this vast room resembles a stage on which all action has stopped and nothing happens, with light streaming in from the wings on the right, a light that seems almost unearthly in contrast to the gloom of the chamber. Yet the obvious antecedent of this morbid space, with its large orthogonal divisions of ceiling

and floor, lies right at the heart of Spanish painting in the "Golden Century," in the work of the artist whom Goya admired to the point of filial piety: the big, brown, receding chamber in which Velázquez set the figures of *Las meninas*.

So *Junta of the Philippines* looks both backward and forward. Backward because of its enormous size, its sense of monumental occasion, and its clear invocation of Velázquez. But forward, too, because of what one could fairly call its incipient modernity: its bareness, staginess, and deliberate cultivation of mystery in the middle of what, by rights, should have been a straightforward narrative of an official event. One hesitates to invoke the word "Surrealist," and yet there is something about the whole tone of the painting that suggests if not Surrealism iself, then certainly the aching distances and enigmatic half-events of its precursor, the *pittura metafisica* of Giorgio de Chirico.

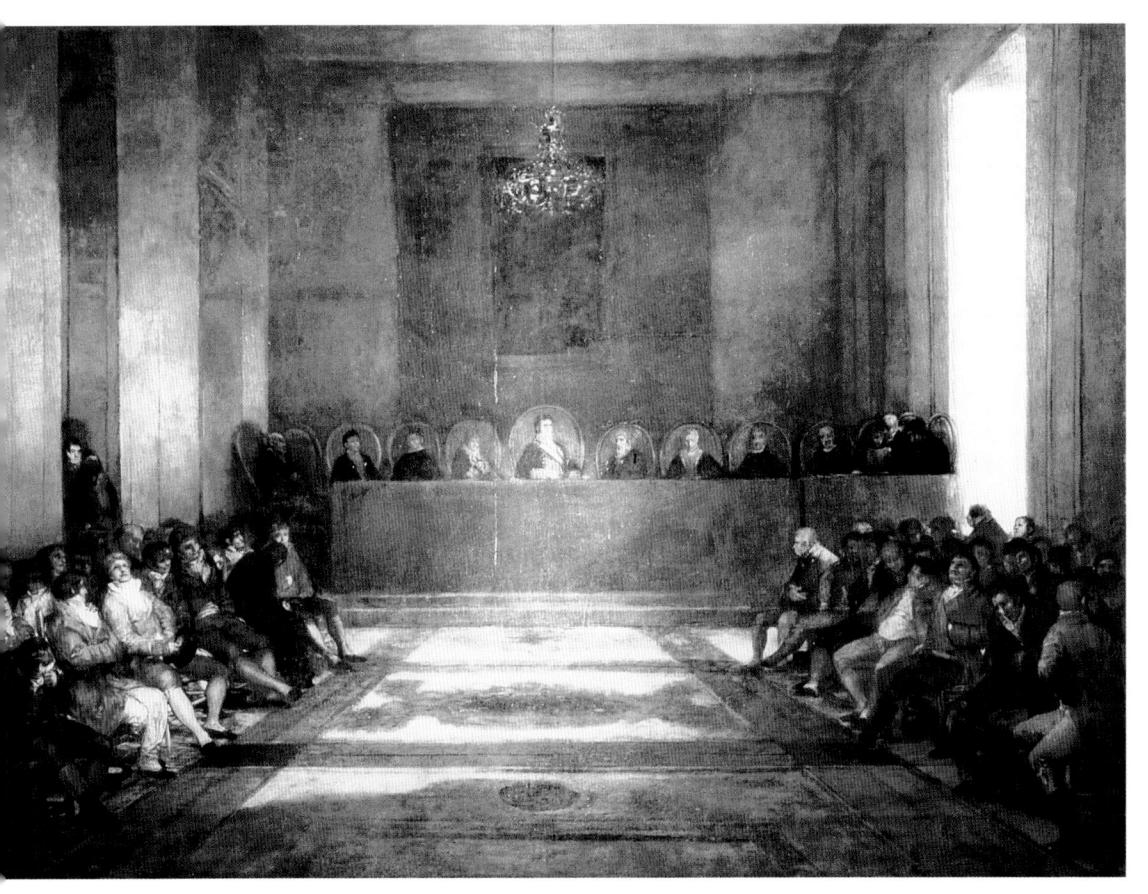

Goya, *Junta de Filipinas (Junta of the Philippines)*, c. 1815. Oil on canvas, 327 x 417 cm. Musée Goya, Castres.

In one of the high wall niches on the left, behind the rows of company directors, one sees an isolated figure, whom the king cannot see and who is clearly detached from the other men in the hall. Who is this mysterious and unique standing watcher? Scholars have determined that he is Miguel de Lardizábal, born in Mexico in 1744, who in 1760 emigrated to Spain and became completely absorbed in the study of Spain's problems of imperial economics.¹¹ Because of his hostility to Fernando's bête noire, Godoy, he became a partisan of Fernando's—neither a happy position nor a secure one, since the Desired One was both paranoid and fickle, and in due course his suspicions of disloyalty fell on Lardizábal. In September 1815 Lardizábal, who had actually commissioned Junta of the Philippines—he was its president by then, as well as minister for the Indies—was dumped by Fernando and imprisoned at Pamplona. Hence, he could not be included at the royal table in the painting. But Gova could not bring himself to leave Lardizábal out of the composition, and so (as a sneaky rebuke to the king) he included the president of the *junta* in the niche, visible to us but not from Fernando's eyeline.

In the closing years of the war Goya also painted a number of decorative and genre canvases that had nothing to do with the conflict. Presumably he wanted relief from its terrible themes; and he must also have wanted to do pictures that were fairly easy to sell, now that official patronage had all but dried up.

Hence the satirical paintings of hags, and the alluring ones of prostitutes at a window, dated between 1808 and 1814. Time, alternatively known as Las viejas ("The Old Girls") is the most acrid of these. A pair of crones are examining, if not exactly admiring, themselves in a hand mirror. On its back is the sardonic inscription ¿Qué tal? ("How's things?"). No good, it seems. The old bat on the right, a chapfallen dame in a beautifully light-struck muslin robe of pale blue and yellow, fiddles with what appears to be a powder compact; in her dyedblond hair is a jeweled arrow, of the kind that Queen María Luisa was wearing in The Family of Carlos IV. (This similarity gave rise to the idea that she is Goya's horrid caricature of María Luisa herself, but there seems to be no real basis for that. Diamanté arrows were a common kind of hairpin.) Artifacts last; their owners decay. Her companion is a horror, a death's head, her nose eaten away by the pox, her hands like claws, her lips and eyes raddled with caked incrustations of lipstick and kohl, her teeth discolored. Rising behind them, also peering at their reflected images, is the ultimate victor of this colloquy: Father Time, with his shag of gray hair and extended wings, grasping not a scythe but a broom with which he will sweep the crones away like the dust they so nearly are.

The Young Ones (c. 1812–14) is of course the antitype of this withered pair, an image of brief beauty: a pretty lady and her maid in front of a frieze of ordinary

Left: Goya, *Time or The Old Ones*, 1808–12. Musée des Beaux-Arts, Lille. Right: Goya, *The Letter or The Young Ones*. Musée des Beaux-Arts, Lille.

working women, laundresses scrubbing their sheets and hanging them up to dry on cords and poles that define the horizon line. Instead of admiring her image in a mirror, the pretty one is reading, with evident satisfaction, a letter that can only be from a lover or admirer—a flattering "reflection," which her maid has evidently just brought her. To strengthen the point, her dog, a King Charles spaniel, is up on its hind legs, devotedly and insistently pawing at her skirt. Her maid raises her parasol to keep the sun from darkening her mistress's rosy complexion, for in Goya's time ideal female beauty did not include a tan: tans were a sign of proletarian work, and would remain associated with labor rather than leisure until well into the twentieth century.

Nothing indicates whether this girl is a prostitute or not. However, Goya's pictures of women on balconies leave no doubt about this. The image of the *ventanera*, or woman looking from a window, had one chief meaning in eighteenth-century Spain: a girl soliciting street trade from above, alone or accompanied by her *celestina*, or bawd. The type was fixed for later use in the seventeenth century, by Murillo in *Two Women at a Window* (c. 1655–60): one of

Goya, *Maja y Celestina en el balcón (Maja and Celestina on the Balcony)*, 1808–10. Oil on canvas. Collection of Bartholomé March, Madrid.

the women veiling her face in mock modesty, the other looking at her target, you, the spectator, with a broad and inviting grin. Goya brought this to a further point, almost of parody, in *Maja and Celestina on the Balcony* (c. 1808–10). The blond *maja* is suggestively disheveled, with plenty of cleavage showing. Behind her lurks the ancient *celestina*, a veritable monster of hypocrisy, fingering her massive rosary beads as she grins in complicity and points at the girl. It is not the subtlest of images, but subtlety—except for the pictorial subtlety of his delectable treatment of the girl's white-and-gold costume—was not Goya's intention here.

As soon as the Peninsular War ended, Goya embarked on another large, private project. Instead of the huge effort of the *Disasters*, he began work on a

shorter series of prints, the *Tauromaquia*, his homage to the great popular ritual uniquely associated with Spain, bullfighting.

There are several possible reasons that he did so. To begin with, he had always been an aficionado, an enthusiast for the rite; and like many other intelligent and perceptive Spaniards, he saw in the corrida a particularly intense metaphor of human fate: the struggle between human consciousness (the torero) and the raw power of nature, as epitomized in the bull. He claimed, probably truthfully, that he had fought bulls in his youth, and that with a sword in his hand he feared nothing and nobody. According to his friends, he went so far as to compare painting to bullfighting—a trope that, after Hemingway's writings popularized bullfighting among Americans in the twentieth century, was to become an irritating feature of the rhetoric of modernist "risk" culture, but was not a cliché in Gova's time—and he had no doubt that the *lidiador* (bullfighter) was practicing a real and valuable art: an idea that had found painted form some years earlier in his celebrated self-portrait of 1794-95, wearing a torero's embroidered jacket while working at the easel. And finally, it may be that despite the tense and frightening content of some of his bullfight plates, Gova just wanted to relax and even to make a bit of money from images of such a popular spectacle. The effort of doing the Desastres was immensely grueling and draining. It could not have been otherwise. But with the Tauromaquia Goya could refresh himself and remember the glorious acts he had witnessed—the fatal errors and unvielding courage of the bullfighters, the stubborn ferocity of the beasts, the archetypal contests between life and death, sun and shadow played out in arenas whose form went back to (and sometimes directly preserved) the circular ring architecture of Spain's ancient Roman past. Today, of course, there are many people who regard Goya's bullfight etchings as not much more than nostalgic evocations of a bloody and disgusting form of entertainment that should be abolished. It is their right to think so. In fact, there was no shortage of liberal, enlightened Spaniards who agreed with them two centuries ago. But it is also true that to understand this artist, you must understand the Tauromaquia.

Perhaps the most salient thing about Goya's bullfight etchings is how little they resemble modern bullfighting. This is partly on purpose, of course, since he meant to give some sense of the origins of the rite before going on to describe what were then (but no longer are) its modern forms. But to scrutinize these images is to become aware of how much bullfighting has changed in the last two hundred years. The subject was one to which Goya returned frequently over the long course of his life. One of his very last paintings—done in

July 1824, shortly before death wrote finis to his exile from Spain, at the Hôtel Favart in Paris during a visit from his place of exile in Bordeaux—was Suerte de varas. The title is a slang-technical term that refers to the opening moves of a bullfight, when the animal is attacked by picadors and their horses are progressively weakened by the wounds inflicted by the furious bull in defending itself. It is a remorselessly bloodthirsty and objectively cruel painting. On the left is a picador on his horse, surrounded by a crowd of chulos, or "assistants," if that is not too clinical a term for the mob in the ring. On the right, superbly profiled, the one clean form in the painting and yet clearly fragile in its isolation, is the bull, still standing erect but with the bright slash of a red wound in its neck. The group on the left is a congested mess of squat humans and dead or dying animals, roughly painted, heavily shadowed in black: you can feel the brutish force in the picador's body as he leans forward, the spear scrunched under his armpit, trying but failing to get his horse to run a few steps at the bull. The horse, for which Goya expresses no sympathy at all, is in terrible shape. The horns of the bull have half-disemboweled it. Blood streams from its anus. A brightly horrible loop of red intestine hangs down from its belly and drags on the ground. It waits passively, in shock, for death. "It is in truth a piteous sight," wrote Richard Ford.

to see the poor mangled horses treading out their entrails, and yet gallantly carrying off their riders unhurt. But as in the pagan sacrifices, the quivering intestines, trembling with life, formed the most propitious omens—to what will not early habit familiarize?—so the Spaniards are no more affected with the reality than the Italians are with the abstract *tanti palpiti* of Rossini.

Horses in the corrida were wholly expendable: old nags without quality, bought cheap from knackers; their death struggles were mere jokes and evoked only hoots and jeers from the packed crowd. The main object, according to Ford, was to keep the wretched animal on its feet long enough to save money:

If the wound received by the horse be not instantaneously mortal, the blood-vomiting hole is plugged up with tow, and the fountain of life stopped for a few minutes. If the flank is only partially ruptured, the protruding bowels are pushed back . . . and the rent is sewn up with a needle and pack-thread. Thus existence is prolonged for new tortures, and a few dollars are saved to the contractor; but neither death nor lacerations excite the least pity, nay, the bloodier and more fatal the spectacle the more brilliant it is pronounced. It is of no use to remonstrate.

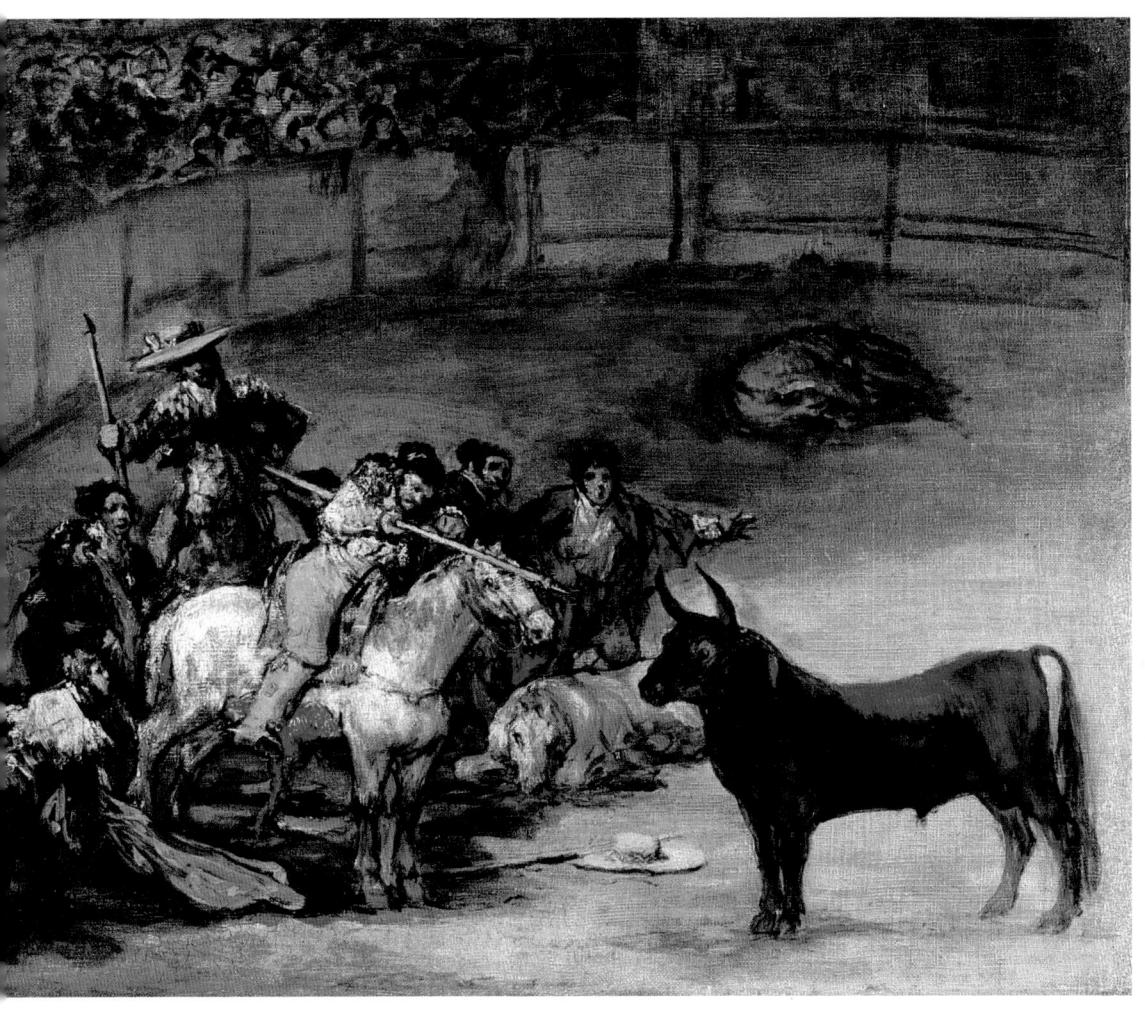

Goya, Suerte de varas, 1824. Oil on canvas, 50 x 61 cm. The J. Paul Getty Museum, Los Angeles.

Much of what seemed entirely normal to Goya, and addictively entertaining to his fellow *aficionados*, would strike a modern connoisseur of tauromachy as gross, comic, and overdone, closer to circus acts than to the restrained, highly stylized, and therefore noble behavior of the torero and the matador in the ring. Probably this was because, by the early nineteenth century, bullfighting itself had turned into a much more popular ritual in Spain. Its origins, as public spectacle, had been chivalrous: a matter of knightly or otherwise noble figures engaging in combat with wild animals, spearing them from horseback. Its development traced a sort of arc, from the primitive to the "noble" to the populist.

Some of the first plates in Goya's *Tauromaquia* seem meant as illustrations to a text by the Francophile writer Nicolás Fernández de Moratín (1737–80), an acquaintance of Goya's, and the father of one of the painter's better friends, the poet and playwright Leandro Fernández de Moratín (whose portrait the artist had done in 1799). Years before, in 1777, Moratín *père* had written a booklet called *Carta histórica sobre el origen y progresos de las fiestas de toro en España* (Historical Outline of the Origin and Development of Bullfighting in Spain). Moratín related how in 1527 the emperor Charles V had celebrated the birth of his son Felipe II by fighting and killing a bull while on horseback in the arena at Valladolid. Goya depicted this in plate 10 of the series: the bull and the emperor's horse are locked together in a solid mass on the left by the rigid diagonal of the spear, while on the right the light-colored reins and the pale curve of the bull's crupper form the other slide of a triangle whose vertex is Charles V's

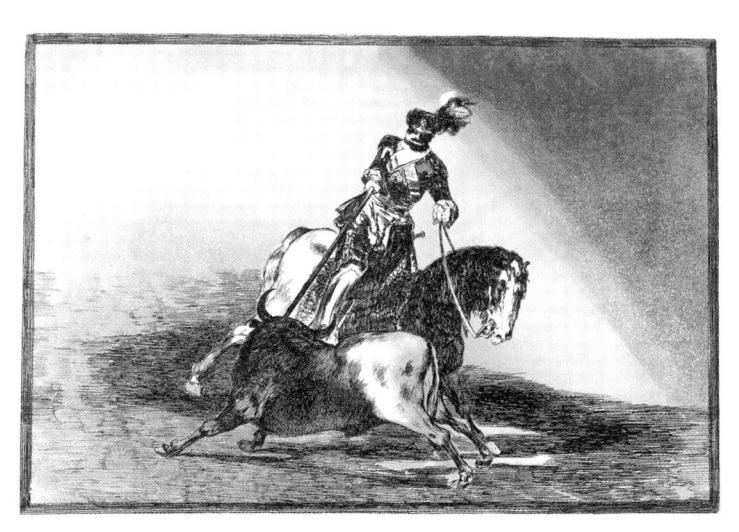

Goya, *La tauro-maquia*, plate 10, *Carlos V lanceando un toro en la plaza Valladolid* ("Charles V wounding a bull in the Valladolid Plaza"), 1816. Etching and aquatint, 25.4 x 35.6 cm.

head. This is yet another example of Gova's singular ability to stabilize scenes of violent action by making them into a framework of almost Neoclassical rigidity. As for costume, he paid no attention to it; the rider representing the emperor is wearing a peculiar pastiche of a cavalry hat, all plumes and froufrou, which is much the same as the headgear sported in plate 11, by Spain's greatest national hero, the legendary warrior El Cid (Rodrigo Díaz de Vivar, c. 1043–99). Though these two historical personages lived some five centuries apart, Goya was not a whit concerned with their dress. Undoubtedly, the remoter origins of the corrida were more religious yet, indeed sacramental—the sacrifice of those dark and dangerous beings to the chthonic deities of the earth. If bullfighting had been nothing more than a sport or a public diversion, it could not possibly have gripped the Iberian imagination for so long. The Spanish Bourbons, however, were not as tolerant of bullfighting as the Hapsburgs. They thought it degrading, as did the *ilustrados*, like Jovellanos and Moratín, who served them. In 1785 Carlos III prohibited bullfights unless their proceeds went to charity; in 1805 his son Carlos IV forbade all corridas, charitable or not. This did nothing to damp public enthusiasm for the rite, and only caused the general public to dislike the *ilustrados* who opposed it.

Goya was careful to show the brutal origins of bullfighting, no doubt because he considered them the authentic root of an immemorial ritual. The tone is set in the first plate, Módo con que los antiguos españoles cazaban los toros a caballo en el campo, "The way in which ancient Spaniards hunted bulls on horseback in the countryside." The "ancient Spaniards" are very primitive indeed, Visigothic peasants (one might think) with their bound leggings and unhemmed skin garments; the landscape around them has the cold, bony, inhospitable look of that in some of the paintings from the Quinta del Sordo. Their role is to look "prehistoric," and they do—as they also do in plate 2, "Another way of hunting, on foot." Here, the horse is gone, and the struggle is between two hairy, ragged primitives and a bull that, transfixed lung and neck by their spearpoints, is beginning to sink into its death. The sense of desolation—the bull's, not the hunters'—is increased by the staging: a flat, bare plain whose horizon line is broken only by a distant clump of trees, a suitably minimal stage set (one feels) for a scene from *Lear* or perhaps *Godot*. It is also the typical staging for some of the Black Paintings, and of course for the Disasters of War. Goya loved the grand bareness of Spanish landscape, and the way the black bulls stood out in it. Had he lived to see them, he would surely have delighted in the advertisements for Osborne Veterano brandy that have become the most beautiful and powerful outdoor sculptures in Spain: those flat iron bull silhouettes, taller than a house,

Goya, La tauro-maquia, plate 1, Modo con que los antiguos españoles cazaban los toros a caballo en el campo ("How the ancient Spanish hunted bulls on horseback in the countryside"), 1816. Etching and aquatint, 25 x 35 cm.

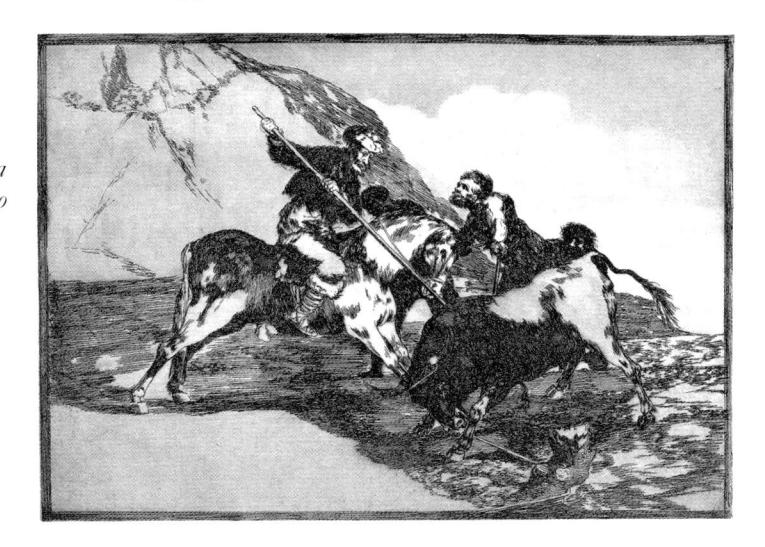

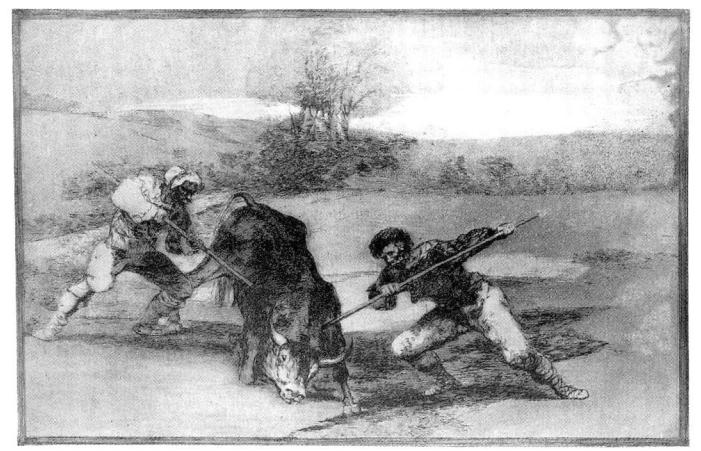

Goya, *La tauro-maquia*, plate 2, *Otro modo de cazar a pie* ("Another way of hunting, on foot"), 1816. Etching and aquatint, 24.7 x 35.5 cm.

that gaze with no eyes aloofly down on the cars scurrying beneath them on the highway.

The next stage in Goya's bullfighting story comes with the introduction of Moorish fighters, which dates the action before the expulsion of the Muslims by Fernando and Isabel in 1502. The idea that the Moors were particularly interested in bullfighting and became largely responsible for making it into a social ritual is historically untrue; in fact, they had no particular interest in the corrida. Padre Sarmiento, an eighteenth-century Spaniard, declared that "it is commonly said that the *corrida de toros* was bequeathed to us by the Mahommedans. I have yet to see any proof." Nicolás Moratín, however,

believed it. Being an ilustrado, he thought the rite of bullfighting was essentially primitive and uncivilized, and one way to reinforce this point was to attribute its origins to the "barbarous" Moors. Goya followed him—partly, one suspects, because it gave him an opportunity to reuse the turbans and exotic baggy-pantalooned costumes that his Mameluke mercenaries would be wearing in his 1814 military setpiece of the Second of May. Plate 3 introduces them with an odd thought: "The Moors being established in Spain, dispensing with the superstitions of the Koran, take up this art of hunting and spear a bull in the countryside." Actually there is no prohibition in the Koran against killing bulls or cattle of any sort—the pig is the unclean animal—but perhaps Goya felt that bullfighting made foreigners more truly Spanish and, in a way, naturalized them. Without question, he thought of bullfighting as a noble sport, one that elevated the torero to heroic stature and did nothing to demean the aficionado. In this, his feelings were completely opposed to the more refined sensibilities of the ilustrados. So we see, once again, how deeply rooted his reactions were in the "old" Spain, despite all the arguments his "enlightened" friends may have made against such preferences. Goya etched his Moorish toreadors and picadors in the Mameluke uniforms he had seen Napoleon's mercenaries wearing in Madrid, and thus garbed, they bring into play tauromachy's basic weapons and some of its popular suertes—suerte being a suggestively ambiguous word that meant, among other things, "fate" or "luck" or "stage of the bullfight." He credits the Moors with inventing the play with the cape or, for their purposes, an albornoz, or burnoose; he follows the opinion of Moratín and of Pepe Illo that

Goya, La tauro-maquia, plate 6, Los moros hacen otro capeo en plaza con su albornoz ("The Moors made another pass at the bull with their cape"), 1816. Etching and aquatint, 24.7 x 35.6 cm.

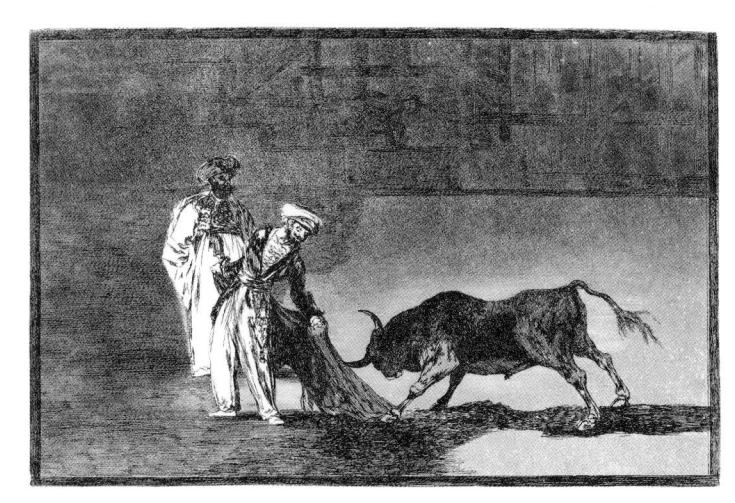

they also introduced "harpoons or banderillas" into the arena to disorient the bull with pain and so wear it down, which we see happening in plate 7.

As bullfighting gradually lost the elitist and ceremonial character it had acquired in its conversion into a "royal" sport in the sixteenth and seventeenth centuries, so the afrancesado culture-snobs who regarded it through French eyes as a barbaric vestige of primitive Iberia turned against it. The development of the modern corrida, with its high degree of formality, its codified passes, and its strict, hierarchical star system, belonged to Goya's youth, the mid-eighteenth century: it happened not in Andalucía (as foreigners, gulled by the image of the hot-blooded south, sometimes mistakenly think) but in central and northern Spain, particularly in Navarra and Aragón. And just as the rules and conventions of the corrida changed, so did the animals themselves. Selective breeding produced the modern bull, which, as a comparison of Goya's etchings with today's animals will instantly show, is a very different beast from those depicted in the Tauromaquia. Goya's bulls are, at a guess, about four hundred pounds lighter in adulthood than today's equivalents. Today's animal is like a big black truck, slow in acceleration but with tremendous inertial power. Goya's bulls could turn on a dime. They had horns like ice picks, deadly sharp. The form of the animal was what gave such thrilling definition to the newly developed forms of the suerte. The desire to torear was constantly producing new moves, which could captivate the fans and become associated with the names of the bullfighters who invented and, at the peril of their lives, refined them. It is not absolutely true, but contains enough truth to be worth repeating, that small, fast bulls favored inventiveness and stardom.

There was no shortage of "enlightened" critics who perceived the corrida as a gaudy and demeaning entertainment, the mob's way of self-debasement. Spanish *ilustrados* had a mean, puritanical streak. They were too apt to invoke the fetish of "utility" when telling their inferiors what they should and should not do. They most emphatically did not believe in art for art's sake. Jovellanos, for instance, held that poetry had a duty to be socially useful. The *luces* opposed bullfighting—shades of the English Puritans and their view of bearbaiting!—not because it was cruel, but because it was a drain on public working time. The corrida reminded them of its Roman ancestor, the circus—and one of the most noted tracts against bullfighting, the anonymously written *Pan y toros*, deliberately echoed in its title the Latin phrase *panem et circenses*, "bread and circuses," as a synonym for vain distraction handed down to pacify the ignorant mob. By the same token, rulers who were *not* "frenchified" (or were actually French but wanted, for political motives, to flatter the crowd's sense of its own Spanish-

ness) were more likely to encourage bullfighting: Fernando VII was all in favor of it, as a means of currying favor with the people whose tyrant he was, and Joseph Bonaparte, during his brief reign in Madrid as José I, spent government money to restore the *plaza de toros* and even abolished the admission fee to corridas. It was a curious fact, noted by several early tourists in Spain, that much as the Spanish clergy might dislike public theater as a source of immorality, they tended not to disapprove of bullfighting and never made a concerted effort to ban it. Unlike the zealous English Methodists, remarked that great Spanish traveler Richard Ford.

neither the cruelty nor the profligacy of the amphitheatre has ever roused the zeal of their most elect or most fanatic. . . . The Spanish clergy pay due deference to bulls, both papal and quadruped; they dislike being touched on this subject, and generally reply *Es costumbre*—it is the custom—*siempre se ha praticado así*—it has always been done so, or *son cosas de España*, these are things of Spain—the usual answer given as to everything which appears incomprehensible to strangers. . . . The sacrifice of the bull has always been mixed up with the religion of old Rome and of old and modern Spain, where they [sic] are classed among acts of charity, since they support the sick and wounded; therefore all the sable countrymen of Loyola hold to the Jesuitical doctrine that the end justifies the means. ¹²

Goya's *Tauromaquia* is generally thought to belong to the years 1814–16. The prints are not the work of a young man. He was on the edge of seventy by then, and at a point midway between the heartrending documentary cruelties of the *Desastres* and the mystifying obscurities of the *Disparates*.

Goya was looking back, mainly to experiences of his youth, when he was an *aficionado* and may even, so legend and rumor had it, have got in the ring with his own sword. That was not necessarily implausible, because although he had not been raised in his rural birthplace, Fuendetodos, the city of Zaragoza was by no means remote either in time or place from the countryside—and country kids were always playing at being toreros, not just with fake wickerwork bulls but with real ones. Charles Yriarte, one of Goya's earliest biographers, wrote that he had seen a letter from him to Martín Zapater (now lost) signed "Francisco, *el de los toros* [he of the bulls]." Certainly, he always found pleasure and sometimes a kind of psychic healing—a relief from depression—in going to the corrida. There is, however, nothing to support the claim of his earliest biographers that he had been a *professional* bullfighter.

Some of the plates in the Tauromaquia show Goya's singular power for

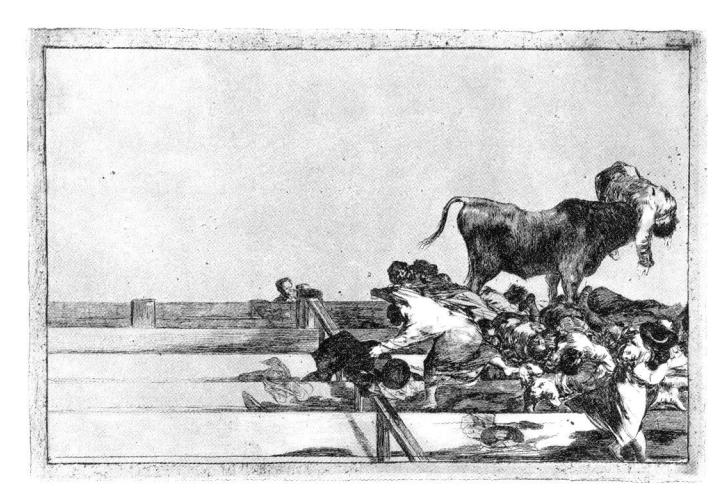

Goya, La tauro-maquia, plate 21, Desgracias acaecidas en el tendido de la plaza de Madrid, y muerte del alcalde de Torrejón ("Fatal mishap in the stands, and the death of the mayor of Torrejón"), 1816. Etching and aquatint, 25.3 x 35.7 cm.

remembering, or at any rate for feigning, the authenticity of documentary events through a mass of sharply specific detail. But here as elsewhere in his graphic work, the dating is unsure. It may be that some of the earliest plates were done before 1808, when the War of Independence broke out, and that the series was then laid aside to be finished later. It begins as a study of the origins of bullfighting and then becomes a description of events in the ring, involving bullfighters he once knew as a younger man or famous events he may or may not have witnessed—the death of the matador Pepe Illo, or the spectacular impalement of the mayor of Torrejón on the horns of a bull run amok in the stands of the Madrid ring in 1801. This latter image is, of all the Tauromaguia plates, the one nearest to modernism. Why? Because of the naked power with which Goya has played off void against solid, black against light, empty space against full. Three quarters of the plate is empty, except for the parallel benches from which the audience has fled. The lower right quarter is jammed with shapes of people darting hither and thither in panic. One's gaze shifts in this melée between huge, blunt shapes and tiny poignant ones-for instance, the minuscule detail, which you do not see at first, of the mayor's shoe protruding beneath the bull's neck, a reminder of the vulnerability of human life in the face of so powerful a killing machine.

The series includes bullfighters who altered the technique and the history of their art. One was Pepe Illo, the literate Sevillian torero who wrote one of the earliest texts on bullfighting; we see him in plate 29, elaborately bowing to the bull, like a noble to his superior, and in the magnificently stark plate 33 he meets his death, on his back on the sand of the Madrid ring in May 1801, the black bull

Goya, La tauro-maquia, plate 33, La desgraciada muerte de Pepe Illo en la plaza de Madrid ("The unfortunate death of Pepe Illo"), 1816. Etching and aquatint, 24.9 x 35.5 cm.

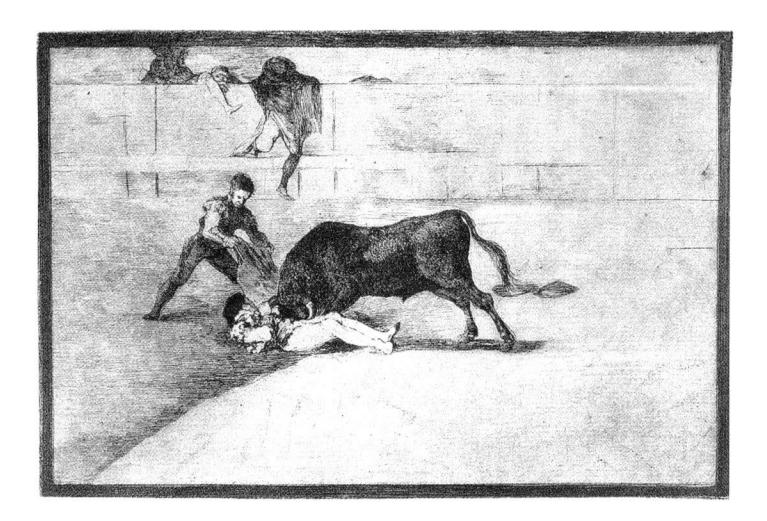

goring him. The death of Illo gets two other plates in the series, 38 and 39, each showing the bullfighter being tossed around on the horn of the beast.

Other notable fighters are commemorated in the series. Goya knew, or had known, some of them. Plate 27 depicts a torero who fought in Zaragoza in 1767 and whom Goya knew: Fernando del Toro, from Almonte, who is shown on horseback inciting a skittish and high-strung bull to charge. Plate 22 celebrates a famous woman bullfighter named Nicolosa Escamilla, a star of the Zaragoza ring in Goya's boyhood, known to her many fans as La Pajuelera (the match seller) for her street career before she made it into the arena. She is lancing a bull from horseback. Goya also paid tribute to what all agreed was the *loco valor* (demented bravery) of a fighter from South America, probably Peru, named Mariano Ceballos, who pursued his career in the Spanish arenas in the 1770s. Goya (and his thousands of other fans) particularly admired how close he worked to the horns, and in plate 23 we see him killing a bull from horseback not with the long spear used by La Pajuelera, but with a sword, which plunges into the bull's spine as its hastas ("spears," the respectful term for horns) are only inches away from him and his horse's belly. Ceballos's specialty, though, was fighting one bull while riding on the back of another, and in plate 24 he is performing this peculiar suerte on a black bull that, rearing up in the air as it closes on its victim, seems to develop a momentum nothing could resist.

But the torero Goya most admired, and was closest to as a friend, was the great Pedro Romero. He was also the first bullfighter to achieve fame and celebrity in the modern sense. His grandfather Francisco had introduced the *muleta*: a fan-shaped short cape that concealed the sword and thus enabled the

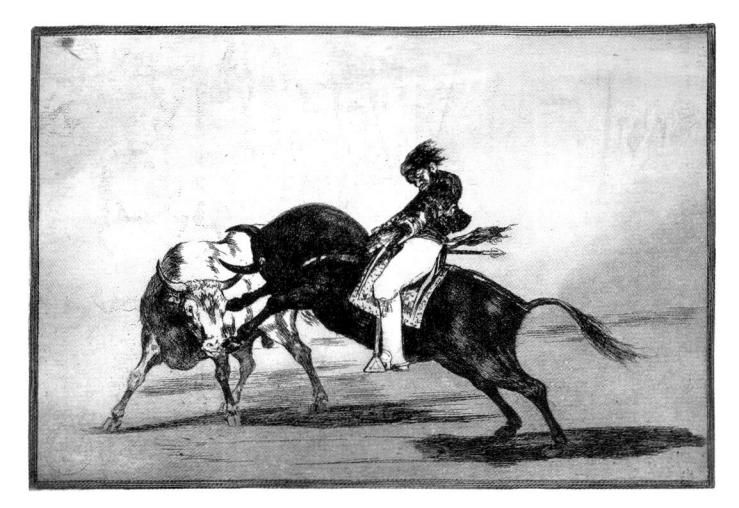

Goya, *La tauro-maquia*, plate 24, *El mismo Ceballos montado sobre otro toro quiebra rejones en la plaza de Madrid* ("This same Caballos mounted on another bull breaking his swords"), 1816. Etching and aquatint, 24.9 x 35.9 cm.

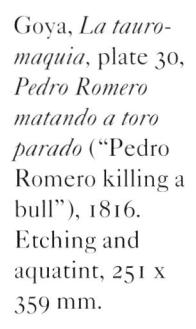

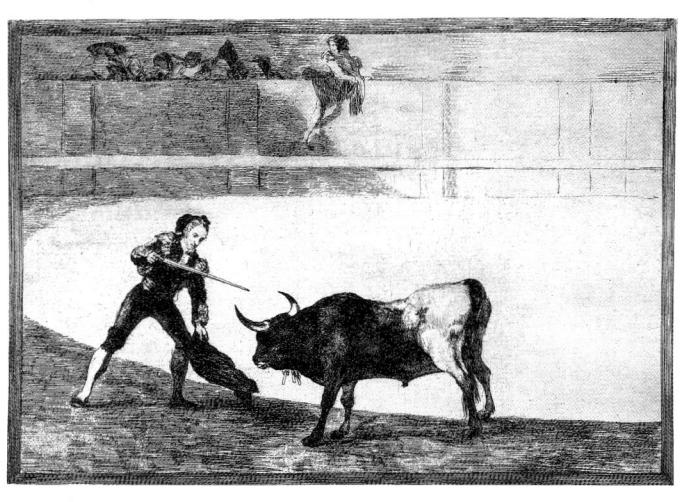

torero to confront the bull face-to-face, on foot, instead of killing it from horse-back. In the mid-1790s Goya painted the dauntless young man (who, by his own count, had killed about 5,600 bulls in three decades of fighting), and two decades later he etched him in plate 30 of the *Tauromaquia*, about to drive his sword into the tense, frozen animal's back—a moment rendered all the more dramatic by the contrast between, on one hand, the curved shadow line on the sand of the arena, the dark garment of the torero, and the black weight of the bull's forequarters and, on the other, the whiteness of the paper on the right side of the print, a whiteness that reads with dazzling, bleached clarity like a blast of sun.

Included in the series are certain oddities that have now disappeared from the vocabulary of Spanish bullfighting, though some of their spirit survives in a mutated, comic form in some rodeo clown acts (mojigangas) in the American Southwest. In one plate, a torero spears a bull while sitting on the shoulders of his *chulo* (ring mate). In another, a bull is fought by two men in a coach drawn by a pair of mules.

The Tauromaguia is part memoir and part fantasy. It is not a systematic "history" of bullfighting, any more than the Desastres make up a "history" of the war against Napoleon. But it is an invaluable record, not least for the peculiarities it pays tribute to. Decades ago, at the outset of his career, the bullfighter El Cordobes was sharply criticized—and wildly adored by fans—for his showbiz innovations, which, along with his romantically long hair, reminded the more conservative bullfight critics of the Beatles or the Rolling Stones. But El Cordobes was a positively "classical" fighter compared with some of the oddities Gova showed in his *Tauromaguia*, forms of behavior that look like a deadlier version of the antics of Western rodeo clowns and would never be permitted in a bullring today. In plate 20, "The agility and daring of Juanito Apiñani in the Madrid Ring," the bullfighter—whose career was at its peak between 1750 and 1770 in Madrid and Zaragoza, and whom Goya almost certainly knew of when he was a boy, as kids today follow the careers of baseball champs—is behaving more like a tumbler, pole-vaulting between the beast's horns. Plates 15-16 and 18-19 commemorate the "locura"—outright craziness—of "the famous Martincho"; his identity is unclear (several toreadors went by that name), but he may have been Antonio Ebassum, who fought in the ring at Zaragoza in 1759, when Goya was still a teenager, and again in 1764. Martincho's special act was confronting the bull while wearing ankle irons, an almost insane handicap that he nevertheless appears to have survived. In plate 18, "The daring of Martincho in the Zaragoza bullring," he perches on the edge of a chair as the bull, horns down, comes bursting out of the gate. He is waving his sombrero like a muleta to incite the great beast, and he sights along the blade of the sword. He will have only one thrust to make the kill, because the bull is almost on top of him and his feet are shackled.

As if this weren't suicidal enough, Martincho has another deranged trick for Goya to record. There he is in the middle of the ring, standing on a cloth-draped table with no visible weapon at all. Once again his feet are bound together—not even with a chain, which permits them some movement, but with a rigid bar, which allows none. A bull is charging at him, and he seems tensed to jump on top of it. Clearly Martincho can't get away from the bull,

Goya, La tauromaquia, plate 20,
Ligereza y atrevimiento de
Juanito Apiñani en
la plaza de Madrid
("The agility and
daring of Juanito
Apiñani"), 1816.
Etching and
aquatint, 25 x
36 cm.

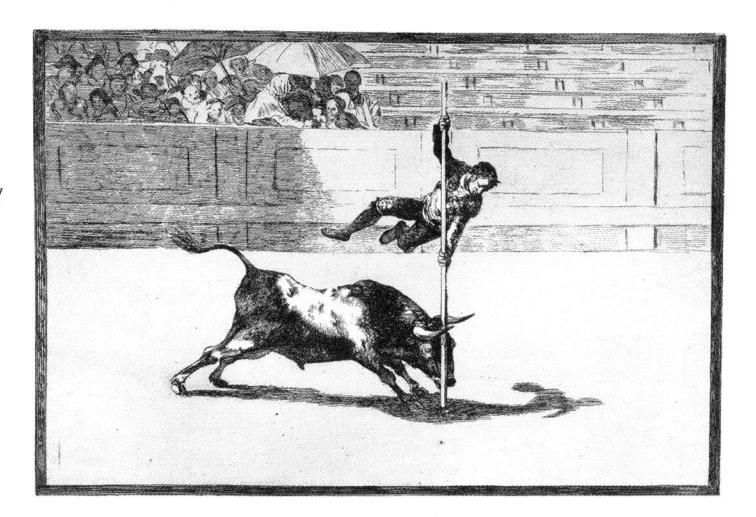

Goya, *La tauro-maquia*, plate 19, *Otro locura suya en la misma plaza* ("More of his craziness in the same bullring"), 1816. Etching and aquatint, 24.7 x 35.5 cm.

since he can't run, and he won't be able to ride the brute, since he can't open his legs. He has no choice, it seems, but to be trampled and gored, unless he manages to leap clear over the animal's back—which, according to the traditions of the ritual, is just what he is poised to do, leg irons and all. Perhaps the assistants, in their long cloaks and wide hats, who are clustered at a prudent distance have some idea; but there is no sign that they do.

The *Tauromaquia* was one of the two series of etchings that Goya printed and published himself, the other being the *Caprichos*. For this reason alone, it has always had a special allure for collectors. Moreover, its popularity, at least in Spain, was more or less guaranteed: it is a "heroic" narrative, with none of the sharp and biting ironies and occasional obscurities of the *Caprichos*. Its subject

matter, though harsh and death-laden—and, of course, repulsive to the animal-rights faithful—is not terrifying like the *Disasters of War*. And anyone who has a minimal acquaintance with the history and vocabulary of bullfighting can understand it, which is certainly not the case with the later, and often hermetically obscure, images of the *Disparates*. Moreover, it had an exotic appeal outside Spain—if not in England, then certainly in France, whose art-following public was also becoming aware of the foreignness of core Spanish rites, epitomized by the corrida. For these reasons, the *Tauromaquia* has long been the most enjoyed of Goya's etched series, if not necessarily the greatest or the most coherent. In fact, its plates vary quite widely in quality. But the best of them, such as that sublimely intense image of the death of the mayor of Torrejón in the front-row seats of the Madrid plaza (plate 21), are among the finest of all Goya's graphic work.

The rituals of the bullring have inspired a deadening mass of kitsch art—and kitsch writing, too, such as Hemingway's Death in the Afternoon, so unreadable today. (Who would have thought Papa would end up sounding like such a lady? Perhaps only those who remembered what his style owed to an American lesbian, Gertrude Stein.) But it is hard to think of any other artist's graphic work that combines such perceptions of animal grace and power with such wonder at the gratuitous stubbornness of human courage as Goya's Tauromaquia. It has the peculiar grace that art about art can sometimes achieve; it has the fascinated reverence that Degas, decades later, would display in his drawings and paintings of the ballet; and it is probably the most deeply felt tribute to other artists (apart from Velázquez and Rembrandt) in all of Goya's work. Much later, Picasso would do many bullfight drawings in partial homage to Goya, but they are mostly doodles, and none of them have the intensity, ferocity, or precision of the Aragonese master's. It was as though Picasso felt compelled not to seem to be trying at full strength, in case his best efforts were seen to be so obviously weaker than Goya's. Homage it may have been, but an evasive homage that skirted true comparison.

EXILE IN FRANCE

BEFORE HE LEFT MADRID and went into exile in France in 1824, Goya finished a set of twenty-two etchings later to be known as the *Disparates*. Like the *Disasters of War*; they were not published during his lifetime, and now we do not know what he meant to become of them. Were they to have been a public statement of irrationality and mystery? A private utterance? A statement that, though distributed to some notional public without notes or a gloss, would have served only to baffle his admirers, no matter how sophisticated they may have been? Would their glancing references to popular customs, superstitions, and carnival amusements have been much clearer to people then than now?

We can't know. A leading Goya authority, Janis Tomlinson, has even raised the possibility that he never *meant* to publish them at all. But this, given the quantity of the plates, their high state of finish, and the fact that none of them were lost, seems very unlikely. Why, especially at his age, with time running out, would Goya commit himself to a project whose result he did not mean to be seen?

They have been variously called the *Sueños* ("Dreams") and the *Proverbios* ("Proverbs") as well as the *Disparates* ("Follies"). *Dreams* is too vague and *Proverbs*, the name under which they were posthumously published by the Royal Academy of San Fernando in Madrid in 1864, simply inapplicable: no Spanish folk sayings that correspond to Goya's disturbing and idiosyncratic images have been unearthed. *Disparate* was Goya's own word for them. Some of the surviving proofs bear titles written in pencil in his hand: *Disparate femenino*

("Feminine folly"), *Disparate ridiculo* ("Ridiculous folly"), and so on. The root of the word *disparate* is *dispar*, "unequal" or "unparalleled," something outside common experience—which Goya's images certainly are. They have a black wildness that appears in many of the *Caprichos*, but certainly not all of them. The pessimistic and arbitrary side of Goya's imagination now moves wholly into the foreground, and there is no pretense of creating rational structures to mock human foolishness, no firm footing of sense from which to criticize nonsense—folly is the "natural," normal human condition. At least in the *Caprichos* you know what abscesses Goya was lancing, but in the *Disparates* not even that is always clear.

Some repeat older themes. Goya found expressive the image of male help-lessness before tough, defiant, or exploitive women. The *pelele*, a stuffed manikin tossed in a blanket by a ring of girls, appears in his tapestry designs. He uses it again in *Disparate femenino*, but with a twist. Six women are tossing a couple of *peleles* in the air. The straw dolls are smaller and more helpless-looking than they were in the tapestry cartoons thirty years before. Not only that, but the blanket bears a painted or embroidered design of a donkey. Does this *asno* imply the "asinine" nature of the flopping little dandies, so easily fooled and manipulated by women?

Again, *Disparate matrimonial* ("Matrimonial folly"), sometimes known as *Disparate desordenado* ("Disordered folly"), repeats the theme of Goya's earlier Capricho, "Who will release us?"—that bound couple surmounted by a giant owl, which is, like other owls in Spanish folklore and in Goya's art, an emblem of stupidity, not wisdom. The couple is turned into a monstrous Siamese twin: two people conjoined in implacable marital loathing as a single body, half male and half female, a parody of Plato's famous account of the origin of the sexes. (Even their feet are doubled, each with two sets of toes facing opposite ways.) They are straining for mutual release, but none has come or ever will, and they are watched by a wailing throng of grotesques who probably represent society at large lamenting the failure of one of its binding institutions. Some have turned into animals. With their distorted faces and the sluggish rhythms of their drapery, they look very much like the crowd of initiate witches being harangued by the Great Goat in Goya's mural of the *Aquelarre* for the Quinta del Sordo.

The clearest rerun of an older motif in the series is *Disparate alegre* ("Happy folly"), a dark and sinister-looking revision of Goya's youthful tapestry design *A Dance of Majos by the Manzanares* (1777). Forty years have elapsed since then; the idyllic scene of Goya's youth has grown older, so have the people in it, and so, Goya does not hesitate to remind us, has he. What was once a group of graceful youths, treading out their ceremonious measures to remind us that

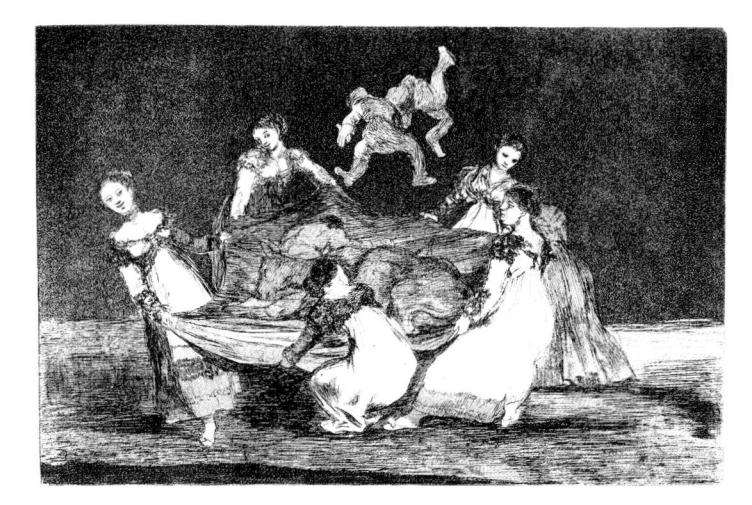

Goya, Los disparates, plate 1, Disparate femenino ("Feminino folly") 1816–23. Etching and aquatint, 24.7 x 35.9 cm.

elegance is not the monopoly of the upper crust, has turned into a capering ring of six oldies in *majo* costume: the women not in the bloom of youth, the men far past it. The men's movements are herky-jerky and ridiculously overstressed in mimicking the gestures of the women. The central man in the trio is afflicted by either a giant hernia or an incompetent trouser cutter. What was once enjoyably graceful is now undignified, though the participants do not seem to realize it.

Surely one is meant to see in this slightly grotesque and pathetic group the image of Goya talking about himself—guying the miseries of old age, including his own, but admitting that it has not subtracted from his desire for pleasure. We dance when young, we dance when old; but the essential thing is that we should dance, even when—like this great and indefatigable spirit—we are too deaf to hear the music and too stiff to move with the grace that belongs to youth. Even when we cannot hear one another, the dance remains. Anyone who interprets this rueful print as a satire on the fact of aging knows neither Goya nor old age.

Some *Disparates* are simple fantasy—dreams, including one of the most common of mankind, the defeat of gravity through flight. *Modo de volar* is one: it shows a number of men gliding on constructed wings, membranes (presumably of silk or fine cotton) stretched over delicate batlike skeleton frames of wood. A rudimentary web of cords running from the fliers' hands and feet to the control surfaces suggests that these may be flapping machines (ornithopters) or perhaps primitive hang gliders maneuvered by the warping of their wing surfaces, though Goya does not seem to have tried to think this through: as flying machines, these are merely emblematic, and their relationship to Leonardo

Exile in France · 369

Goya, Los disparates, plate 7, Disparate matrimonial o Disparate desordenado ("Matrimonial fully or Disordered folly"), 1816–23. Etching and aquatint, 24.7 x 35.9 cm.

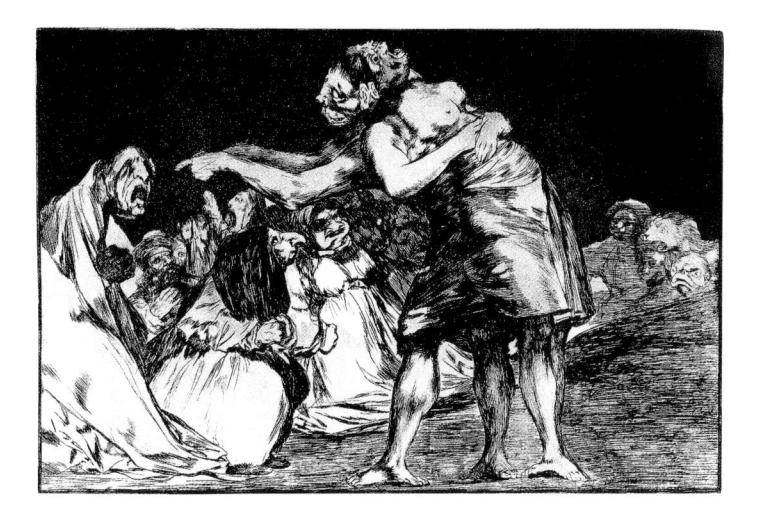

da Vinci's flight studies, which he could not have known about, is only coincidental. (It is true that the Royal Library in Madrid did contain some codices by Leonardo, brought to Spain in the sixteenth century, but it is unlikely that Goya would ever have seen them, and even if he had, none of the sheets they contain have anything to do with flight.)

Some of the *Disparates* hold an element of religious satire. In plate 4, for example, a man, possibly a friar, holds up a life-size carved effigy of a saint, as though to conceal himself from and fend off an enormous, moronic, dancing figure that advances on him, clicking its castanets. This creature is a carnival fool of the kind known, for its size, as a *bobalicón*. It does not seem to pose any threat to the holy sculpture or to the friar cowering behind it. In fact, given its half-

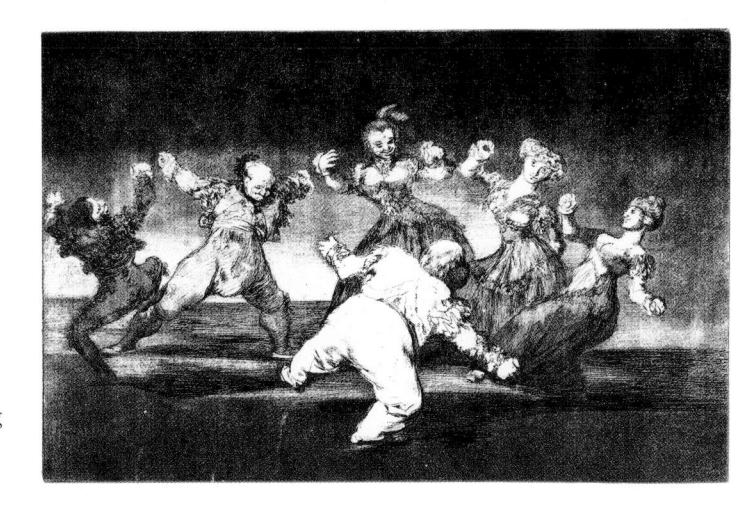

Goya, *Los disparates*, plate 12, *Disparate alegre* ("Happy folly"), 1816–23. Etching and aquatint, 24.6 x 35.8 cm.

Goya, Los disparates, plate 13, Modo de volar ("Flying method"), 1816–23. Etching and aquatint, 24.7 x 35.9 cm.

Goya, Los disparates, plate 4, Bobalicón ("Big fool"), 1816–23. Etching and aquatint, 24.7 x 35.9 cm.

witted grin and the castanets it wields, it would seem rather to be adoring or propitiating the image. Goya is showing us an imbecilic devotion to images, out of intelligent control: religious superstition turned into a *disparate*, a folly.

Some of the *Disparates* have political significance, or is it just that they can be read that way with the exercise of a little ingenuity? One such is *Disparate de bestia* ("Animal folly") which most unexpectedly features a giant, exotic beast of a kind that figures nowhere else in Goya's work, not even in the *Caprichos:* an Indian elephant. It is being lured or cajoled by four men dressed in Oriental costume, in caftans and Moorish headgear. The historian Michael Roche argued that this is an allegory of right-wing politics under the reign of

Goya, *Los disparates*, plate 21, *Disparate de bestia* ("Animal folly"), 1816–23. Etching and aquatint, 25 x 35 cm.

Fernando VII.² Unlikely as this may seem at first glance, it is not without a certain logic. When Fernando returned to the throne, he was surrounded by conservative advisers, all competing to confirm his own autocratic opinions and thereby ingratiate themselves with the vengeful and reinstated king. These were known as the Persians because of their belief in despotism. Their 1814 letter to Fernando exhorting him to assume absolute power and erase the 1812 Constitution was familiarly called the Persian Manifesto. So perhaps these Orientals, who are bowing and scraping to the elephant, seeking to attach bells to it and showing it an important-looking document, are trying to convince it of the charms of absolute power—not that Fernando, then or earlier, had ever needed much convincing on that point.

Elephants had no heraldic association with either the Bourbons as a dynasty or Fernando in particular, but there had been an elephant in the royal zoo in Aranjuez, the property of Carlos III; and though the beast died in 1777, well before Goya was likely to have seen it, he would certainly have heard of it. Perhaps the corpse had been skinned and the skin stuffed by a taxidermist, later serving as a model for Goya; that might help explain the baggy and pathetically wrinkled appearance of Goya's elephant, which has none of the solid appearance of a live one. Its ears are disappointingly vestigial. In any case, what did elephants symbolize? Strength, mildness, sagacity—the flattering attributes of wise kingship. This elephant seems particularly mild because it has lost its only weapons, its tusks. Perhaps the constitutionalists, seeking to disarm the king and limit his powers, have taken them away—while the Persians would like to see them replaced: an impossible project, but an alluring one for a despot like

Fernando. Roche thought the elephant is a symbol of the naïve Spanish people, gulled by the Persians, but it seems more likely that Goya meant it to represent the king himself. But for all one's hopes of exegesis, there seems to be no skeleton key to the *Disparates*.

THE GREAT SERIES of paintings Goya made for his own pleasure at about the same time is equally enigmatic, and likely to remain so. These were the Pinturas negras, the so-called Black Paintings with which, in his last Madrid years, Gova was covering the walls of his farmhouse on the other side of the Manzanares outside the city, now converted into his studio and semi-solitary hermitage. Nothing, he felt, obliged him to be available to the court anymore; as for private clients, they could come to him. The new house, according to its title deed, was "beyond the Segovia bridge . . . on the site where the Hermitage of the Guardian Angel formerly stood." It had twenty-two acres of arable land, and a vegetable garden. Comfortable but not palatial, and in need of some renovation, it was sturdily built of brick and adobe, with two stories divided into several rooms, two attics, a well by the garden, and another in the courtyard. Goya paid 60,000 reales for it, cash. By a peculiar coincidence, the property next door had been owned by a farmer who was deaf, and so was named the Quinta del Sordo, the Deaf Man's House. This name passed to Gova's own property, since he was the only notable deaf man around.

He moved in with a small *ménage*. His housekeeper was a woman named Leocadia Zorilla de Weiss, about whom not much is known but quite a lot has been assumed. She was a handsome woman of uncertain age, somewhere in her early thirties, and related to the wealthy Goicoechea family into which Javier, Goya's son and heir, had married in July 1805. This made Doña Leocadia a very distant relative of Goya's: the cousin of his daughter-in-law. She had married Isidro Weiss, a German Jewish jeweler working in Madrid, and borne him two sons. The marriage seems not to have been happy, for in September 1811 Weiss denounced her for "illicit conduct," presumably adultery, and in October 1814 Leocadia gave birth to a daughter, not Weiss's, who was christened Rosario. It has often been assumed that Goya was this child's real father, and so he may have been, but there is no evidence for this except the kindly interest the old painter took in the child's upbringing and welfare.

Weiss himself was not doing well; in fact, he was nearly bankrupt by 1817. Leocadia prudently left him and attached herself to Goya as his "house-keeper," for which read "mistress." Reportedly, she was not only a handsome woman but a shrewish one as well, which cannot have greatly dismayed the old

artist: he was too deaf to hear her tirades. His wife was long dead; she had died in 1812, leaving no offspring except her son Javier, the only child of their union who had grown to adulthood. There is nothing one can say about her, because neither Goya nor any of his friends saw fit to comment on her, and neither did Javier. One of millions of unrecorded Spanish wives, she was different from them only in having married a genius: not a curse, to be sure, but hardly an unmixed blessing.

Javier was, one may presume, a disappointment to his father, but that did not stop Goya from loving him and doing his considerable best to support him. In 1803, for instance, Goya negotiated with the Crown to exchange the original copperplates of the *Caprichos* and 240 unsold sets of the prints for a lifetime annuity for his son. In 1806, after Javier married Gumersinda Goicoechea, Goya presented his substantial house at 7, calle de los Reyes in Madrid to the newlyweds so that they would always have a free home. His fondness was not strongly reciprocated. Javier Goya turned out to be a flop of a son, lazy and just short of a wastrel. He made no career for himself (Goya referred to him as a *pintor*; though that was a piece of wishful thinking, since Javier painted nothing), depending instead on regular support money from the Quinta del Sordo and living off inheritances and annuities—including one from the duchess of Alba, which did much to keep him going after her early death—together with the proceeds from selling works of art his father deeded to him. He died at the age of sixty-nine, having done very little with his life.

In 1819, another severe illness struck Goya. It was probably not a recurrence of the one that felled him at the end of 1792, but we do not know enough about its symptoms to be able to say. He was treated for it, though the doctor's notes on medication, if he made any, have not survived. The doctor was his friend Eugenio García Arrieta. Goya commemorated his gratitude to this man, whom he trusted implicitly and who saved his life, in a double portrait of healer and patient that bore a long inscription, in the manner of the ex-votos commonly hung in Spanish churches, thanking Mary or a saint for miraculous intervention in a crisis. It gives no clue about the nature of the disease: "Goya in gratitude to his friend Arrieta for the skill and great care with which he saved his life in his acute and dangerous illness, suffered at the end of 1819, at the age of seventythree years. He painted this in 1820." A faint clue to the nature of Goya's malady may lie in the fact that Dr. Arrieta is known to have gone to North Africa in 1820 to study Eastern plague. Epidemics of such plagues, which included yellow fever, happened from time to time in Spain because of contagions brought by Mediterranean shipping. Since Arrieta was considered a plague specialist, Goya may have been stricken by such a virus. But this is highly speculative.

In Goya's portrait, Arrieta bends over him, protectively encircling him with his arm and holding up, with gentle insistence, a glass of medicine for him to drink. Goya seems to be at death's door. He sits up in bed, but with difficulty. His head lolls away from Arrieta, and you can almost hear his labored breathing. His hands pluck restlessly at the counterpane. Behind him are several figures, not identifiable in the gloom, which have been variously interpreted as concerned friends, psychopomps, soul-snatching devils waiting for his death (unlikely, this), and modernized Fates.

The whole image exhales a strong religious atmosphere, a reverence for Arrieta as curandero (healer). It could hardly be less like Goya's previous depictions of the work of doctors, whom he invariably guyed—as in the Caprichos—as incompetent, stupid quacks, matasanos (killers of the healthy). It has some of the character of a religious icon, meant to remind you of old pictures of the dead Christ supported by angels. But it is conceived in praise of science: science imagined not as "cold," factual study but as a "warm" channel of empathy. Goya would almost certainly have known the work of the English artist Joseph Wright of Derby-not from the originals, of course (there were none in Spanish collections), but from the engravings of Wright's pictures, such as An Experiment on a Bird in the Air-Pump (printed 1769), which were widely circulated and were likely to have found a place in his friend Sebastián Martínez's voluminous collection. The lighting, from below, is particularly reminiscent of Wright, but most striking of all is the spirit of admiration for science. The painting shows Goya growing in sympathy for doctors, a group he once despised, for assuaging his feeble age.

In a similar way, his painting of the aged San José de Calasanz, done the same year (page 342), shows a view of human age completely free of the corrosive satire he had brought to the vain, hopelessly primping old crones in *Time* in 1810–12. He has perhaps become gentler, if not humbler, with the passing of time.

When his health allowed it, Goya was working on the walls of the Quinta del Sordo. X-ray studies of the now detached and remounted mural paintings suggest that his original project was not by any means the frightening and pessimistic one that we see today. In fact, they suggest a decorative scheme that was (relatively) pastoral, conceived and in part done in a quite different state of mind. Beneath the grim and ashily claustrophobic surface of the *Pilgrimage of San Isidro*, for instance, there was an open view of a river reflecting a three-span bridge: perhaps the Manzanares and the Puente de Segovia. Underneath the cannibal Saturn eating his son, there are traces of a dancing figure with one foot

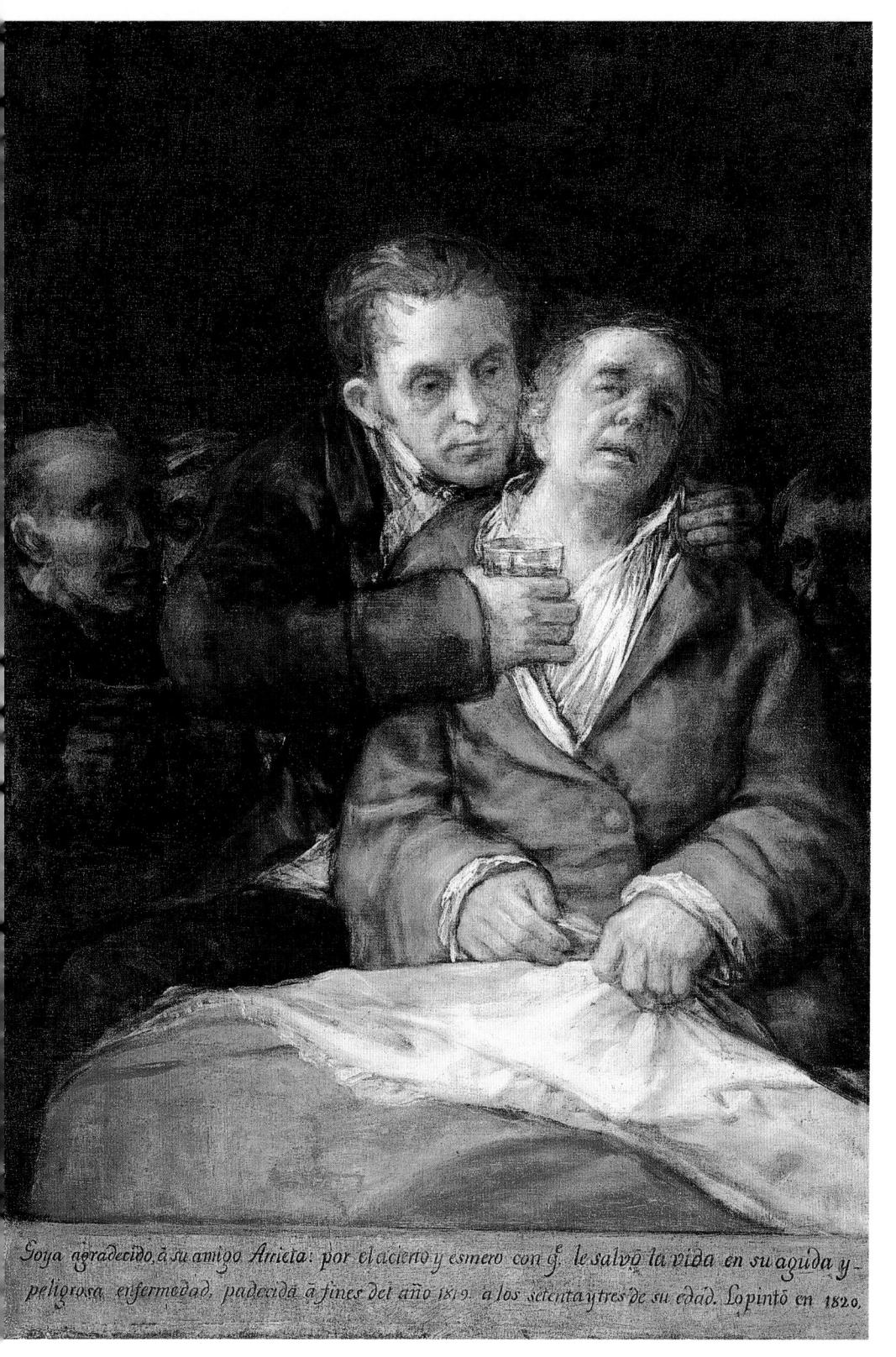

Goya, *Goya curado por el doctor Arrieta (Self-portrait with Dr. Arrieta)*, 1820. Oil on canvas, 116 x 79 cm. The Minneapolis Institute of the Arts.

raised. The melancholy, black-veiled portrait of Leocadia Weiss as a widow, leaning on what has been interpreted as a tomb (perhaps Goya's own) with a railing on top of it, seems to have had no such funereal overtones at the beginning—it was simply a woman, not visibly in mourning, leaning on a mantel-piece as though in her own living room.

Why should Goya have switched from what may have been a less fearsome decorative scheme for his farmhouse to one of such surpassing pessimism as the Black Paintings? Why this passage from the tolerable to the oppressive? Perhaps the answer does not lie in the real world of people and actions. Maybe it existed entirely in Goya's brain, was inseparable from his depression, and can now never be retrieved or explained. And yet the *Pinturas negras* were certainly painted in strange times, both for Goya and for Spain.

The regime of Fernando VII had staggered on from one crisis to another. The country, as someone said of Ireland, was "like the carcass of a goose standing up"—skeletal, picked clean, but preserving a macabre parody of normality. Fernando's economic policies, which absolved the Church from all interference or reform, were a disaster. He could not accept or even perceive the realities of post-colonial South America, and kept having impractical fantasies of seizing the colonies back. And his army officers, far from backing him, were a menace to his regime. Many of them were Masons and bitterly opposed to Fernando's theocratic absolutism. The Church hated Freemasonry, and so did Fernando (as would every Spanish absolutist down to the days of Franco). But many, if not most, of the leaders and military heroes of the War of Independence were practicing Freemasons. Lodges had sprung up everywhere in Spain over the duration of the war. So when Fernando, inspired by his pipe dream of creating a new army that would cross the Atlantic and recolonize Peru, actually brought together such a force in Cádiz in 1820, all he achieved was to consolidate his opposition. His orders assembled a wasps' nest of Masons and other members of secret societies, all of whom loathed Fernando, not least because he lacked the money to pay them.

The immediate result was a *pronunciamiento*, or "pronouncement," the classical method of transfer of Spain's civilian power through its nineteenth-century military. It was an officers' rebellion. Officers would sound one another out, bet on a general resentment, and then "pronounce" by raising the *grito*, the cry of heroic, principled dissent.³

Since Fernando, in the few short years since he returned to power, had reduced civilian life to an insipid and spied-on monotony while greatly curtailing the perquisites of the military elite that had sacrificed so much for Spanish independence, he was a natural target for a *pronunciamiento*. The officers' *grito*

Lecomte, *General Rafael del Riego y Núñez*, n.d. Engraving. Museo Municipal, Madrid.

was duly raised at Cádiz in 1820 by a dashing, brave, and extremely vain young liberal officer named Rafael del Riego y Núñez (1785–1823). His aim was to force Fernando to swear on the document he had set out to annihilate, the liberal Constitution of 1812. And for a while, "pallid with rage and fear," the Desired One had no choice about it.

The rank and file went along with their officers against the king because they had no wish to die of tarantula bites and tropical fevers in an unwinnable invasion of Peru. The government of Spain now split into a mosaic of local *juntas*, most of which gave their allegiance to Riego and the sacred Constitution instead of Fernando VII. Thus began the Trienio Liberal, the three years from 1820 to 1823—a uniquely Spanish situation in which an absolute monarch was rendered impotent by two kinds of liberal sentiment: a moderate constitutionalism that accepted the Church, and the more radical views of the anti-clerical *exaltados*, both entirely dependent on a sedition-ridden army.

Obviously this was (to put it mildly) an unstable situation. The liberals were a bitterly feuding family. Its moderates were not even sure of the feasibility of every clause in the 1812 Constitution. It had been written for the *pueblo*, but the *pueblo* was too ignorant to really deserve it. And the old *afrancesados*, the Spanish "Frenchies," who hated being seen as traitors and excluded from political life, turned against the liberals, peppering them with often effective criticism.

Meanwhile, Fernando was too stupid, paranoid, and obstinate to see that some limited gesture from him in favor of the 1812 Constitution might actually have increased his power instead of isolating him.

In the end, the weak liberal coalition was defeated from outside, and Fernando, exiled by one French regime, had his bacon saved by another. He appealed to the conservative European powers, which were meeting in 1822 at the Congress of Vienna. These decided to send a force to reinstate Fernando for the second time. Under the terms of the Holy Alliance among Austria, Prussia, and Russia, and the command of the vehemently conservative duke of Angoulême, an army called the Hundred Thousand Sons of St. Louis (the highflown name is thought to have been coined by Chateaubriand, then France's minister of foreign affairs, and it certainly fit his rhetorical style) marched into Spain. This time it met practically no resistance. It crushed the liberals and replanted Fernando securely on the throne. The Spanish Bourbon had been rescued by the French one, Louis XVIII.

This released a wave of revenge and counterterror. It was so extreme that Chateaubriand had to warn Fernando that he would withdraw all French military support if his persecution of real or imagined liberal enemies did not cease at once. Ultraroyalist secret societies, which bore picturesque names like the Exterminating Angel (later to be the title of a film by Luis Buñuel), abetted by priests and nobles, went on a rampage against all those who could, however remotely, be suspected of liberalism. Despite the restraining influence of the French Sons of St. Louis, who occupied Barcelona, between October and December 1824 about two thousand people were murdered there by these extremist secret societies, and of course the level of terror and reprisals in Spanish-controlled cities was far worse. Gangs of ultraroyalists ruled the streets, chanting their slogans: "Long live the Absolute King! Death to the Frenchies! Long live religion! Death to politics! Long live the Inquisition!"

Fernando was so jubilant that he declared he now had "a stick for the white ass and a stick for the black one," meaning for both liberals and ultras. He appointed some remarkable fanatics to power: the new captain-general of Cataluña, for instance, was the demented Carlos, count of Spain, who had his own wife arrested for treason and danced a jig, in full gala uniform, upon the scaffold at the hanging of some liberals. As for Riego, he was captured in March 1823, jailed, and ignominiously dragged to his place of execution (Plaza de la Cebada, in Madrid) on a travois behind a donkey, sitting on coal sacks. This event set off a wave of powerless liberal sympathy and lithographed ex-votos in France, and caused him to be remembered by the English master of light verse

W. M. Praed as the man "whom Tyranny drew on a hurdle / That artists might draw him on stone."

So the high hopes of the 1812-ers came down to this: a weak but still absolute tyranny, the Church in the saddle, the Inquisition back, the Constitution erased. "El sueño de la razón produce monstruos," Goya had written on one of the Caprichos plates a generation before, and now he set out to record those monsters all over again, at mural scale, in the main upstairs and downstairs rooms of his tranquil farmhouse outside Madrid.

Clearly he did not care about creating a unified allegory or a coherent story. The images of the Black Paintings do not cohere, or not in that way. One cannot even be sure of the apparent links between them, although their original spatial relation to one another is known from old photographs taken while the paintings were still in place.

The rooms were large, each probably 33 by almost 15 feet. Originally the main ground-floor door was flanked by two paintings, the one of Leocadia by the mantelpiece (or tomb) and, on the other side of the door, a vertical image of an old man with a long white beard leaning on a crooked stick while a skinny, wide-mouthed creature (the big mouth being one of Goya's favorite signs for the demonic) talks in his ear. Or is he yelling in the ear of an old, deaf man—which might make him Goya himself, the infirm patriarch, on the opposite side of the door from Leocadia? It's anyone's guess.

The only "historical" personage who can be identified among the paintings is the Biblical heroine Judith, seen brandishing her knife before cutting off the head of the evil general Holofernes. Given Goya's anger and disappointment over the second restoration of Fernando, it is not implausible that Holofernes stands in for Fernando VII. Many other artists had used the death of Holofernes as a symbol of the defeat of tyranny. But again, this is speculative. Goya leaves no explicit clues, and indeed he would have been foolish to do so, in case some agent of the Bourbon monarch happened to enter the Quinta del Sordo and see the mural. One should remember that these were not only among the most dramatic painted images Goya ever made; they were the most private by far. He had no audience in mind. He was talking to himself. He never imagined that the Black Paintings would be seen anywhere except where he was. Therefore, he could bypass explicit symbolism, and all narrative connections could stay in his own head.

This collision of the laceratingly rhetorical with the hermetic is what gives the Black Paintings their peculiar character, and makes them seem like freakish, vivid precursors of modernity. But they are also strongly fixed in their own

Goya, *Judith and Holofernes*, 1820–24. Oil transferred to canvas from mural, 144 x 82 cm. Museo Nacional del Prado, Madrid.

time, for they bring to a climax the obsession with extreme feeling that characterizes so much of European Romanticism. A work like Henry Fuseli's Nightmare (1781) may seem mannered and style-bound compared with these Goyas, but it belongs to the same area of imaginative experience. And while one peers at Goya's paint surface, so thick, corroded, and mortared; while one admires the daring of its contrasts of tone, the deep chasms of shadow against the glaring highlights that establish the structure of a face, the way a chin or a cheekbone is dragged into being against the surrounding dark by a single oily swipe of a wide, loaded brush, so that the flesh and bone seems as twisted as a Francis Bacon—before finding this wholly unique, it is a good idea to remember how bizarre and without precedent some of J. M. W. Turner's effects, the "soapsuds and whitewash" of his later landscapes, the strange dazzle and looming fogs of his Petworth interiors, seemed at the time they were painted. It's just that we are more used to radically extreme and abstract formulations of paint in landscape than in the figure, because we "know" what figures "ought" to look like, what they "really" are.

Certainly Goya reveled in the emotional power that such direct painting

Goya, *Perro semihundido (Head of a Dog)*, 1820–24. Oil transferred to canvas from mural, 134 x 80 cm. Museo Nacional del Prado, Madrid.

could generate. The Black Paintings are a veritable encyclopedia of its effects. Perhaps the most powerful and weirdly beautiful example is the humped mass of pilgrims' faces in the foreground of the *Pilgrimage of San Isidro*, the large mural (approximately $4\frac{1}{2} \times 14\frac{1}{2}$ feet) that, along with the *Aquelarre* (pages 386–7), dominated the ground-floor room of the house. They are all painted *alla prima*, in slashing strokes. Most are composed around a gaping hole, the subject's mouth; the alternation of these black voids with the dense, dirty-creamy impasto of the flesh tones sets up an irregular rhythm across the surface that increases the sense of chaotic energy arising from the howls we fancy the pilgrims are uttering. Their features are deformed, beyond grotesqueness. This is Goya's bitter and contemptuous vision of the *populacho*, or pig-ignorant mob, and we may well think that his disgust for it was reawakened by the stirring-up of the masses that Fernando's henchmen had been practicing all over Spain.

Not all the images from the Quinta del Sordo can be read, even speculatively, as protests against a failing and unjust absolutism. The dog, imploring us with its eyes from the bottom of what seems to be a well of quicksand, seems to have no political meaning, though it is a sublimely poignant image. That dog's terrified yearning for safety and its absent master is the misery of man in a comfortless world from which God has withdrawn. We do not know what it means, but its pathos moves us at a level below narrative.

But then, here are two peasants (originally on the upper floor of the Quinta) flailing at each other with cudgels as they sink up to their thighs in some cold bog, under an icy sky. The place is deep country somewhere; a farmhouse and

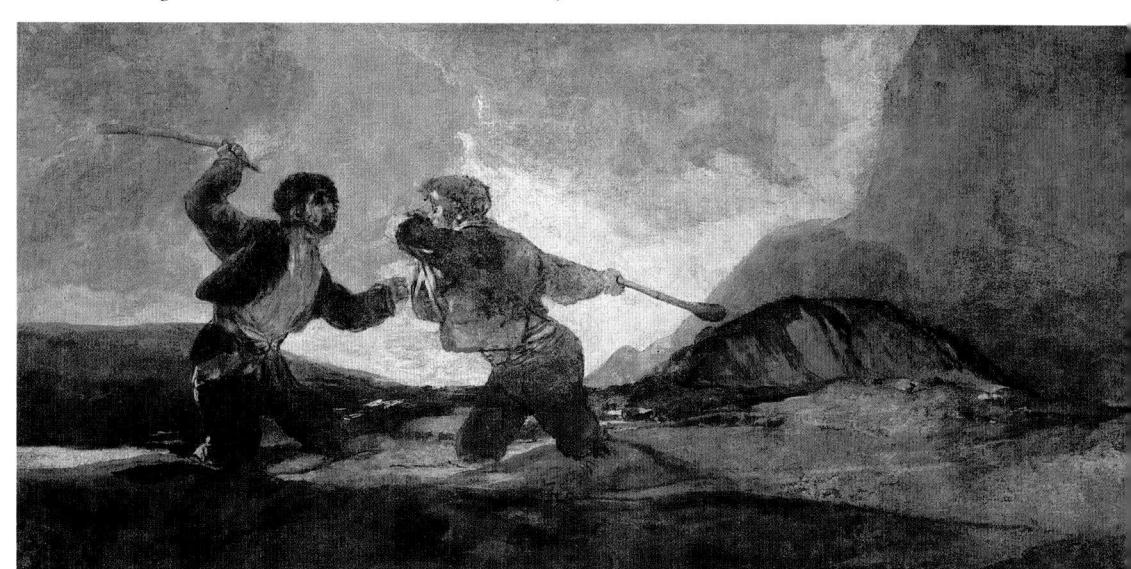

some grazing cattle can be made out in the background. Both men are doomed. They will drown in this mud, whether they keep fighting or not. The face of the peasant on the left is a mask of blood. The one on the right throws up his arm to ward off his enemy's blows. Nothing can stop this unappeasable feud. One thinks of Bosnia, of Northern Ireland—a condensation of all civil wars into this one murderous pair, Cain and Abel, or perhaps more properly Cain and Cain, in their grubby clothes. We don't know what they are fighting over. It hardly matters. But someone looking at this painting in 1820 might well connect it to the general suffering of Spain—to that homicidal world of *liberales* and Exterminating Angels, where men slaughtered others behind the city wall or the pigpen over their allegiance to an absolute but worthless king. This reading does not exclude others, of course. It could be that Goya meant no specific political comment; that he only wanted to make an image of irrational, self-propagating male aggression. Here, as in other rooms of the Deaf Man's House, we do not and cannot know.

Or take the painting that for most people is the most melodramatically horrible of the lot, Saturn Devouring His Son. Actually, the gory cadaver may be a son or a daughter, its gender is undecidable; but its proportions are certainly those of an adult body and not, as in Rubens's painting of the same theme, which was the origin of Goya's idea, a chubby infant. Originally, as noted earlier, Goya had a standing figure, doing what seems to be a dance step, against a mountainous landscape; this may even have been an image of life's joy. But then the darkness closed in, the background was painted out, and Saturn-god of melancholy and, presiding over the "saturnine temperament," the deity of painters as well—filled the whole frame. The aficionado of Surrealism has seen this awful, stringy body before: Salvador Dalí appropriated the horizontal thigh of Goya's crouching Saturn for the hybrid monster in the painting Soft Construction with Boiled Beans (1936), commonly known as Premonition of Civil War, whichrather than Picasso's Guernica—is the finest single work of visual art inspired by the Spanish Civil War. What Goya painted is the combination of uncontrollable appetite and overwhelming shame that comes with addiction—Saturn goggleeved and gaping, tormented by his lust for human meat, for an unthinkable incest. If he were merely hungry, he would not appall and move us so. And in what sort of society would the fathers eat the young? Surely, one in which the old perceive the new as a deadly threat: a society so reactionary that "tradition," imagined as the absolute reign of total authority, is worth murdering for.

In this way Goya's Saturn may be meant to direct our gaze back to the values of Fernando VII and his loyalists, an incarnation of a revolution that ended by eating its children. He is, so to speak, Goya's contemporary—the Exterminat-

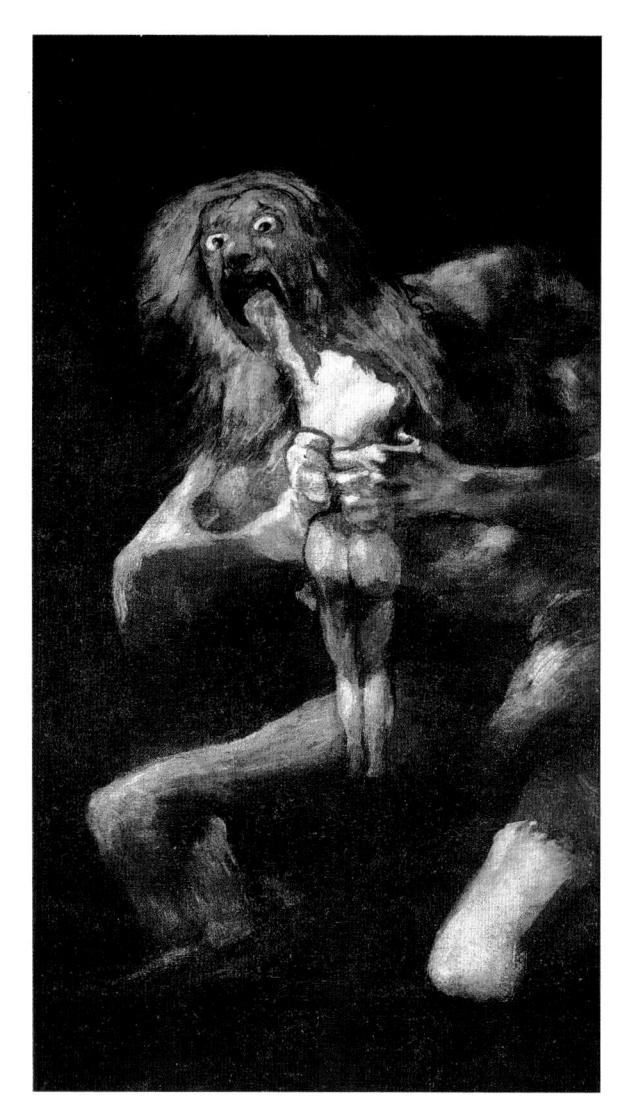

Salvador Dalí, *Soft Construction with Boiled Beans (Premonition of Civil War)*, 1936. Oil on canvas, 99.8 x 100.3 cm. Philadelphia Museum of Fine Art, The Louise and Walter Arensberg Collection.

Goya, *Saturno devorando a su hijo (Saturn Devouring His Son)*, 1820–24. Oil transferred to canvas from mural, 144 x 82 cm. Museo Nacional del Prado. Madrid.

ing Angel. There is also a theory that depends on identifying Saturn's child as female. If it is, then Goya may have meant the eating of the daughter by her father as a match to the scene next to it: Judith's murder of the patriarchal Holofernes.

But then there are paintings, among them some of the greatest in the Quinta, which seem to have nothing to do with the politics or society of Spain, because they are about that favorite theme of Goya's: witches and their spiritual relatives. One of these paintings is not clearly about witches, but it is hard to imagine what else its subject might be. It shows an open, windy landscape—Goya excelled at those cold blues, which suggest blasts of air sweeping down from distant mountains—in the middle of which stands an isolated butte of rock with
a town perched on it. No way of access to the town can be seen. There is nothing quite like this dramatic inhabited outcrop in Spain, or anywhere else in Western Europe, and possibly Goya derived it from the accounts that were common reading in Spanish descriptions of the Hispanic empire in America—specifically, from the descriptions of the oldest continually inhabited city in North America, the *pueblo* of Ácoma in New Mexico, forcibly brought into the Spanish empire by the conquistador Juan de Oñate in 1599 and well known, at least from hearsay, by Goya's time.

Two hags are floating in the sky. One has a bony mask of a face, somewhat like Katharine Hepburn far gone in old age. The other, bundled in a red cloak, clings to her as they fly. In the foreground are two uniformed French soldiers, one aiming a *trabuco* (short blunderbuss) not at the flying witches but at a straggle of horsemen and foot soldiers in the farther distance. What is going on here? Have the witches appeared to put a curse on the French? No really plausible readings present themselves. The painting is a riddle.

The second big picture on the ground floor, facing the *Pilgrimage of San Isidro*, is the *Aquelarre (Witches' Sabbath)*. Its chief figure is the devil, in the shape of a gigantic *cabrón*, or billy goat, sitting on the left with his back to us. It is haranguing an unruly, fascinated crowd of witches, old and young, whose distended and smearily twisted faces are a veritable lexicon of expression, snarling, scolding, glaring. Next to the billy goat, likewise facing the crowd but with her face half-seen in profile, is a squat, coarse-faced woman in a white hooded costume resembling a nun's habit; to her right she has an array of bottles and vials (a dark and sinister still life that echoes the picnic things Goya often painted in his fêtes champêtres in earlier years) that must contain the drugs and philters needed for devilish ceremonies.

The only female figure not caught up in emotion at Satan's diatribe is a young and perhaps beautiful woman who sits well apart in a chair on the right—all the others are sitting or squatting on the ground. Her head is mostly hidden by a black veil, her features are blurred, her hands covered by a muff. This is perhaps a postulant witch who is about to be received into full membership in the coven. The serenity expressed by the flowing lines of her body and the lack of emotion on her face contrast sharply with the jabber and clash of expression in the crowd of women.

Much of the work, including some of the witches' faces and the horns of the billy goat, was repainted by the Prado's restorer Martín Cubells when the *Aquelarre* was remounted on canvas; he also suppressed about a meter's width of landscape to the right of the young postulant.⁵ Perhaps these areas were too

Goya, *Aquelarre (Witches' Sabbath)*, 1820–24. Oil transferred to canvas from mural, 140 x 438 cm. Museo Nacional del Prado, Madrid.

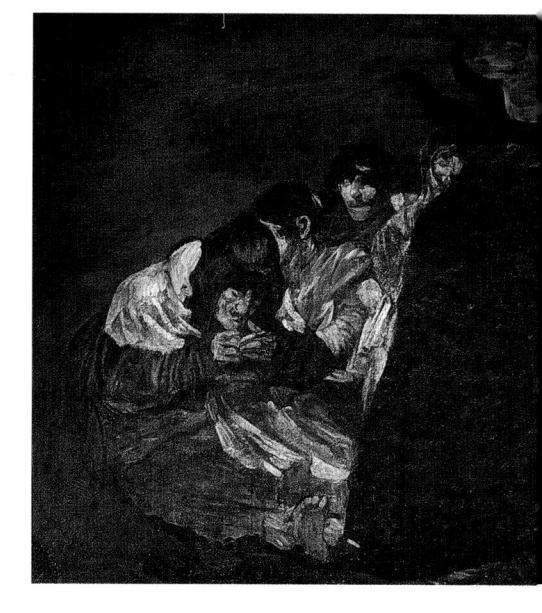

Goya, *Sabbath-Asmodeus*, 1820–24. Oil transferred to canvas from mural, 122 x 261 cm. Museo Nacional del Prado, Madrid.

damaged to keep, for otherwise it is difficult to see why Cubells should have edited them out.

Goya's large composition *Las parcas (The Fates)* is not strictly a witchcraft picture at all, since the Fates, or Moirai, were not witches. Daughters of Night, they determined the course of human life and hence were credited by classical myth with enormous power. In Homer, Hesiod, Virgil, and other classical authors, this life was imagined as a thread. The first Fate, Clotho, wielded the distaff that spun the thread. The second, Lachesis, measured its length. The

third, Atropos, snipped it off with scissors, and so was in charge of death—a moment that not even Zeus himself could alter.

It was typical of Goya, however, that he did not stick to this classical and ancient scheme. Floating in the air above that cold, brown-toned landscape with a river meandering through it, we see four figures, not three. They are all of exceptional ugliness.

Goya, *Las parcas (The Fates)*, 1820–24. Oil transferred to canvas from mural, 123 x 266 cm. Museo Nacional del Prado, Madrid.

On the left of the group, Clotho holds a doll between her hands—a manikin that, in place of the thread, presumably represents a human life.

Next to her is Lachesis, peering through a magnifying glass at what must be the life thread, so fine that her old eyes cannot discern it without a lens.

The third weird sister, on the far right with her back turned to us, holds up a small pair of scissors to cut the thread: she must be Atropos.

The problem is the fourth figure, who seems to be male. His arms are bound behind him. He is a captive, and seems to some critics to represent Prometheus, the hero bound on a mountain peak to be torn apart by an eagle for his crime in stealing fire from Zeus on Mount Olympus and bringing it down to earth for human use. But it is not clear from Goya's painting what possible relation might exist between Prometheus and the offended Fates, so perhaps the bound figure is not Prometheus at all.

GOYA WAS NATURALLY DISTURBED, perhaps even terrified, by the turn of events in Madrid. Chateaubriand's warning to Fernando VII to moderate the terror had little or no effect on the inflamed king, and the persecution of liberals and Freemasons only gathered momentum. Accordingly, Goya decided to remove his property from the reach of the confiscators. On September 17, 1823, he deeded the Quinta del Sordo over to his grandson Mariano, "because," the document said, "of the affection I bear him." He now prepared to quit Spain. For the first few months of 1824, he took shelter in the house of his friend José Duaso y Latre, a Jesuit priest whom he paid for his trouble with a portrait. An inventory of Goya's possessions at the Quinta del Sordo was made, under his direction and with the help of Leocadia and a young painter friend, Antonio Brugada, who had become his close disciple and owned a farmhouse not far from Goya's. The old painter now had to devise a way of making an expeditious departure from Spain without arousing the suspicions of the king and his court. This proved easier than anyone thought.

Fed up by now with the arbitrary ferocity of Fernando's revenge, the allies—France, England, and Russia—determined to apply real pressure to him. In the spring of 1824 the Russian ambassador managed to persuade the king's confessor to get Fernando to issue and publish a general amnesty. It was seized on at once by discontented Spaniards, and the king had enough sense to perceive that it was the easiest way of getting rid of them: he simply signed passports for everyone who applied for them, and a rush of emigrations ensued. On May 2, 1824, Goya applied for leave to take the waters of the hot springs at Plombières,

in southern France, "as his doctors have advised him." It was almost immediately granted.

Goya never went to Plombières. Instead, he headed for Paris via Bordeaux, where the police spies of the French minister of the interior were ready to keep an eye on him; but they soon decided that he was obviously harmless, a seventy-eight-year-old man who "seems older than he is and is extremely deaf." In Bordeaux a small group of *afrancesado* Spanish exiles was eagerly awaiting him. Goya made landfall with an old friend, the writer Leandro Moratín, who reported to his friend the abbé Juan Antonio Melón that the painter had arrived, "deaf, old, awkward and weak, and without knowing a word of French," as well as without a servant, which he badly needed, but "he was so happy and anxious to see the world."

He spent three days in Bordeaux and ate with Moratín and his friends "like a young student." Then he moved on to Paris, armed with a letter from Moratín to his friend, a Spanish lawyer named González Arnao, who was in the habit of helping out Spanish émigrés in need of advice. Arnao arranged lodgings for Goya on the third floor of the Hôtel Favart, in the rue Marivaux. Going up and down the stairs must have been a struggle for the old man, but apart from that we know nothing about Goya's movements in Paris. He was a complete stranger to its art world, and there is no record that he ever met Delacroix (then twenty-six and already conversant with Goya's drawings and prints, which he unreservedly admired) or Jean-Auguste-Dominique Ingres. Did he perhaps visit the Salon of 1824? And if he did, what good would have resulted? He was too old to be influenced by other men. Few people in Paris had so much as heard his name. He was too deaf to talk to them, and knew no French anyway. Ingres, in Rome, had filled sheet after sheet with drawings of the young, the rich, and the talented who came to his studio in the Villa Medici. But Gova scarcely had anything you could call a studio, and the only works he did during his brief sojourn in Paris were two portraits—of a Spanish banker, Joaquín María Ferrer, and his wife—and a fiercely nostalgic little bullfight scene. He saw a number of old acquaintances, refugees from Madrid whose portraits he had painted earlier: the condesa de Chinchón (now entirely separated from the faithless Godoy), whom he had painted as a child and again as a pregnant wife; Pepita Tudo, her rival for the choricero's love; and the dukes of San Fernando and San Carlos. But there was little to detain him in Paris, and so, his curiosity satisfied, he left in the fall of 1824 for Bordeaux, never to see the capital again. He stayed for a while at a hotel in the rue Esprit des Lois, and then on September 16 moved to a house at 24, cours de Tourny. There he was joined by Leocadia Weiss and her two children, Guillermo and Rosario, who had come north from Spain to be with him.

Goya's friendship with Moratín continued undisturbed. His relationship with Leocadia was not always so idvllic. "Gova is here with his lady Leocadia." wrote Moratín on October 23, "and the best of harmony does not prevail between them." Perhaps it was to keep Leocadia happy that Goya showered praise on her daughter, Rosario Weiss, for her precocity as a painter. Not only was this the first time Goya had praised the artwork of a ten-year-old child; it was one of the few occasions on which he had lauded anyone else's efforts, child or adult—the old man was not lavish with his compliments. For Rosario, he wanted to lay the foundation of a career as an infant prodigy, and wrote enthusiastically to Joaquín Ferrer: "This amazing child wants to learn miniature painting, and I want her to as well. She has remarkable qualities, as you will see. If you will do me the honor of helping me, I would like to send her to Paris for a while, but I want you to look after her as though she were my own daughter." Little came of this, though it speaks eloquently of Goya's readiness to help members of his family and to keep Leocadia happy. Little Rosario did not find a position with a studio in Paris, but she took lessons in the atelier of Pierre Lacour, the head of the Bordeaux School of Design and Painting. Later, in 1833, she appears registered as a copyist in Paris, and in 1842 she was appointed drawing teacher to Queen Isabel II, Fernando VII's daughter.

As for Goya, despite his infirmities, he was excited and optimistic. Already a master without rival of etching, he now embarked on the conquest of a new medium: lithography. At the end of 1825, he wrote to Joaquín Ferrer in Paris:

I sent you a lithographic proof that shows a fight with young bulls . . . and if you found it worthy of distribution, I could send whatever you wish; I put this message with the print, but hearing no news, I once again ask your advice, for I have three others made, of the same size and bullfight subjects.⁸

These prints, collectively known as the Bulls of Bordeaux, are the rarest Goya ever did, being issued in a small edition of one hundred sets by the Bordeaux printer Gaulon. The large print of the "fight with young bulls" (1825) shows their experimental nature. Compared with the earlier etchings, it is rough and summary, and in places almost parodic. It represents the moment when the ring of spectators has charged among the bulls, reducing the severity of the ritual to a kind of absurdity, a populist slapstick analogous to the amateurishly chaotic "running of the bulls" in Pamplona. It is drawn in a very broad manner, quite different from the refinement of the etching needle in earlier series, the *Captri*-

chos and Disparates. The crowd is swarming all over the place, as suggested by the title, Dibersión de España (Spanish Entertainment). Areas of dark, scribbled rapidly in with the soft lithographic crayon, are then relieved by scraping and scratching to bring back streaks and highlights of white.

Goya's much younger friend, the painter Antonio Brugada, witnessed him at work in the studio, in all his eccentricity of method. Lithographic stones, being extremely heavy, were generally worked on laid out flat on a table, but Brugada told Goya's memoirist Matheron:

The artist worked at his lithographs on the easel, the stone placed like a canvas. He manipulated his crayons like brushes and never sharpened them. He remained standing, walking backwards and forwards every other minute to judge his effects. Usually he covered the whole stone with a uniform gray tone and then removed with a scraper those parts which were to appear light: here a head, a figure; there a horse, a bull. Next, the crayon was again employed to strengthen the shadows, the accents, or to indicate the figures and give them movement. . . . You would perhaps laugh if I said that all Goya's lithographs were executed under a magnifying glass. In fact, it was not in order to do very detailed work but because his eyesight was failing. 9

Actually this was not quite the way Goya did *Spanish Entertainment*. The whole stone was not covered with a "uniform gray tone"; plenty of its surface was left untouched, whether by crayon or scraper. But there was plenty of scraping and retouching, and the whole effect is much rougher and more emphatic—more caricatural, almost—than in the earlier etchings. Its effects, and those of the subsequent lithographs, are more "painterly."

That Goya should have taken up lithography when he was already the complete master of etching and aquatint shows his curiosity and willingness to try new mediums, for lithography was very new indeed: it had been invented in the late 1790s. 10 It had the great advantage over copper engraving that the design lasted longer under repeated runs through the press, whereas the copper plate tended to degenerate. Lithography is a planographic process, meaning that the design is made on the actual surface plane of the printing "matrix" (in Goya's time, smooth limestone; later, zinc or even paper) instead of being cut into it by acid or a sharp tool, as in the various forms of etching and engraving. Lithography relies on the proverbial fact that oil and water won't mix. A design is drawn on a stone in greasy crayon or *tusche* (lithographic ink). The preferred stone is fine-grained Bavarian Kelheim limestone. It is then treated with nitric acid and gum arabic. The grease in the crayon or ink fuses with the stone. After

Goya, *Dibersión de España (Spanish Entertainment)*, 1825. Lithograph. National Gallery of Art, Washington, D.C. Gift of W. G. Russell Allen.

washing to remove the soluble remnants, the stone is inked. The grease in the printing ink adheres only to the greasy marks on the stone (the design) but is repelled by the wet, unmarked stone. The stone now runs through a press and transfers the design on it to previously dampened, but not soaking wet, paper.

So much for the technique, very roughly described. What opportunities did it hold for Goya? Spontaneity and directness. The creation of form and tone by scratching on copper with a needle means that you have to think about the design not only in reverse (flip-flopped) but also in *tonal* reverse: the lines that will trap ink and print black on the paper are seen as bright shining copper on the plate.

Lithography, though, is direct. The black mark on the stone will be black on the paper. Moreover, the stone can be worked on directly, scratching and wiping away marks to make the erased portions print white—a process that, with copperplate etching, is either impossible or very laborious.

However, if Goya thought he was going to make money with the Bordeaux bullfight prints, he miscalculated badly. They did not sell. French collectors were not interested in bullfighting. Worse, neither were Spanish ones in Paris, for the simple reason that most of them were émigrés. The Spaniards who had fled from Fernando VII to France were *afrancesados*, enlightened liberals who tended to regard the corrida as an old-fashioned and barbarically proletarian ritual that did not deserve a place in their refined salons. Knowing and loving the corrida for what it was, Goya did not euphemize. The first of the five Bordeaux bullfighting lithographs (1825) shows a confused melée of dead and dying horses and men, surrounding a tormented bull. One man is impaled on its horn in a terrible *cornada*. Others, both mounted and on foot, are jabbing their *garrochas* into the bull to make it back off and free the man; a blindfolded white horse has collapsed on its knees in the foreground, and other half-dead horses can be made out behind the shapes of man and bull. The figures of the picadors are stock, brutal, and almost simian.

This is no elegant ballet, such as is occasionally seen in the *Tauromaquia*. It is rawly, almost shockingly, original, as are the remaining four plates, all from 1825. The first, *El famoso americano Mariano Ceballos*, depicts the Peruvian bullfighter Goya had already etched in the *Tauromaquia* (plates 26–29), doing his crazy trick of riding a bull straight at another bull, about to lance the beast. It is all power and no grace, and much the same is true of the other lithographs.

Since these appeared both clumsy and repulsive to an eye used to French taste, Goya's friend in Paris Joaquín Ferrer advised him to recoup his fortunes by another means. Why not reissue the *Caprichos*, which were known to French connoisseurs (including Delacroix) and would find a ready market among them? Goya's reply to him is a classic of old man's determination. He felt he was failing. His body told him so. "Pardon me infinitely for this bad handwriting," he wrote to Ferrer on December 20, 1825. "I've no more sight, no hand [poigne], nor pen, nor inkwell, I lack everything—all I've got left is will." But he was not going to admit a failure of will: he would not repeat himself by reprinting fifteen-year-old plates. In any case, he had traded off the plates of the *Caprichos* to the Royal Calcografía in return for an annuity for his son long ago; and he had new things to do.

I wouldn't copy them, because today I have better possibilities that would sell more usefully. As a matter of fact, last winter I was painting on ivory; I've already got a collection of forty studies, but these are original miniatures, of a kind I've never seen before, entirely done with the point of a brush, with details that are closer to the brushwork of Velázquez than to that of Mengs.¹¹

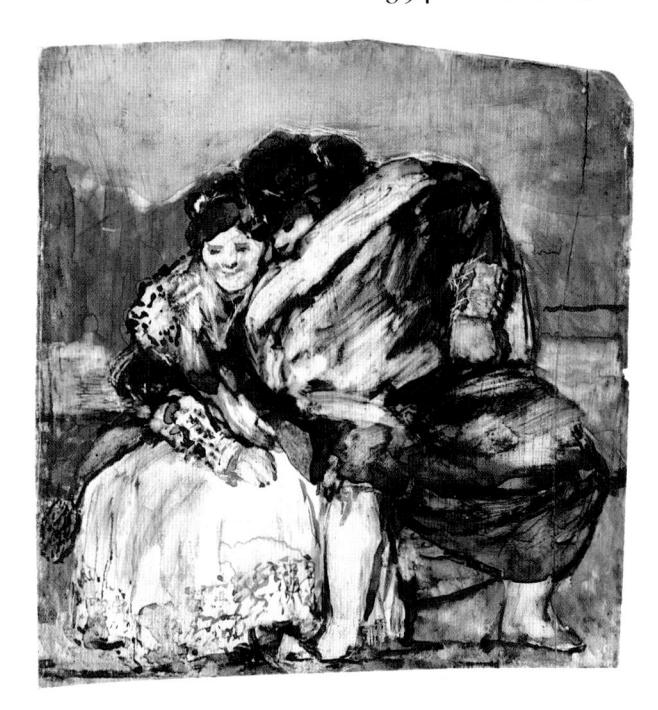

Goya, "Seated *maja* and *majo*," 1824–25. Carbon black and watercolor on ivory, 90 x 84 mm. Nationalmuseum, Stockholm.

Goya was referring to the striking contrast between the tiny size of these figures on ivory plaques—no more than two or three inches square—and the broad scale on which they were painted. Normally a miniature on ivory was tightly rendered, its brushstrokes almost indistinguishable in their licked stippling—like a Mengs, in fact.

But these were rough for their size, their treatment broad, more reminiscent of the big planes of Velázquez that fell into proportion when seen from a distance. Goya did them by covering the little ivory plaque with a dark ground and then letting fall a drop or two of water, dissolving the pigment, making it blot, flow, and granulate. Blots suggested shapes, light welled up inside the darkness, and Goya—like Leonardo before him, prompted by the random patterns of salts or lichens on old walls—encouraged chance to do the work of suggestion, prodding it along with feathery touches of the brush and cunning applications of a darker shadow. On this tiny scale he produced broad effects, as in the Stockholm "Seated *maja* and *majo*" (1825), where the leaning black bulk of the man's cloak seems about to overwhelm the more delicate shawl and skirt of the *maja*.

These were Goya's last true paintings in a liquid medium, tiny though they were. The old man's strength and stamina were fading. But the intensity of the

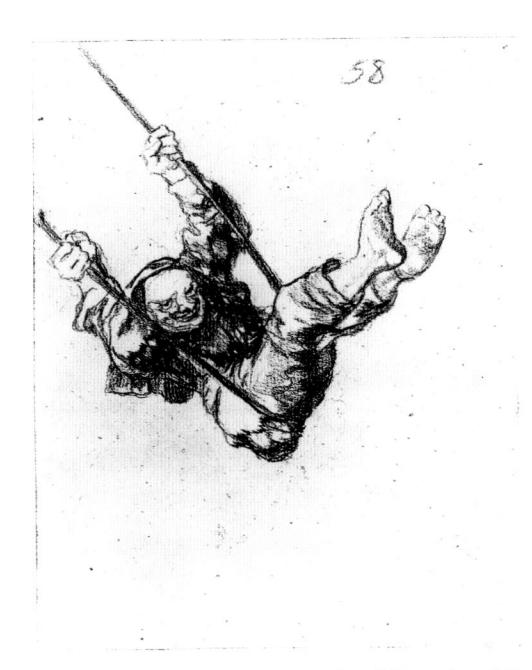

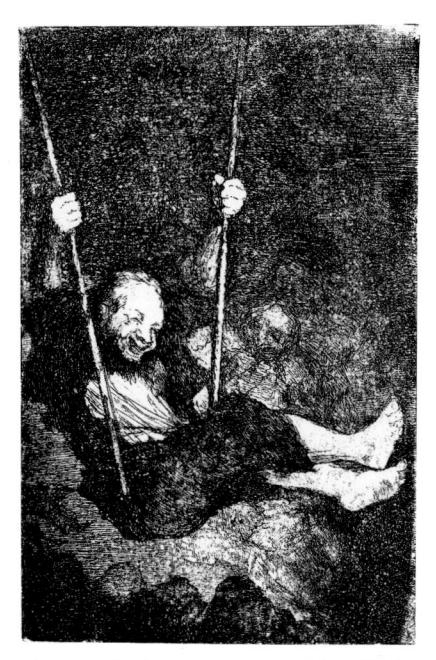

Left: Goya, "Old man on a swing." Drawing. The Hispanic Society of America, New York. Right: Goya, "Old man on a swing," 1824–28. Etching and burnished aquatint. Bildarchiv Prenssischer Kulturbesitz, Berlin.

marks he made was not. It was as though the pictures were becoming smaller in order to concentrate the same pressure of feeling, of that vitality of touch, living in every line, which the Chinese called *ch'i*. He would not condescend to make works of art merely to sell them. He still despised self-repetition. Instead of creating a little stock of images to sell, Goya did not hesitate—due to the scarcity of ivory—to erase one image to make room for another. They were all jostling at the base of his brain, demanding release. He was truly off on his own now, making for making's sake, on the tiniest of scales. Sometimes he would do an etching, based on a drawing. One such drawing is the marvelously energetic image of a wildly grinning old troll with horny feet, swinging on a rope, in total disregard of the dignity of age. This translates into one of his last etchings—the same subject, the crazy old barefoot sage, ignoring gravity and cackling to himself like a Zen patriarch absorbed in a private but cosmic joke: Goya himself, high in the air.

He had no real studio. That is why his output of paintings dwindled to a few portraits: that, and the depletion of his energies—one finds him complaining that even the effort of writing a letter tired him out.¹² But when Goya really

wanted to paint someone, he insisted on it, and Leandro Moratín (whose likeness, heavy-jowled and potato-nosed, he had done in 1824, a quarter-century after first painting him as a young and sensitive-looking playwright) reported from Bordeaux that "he wants to paint me, and from that you can imagine how pretty I am, when such expert brushes aspire to multiply my images." ¹³

But beyond formal portraiture, the old curiosity was still there, burning and scratching through his drawings, of which two small albums (labeled G and H) survive. It may be that Goya thought of them as possible elements in a set of new *Caprichos*, easier to sell than his corrida lithographs—but that is only a guess.

The drawings in the first Bordeaux album, G, are of two main subjects: forms of transport (mostly for the disabled) and states of insanity. They are done not with the brush, pen, and ink he had used in earlier studies for etchings, but with a soft black crayon resembling the greasy lithographic crayon he had used in the bullfight prints. It produced a more blurred and atmospheric line, which is sometimes at odds with the ferocious weirdness of the subject he was drawing. The drawings fall into two broad groups: things that he saw or might have seen in real life, and things he imagined. In the first group were some figures and scenes whose reality cannot now be tested. Did he actually "see" the extraordi-

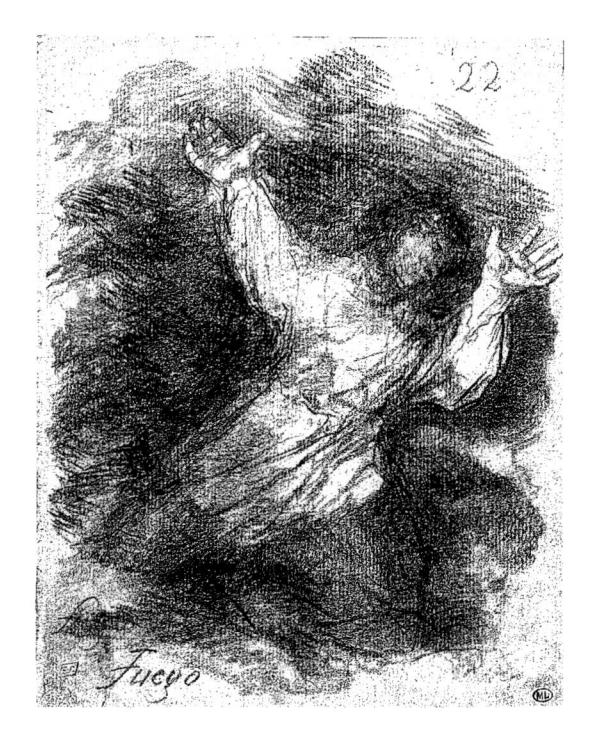

Goya, Bordeaux Album I, 22, Fuego ("Fire") 1825–28. Charcoal. Museé du Louvre, Paris.

Left: Goya, Bordeaux Album I, 29, *Mendigos que se lleban solos en Bordeaux* ("Beggars who get around on their own in Bordeaux"), 1824–27. Black chalk on gray laid paper, 19 x 14 cm. Woodner Collection, National Gallery of Art, Washington, D.C. Right: Goya, Bordeaux Album I, 32, *Locos patines* ("Crazy skates"), 1825–28. Black

crayon, 19.2 x 15.2 cm. Museum of Fine Arts, Boston.

nary, onrushing figure engulfed in flames and smoke (#22), or is it an aftermemory of one of the painted *Caprichos* he did after his 1792 illness, "Fire at night"? But there can be little doubt that the amputated beggar in his wheelchair (#29) and the hunched figure pulled in a dogcart behind an eager, straining mastiff (#31, captioned "I saw this in Paris") are things he witnessed. So are the wobbling roller skater and the more lightly traced velocipedist behind him (#32, "Crazy skates").

Just as he had visited the madhouse in Zaragoza so long ago to jot down material for his paintings of lunatics, so he went to the madhouse in Bordeaux; and from this visit (or visits) came some of his most terrifying images of lunacy, in which the madmen acquire a sullen, titanic power and seem on the verge of bursting their bonds—Prometheuses barely chained. Here, in Album G, is a half-naked madman crawling under the massive arch of another's legs, as though taking refuge in a cave of flesh (#39). Here is a man *Gimiendo y llorando* ("Weeping and wailing," #50), down on his knees on the hard ground in front of a stone wall, his outflung arms reminding us—and Goya too, of course—of the

Above, left: Goya, Bordeaux Album I, 39, *Locos* ("Madmen"), 1825–28. Black crayon, 19.2 x 14.8 cm. The British Museum, London.
Above, right: Goya, Bordeaux Album I, 50, *Gimiendo y llorando* ("Weeping and wailing"), 1825–28. Private collection.
Right: Goya, Bordeaux Album I, 40, *Loco furioso* ("Raging lunatic"), 1825–28. Private collection.

imploring Christ figure who sets off the power train of unbearable memory and foreboding in the first plate of the *Desastres de la guerra*, and of the *pueblo* Christ in the white shirt defying the French muskets in the *Third of May*. Most dreadful of all is the power and malevolence of the madman's eye in *Loco furioso* ("Raging lunatic," #40), an eye swiveling at the shadowy terrors that beset him. Only

Goya, Bordeaux Album I, 12, *Mal sueño* ("Bad dream"), 1825–28. Black crayon, 19.2 x 15.2 cm. Museo Nacional del Prado, Madrid.

an old man who had suffered immensely and known every last terror of black melancholy could have imagined and drawn such an eye.

In a lighter vein, there are things in both albums that Goya had seen on the street, in raree-shows, or perhaps at the circus. A donkey walking on its hind legs. A man standing on his head on a platform, waving his legs in the air, semaphoring messages—this primitive but useful code had been in military use for many years, but here (*Telégrafo*; Album H, #54) Goya observes its comic or parodic aspect. A mild, sweetly bewildered-looking giantess he had noticed among the exhibits at a fair in Bordeaux, towering over her spectators.

And there were the things that had no existence outside Goya's head, fantasies thrown off by the old laboring brain and its obsessions, perhaps the basis of future *Caprichos* that he would not live to etch. Some of these look not so much like inventions as transcriptions of dreams and visions that came to Goya fully formed and without editing. Thus *Mal sueño* ("Bad dream" or "Talking apparition"), an unnumbered sheet from Album G. A man wrapped in what seems to be a torn cape is gazing in open-mouthed fright at a head. Its eyes are bulging with horror, and it is supported by a dozen blackbirds or starlings,

which are pecking at it. Two cats are also looking, with the head and the birds. The man is so appalled by this enigmatic vision that his hair stands on end.

What can this mean? Who can say? It is beyond interpretation. The same is true of Album G's *Cómico descubrimiento* ("Comic discovery," #51), which is anything but comic. A hole has opened in the page: a little gulf, crammed with heads. They are shouting, whispering, squalling, jabbering. You can almost hear their dull incoherent prattle. Is this human paste a vision of hell? A reflection on the mindlessness of crowds, for which Goya had always felt such contempt?

There are more compressed, many-leveled images, such as Album G's #53: "They fly and fly. Fiesta in the air. The Butterfly Bull." It is a sketch of a black bull, caught in midleap, with what seems to be a bouquet of faces and butterflies flowering from its back. The idea of a *toro mariposa* suggests sexual ambiguity—a homosexual bull, a *maricón*.

If Goya had been younger and stronger, what might such urgently drawn visions have produced? But he was neither young nor strong. In 1825 his doctors diagnosed paralysis of the bladder, and an enormous tumor appeared on the bone of one of his legs. Despite his collapsing health, Gova made up his mind to settle matters once and for all with the court in Madrid. He would sort out the matter of his retirement and his pension. He wrote a memorial to Fernando VII, reminding his sovereign of his age (eighty), his length of service to the Spanish Crown (fifty-three years), and his need of a retirement pension. In June 1826 one of Fernando's advisers, the duke of Hijar, took up Goya's cause, reminding the king that "the artist has worked for a long time and with the utmost care, taste, and intelligence on the numerous commissions he has been given; his artistic merit is so unsurpassable that other artists and the general public all extol his work." Such long service and quality of work deserved a substantial reward; and the king agreed, giving him a pension of 50,000 reales a year and, equally important, permission to keep living in France. In this way Fernando proved that he had no further quarrel with Goya and that he had realized, at last, that the old man posed no menace, not even so much as an inconvenience, to him.

Goya went back to Bordeaux. We do not know the details of the journey, but before he left, he was painted by Fernando's artist-laureate Vicente López: he appears as a crusty, wrinkled, indomitable old cuss, the daddy of all Spanish artists, but a daddy only just living. In July 1826, he arrived back in the presumably welcoming arms of Leocadia. "Goya is fine," wrote Moratín. "He keeps busy with his sketches, he walks, eats, takes his siestas; it seems that right now peace reigns over his hearth." Then, quite unexpectedly, Goya took off for Madrid again in the summer of 1827, possibly to finalize the details of his

passport—though in fact we know nothing for sure about his reasons for going, and they must have been pressing, given the great discomfort of the journey, its length, and his ever-worsening health. In Madrid, he painted at least one final portrait, that of his grandson Mariano, before pressing on to Bordeaux.

Goya wrote four letters to Javier, all fond, all yearning for the company of his "beloved travelers." "Everything you tell me in your last letter, which is to say that to spend more time with me they will give up on going to Paris, fills me with the greatest pleasure. . . . I find myself much better, and I hope to be back where I was before. . . . I am happy to be better to receive my most beloved travelers. This improvement I owe to Molina, who has told me to dose myself with the herb valerian, ground to a powder." 15

The improvement was an illusion. On April 2, Goya suffered a stroke, which paralyzed the right side of his body. He lingered in a coma, speechless and unresponding, and died two weeks later, at two in the morning on April 16, 1828. Brugada, Molina, and Leocadia were present at his bedside; Brugada supported his head as his breathing grew feebler and less regular. A young lithographer, Francisco de la Torred, drew a record of that deathbed scene, which was printed in a sizeable edition by Gaulon, the firm which had published Goya's own Bulls of Bordeaux.

Most of Goya's estate went to Javier, who did not get to Bordeaux in time for his death. Some was left to Mariano. This was under an irrevocable will Goya had made years before in 1811.

He left Leocadia nothing.

Javier, who loathed Leocadia—the feeling seems to have been amply reciprocated—let her take a few orts and leftovers: some furniture, household linen, clothes, and, in case she decided to go back to Spain, the sum of one thousand francs. She had to vacate the house, whose rent was only paid up to the end of April.

She also got one painting, *The Milkmaid of Bordeaux*, which may or may not have been a portrait of her daughter Rosario, and may or may not have been painted by Goya. A year later, poverty compelled her to sell it to one of Goya's distant relatives, Juan Bautista de Muguiro, whose descendants gave it to the Prado in 1946.

Goya was buried on the morning of April 17, the day after his death. A Mass was said for the repose of his soul in the nearby Church of Nôtre-Dame, and he was interred in the cemetery of the Chartreuse in Bordeaux beside his son's father-in-law, Martín Miguel de Goicoechea.

In 1901, not deeming it proper that one of Spain's greatest sons should lie for-

Goya, *La lechera de Burdeos (The Milkmaid of Bordeaux)*, c. 1827. Oil on canvas, 74 x 68 cm. Museo Nacional del Prado, Madrid.

ever in French soil, the Spanish government asked for his remains to be exhumed and given back for burial in Spanish earth. They were transferred to Madrid in 1901. Then, in 1929, it was decided to rebury Goya under the floor of the church he had so beautifully decorated with his angels, Santa María de la Florida. He was dug up again, but this time his skull was missing. It has never been found, so one can only hope that the souvenir hunter respected it and that it ended up in Spanish, not French, soil.

NOTES

2 GOYA'S BEGINNINGS

- I. Lafuente Ferrari, Antecedentes, p. 25.
- 2. Cited in ibid., p. 27.
- 3. Iglesias, "Una historia no lineal de progreso y modernización," in *Ilustración y proyecto liberal*, p. 22.
- 4. Tom Lubbock, in "Holding Their Ground," catalog essay in *Goya: Drawings from His Private Albums* (London: Hayward Gallery, 2001), p. 27.
- 5. On Goya's posthumous market fortunes in England, see Nigel Glendinning, "Goya and England in the Nineteenth Century," *Burlington Magazine* 106 (1964), pp. 4–14; also Tomlinson, *Francisco Goya y Lucientes* (London, 1994), p. 287.
- John Russell in introduction to Eugène Delacroix's diaries. Selected Letters 1823–1863 (New York, 1970), p. 1.
- 7. Baticle, Goya, pp. 39-40.
- 8. Baticle, Goya, p. 47.
- It is painted on a previously used canvas suggests a date toward the end of the War of Independence, probably around 1814, when the shortage of canvas was acute. See Fundación Amigos de Museo del Prado, ed., Goya: La imagen de la mujer; pp. 206–28.
- 10. Juan Álvarez Mendizabal (1790–1853), Jewish, liberal, and a Mason, was born in Cádiz and became a trusted friend of Rafael de Riego's. After a sojourn as a banker in London, Mendizabal returned to Spain in 1835 with the almost incredibly radical proposal to defray the country's national debt of 4.4 billion reales by nationalizing all of the real estate, revenues, and shares belonging to religious communities. Purchasers of these confiscated properties could use either cash or state scrip.

3 COMING TO THE CITY

- For Esquilache and the motin, see Franco Strazzullo, Il Marchese di Squillace. Leopoldo de Gregorio ministro al Carlo di Borbone (Naples, 1997).
- Campomanes, letter IV in Cartas político-económicas, cited in Díaz-Plaja, La vida española en el siglo XVIII, p. 19.
- 3. Fernán-Núñez, Conde de, Vida de Carlos III (Madrid, 1898), p. 38.
- 4. Abbé Vayrac, État présent de l'Espagne (Amsterdam, 1731), vol. 2, p. 237.

- 5. Cited in Kamen, Spanish Inquisition, p. 308.
- 6. Ibid., p. 16.
- 7. Ibid., p. 191.
- 8. Díaz-Plaja, La vida española, pp. 111 ff.
- 9. Keith Christiansen, catalog to *Giambattista Tiepolo: Modelli, Capricci and Prints* (New York: Metropolitan Museum of Art, 1996), entry #53, p. 325.
- L. F. de Moratín, *La comedia nueva*, ed. John Dowling (Madrid, 1970), pp. 291–2; cited in J. Dowling, *Ramón de la Cruz*, *Sainetes I* (Classica Castalia, 1981), pp. 24–5.
- 11. Ibid., p. 26.
- 12. Duro, Historia de Zamora, cited in Díaz-Plaja, La vida española, p. 149.
- 13. Goya, MS letters to Zapater, July 7, 1786, #108, p. 209.

4 FROM TAPESTRY TO SILENCE

- Held, "Los cartones para tapices," Fundación Amigos del Museo del Prado, ed., Goya (Barcelona: Galaxia Gutenberg/Círculo de Lectores, 2002), p. 36.
- 2. Ford, Gatherings, pp. 165-6.
- 3. Klingender, Goya in the Democratic Tradition, p. 84.
- 4. See Margarita Moreno de las Heras, "The Wounded Mason," note to cat. #13, Goya and the Spirit of Enlightenment, pp. 29–30.
- 5. See Tomlinson, Francisco Goya y Lucientes, pp. 30 ff.
- 6. Ibid., p. 31.
- 7. On Mengs and the engravings see ibid., p. 38. Mengs wrote to Carlos III in 1777, shortly before he left Madrid to return to Rome, expressing regret that the royal collection was not more accessible, if not to the general public, then at least to connoisseurs; it was one of the glories of the Bourbon realm, he wrote, and would be worth advertising through well-circulated printed copies.
- 8. Ibid., p. 49.
- 9. Reuter, in cat. note to #6, "La cita," in Fundación Amigos del Museo del Prado, ed., *Goya: La imagen de la mujer* (Madrid: Fundación Amigos del Museo del Prado, 2001), p. 128, takes a somewhat different tack: the leafless tree behind her, an image of sterility, is the cause of her grief; it symbolizes the woman's inability to conceive as a result of too many abortions. This connects to Goya's corrosive skepticism about doctors.
- 10. Tomlinson, Francisco Goya y Lucientes, p. 89.
- 11. See Baticle, Goya, pp. 80-81.
- 12. Goya, MS letters to Zapater, pp. 64-5.
- 13. Goya, MS letters to Zapater, #22, p. 61.
- 14. Goya, MS letters to Zapater, Feb. 25, 1785, #64, p. 130.
- 15. See A. Pérez Sánchez, in catalog to Goya and the Spirit of Enlightenment, p. 10.
- On Pignatelli and the Aragón canal, see Alejandro Diz in Iglesias, ed., La lucha contra la pobreza, p. 347.
- 17. Goya, MS letters to Zapater, p. 110.
- 18. Eleanor Sayre, catalog note in Goya and the Spirit of Enlightenment, p. 12.
- 19. Goya to Zapater, #109 in A. Canellas López, ed., Goya, Diplomatario, pp. 269-70.
- 20. Goya, MS letters to Zapater, #82, p. 154; cited in Baticle, Goya, p. 127.
- 21. Goya, MS letters to Zapater, Oct. 6, #26, p. 73; cited in Baticle, Goya, p. 82.
- 22. Holland, Spanish Journal, p. 195.
- 23. On Goya's portrait prices at this early stage of his work see Miguel Artola, "La Condesa

- de Chinchón," in Fundación Amigos del Museo del Prado, ed., *Goya* (Barcelona: Galaxia Gutenberg/Círculo de Lectores 2002), p. 207.
- 24. On the Osuna family portrait and its dating, see Anna Reuter, in Fundación Amigos, *Goya: La imagen de la mujer*, entry #32, p. 182.
- 25. Tomlinson, Francisco Goya y Lucientes, p. 70.
- 26. Cited in ibid., pp. 306 ff.
- 27. Goya, MS letters to Zapater, p. 211.
- 28. Goya to Iriarte, in Gassier and Wilson, p. 382.
- 29. Juliet Wilson-Bareau, in *Goya, Truth and Fantasy: The Small Paintings*, p. 203; also Tomlinson, *Francisco Goya y Lucientes*, pp. 98 and 14–15*n*.
- 30. See "La herida y el arco: Arte y psychologia en la vida de Goya," in Glendinning, *Goya: La década de los Caprichos*, pp. 33 ff.

5 WITCHES AND ANGELS

- 1. Gova to Zapater, in A. Canellas López, ed., Goya, Diplomatario, letter #72, Sept. 20, 1783.
- 2. Goya, MS letters to Zapater, p. 200.
- 3. Related in Tomlinson, Francisco Goya y Lucientes, p. 83.
- 4. Goya to Zapater, in López, Goya, Diplomatario, letter #77, Feb. 1784.
- J.-W. Bareau, "Witchcraft and Allegory," in Goya, Truth and Fantasy: The Small Paintings," p. 215.
- Fleuriot de Langle, Voyage en Espagne (ed. 1785), vol. II, p. 76; cited in Baticle, "Goya y la Duquesa de Alba: ¿Que tal?" in Fundación Amigos del Museo del Prado, ed., Goya: Nuevas visiones and Homenaje a Enrique Lafuente Ferrari, 2 vols. (Madrid: Fundación Amigos del Museo del Prado, 1987).
- 7. Tomlinson, Francisco Goya y Lucientes, p. 108.
- 8. Symmons, "La mujer vestida de blanco," pp. 54-7.
- 9. Herman de Schubart, "Lettres d'un diplomate danois en Espagne," *Revue hispanique*, 1902, pp. 393–439; cited in *Goya and the Spirit of Enlightenment*, p. 76.
- See Jeannine Baticle, El arte Europeo en la Corte de España durante el siglo XVIII, catalog for an exhibition at the Museo del Prado, 1980, p. 78.
- For Jovellanos, see Hugh Thomas, "Gaspar Melchor de Jovellanos" in Fundación Amigos del Museo del Prado, ed., Goya (Barcelona: Galaxia Gutenberg/Círculo de Lectores, 2002), pp. 119–30.
- 12. Helman, Trasmundo, pp. 103-4.
- 13. On Jovellanos as collector, see Glendinning, *Goya: La década de los Caprichos*, pp. 52–3. He was a more conservative collector than some other middle-class acquaintances of Goya's, such as the brothers Iriarte.
- 14. Quoted in Thomas, "Gaspar Melchor de Jovellanos," p. 120.

6 THE CAPRICHOS

- 1. To the author, in 1975.
- 2. For Goya's collaborators on the *Caprichos*, see Patricia E. Muller, "*Los Caprichos* como obra in curso," in Fundación Amigos del Museo del Prado, ed., *Goya*, (Barcelona: Galaxia Gutenberg/Círculo de Lectores, 2002), p. 93.
- 3. Tomlinson, Francisco Goya y Lucientes, p. 125.

- 4. Goya and the Spirit of Enlightenment, #30, p. 86.
- 5. Tomlinson, Francisco Goya y Lucientes, p. 133.
- 6. See Vinaza, Goya.
- 7. See Leandro Moratín, Obras postumas (Madrid, 1867-68), vol. III, p. 255.
- 8. See biographical notice on Javier Goya by Valentín de Carderera, cited in Lafuente Ferrari, *Goya: The Frescoes in San Antonio de la Florida*, p. 144, n. 24.
- 9. Biography of Goya in Almanaque de la ilustración española y americana (Madrid, 1880).

7 THE FALL OF THE BOURBONS

- 1. On the Castillo crime, see Juliet Wilson-Bareau, "The *Caprichos* of the Marquess of la Romana," in *Goya, Truth and Fantasy: The Small Paintings* (London, 1994), pp. 272–6.
- 2. For the story of El Maragato and the friar, see Wilson-Bareau, "Caprichos of the Marquess," op. cit., pp. 292–3.
- 3. On the real-life Maragatos, see Ford, Gatherings from Spain, p. 73.
- 4. Westminster Review, April 1836; cited in Sencourt, Spain's Uncertain Crown, p. 31.
- 5. Raymond Carr, Spain, 1808-1939 (London, 1966), p. 82.
- 6. C. Pereira, Cartas confidentiales de María Luisa y Godoy (Madrid, n.d.).
- 7. Anna Reuter, in Fundación Amigos del Museo del Prado, ed., *Goya: La imagen de la mujer* (Madrid: Fundación Amigos del Museo del Prado, 2001), p. 224.
- 8. Holland, Spanish Journal, p. 75.
- 9. Cited in Glendinning, La década de los Caprichos, p. 83, n. 247.
- Antonio Ortiz, La sociedad española en el siglo XVIII (Madrid, 1955), p. 35; cited in Goya and the Spirit of Enlightenment, p. 144.
- 11. Fred Licht, "Ya no es una diosa: Las majas de Goya y el desnudo en los origines de la época moderna," in Fundación Amigos del Museo del Prado, ed., El desnudo en el Museo del Prado (Barcelona: Galaxia Gutenberg/Círculo de Lectores, 1998), p. 121.
- 12. Ibid., p. 123.
- 13. Miguel Artola, "La condesa de Chinchón," in Fundación Amigos del Museo del Prado, ed., *Goya* (Barcelona: Galaxia Gutenberg/Círculo de Lectores, 2002), p. 205.
- See Véronique Gerard Powell, "El retrato de Godoy," in Fundación Amigos, Goya, op. cit., p. 235.
- 15. Juan Escoiquiz, "Idea sencilla de las razones que motivaron el viaje del rey don Fernando VII a Bayona" (Madrid, 1814), p. 8.
- 16. Cited in Sencourt, Spain's Uncertain Crown, pp. 112–13.
- 17. Henry Richard Holland, Foreign Reminiscences (London, 1851), p. 208.
- 18. For the putative influence of Meléndez's Aranjuez paintings on Goya, see Bodo Vischer, "Entre la vida y la muerte: Los bodegones de Goya en el Museo del Prado, in Fundación Amigos del Museo del Prado, ed., El bodegón (Barcelona: Galaxia Gutenberg/Círculo de Lectores, 2000), p. 374.

8 WAR WITH NAPOLEON

- 1. Col. Juan José Sanudo, "Oman's View of the Spanish Army in the Peninsular War Reassessed," in *A History of the Peninsular War*; ed. Paddy Griffith, vol. 10 (London, 1999), p. 155.
- 2. A. Brett-James, ed., Edward Costello: Military Memoirs (London, 1967), p. 112.

- 3. "A Short Account of the Celebrated Guerrilla... Espoz y Mina," in *Gentleman's Magazine*, supp. for 1811, pp. 619–25.
- 4. From Espoz y Mina's memoirs in A. Hugo, France militaire, vol. 4 (Paris, 1837).
- 5. Espoz y Mina, ibid.
- 6. Cited in La Rosa, España, p. 27.
- 7. Ibid., p. 53.
- 8. For a carefully nuanced discussion of the iconography of this painting, see Eleanor Sayre in *Goya and the Spirit of Enlightenment*, pp. 167–9.
- 9. To D. Josef Muñarriz, Real Academia de San Fernando, Oct. 2, 1808; quoted in Sayre, *Changing Image*, p. 126, n. 9.
- 10. See Eleanor Sayre in Goya and the Spirit of Enlightenment, catalog #97, pp. 214–16.
- 11. See Richard Holmes, Wellington, the Iron Duke (New York: HarperCollins, 2002), p. 187.
- 12. See Nigel Glendinning, "Goya and England in the Nineteenth Century," *Burlington Magazine* 106 (Jan. 1964), p. 5.
- 13. Letter to Muñarriz, op. cit.
- 14. See Glendinning, "Goya and Arriaza's *Profecía de los Pireneos*," cited in Manuela Mena Marques, "*The Colossus*," catalog #69 in *Goya and the Spirit of Enlightenment*, pp. 157–8. From Arriaza to the later nineteenth-century Catalán poet Jacint Verdaguer, the nineteenth century produced a fairly constant stream of invocations to the Pyrenees as guardian of Spanish integrity and independence.
- 15. See Jesusa Vega in Goya and the Spirit of Enlightenment, p. 185.
- 16. Ibid., p. 207, catalog #93, quoting from Gaceta de Madrid, May 8, 1812, p. 523.
- 17. See note by MMH in Goya and the Spirit of Enlightenment, catalog item #118, p. 265.
- 18. Baticle, Goya, p. 360, n. 21.
- 19. One need not, perhaps, take seriously the contention of an American art historian, John Moffitt in "Francisco de Goya y Paul Revere" in Fundación Amigos del Museo del Prado, ed., *Goya: Nuevas visiones* and *Homenaje a Enrique Lafuente Ferrari*, 2 vols. (Madrid: Fundación Amigos del Museo del Prado, 1987) that Goya based his firing squad on a copy of Paul Revere's print of the Boston Massacre that had found its way into Spanish *ilustrado* hands and thus been seen by Goya. It is an attractive thought, especially since, if true, it would have claims to be the most extreme example in history of poor art inspiring a great masterpiece. But there is no evidence for it beyond a superficial resemblance.

9 THE RESTORATION

- 1. On the relations between the princess and her mother-in-law, see Marqués de Villaurrutia, *Las mujeres de Fernando VII* (Madrid, 1916), p. 36.
- 2. Marqués de Villaurrutia, Fernando VII: Rey Constitucional (Madrid, 1931), pp. 21-2.
- 3. On the morals of Fernando VII, see Mesonero Romanos, Memorias.
- 4. Goya and the Spirit of Englightenment, p. 164.
- Joseph was not Joseph "Napoleon," of course, but Joseph Bonaparte. Napoleo sounded more impressive.
- 6. On Fernando, Goya, and the Eggplant, see Baticle, Goya, p. 358.
- 7. Raymond Carr, Spain, 1808-1939 (Oxford, 1966), p. 78.
- 8. On Zapata, see SLS's catalog entry to #106 in *Goya and the Spirit of Enlightenment*, pp. 236–8.

- 9. On Goya's debt to literary polemic against the Inquisition, see Glendinning, "A Solution to the Enigma," pp. 186–91.
- 10. Cited in Glendinning, Goya and His Critics, p. 56.
- 11. See Baticle, *Goya*, pp. 416–17; for a long and more detailed treatment of the painting and its implications, see Albert Boime, "Oscuridad al mediodía: 'La Junta de Filipinas,' " in Fundación Amigos del Museo del Prado, ed., *Goya* (Barcelona: Galaxia Gutenberg/Círculo de Lectores, 2002), pp. 301–24.
- 12. Ford, Gatherings from Spain, pp. 284-5.
- 13. Enrique Lafuente Ferrari, "Celebration and Sacrifice of the Bull," in J. and M. Guillaud, *Goya: The Phantasmal Vision* (New York, 1987), p. 66.
- 14. Goya, MS letters to Zapater, Apr. 23, 1794.

IO EXILE IN FRANCE

- See "Los Disparates," in J. Tomlinson, Graphic Evolutions: The Print Series of Francisco Goya, Columbia Studies in Art, no. 2 (New York, 1989), p. 47.
- 2. See Michael Roche in *Goya and the Spirit of Enlightenment*, catalog item 143, *Disparate de bestia*, pp. 318–19.
- 3. On the mechanism of the pronunciamiento, see Carr, Spain, 1808-1939, op. cit.
- 4. Proposed by Baticle, in Goya, p. 454.
- See Anna Reuter in catalog entry to El Aquelarre, in Fundación Amigos del Museo del Prado, ed., Goya: La imagen de la mujer (Madrid: Fundación Amigos del Museo del Prado, 2001), p. 290.
- See José López Vega, Goya: El programa neo-Platónico de las pinturas de la Quinta del Sordo (Santiago de Compostela, 1981).
- 7. Epistolario de Moratín, 1973, items 308 and 309, pp. 595-6.
- 8. A. Canellas López, ed., Goya, Diplomatario, p. 309.
- 9. Cited in Tomás Harris, Goya: Engravings and Lithographs, vol. 1, p. 222.
- By Aloys Senefelder, a Prague-born dramatist living in Munich. His own writings differ on the exact year.
- 11. Goya to Ferrer, Dec. 20, 1825, in A. Canellas López, ed., Goya, Diplomatario, pp. 389-90.
- 12. Moratín, in A. Canellas López, ed., Goya, Diplomatario, p. 498.
- 13. Rene Andioc, ed., Epistolario, 1873, no. 374, p. 679.
- 14. A. Canellas López, ed., Goya, Diplomatario, no. 280, p. 394.

BIBLIOGRAPHY

Abrantès, Duchesse d'. Mémoires de Madame la Duchesse d'Abrantès. Paris, 1893.

Agueda, Mercedes, and Xavier De Salas. Cartas de Francisco Goya a Martín Zapater. Madrid, 1982.

Aguilera, E. M. Las pinturas negras de Goya. Madrid, 1935.

Alcalá Flecha, R. Literatura e ideología en el arte de Goya. Zaragoza, 1988.

Alcalá Galiano, A. Recuerdos de un anciano. Madrid, 1878.

Alcázar Molina, Cavetano, El Conde de Floridablanca, Madrid, n.d.

Altamira v Crevea, Rafael. A History of Spain. Trans. Muna Lee. New York, 1949.

Anderson, J. J. Recollections of a Peninsular Veteran. London, 1913.

Andioc, Rene, ed. Epistolario de Leandro Fernández de Moratín. Madrid, 1973.

Anes, G. El siglo de las luces. Madrid, 1994.

——. "Jovellanos y la Inquisición." In *Jovellanos, Ministro de Gracia y Justicia*. Barcelona, 1998.

Artola, Miguel. Los afrancesados. Madrid, 1976.

Baticle, Jeannine. "L'activité de Goya entre 1796 et 1806 vue à travers le Diario de Moratín." *Revue d'Art* 13 (1971).

——. Goya. Paris, 1989.

Baudelaire, Charles. "Quelques Caricaturistes français: Goya." Le Présent. Paris, 1857.

Blackburn, Julia. Old Man Goya. New York, 2002.

Blanco Soler, C. La Duquesa de Alba y su tiempo. Madrid, 1949.

Boime, Albert. "Oscuridad al mediodia: 'La Junta de Filipinas.' " In Fundación Amigos del Museo del Prado, ed. *Goya*. Barcelona, 2002.

Bosquet Fajardo, J.-R., ed. La Cartuja de Aula Dei de Zaragoza. Zaragoza, 1986.

Bourgoing, Jean-François. Nouveau Voyage en Espagne. 3 vols. Paris, 1789.

Bozal, V. Imagen de Goya. Madrid, 1983.

-----. Goya y el gusto moderno. Madrid, 1994.

Brenan, Gerald. The Spanish Labyrinth. Cambridge, 1943.

Cadalso, José. Ocios de mi juventud. Madrid, 1773.

-----. Cartas marruecas. Madrid, 1793.

Camón Aznar, José. Los Disparates de Goya y sus dibujos preparatorios. Barcelona, 1952.

——. "Goya en los años de la Guerra de la Independencia." El Congreso de la Guerra de la Independencia y su Época. Zaragoza, 1959.

Campomanes, Conde de. Discurso sobre el fomento de la industria popular. Madrid, 1774.

Carderera, Valentín. "Biografía de D. Francisco Goya, pintor." El Artista. Madrid, 1835.

410 · Bibliography

- ——. "François Goya: Sa vie, ses dessins et ses eaux-fortes." *Gazette des Beaux-Arts* 7. Paris, 1860.
- Casanova, Giacomo. Memoirs. Ed. Robert Abirached. Paris, 1960.
- Ceán Bermúdez, Juan Agustín. *Diccionario histórico de los mas ilustres profesores de las Bellas Artes en España*. Madrid, 1800.
- . Memorias para la vida del Excmo. Señor D. Gaspar Melchor de Jovellanos. . . . Madrid, 1814.
- Cela, Camilo José. Enciclopedia del erotismo. Obra Completa. Barcelona, 1982–86.
- Chastenet, Jacques. *Godoy, Master of Spain, 1792–1808.* Trans. J. F. Huntington. London, 1953.
- Cossio, José María de. Los toros. Madrid, 1961.
- Custine, Astolphe, Marquis de. L'Espagne sous Ferdinand VII, 2 vols. Paris, 1838.
- Delgado, Sabino, ed. Guerra de la independencia: Proclamas, bandos y combatientes. Madrid, c. 1979.
- Derozier, Albert. Escritores políticos españoles, 1789–1854. Madrid, 1975.
- Desdevises du Dezert, G. L'Espagne de l'Ancien Régime. Les Institutions. Paris, 1889.
- Díaz-Plaja, Fernando. La vida española en el siglo XVIII. Barcelona, 1946.
- Díaz-Plaja, Guillermo. Goya en sus cartas y otros escritos. Zaragoza, 1980.
- Domínguez Díaz, R., and A. Gallego. "El teatro y los tipos populares en el Madrid del siglo XVIII." In *El arte en las cortes europeas del siglo XVIII*. Madrid, 1989.
- Edwards, John. The Spanish Inquisition. London, 1999.
- Ezquerra del Bayo, Joaquín. La Duquesa de Alba y Goya. Madrid, 1959.
- Fauque, Jacques. Goya y Burdeos, 1824–28. Zaragoza, 1982.
- Fitz-Gerald, X. Desparmet. L'oeuvre peint de Goya, 4 vols. Paris, 1928-50.
- Ford, Richard. Gatherings from Spain. Ed. Ian Robertson. London, 2000.
- Fundación Amigos de Museo del Prado, ed. Goya. Barcelona, 2002.
- -----. Goya: La imagen de la mujer. Madrid, 2001.
- Garrido, M. del C. "Algunas consideraciones sobre la técnica de las pinturas negras de Goya." *Bol. Mus. Prado* 13 (1984).
- Gassier, Pierre. Dibujos de Goya. Los albumes. Barcelona, 1973.
- -----. Goya. Todas sus pinturas, 2 vols. Barcelona, 1981.
- ———. Catalog to Goya, toros y toreros. Arles, 1990.
- Gassier, Pierre, and Juliet Wilson. Goya: His Life and Work. London, 1971.
- Gautier, Théophile. Voyage en Espagne. Paris, 1845.
- Glendinning, Nigel. "A New View of Goya's Tauromaquia." *Journal of the Warburg and Courtauld Institutes* 24 (1961): 120–27.
- -----. Goya and His Critics. New Haven, 1977.
- ——. "A Solution to the Enigma of Goya's Emphatic Caprices: Nos. 65–80v of the 'Disasters of War.' " *Apollo* 107 (March 1978).
- ——. "Goya's Patrons." *Apollo* (Oct. 1981).
- ———. Goya: La década de los Caprichos. Retratos 1792–1804. Madrid, 1992.
- Godoy, Manuel. Memorias de Don Manuel Godoy. . . . Paris, 1839.
- Goya, Francisco de. MS letters to Martín Zapater, 1774–99. Collection of Prado, Madrid, published as Cartas a Martín Zapater. Ed. Xavier de Salas and Mercedes Agueda. Madrid, 1982.
- Goya, Truth and Fantasy: The Small Paintings. Exhibition catalog. Eds. J. Wilson-Bareau and M. B. Mena Marques. Madrid, London, Chicago, 1993–94.
- Goya and the Spirit of Enlightenment. Exhibition catalog. Madrid, New York, Boston, 1988–89.

Bibliography · 411

412 · Bibliography

Moratín, Leandro Fernández de. MS Diary. Madrid, Biblioteca Nacional, Ms. #5617,

—. Memorias de un setentón, natural y vecino de Madrid, 2 vols. Madrid, 1861.

1782-1808. Moratín, Nicolas Fernández de. Carta histórica sobre el origen y progreso de la corrida de toros en España. Madrid, 1777. Muller, P. E. Goya's "Black" Paintings: Truth and Reason in Light and Liberty. New York, 1984. Núñez de Arenas, Manuel. "La suerte de Goya en Francia." Bulletin Hispanique (Bordeaux) 52, #3 (1950). Oman, Sir Charles. Wellington's Army 1809–1814. London, 1986. Ortega y Gasset, José. Velásquez, Goya and the Dehumanization of Art. Trans. Alexis Brown. London, 1972. Parkinson, Roger. The Peninsular War. London, 1973. Pérez Sánchez, Alfonso, and Juan Gallego. Goya grabador: Madrid, 1994. Ponz, Antonio. Viaje de España, en que se da cuenta de las cosas apreciables y dignas. . . . Vol. 5. Madrid, 1776. Quintana, Manuel José. Al Combate de Trafalgar. Madrid, 1806. Quinto y de los Ríos, Pasqual. Los sitios de Zaragoza, 1808–1809. Zaragoza, 1986. Rabaza, Herminio Lafoz. José de Palafox y su tiempo. Madrid, 1992. Reuter, Anna. In Fundación Amigos del Museo del Prado, ed. Goya: La imagen de la mujer. Madrid, 2001. Reynaud, Jean-Louis. Contre-guérilla en Espagne (1808–1814). Paris, 1992. -----. Los Proverbios o Disparates. Barcelona, 1968. —. *Goya.* London, 1979. —. "Light on the Origin of Los Caprichos." The Burlington Magazine 121 (1979): 920. Sambricio, Valentín de. Tapices de Goya, 2 vols. Madrid, 1946. Sánchez Cantón, Francisco J. Los Caprichos de Goya y sus dibujos preparatorios. Barcelona, ----. Vida y obras de Goya. Madrid, 1951. —. Goya and the Black Paintings. London, 1964. ——. "Los niños en las obras de Goya." Goya, cinco estudios. Zaragoza, 2nd ed., 1978. Sarasua, C. "El mundo de hombres y mujeres." In exhibition catalog to Vida cotidiana en tiempos de Goya. Madrid, 1996. Sayre, Eleanor. "Goya's Bordeaux Miniatures." Boston Museum Bulletin 64 (1963). —. Late Caprichos of Goya. New York, 1971. —. The Changing Image: Prints by Francisco Goya. Boston, 1974. Schickel, Richard. The World of Goya, 1746-1828. Ed. Time-Life Books. New York, 1974. Sencourt, Robert. Spain's Uncertain Crown. London, 1932. Serraller, Francisco Calvo. "Mujeres en el diván: Majas y marquesas." In Fundación Amigos del Museo del Prado, ed. Goya. Barcelona, 2002. Stolz, Ramón. "La técnica de Goya fresquita." In E. Lafuente Ferrari, Goya, los frescos de San Antonio . . . , pp. 141-5. Barcelona, 1976. Symmons, Sarah. "John Flaxman and Francisco de Goya: Infernos Transcribed." The Burlington Magazine 113 (1971). —. *Goya*. London, 1977. —. "La mujer vestida de blanco: El primer retrato de la duquesa de Alba." In Fundación Amigos del Museo del Prado, ed. Goya. Barcelona, 2002. Thomas, Hugh. Goya: The Third of May 1808. New York, 1973.

Bibliography · 413

Tomlinson, Janis A. Francisco Goya: The Tapestry Cartoons and Early Career at the Court of
<i>Madrid</i> . Cambridge, 1989.
———. Goya in the Twilight of the Enlightenment. London, 1992.
———. Francisco Goya y Lucientes: 1746–1828. London, 1994.
Barcelona, 2002.
Townsend, Joseph. Journey Through Spain in the Years 1786 and 1787. London, 1791.
Trapier, Elizabeth. "Only Goya" (on cleaning the Hispanic Society's Alba portrait). The
Burlington Magazine 102 (1960).
———. Goya and His Sitters. New York, 1964.
Valdés, Manuel Antonio. Elogios de Carlos III, Rey d'España Mexico, 1791.
Vargas Ponce, José de. Probably author of "Pan y Toros." Madrid, c. 1796.
Vicens Vives, Jaime. Historia económica de España. Barcelona, 1955.
Vinaza, Conde de la. Goya: Su tiempo, su vida, sus obras. Madrid, 1887.
Wellington, Arthur Wellesley, Duke of. Wellington's War Dispatches: or "Atty, the Long-Nosed
Bugger That Licks the French." London, 1994.
Williams, Gwyn A. Goya and the Impossible Revolution. London, 1976.
Wilson-Bareau, Juliet. Goya's Prints: The Tomás Harris Collection in the British Museum. London,
1981.
Goya, la década de los Caprichos: Dibujos y aguafuertes. Madrid, 1992.
——. "La Lechera de Burdeos." In Fundación Amigos del Museo del Prado, ed. Goya.
Barcelona, 2002.
Wolf, Reva. Goya and the Satirical Print in England and on the Continent, 1730-1850. Boston,
1001

Young, Eric. Francisco Goya. London, 1978.

Yriarte, Charles. Goya. Paris, 1867.

Zapater y Gómez, Francisco. Goya: Noticias biográficas. Zaragoza, 1868.

Zorrilla de Weiss, Leocadia. MS letters (to Leandro de Moratín), Apr. 28 and May 13, 1828. Madrid, Biblioteca Nacional, MS 12963–40.

INDEX

Page numbers in italics refer to illustrations.

Abenasaya, David, 57 Abrantès, duchess d', 12, 230 Addison, Joseph, 66 Adoration of the Holy Name, 39-40, 39 Adoration of the Magi, 42, 42 afrancesados, 68, 76, 117, 170, 186, 259, 267, 295, 304, 324-6, 328, 354, 358, 377, 389, 393 agarrotado, El, 97-8, 97, 177 Agriculture, 233 Agustín, Maria, 283-4 Agustina of Aragón, 288–9 Alba, duke of, 157-8, 158, 159, 162, 255 Alba, María del Pilar Teresa Cayetana de Silva Álvarez de Toledo, duchess d', 21, 81, 118, 157–64, 158, 172, 188, 189, 192, 241, 373 portraits of, 158, 161-4, 161, 163 Album C, see Inquisition Album Album G, see Bordeaux Album I Album H, see Bordeaux Album II Alfonso of Aragón, king of Naples, 105 Allegory of Industry, 233-5, 233 Allegory of Madrid, 270, 304-7, 305, 328 Allegory of the Constitution of 1812, 270-72, Altamira, conde de, 114-15, 114 Angoulême, duke of, 378 "Annunciation" (Buffet), 42 Anthony of Padua, Saint, 156, 208, 211-13 anti-Semitism, 57, 186, 332-3 Antonio Pascual, 229, 253-4

Apiñani, Juanito, 363, 364 Apollo and the Four Continents (Tiepolo), 72 aquatint, 96, 178-9, 199, 298, 391 Aquelarre, 367, 382, 385-6, 386-7 Arabs, Spanish, 57-8, 107, 310, 340, 357 Aragón, 27, 30-32, 45, 70, 109, 110, 111, 175, 280, 282-3, 284, 342, 358, 365 Aranda, Pedro Pablo, conde de, 50, 65, 68, 238-9 Aranjuez, 40, 53, 55, 149, 227, 250, 251, 257, Arenas de San Pedro, 112, 120, 145 Arnal, Pedro de, 157 Arnao, González, 389 Arriaza, Juan Bautista, 287 Arrieta, Eugenio García, 201, 373-4, 375 arte de torear, El (Delgado), 133-4 Arthur Wellesley, 1st Duke of Wellington, 278-9, 279 Asalto de bandidos I. 219 Asensio Juliá, 210, 210 Asturias, prince of, see Carlos IV, king of Spain: Fernando VII, king of Spain Attack on a Coach, 136, 136 Aula Dei, 40-44, 103, 106, 208 Aún aprendo, 22, 22 Avala, Adelardo López de, 182 Bacon, Francis, 380

Bacon, Francis, 380
Ballester, Joaquín, 179
Bandido apuñalando a una mujer/Asalto de bandidos III, 221–2, 221

Bandido desnudando a una mujer/Asalto de 39 Locos, 397, 398 bandidos II, 219-21, 220 40 Loco furioso, 398-9, 398 Baroque, 8, 212, 334 50 Gimiendo y llorando, 397-8, 398 Basílica del Pilar, see Santa María del Pilar 51 Cómico descubrimiento, 400 Batoni, Pompeo, 128, 162 53 "They fly and fly. Fiesta in the air. Bayeu, Josefa "Pepa," see Goya, Josefa The Butterfly Bull," 400 "Pepa" Bayeu 54 Aún aprendo, 22, 22 Bayeu, Ramón, 34, 38, 44, 81–2 Bordeaux Album II, plates, 54 Telégrafo, 399 Bayeu y Subías, Francisco, 33-4, 37, 38, Bordeaux School of Design and Painting, 44-5, 45, 85, 103, 128 390 as director of the Royal Tapestry Factory, borrachos, Los (Goya), 96, 96 44-5, 74, 81-2, 83, 130, 150 borrachos, Los (Vélasquez), 96 Beardsley, Aubrey, 3 Bort, Julián, 108, 110 Beata, La, 160-61, 161 Bosch, Hieronymus, 8, 25 Beata with Luis de Berganza and María de la Boullée, Étienne-Louis, 206, 327, 327 Luz, La, 161 Bourbon monarchy, 5, 19, 20, 24, 25, 29, 34, Beccaria, Cesare, 168 35, 45, 47, 48, 69, 77, 84, 109, 111, 113, Bellini, 35 144, 164, 169, 193, 194, 196–7, 209, Benavente, countess of, see Osuna, María 237-8, 239, 247, 248, 251, 252, 253, Josefa de la Soledad Alonso-Pimentel 255, 267, 268, 272, 282, 320, 325, 355, y Téllez-Giron, duchess of 371, 378, 379 Bentham, Jeremy, 139 Bravo de Rivero, Tadeo, 304-5 Berganza, Luís de, 160, 161 Brazil, 248 Bernardino, Saint, 105, 114 Brébeuf, Jean de, 223 Bessières, Marshall, 265 Brugada, Antonio, 388, 391, 401 Betrothal of the Virgin, 43, 44 Bry, Theodor de, 223 Birth of the Virgin, 43 Buffet, Amadée, 41-4 Black Border Album, 176 Buffet, Bernard, 41 "Black Duchess," 161-2, 163 Buffet, Paul, 41-4 Black Paintings (Pinturas negras), 11, 15-17, Buffon, Comte de, 60 25, 31, 208, 234, 312, 355, 372, 374-6, Bulloes, Don Martín, 211-12 379-87; see also specific paintings Bull's Capture, The, 132 Blake, William, 23, 126, 128, 139, 142, 160, Bulls of Bordeaux, 390-93, 401 176 Buñuel, Luis, 19, 378 Blind Chicken, The, 89-90, 90 Byron, George Gordon, Lord, 26, 235, 288 Blind Guitarist, The, 92-3, 93, 97 Boccherini, Luigi, 117 Cabarrus, Francisco, conde de, 12, 120, 169 Bolívar, Simón, 321 cabinet pictures, 130-43, 255-9 Bonaparte, Joseph, see José I, king of Spain Cadalso, José, 77-8 Borbón, Infante Don Luis de, 111-13, 112, Calasanz, San José de, 32, 342-3, 342, 374 117, 120, 145-6, 243, 252 Calleja, Andrés de la, 105 Bordeaux Album I, plates: Callot, Jacques, 265 12 Mal sueño, 399-400, 399 Campo, Francisco del, 113 22 Fuego, 396, 397 Campomanes, Pedro Rodríguez, conde de, 29 Mendigos que se lleban solos en Bordeaux. 51-2, 62, 63-4, 66, 67, 90, 108, 167, 397, 397 169, 233, 238 31 "I saw this in Paris," 397 Cannibals Beholding Human Remains, 222, 32 Locos patines, 397, 397 223

Cannibals Preparing Their Victims, 223-4 54 Mucho hay que chupar, 206 caprichos, 130, 179-80, 300, 397, 399 46 Corrección, 204-5 Caprichos, 23, 24, 38, 66, 84, 89, 97, 100, 47 Obseguió al maestro, 204 105, 166, 167, 171, 176, 177, 179-208, 52 ¡Lo que puede un sastre!, 194, 194 53 ¡Qué pico de oro!, 194 212, 227, 290, 295, 365, 367, 370, 374, 56 Subir y bajar, 182-3, 183 Ayala text of, 182, 183, 187, 206 58 Trágala perro, 194-5, 195 60 Ensayos, 204, 205 cannibalism in, 195-6, 224 65 ¿Dónde va mama?, 205-6, 205, 223 Church in, 193-8 68 ¡Linda maestra!, 204, 205 copperplates given to Carlos IV, 20, 332, 69 Sopla, 205, 206 373, 393 Gova's expectations for, 181, 216 79 Nadie no ha visto, 195, 195 political commentary in, 183-4 Volaverunt, 32 "Who will release us?," 367-8 Prado text of, 182, 187, 188, 190, 196 publication of, 20, 207-8, 364 Caprichos enfáticos, 273, 300-4 Ruskin's burning of, 25, 202 Caravaggio, Michelangelo de, 255 sexuality and sexual mores in, 159, caricature, 23, 128-9, 173, 175, 181-2, 184-93 348 witchcraft in, 11, 32, 153, 184, 201-6 Carlos, count of Spain, 323, 378 Carlos I, king of Spain, see Charles V, Caprichos, plates: emperor 2 El sí pronuncian y la mano alargan al Carlos II, king of Spain, 337 primero que llega, 184-6, 185 3 Que viene el coco, 217 Carlos III, king of Spain, 43, 77, 92, 103, 5 Tal para qual, 187-8, 187 106, 111, 124, 324, 333, 371 appearance and character of, 51-3 7 Ni así la distingue, 187, 188 8 ¡Que se la llevaron!, 4, 206-7, 207, 298 as arts patron, 10, 22, 24, 27, 29, 43, 68–75, 96, 131, 150, 180 9 Tántalo, 4, 173, 192, 193, 207 bullfighting disliked by, 249, 355 13 Están calientes, 195-6, 196 death of, 15, 144, 145 14 ¡Qué sacrificio!, 185, 186 16 Dios la persone: y era su madre, 189-90, Enlightenment and, 27, 51–2, 55–6, 60-61, 68, 106, 232, 238 17 Bien tirada está, 172, 173, 188, 189 hunting loved by, 53-4, 146 19 Todos caerán, 191-2, 192 Italophilia of, 34, 35, 40 and modernization of Spain, 49, 109 20 Ya van desplumados, 190, 191 21 ¡Qual la descañonan!, 191 portraits of, 108-9, 112, 146 as ruler of Naples, 48-9, 70-71 23 Aquellos polbos, 197, 197 24 No hubo remedio, 197-8, 197 as social reformer, 61–4, 90, 168–9 28 Chitón, 188, 189 Spanish throne assumed by, 71 as urban reformer, 50, 68-70 30, 272-3 32 Por que fue sensible, 4, 198-9, 198, 217 Carlos III in Hunting Costume, 54, 146 Carlos III Lunching Before His Court (Paret), 37 ¿Si sabrá más el discípulo?, 199, 200 38 ¡Bravísimo!, 199 52-3, 53 Carlos IV, king of Spain, 52, 65, 69, 118, 183, 39 Asta su abuelo, 199 40 ¿De qué mal morirá?, 199-201, 200 209, 217, 243 41 Ni más ni menos, 199 accession to throne of, 144, 235 as arts patron, 20, 24, 27, 86, 98, 100, 144, 42 Tú que no puedes, 200, 201 43 sueño de la razón produce monstruos, El, 148-50, 229 bullfighting disliked by, 249, 355 3, 4, 73, 74, 170–71, 180–81, 271, 379

Carlos IV, king of Spain (continued) Conde de Altamira, 114-15, 114 Caprichos copperplates bought by, 20, Conde de Floridablanca and Goya, 94, 107, 332, 373, 393 108-11, 118, 227 exile of, 235, 252 Condesa de Chinchón, 244, 245 Congress of Vienna, 378 family portrait of, 120, 145, 226-9, 228, Constable, John, 317 240, 257 hunting loved by, 145-6, 148 Constitution: political disasters of, 144-5, 229, 230, Bayonne, 259-60 231, 238-9, 247-52, 261 of 1812, 268-70, 273, 306, 320, 322, 324, portraits of, 83, 112, 146-8, 226-9, 325, 371, 377-9 239-40, 276 conversation pieces, 112, 120 as theater lover, 74-5, 92 conversos, 57, 337 Carlos IV in Hunting Clothes, 146-7 147 Copyright Act of 1735, 182 Carnicero, Antonio, 12 Cornel, Antonio, 230 Carr, Raymond, 231, 333 cortejos, 77, 232 Carreño de Miranda, Juan, 167 Cortes (parliament), 268, 306, 322, 325 Carthusians, 40–41, 255 Cotán, Juan Sánchez, 255-6, 256 cartoons, see tapestries Countess of Altamira and Her Daughter, The, Casanova, Giacomo, 110 115 Crockery Vendor, The, 94-5, 95 Castillo, Francisco de, 217 Castillo, José del, 105 Crucified Christ, The, 99-100, 99 Ceán Bermúdez, Juan Agustín, 12, 167, Cruz, Ramón de la, 47, 75–7, 75, 79, 81, 84, 340-41 117, 118 Ceballos, Mariano, 361, 362 Cuba, 269, 321 censor, El, 66-7 Cubells, Martín, 17, 385-6 censorship, 55-6, 65-6, 117, 118, 168, 238, Cubism, 18 273, 323, 326, 333 currutacos, 78, 79-80 Cervantes Saavedra, Miguel de, 59, 67 Chapel of the Counts of Sobradiel, 40 Dalí, Salvador, 18-19, 307, 383 Chardin, Jean-Baptiste-Siméon, 256-7 Dance of Majos by the Manzanares, A, 367 Charles V, emperor (Carlos V; Carlos I, king David, Giovanni, 179 of Spain), 13-14, 46, 147, 354-5 David, Jacques-Louis, 206, 288, 309 Chateaubriand, François René, vicomte de, Davidsz de Heem, Jan, 255 Dead Birds, 257-8, 257 378, 388 Cher, 159 Dead Turkey, The, 258-9, 258 Chinchón, condesa de, 113-14, 113, 242, Death of the Picador, 133, 134-5, 142-3 243-5, 244, 389 Degas, Edgar, 365 Chirico, Giorgio de, 347 Dei delitti e delle pene (Beccaria), 168 Cid, El (Rodrigo Díaz de Vivar), 310, 355 Déjeuner sur l'herbe (Manet), 88 Cimabue, Giovanni, 34 Delacroix, Eugène, 10, 17, 27, 214, 389, 393 Circumcision of Christ, 43-4, 44 Delgado, José, see Illo, Pepe Clearing the Ring, 132 Delizie mondane (Ripa), 98 Clothed Maja, The, 159, 240-42, 241, 332 del Toro, Fernando, 361 Desastres de la guerra, 31, 84, 89, 97, 224, 258, Cobbin, Ingram, 56–7 Colombia, 321 265, 272-6, 285, 287-304, 316-19, 333, Colossus, The, 286-7, 286 350, 351, 359, 363, 365 Columbus, Christopher, 29, 57 Caprichos enfáticos in, 273, 300-4 commedia dell'arte, 84, 92, 131, 142 guerrilla wars in, 273, 283-97 Commerce, 233 impact of, 5-6, 7, 38, 74, 153

Madrid in, 273, 297-300 publication history of, 24, 208, 304, 366 Desastres de la guerra, plates: 1 Tristes presentimientos, 273-5, 274, 398 2 Con razón o sin ella, 317 3 Lo mismo, 275, 276 5 Y son fieras, 283, 288-9, 289 7; Que valor!, 287, 288-9 9 No quieren, 290-92 10 Tampoco, 291, 292 11 Ni por esas, 291, 292 12 Para eso habéis nacido, 296, 297 15 Yo no hai remedio, 317–18 18 Enterrar y callar, 296–7, 296 26 No se puede mirar, 220, 318-19, 318 27 Charity, 312 28 Populacho, 292-3, 293 30 Estragos de la guerra, 276 31 "¡Fuerte cosa es!," 290 32 ¿Por que?, 290, 290 36 Tampoco, 294 37 Esto es peor, 294-5, 294 39 ¡Grade hanzaña! ¡Con muertos!, 294, 295 44 Yo lo vi, 5, 259, 272, 274 45 Yo esto también, 273, 274 48 "Cruel lástimas," 297-8 50 ¡Madre infeliz!, 298-9, 298 56 Al cementerio, 299 64 Carretadas al cementerio, 298, 299 67 Ésta no lo es menos, 300–1, 300 69 Nada. Ello dirá., 302-3, 302 70 No saben el camino, 301 71 Contra el bien general, 301 72 Las resultas, 301–2, 301 76 El buitre carnívore, 302 77 Que se rompe la cuerda, 124-5, 301, 302 79 Murío la verdad, 303 80 ¿Si resuscitará?, 303, 303 "For having a clasp knife," 98, 285 Descartes, René, 55 Dibersión de España, 391, 392 Diderot, Denis, 11, 60 Disparates, 24, 97, 100, 359, 365, 366-71, 391 Disparates, plates: 1 Disparate femenino, 100, 366, 368 4 Bobalicón, 369-70, 370

7 Disparate matrimonial/Disparate

desordenando, 367-8, 369

12 Disparate alegre, 367-8, 369

13 Modo de volar, 368, 370 21 Disparate de bestia, 370-72, 371 Disparate ridículo, 367 Dolorez López, María de, 333 Don Manuel Osorio Manrique de Zúñiga, 114, Don Pedro Rodríguez, Conde de Campomanes (Mengs), 62 Don Sebastian Martínez y Pérez, 129, 129 drawings, 171-6 see also Madrid Album; Sanlúcar Album Dryden, John, 139 Duaso y Latre, José, 388 Duchess of Alba, The, 161-2, 163 Duchess of Alba and La Beata, The, 161, 161 Duel with Clubs, 382-3, 382 Dürer, Albrecht, 34-5, 95, 170 Economic Societies of Friends of the Nation, 109, 117, 169, 233 Eleta, Joaquín, 103 England, 48, 51, 60, 64, 67, 98, 139, 157–8, 168, 169, 218, 267, 321, 358, 359, 378-9, 388 caricature in, 23, 128-9, 173, 181-2 military portraits in, 246 in Napoleonic wars, 280 painting in, 317 prints from, 23, 28, 147, 162, 374 engravings, 95-8, 103 Enguidanos, López, 309 Enlightenment (ilustración), 11, 67, 122 Carlos III and, 27, 51-2, 55-6, 60-61, 68, 106, 232, 238 French, 224, 272 Protestant Reformation and, 56 scientific inquiry in, 59-61, 126 Spanish, 11-12, 67, 108, 118, 169, 184, 201, 247, 329; see also ilustrados tondos representing, 233-5 Equestrian Portrait of General Palafox, 276-7, Equestrian Portrait of the Duke of Wellington, 279-80, 279 Erlanger, Baron Frédéric d', 16-17 Escamilla, Nicolosa ("La Pajuelera"), 361

Escóiquiz, Juan de, 237

espejo indiscreto, El: el hombre mono, 79

Espoz y Mina, Francisco, 263-4

Espronceda, José de, 307 restoration of, 24, 125, 197, 229, 251-2, Esquilache, Leopoldo Gregorio, marqués 268, 273, 299-300, 307-8, 320-27, 329, de, 48-51, 106 331, 335–6, 371, 378–9 Esteve, Agustín, 12 Fernán Núñez, conde de, 12 Esteve y Vilella, Rafael, 179 Ferrer, Joaquín María, 332, 389, 390, 393 etchings, 3-4, 24, 97-8, 100, 166, 177-8, Ferro, Gregorio, 105 207, 208, 275, 300, 364-5, 390, 391, Fight at the New Inn, 85-7, 85 Fire at Night, 135, 142, 397 395, 399 see also Caprichos; desastres de la guerra, Flaxman, John, 23, 162, 176 Los; Disparates; Tauromaguia Fleuriot de Langle, Jean-Marie, 158-9 Execution of the Emperor Maximilian of Mexico Flight into Egypt (engraving), 70 (Manet), 313 Flight into Egypt (mural), 42 Experiment on a Bird in the Air-Pump, An Floridablanca, José Moñino, conde de, 63, (Wright), 374 65, 70, 105, 106–11, 231, 238 Goya's portrait of, 94, 107, 108-11, 118, Fabre, Francisco José, 72–3 Fair of Madrid, The, 93-4, 94 Fontaine, Pierre-François-Léonard, 149, 150 Family of Carlos IV, The, 120, 145, 226-9, Fontana, Carlos, 209 228, 240, 257, 348 Fontana, Domenico, 209 Family of the Duke of Osuna, The, 120-22, Fontano, Filippo (Felipe), 290 121 Ford, Richard, 86-7, 352, 359 Family of the Infante Don Luis de Bourbón, Forge, The, 275, 284-5, 285 The, 112, 112, 120, 145 Fragonard, Jean Honoré, 122, 124-5 Farinelli (Carlo Broschi), 53 France, 24, 48, 51, 63, 67, 247, 248, 252, 260, Feijoo, Benito Jerónimo, 66, 202-4 321, 325, 344, 388, 393 Felipe (brother of Carlos IV), 145 Constitution of, 259 Felipe II, king of Spain, 8, 13-14, 30, 354 Enlightenment in, 51 Felipe III, king of Spain, 58 Goya in, 16, 24, 157, 306, 352, 366, Felipe IV, king of Spain, 146, 227 389-402 Felipe V, king of Spain, 51, 53, 55, 69, 84, growing cultural importance of, 34 324, 337 see also Peninsular War Ferdinand Guillemardet, French Ambassador to Francisco de Paula, 228, 235, 253 Spain, 165-7, 165 Francis of Borgia, Saint, 125-6, 125 Fernando and Isabel, 30, 57, 107, 323, 333, Franco, Francisco, 306-7, 320 Franklin, Benjamin, 170, 238 Fernando VI, king of Spain, 40 Freemasons, 238, 376, 388 Fernando VII, king of Spain, 25, 231, 237, French Revolution, 65, 106, 144-5, 162-4, 247-50, 302, 359, 382, 383-4, 390, 393, 165, 168, 224, 238-9, 266, 327 frescoes, 39, 41, 103, 156, 208–15 Godoy opposed by, 243, 248, 250-51, Friar Pedro Shoots El Maragato, 225-6, 226 253, 320, 348 Friar's Visit, The/The Castillo Affair I, 217 Goya's dislike of, 5, 20, 24, 27, 304, Fuentes, Pignatelli, count of, 33 328-38, 379 Fuseli, Henry, 26, 380 marriages of, 323 portraits of, 12, 226, 228-9, 276, 282, 300, Gabinete del Platino (Percier and 306, 323, 344-5, 345 Fontaine), 149, 150 reactionary opinions of, 51, 302, 376-8, Gainsborough, Thomas, 128, 147, 162 388 Galilei, Galileo, 338–9
Bordeaux residence of, 16, 24, 157, 306, Garden of Earthly Delights, The (Bosch), 8 352, 366, 389-402 Gardner, Ava, 159 Gaspar de Jovellanos, 166, 167, 170 burial and reburial of, 401-2 character and personality of, 26-7 Gaulon, 390, 401 Gautier, Théophile, 227 common sense of, 26-7 competitions entered by, 33-4, 37, 98-9 General Rafael del Riego y Núñez (Lecomte), as court painter, 19-20, 26, 47, 144, 145, 149, 171, 226-9, 299-300, 308, 328, genre painting, 23, 94, 348 345-6, 400 Germany, 51, 67, 266 deafness of, 16, 18, 24, 27, 38, 127-8, 134, Giaquinto, Corrado, 29, 35, 69, 71 137-40, 141-3, 159, 165, 280, 372, 379, Gillray, James, 23, 181 Giordano, Luca, 110 389 depression of, 141-3 Giotto, 34 education of, 20, 26, 32-3, 344 Glendinning, Nigel, 141, 287 heroism and independence of, 5, 19 Godoy, Carlota Luisa, 243 illness of, 127–8, 147, 209–10, 400 Godov, Manuel de, 76, 114, 146, 157, as ilustrado, 126, 269 169-70, 183, 187, 230-33, 237-8, 246, Italian travels of, 16, 24, 34-7, 39, 46, 50, 247-54, 279, 323, 348, 389 as arts patron, 233-5, 239-47, 329-31, longevity of, 14, 21-2 332 marriage of, see Goya, Josefa "Pepa" as lover of queen María Luisa, 148, 182, 230-31, 232, 235-6, 237 Bayeu move to Madrid by, 46-7 Goicoechea, Gumersinda, see Goya, myths surrounding, 17, 19–20, 25–6, 37, Gumersinda Goicoechea 157, 159, 280 Goicoechea, Martín Miguel de, 401 popular culture loved by, 75, 92 Golub, Leon, 7 portraits of, 23, 400 Gómez, Dionisio, 306 religious beliefs of, 126, 156-7, 302 Góngora y Argote, Luis de, 59, 86 skepticism of, 84-5, 151, 374 González Velázquez, Antonio, 29, 39, 105 Goya y Lucientes, Francisco, works: Goya, Camilo, 27 banditry in, 122-3, 134, 136, 217-22, 295 Goya, Francisco Javier, 20, 38, 153, 255, 373, bawdiness in, 173-5, 196 393, 401 bullfighting in, 37, 80-81, 131-5, 142-3, Goya, Gracia Lucientes, 29-30 148, 164, 249, 335, 351-65, 389, Goya, Gumersinda Goicoechea, 372, 373 390-93 Goya, Jacinta, 27 cabinet pictures in, 130-43, 255-9 Goya, José, 27–30, 32, 33 cannibalism in, 17, 195-6, 216, 222-4 Goya, Josefa "Pepa" Bayeu, 33, 38, 129-30, decorative paintings, 122-5 153, 372-3 drawings, 171-6 Goya, Mariano, 27, 278, 388, 401 dubious attributions of, 25, 35-6, 36, Goya, Rita, 27 37-8, 401 Goya, Tomás, 27 engravings, 95–8, 103, 177–9 Goya (Matheron), 19, 20, 176, 391 Enlightenment tondos, 233–5 Goya (Yriarte), 19, 20, 359 etchings, 24, 97-8, 100, 166, 171; see also Goya y Lucientes, Francisco: Caprichos; Desastres; Disparates; artistic education of, 33–8 Tauromaquia artistic remaking of, 13-18, 84-5 fashion depicted in, 80-81, 88-9, 157-8, background of, 20, 26, 27-32 birth of, 27 164

Goya y Lucientes, Francisco, works Guye, Victor, 328 (continued): Gypsies, 63-4, 124-5, 225 frescoes, 39, 41, 103, 156, 208-15 geometrical forms in, 89, 206-7, 288-9, Hapsburg dynasty, 13-14, 30, 34, 46, 144, 255, 355 horses in, 276–7 Haw Seller, The, 95 Inquisition attacked by, 4-5, 333-40 Haydn, Franz Joseph, 117, 158 ivory painting by, 393-5 Head of Dog, 381, 382 madness as in, 17, 25-6, 131, 136, 138, Held, Jutta, 84 139-41, 397-9 Helman, Edith, 167 modernist elements in, 10-11, 12, 19, 24, Hemingway, Ernest, 351, 365 156, 360 Hercules and Omphale, 100, 102 portraits, 11–12, 47–8, 106–22, 129, 133, hidalgos, hidalguía, 29-30, 61, 77, 107 145-8, 157-8, 161-4, 165-7, 170, 210, Highwaymen Attacking a Coach, 122-4, 123, 226-9, 239-40, 243-7, 255, 276-80, 134, 136, 295 282, 300, 328-9, 344-7, 373-5, 388, Hijar, duke of, 400 389, 396 Hirst, Damien, 21 prisons in, 36-7, 131, 136-9, 168, 180, history paintings, 99-100, 221 Hogarth, William, 23, 86, 128, 182, 184 realism of, 84, 85, 122, 124, 126-7, 172, Holland, Lady, 118, 230, 237, 276 176, 212 Holland, Lord, 151, 167, 168, 230, 253 religious paintings, 38-44, 83-4, 99, Holy Office, see Inquisition 103-5, 125-6, 156, 208-15, 340-43 Holy Trinity Freeing a Captive Slave, The reputation of, 4, 6, 17, 20-21, 24-5, 27, (Giaquinto), 40 111, 116, 216, 303-4 Homer, 77, 92, 193, 313, 386 restoration of, 16-17, 41-4, 374, 385-6 Hugo, Victor, 328 as revolutionary, 19, 20, 47, 85, 156, 227 Hundred Thousand Sons of St. Louis, 378 self-portraits, 38, 81, 164, 192, 343, 344, Illo, Pepe (José Delgado), 133, 134, 142, 373-5, 375 sensational subjects in, 216-26 357-8, 360-61, 361 sketchbooks, 159-60, 172-6, 255; see also ilustrados, 11, 12, 51, 56, 63, 64-8, 76, 84, specific sketchbooks and albums 106, 117, 122, 126, 148, 153, 165, 168, still lifes, 255-9 170, 183, 184, 197, 202, 217, 232, 238, tapestries, see tapestries 242, 249, 267-9, 273, 329, 335, 338, war in, 5-6, 7; see also desastres de la 355, 357, 358 guerra, Los; Second of May, 1808; Third Imaginary Prisons (Piranesi), 36–7, 137, of May, 1808 180 witchcraft paintings, see witches, Immaculate Conception (Zurbarán), 167 witchcraft Imperial Canal, 70, 109-10 Great Pyramid, 327 Ingres, Jean-Auguste-Dominique, 10, 389 Greco, El (Doménikos Theotokópoulos), 18 Injured Mason, The, 90-92, 91 Gregory IX, Pope, 332 Inquisition, 4-5, 26, 55, 56-9, 63, 64, 67, Grünewald, Matthias, 8 169-70, 182, 193, 204, 205, 208, 209, Guernica (Picasso), 313, 383 238, 273 guerrillas, 262-4, 273, 282, 283-97 books banned by, 55-6, 65-6, 117, 118, Guiaquinto, Corrado, 39-40 168, 193-4, 333 Guillemardet, Ferdinand, 12, 165-7, 165 Fernando's restoration of, 321, 324, 378 Guye, Nicolas, 328 Goya investigated by, 331-2

Goya's depictions of, 5, 98, 184, 196-8, 333-40 Napoleon's abolition of, 260, 268, 269 tortures of, 57, 59, 332-3, 338, 340 Inquisition Album, plates: 93 Por casarse con quien queso, 339-40, 339 94 Por descubrir el mobimiento de la tierra, 338-9, 338 98 ¿Por liberal?, 339, 339 109 Zapata, tu gloria será eterna, 337-8, Lux et tenebris, 269, 270 Sol de justicia, 269, 270 P.r mober la lengua de otro modo, 340 P.r q.e sabía hacer ratones, 340 Inquisition Scene, 335-6, 336 intaglio printing, 178 Interior of a Prison, 136-9, 138, 140 intonaco, 210 Inza, Joaquín, 12 Iriarte, Bernardo de, 16, 130, 140, 142 Isabel, empress, 13 Isabel II, queen of Spain, 323, 390 Isabella Farnese, queen of Spain, 55, 111 Isla, José, 211 Italian sketchbook, 35 Italy, 16, 24, 34-7, 46, 48, 51, 67, 193, 266, ivory painting, 393-5

Jay, John, 238 Jesuits, 4, 65, 68, 103, 106, 223, 324, 388 Jews, 56, 57-9, 65, 225, 337 José I, king of Spain, 157, 259-60, 264, 268, 270, 279-80, 297, 300, 304-6, 308, 309, 325, 328, 329, 331, 359 Josephine, empress of France, 251 Jovellanos, Gaspar Melchor de, 12, 56, 106, 117, 151, 166, 167–71, 183, 184–5, 238, 242, 292, 355 Goya's friendship with, 64, 167, 169, 209, as reformer, 62, 108, 167–8, 201, 232, 233 Juan Antonio Llorente, 329, 330 Judith and Holofernes, 379, 380, 384 Juliá, Asensio, 23, 210-11, 210 Julie, queen of Spain, 329 Junot, Andoche, 248

Junta de la Real Compañia de Filipinas, 346 *Junta of the Philippines*, 346–7, 347 Justa, Saint, 9, 340

Kamen, Henry, 59 Klingender, F. D., 87 *Knife Grinder, The*, 284–5, *285* Kuntz, Taddeo, 36

Lacour, Pierre, 390 Lafuenta Ferrari, Enrique, 19 Lalemant, Gabriel, 223 Lancaster, count of, 230 Lanuza, Juan de, 30-31 Lardizábal, Miguel de, 348 Last Communion of St. Joseph Calasanz, The, 342-3, 342 Last Judgement (Michelangelo), 316 Lavoisier, Antoine Laurent, 60 León, battle of, 262 Leonardo da Vinci, 128, 172, 243, 368-9, 394 Lerma, duke of, 58 Lewis, Matthew, 151 Licht, Fred, 243 Lindsay, Norman, 3 line etching, 178–9 lithography, 390-93, 401 Llorente, Juan Antonio, 12, 329, 330, 333 Locke, John, 11 López y Portaña, Vicente, 23, 24, 306, 331, *345*, 346, 400 Louis XIV, king of France, 34, 265 Louis XVI, king of France, 144–5, 165–6, 238, 239 Louis XVIII, king of France, 378 Louisiana, 145 lower classes, 84, 85, 88, 92, 201, 249-50, 285 see also pueblo Lubbock, Tom, 22 Luis María, Don, 113 Luther, Martin, 56 Luz, María de la, 160, 161 Luzán, Juan, 33 Luzán v Martínez, José, 33

McAuliffe, Anthony, 285 Madhouse, The, 140–41, 141

Madrazo, Pedro de, 215	María Josefa de la Soledad, duquesa de Osuna,
Madrid:	o La condesa duquesa de Benavente,
in Goya's day, 46–8	118–20, <i>119</i>
in Los desastres de la guerra, 273, 297–300	María Luisa of Parma, queen of Spain, 24,
Madrid Album, plates, 172–5	74, 86, 92, 98, 100, 144, 170, 187,
23, 174	250–53, 323
82, 233–4 84 San Fernando : como hidant 224, 224	portraits of, 226–9, 236, 237, 239, 276,
84 San Fernando ¡como hilan!, 234, 234	348
86 Buen sacerdote, ¿dónde se ha celebrado?,	reputed lovers of, 109, 148, 182, 229–32,
174–5, 174	235-7, 239, 242-3
89 El abogado, 218–19, 219	vanity of, 81, 164, 236–7, 245
90 <i>Nobia.</i> , 173, 174	María Luisa of Savoy, queen of Spain, 55
91, 175 Madrid Foonamia Society 64, 117, 118	María Teresa de Borbón y Vallabriga, see
Madrid Economic Society, 64, 117, 118	Chinchón, condesa de
Maella, Mariano, 74, 81–2, 105	María Teresa de Borbón y Vallabriga, 113–14,
Máiquez, Isidoro, 12, 117, 118	II3
Maja, 80	María Teresa de Vallabriga, 111–13, 112
Maja and Celestina on the Balcony, 350, 350	Marie-Antoinette, queen of France, 120,
majas, 8, 77, 79–81, 164, 213	224 M - (FIF 1) - (-
aristocratic, 80, 81, 157, 160, 162	Martín, Juan (El Empecinado), 264
in Caprichos, 188, 190	Martincho, 363–4, 364
in Goya's paintings, 8, 141, 159, 240–43,	Martínez, Sebastián, 23, 127, 128–9, 129,
331-2, 350, 394 in Covy's tapactery designs 84, 88, 62, 67	147, 162, 173, 210, 374
in Goya's tapestry designs, 84, 88, 93, 95 <i>majos</i> , 8, 9, 77, 79–81, 100	Mary in the House of Martha, 43
aristocratic, 80	Masefield, John, 309
in Goya's paintings, 124, 312, 316, 367–8,	Massacre in Korea (Picasso), 313
	Mastroleo, Giuseppe, 33
394 in Goya's tapestry designs, 84, 85, 87, 88,	Matheron, Laurent, 19, 20, 176, 391 May, Phil, 175
89, 93, 95, 98, 100	Medinaceli, dukes of, 337
Majo sentado con espada, Un, 80	Melancholia (Dürer), 170
Making Powder in the Sierra de Tardienta, 281,	
282–3	Meléndez, Luis, 167, 257 Melón, Juan Antonio, 389
Making Shot in the Sierra de Tardienta,	Menander, 142
280–82, <i>281</i>	Mendieta, María Vicenta, 198, 217
Mallén, José, 282–3	Mendizabal laws, 41, 168
Mamelukes, 254, 310–12, 314, 316, 357	Mengs, Anton Raphael, 10, 35, 36, 40, 70,
Manet, Éduouard, 17, 24, 88, 214, 242, 258,	71–4, 96, 98, 393–4
313	Goya supported by, 73–4, 100, 106
Manrique de Zúñiga, Don Manuel Osorio,	as neoclassicist, 23, 34, 43, 71–3, 126,
114, 115	176, 295
Mantegna, Andrea, 312	meninas, Las (Velázquez), 112, 227, 347
Manuel Godoy, Duke of Alcudia, Prince of the	Mexico, 321
Peace, 244-7, 246	Michelangelo Buonarroti, 35, 316
Maragato, El (Pedro Pinero), 216, 224–6,	Milkmaid of Bordeaux, 25, 401, 402
226	Miracle of St. Anthony of Padua, The, 209–15,
Maria Amalia, queen of Spain, 71	211, 214
María Cristina, queen of Spain, 323	Miranda del Castanar, count of, 106

No sabe lo que hace, 326, 326 Miseries of War (Callot), 265 nudes, 3, 33, 74, 141, 240-43, 332 Modernism, 10-11, 24, 360 Molière, 76, 117 Olavide, Pablo de, 63 Mona Lisa (Leonardo), 243 "Old Man on a Swing" (drawing), 395, 395 monarchy, absolute, 47, 52, 144, 232, 250, "Old Man on a Swing" (etching), 395, 395 260, 268, 273, 322, 323, 378–9, 382 Old Masters, 10, 24, 120 Montehermoso, marquis of, 329 Olympia (Manet), 242 Montesquieu, 11, 66 Omulryan, Ignacio, 12 Montijo, conde de, 249, 250 Oñate, Juan de, 385 Moors, see Arabs, Spanish Order of Carlos III, 146, 147, 229, 344 Moratín, Leandro Fernández de, 76, 117, Orry, count Jean, 84 118, 212, 354, 355, 389, 390, 396, 400 Osuna, María Josefa de la Soledad Alonso-Moratín, Nicolás Fernández de, 354-5, Pimentel y Téllez-Giron, duchess of, 356 - 7116-27, 119, 152-4, 159 Morillo, Pablo, 320 Osuna, Pedro de Alcántara, duke of, 116-17, Motín d'Aranjuez, 243, 322, 324 118-27 Motín d'Esquilache (Esquilache Mutiny; Osuna family, 65, 116–27, 131, 134, 136, Hat and Cloak Revolt), 48, 50, 68, 151, 157, 159, 208, 295 106 Mozart, Wolfgang Amadeus, 78, 108 Owen, Wilfred, 292 Muguiro, Juan Bautista de, 401 Palafox v Melci, José, 12, 276-7, 277, 282, Murat, Joaquim, grandduke of Berg, 248, 250, 251, 254, 309 Palomino, Antonio, 110 Murillo, Bartolomé Esteban, 128, 173, 349 Pan y toros, 358 Muslims, 46, 56, 57, 356 Parasol, The, 88-9, 88 Mutis, José Celestino, 60-61 parcas, Las, 386-7, 387 Pardo, El, 15, 53, 55, 76, 81, 85, 87, 149 Naked Maja, The (film), 159 Paret v Alcázar, Luis, 22–3, 52–3, 53, 89, Naked Maja, The (Goya), 8, 141, 159, 240-43, HI 240, 33 I-2 Pass with a Cape, 132-4, 133 Naples, princess of, 323-4 Pasture, The, or Sorting the Bulls, 132 Naples, queen of, 323 Peñafiel, Pedro de Alcántara, see Osuna, Napoleon I, emperor of France, 7, 11, 24, Pedro de Alcántara, duke of 25, 31, 41, 48, 145, 146, 170, 224, 230, Peninsular War, 7, 11, 24, 25, 31, 41, 48, 110, 235, 247-54, 259-60, 261-2, 264-8, 145, 170, 224, 247-55, 259-319, 325-6, 270, 272-5, 287, 306-7, 309, 314, 344, 345–6, 350, 360, 363, 376 325-6, 329-31, 344, 363 Pepita (mistress of José I), 329 caricatures of, 181-2 Percier, Charles, 149, 150 Napoleonic Code, 267-8, 325 Peru, 321, 361, 376, 377 Nelson, Horatio, 247 Pestalozzi, Johann, 232 Neoclassicism, 23, 24, 47, 71, 72, 73, 89, 126, petimetres, petimetras, 77-81, 88-9, 95, 100, 149, 157, 162, 173, 176, 206, 288, 295, 113, 184, 213 306, 327, 355 Philippines, 346 Newton, Sir Isaac, 55 Picasso, Pablo, 3, 10, 18, 20, 92, 313, 365, Newton's Cenotaph (Boullée), 327 383 Nightmare (Fuseli), 380 Picnic on the Banks of the Manzanares, 87 nobility, 84, 247-50, 265, 321, 344 Piero della Francesca, 256 land ownership of, 61-3, 106-8, 232

Pignatelli, Ramón de, 109-10, 230 Rake's Progress, The (Hogarth), 184 Pilgrimage of San Isidro, The, 15-18, 15, 374, Raphael, 35, 95 382, 385 Rauschenberg, Robert, 179 Piranesi, Giambattista, 36-7, 137, 180, 206, realism, 84, 85, 122, 124, 126, 172, 176, 212, 207 334 Pius XII, Pope, 4 Rembrandt, 23, 178, 365 Placing the Banderillas, 132 Renaissance, 310, 313 Plato, 367 Renato, king of Sicily, 105 Pollock, Jackson, 21 Rendezvous, The, 98 Pope, Alexander, 175 Renoir, Pierre Auguste, 15, 214 populacho, 18, 293, 382 Reuter, Anna, 234-5 Portrait of Francisco Bayeu, 45 Reynolds, Sir Joshua, 23, 126, 128, 147, 162 Portrait of Ramón de la Cruz, 75 Ribera, Jusepe de, 35, 37, 47, 128 portraits: Riego y Núñez, Rafael de, 327, 376–9, 377 mirror, 108 Ripa, Cesare, 98 Spanish tradition of, 121 Robert, Hubert, 180 see also specific works Rocafort, Tomás, 179 Portugal, 229, 245, 247, 248, 250 Roche, Michael, 370, 372 Poussin, Nicolas, 26, 313 Rococo, 39, 71, 89, 111, 122, 124, 305 Power of the Spanish Monarchy, The (Tiepolo), Rodríguez, Ventura, 29, 47 72-3, 72 Rojas, Fernando de, 188 Prado Museum, 15-16, 17, 24-5, 69, 83, 120, Romana, marquis de la, 216 122, 131, 147, 149, 182, 226, 254, 300, Roman Catholic Church, 4-5, 66, 139-40, 309, 326, 328, 401 155-7, 168, 231, 238, 316 Praed, W. M., 378-9 in Caprichos, 193-8 Presentation of the Virgin at the Temple Holy Office of, see Inquisition (Buffet), 42 as landowner, 61-3, 169, 232, 247 Príncipe Pío, 255, 275, 316 power of, in Spain, 26, 52, 55-9, 64-5, 67, prints, 177, 217 106, 182-3, 242, 260, 266-8, 269, 302, English, 23, 128, 147, 162, 374 320-22, 376, 379 Procession of Flagellants, 333-5 Romanticism, 25-6, 136, 307, 380 proofs, 178, 207 Romero, Francisco, 362 Prussia, 378 Romero, José Manuel, 328 pueblo, 267, 273, 283, 286, 326, 377, 398 Romero, Pedro, 133, 362-3, 362 see also lower classes Romney, George, 128, 162 Puerto Rico, 111, 321 Rosa, Salvator, 123 Puvis de Chavannes, Pierre, 44 Rousseau, Jean-Jacques, 11, 51, 63, 66, 118 Rout of San Romano (Uccello), 310 Queen María Luisa Mounted on Marcial, 236, Rowlandson, Thomas, 23, 181 237 Royal Academy of Fine Arts of San Quevedo y Villegas, Francisco de, 59, 180 Fernando, 33-4, 39, 40, 48, 70, 98-Quinta del Sordo ("Deaf Man's House"), 100, 126, 130, 140, 175, 280, 282, 366 11, 16–17, 25, 224, 234, 355, 367, 372, Royal Order of Spain, 308, 329, 331 373, 374-6, 379, 382-5, 388 Royal Palace, Madrid, 40, 69, 72, 83, 120, Quintana, Manuel José, 292 209, 227, 247, 253 Royal Tapestry Factory of Santa Bárbara, Radcliffe, Ann, 151 40, 44, 48, 74, 81–2, 83, 84, 98, 106,

130, 149, 233

Raimondi, Marcantonio, 95-6

Rubens, Peter Paul, 3, 8, 128, 312, 313, 383 Rufina, Saint, 9, 340 Ruskin, John, 25, 202 Russell, John, 27 Russia, 59, 323, 378, 388 Saavedra, Francisco de, 183 Sabatini, Francisco, 69-70 Sabbath-Asmodeus, 386-7, 386 Sacrifice to Pan, 35-6, 36, 38 Sacrifice to Vesta, 35, 36 Sade, Marquis de, 221, 222, 224 sainetes, 75-7, 81, 84, 87, 88, 117, 118, 142, 216 St. Bernardino of Siena Preaching before King Alonso V of Aragón, 103-5, 104 St. Francis of Borgia at the Deathbed of an Impenitent, 125-6, 125 St. Isidro's Meadow, 14-15, 14, 17 Salamanca, battle of, 264, 278 Salas, Don Juan de, 216 San Antón Abad, 344 San Antonio de la Florida, 8, 103, 156, 208-15, 402 San Carlos, duke of, 389 San Fernando, duke of, 389 San Francisco el Grande, 103-5, 114 San Juan, Santiago, 217 Sanlúcar Album, 160, 188-9 "Young woman pulling up her stocking," 172, 173 San Martín, General, 321 Santa María del Pilar, 28-9, 29, 39, 44, 210 Santander, 344-6 Santas Justa y Rufina, Las, 340-41, 341 Sargent, John Singer, 48 Sarmiento, Padre, 356 satire, 47, 66, 98, 128-9, 150, 180, 181, 182, 184, 227, 348-50 Saturn Devouring His Son, 17, 195, 224, 383-4, 383 Sayre, Eleanor, 159-60, 172, 184 Scene from "The Forcibly Bewitched, A," 152 Scherzi di fantasia (Tiepolo), 73, 74, 171 Schubart, Herman de, 164 Science, 233 "Seated maja and majo," 394, 394

Second of May, 1808/Charge of the Mamelukes, 272, 307–13, 311, 316, 326, 331, 357 Self-portrait, 343, 344 Self-Portrait (Mengs), 70 Self-portrait in the Studio, 81 self-portraits, 38, 81, 164, 192, 343, 344, 373-4, 375 Self-portrait with Dr. Arrieta, 373-4, 375 Sevilla Cathedral, 340-41 Shakespeare, William, 26, 117, 302 Sherman, William Tecumseh, 289 Shipwreck, The, 135-6, 135 Showing of the Infant Jesus to the Shepherds (Buffet), 42 Sixtus IV, Pope, 57 Sketchbook A, see Sanlúcar Album Sketchbook B, see Madrid Album Smith, Adam, 106 Soane, John, 206 Soft Construction with Boiled Beans (Dalí), 383, 384 Soult, Nicolas-Jean de Dieu, 262 South America, 60, 61, 77, 103, 109, 261, 320, 321, 361, 376 Spain, 139, 344 agrarian land reform in, 61-4, 106-8, 169, 232, 247 art in, 18-19, 23, 24 colonies of, 60, 61, 77, 103, 109, 145, 167, 223, 261, 269, 320–22, 346, 374, 385 Constitutions of, see Constitution culture of reproduction in, 95-6 education in, 55-6, 59, 68, 168, 232, 323, 324, 342-3 industry in, 60, 64, 167-8 literature in, 59, 67 modernization of, 249, 321 Napoleonic wars in, see Peninsular War nationalism in, 48, 49, 266 Spell, The, 152, 154, 154 Spinners, The (Velázquez), 233 Spring or The Flower Gatherers, 91, 92 Squillaci, Leopoldo de Gregorio, marquis de, see Esquilache, Leopoldo Gregorio, marqués de Steele, Richard, 66 Stein, Gertrude, 365 still lifes, 255-9

Still Life with Cardoon (Cotán), 256 toro quiebra rejones en la plaza de Stone Guest, The, 152 Madrid, 361, 362 Straw Man, The, 100, 101 27, 361 Strolling Players, The, 142 29, 361 Stubbs, George, 278 30 Pedro Romero matando a toro parado, Sueño de unos hombres que se nos comían, 196, 362-3, 362 196 33 La desgraciada muerte de Pepe Illo en la Sueños, see Disparates plaza de Madrid, 361, 362 Suerte de varas, 352, 353 38, 361 Sureda, Bartolomé, 179 39, 361 Surrealism, 11, 347, 383 Teba, Eugenio Palafox, count of, 230, 250 Swift, Jonathan, 139, 180 Terence, 26 Swing, The, 124-5 tertulias, 324 Symmons, Sarah, 162 theater, 47, 53, 117, 148, 151-3, 190 Third of May, 1808, 124, 226, 272, 275, 285, Talleyrand Perigord, Charles Maurice de, 308-9, 313-19, 315, 326, 331, 398 Thomas, Hugh, 167 tapestries, 8, 15, 22, 44-5, 74, 81-2, 83-95, Thorak, Josef, 308 Tiepolo, Giambattista, 10, 34, 35, 43, 71-4, 98, 100, 103, 106, 127, 130, 131, 134, 142, 149-51, 167, 208, 216, 367, 367 72, 73, 131, 171, 180, 212, 213 Tauromaquia, 97, 131, 133-4, 351-65, 393 Time, 348-9, 349, 374 publication of, 364 Titian, 22, 35, 88, 128, 147 Tauromaquia, plates: Tomlinson, Janis, 92, 98, 103, 161, 366 1 Módo con que los antiguos españoles Torred, Francisco de la, 401 cazaban los toros a caballo en el campo, Trafalgar, battle of, 247 355, 356 Treaty of Basel, 239 2 Otro modo de cazar a pie, 355-6, 356 Treaty of Fontainebleau, 247-8 Trienio Liberal, 327, 377-8 6 Los moros hacen otro capeo en plaza con su tuberculosis, 158, 241 albornoz, 357 Tudo, Pepita, 237, 241-2, 245, 389 7, 358 Turner, J. M. W., 317, 380 10 Carlo V lanceando un toro en la plaza Turpin, Ben, 218 Valladolid, 354-5, 354 Two Sicilies, Kingdom of the, 48 15, 363 Two Women at a Window (Murillo), 349 16, 363 18 "The daring of Martincho in the Uccello, Paolo, 310 Zaragoza bullring," 363 19 Otro locura suya en la misma plaza, Valdés, Juan Meléndez, 217 363-4, 364 van Gogh, Vincent, 127 20 Ligereza y atrevimiento de Juanito Vanvitelli, Luigi, 70 Apiñani en la plaza de Madrid, 363, Vayrac, abbé, 55 Vega, Antonio de, 106 21 Desgracias acaecidas en el tendido de la Velázquez, Diego, 18, 19, 23, 35, 37, 47, 92, plaza de Madrid, y muerte del alcalde de 96, 112, 120, 121, 128, 146, 177, 178, Torrejón, 360, 360, 365 226, 227, 233, 240, 278, 331, 344, 347, 22, 361 365, 393-4 23, 361 Venezuela, 61, 269, 320–21 24 El mismo Ceballos montado sobre otro Venus and Cupid (Velázquez), 240

Index · 429

Verdier, Baron, 275 Vernet, Joseph, 135 Veronese, Paolo, 34, 71 Villanueva, Juan de, 47, 69, 70, 149 Vinaza, conde de, 182 Virgil, 32, 77, 386 Voltaire, 11, 51, 52, 63, 66, 117, 238, 266

Walpole, Horace, 123, 151 Warhol, Andy, 308 War of Independence, see Peninsular War Water Carrier, The, 284, 284 watercolor, 179 Watteau, Antoine, 3, 22, 84, 90 Wedding, The, 102, 103, 130, 150 Wedgwood, Josiah, 23 Weiss, Guillermo, 390 Weiss, Isidro, 372 Weiss, Leocadia Zorilla de, 372, 376, 379, 388, 389-90, 401 Weiss, Rosario, 372, 390, 401 Wellington, Arthur Wellesley, duke of, 262, 263-4, 278-80, 279, 306, 325 "White Duchess," 161, 162-4 Wilson-Bareau, Juliet, 152

Winckelmann, Johann Joachim, 71, 72 witches, witcheraft, 329, 340, 367 in Black Paintings, 384–6, 386 in Caprichos, 11, 32, 153, 184, 201–6 paintings of, 126, 152–5, 152, 154, 155, 157 Witches in the Air, 154–5, 155, 298 Witches' Sabbath, The, 153–4, 154 Wright of Derby, Joseph, 374

Ximeno y Carrera, José, 179

Yard with Lunatics, 136, 138, 139–41 Young Ones, The, 348–50, 349 Yriarte, Charles, 19, 20, 359

Zaldivia, Pedro de, 216, 225–6, 226
Zamora, Antonio, 152
Zapata, Diego Mateo, 337, 338
Zapater, Martín, 27, 29, 32, 38, 81, 103, 105, 111, 116, 127, 145–6, 150, 240, 359
Zaragoza, Napoleonic wars in, 41, 110, 275–7, 280–83, 287–9
Zorilla de Velasco, Dr., 332
Zurbarán, Francisco de, 167, 256, 256, 331

PHOTOGRAPHIC CREDITS

- Alinari/Art Resource, New York: 97 The Art Institute of Chicago: 226 (1993.1075), Photograph © The Art Institute of Chicago. All Rights Reserved
- Bibliothéque Nationale, Paris, France/ Roger-Viollet, Paris/Bridgeman Art Library: 327 (top)
- Bildarchiv Prenssischer Kulturbesitz, Berlin: 326, 395 (right)
- The Bowes Museum, Barnard Castle, County Durham, UK/Bridgeman Art Library: 138 (top)
- British Museum: 279 (left), 398 (top left) The Frick Collection, New York: 285
- Fundación Casa de Alba, Madrid: 158 (left)
- Fundación Lázaro Galdiano, Madrid: 154 (both)
- Gala–Salvador Dali Foundation/Artists Rights Society (ARS), New York, Photograph: Philadelphia Museum of Art: 384 (right) © 2003 Salvador Dali
- Giraudon/Art Resource, New York: 125, 265, 350
- The Hispanic Society of America, New York: 80 (right), 163, 395 (left)
- The J. Paul Getty Museum, Los Angeles, 353
- Erich Lessing/Art Resource, New York: 284, 382
- Marqués de la Romana Collection: 218, 220,
- The Metropolitan Museum of Art: 114
 (right), The Jules Bache Collection,
 1949 (49.7.41), Photograph © 1994
 The Metropolitan Museum of Art;
 129, Rogers Fund, 1906 (06.289),
 Photograph © 1994 The Metropolitan
 Museum of Art, New York, New York

- The Minneapolis Institute of Arts, The Ethel Morrison Van Derlip Fund: 375
- Musée des Beaux-Arts et d'Archéologie, Besançon, France: 222, Photograph: Charles Choffet, Besançon
- Musée GOYA-Cliché J. CI. Ouradou: 347 Museo de l'Almodí de Xàtiva (Spain): 345 (right)
- Museo Nacional del Prado, Madrid: 14, 15, 22, 45, 53, 54, 73 (left), 79, 85, 87, 89, 90, 91 (both), 93, 94, 95, 99, 101, 102 (bottom), 121, 155, 158 (right), 161 (right), 166, 173 (both), 183, 185 (both), 187 (both), 189 (both), 190, 192 (both), 194, 195 (both), 196 (both), 197 (both), 198, 200 (all), 204 (both), 205 (both), 207, 228, 233, 236, 240, 241, 244, 257, 258, 270 (both), 276, 277, 286, 289, 291 (top), 294 (both), 299, 311, 315, 318, 337, 338, 339 (both), 343, 354, 356 (both), 357, 360, 361, 362 (both), 364 (both), 368, 369 (both), 370 (both), 371, 380, 381, 384 (left), 386, 386-7, 387 (bottom), 399, 402. All Rights Reserved
- Museo Thyssen-Bornemisza, Madrid: 210 Museu de Arte de São Paolo Assis Chateaubriand, Brazil: 330, Photograph: Luiz Hossaka
- Museum of Fine Arts, Boston: 174 (right),
 Catalogue Raisonné: Gassier I, no. 68,
 Museum of Fine Arts, Boston, Ernest
 Wadsworth Longfellow Fund;
 63.984b, © 2003 Museum of Fine
 Arts, Boston; 398 (right), Catalogue
 Raisonné: Gassier I, no. 390, Museum
 of Fine Arts, Boston, Arthur Cabot
 Fund; 53.2377, © 2003 Museum of
 Fine Arts, Boston

The Museum of the Royal Academy of San Fernando, Madrid: frontis, 246, 334, 336

National Gallery, London: 152

National Gallery of Art, Washington, D.C.: 73 (right), 96, 113, 392, 397 (left), © 2003 Board of Trustees; 274 (bottom), 287, 291 (bottom), 293, 296 (both), 298 (bottom), 300, 301 (both), 302, 303 (both), Rosenwald Collection, Image © 2003 Board of Trustees

The National Museum of Fine Arts, Stockholm: 271, 394

Oronoz fotografós: 28, 36 39, 42, 43, 50, 62, 72, 75, 80 (left), 114 (left), 119, 123, 133 (right), 135, 136, 138 (bottom), 148, 150, 161 (left), 211, 214, 256

(bottom), 274 (both), 298 (top), 305, 327 (bottom), 341, 345 (left), 377

Patrimonio Nacional: 147, 281 (both) Réunion des Musées Nationaux/Art Resource, New York: 165, 349 (both), 396

San Francisco el Grande, Madrid: 104 Scala/Art Resource, New York: 107, 112, 256 (top)

Szépművészeti Muzeum, Budapest: 285 (right)

Sotheby's Picture Library: 133 (left) The State Hermitage Museum, St. Petersburg, Russia: 70 V & A Picture Library: 279 (right)

Picture researcher: Karen Broderick

A NOTE ABOUT THE AUTHOR

Robert Hughes was born in Australia in 1938. Since 1970 he has lived and worked in the United States, where until 2001 he was chief art critic for *Time*, to which he still contributes. His books include *The Shock of the New, The Fatal Shore, Nothing If Not Critical, Barcelona, The Culture of Complaint, American Visions*, and most recently his memoir, *Things I Didn't Know*. He is the recipient of a number of awards and prizes for his work.

. . .